THE LIBRARY OF LIVING PHILOSOPHERS

THE PHILOSOPHY OF

A.J. AYER

THE LIBRARY OF LIVING PHILOSOPHERS

PAUL ARTHUR SCHILPP, FOUNDER AND EDITOR 1939–1981
LEWIS EDWIN HAHN, EDITOR 1981–

Paul Arthur Schilpp, Editor
THE PHILOSOPHY OF JOHN DEWEY (1939, 1971, 1989)
THE PHILOSOPHY OF GEORGE SANTAYANA (1940, 1951)
THE PHILOSOPHY OF ALFRED NORTH WHITEHEAD (1941, 1951)
THE PHILOSOPHY OF G. E. MOORE (1942, 1971)
THE PHILOSOPHY OF BERTRAND RUSSELL (1944, 1971)
THE PHILOSOPHY OF ERNST CASSIRER (1949)
ALBERT EINSTEIN: PHILOSOPHER-SCIENTIST (1949, 1970)
THE PHILOSOPHY OF SARVEPALLI RADHAKRISHNAN (1952)
THE PHILOSOPHY OF KARL JASPERS (1957; aug. ed., 1981)
THE PHILOSOPHY OF C. D. BROAD (1959)
THE PHILOSOPHY OF RUDOLF CARNAP (1963)
THE PHILOSOPHY OF C. I. LEWIS (1968)
THE PHILOSOPHY OF KARL POPPER (1974)
THE PHILOSOPHY OF BRAND BLANSHARD (1980)
THE PHILOSOPHY OF JEAN-PAUL SARTRE (1981)

Paul Arthur Schilpp and Maurice Friedman, Editors
THE PHILOSOPHY OF MARTIN BUBER (1967)

Paul Arthur Schilpp and Lewis Edwin Hahn, Editors
THE PHILOSOPHY OF GABRIEL MARCEL (1984)
THE PHILOSOPHY OF W. V. QUINE (1986)
THE PHILOSOPHY OF GEORG HENRIK von WRIGHT (1989)

Lewis Edwin Hahn, Editor
THE PHILOSOPHY OF CHARLES HARTSHORNE (1991)
THE PHILOSOPHY OF A. J. AYER (1992)

In Preparation:

Lewis Edwin Hahn, Editor
THE PHILOSOPHY OF PAUL RICOEUR
THE PHILOSOPHY OF HANS-GEORG GADAMER
THE PHILOSOPHY OF PAUL WEISS
THE PHILOSOPHY OF DONALD DAVIDSON
THE PHILOSOPHY OF RODERICK M. CHISHOLM
THE PHILOSOPHY OF SIR PETER F. STRAWSON
THE PHILOSOPHY OF THOMAS S. KUHN
THE PHILOSOPHY OF JÜRGEN HABERMAS
THE PHILOSOPHY OF SEYYED HOSSEIN NASR

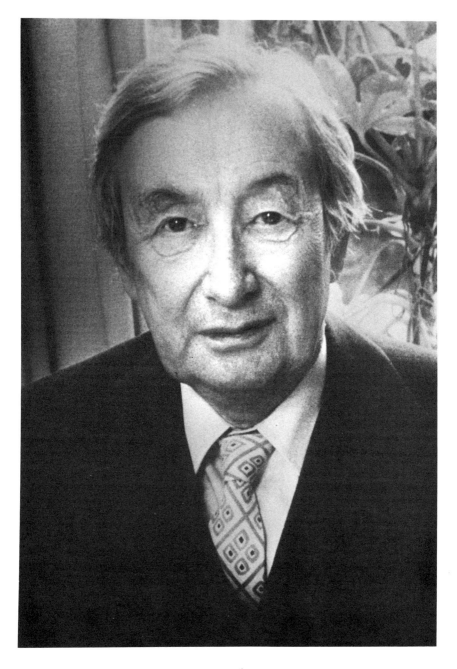

A. J. Ayer

THE LIBRARY OF LIVING PHILOSOPHERS
VOLUME XXI

THE PHILOSOPHY OF
A.J. AYER

EDITED BY

LEWIS EDWIN HAHN
SOUTHERN ILLINOIS UNIVERSITY AT CARBONDALE

LA SALLE, ILLINOIS • OPEN COURT • ESTABLISHED 1887

B
1618
$.A94$
$P45$
1992

 THE PHILOSOPHY OF A.J. AYER

Copyright © 1992 by The Library of Living Philosophers

First printing 1992
Second printing 1993

Printed and bound in the United States of America.

Library of Congress Cataloging-in-Publication Data

The Philosophy of A.J. Ayer/edited by Lewis Edwin Hahn.
 p. cm.—(Library of living philosophers; v. 21)
 Includes bibliographical references and index.
 ISBN 0-8126-9172-5 (hard).—ISBN 0-8126-9173-3 (pbk.)
 1. Ayer, A. J. (Alfred Jules), 1910– . I. Hahn, Lewis E.
II. Series.
B1618.A94P45 1992
192—dc20 92-6249
 CIP

The Library of Living Philosophers is published under the sponsorship of Southern Illinois University at Carbondale.

INTRODUCTION

Founded in 1938 by Professor Paul Arthur Schilpp and edited by him until July 1981, when the present writer became editor, the Library of Living Philosophers is devoted to critical analysis and discussion of some of the world's greatest living philosophers. The format for the series provides for setting up in each volume a dialogue between the critics and the great philosopher. The aim is not refutation or confrontation but rather fruitful joining of issues and improved understanding of the positions and issues involved. That is, the goal is not overcoming those who differ from us philosophically but interacting creatively with them.

The underlying conception of the Library, however, is admirably summarized in Professor Schilpp's general introduction as it appeared year after year in earlier volumes from the first one on John Dewey through the one on G.H. von Wright; and in view of its historical importance we are reprinting his account immediately after this introduction. As he notes in it, the basic idea for the series came from the late F.C.S. Schiller, who declared in his essay on "Must Philosophers Disagree?" (In *Must Philosophers Disagree?* London: Macmillan, 1934) that the greatest obstacle to fruitful discussion in philosophy is "the curious etiquette which apparently taboos the asking of questions about a philosopher's meaning while he is alive." The "interminable controversies which fill the histories of philosophy," in Schiller's opinion, "could have been ended at once by asking the living philosophers a few searching questions." And while he may have been overly optimistic about ending "interminable controversies" in this way, it seems clear that directing searching questions to great philosophers about what they really mean or how they think certain difficulties in their philosophy can be resolved while they are still alive can produce more comprehensible understanding and more fruitful philosophizing than might otherwise be had.

And to Paul Arthur Schilpp's undying credit, he acted on this basic thought in launching in 1938 the Library of Living Philosophers. It is planned that each volume in the Library of Living Philosophers shall include preferably an intellectual autobiography by the principal philoso-

pher or an authorized biography as well as a bibliography of that thinker's publications, a series of expository and critical essays written by a wide range of leading exponents and opponents of the philosopher's thought, and the philosopher's replies to the interpretations and queries in these articles. The intellectual autobiographies usually shed light on both how the philosophies of the great thinkers developed and the major philosophical movements and issues of their time; and many of our great philosophers seek to orient their outlook not merely to their contemporaries but also to what they find most important in earlier philosophers. The bibliography will help provide ready access to the featured scholar's writings and thought.

With this format in mind, the Library expects to publish at more or less regular intervals a volume on one of the world's greater living philosophers.

In accordance with past practice, the editor has deemed it desirable to secure the services of an Advisory Board of philosophers to aid him in the selection of subjects of future volumes. The names of nine prominent philosophers who have agreed to serve appear on the page following the Founder's General Introduction. To each of them the editor is most grateful.

Future volumes in this series will appear in as rapid succession as is feasible in view of the scholarly nature of this Library. It is planned that the next volume in the series will be devoted to the philosophy of Paul Ricoeur.

Volumes are also projected on H.G. Gadamer, Paul Weiss, Roderick M. Chisholm, Donald Davidson, Peter F. Strawson, Thomas S. Kuhn, Jürgen Habermas, and Seyyed Hossein Nasr.

Throughout its career, since its founding in 1938, the Library of Living Philosophers, because of its scholarly nature, has never been self-supporting. We acknowledge gratefully that the generosity of the Edward C. Hegeler Foundation has made possible the publication of many volumes, but for support of future volumes additional funds are needed. On 20 February 1979 the Board of Trustees of Southern Illinois University contractually assumed sponsorship of the Library, which is therefore no longer separately incorporated. Gifts specifically designated for the Library, however, may be made through the Southern Illinois University Foundation, and inasmuch as the latter is a tax-exempt institution, such gifts are tax-deductible.

LEWIS E. HAHN
EDITOR

DEPARTMENT OF PHILOSOPHY
SOUTHERN ILLINOIS UNIVERSITY AT CARBONDALE

FOUNDER'S GENERAL INTRODUCTION*
TO
THE LIBRARY OF LIVING PHILOSOPHERS

According to the late F. C. S. Schiller, the greatest obstacle to fruitful discussion in philosophy is "the curious etiquette which apparently taboos the asking of questions about a philosopher's meaning while he is alive." The "interminable controversies which fill the histories of philosophy", he goes on to say, "could have been ended at once by asking the living philosophers a few searching questions."

The confident optimism of this last remark undoubtedly goes too far. Living thinkers have often been asked "a few searching questions", but their answers have not stopped "interminable controversies" about their real meaning. It is nonetheless true that there would be far greater clarity of understanding than is now often the case if more such searching questions had been directed to great thinkers while they were still alive.

This, at any rate, is the basic thought behind the present undertaking. The volumes of the Library of Living Philosophers can in no sense take the place of the major writings of great and original thinkers. Students who would know the philosophies of such men as John Dewey, George Santayana, Alfred North Whitehead, G. E. Moore, Bertrand Russell, Ernst Cassirer, Karl Jaspers, Rudolf Carnap, Martin Buber, et al., will still need to read the writings of these men. There is no substitute for first-hand contact with the original thought of the philosopher himself. Least of all does this Library pretend to be such a substitute. The Library in fact will spare neither effort nor expense in offering to the student the best possible guide to the published writings of a given thinker. We shall attempt to meet this aim by providing at the end of each volume in our series as nearly complete a bibliography of the published work of the philosopher in question as possible. Nor should one overlook the fact that essays in each volume cannot but finally lead to this same goal. The interpretative and critical discussions of the various phases of a great thinker's work and, most of all, the reply of the thinker himself, are bound to lead the reader to the works of the philosopher himself.

*This General Introduction sets forth in the founder's words the underlying conception of the Library. L.E.H.

At the same time, there is no denying that different experts find different ideas in the writings of the same philosopher. This is as true of the appreciative interpreter and grateful disciple as it is of the critical opponent. Nor can it be denied that such differences of reading and of interpretation on the part of other experts often leave the neophyte aghast before the whole maze of widely varying and even opposing interpretations. Who is right and whose interpretation shall he accept? When the doctors disagree among themselves, what is the poor student to do? If, in desperation, he decides that all of the interpreters are probably wrong and that the only thing for him to do is to go back to the original writings of the philosopher himself and then make his own decision— uninfluenced (as if this were possible) by the interpretation of anyone else—the result is not that he has actually come to the meaning of the original philosopher himself, but rather that he has set up one more interpretation, which may differ to a greater or lesser degree from the interpretations already existing. It is clear that in this direction lies chaos, just the kind of chaos which Schiller has so graphically and inimitably described.[1]

It is curious that until now no way of escaping this difficulty has been seriously considered. It has not occurred to students of philosophy that one effective way of meeting the problem at least partially is to put these varying interpretations and critiques before the philosopher while he is still alive and to ask him to act at one and the same time as both defendant and judge. If the world's greatest living philosophers can be induced to cooperate in an enterprise whereby their own work can, at least to some extent, be saved from becoming merely "desiccated lecture-fodder", which on the one hand "provides innocuous sustenance for ruminant professors", and on the other hand gives an opportunity to such ruminants and their understudies to "speculate safely, endlessly, and fruitlessly, about what a philosopher must have meant" (Schiller), they will have taken a long step toward making their intentions more clearly comprehensible.

With this in mind, the Library of Living Philosophers expects to publish at more or less regular intervals a volume on each of the greater among the world's living philosophers. In each case it will be the purpose of the editor of the Library to bring together in the volume the interpretations and criticisms of a wide range of that particular thinker's scholarly contemporaries, each of whom will be given a free hand to discuss the specific phase of the thinker's work that has been assigned to

1. In his essay "Must Philosophers Disagree?" in the volume of the same title (London: Macmillan, 1934), from which the above quotations were taken.

him. All contributed essays will finally be submitted to the philosopher with whose work and thought they are concerned, for his careful perusal and reply. And, although it would be expecting too much to imagine that the philosopher's reply will be able to stop all differences of interpretation and of critique, this should at least serve the purpose of stopping certain of the grosser and more general kinds of misinterpretations. If no further gain than this were to come from the present and projected volumes of this Library, it would seem to be fully justified.

In carrying out this principal purpose of the Library, the editor announces that (as far as is humanly possible) each volume will contain the following elements:

First, an intellectual autobiography of the thinker whenever this can be secured; in any case an authoritative and authorized biography;

Second, a series of expository and critical articles written by the leading exponents and opponents of the philosopher's thought;

Third, the reply to the critics and commentators by the philosopher himself; and

Fourth, a bibliography of writings of the philosopher to provide a ready instrument to give access to his writings and thought.

<div align="right">

PAUL ARTHUR SCHILPP
FOUNDER AND EDITOR, 1939–1981
</div>

DEPARTMENT OF PHILOSOPHY
SOUTHERN ILLINOIS UNIVERSITY AT CARBONDALE

ADVISORY BOARD

ACKNOWLEDGMENTS

The editor hereby gratefully acknowledges his obligation and sincere gratitude to all the publishers of A.J. Ayer's books and publications for their kind and uniform courtesy in permitting us to quote—sometimes at some length—from Professor Ayer.

LEWIS E. HAHN

*Deceased.
#Added to the Board after the subject of this volume was chosen.

TABLE OF CONTENTS

PREFACE

Sir Alfred Ayer's *Language, Truth and Logic*, which, as he tells us in his Intellectual Autobiography, he finished writing in July 1935, is arguably the most influential single book written by a philosopher in this century. It served as a handbook for the Logical Positivists and brought vigorous negative reactions from a host of other writers. No one of his other writings or special addresses created quite the stir that this volume did; but he also wrote or edited fifteen or twenty other important volumes, sufficient to win for him unusual distinction and numerous honors. For example, he gave the Gifford Lectures at Saint Andrews, the William James Lectures at Harvard, and the John Dewey Lectures at Columbia University.

He served three years as President of the International Institute of Philosophy, was decorated Knight Bachelor by Great Britain, was a Fellow of the British Academy, and held the French Chevalier de la Legion d'Honneur and the Bulgarian award of the Order of Cyril and Methodius first class. He taught for years at the University of London and Oxford University with visiting appointments at New York University and City College of New York, among others.

Partly because of his publications, he was a prominent figure at international philosophical meetings for more than fifty years. He traveled widely, and he spoke to an unusually wide range of audiences in Russia, Bulgaria, China, South America, North America, and other parts of the world. His was a lively and nimble mind, and he obviously enjoyed the give and take of a philosophical discussion. As Professor Elizabeth R. Eames, one of his critics in this volume, put it: "Since 1935 Ayer's writings on philosophical topics have represented a clarity of expression, a sense of the history of contemporary problems, and an awareness of current philosophical alternatives which are rare in the literature of analytic philosophy in the last half century."

Not merely, moreover, was Sir Alfred a person who communicated with elegant grace and clarity with other professional philosophers, he was for many years on various panels for the British Broadcasting Company and was very well received. He was also invited to speak at high level government sessions in different parts of the world. Among others, as we learn from his Intellectual Autobiography, President John Kennedy invited him to talk on the nature of philosophy at one of the series of seminars which members of his family and his cabinet were expected to attend.

Sir Alfred was a highly articulate, urbane philosopher with broad interests in the arts and sciences; and we were delighted to have him on our campus in November 1987 to confer concerning progress of this volume and to deliver an honors address on "Society and Government," for which he drew upon his then forthcoming book on *Thomas Paine*. In 1989, moreover, we were happily anticipating another visit by him in the fall when he was to be back at Bard College once again. But, of course, these plans were frustrated by his death on 27 June 1989.

Fortunately, however, he had completed virtually all of his work for *The Philosophy of A.J. Ayer*. His Intellectual Autobiography had been in since July 1986, and he had replied to all but three of the twenty-four critical essays. His assistant, Guida Crowley, still had some work to complete his Bibliography; but in one of his last letters to me he indicated that it was near completion and that he thought I would be pleased with it.

I am grateful to Sir Alfred and all the other contributors for their co-operation in producing a lively and fruitful set of exchanges which illuminate his central theses in varying formulation.

I very much appreciate also the support, encouragement, and co-operation of our publisher, Open Court Publishing Company, particularly M. Blouke Carus, David R. Steele, Kerri Mommer, and Edward Roberts. And to the administration of Southern Illinois University I am most grateful for continued support and encouragement.

As always, moreover, my grateful appreciation goes to the staff of the Morris Library for help with references. My warm thanks also go to Sharon Grissom, Vernis Shownes, and the Philosophy Department secretariat for their assistance in many ways; and, of course, special thanks are due to Sharon Langrand for help with manuscripts and proofs and with keeping the lines of communication open.

Finally, I am deeply grateful for the warm support, intellectual

stimulation, and sage counsel of my colleagues, especially Elizabeth R. Eames, John Howie, Matthew J. Kelly, and G.K. Plochmann.

LEWIS EDWIN HAHN
EDITOR

DEPARTMENT OF PHILOSOPHY
SOUTHERN ILLINOIS UNIVERSITY AT CARBONDALE
SEPTEMBER 1991

PART ONE

INTELLECTUAL AUTOBIOGRAPHY OF A.J. AYER

I was born in London on 29ᵗʰ October 1910, the only child of parents neither of whom was of English origin. My grandfather, on my father's side, was Rector of the Academy of Neuchâtel in Switzerland where he simultaneously occupied the chairs of French, Geography and Economics. He was best known for his *Grammaire de la Langue Française*, which remained a standard work for many years. When he died, my father, in his nineteenth year, emigrated to Britain and eventually became a British citizen. After working in a bank and publishing a set of *Financial and Comparative Tables of the World's Statistics*, he secured a partnership in a firm of timber merchants, a business in which he took increasing interest. He wrote one or two plays but did not succeed in getting them produced. He died in 1923.

My mother, whose maiden name was Rosa Cilleron, belonged to a Jewish family who had established themselves as jewellers in Amsterdam. A branch of the family migrated to France and a cousin of my grandfather's, calling himself André Cilleron, founded the well-known firm of motor cars. After trading in France at Antwerp, where my mother was born in 1887, and prospecting for diamonds in South Africa, my grandfather, David Cilleron, also became a pioneer in the motor car industry. The cars which he manufactured were Minervas, luxurious cars which enjoyed a high reputation in the first quarter of this century.

MY MENTAL DEVELOPMENT

I was born in London on 29 October 1910, the only child of parents neither of whom was of English origin. My grandfather, on my father's side, was Rector of the Academy of Neuchatel in Switzerland, where he simultaneously occupied the chairs of French, Geography, and Economics. He was best known for his *Grammaire Comparée de la Langue Française*, which remained a standard work for many years. When he died in 1884, my father, in his seventeenth year, emigrated to England and eventually became a British citizen. After working in a bank and publishing a set of General and Comparative Tables of the World's Statistics, he secured a partnership in a firm of timber merchants, a business in which he took decreasing interest. He wrote one or two plays but did not succeed in getting them produced. He died in 1928.

My mother, whose maiden name was Reine Citroen, belonged to a Jewish family who had established themselves as jewellers in Amsterdam. A branch of the family migrated to France and a cousin of my grandfather's, calling himself André Citroën, founded the well-known firm of motor cars. After trading in fruit at Antwerp, where my mother was born in 1887, and prospecting for diamonds in South Africa, my grandfather, David Citroen, also became a pioneer in the motor car industry. The cars which he manufactured were Minervas, luxurious cars which enjoyed a high reputation in the first quarter of this century. With a partner in Belgium, he settled in England at around the turn of the century to promote the sale of Minervas there. In addition to his native Dutch, he spoke German, French, and English fluently and my mother and her siblings, two younger sisters, were brought up to speak English.

While his wife was Jewish, of Dutch extraction also but belonging to a family which had settled in England a generation earlier, and while he was in no manner ashamed of his Jewishness, my grandfather, an outspoken agnostic, was especially hostile to the Jewish religion. He

believed that their obstinate adherence to this religion, which preserved them as a separate community, was a principal factor in causing the Jews to suffer persecution. He therefore made sure that all his daughters married gentiles. He had five grandchildren, three boys and two girls, of whom I was the eldest by over two years. While he was a man of wide reading, with a strong interest in history, he attached what might have been thought excessive importance to worldly success. This put pressure on his grandsons, especially myself. It probably stimulated a competitive strain in me, which was very strong in my youth, though it has weakened with the passage of years. He was proud of my early academic achievements, such as they were, though I think that he was disappointed when I embarked on an academic career. He had hoped that I would become a second Disraeli. I wished to please him and it is a grief to me that he died in 1935, only a few months before the publication and favourable reception of my first book.

My father also had high hopes of me. He used to encourage me and comfort himself by repeating, not quite accurately, that the younger Pitt had become Prime Minister at the age of twenty-two. He was a milder man than his father-in-law and though I was fond of him, he had less influence over me. His mother, who lived to be nearly eighty, and one of his sisters had both settled in London and it was thanks to them that I spoke some French with a good accent as a child. I still speak French with a good accent, though the gaps in my French vocabulary discredit the claim that I occasionally make to be bilingual.

Though it is unlikely to have been the first book that I actually read, the first book that I remember reading is *Robinson Crusoe*. It caught my imagination less than the Uncle Remus stories of Joel Chandler Harris. I enjoyed books of adventure, most of which in those days had a strong jingoistic flavour and developed a precocious taste for the novels of Captain Marryat. From the age of about five I was an enthusiastic collector of postage stamps and cigarette cards. I fairly soon lost these interests though I started a new collection of cigarette cards when in my early twenties I myself became a serious smoker, a habit from which I was able to free myself only some six years ago. If I had preserved these early collections, I could sell them now at a high price, but in the matter of making money I belong rather to my father's than to my mother's side of my family.

Like other children, I was given a model railway set to play with and a series of Meccano sets, containing instructions which I conscientiously tried to implement, but usually failed. Apart from a fair ability to play games like lawn tennis, I have always been embarrassingly deficient in

manual skills. To this day, for example, I have never learned how to drive a motor car.

After attending one or two local day-schools of which I have no recollection, I was sent at the age of seven in the summer of 1918 to a boarding school at Eastbourne, a holiday resort on the south coast of England, and the locus of a number of private preparatory schools. Presumably the climate was thought to be healthy. Ascham St. Vincent's, the school which I attended, was typical of its class and period. It contained about seventy boys of whom I was the youngest when I came there. The upper age was normally thirteen. The proprietor and head-master was a clergyman who was reputed to have played Association Football for Cambridge University. There were four or five assistant masters and a matron. The school was housed in an ugly late Victorian building with a large playing field. The boys slept in dormitories and were adequately if plainly fed. Discipline was strict though the headmaster was not the sadist that many of his counterparts at other schools appear to have been. I was caned by him only once, though severely, for taking part in a dormitory rag. The worst feature of the school was the bullying of boys by one another, which the masters did hardly anything to check. It was more psychological than physical. For several terms I was the victim of xenophobia, surprisingly not because I was known to be partly Jewish but because I had confessed to being partly Swiss.

What parents expected as a return for the fees which they paid to such schools was that their boys be enabled to pass the entrance examinations into the private establishments which continue in England to be known as public schools. The teaching was therefore adapted to what the requirements of these public schools were known to be. This still meant a heavy concentration on the classics, a good grounding in mathematics for those, unlike myself, who were able to take advantage of it, some temperate instruction in the Anglican religion, a modicum of history, some very elementary French and next to no science. In fact I cannot remember being taught any science at all at Ascham, though I started learning Latin as soon as I went there at seven years of age. There was none of the ill-advised contemporary mistrust of formal teaching. We learned our conjugations, declensions, and irregular verbs by rote.

It was a credit to the school, contributing to its growth and to the income of the proprietor, if its pupils obtained scholarships, especially to the major public schools. Boys who appeared capable of reaching this standard were given special coaching in ancient Greek, on which I was launched at the age of eleven. It had been arbitrarily decided that I should proceed to Charterhouse but in the summer of 1923 a boy, a year

older than I, was thought good enough to try for a scholarship at Eton and I was taken along with him to keep him company and for my own part to acquire some practice in undergoing examinations of this type. To everyone's surprise at Ascham, including my own, I came third on the list of admissible candidates and was offered a scholarship at Eton. My companion also made his way on to the list but was ranked too low down to obtain a place in a year when relatively few scholars were admitted.

I was not particularly elated by my success. On the contrary I thought of Eton as a snobbish school in which I should be out of place and even put some pressure on my parents to decline the scholarship. We were, however, persuaded by my grandfather that becoming an Etonian would be a source of future advantages which it would be stupid of me to forego. On the whole, I think that he was right.

I entered Eton in September 1923, just over a month before my thirteenth birthday, and remained there until the beginning of the Easter holidays of 1929. The King's scholars, the king in question being Henry VI who had founded the school in 1440, were known as Collegers and were housed together apart from the other boys. Their number was kept at seventy, out of a total number of boys, at that time, of about eleven hundred. There had been a tendency for the other boys, known as Oppidans, to despise Collegers as their social inferiors, but in the nineteen twenties this was already ceasing to be the case. Certainly, I was never made aware of it. Except that our schoolwork was expected to maintain a higher standard, so that we were obliged to take it more seriously, our way of life in College was not markedly different from that which prevailed in the Oppidan houses. We played organized games just as strenuously and were subject to the same forms of discipline, the task of keeping order being chiefly entrusted to the senior boys who had the right to cane their juniors usually for quite trivial offences. I suffered this punishment several times but refused to inflict it when I was in a position to do so and indeed conducted an ineffective campaign against the whole practice, which I am glad to learn has now been discontinued at Eton and at other public schools.

I was not very happy at Eton mainly because I was unpopular with my seniors and contemporaries in college. I was not friendless but I had an unguarded tongue and a propensity for showing off which caused more offence than perhaps it merited, certainly more than I realized. Not that I had anything extraordinary to boast about. My schoolwork was competent but not outstanding. I enjoyed playing games but except possibly at tennis and in a specialized position at the Wall Game, a sport peculiar to Eton and even there not much played except by Collegers, my skills were not much above the average. In particular, the fantasy which I had

nourished since my early childhood of excelling at cricket never came at all near to being transmuted into fact. This did not destroy my enthusiasm for the game which endures until this day. I should perhaps remark at this point that throughout my life, since I was nine or ten years old, I have taken a very lively interest in nearly all forms of sport. For example, I have supported the same professional soccer team for over sixty-five years and still watch as many of their home matches as I conveniently can. Many people have found this incongruous with my being a philosopher and in some cases treated it as an affectation. They are quite mistaken. It may be the case that not many philosophers, or indeed academic persons of any calling, take a strong interest in sport; but this in no way implies that the exceptions are not straightforwardly sincere.

Traditionally, an Eton education was heavily biassed on the side of the classics, and this tradition was still maintained in my own time there. Not only did we painfully construe Virgil's *Georgics* and his *Aeneid* and the plays of Aeschylus, Sophocles, and Euripides, but we had to render pieces of English prose into Latin and Greek and very soon we were put on to verse. In our earliest days in college we were expected to master books of Homer's *Odyssey* in our spare time to a point where we knew them practically by heart. Mathematics was well taught to those who had a gift for it, which I was soon discovered to lack, and so was history, mainly English history, which I enjoyed. Modern languages were taught poorly and the sciences hardly at all.

The standard of music at Eton was high, but at that time my own taste did not rise above the musical comedies to which my parents took me in the holidays. I still have a vivid recollection of the popular tunes of the nineteen twenties and thirties. At the age of fifteen or so I toyed with the idea of going on the stage and went so far as to teach myself to tap dance, but I was never very skilful at it, and though I had quite a pleasant light tenor voice, this was offset by a tendency to sing out of tune. My taste for musical comedies extended to the film musicals of the nineteen forties and fifties, though not to the popular music of the present time. I advanced to an enduring love of opera, especially the works of Mozart, Verdi, and Rossini, in my early twenties but on the whole I cannot claim that music has played a dominant part in my life.

I was slow also in taking an interest in the visual arts. It was not until my eighteenth year when I went with my mother, after my father's death, to stay with her relations in Holland that visits to the Rijksmuseum in Amsterdam and the Mauritshuis in The Hague caused me to take a pleasure in seventeenth-century Dutch painting which I have never lost. For many years Vermeer was my favourite painter. My newly found interest in painting was further stimulated by the writings of Clive Bell,

and I soon took a delight in the work of the French Impressionists, especially Renoir. In the course of years my taste in painting has constantly broadened, so that it easily encompasses such diverse artists as El Greco, Cranach, Mantegna, Stubbs, Bonnard, and Hopper. It has not, however, progressed beyond Surrealism.

In my early years at Eton I preserved my taste for stories of adventure, devouring the works of the older Dumas in translation and those of such English writers as Sapper and John Buchan. I soon succumbed to P.G. Wodehouse, and gained a distorted view of life from the manly novels of Ian Hay and the short stories of Rudyard Kipling, in which I still see merit, as well as in his verse. Later on I acquired a strong appetite for humorous verse, especially the Bab Ballads of W.S. Gilbert and the fruit of A.P. Herbert's contributions to *Punch*. My taste in serious poetry was conventional, except perhaps for its including Andrew Marvell. Otherwise I chiefly admired Shelley, Tennyson, and Swinburne.

English literature was not much taught at Eton, but it was the custom at least in the junior divisions for books to be set as holiday tasks. Examinations were held on them when we returned to school and prizes awarded. The books were invariably selected from the plays of Shakespeare and the novels of Walter Scott, in alternate holidays. Though I read them conscientiously, I never gained much pleasure from any of Scott's novels, but I at once became a devotee of Shakespeare, winning the prize for the examination on the set play more than once. My favourites were *Twelfth Night*, *As You Like It*, and *Macbeth*. I think that I read nearly all the plays of Shakespeare before I saw one of them acted, though later I had the pleasure of seeing John Gielgud's *Hamlet* and Paul Robeson's *Othello*. At school my predilection for Shakespeare's plays extended to his sonnets, several of which I knew by heart.

As I grew older, I took to reading Bernard Shaw and H.G. Wells. I suppose that Shaw's *The Intelligent Woman's Guide to Socialism and Capitalism*, which I read when I was seventeen, was my introduction to political theory. If it did not immediately turn me into a Socialist, it set me on a radical course from which I have never deviated.

In my last years at school, my favourite authors were Aldous Huxley and Lytton Strachey. I still have a vivid recollection of Huxley's early novels, *Crome Yellow*, *Antic Hay*, *Those Barren Leaves*, and *Point Counterpoint*, though it is a long time since I reread them, and still occasionally divert myself with the works of Lytton Strachey, especially his brilliant *Portraits in Miniature*.

I have said that I was instructed in the Anglican religion at my preparatory school. This did not go much further than attendance at the school chapel on Sundays. At Eton there was a daily morning service in the school chapel, fairly short on weekdays, and long on Sundays,

evensong in the chapel on Sundays, and evening prayers every day in College and Oppidan houses. Participation in these ceremonies was compulsory except that Roman Catholics, for whom separate provision was made, were excused attendance at chapel. I cannot remember whether the same privilege was extended to non-conformists or orthodox Jews. They too, I think, would have been required, like the rest of us, to write an essay every Sunday in their own time on some set religious topic. These exercises, known as Sunday questions, were beneficial not only, or even primarily, as improving our understanding of the Christian religion, but as making us familiar with the authorized version of the English translation of the Old and New Testaments, a prerequisite to the understanding of much of English literature.

I had been baptised into the Church of England and at the age of fifteen underwent confirmation. I had never given much thought to religion, but yielded to the pressure put upon me by the master in college and to a lesser extent by my parents. Not that my parents were religious, though my mother, a nominal convert to Christianity, was at least a deist, but they wished me to conform to what they took to be a common practice. I took communion two or three times and then began to ask myself what the performance implied. It was not long before I decided that not only the theory of the Eucharist, but the doctrine of the Trinity, the assumption that Jesus had been divine, and indeed the hypothesis that the universe had been divinely created were all intellectually untenable. I became a militant atheist and annoyed my school fellows, who took little interest in the subject, by haranguing them about such things as the contradictions in the Book of Genesis and the inconsistencies in the Gospels. I did not disguise my views in my replies to Sunday questions, but this did not make trouble for me with the masters who read them, least of all with the headmaster Dr. C.A. Alington, who was himself a clergyman. He insisted on my continuing to attend chapel services as a matter of school discipline, but so far from attempting to put obstacles in the way of my disbelief, drew my attention to books which would provide me with arguments to support it. But for him, I might never have discovered W.E.H. Lecky's *History of European Morals from Augustus to Charlemagne*, first published in 1869, and still as good an exposition as I know of the historical evils attendant on the early growth of Christianity.

I should add at this point that in the sixty years since I first became an atheist, I have never yet discovered any good reason to believe in the existence of a deity.

My lack of religious belief did not prevent me from gaining a mark of distinction for my paper on Divinity which was one of the subjects that I took in the examination for what was then called the School Certificate,

for which I entered at the age of fifteen. I gained distinctions also in Latin, Greek, French, English, History, and Mathematics, failing only in Higher Mathematics. My incompetence in mathematics, once it ceases to be elementary has, I think, been a handicap to me as a philosopher.

General education came to a stop at Eton with the obtaining of one's School Certificate. After that one was obliged to specialize. The subject that most attracted me was history, but I needed to win a scholarship if I was to go on to Oxford or Cambridge, and I was advised that my chances would be better, mainly because there would be less competition, if I specialized in classics. Accordingly, for the next three years I concentrated almost exclusively on Latin and Greek, becoming well read in the literature of both ancient languages, and acquiring some mechanical skill in composing Greek and Latin prose and verse. My concern with the works I read was predominantly but not wholly philological. I read some plays of Euripides for pleasure, as well as the poems of Catullus and the Greek Anthology.

I was not an outstanding classical scholar, but I was well enough trained to be elected by Christ Church, Oxford to the first of its open classical scholarships in the winter of 1928–29. I was able to supplement the income which this brought me by a leaving scholarship from Eton which I had obtained in the previous summer in an examination open to specialists in all subjects. I came second to a modern linguist.

At that time members of the top classical form had the advantage of being taught not only by Dr. Alington but by two remarkable young masters: Jack McDougall, who remained with us only a short time before joining a firm of publishers, and Richard Martineau, who came straight back from Cambridge, having been Head Boy at Eton when I first went there. His leaving present to me, F.L. Lucas's short book on *Tragedy*, made a lasting impression on me.

One or other of them, most probably Jack McDougall, took us outside our classical syllabus by devoting a weekly period to the pre-Socratic philosophers. I found these lessons fascinating, though, as it happened, I never delved much further into this branch of philosophy, apart from a persistent interest in Zeno's paradoxes. I still think that if there is to be any teaching of philosophy in schools, it should be done in this way, not made a subject for examination, but allowing a master to communicate his own interest in some aspect of it, taking his pupils on a holiday from their curriculum.

My own interest in philosophy had already been awakened as an indirect consequence of my late development of some sensitivity to painting. As an introduction to aesthetics I bought and read Clive Bell's *Art*, first published in 1914 though I did not discover it until 1928. The

book retains a historical interest through its championship of Clive Bell's and Roger Fry's concept of 'significant form', a concept that was never adequately defined, or even explained, but one that rendered service to its inventors in their rejection of a representational assessment of visual art. If I ever succumbed to their argument, I have long ceased to do so, but it was anyhow not on this account that the book was important to me. What made it so was Bell's inclusion of a chapter on Art and Ethics in which he asserted that 'good' is an indefinable quality and advised any of his readers who wanted a proof of this assertion to procure a copy of G.E. Moore's *Principia Ethica*. I took his advice and, like the members of the Bloomsbury circle when the book was first published in 1903, swallowed Moore whole. It was not until my second year at Oxford that I began to doubt whether 'good' was a simple indefinable non-natural quality or whether the rightness of an action entirely depended on the goodness of its consequences.

There is no reference to Bertrand Russell in Moore's *Principia Ethica* so that it must have been on my own initiative that I bought and read Russell's *Sceptical Essays*, when it was published in 1928. The opening sentence of this book has served me as a motto throughout my philosophical career. It runs:

> I wish to propose for the reader's favourable consideration a doctrine which may, I fear, appear wildly paradoxical and subversive. The doctrine in question is this: that it is undesirable to believe a proposition when there is no ground whatever for supposing it true.

I left Eton at the end of the Easter half in 1929 and passed most of the summer at Santander in Spain, taking lessons in Spanish from the householder with whose family I boarded and attending a summer school run by a professor of Liverpool University. In preparation for the work I knew that I should have to do at Oxford I took with me a copy, which I still possess, of Adam's edition of Plato's *Republic*. Judging by my annotations of the text, I appear to have got no further than a quarter of the way through it, but my detailed and disrespectful criticisms of the arguments of the first book still seem to me creditable for a beginner. It was at Santander that I attained my peak as a tennis player, reaching the semifinals of what was in fact a modest tournament but one that bore the grandiloquent title of the Championship of Northern Spain. In the following year, when I entered for the Freshmen's tournament at Oxford I was defeated in the first round. I found it very easy to acquire a smattering of Spanish but did not take the trouble to master the language thoroughly.

The classics course at Oxford normally took four years, the first five of the twelve terms being devoted to Honour Moderations, an intensifica-

tion of the kind of work that one had done at school and the remaining seven to Literae Humaniores or Greats, devoted to Philosophy and Ancient History. I had tired of the classics and obtained leave from my college to reduce the four to three, taking a preliminary examination, requiring some acquaintance with the Annals of Tacitus and Aristotle's ethics, at the end of my first term, and gaining an extra term for reading Greats. The tutorial system was in force, perhaps to an even greater extent than it is now. From the beginning I was taught singly, and went for an hour's tutorial every week, once in philosophy, and once in ancient history, coming with a written essay on each occasion. Attendance at lectures was voluntary, as it still is, and I rarely attended them. An important exception was a preview of H.H. Price's book *Perception*, delivered in the form of lectures in 1932. This book has fallen out of fashion but it brought some Cambridge freshness into the stale philosophical climate of Oxford and I consider it a landmark in the development of its subject.

My Christ Church tutors were Gilbert Ryle and Michael Foster for philosophy, Robert Longden for Roman history, and Robin Dundas for Greek history. Because I perversely took the unfashionable option of reading the later period of Greek history, covering the fourth century B.C., which Dundas was not equipped to teach, I was taught Greek history also by 'Tom Brown' Stevens, a learned eccentric who was later to become one of the most distinguished Fellows of Magdalen. I believe that I was his first pupil and he took immense trouble over me.

Philosophically, I owed a great debt to Gilbert Ryle. Indeed, it was his appreciation of the essays I wrote for him and of my resourcefulness in our discussions that first made me think that I might have an aptitude for philosophy. He was ten years older than I, just young enough to have escaped service in the First World War. He was one of the few Oxford philosophers of that time to take any positive interest in the work of contemporary philosophers outside Oxford. At the start of his career he had been captivated by the Austrian and German school of Phenomenologists, notably Brentano, Meinong, and Husserl. He had even ventured into Existentialism, writing a not unfriendly review in *Mind* of Heidegger's *Sein und Zeit*. By 1929, when I became his pupil, he had decided that he was being led into a blind alley and was turning his sights upon Cambridge, being most strongly impressed by Russell's distinction between logical and grammatical form, evinced in Russell's Theory of Descriptions and his Theory of Types. Ryle's article "Systematically Misleading Expressions" which he published in the *Proceedings of the Aristotelian Society* for 1932 clearly showed the new direction which his thought was taking. A tutor whose merit lay less in dominating

his pupils than in knowing how to guide them, he introduced me to Russell's books and also to the work of the Cambridge philosopher C.D. Broad. I remember writing essays for him on Broad's *Scientific Thought* and *The Mind and Its Place in Nature.*

I had less respect for Michael Foster, either personally or professionally. He was a shy, awkward man who found it difficult to communicate with his pupils. He was, however, a good historian of philosophy, within rather narrow limits, and I am indebted to him for such understanding as I achieved of the complexities of Kant's *Critique of Pure Reason.*

Though I took my work seriously, I had abundant leisure and led a full social life. My closest friend was Andrew Wordsworth, who had won an open classical scholarship from Marlborough to Christ Church, and like me had proceeded directly to Greats. He was more widely read than I, outside the classics, and introduced me not only to such contemporary writers as James Joyce, D.H. Lawrence, and Marcel Proust, but also to the novels of Thomas Love Peacock, for which I have retained a lasting affection. It was through Andrew that I came to know Maurice Bowra, then Dean and subsequently Warden of Wadham, a man at that time in his early thirties, a generous host and brilliant talker, who had a very strong influence on all the undergraduates of my generation who had the good fortune to enjoy his patronage.

I joined the Poetry Society in my first term at Oxford and remember being vastly impressed by a speech delivered by Louis MacNeice, then in his final year. Of the group with which he has always been associated, Auden and Day Lewis had already left Oxford, but I overlapped with Stephen Spender, who remains my friend. Although I did not meet either of them until several years later it was at this time also that I acquired a taste for the poems of William Empson and the early poems of T.S. Eliot. My taste extended to French poetry of the nineteenth and early twentieth centuries. Verlaine was and still is my favourite, but I also admired Baudelaire, Mallarmé, and Valery. In the field of classical French poetry I came greatly to enjoy Racine.

In general, I read at least as much French as English literature. I felt great enthusiasm for Stendhal, embracing his treatise *De l'Amour* as well as the famous novels, *Le Rouge et le Noir* and *La Chatreuse de Parme.* I read a great deal of Balzac, especially admiring *Le père Goriot* and *La Cousine Bette.* Among contemporary writers I discovered Malraux and Céline as well as Proust.

My francophilia extended to films. Talking films had just come into fashion and René Clair was my favourite director. I still think *Sous les tois de Paris, Le Million,* and *A Nous la Liberté* three of the best films ever made. I went on to admire the French films of the 1930s with such

directors as Marcel Carné and actors like Jean Gabin. In my undergraduate days at Oxford there was still a cinema that showed silent films and this enabled me to see and admire the work of the Russian directors Eisenstein and Pudovkin and that of the German expressionists, in which my favourite actor was the young Conrad Veidt. I was also entranced by the early German talking films, especially of course *The Blue Angel* with Emil Jannings and Marlene Dietrich, but also the comedies of the early nineteen thirties, usually featuring Lilian Harvey.

It was not long before I succumbed to Hollywood. My taste was very catholic. I enjoyed westerns, comedies, gangster films, and musicals throughout the next decade and still have a vivid recollection of many of them. My love of films outlasted the war and while it has diminished in more recent years I still regard it as an important factor in my life.

My addiction to the cinema reinforced, rather than replaced, my love of the theatre, but it at no time revived my juvenile ambition to go on the stage. I joined the Oxford University Dramatic Society, but used its premises merely as a club. I never volunteered to take even the humblest part in any of its productions.

In common with most of my undergraduate contemporaries, I took little interest in politics. Nevertheless I joined the Oxford Union and spoke in several debates in the course of my first year. I was nervous, spoke much too fast, and after a conspicuous failure as one of the principal speakers at the end of my first summer term never again attempted to speak there. At that time I called myself a Liberal. This did not prevent me from being secretary of the Conservative Canning Club, but this was a purely social commitment, on a level with my membership of the White Rose Society, where one meeting to drink the health of the King over the Water did not imply any genuine allegiance to the Jacobite cause.

An office which I did take seriously was my secretaryship of the Jowett Society, the philosophical society for undergraduates. It was through this society that I met Isaiah Berlin, then an undergraduate at Corpus Christi College, and started a friendship that has lasted for close on sixty years. He was a year senior to me, but spent a year longer as an undergraduate, thereby securing a double first.

I think it probable that I read more than one paper to the Jowett Society, but the only one that I remember was a paper on the philosophy of Ludwig Wittgenstein, to which I had been introduced by Gilbert Ryle. Wittgenstein's famous book, *Tractatus Logico-Philosophicus*, had been published as long ago as 1922, but hardly any notice had been taken of it at Oxford and I believe that this meeting at which I gave an enthusiastic account of Wittgenstein's system, as I understood it, was the first

occasion on which Oxford had been treated to any public discussion of his work.

My captivation by the *Tractatus* increased my appetite for philosophy. It had been intended that I should become a barrister and I had been enrolled in the Inner Temple and eaten my quota of Bar Dinners. I had read no law but it was then quite a common practice for prospective barristers to take their Oxford degree in Greats and then devote some time on their own to acquiring the modest amount of legal knowledge that would enable them to pass the Bar Examination. I was not averse from this course but thought that there would be no harm in my spending at least another year at Oxford and making some further progress in philosophy. I therefore applied for a Research Lectureship which Christ Church was offering. It happened, however, that Michael Foster had put in for a Professorship at the University College of Aberystwyth and the Governing Body of Christ Church took it for granted that he would obtain it. Accordingly, they appointed me, not to the position for which I had applied, but to a special lectureship with the intention that after the probationary year to which Christ Church subjected all its prospective Students, as it persists in calling those who would elsewhere be entitled Fellows, I should succeed Michael Foster. I had no hesitation in accepting this offer. Unfortunately, Michael Foster did not secure the Welsh professorship, so that Christ Church, having committed itself to employing me, awarded me a two-year lectureship with the possibility of an extension for one further year.

In these circumstances, it would have been an embarrassment to the college as well as myself if I had failed to obtain a first in Greats. This very nearly happened, as two of my three philosophy examiners were hostile to my Cambridge orientation and the third, who was more sympathetic, intended to subject me to a searching viva. I was spared this ordeal, only because I had displayed an adequate knowledge of ancient history and Professor Wade-Gery, suspecting that the philosophers were treating me unfairly, gave me such high marks on my history papers that I emerged with a first, after only a formal viva on my performance in ancient history. This narrow escape was followed in the autumn by my failure to be elected to All Souls, Isaiah Berlin being one of those preferred to me.

With Michael Foster retaining his Studentship, Christ Church had no need of my services as a tutor and I was given two terms leave of absence. I proposed to spend them in Cambridge, learning from Wittgenstein, but Gilbert Ryle persuaded me to go to Vienna instead. He had met Moritz Schlick, the leader of the group of philosophers and scientists, mainly mathematicians, who entitled themselves the Vienna Circle, at some

international congress a year or two previously and had been favourably impressed by him, and thought that it would be a good thing if I could discover what work was going forward under his auspices. For my part I had become engaged to be married and thought that Vienna would be a nice place in which to spend a honeymoon. I was married to Renée Lees on 25 November 1932 and we went almost immediately to Vienna.

As soon as we had found lodgings I called upon Schlick with a letter of introduction from Ryle and was invited by him not only to attend his lectures at the University but also to participate in the weekly meetings of the Circle. There was, indeed, the difficulty that I knew next to no German but I took private lessons and within a few weeks had learned enough German to follow the discussions that went on in the Circle, if not to make any positive contributions to them. In my private lessons I mainly studied the novels and plays of Arthur Schnitzler, of whose work I have always thought very highly.

Rudolf Carnap, perhaps the most famous member of the Circle, had left Vienna for the German University in Prague, but he continued to exert a strong influence through his writings, including the articles that he published in *Erkenntnis*, the Circle's official journal, which he edited jointly with Hans Reichenbach, the leader of a similar though smaller group in Berlin. I was impressed by Carnap's articles and still more by the book *Der Logische Aufbau der Welt (The Logical Construction of the World)*, which he had published in 1928. From the standpoint of what Carnap, somewhat disingeniously, called methodological solipsism, it consisted in a valiant attempt to use Russell's logic to develop a hierarchy of concepts, sufficient for the description of every aspect of reality, on the basis of the single empirical relation of remembered similarity between total states of the subject's consciousness. I now see that such an enterprise was bound to fail but I did not think so at the time.

Apart from Schlick, the chief participants in the meetings that I attended were the philosopher and sociologist, Otto Neurath, the philosopher Friedrich Waismann, and the mathematicians Karl Menger and Hans Hahn. The logician Kurt Gödel, who had already published, at the age of twenty-five, his famous proof that even in elementary parts of arithmetic there exist propositions which cannot be proved or disproved within the system, was usually present but very seldom spoke. It is probable that he already dissented from the orthodox view of the Circle that the true propositions of logic and pure mathematics were tautologies, owing their necessity to linguistic conventions. Officially also, they were united in accepting the principle of verification as a criterion of empirical significance. Any nonformal utterance that could not be empirically verified was held to be literally nonsensical and this included

most of what went under the name of metaphysics or theology. At that time the prevailing view was that empirical statements, other than those that were themselves directly observational, were reducible to the observational statements that would validate them. Later this requirement was relaxed to the point where nothing more was required of a scientific hypothesis than that observational statements be derivable from it. With regard to the criterion of significance and the character of explanation, no distinction was made between the natural and the social sciences. As for philosophy, apart from the exposure of metaphysical nonsense, its function was purely that of clarifying and analysing the statements that were allowed to be literally meaningful.

The principal subject of debate, at the meetings which I attended over a period of three months, was the character of observation statements or *Protokollsätze* as they were called. One party led by Schlick held that they were statements referring to sense-data. His opponents, led by Neurath, refused to go below the level of references to physical objects. Neurath was soon to convert Carnap to the view that 'the physical language was the universal language of science'. On this issue I sided with Schlick.

A philosopher, a year or two older than myself, who also came to these meetings, was the American W.V. Quine, who went on to become perhaps the foremost philosopher of my generation. He had taken his doctorate in logic at Harvard, and was making a tour of Europe, in order to converse with mathematical logicians not only in Vienna but in Prague and Warsaw. He has a remarkable facility for languages, and I was deeply impressed by his delivering a lecture on logic to the Circle in fluent German.

It was in Vienna that I acquired a taste for opera which has never left me. One could get seats in the Upper Circle very cheaply, and Renée and I went to many performances, mainly of works by Mozart and Verdi. I remember also a superb production of Hofmannsthal's and Strauss's *Der Rosenkavalier*. Wagner was not in favour, but we saw a good production of *Lohengrin*. We also paid frequent visits to the Kunsthistorisches Museum with its splendid collection of Breughels, surpassed only in our favour by Tintoretto's *Susanna and the Elders*.

When we returned to Oxford for the summer term of 1933 I gave a course of lectures on Wittgenstein and Carnap. They did not attract a large audience, but I had prepared them carefully and they were well received. Altogether I showed so much enthusiasm for what I had learned in Vienna that Isaiah Berlin advised me to put it all into a book. I accepted his advice but did not wish to undergo the labour of writing a book, without a guarantee that it would be published. At a dinner party given by Richard Crossman, who was still a Fellow of New College, I met

a girl who worked in the office of the publisher Victor Gollancz and she made an appointment for me to see him. I outlined the plan of my book to him and came away with a contract. The result was *Language, Truth and Logic*, which I started writing at Christmas and finished nineteen months later in July 1935. It was published by Gollancz in England in 1936 and later in the same year by the Oxford University Press in the United States. Its title was to some extent a plagiarism of Waismann's *Logik, Sprache, Philosophie*, advertised as the first of a series of books which the Vienna Circle was sponsoring, but never published, though a version of it appeared many years later after Waismann's death.

Language, Truth and Logic was a short book, running to about 60,000 words. Its content was very much a summary of the views which I have attributed to the Vienna Circle, though my admiration for Russell and Moore led me to a stronger commitment to phenomenalism. I had also been influenced by C.I. Lewis's *Mind and the World Order*, and adopted his pragmatic view that all empirical statements, including those ostensibly about the past, were hypotheses the content of which was taken to be equated with what would count as the present or future evidence bearing upon them which was available to their interpreter. I also took what I later discovered to be the untenable position of adopting a mentalistic analysis of statements about one's own experiences and a behavioural analysis of statements about the experiences of other persons. A feature of the book, which became notorious, was its advocacy of the so-called emotive theory of ethics, according to which ethical judgements did not issue in true or false statements but only in expressions of moral approval or disapproval, which they encouraged others to share. I had in fact forgotten that a similar theory had been advanced as early as 1923 by C.K. Ogden and I.A. Richards in their book *The Meaning of Meaning*, though I was aware that the use of the word "emotive" to embrace other than factual uses of language derived from them.

Mainly in England, *Language, Truth and Logic* enjoyed an immediate *succés de scandale*. It was extensively reviewed and four impressions of the original Gollancz edition appeared before the war. Unhappily, this does not imply that a great many copies were sold. Victor Gollancz, when he received the manuscript, found it difficult to believe that many people would want to read a philosophical work of this kind and none of the impressions exceeded five hundred copies. It was only after the war when Gollancz consented to reprint the book on condition that I supplied it with a second introduction, which was in fact a misplaced appendix, that the book approached the status of a best seller. A new impression of the second edition appeared almost annually for the next twenty-five years. It was translated into a dozen foreign languages—for some reason being

especially well received in Japan, and it still maintains a steady sale in paperback, both in England and the United States.

I am not sure that I can wholly account for the book's popularity. I suppose that part of the reason lies in its simplicity and verve. I wrote it in the conviction that I had been led to discover the proper path for philosophy to follow, and this conviction, however ill-founded it may turn out to have been, does give the book an abiding force. There is also the factor that it created a disturbance in what, at any rate at Oxford before the war, had been a stodgy philosophical atmosphere. After the war it was seen as crystallizing several analytic tendencies that had been slowly coming to the fore and it also served as a springboard for the development of at least some variants of what came to be known as linguistic philosophy. All this made for its survival as a text book if nothing else.

The terms of my lectureship at Christ Church allowed me to function in a small way as a college tutor. I enjoyed this form of teaching and believe that I succeeded in arousing in at least some of my pupils quite a strong interest in philosophy. I also took an active part in the meetings of philosophical societies at all levels. Outside Oxford I found more sympathy for my views among the younger philosophers, mainly from Cambridge, whom I met at the annual Joint Sessions of the Mind Association and the Aristotelian Society. The first of these sessions that I attended took place at the University of Birmingham in 1933 and resulted in the founding of the journal *Analysis* which has continued publication to this day.

The sessions, consisting in four or five symposia, always took place over a week-end and one of their chief attractions was the presence of G.E. Moore who held an informal seminar on the Sunday afternoons. I was charmed by Moore as a person and much admired the wholehearted devotion to philosophical argument which he displayed in the discussions over which he presided.

A prominent disciple of Moore's and a senior member of the Editorial Board of *Analysis* was Professor L. Susan Stebbing who occupied the Chair of Philosophy at Bedford College, London. She had written *A Modern Introduction to Logic*, which I had read as an undergraduate and found very useful. It was through her that I first met Rudolf Carnap, whom she had invited to give a series of lectures at Bedford College in 1934. He had just published his *Logische Syntax der Sprache (Logical Syntax of Language)* in which he drew his celebrated distinction between the material and formal modes of speech and made a forlorn attempt to treat all philosophical statements as syntactical. He was persuaded of the legitimacy of semantics by an abstract of Alfred Tarski's "The Concept of

Truth in Formalized Languages" delivered in German by Tarski at a large congress organized by the Vienna Circle in Paris in 1935. It was at this congress that I first set eyes on Bertrand Russell, then aged sixty-three, who was deservedly lionized, so much so that I did not then venture to approach him. I did make friends with Karl Popper, whom I had not met in Vienna because he was not admitted to the Circle, though it sponsored the publication of his *Logik der Forschung (The Logic of Scientific Discovery)* which I had read and admired when it came out in 1934. He departed from the orthodoxy of the Circle to the extent that he put forward a principle of falsifiability not as a criterion of meaning but as a scientific shibboleth, a proposal which many scientists have welcomed as a faithful account of their procedure.

My enthusiastic advocacy of what had already come to be known as Logical Positivism had not endeared me to the senior philosophers in Oxford, so that it was clearly not going to be easy for me to secure a permanent position there. I had had some warning of this in the fact that when I competed for the John Locke Prize in Philosophy in 1933, the prize was not awarded. Nor was I the only victim of the examiners' prejudices. One of the other competitors was J.L. Austin, who had just been elected to All Souls.

My lectureship at Christ Church was extended for a third year but by 1935, since I was not inclined to take a junior post at another university, even if I could obtain one, it looked as if I should have to renounce any ambition of pursuing an academic career and address myself after all to the study of the law. I owed my salvation to the economist Roy Harrod who took a strong interest in philosophy and sympathized with my approach. *Language, Truth and Logic* had not yet been published but I gave Harrod the typescript of two of the central chapters to send to Whitehead, then at Harvard, for his opinion. Whitehead had become an out and out metaphysician, so that he might have been expected to disapprove of my work, but in fact he gave me an enthusiastic testimonial, saying among other things that he could not imagine a greater blessing for English philosophical learning than the rise in Oxford of a vigorous young school of Logical Positivists. Harrod also asked Moore and Price for their opinion of my philosophical ability and obtained favourable answers in both cases. The result was that Christ Church elected me to a Research Studentship (i.e. Fellowship), for a period of five years, thereby making me a member of the Governing Body of the College.

Owing to the influence behind the scenes of Professor Lindemann, it was stipulated in the terms of my appointment that I should research into Symbolic Logic and the Philosophy of Physics, but I soon discovered that I had no aptitude for either of these pursuits. I continued to champion

the main principle of Logical Positivism, but concentrated mainly on the Theory of Knowledge. Such tutorials as I gave were mainly devoted to the history of philosophy. I had one or two youthful disciples, but was careful not to foist my opinions on my pupils. During these years I owed a great deal to the weekly meetings of a group consisting originally only of Berlin, Austin, and myself but later augmented by Donald Macnabb, A.D. Woozley, Stuart Hampshire, and Donald Mackinnon. Even at that date Austin and I tended to disagree, but as his early essays show our divergencies were much less great than they subsequently became.

It was in the 1930s that like other members of my generation I began to take an active interest in politics. I gave a course of lectures on political theory and held a joint class with Frank Pakenham, the present Lord Longford, who had been elected to a Studentship in Politics at Christ Church. Because of its contribution to the Republican cause in the Spanish Civil War, I briefly considered joining the Communist Party, but decided that I did not believe in Dialectical Materialism. There was an institution appropriately known as the Pink Lunch which served as a political forum for dons of at least a liberal persuasion and I regularly attended its meetings in Oxford. It was, however, in London, where we had taken a flat in 1935, that my political activity chiefly took place. I had joined the Labour Party and soon found myself Chairman of the Soho Branch of its Westminster Abbey division. It was a branch with few active supporters and the amount of canvassing and public speaking, especially at street corners, in which I felt obliged to engage was greater than I could have wished. In 1937 I stood for election in my local ward for the Westminster City Council, which was then composed entirely of Conservatives, and was narrowly defeated in a small poll. On that occasion I composed and published a shilling pamphlet entitled 'Your Westminster', of which I no longer possess a copy. I doubt if one is still in existence.

My absorption in philosophy and politics still left me leisure to read widely in other subjects. It had somehow come about that I had read hardly any of the novels of Dickens or Jane Austen in my adolescence and I made good this omission, acquiring a special affection for Dickens's *Bleak House* and Jane Austen's *Mansfield Park*. Among other nineteenth-century English novelists my favourite in addition to Peacock was Wilkie Collins and I frequently re-read them both. I also read a great many detective stories, a taste which I discovered that I shared with Bertrand Russell of whom I saw a certain amount when he came to deliver a series of lectures in Oxford in 1938. It was in the same year that on a scholarship from the English Speaking Union I paid my first visit to the United States, renewing my friendship with the poet e.e. cummings,

whom I had already met in Oxford and making the acquaintance also in New York of the philosophers Sidney Hook and Ernest Nagel, and the polymath art-historian, Meyer Schapiro.

The main fruit of my five years Research Studentship was my book *The Foundations of Empirical Knowledge* which appeared in March 1940, under the imprint of Macmillan, who became my regular publishers. The book was primarily a defence of a slightly weaker form of phenomenalism than I had embraced in *Language, Truth and Logic*. Its fidelity to the theory of sense-data provided Austin with most of the ammunition for his onslaught on the theory, delivered in the lectures which were eventually published under the title of *Sense and Sensibilia*.

Besides writing the two books that I have mentioned, I wrote and published about a dozen philosophical articles in the nineteen thirties. The most important of them was "Verification and Experience" which I contributed to the *Proceedings of the Aristotelian Society* for 1936–37. It contained what I still believe to be a decisive refutation of the manner in which Carnap and Neurath were then upholding a coherence theory of truth.

When *The Foundations of Empirical Knowledge* was published I was already a soldier. On the way to becoming an officer in the Welsh Guards I had first to spend some months as a Guardsman Recruit and an Officer Cadet. In 1941 I was seconded to Military Intelligence, spending most of my time in offices in London, New York, and Algiers but having a roving commission in the South West of France after the Allied landing in 1944. I spent most of 1945 as an attaché at the British Embassy in Paris and was demobilized with the rank of Captain in November 1945.

I did most to no philosophical work during these years. It was not until 1945 that I found time to publish an article in *Mind* which was critical of Moore's treatment of sense-data. Moore replied to it in an appendix to the second edition of *The Philosophy of G.E. Moore* in the Library of Living Philosophers. In the same year I published a hostile review of Jean-Paul Sartre's *L' être et le néant*, and a mainly favourable appreciation of the work of Albert Camus, both in Cyril Connolly's journal *Horizon*.

A short-lived successor to Horizon was the journal *Polemic*, on the editorial board of which I served together with Bertrand Russell and George Orwell, with whom I had made friends when he came to Paris as a journalist. I published various articles in this journal including a survey of contemporary British philosophy, in which I unwittingly offended Wittgenstein, who had been well disposed towards me since Gilbert Ryle first took me to visit him in Cambridge in 1932.

The Fellow and Tutor in Philosophy at Wadham had retired through

ill health during the war and I was elected, in absence, to replace him. My first marriage had been dissolved in 1942, and as soon as I was demobilized I moved into a set of rooms in Wadham, being immediately appointed Dean of the College, a disciplinary office which gave me no trouble, mainly owing to the maturity of the undergraduates, most of whom had served in the war. I resumed lecturing on Perception and being the only philosophical Fellow in the college undertook a full stint of tutorial teaching.

Though I was very well satisfied with my position at Wadham, I remained only a very short time there. An approach was made to me late in 1946 by the Provost of University College London, to become a candidate for the vacant Grote Professorship of the Philosophy of Mind and Logic in the University of London, tenable at University College. After some hesitation I applied for the position, was interviewed and elected. Wadham repaid my defection more generously than I deserved by making me an Honorary Fellow in 1957.

I had rashly accepted the appointment at University College London without inspecting its department of philosophy, and when I did inspect it found that it was moribund. My predecessor in the Chair had migrated to Scotland just before the war and had not been replaced. All that remained was one senior lecturer, an unqualified assistant, and at most half a dozen dispirited undergraduates. I put a great deal of energy into reviving the department and very much enjoyed doing so. I replaced the unqualified assistant with the highly qualified Stuart Hampshire, recruited the promising Richard Wollheim from Oxford and in the succeeding years promoted five of my London pupils, James Thomson, John Watling, Peter Long, Peter Downing, and Anthony Basson to lectureships. I recruited a great many more undergraduates, as well as graduates, revived the University College Philosophical Society which had ceased to function for the previous fifteen years, and made the department into a flourishing self-contained unit, installed in a house which it continues to occupy.

My inaugural lecture "Thinking and Meaning" was published as a pamphlet in 1947. I still believe that it posed some of the right questions but doubt if it gave many of the right answers to them. When I repeated it before a small audience of philosophers in New York in 1948 Nelson Goodman raised objections to it which I could not meet. I had gone to New York to spend the autumn semester, lecturing at New York University, as well as at Bard in New York State. Apart from visiting Harvard and briefly attending a meeting of the Eastern Division of Philosophy at the University of Virginia, I met few American philosophers outside New York.

When I returned to London, I founded the Metalogical Society, remotely imitative of the nineteenth-century Metaphysical Society, though it contained no poets. There were about twenty members, mostly philosophers and biologists, as well as a physicist, a psychiatrist, and a Professor of History from University College, the Dutchman G.J. Renier, best known for his book *The English Are They Human?* We met once a month in my flat, to discuss a paper which one or other of us had volunteered to read. A good account of these meetings is to be found in the book *Russell Remembered* by Rupert Crawshay-Williams, who was a friend and neighbour of Bertrand Russell's in Wales. Russell attended the meetings regularly and obviously enjoyed them. In the early 1950s he was living at Richmond and I quite often visited him there. I saw less of him when he returned to live in Wales and became increasingly absorbed in politics but our friendship lasted for the remainder of his life. I think that it was partly sustained by the fact that I upheld his approach to philosophy at a time when he had been given some reason to believe that his reputation had fallen below that of Wittgenstein and Moore. Current fashion has turned rather against Moore, but I fear that my preference for Russell over Wittgenstein is one that many of my younger colleagues do not share.

A year or two after my appointment to the Grote Chair I was invited by the publishers of Penguin Books to edit a series of books on philosophy, all of them original works. The plan was that the series should cover the history of philosophy from Plato to F.H. Bradley, and that there should also be books on general topics, such as logic, ethics, and politics. I was effectively in charge of the series from 1951, when it got off to a very good start with the publication of *Peirce and Pragmatism* by Bryce Gallie and *Spinoza* by Stuart Hampshire, until 1963 when Patrick Gardiner contributed an excellent book on Schopenhauer. It was then merged into the empire of Ted Honderich of University College London, an enterprising and imaginative editor who has widened the range of Penguin Publications in philosophy. My series contained serious lacunae, since the books which I commissioned on Plato, Aristotle, Hegel, the philosophy of science, aesthetics, and the philosophy of religion were all rejected by the publishers as unsuitable for their readership, and the authors who agreed to write books for the series on logic and on Jeremy Bentham never fulfilled their undertaking. Even so, the series did include books on many of the most eminent figures in the history of philosophy, as well as books on ethics, political philosophy, and the theory of knowledge.

The book on the theory of knowledge was written by myself. It was entitled *The Problem of Knowledge* and published in 1956 simultaneous-

ly by Penguin in paperback and Macmillan in hardback. Next to *Language, Truth and Logic*, it has been my most successful book, and I myself consider it the better of the two. It represented the theory of knowledge as a set of attempts to rebut a characteristic pattern of sceptical argument. In a variety of instances such as the step from our acquaintance with sense-data to our belief in the existence of physical objects, the step from observation of other people's behaviour and their physiological condition to the ascription to them of mental states, the transition from what appear to be present memories to the belief in the occurrence of past events, the sceptic argues that we make light of a gap which we are not justified in bridging. The theorist of knowledge responds sometimes by trying to bring the evidence up to the level of the conclusion, as when it is claimed that we are directly acquainted with the past, sometimes by trying to reduce the conclusion to the evidence, as in the phenomenalist analysis of statements about physical objects or the behaviourist's account of mental states, sometimes by treating the conclusion as the best explanation of the evidence, sometimes by simply disqualifying the sceptic for setting his standard of justification so high that it could not possibly be satisfied. For the most part in my book I followed the last of these courses, not without feeling that I was disposing of the problem rather too easily.

In 1950 it became my turn to be elected President of the Aristotelian Society. My presidential address was entitled "Statements about the Past". Its most controversial thesis was that events could be located in time simply by means of the relation of temporal priority, the terms of the relation being uniquely identified by description. There was, indeed, no logical guarantee that such a description would always be available but it was a safe empirical assumption. This was indeed one application of the general thesis that demonstrative expressions, including tenses, are not linguistically essential. They are eliminable by paraphrase, through the use of descriptions. This view, which I have put forward on various occasions, is one that has also been espoused by Quine and Goodman. Even so, I have come to doubt whether it is correct, partly because it allows only for indefinite reference. The chief argument on the other side is that if demonstratives are not eliminable, a large part of our use of language is incurably subjective.

I included "Statements about the Past" in a collection of twelve essays ranging in date from 1943 to 1954 and published by Macmillan in 1954 under the title of *Philosophical Essays*. It included an essay "On the Analysis of Moral Judgements", refining my emotive theory, as well as the reprint of a lecture entitled "Phenomenalism" which I had delivered to the Aristotelian Society in the session of 1947–48. It marked my final

abandonment of this doctrine, on the ground that the obstacles in the way of translating sentences about physical objects into sentences about sense-data were logically insurmountable. From that time onwards I have treated the common-sense conception of the physical world as a theory created on the basis of sense-data, or rather, since I think that there are advantages in starting with universals rather than particulars, on the basis of what, following the example of C.I. Lewis and Nelson Goodman in his *Structure of Appearance*, I refer to as sense-qualia, and I have made successive attempts in my later works to develop this view in detail.

Throughout the 1950s and 1960s I very frequently lectured abroad. In 1951 I was invited by the University of San Marcos in Lima, Peru, to take part in the celebration of the four hundredth anniversary of its foundation and I was then employed by the British Council to lecture in Chile and Uruguay, where I spoke in Spanish, and in Rio de Janeiro, where, in default of Portuguese, I spoke in French. I think that I was independently invited to lecture in Denmark and Sweden but it was on behalf of the British Council that I lectured at a series of Italian Universities, again speaking in French, and toured India and Pakistan in 1958, discovering that the philosophers in the Indian universities still taught versions of the Bradleian idealism to which their predecessors had been converted by Scottish evangelists in the late nineteenth century. Despite its aesthetic attractions, and the generous hospitality which I encountered especially in Delhi, I did not greatly care for India. What chiefly shocked me was the prevailing acquiescence in human misery. I much preferred China to which I had been invited as one of a small cultural delegation in 1954. Although the Communists had been in power for five years they had not yet ventured upon any violent reforms. Peking, which had been left untouched, appeared to me the most beautiful city that I had ever seen. The philosophers whom I met there had nearly all been trained in England, Germany, or the United States and they were much less interested in Marxism than in formal logic.

There were other countries such as Jugoslavia and Holland in which I lectured in response to special invitations, but the majority of my professional visits abroad occurred as a result of my attendance at an international congress in Brussels in 1953 under the auspices of the *Fédération Internationale des Sociétés de Philosophie* and my there joining the *Institut International de Philosophie*. The world congresses of which the one in Brussels was the eleventh to be held in all and the second since the war took place with a change of venue at five-yearly intervals; they are open to anyone who consents to pay the admission fee, though some effort is made to limit the number and sustain the level of the papers which are delivered at them. The I.I.P. which has continued to

maintain a secretariat in Paris was founded shortly before the war by a Swedish philosopher, Åke Patzäll, and a French philosopher, Raymond Bayer. It meets annually in a different country and its members are individually elected with respective quotas from different nations, in no case exceeding seven, apart from the rider that members over the age of seventy are not counted in the quota. When I first joined, the membership was predominantly European, with English philosophy weakly represented, and next to no recruitment from the United States. In the course of time both the English and the American representation has been greatly strengthened, and the geographical coverage extended to cover every country in which philosophy is seriously practised, including those beyond the Iron Curtain. I am not aware that the solitary Chinese member has yet attended a meeting, but the several Polish, Bulgarian, Czech, and Russian members have frequently thought it well worth their while.

Owing to my membership of this organization I have attended congresses in France, Italy, West Germany, Austria, Denmark, Finland, Greece, Switzerland, Poland, Bulgaria, Egypt, Mexico, and the United States. On occasions I was one of the principal speakers, sometimes I opened the discussion, almost always took some part in it. I have to admit that the profit derived from these encounters was more social than philosophical, but I think that they did something to bridge the gap between the analytical approach to philosophy that increasingly came to the fore in England, Australia, the United States, the Scandinavian countries and to a limited extent in Holland and Belgium, and the Hegelianism, Thomism, phenomenology, existentialism, and hermeneutics that prevailed in France, West Germany, Spain, Italy, and Latin America. Marxism was still officially dominant in Communist countries, but it was seldom presented in a dogmatic form.

The decade of the fifties was that in which I most frequently broadcast on philosophical topics, and also appeared on television. The BBC had devised a programme called "The Brains Trust" which became very popular during the war when it was put out over the wireless, and was transferred to television after the war. When I first appeared on it, the programme went out live on Sunday afternoons and lasted for three quarters of an hour. It took the form of a discussion between four persons under the control of a chairman, debating questions which had, at least in theory, been submitted by members of the public. From five to seven questions were commonly got through. They covered a wide range of subjects but chiefly concentrated on concrete and abstract moral issues. The membership of the panel changed from week to week but a few persons, notably Julian Huxley, Alan Bullock, and the versatile Jacob

Bronowski, were invited sufficiently often to count as regulars. I myself made over forty appearances on the programme before it was discarded by the BBC in 1961.

I played very little active part in politics after the war, but I was still sufficiently attached to the Labour Party to write occasional newspaper articles on its behalf and I appeared on a television programme in support of its unsuccessful campaign in the general election of 1959. By that time I had become quite a close friend of its leader Hugh Gaitskell and I still count his early death in 1963 as a factor in England's political decline.

My most effective involvement in public affairs consisted in my Chairmanship of the Society for Homosexual Law Reform. This society came into being as a result of the publication in 1957 of the Wolfenden Report which among other things recommended that the conduct of homosexual relations in private between consenting male adults should cease to be a criminal offence. We acted as a pressure group over nearly a decade and I think that we made some contribution to the change in the climate of public opinion which made it possible for a private bill, enacting the desired reform, to be introduced successfully by Lord Annan in the House of Lords and then to be accepted by the House of Commons.

In 1959 Henry Price retired from the Wykeham Professorship of Logic at Oxford and I decided to apply for it. Part of my motive was that the position carried greater prestige, part that I wanted to provide some local opposition to the form of linguistic philosophy which Austin had made fashionable, with what appeared to me its excessive concentration on the niceties of ordinary English usage. I had no particular wish to leave U.C.L., though I did feel that if I remained there I should be in some danger of resting on my laurels. Bertrand Russell and Isaiah Berlin consented to act as my referees and I was elected by a narrow majority. The professorship carried with it a fellowship at New College and I was allotted a very handsome set of rooms there. I was in danger of having to vacate them when I married the journalist Dee Wells in 1960, but since I arranged to spend the greater part of the week in Oxford during term, returning to our house in London only for long week-ends, I was allowed to keep them for the nineteen years that I continued to occupy the Chair.

My statutory duty was to give thirty-six lectures or classes in the course of an academic year. I slightly exceeded this quota by lecturing twice a week during two of the three eight-week terms and giving what was known as informal instruction once a week in every term. This was in fact a seminar attended by both graduates and undergraduates, about twenty-five in number. In its early days the seminar was devoted to a single topic such as 'causality' or 'time'. Later I tended to go through a

volume of essays, preferably one that had been recently published. My method was to open the proceedings at the first meeting but afterwards to persuade members of the audience to volunteer to fulfil this role. Rather than indulge in lengthy expositions of my own views I tried to get the members of my audience to argue with me and with one another and in the main I was successful. A good many of these meetings were very lively and I believe that I was not alone in finding them intellectually profitable.

My lectures gave me less satisfaction. I prepared them carefully even to the extent on occasion of writing them out in full but I spoke too fast and tended to cover too many topics in a single lecture. As a rule they began by attracting quite large audiences, whose number steadily dwindled. Even so the few who remained faithful seemed to enjoy them.

One of the distinguishing features of post-war Oxford was the large increase in the number of graduates. This applied also to philosophy, mainly as the result of the introduction by Gilbert Ryle, who had succeeded Collingwood in the Chair of Metaphysics, of the new higher degree of B.Phil. combining a dissertation with a choice of several set papers. To reassure the college tutors whom he thought unlikely to welcome any increase in their load of teaching, Ryle had given the undertaking that the supervision of candidates for the B.Phil. degree should be entrusted solely to the three professors of philosophy, respectively holding the Chairs of Logic, Morals, and Metaphysics. The degree, however, soon became so popular that the professors, if they were to give their nominal pupils anything like an adequate measure of supervision, were not equal to the demand. When the number of graduates for whom I was officially responsible rose to twenty-two, I suggested to Ryle that some of the better college tutors would be happy to take some graduate pupils, as a relief from the routine of teaching undergraduates. This turned out to be true and from then onwards I do not think that I ever had more than eight graduates to supervise. I saw them for an hour each once a fortnight and almost always enjoyed our arguments. Many of those whom I supervised became successful teachers of philosophy.

The International Library of Psychology, Philosophy and Scientific Method for which its editor C.K. Ogden had secured such important books as G.E. Moore's *Philosophical Studies*, Bertrand Russell's *The Analysis of Matter* and Wittgenstein's *Tractatus* had been wound up. In 1960, the firm of Routledge and Kegan Paul, who overlapped with its original publishers decided to revive it, under the same title with the omission of Psychology, for which a separate series was created, and to appoint me as its editor. In the five years during which I remained in charge of it, before resigning in favour of Bernard Williams, himself soon to be replaced by the indefatigable Ted Honderich, I was responsible for

the publication of twenty-six books, including translations of Maurice Merleau-Ponty's *Phénoménologie de la Perception* and the Marxist Lucien Goldmann's *Le Dieu Caché*, several books written by American philosophers, contributions from Denmark, Finland, Australia, and Canada, and among the works of English authors C.D. Broad's *Lectures on Psychical Research*. Naturally the books varied in merit but at least I made good my editorial promise that my choice of books to include in the series would not be narrow-minded.

In the autumn of 1960, a year after my introduction into the Chair, I gave my inaugural lecture entitled "Philosophy and Language". Its main purpose was to show that philosophers like Ryle and Wittgenstein, though they might make verbal points, were not concerned in the same way as Austin and his disciples with the elucidation of ordinary linguistic usage. Their object was rather to induce their audience to take a different and clearer view of the facts which language was used to describe. In fairness to Austin, it should be said that he also claimed that the study of language illuminated the facts. In the end my opposition to his approach might have shown itself to be no more than a difference of emphasis. The question was never settled since he died before the end of the year and the interest shown by Oxford philosophers in ordinary usage, as such, virtually died with him.

One way in which Austin had maintained his philosophical power in Oxford had been his dominance of a class, meeting on Saturday mornings, attendance at which was confined to college tutors younger than himself. Conformably to my original intention of counter-acting his influence, I founded a rival class of a very different character. It met on Tuesday evenings from five to seven o'clock from the second to the seventh week of term. A different member acted as host to the group each term and provided drinks which were served during the discussion of the paper devoted to a subject of the speaker's choosing. There was no question of my organizing the programme or controlling the discussion. The original members of the group, besides myself, were Peter Strawson, David Pears, Michael Dummett, Brian McGuinness, Michael Woods, Patrick Gardiner, Tony Quinton, David Wiggins, and James Thomson. Later nearly a score of others were asked to join, including promising younger philosophers like Gareth Evans, John McDowell, Derek Parfit, and Christopher Peacocke, and when distinguished philosophers from the United States came to Oxford for a term or more they were also invited and often contributed papers. I do not believe that anyone ever refused an invitation to belong. In the course of time, three members have died, and several have ceased coming to meetings for one reason or another, but the group still meets regularly after twenty-seven years.

Though it is now eight years since Michael Dummett succeeded me in the Chair of Logic at Oxford, and I live in London, I still attend a fair number of its meetings.

In the autumn of 1961 I took a term's sabbatical leave from Oxford in order to spend a semester teaching at City College, New York. I gave an undergraduate and a graduate course and enjoyed them both very much. My audience of undergraduates was as responsive as any that I have ever had. I gave occasional lectures at a number of other universities, mostly in the eastern part of the United States and accepted a more exotic invitation to give a talk on the nature of philosophy at one of the seminars that President Kennedy was requiring the members of his family and his cabinet to attend in Washington. The President and his wife were absent on this occasion and the proceedings were conducted by his brother, Bobby, the Attorney-General. It being hardly possible to summarize the whole of philosophy in an hour, I contented myself with trying to show that the analytic conception of philosophy which I favoured stood squarely in the Socratic tradition. On the whole the meeting went well, though some members of the Kennedy family were shocked by my patent disbelief in the existence of God.

From New York I went almost immediately to Moscow. I had visited Moscow over seven years before on my way to China but had not then made contact with any Russian philosophers. My current invitation to lecture in Moscow and Leningrad was the remote result of my making friends with members of the Russian delegation to the World Congress of Philosophy held in Venice in 1958 and the immediate result of my agreeing to contribute to the Soviet journal *Voprosi Filosofii* (Problems of Philosophy). My paper, to which Professor Kuznetsov wrote a reply, was entitled "Philosophy and Science" and stressed the difference between them. This contradicted one of the basic principles of *Dialectical Materialism*, but so far as our argument went I fancy that our disagreement was mainly verbal.

I gave four lectures in Moscow, one of which, a lecture on Truth, I repeated in Leningrad. I spoke in English and the fact that my lectures and the lengthy discussions which followed them had to be interpreted into and out of Russian extended the proceedings, on one occasion to as much as four hours. I was struck by the interest which the students took in what I had to say and surprised by the extent of their acquaintance with recent English philosophy. Dee had been invited to accompany me and my schedule of lectures allowed us some leisure for tourism. We were enchanted by Leningrad, which had been admirably restored after its destruction in the war. Unfortunately we were not given enough time to explore all the glories of the Hermitage gallery, though we did manage to

discover its magnificent collection of Impressionist and post-Impressionist paintings.

One of my Moscow lectures "The Concept of a Person" gave its title to a collection of twelve essays which Macmillan published for me in 1963. The lecture was provoked by Peter Strawson's thesis, expounded in his remarkable book *Individuals*, that the concept of a person is not susceptible to reductive analysis. Against this I argued that persons were identifiable by their bodies, and that the association of different sets of experiences with different bodies and so with different persons could be explained in causal terms. I have since come to doubt whether my causal explanation was satisfactory.

The Concept of a Person contained two essays in which I tried to clarify the notion of privacy and also took issue with Wittgenstein's so-called private language argument to which the majority of contemporary English and American philosophers appear to me to have assented far too readily. I contended that objects were intrinsically neither public nor private. A chair is a public object because we attach sense to saying that different persons perceive one and the same chair; headaches are private because we do not speak of different persons' feeling the same headache. But these locutions are adapted to empirical circumstances which might well have been otherwise. As for the ban on private language it results from Wittgenstein's requirement that there be criteria for deciding whether a word is being used correctly, that is, in accordance with a rule. The requirement is unobjectionable, but the belief that the criteria are satisfied must itself be grounded. In the end any descriptive use of language rests on what I call acts of primary recognition, and here it makes no difference what one is referring to.

I also included in the volume two notes on Probability. In the first of them, which I had previously published, I put forward what I still regard as a decisive argument against the interpretation, adopted by Keynes and Carnap among others, of statements of probability as assessing a logical relation between some conclusion and a given body of evidence. The argument is simply that by turning all correct statements of probability into logical truths, this procedure puts them all on an equal footing, so that so far as the estimate of probability goes there seem no rational motives for looking for further evidence. The second note showed that a somewhat similar difficulty arises for the frequency theory of probability, since any event will belong to a number of different classes in which the incidence of whatever property is in question occurs with a different frequency, so that one is faced with the problem how the choice of one reference class, in preference to the others, is to be justified.

Another of my Moscow lectures was entitled "Pragmatism", a form

of philosophy which had interested me ever since my last year as an undergraduate when I read F.P. Ramsey's praise of it in his posthumously published collection of papers *The Foundations of Mathematics*. I had dealt with it rather summarily in a series of lectures comparing contemporary or near-contemporary English and American philosophers, which I had delivered at U.C.L. in 1957 and in the course of the 1960s I narrowed it down to a study of what I took to be the cardinal features of the work of Charles Sanders Peirce and William James. It was published under the title of *The Origins of Pragmatism* by Macmillan in England and by Freeman, Cooper, a California firm, in the United States. It was not a success in either country. The American devotees of Peirce found it insufficiently scholarly and other readers who might have been interested in some of my own ideas which it incorporated were put off by its title. I valued it chiefly for its critical treatment of Peirce's theory of induction and James's attempt to make good Hume's failure to analyze personal identity in terms of a series of experiences. I refined James's thesis in various ways and came quite near to validating it but in the end I encountered obstacles which I had to confess that I could not overcome.

In 1967 I accepted an invitation to become a Visiting Professor at the University of Toronto. My lectures there were a preview of my book on Pragmatism. I lectured also in Toronto and Montreal. In Montreal I replied at long last to Austin's *Sense and Sensibilia*, a posthumously published book fashioned out of the notes of a series of lectures which he repeatedly gave in Oxford, attempting to demolish the whole theory of sense-data and singling out for especial ridicule the opening pages of my *Foundations of Empirical Knowledge*. I extracted fourteen arguments from his book and rebutted all of them. I did not claim that my account of sense-data in that early book was faultless but I did and do claim that Austin's arguments did not refute it.

I included this piece, entitled "Has Austin Refuted the Sense-Datum Theory?" in a collection of essays, again published by Macmillan in England and Freeman, Cooper in the United States, entitled *Metaphysics and Common Sense*. In the essay from which the book acquired its title I treated metaphysics more leniently than I had in *Language, Truth and Logic*, arguing that G.E. Moore, in particular, had taken unfair advantage of the metaphysicians whom he criticized by assuming that they literally meant what they said. I remarked that while the conclusions which they advanced might be patently false or even nonsensical, the arguments by which they professed to reach them might well be of logical interest. My chief examples were McTaggart's denial of the reality of time and Zeno's denial of the reality of motion. In both cases the conclusion is absurd, but McTaggart raises acute questions about our

concept of time and I am not at all sure that Zeno's paradoxes have yet been adequately solved.

In the nineteen sixties I spent a couple of years serving on a Commission set up by the Department of Education and Science under the Chairmanship of Lady Plowden to enquire into the Conditions and Prospects of Primary Education in the British Isles. At that time the Department succumbed to the theory that so far as possible children should find things out for themselves, and accordingly displayed a pronounced hostility to formal methods of teaching. It appeared to me, as it turned out rightly, that this prejudice, which most of my colleagues unquestioningly shared, was being carried much too far, but I lacked the energy and confidence to write a dissenting report. I failed also to fulfil the hope, which I had entertained, of persuading the Commission to find some effective means of lessening the disparity in the academic standards of the private and state elementary schools. My only successes lay in obtaining a recommendation, by now very widely accepted, that corporal punishment be abolished in primary schools and in persuading a minority of my colleagues to join me in advocating the abandonment of compulsory religious instruction. The best part of our final report, on which some limited action was taken, consisted in its suggestions for paying special attention to the plight of schools in deprived areas, but this was not a subject to which I contributed anything of special importance.

In 1969, when Maurice Bowra was due to retire from the Wardenship of Wadham, one or two of the Fellows let me know that they would like me to succeed him. I was attracted by the idea and would have accepted the position had it been immediately offered to me. There was, however, a delay of some months, while the Governing Body of the College considered the choices open to them, and during this interval I came to doubt whether the administrative duties incumbent on the Warden were compatible with my dominant wish to pursue my philosophical career. As a result, though I went so far as to submit myself to an interview, I formally withdrew my candidature. In retrospect, I am inclined to think that this was a mistake.

Perhaps in an effort to prove my point, I got through a great deal of work in the following decade. In 1970 I spent a semester at Harvard, in response to an invitation to deliver the William James lectures. I lost no time in reproducing them as a book entitled *Russell and Moore: The Analytical Heritage*, published by the Harvard University Press in the United States and Macmillan in England. I think that my account, especially of Moore's work, was thorough and perceptive but that the book as a whole was somewhat pedestrian. So far as Russell goes, I rather prefer the book about him that I wrote shortly afterwards for the Fontana

Library of Modern Masters. When some years later the Oxford University Press inaugurated a series on Past Masters, I wrote *Hume* for them. Since Hume and Russell are the philosophers for whom I feel the greatest intellectual sympathy, I found both books enjoyable to write.

From Boston I proceeded to New York to give the second series of John Dewey Lectures at Columbia University. The first series had been given by Quine and formed the substance of his book *Ontological Relativity*. Mine consisted of three lectures on probability, in which I expounded and in the main defended Hume's strictures on induction, and pointed out the fallacies involved in basing what I called judgements of credibility on the a priori calculus of chances. Conjoining with these lectures an essay on causality and a refutation of Roy Harrod's ingenious attempt in his book *Foundations of Inductive Logic* to justify induction on the basis of a logical theory of probability, I produced a book entitled *Probability and Evidence*, published by Macmillan again in England and by the Columbia Press in the United States. I think quite well of this book though I doubt if it gets to the root of the difficult problems with which it deals.

In 1972 I accepted an invitation to give the Gifford Lectures at the University of Saint Andrews. Since the intention of Lord Gifford, the nineteenth-century Scottish lawyer who bequeathed a sum of money sufficient for the regular provision of lectures at one or other of four Scottish universities was that they should examine the claims of natural theology, I felt bound to devote one lecture to this topic. Taking a less short way with theism than I had in *Language, Truth and Logic*, I nevertheless argued that there was no ground for believing in the existence of a supernatural deity. Even if it were allowed to be intelligible as an explanatory hypothesis, it would still succumb to the charge of being vacuous, since in view of the fact that the course of nature as a whole exhibits no discernible purpose, it would be consistent with anything that happened.

My other seven lectures were, I think, such as to justify my calling the series, and the book which resulted from it, *The Central Questions of Philosophy*. The best chapters were the two in which I developed my thesis that the common-sense conception of the natural world should be treated as a theory created on a basis of sense-qualia. What was most original in them was my attempt to separate priority in the theory of knowledge from priority in existence. I suggested that the data on which the common-sense theory was based were taken over by the theory, being reinterpreted into it as states of the subclass of bodies which were represented in the theory as persons, and thereby assigned a minor existential role. In turn, I suggested that the entities which figured in the

theories of physics could be regarded in much the same way as taking over the common-sense world which they were designed to explain. Borrowing the idea of Peirce, I argued that the person who emerged in the first theory as oneself was originally identified as the central body.

I had become dissatisfied with Macmillan mainly because it seemed to me that they were over-pricing my books and I entrusted *The Central Questions of Philosophy* to George Weidenfeld whose firm handled it very successfully, placing it with Random House in the United States, procuring its translation into other languages, including French and German, and allowing Penguin to publish it in paperback. My association with Weidenfeld continued with the publication of *Philosophy in the Twentieth Century* in 1982, *Wittgenstein* in 1985, and *Voltaire* in 1986.

Among my philosophical works, *Philosophy in the Twentieth Century* is probably the one which I found the most troublesome to write, partly because of the necessary presence of a chapter on Russell, where I was not happy simply to repeat what I had already written, partly because it was not clear to me what I could venture to include. The book was intended to be a sequel to Russell's *History of Western Philosophy* and it was eventually packaged in paperback by Allen and Unwin, who had published Russell's book. There is, however, no question but that it is a far less ambitious work. Understandably, in view of my own convictions, it devotes an amount of space to the ramifications of analytical philosophy that is out of proportion to its historical influence. Not that other avenues of philosophy are totally neglected. C.I. Lewis is selected as the representative of Pragmatism. A careful study of the work of Collingwood exemplifies Metaphysics. In choosing to expound and criticize Maurice Merleau-Ponty's *Phenomenology of Perception*, I believed that I was tackling the legacy of Husserl at its best. I did, indeed, ignore the later development of Marxism, but it was a subject on which Professor Kolokowski had published a detailed work of scholarship and I was content to refer my readers to his writings, rather than indulge in what would have been no more than plagiarism.

Both in my treatment of his work in *Philosophy in the Twentieth Century* and in the book which I devoted to him I was critical of most of the arguments that feature in the great bulk of Wittgenstein's posthumously published writings. My account of the *Tractatus*, though friendly, also failed to recapture the enthusiasm with which it originally overwhelmed me. In these circumstances it is surprising that I ended by marking him second only to Russell among twentieth-century philosophers. I think that I may have been swayed by my memory of his formidable personality and also, less justifiably, by the fervour of his admirers.

As president of the I.I.P. from 1969 to 1972 I played a fairly considerable part in helping the Bulgarians organize the World Congress of Philosophy which took place at Varna in 1973. I paid several visits to Sofia both before and after the congress, stayed in a monastery at Plovdi, the ancient Philippi, admired the frescos in Bulgarian churches, and made good friends with several Bulgarian philosophers and a man whom I now assume to have been a member of the secret police. We had no language in common, but played numerous games of chess, at which he usually beat me, and shared an interest in football.

All this contrasted with a visit that I paid to Japan not long afterwards as a guest of the Japanese Foundation. I found a great deal to admire in the architecture of Kyoto and more in Tokyo than I had expected. I greatly enjoyed the single performance that I attended of a Kabuki play though it lasted for the best part of a day and I speak no Japanese. In general, I was struck by the contrast between Japan's industrial efficiency and its resistance to modernity, especially with regard to the standing of women. The Japanese philosophers with whom I conversed appeared mostly to have been trained in Germany and consequently to favour phenomenology, but I was pleased to discover that the translation of *Language, Truth and Logic* had gone into eighteen editions.

Professors at Oxford are obliged to retire at the end of the academic year in which they reach the age of sixty-seven and this happened to me in 1978. This entailed that I was eligible only for an honorary fellowship at New College and forfeited my rooms there. It was some compensation that I was immediately elected to a five-year fellowship, entitling me to a set of rooms, at Wolfson. As it turned out, I made relatively little use of the facilities at Wolfson, but I was grateful for their being made available to me.

One of the colleges for graduates which had been founded at Oxford after the war, Wolfson had become, among other things, a centre for the advancement of mathematical logic. Though I was titularly the professor of logic first in London and then in Oxford, I have never had anything more than a very slight command of logic, in the technical sense of the term, with the result that I entirely welcomed the appointment of a Professor of Mathematical Logic, assisted by two University Readers and a University Lecturer, to take charge of the new School of Philosophy and Mathematics which I was perhaps primarily responsible for bringing into being. I had previously tried to inaugurate the same combination at University College London but was frustrated by the opposition of the Professor of Mathematics. There was some opposition from the mathematicians at Oxford but just enough co-operation also to assist the logicians in making the venture a success. Unfortunately this was not

true of the Joint School of Philosophy and Physics which was instituted at the same time, again chiefly at my instigation. It has not been a total failure but the physicists at Oxford have not so far shown enough enthusiasm for it to enable it to prosper to the same extent as the School of Philosophy and Mathematics. It has also suffered from the fact that of the seventy or more philosophers who hold teaching posts in Oxford the great majority resemble myself in having been trained in the humanities and not in science.

To mark my retirement from my Chair, Graham Macdonald, a lecturer at Bradford University who had obtained the B.Phil. degree at Oxford under my supervision, organized a symposium exactly along the lines of the present volume, except that it was not prefaced by an autobiography. The book was published by Macmillan in 1979, under the title of *Perception and Identity*. The contributors, to whose criticisms of my work I did my best to reply, were Michael Dummett, Peter Strawson, David Pears, David Armstrong, Charles Taylor, John Mackie, Peter Unger, Bernard Williams, Stephen Körner, David Wiggins, Richard Wollheim, and John Foster. A former pupil of mine who has been a Fellow of Brasenose, John Foster also published in 1985 a book about my philosophy, simply entitled *A.J. Ayer*, which had been commissioned by Ted Honderich for the series *The Arguments of The Philosophers* which he edits for Routledge and Kegan Paul. Foster paid a handsome tribute to my writing, while criticising my theories in detail from the currently uncommon standpoint of subjective idealism.

I found time in the concluding years of my professorship to write a volume of autobiography, bringing me up to the age of thirty-five. Entitled *Part of My Life* it was published in 1977 by Collins in England and by Harcourt Brace rather unwillingly in the United States and in paperback a year later by the Oxford University Press. A sequel, carrying the story seventeen years forward to the birth of my younger son in April 1963, and entitled *More of My Life*, was brought out by the same publishers in England in the same respective formats in 1983 and 1984. It was not published in the United States. The first volume was much the more successful and I am inclined to think also the better of the two.

In 1983 I accepted an invitation to deliver the Whidden Lectures at McMaster University, Ontario, with which I was already associated as one of its committee of advisers concerning the publication of items from its collection of Bertrand Russell's papers. The lectures, three in number, were devoted to moral philosophy and began with a fresh attack on the problem of free will. Many years earlier I had published in *Polemic* and reprinted in my *Philosophical Essays* an essay entitled "Freedom and Necessity", in which I had argued that there was no inconsistency

between free will and determinism as such but only an opposition between freedom of choice or action and the sub-class of causes which counted as constraint. In the interval, however, I had come to doubt whether this sub-class could be adequately identified. Accordingly, in the first of my Whidden lectures, I approached the problem from a different angle, endeavouring to pin-point the conditions under which our choices were considered not to be free. My suggestion was that they were held not to be free to the extent that they were deducible from some accepted totality of singular and general propositions. Though it may appear paradoxical that an increase in what we take to be knowledge should in any way diminish freedom, I am still disposed to argue in favour of some such relativisation of freedom to ignorance. Even so, I have no thought of claiming a final dissolution of the problem of free will.

Conjoining the Whidden lectures with some other essays, two of them on the topic of causality, I compiled a book which was published by the Oxford University Press in 1985 under the overall title of *Freedom and Morality*.

My marriage to Dee Wells was dissolved in 1981 and I subsequently married Vanessa Lawson, only to suffer the great misfortune of her dying in August 1985. Just under three years previously we had spent a very happy period of two terms at Dartmouth College in New Hampshire, where I had enjoyed the honour of being appointed to a Montgomery Fellowship.

The year 1986 marked the fiftieth anniversary of the original appearance of *Language, Truth and Logic*. The occasion gave rise to the publication of two sets of lectures about the book, one organized by Graham Macdonald and Crispin Wright, the Professor of Logic at the University of Saint Andrews, and the other by Dr. Barry Gower, a lecturer in philosophy at Durham University. I contributed a retrospective essay to the Durham volume and a short preface to the other.

In under two months' time I shall be spending a semester as a Visiting Professor at Bard in New York State, where my younger son will be entering on his third year as an undergraduate. I have agreed to give courses on the classical British empiricists and on *Language, Truth and Logic*, thereby completing a circle in my philosophical career.

LA MIGOUA
VAR
21 JULY 1986

POSTSCRIPT TO THE INTELLECTUAL AUTOBIOGRAPHY OF A.J. AYER

STILL MORE OF MY LIFE

It seems likely that Sir Alfred would have wanted to add to his intellectual autobiography his account of "a somewhat agonising but very astonishing experience" (Spectator *[16 July 1988], 7) which occurred in June 1988 when, according to one of his doctors, his heart stopped for four minutes. He speaks of being confronted by an exceedingly bright, painful, red light, which he took to be responsible for the governance of the universe, and he also refers to two creatures functioning as ministers for space and another couple for time. More importantly, his account is also filled with philosophical reflections on such topics as the evidential value of his experiences, space, time, and deity, the relation between mind and body, life as an extended series of experiences, personal identity, immortality, whether death ends consciousness, possibility of a future life, continuation of experience after death, relative merits of theism and atheism, and the superior claims of the doctrine of reincarnation over the notion of the resurrection of the body. As might be expected, however, throughout his discussion he speaks out forcefully against what he regards as the prevalent fallacy that a proof of an after-life, if one had such proof, would also be a proof of the existence of a deity.*

One of the readers of the Spectator *(Mr. Kenneth Carrdus) catches the spirit of Sir Alfred quite well in a limerick and letter to the editor in the issue of 16 July 1988:*

> *The rationalist, A. J. Ayer,*
> *Has answered the atheist's prayer:*
> *A Hell you can't verify*
> *Surely can't terrify*
> *Until you confirm that it's there.*

Sir Alfred's account of his remarkable brush with death and his reflections on it appeared in the London Sunday Telegraph **for 28 August 1988 with the title "What I Saw When I Was Dead . . ." and the London**

Spectator *for 15 October 1988 under the heading "Postscript to a Postmortem". In the latter he tells us that the title he gave the former was the Shakespearian "That Undiscovered Country".—LEH*

WHAT I SAW WHEN I WAS DEAD . . .

My first attack of pneumonia occurred in the United States. I was in the hospital for ten days in New York, after which the doctors said that I was well enough to leave. A final X-ray, however, which I underwent on the last morning, revealed that one of my lungs was not yet free from infection. This caused the most sympathetic of my doctors to suggest that it would be good for me to spend a few more days in the hospital. I respected his opinion but since I was already dressed and psychologically disposed to put my illness behind me, I decided to take the risk. I spent the next few days in my stepdaughter's apartment, and then made arrangements to fly back to England.

When I arrived I believed myself to be cured and incontinently plunged into an even more hectic social round than that to which I had become habituated before I went to America. Retribution struck me on Sunday, May 30. I had gone out to lunch, had a great deal to eat and drink and chattered incessantly. That evening I had a relapse. I could eat almost none of the food which a friend had brought to cook in my house.

On the next day, which was a bank-holiday, I had a long-standing engagement to lunch at the Savoy with a friend who was very eager for me to meet her son. I would have put them off if I could, but my friend lives in Exeter and I had no idea how to reach her in London. So I took a taxi to the Savoy and just managed to stagger into the lobby. I could eat hardly any of the delicious grilled sole that I ordered but forced myself to keep up my end of the conversation. I left early and took a taxi home. That evening I felt still worse. Once more I could eat almost none of the dinner another friend had brought me. Indeed, she was so alarmed by my weakness that she stayed overnight. When I was no better the next morning, she telephoned to my general practitioner and to my elder son Julian.

The doctor did little more than promise to try to get in touch with the specialist, but Julian, who is unobtrusively very efficient, immediately rang for an ambulance. The ambulance came quickly with two strong attendants, and yet another friend, who had called opportunely to pick up a key, accompanied it and me to University College Hospital.

Sunday *Telegraph,* 28 August 1988.

I remember very little of what happened from then on. I was taken to a room in the private wing, which had been reserved for me by the specialist, who had a consulting room on the same floor. After being X-rayed and subjected to a number of tests, which proved beyond question that I was suffering from pneumonia, I was moved into intensive care in the main wing of the hospital.

Fortunately for me, the young doctor who was primarily responsible for me had been an undergraduate at New College, Oxford, while I was a Fellow. This made him extremely anxious to see that I recovered; almost too much so, in fact, for he was so much in awe of me that he forbade me to be disturbed at night, even when the experienced sister and nurse believed it to be necessary.

Under his care and theirs I made such good progress that I expected to be moved out of intensive care and back into the private wing within a week. My disappointment was my own fault. I did not attempt to eat the hospital food. My family and friends supplied all the food I needed. I am particularly fond of smoked salmon, and one evening I carelessly tossed a slice of it into my throat. It went down the wrong way and almost immediately the graph recording my heart beats plummeted. The ward sister rushed to the rescue, but she was unable to prevent my heart from stopping. She and the doctor subsequently told me that I died in this sense for four minutes, and I have had no reason to disbelieve them.

The doctor alarmed my son Nicholas, who had flown from New York to be by my bedside, by saying that it was not probable that I should recover and, moreover, that if I did recover physically it was not probable that my mental powers would be restored. The nurses were more optimistic and Nicholas sensibly chose to believe them.

I have no recollection of anything that was done to me at that time. Friends have told me that I was festooned with tubes but I have never learned how many of them there were or, with one exception, what purposes they served. I do not remember having a tube inserted in my throat to bring up the quantity of phlegm which had lodged in my lungs. I was not even aware of my numerous visitors, so many of them, in fact, that the sister had to set a quota. I know that the doctors and nurses were surprised by the speed of my recovery and that when I started speaking, the specialist expressed astonishment that anyone with so little oxygen in his lungs should be so lucid.

My first recorded utterance, which convinced those who heard it that I had not lost my wits, was the exclamation: "You are all mad". I am not sure how this should be interpreted. It is possible that I took my audience to be Christians and was telling them that I had not discovered anything "on the other side". It is also possible that I took them to be sceptics and was implying that I had discovered something. I think the former is more

probable as in the latter case I should more properly have exclaimed "We are all mad". All the same, I cannot be sure.

The earliest remarks of which I have any cognisance, apart from my first exclamation, were made several hours after my return to life. They were addressed to a French woman with whom I had been friends for over 15 years. I woke to find her seated by my bedside and started talking to her in French as soon as I recognised her. My French is fluent and I spoke rapidly, approximately as follows: "Did you know that I was dead? The first time that I tried to cross the river I was frustrated, but my second attempt succeeded. It was most extraordinary. My thoughts became persons."

The content of those remarks suggests that I have not wholly put my classical education behind me. In Greek Mythology the souls of the dead, now only shadowly embodied, were obliged to cross the river Styx in order to reach Hades, after paying an odol to the ferryman, Charon.

I may also have been reminded of my favourite philosopher, David Hume, who, during his last illness, "a disorder of the bowels", imagined that Charon, growing impatient, was calling him "a lazy loitering rogue". With his usual politeness, Hume replied that he saw without regret his death approaching and that he was making no effort to postpone it. This is one of the rare occasions on which I have failed to follow Hume. Clearly I had made an effort to prolong my life.

The only memory that I have of an experience, closely encompassing my death, is very vivid. I was confronted by a red light, exceedingly bright, and also very painful even when I turned away from it. I was aware that this light was responsible for the government of the universe. Among its ministers were two creatures who had been put in charge of space. These ministers periodically inspected space and had recently carried out such an inspection. They had, however, failed to do their work properly, with the result that space, like a badly fitting jigsaw puzzle, was slightly out of joint.

A further consequence was that the laws of nature had ceased to function as they should. I felt that it was up to me to put things right. I also had the motive of finding a way to extinguish the painful light. I assumed that it was signalling that space was awry and that it would switch itself off when order was restored. Unfortunately, I had no idea where the guardians of space had gone and feared that even if I found them I should not be able to communicate with them.

It then occurred to me that whereas, until the present century, physicists accepted the Newtonian severance of space and time, it had become customary, since the vindication of Einstein's general theory of relativity, to treat space-time as a single whole. Accordingly, I thought that I could cure space by operating upon time. I was vaguely aware that

the ministers who had been given charge of time were in my neighbour-hood and I proceeded to hail them. I was again frustrated. Either they did not hear me, or they chose to ignore me, or they did not understand me. I then hit upon the expedient of walking up and down, waving my watch, in the hope of drawing their attention not to my watch itself but to the time which it measured. This elicited no response. I became more and more desperate, until the experience suddenly came to an end.

This experience could well have been delusive. A slight indication that it might have been veridical has been supplied by my French friend, or rather by her mother, who also underwent a heart arrest many years ago. When her daughter asked her what it had been like, she replied that all that she remembered was that she must stay close to the red light.

On the face of it, these experiences, on the assumption that the last one was veridical, are rather strong evidence that death does not put an end to consciousness. Does it follow that there is a future life? Not necessarily. The trouble is that there are different criteria for being dead, which are indeed logically compatible but may not always be satisfied together.

In this instance, I am given to understand that the arrest of the heart does not entail, either logically or causally, the arrest of the brain. In view of the very strong evidence in favour of the dependence of thoughts upon the brain, the most probable hypothesis is that my brain continued to function although my heart had stopped.

If I had acquired good reason to believe in a future life, it would have applied not only to myself. Admittedly, the philosophical problem of justifying one's confident belief in the existence and contents of other minds has not yet been satisfactorily solved. Even so, with the possible exception of Fichte—who proclaimed that the world was his idea but may not have meant it literally—no philosopher has acquiesced in solipsism. No philosopher has seriously asserted that of all the objects in the universe, he alone was conscious.

Moreover it is commonly taken for granted, not only by philosophers, that the minds of others bear a sufficiently close analogy to one's own. Consequently, if I had been vouchsafed a reasonable expectation of a future life, other human beings could expect one too.

Let us grant, for the sake of argument, that we could have future lives. What form could they take?

The easiest answer is that they would consist in the prolongation of our experiences, without any physical attachment. This is the theory that should appeal to radical empiricists. It is, indeed, consistent with the concept of personal identity which was adopted both by Hume and by William James, according to which one's identity consists, not in the possession of an enduring soul but in the sequence of one's experiences,

guaranteed by memory. They did not apply their theory to a future life, in which Hume at any rate disbelieved.

For those who are attracted by this theory, as I am, the main problem, which Hume admitted that he was unable to solve, is to discover the relation, or relations, which have to hold between experiences for them to belong to one and the same self.

William James thought that he had found the answers with his relations of the felt togetherness and continuity of our thoughts and sensations, coupled with memory, in order to unite experiences that are separated in time. But while memory is undoubtedly necessary, it can be shown that it is not wholly sufficient.

I myself carried out a thorough examination and development of the theory in my book *The Origins of Pragmatism.* I was reluctantly forced to conclude that I could not account for personal identity without falling back on the identity, through time, of one or more bodies that the person might successively occupy. Even then, I was unable to give a satisfactory account of the way in which a series of experiences is tied to a particular body at any given time.

The admission that personal identity through time requires the identity of a body is a surprising feature of Christianity. I call it surprising because it seems to me that Christians are apt to forget that the resurrection of the body is an element in their creed. The question of how bodily identity is sustained over intervals of time is not so difficult. The answer might consist in postulating a reunion of the same atoms, perhaps in there being no more than a strong physical resemblance, possibly fortified by a similarity of behaviour.

A prevalent fallacy is the assumption that a proof of an after-life would also be a proof of the existence of a deity. This is far from being the case. If, as I hold, there is no good reason to believe that a god either created or presides over this world, there is equally no good reason to believe that a god created or presides over the next world, on the unlikely supposition that such a thing exists.

It is conceivable that one's experiences in the next world, if there are any, will supply evidence of a god's existence, but we have no right to presume on such evidence, when we have not had the relevant experiences.

It is worth remarking, in this connection, that the two important Cambridge philosophers in this century, J.E. McTaggart and C.D. Broad, who have believed, in McTaggart's case that he would certainly survive his death, in Broad's that there was about a 50 per cent probability that he would, were both of them atheists.

McTaggart derived his certainty from his metaphysics, which implied

that what we confusedly perceive as material objects, in some cases housing minds, are really souls, eternally viewing one another with something of the order of love.

The less fanciful Broad was impressed by the findings of psychical research. He was certainly too intelligent to think that the superior performances of a few persons in the game of guessing unseen cards, which he painstakingly proved to be statistically significant, had any bearing upon the likelihood of a future life. He must therefore have been persuaded by the testimony of mediums. He was surely aware that most mediums have been shown to be frauds, but he was convinced that some have not been.

Not that this made him optimistic. He took the view that this world was very nasty and that there was a fair chance that the next world, if it existed, was even nastier. Consequently, he had no compelling desire to survive. He just thought that there was an even chance of his doing so. One of his better epigrams was that if one went by the reports of mediums, life in the next world was like a perpetual bump supper at a Welsh university.*

If Broad was an atheist, my friend Dr. Alfred Ewing was not. Ewing, who considered Broad to be a better philosopher than Wittgenstein, was naïf, unworldly even by academic standards, intellectually shrewd, unswervingly honest and a devout Christian. Once, to tease him, I said: "Tell me, Alfred, what do you most look forward to in the next world?" He replied immediately: "God will tell me whether there are *a priori* propositions." It is a wry comment on the strange character of our subject that this answer should be so funny.

My excuse for repeating this story is that such philosophical problems as the question whether the propositions of logic and pure mathematics are deductively analytic or factually synthetic, and, if they are analytic, whether they are true by convention, are not to be solved by acquiring more information. What is needed is that we succeed in obtaining a clearer view of what the problems involve. One might hope to achieve this in a future life, but really we have no good reason to believe that our intellects will be any sharper in the next world, if there is one, than they are in this. A god, if one exists, might make them so, but this is not something that even the most enthusiastic deist can count on.

The only philosophical problem that our finding ourselves landed on a future life might clarify would be that of the relation between mind and

*In May 1989 Ayer changed this to read: "if one went by the character of spiritualistic seances, life in the next world was like 'a "pleasant Sunday afternoon" at a nonconformist chapel, enlivened by occasional bump-suppers'." Cf. *The Meaning of Life,* pp. 198, 203.

body, if our future lives consisted, not in the resurrection of our bodies, but in the prolongation of the series of our present experiences. We should then be witnessing the triumph of dualism, though not the dualism which Descartes thought that he had established. If our lives consisted in an extended series of experiences, we should still have no good reason to regard ourselves as spiritual substances.

So there it is. My recent experiences have slightly weakened my conviction that my genuine death, which is due fairly soon, will be the end of me, though I continue to hope that it will be. They have not weakened my conviction that there is no god. I trust that my remaining an atheist will allay the anxieties of my fellow supporters of the Humanist Association, the Rationalist Press, and the South Place Ethical Society.

POSTSCRIPT TO A POSTMORTEM

My purpose in writing a postscript to the article about my "death", which I contributed to the 28 August issue of the Sunday *Telegraph,* is not primarily to retract anything that I wrote or to express my regret that my Shakespearian title for the article, "That undiscovered country", was not retained, but to correct a misunderstanding to which the article appears to have given rise.

I say "not primarily to retract" because one of my sentences was written so carelessly that it is literally false as it stands. In the final paragraph, I wrote, "My recent experiences have slightly weakened my conviction that my genuine death . . . will be the end of me." They have not and never did weaken that conviction. What I should have said and would have said, had I not been anxious to appear undogmatic, is that my experiences have weakened, not my belief that there is no life after death, but my inflexible attitude towards that belief. Previously my interest in the question was purely polemical. I wished to expose the defects in the positions of those who believed that they would survive. My experiences caused me to think that it was worth examining various possibilities of survival for their own sakes. I did not intend to imply that the result of my enquiry had been to increase the low probability of any one of them, even if it were granted that they had any probability at all.

My motive for writing the original article was twofold. I thought that my experiences had been sufficiently remarkable to be worth recording, and I wished to rebut the incoherent statement, which had been

(London) *Spectator,* 15 October 1988.

attributed to me, that I had discovered nothing "on the other side". Evidently, my having discovered something on the other side was a precondition of my having completed the journey. It follows that if I had discovered nothing, I had not been there; I had no right to imply that there was a "there" to go to. Conversely, if there was evidence that I had had some strange experiences, nothing followed about there being "another side". In particular, it did not follow either that I had visited such a place, or that I had not.

I said in my article that the most probable explanation of my experiences was that my brain had not ceased to function during the four minutes of my heart arrest. I have since been told, rightly or wrongly, that it would not have functioned on its own for any longer period without being damaged. I thought it so obvious that the persistence of my brain was the most probable explanation that I did not bother to stress it. I stress it now. No other hypothesis comes anywhere near to superseding it.

Descartes has few contemporary disciples. Not many philosophers of whatever persuasion believe that we are spiritual substances. Those who so far depart from present fashion as not to take a materialistic view of our identities are most likely to equate persons with the series of their experiences. There is no reason in principle why such a series should not continue beyond the point where the experiences are associated with a particular body. Unfortunately, as I pointed out in my article, nobody has yet succeeded in specifying the relations which would have to hold between the members of such a series for them to constitute a person. There is a more serious objection. Whatever these relations were, they would be contingent; they might not have obtained. But this allows for the possibility of there being experiences which do not belong to anybody; experiences which exist on their own. It is not obvious to me that this supposition is contradictory; but it might well be regarded as an irreparable defect in the theory.

If theories of this type are excluded, one might try to fall back on the Christian doctrine of the resurrection of the body. But, notoriously, this too encounters a mass of difficulties. I shall mention only one or two of them. For instance, one may ask in what form our bodies will be returned to us. As they were when we died, or when we were in our prime? Would they still be vulnerable to pain and disease? What are the prospects for infants, cripples, schizophrenics, and amnesiacs? In what manner will they survive?

"Oh, how glorious and resplendent, fragile body, shalt thou be!" This body? Why should one give unnecessary hostages to fortune? Let it be granted that I must reappear as an embodied person, if I am to reappear

at all. It does not follow that the body which is going to be mine must be the same body as the one that is mine now; it need not be even a replica of my present body. The most that is required is that it be generically the same; that is, a human body of some sort, let us say a standard male model not especially strong or beautiful, not diseased, but still subject to the ills that flesh is heir to. I am not sure whether one can allow oneself a choice with respect to age and sex. The preservation or renewal of one's personal identity will be secured, in this picture, by a continuity of one's mental states, with memory a necessary, but still not a sufficient, factor. I am assuming now that these mental states cannot exist on their own; hence, the need for a material body to sustain them.

I am far from claiming that such a scenario is plausible. Nevertheless it does have two merits. The first is that we are no longer required to make sense of the hypothesis that one's body will be reconstructed some time after it has perished. The second is that it does not force us to postulate the existence of a future world. One can live again in a future state of the world that one lives in now.

At this it becomes clear that the idea of the resurrection of the body had better be discarded. It is to be replaced by the idea of reincarnation. The two are not so very distinct. What gives the idea of reincarnation the advantage is that it clearly implies both that persons undergo a change of bodies and that they return to the same world that they inhabited before.

The idea of reincarnation is popular in the East. In the West it has been more generally ridiculed. Indeed, I myself have frequently made fun of it. Even now, I am not suggesting that it is or ever will be a reality. Not even that it could be. Our concept of a person is such that it is actually contradictory to suppose that once-dead persons return to earth after what may be a considerable lapse of time.

But our concepts are not sacrosanct. They can be modified if they cease to be well adapted to our experience. In the present instance, the change which would supply us with a motive for altering our concept of a person in such a way as to admit the possibility of reincarnation would not be very great. All that would be required is that there be good evidence that many persons are able to furnish information about previous lives of such a character and such an abundance that it would seem they could not possess the information unless they themselves had lived the lives in question.

This condition is indispensable. There is no sense in someone's claiming to have been Antony, say, or Cleopatra, if he or she knows less about Antony or Cleopatra than a good Shakespearian scholar and much less than a competent ancient historian. Forgetfulness in this context is literally death.

I should remark that even if this condition were satisfied, our motive for changing our concept of a person would not be irresistible. Harmony could also be restored by our changing our concept of memory. We would introduce the ruling that it is possible to remember experiences that one never had; not just to remember them in the way that one remembers facts of one sort or another, but to remember these experiences in the way that one remembers one's own.

Which of these decisions would lead us to the truth? This is a senseless question. In a case of this kind, there is, as Professor Quine would put it, no fact of the matter which we can seek to discover. There would indeed be a fact to which we should be trying to adjust our language; the fact that people did exhibit this surprising capacity. But what adjustment we made, whether we modified our concept of a person, or our concept of memory, or followed some other course, would be a matter for choice. The most that could be claimed for the idea of reincarnation is that it would in these circumstances be an attractive option.

This time let me make my position fully clear. I am not saying that these ostensible feats of memory have ever yet been abundantly performed, or indeed performed at all, or that they ever will be performed. I am saying only that there would be nothing in logic to prevent their being performed in such abundance as to give us a motive for licensing reincarnation; and a motive for admitting it as a possibility would also be a motive for admitting it as a fact.

The consequence of such an admission would be fairly radical, though not so radical as the standbys of science fiction such as brain transplants and teleportation. Less radical too than the speculations of mathematical physicists. These speculations titillate rather than alarm the reading public. Professor Hawking's book *A Brief History of Time* is a best-seller. Perhaps the reading public has not clearly understood what his speculations imply. We are told, for example, that there may be a reversal in the direction of the arrow of time. This would provide for much stranger possibilities than that of a rebirth following one's death. It would entail that in any given life a person's death preceded his birth. That would indeed be a shock to common sense.

PART TWO

DESCRIPTIVE AND CRITICAL ESSAYS ON THE PHILOSOPHY OF A.J. AYER, WITH REPLIES

1

Evandro Agazzi
VARIETIES OF MEANING AND TRUTH

A sign of the significance and depth of a philosophical approach is often provided both by its fertility in applications and the possibility it allows of going beyond its original limits. Indeed any intellectual perspective, to the extent that it is sharp and precise, implies the proposal of significant and illuminating views concerning a certain field, but at the same time may tend to push to an inferior level of validity some other fields, or even to deny their intellectual legitimacy. This usually gives rise to criticisms, which may be met by defending or restoring the 'internal' consistency of the approach in question, and by showing that it is susceptible of certain developments which may give a more satisfactory account of those issues that had been less convincingly accounted for at the beginning.

Alfred Ayer's philosophy seems to be really in this position. For it certainly counts among the most significant doctrines in contemporary philosophy. It has provided one of the most precise and rigorous characterizations of the concepts of meaning and truth, proposing what could honestly be qualified as the paradigm of analytic philosophy under this respect. The field where his approach has shown its special merits is that which we could label as the domain of 'descriptive truth', which includes the sciences and a wide spectrum of common sense knowledge. However, the sharpness and cogency of his criteria have led Ayer to seriously degrade the cognitive status of other domains, in particular those where value judgments are involved (such as ethics and aesthetics) and those of metaphysics and religion. Criticisms addressed to his philosophy have been met by him (and in general by the representatives of analytic philosophy) especially as far as the internal consistency of the

This essay was on my desk when I received word of Professor Ayer's death.—ED.

stated paradigm is concerned, but it seems possible and interesting to investigate how far one could go in overcoming certain limitations of his original outlook without dismissing its basic ideas by developing the potentialities of other less exploited aspects of his thought.

In so doing one will certainly have to propose amendments to some of his original claims, but this may be done rather in the spirit of certain 'liberalizations' of his empiricist position, a liberalization which is fully in keeping with the openness of mind which was already so clearly evident in the introduction to the second edition of his *Language, Truth and Logic*. He accepts there modifications and corrections of his previous views, and even recognizes certain "mistakes", with an intellectual honesty and courage which are not very common in the philosophical literature.

1. PROPOSALS FOR A LIBERALIZATION OF CERTAIN OF AYER'S VIEWS

In trying to propose these 'liberalizations' I shall refer to certain elements of Ayer's thought which are already present in the second edition of his *Language, Truth and Logic*, which is rightly considered as a 'classic' in contemporary philosophy and which (as I have just said) is seminal —as every real classic is—both in terms of what can be developed according to it and also beyond it. In this spirit we may find an implicit legitimation of our proposal in these clear statements of Ayer himself:

> In putting forward the principle of verification as a criterion of meaning, I do not overlook the fact that the word "meaning" is commonly used in a variety of senses, and I do not wish to deny that in some of these senses a statement may properly be said to be meaningful even though it is neither analytic nor empirically verifiable. . . . Thus, while I wish the principle of verification itself to be regarded, not as an empirical hypothesis, but as a definition, it is not supposed to be entirely arbitrary. It is indeed open to anyone to adopt a different criterion of meaning and so to produce an alternative definition which may very well correspond to one of the ways in which the word "meaning" is commonly used. And if a statement satisfied such a criterion, there is, no doubt, some proper use of the word "understanding" in which it would be capable of being understood. Nevertheless, I think that, unless it satisfied the principle of verification, it would not be capable of being understood in the sense in which either scientific hypotheses or common sense statements are habitually understood.[1]

The significance of this passage is twofold. First it clearly states an explicit openness to a variety of meanings; secondly it specifies the restricted sense of "meaning" adopted in the book, i.e., the sense which is

implicit in our 'understanding' of the statements of science and "habitually" also in those of common sense. It seems correct to identify this sense of "meaning" as that which is involved in statements regarding 'matters of fact', and which is attached to what we could call "descriptive sentences" in a rather broad sense (i.e., a sense which includes also scientific hypotheses, which are usually meant to be there in order to 'explain' facts, but which are intended, after all, to help us understand 'how things are'). Now, among the statements of common sense (perhaps occurring less "habitually"), there are many that are not descriptive, since they express not so much 'how things are', but rather 'how things ought to be': in short, they express value judgments. It seems therefore advisable to see whether they may be equipped with some 'meaning' (since it is undeniable that people 'understand' them), and since having meaning (also according to Ayer) is a sufficient precondition for being true or false, this generates the problem of investigating the conditions of truth or falsity of these statements. Ayer's position is that ethical or aesthetical statements are "expressions of feelings" and not propositions which might be true or false. My aim is to see whether a liberalisation of the concepts of meaning and truth could lead to a certain modification of this position.

This issue is also important in order to see whether philosophy may have a certain specific domain of knowledge. In the last page of the introduction to the second edition of his book, Ayer mitigates the rather negative answer he had given to this question in the first edition, however without providing a characterization of the specificity of the philosophical propositions which—he says—"are true or false" and "fall into a special category". How may one recognize this specificity? At the very beginning of Chapter I of the book he gives us an indication:

> For if there are any questions which science leaves to philosophy to answer, a straightforward process of elimination must lead to their discovery.[2]

Are there such questions? Of course there are: questions connected with value judgments are of the sort, but also questions concerning the sense of life, the existence of God, and so on. Ayer does not disregard these questions (and by this very fact he implicitly admits that they belong to philosophy) and gives them also an answer, usually in the negative. This answer however comes from having applied to the investigation of these questions the criteria of meaning and truth which he has proposed as being typical for science, and in such a way he risks being at least unfair, since it does not seem fair to "leave to philosophy" an issue, and then to demand that philosophy tackle it with the criteria of science. It seems therefore more advisable to see whether criteria of

meaning and truth, different from those useful for answering questions regarding matters of fact, could be proposed for treating questions which are not of a 'descriptive' nature.

2. VALIDATION AND VERIFICATION

This possibility is again not in contrast with Ayer's intellectual attitude. At a certain point of his book he says:

> In saying that we propose to show "how propositions are validated," we do not of course mean to suggest that all propositions are validated in the same way. On the contrary we lay stress on the fact that the criterion by which we determine the validity of an *a priori* or analytic proposition is not sufficient to determine the validity of an empirical or synthetic proposition. For it is characteristic of empirical propositions that their validity is not purely formal.[3]

What is interesting in this passage is that Ayer recognizes here that the criteria of "validation" for propositions are at least of two kinds even in science, i.e., the criterion of analyticity and the criterion of verifiability. One might also go further and say that even verifiability takes many different forms in the empirical sciences, but this is not very important at this stage. What is spontaneously suggested by this passage is that, in the same way as a plurality of validation criteria is admitted for science, an enlarged plurality should be admitted for "validation" outside science itself. In particular, if it is true that a given criterion "is not sufficient to determine the validity of an empirical or synthetic proposition", why should it not be true that the scientific criteria as a whole are "not sufficient to determine the validity" of a proposition which does not deal with matters of fact?

The legitimacy of this question becomes even more clear if one considers the invincible criticism that Ayer is able to concentrate in less than one page against any subjectivist and utilitarian analysis of ethical concepts, arriving at the conclusion that "it is only normative ethical symbols, and not descriptive ethical symbols, that are held by us to be indefinable in factual terms."[4] Here a decisive difference surfaces between 'descriptive' and 'normative', which already entails that the validation criteria which are appropriate for the descriptive domain may be (and are indeed) inadequate for the normative domain. And this is actually what Ayer goes on to develop. Having restricted (practically if not theoretically) his admitted criteria of validation to those which are used in the descriptive domain, he comes to the conclusion that no validation proper is possible in the domain of norms: "We can now see

why it is impossible to find a criterion for determining the validity of ethical judgments."[5] But since these judgments are very commonly expressed and defended, he accounts for them as being mere expressions of feeling and concludes:

> For we have seen that, as ethical judgments are mere expressions of feeling, there can be no way of determining the validity of any ethical system, and, indeed, no sense in asking whether any such system is true.[6]

Is this solution really satisfactory? It seems difficult to say that it is, and this may be shown by resorting to the method of the "definition in use" advocated by Ayer himself and briefly described at p. 60 of his work. Let us consider his example:

> If I say to someone, "You acted wrongly in stealing that money," I am not stating anything more than if I had simply said, "You stole that money." In adding that this action is wrong I am not making any further statement about it. I am simply evincing my moral disapproval of it. It is as if I had said, "You stole that money," in a peculiar tone of horror, or written it with the addition of some special exclamation marks. The tone, or the exclamation marks, adds nothing to the literal meaning of the sentence. It merely serves to show that the expression of it is attended by certain feelings in the speaker.[7]

What prevents this analysis from falling into a subjectivist interpretation of ethical terms is the adjective "moral" attached to "disapproval", and to see how a moral disapproval is different from a mere subjective disapproval one may go back to Ayer's criticism of the subjectivist analysis of ethical terms, when he correctly points out that "a man who confessed that he sometimes approved of what was bad or wrong would not be contradicting himself."[8] Now what makes an action "bad or wrong" independently from one's approval? The fact that he attaches to it a feeling of "horror"? But how could one 'approve' something which produces in him a feeling of horror? A more satisfactory analysis of the above sentence seems to be the following: the *intention* in my saying, "you acted wrongly in stealing that money" is to express a value judgment on that action, whose correct linguistic translation could be, "You *ought not* have stolen that money." My intention is that of manifesting a discrepancy between a matter of fact (which is expressed by the "literal meaning" of the last part of the statement) and an ought-to-be which is expressed by the first part, in which I said, "You acted wrongly." The feeling of horror may be the *consequence* of considering this departure from the ought-to-be, so that I implicitly maintain that also the other person *should* have horror of acting this way.

As is clear, the *meaning* of the statement expressing a moral judgment results from the consideration of its *use* within a given *context*, and taking into account the *intention* with which it is uttered. All these

factors are actually present in Ayer's book, though with a different degree of explicitness. The most explicit is the reference to use, but a significant reference to the context is also to be found, though in a rather disguised way, in particular where he discards the possibility of purely ostensive propositions:

> For the notion of an ostensive proposition appears to involve a contradiction in terms. It implies that there could be a sentence which consisted of purely demonstrative symbols and was at the same time intelligible. And this is not even a logical possibility. A sentence which consisted of demonstrative symbols would not express a genuine proposition. It would be a mere ejaculation, in no way characterizing that to which it was supposed to refer. The fact is that one cannot in language point to an object without describing it. If a sentence is to express a proposition, it cannot merely name a situation; it must say something about it.[9]

These statements (where one can find a kind of anticipation of the 'theory-ladenness' of observational terms) should be already sufficient for making clear that simply in order to say, "You have *stolen* that money," I must presuppose along with my interlocutor a context in which to "steal" has a meaning, and this meaning cannot be captured by any purely empirical device, such as "picking up" the money. In fact it is not the fact of picking up the money that makes that action a stealing, but the circumstance that this money was the *legitimate* property of someone else, and this is by no means an empirical feature. Moreover, when I say, "You acted wrongly in stealing that money," I do not simply recognize the action as being a theft, but in addition express a moral negative judgment about it. This further step comes from the intention of evaluating this action with respect to a certain ought-to-be, and not from the intention of expressing any feeling of mine. To see this it is sufficient to consider how often we ask ourselves moral questions, and try honestly to see what we really ought to do: in these situations we are not at all aiming at expressing our feelings, but at making the morally right choice, which may imply sometimes making a choice between the course of action that would be suggested to us by conflicting feelings.

3. CONTEXT AND INTENTION

What I have said here was put forward not so much with the view of stressing the difference between judgments of fact and judgments of value, but rather as an opportunity for calling attention to the role that 'intention' plays in determining the nature of contexts and the criteria of meaning. This is not explicitly recognized by Ayer, but is actively present

in a covert way in his characterization of the criteria for meaning and truth. For example, the principle of verification is introduced as a criterion of meaning as follows:

> The criterion which we use to test the genuineness of apparent statements of fact is the criterion of verifiability. We say that a sentence is factually significant to any given person, if, and only if, he knows how to verify the proposition which it purports to express—that is, if he knows what observations would lead him, under certain conditions, to accept the proposition as being true, or reject it as being false.[10]

Here it is not only clear that verifiability is advocated as a criterion for "statements of fact", but also that it practically consists in predicting future observations, and this implicitly implies that this 'intention' of always securing such predictions is involved in the decision of accepting this criterion. This circumstance is even clearer in the definition of truth, which Ayer discusses especially with regard to scientific hypotheses:

> What is the purpose of formulating hypotheses? Why do we construct these systems in the first place? The answer is that they are designed to enable us to anticipate the course of our sensations. The function of a system of hypotheses is to warn us beforehand what would be the course of our experience in a certain field to enable us to make accurate predictions.[11]

> We have now obtained the information we required in order to answer our original question, "What is the criterion by which we test the validity of an empirical proposition?" The answer is that we test the validity of an empirical hypothesis by seeing whether it actually fulfils the function which it is designed to fulfil. And we have seen that the function of an empirical hypothesis is to enable us to anticipate experience.[12]

The validation (i.e., the test of truth) of an empirical proposition is therefore defined in terms of "the function *which it was designed* to fulfil", and this is tantamount to explicitly including a reference to the *intention* in the criterion of truth. I have not made these remarks as a kind of negative criticism of Ayer. Quite the contrary. I believe that such references to the context, and the intention presiding over the determination of the context, are of paramount importance, and deserve much more attention than that which has been paid them till now. In the sequel I shall try to show how a consistent application of this approach can lead to an enlargement of Ayer's criteria of meaning and truth, in those cases in which the context of the "statements of fact", and the related intention of "anticipating our experience" are no longer the fields in which we *use* our concepts and construct our discourse. In developing these reasonings I shall now depart from a strict reference to Ayer's work, in order to organize a self-contained set of arguments. Since meaning and truth are strictly interconnected, I will prefer—also for reasons of brevity—to

devote my analysis to only one of these issues, i.e., to truth. Explicit reference to meaning will be made only when it appears to be particularly useful.

4. The Polysemy of "Truth"

Let us begin with a factual remark: the notion of truth is frequently *used* in ethics, aesthetics, and political philosophy, no less than in ontology, logic, philosophy of language, and epistemology; and differences between these uses are certainly not negligible. Hence the question: *which* one, among these different meanings, should be selected as being the correct, proper and clear one, and by *virtue of what* could we legitimate such a choice? As is easy to see, the difficulty in answering this question does not reside so much in the fact that every specialist would probably find good reasons for claiming that the proper concept of truth is that which is actually adopted in his own discipline, but rather in the fact that *whatever* effort we might undertake to justify our choice, it would always be based upon some *presupposed* conception of truth (be it general, as it might); so we would be unable to avoid the pitfall of circularity. Should we then accept a plurality of meanings for the term "truth"? I believe so, but not simply as a consequence of the fact that, for practical or theoretical reasons, we fail to have adequate means for making a choice among too many candidates; rather we should accept this plurality of meanings just because it parallels the existence of different *kinds* of truth.

In order to clarify this point, let me begin with the remark that polysemy is a quite general feature of terms, including those which serve to establish classifications. This is widely recognized and is usually explained as a consequence of the fact that the meaning of a term depends to a large extent (some even say completely) on the *context* in which it occurs. Without undervaluing this statement, I have the impression that not enough stress has been put on the importance of another aspect of the issue, i.e., on the *intention* of those who accept or decide to use the term in a particular context. However, I want immediately to avoid a possible misunderstanding: I am not maintaining here that there are two things to be considered, namely the context on the one hand and the intention on the other, but that the intention is a part, and indeed a very essential part, of the context itself, so that no sufficient presentation of a context could be given by simply indicating its *structure*.

What is meant here may perhaps be made easier to understand by resorting to Wittgenstein's model of a language game, which we shall

consider as an acceptable equivalent to the concept of a *context*. In order really to be a game, a language game cannot be characterized by *only* giving its rules, but it must include the specification of the *winning situation* and also imply that whoever accepts to engage himself in the game, also accepts to *strive* toward the winning situation. In this sense we must say that the *intention* of winning is objectively and not simply subjectively included in any definition of a game, so that someone who behaves simply according to the rules of a game, without seeking to win, is not really playing the game, but only acting capriciously, or perhaps pursuing other goals (including that of losing, for reasons external to the game). As a matter of fact, whoever "learns a game" tries to learn how to win, and the learning of the rules is simply instrumental to the central aim which is that of becoming more and more skilled in the practice of the game, so as to be able to win in more cases and against more expert players. As a consequence, we must say that the intention to win is an intrinsic part of the general concept of a game, while the different sets of rules serve to specify different games, in the sense that they describe the winning situation differently, as well as the admissible ways to reach it. Someone who does not play with the intention of winning could be said to be unfair toward the other players in that he is not really playing the game he seems to be playing.

Putting aside our analogy with the language game (without discussing if and how far what we have said is explicitly or implicitly included in Wittgenstein's doctrine), we must say that we cannot give an adequate characterization of a concept simply by describing those circumstances in which we do (or do not) *use* the corresponding *term;* we also need to make clear the *point* of the concept, that is, to specify what we use the corresponding term *for*. A straightforward consequence of this fact is that, although every concept primarily has the effect of determining a classification, this does not happen in a kind of unique way, but depends on the particular 'interest' (in the broadest sense of this word) which orients our search for a classification: it is this 'interest' that suggests the ways of 'contextualization' which may better fit our purpose, and in such a way in different contexts the term actually has different (although somewhat related) meanings.

If we consider now the concept of *truth* in particular, we cannot deny that its meaning includes the idea that we *aim at* making *true* statements (rather than, e.g., amusing, elegant, imperative, or exhortatory statements) in very different fields, including not only that of factual knowledge, but also domains related to duties, obligations, beauty, justice, human destiny, the meaning of life, and so on. This means that (in analogy with the case of games, where winning is the generic aim, but

gives rise to different *kinds* of games according to other complementary 'interests' or 'intentions') the generic aim of making true statements gives rise to different *kinds* of truth according to the different 'interests' (e.g., ethical, aesthetical, political, or religious) which determine the choice of the *field* in which we want to search for true statements, and in which our particular definition of truth could provide us with a classification in keeping with the features of the subject matter. Therefore, it may well be the case that a certain *kind* of classification (i.e., of definition of truth) turns out to be particularly clear, widely accepted, and of special importance, but this by no means implies that other kinds cannot be taken into serious consideration according to *other* perspectives or interests, even though their explicit elaboration might still leave much to be desired. Without going too far from the examples just mentioned, the claim that ethical statements cannot be called "true" or "false" may turn out to be an arbitrary restriction of the legitimate use of the notion of truth to just *one kind* of statement, e.g., to statements 'aiming' at describing how things are (and even in the more restricted sense of fruitfully anticipating the course of our experience, as Ayer's principle of verification is expected to do).

It is by recognizing this difference in kind, depending on the particular "point of view" under which one's investigation is carried out, that useless and meaningless polemics and contrasts, which are at the root of many misunderstandings and also of several manifestations of intolerance, may be avoided. For instance, to someone deeply inspired by religious interests, scientifically true statements might seem to be insignificant, to have nothing to do with 'the real truth' (i.e., with religious truth, which is the only one that matters to him); and conversely someone who is strongly positivistically minded might say that only statements of the sciences, or at least statements showing some of their fundamental features, may be true, while religious or ethical statements must be regarded as emotional expressions, for which the application of the concept of truth is simply meaningless. These are examples of contrasts that may arise from assuming a *particular kind* of truth as being the only legitimate one; but other contrasts are the consequence of conceiving of truth as a single *unarticulated* field. In this case, when two statements belonging to different domains come to a verbal collision, at least one of the two is thought to be necessarily false, while they might both be true *within (or relative to)* their respective contexts, the difference of which is not taken into consideration. For instance, the tragic conflict between Galileo and the Church was a case in point because the theologians who condemned him were unable to see that the statement that the Earth is revolving around the Sun was *true* in astronomy without being *false* in religion or in theology; in fact, although contrary to some

literal renderings of the Bible, they were *not* proper religious or theological statements. This, however, cannot be established by simply investigating the *context* of the statements (they actually *belong* to the Bible, which is one of the religious contexts par excellence), but can be seen only if we regard the *point, intention,* or *interest* of this context, which is surely not that of providing correct astronomical information. For that reason, taking those statements of the Bible as expressing an astronomical truth was simply depriving them of their proper possible meaning, and thereby making them incapable of being either true or false. It should be clear from this discussion that the only viable way of conceiving of truth is that which sees it as articulated in different ways (these, however, preserve a certain unity which we shall investigate later).

5. AMBIGUITIES ABOUT TRUTH

So far we have spoken of different kinds of truth in the sense of recognizing that in various domains truth is not only established according to different *criteria*, but also receives different *meanings*. (To a certain measure this is obvious, as the meaning of a concept certainly includes some reference to the criteria of truthfulness to which it is related, but the question remains open whether these determine the meaning entirely.) There is, however, also another and more drastic diversity in the way of conceiving of truth which I shall mention only briefly. This difference I have for many years characterized as that between an "adjectival" and a "substantival" conception of truth.[13] The reason for these denominations is that in our linguistic practice we use both the adjective "true" and the substantive "truth", but in this use some important philosophical presuppositions may be concealed. Indeed the normal use of an adjective is to attribute a property to something, while a substantive, as its etymology suggests, is primarily intended to designate "substances", i.e., really existent entities.

Now, the 'adjectival use' of truth is somehow ambiguous in the common language, since "true" is usually said of a proposition, but on the other hand locutions such as "true friend", "true communist", and so on are by no means exceptional. In our present discussion we want to restrict the use of "true" primarily to propositions, following in such a way a line of thought which goes back to Aristotle, and which is also the one accepted by Ayer. Discussing the legitimacy and the linguistic conditions for using "true" also in other 'non-propositional' senses might be interesting, but will not concern us here.

In the case of "truth", it is clear that this noun may be taken in the singular as denoting a specific *property* (e.g., the property that certain

propositions may or may not have according to some suitable definition of "truth"); we shall call this the "property-meaning". But it is no less clear that we also use this noun in the plural, as, e.g., in locutions such as: "the truths of physics", "the truths of the Christian faith", "the most elementary geometrical truths", and "the deepest philosophical truths". Locutions of this kind tend to give the impression that "truth" is a term like "animal", which has an extension compartmentalizable into sub-classes and sub-subclasses (like those of "mammals", "dogs", "fox terriers", down to individual dogs) whose members are 'at the bottom' individually existing substances. Similarly, we should have subclasses and sub-subclasses of truth, whose ultimate members are 'at the bottom' individual truths.

It is undeniable that this corresponds to a real *substantialization of truth*. This is however the meaning which I reject in this discourse (again in keeping with Ayer). Without discussing here the reasons of this rejection,[14] let me simply say that, at least for reasons of clarity, I prefer here to stick to the view—expressed in the history of philosophy at least from the time of Aristotle's *Organon*—that declarative propositions and only these, *may* be true (or false) and *necessarily are* either true or false, this property depending on their saying or not saying "what actually is the case". As a consequence, truth (and falsity) were recognized as being properties of declarative propositions depending not on the existence of some substance called "truth", or on various individual substances constituting single truths, but simply on the obtaining of a certain relation between the proposition and reality in a very broad sense (the "correspondence theory of truth" is not necessarily implied by this definition, nor by the modern Tarskian definition, as could be shown).

The 'adjectival' conception of truth, even if we further restrict it to what we have called its "propositional" meaning, allows a great variety of specifications, according to the various kinds of propositions it makes sense to consider as being true (or false). The first class of such propositions is the certainly very important classical one, which contains the so-called "descriptive propositions"; this is also the class which is referred to in Ayer's philosophy. However this is surely not the only class of propositions which are *meant* to be possibly true or false, according to both everyday language and the philosophical tradition. Indeed *declarative propositions* are not thought to be restricted to being 'descriptive propositions' in the empirical sense usually attached to this expression. Therefore the original Aristotelian doctrine that truth is a characteristic of declarative propositions in general has rather encouraged people to think that *true* statements are to be aimed at concerning, e.g., ethical, aesthetical, religious, political, and juridical matters, where descriptive

moments may be included, but do not really constitute the core of the issues. Aside from that, further differentiations occur within the single classes of the partition just mentioned. Our proposal is to provide an idea of this articulation first by analyzing the internal differentiation of the descriptive propositions and then by hinting at possible criteria for admitting other kinds of truths of a non-descriptive character.

6. The Field of Descriptive Truth

Descriptive propositions, according to the rather general characterization which is suitable for our discourse here, are meant to be those whose intention is that of saying 'how things are' (and not simply those which restrict themselves to reporting some immediate evidence). It is important to note that we have made reference to *intention* in our characterization, and this is not just accidental, but is rather a necessary condition for making this characterization sufficiently precise. Indeed, we could not make it such by simply pointing out the *structure* of such propositions, for on this basis we would not be able to distinguish the descriptive statements of a novel (which *do not intend* to speak of real states of affairs, but of imagined situations) from, let us say, a scientific geographical report (which does *intend* to say 'how things are'). This is why no one requires the single descriptive statements of a novel to be true (such a requirement would not even make sense), though in some other respect not the single statements, but the whole novel, or perhaps some part of it, might be said to be "true" in some *special* sense.

Now taking into consideration those propositions whose aim is to describe how things are, we can say that they are true if and only if they are successful in the pursuit of this aim. From this point of view it is clear that the property of being true pertains to a proposition if it stands in a certain *relation* to reality (i.e., to the way things are or to the actual 'state of affairs'), and it is quite plausible that something like the criterion of verifiability (with the necessary liberalizations and corrections which have been put forward during the development of analytic philosophy) offers a valuable means for pursuing this aim. What may be noted here is that the truth of a descriptive proposition appears to reside in a certain relation between the proposition and something different from it to which it refers, and which we may call for that reason its *referent*.

The mention of this word immediately reminds us that it is already in use in connection with concepts or *terms*, so that the question spontaneously arises whether (and how) the referent of a proposition might be obtained from the referents of the terms which compose the sentence, the

question also being reinforced by the widespread conviction that truth-conditions are intrinsically involved in the determination of *meaning*. We are therefore obliged at this stage to devote a digression to the problem of meaning.

6.1 Meaning and Reference

Unfortunately the issue is complicated by the controversies regarding the ways of distinguishing the meaning and the referents of a term from the meaning and the reference of a proposition. Without entering into all the details of this controversy, it seems reasonable to recognize that the referents of several terms may be established directly by means of non-linguistic procedures (while their meaning always involves a relation to an intra-linguistic *context*), and that these procedures also determine the (always extra-linguistic) truth-criteria for propositions made entirely of such terms (while the meaning of these propositions is linguistically dependent on the meaning of their constitutive terms through the *context*).

Now there has often been a tendency to identify the meaning of a term with its reference, and the meaning of a proposition with its truth-criteria. This has led to undesirable, and also mutually incompatible consequences. We are, however, not interested in following this complicated story, but simply in investigating a problem which it leads to, i.e., the question of the mutual relationships between meaning and reference (and in particular their 'order of precedence'). Actually it seems all too natural, on the one hand, that we *first* have to understand the meaning of a term in order to be able to capture its possible referents, and that we first have to understand the meaning of a proposition in order to be able to test it and find out whether it is true or false. But on the other hand it should be no less clear that whenever we mention a concept, it is always a concept of something, and this is already sufficient to prove that no concept may be expressed at all without including a specific link with its *intended* referents, so that one might legitimately claim that we *first* concentrate our attention on certain referents and then try to express 'what they are' by verbally expressing certain concepts 'about' them, concepts which are to be judged on the basis of their 'adequacy' in capturing what the intended referents are.

The case of propositions, however, is only partially similar to that of terms, and this because we have to take into consideration here *two* steps and not just one (overlooking this difference may lead to several unnecessary difficulties). The first is the step of meaning, or the semantic level, and the second is the step of asserting, or the *apophantic* level. Understanding (completely) the meaning of a sentence always implies

understanding the meaning of the terms occurring in it and also knowing what they *refer* to; but this is not sufficient, since these terms are interconnected by relations constituting a certain structure, so that the meaning of the sentence jointly depends upon the said *structure* and the meaning of the isolated terms (and also on the broader *context* to which the sentence belongs).

But now comes the second step: we have to know whether or not the sentence is *intended* to be *asserted* of its referents, and only in this case does the problem of its truth emerge (of course, this step may quite often remain implicit, as when we directly ask about the truth of a given sentence, tacitly acknowledging that the proposition has not only been formulated, but also that it has, at least possibly or potentially, been asserted). From this analysis it appears that, while in the case of terms we often (not always!) are in the situation where the reference precedes and determines the meaning, in the case of sentences the meaning determines the reference (we have to understand the meaning of the terms occurring in the sentence and know their reference in order to know what the sentence is about); moreover, only *after* one has obtained an understanding of the meaning of the sentence can the question arise regarding its truth, and a fortiori, can the problem arise as to *how* to answer this question. This fact is often stressed by the obvious remark that we very often understand what a sentence means, without knowing whether it is true or not, while the contrary can never happen.

6.2 The Role of Intention

All we have said so far is probably satisfactory from the point of view of a logical analysis, but a kind of reversal of the whole situation occurs as soon as we take into consideration the *intention* which presides over the construction of descriptive propositions, i.e., the intention of saying 'how things are'. This intention can only be satisfied if we are able to arrive at propositions which can be recognized as being *true* about their intended reference. Thus the *importance* of the problems reveals an order which is inverse with respect to the logical order just examined: the requirement of determining truth-criteria becomes of *first* importance (since there does not seem to be much interest in having sentences which, although meaningful, cannot in principle be determined to be true or false, possibly with some margin of incertitude). But this first condition entails that only a limited number of properties and relations of things should be recorded in our propositions (i.e., those properties for which we have some testing procedures to be used also as truth-criteria for the corresponding sentences) and, therefore, that only things endowed with those

properties could be referents of our propositions. Hence a *restriction* of the possible referents is the *second* feature involved in this order-reversal.

However, there are still further implications to be seen: the restriction just mentioned not only entails that many things may be excluded from the reference of certain propositions, but also that things which are included will be considered only *as far as* they are endowed with the selected set of properties being considered, other properties being left out of account. This use of the truth-criteria as referentiality-criteria as well determines a third consequence: the meaning of the concepts related to those 'specialized' referents also becomes specialized and partial, with respect to the much more general meaning they had before the establishment of the truth-criteria in question.

6.3 The Compartmentalization of Descriptive Truth

We shall not go on presenting further details of the foregoing discourse. What we have said is enough to suggest that a suitable balance should be reached between the two opposite dynamics considered here, and this balance may be described as follows. Descriptive propositions tend to be organized according to some fundamental *viewpoints* under which reality is going to be scrutinized (e.g., those of life, motion, shape, consciousness, the internal constitution of material bodies, etc.), and every such viewpoint is characterized by the occurrence of certain central concepts, which already determine a certain partition of the domain of possible referents. These concepts, however, are usually still too general to give rise to sentences for which truth-criteria could be effectively given. Therefore, they are further analyzed into other more detailed concepts, some of which, at last, can be equipped with extra-linguistic criteria which serve at the same time as specific (and specialized) criteria for *referentiality* and as specific (and specialized) criteria for *truth*. For example, the general proposal of seeing reality as consisting essentially of matter may lead to the more specific concept of mass, which can be associated with some operational procedure such as that of comparing the mass of two things by using a balance. This procedure determines at the same time which referents we shall be concerned with (i.e., only those which reveal a mass when put on a balance) and how we can establish the truth of sentences attributing a given mass to a given thing.[15]

6.4 From Compartmentalization to Plurality of Truth

The above enables us to see that many kinds of truth are already present in the domain of descriptive propositions. Indeed every point of view predetermines the conceptual horizon, the *domain of discourse*, in which

concepts receive their specific meaning and their specific referents, which is also the domain in which, accordingly, all sentences receive their specific meanings and are submitted to specific truth-conditions. If we now take the liberty of employing in a colloquial sense the substantival use of "truth", we may say that each domain of discourse contains its specific truths, which are specific both in the sense of being about specific (or specialized) referents and of being established according to specific (and specialized) truth-criteria. These truths, though possibly related to the truths of other domains, never confuse themselves with them: they are of a different kind and any effort to check the truth of one domain by means of criteria pertaining to another is doomed to lead to misunderstanding. This is why the specific outlooks, ways of thinking, of 'seeing', testing, proving, and stating arguments are different, e.g., in mathematics, physics, biology, psychology, historiography, linguistics, and sociology, though all these disciplines construct their discourse by means of descriptive sentences, with the intention of saying 'how things are' in their respective fields (i.e., with the intention of producing true sentences in their fields).

The awareness of this multiplicity, which obtains at the level of descriptive sentences, and which we could therefore call a difference in kinds of 'descriptive truth', is already such as to suggest that we explore the legitimacy of new *kinds* of truth in the sense of 'non-descriptive truth'. As we have already noted, we feel encouraged in pursuing this research by a well known fact: that we all very commonly claim to affirm *true* statements not only about 'how things are' but also, e.g., about 'how things ought to be' (covering by this expression the wide spectrum of 'value statements' or 'value judgments', as distinct from the field of 'factual statements' or 'factual judgments'). This suggestion will prove correct in the sequel but, before coming to that, we need to prepare the path by enlarging the use of the notion of truth on the plane of descriptive intention itself and, in order to see that, we shall begin by considering some cases in which the property of being true is not attributed to statements, sentences, or propositions proper.

6.5 *The Truth of Theories*

The proposal of extending the concept of truth beyond the domain of propositions may at first generate some suspicion of inconsistency, with regard to what we have said concerning the choice made here in favour of the 'propositional meaning' of truth. But this suspicion disappears if we attentively consider what is really meant when we say that a certain scientific *theory* is true (or false). There is a classical answer to this

question, which we find in dozens of books and articles belonging to the empiricist-analytical tradition in the philosophy of science; it says: (i) any scientific theory is a set of sentences, so that (ii) it could ideally be identified with the logical conjunction of these sentences, which implies (iii) that it is true if and only if *all* its component sentences are true, and in particular (iv) that if a false sentence may be correctly deduced from a given theory, this automatically means that the theory itself is false. Against this view, which has been labelled as the 'statement view' of scientific theories, violent criticism has been exercised during the last two decades, which has had as a common starting point the historical consideration that theories that are determined to be 'false' according to the above scheme, are often nevertheless not discarded or dismissed for that reason. This has generally led to a rejection of the idea that theories are sets of sentences, and to the proposing of a variety of alternative conceptions which we are not interested in taking up here.[16]

I am convinced that this reaction has gone too far, because theories after all *are* sets of sentences, though not *only* that: they are sets of *structurally* organized sentences; and the weak point of the 'sentential view' was that of seeing these structural relations simply as *formal logical* ones (so as to consider a theory as equivalent to a logical conjunction of its sentences). What escapes this rather oversimplified view is that different sentences play different roles in a theory and that the 'hierarchical' importance of a sentence is a determinant in the appreciation of the truth of the whole theory, while no hierarchical difference exists among the sentences of a logical conjunction: the falsity of any one of them entails the falsity of the *whole*.

Now we may be ready to admit that a theory is 'true' globally or as a whole, while admitting that some of its 'details' are false. So the explanation that many give of the fact that 'false' theories (in the logico-sentential sense) are not abandoned for *practical* reasons until a better theory is available is fallacious. Indeed theories containing some false sentences may still be kept for *intellectual* reasons, as long as their most strategic statements (i.e., those which determine the basic features of their *structure)* remain solid. This structure provides a kind of intellectual *image*, which we say may be true in spite of containing some false details. Here we are confronted with a *different kind* of truth, which occurs in descriptive discourse: the truth of 'wholes' or 'structured systems' of sentences, which is identical neither with the truth of single sentences nor with their logical product. We have hinted that this has to do with the fact that structured systems of sentences are such as to produce a kind of intellectual image or *Gestalt*, which may be seen as a good 'interpretation' of the field of reference of a theory, even though

they may contain some imperfections. By mentioning an *interpretation* we have made allusion to an important dimension of truth which comes out with force when structured systems of elements are concerned, namely the *hermeneutic* dimension.[17]

7. THE HERMENEUTIC TRUTH

It unfortunately oversteps the limits of this paper to include here a consideration of the relationship between truth and interpretation, which constitutes a major topic in the philosophical school which is nowadays known under the name of "hermeneutics". However, what we want to underline is that the hermeneutic perspective is by no means restricted to the domain of literature, art, and perhaps some other disciplines such as psychology or sociology. Indeed even in the 'hardest' of the natural sciences it is obvious that observational or experimental evidence must be correctly *understood*, before being satisfactorily *explained* by means of a theory; and I have the impression that till now not enough attention has been paid in the philosophy of science to the fact that some modifications in the *understanding* of facts can lead (and actually have led in the course of history) to the retention or rejection of theories. But this (in spite of its importance) is not the problem which I have in mind here, for I want to draw attention to another fact, i.e., that not only single sentences must be interpreted, but that scientific theories themselves are to a large extent *interpretations* of reality, within which a certain *explanation* of facts can be proposed, and upon which that explanation depends. In this sense an important analogy seems to me to hold between, e.g., different scientific theories regarding a certain subject matter and different interpretations of one and the same musical score. However I shall not develop this analogy here.[18]

8. OTHER KINDS OF TRUTH

The diversification of kinds of truth entailed by the foregoing reflections has paved the way for the consideration of still more differentiated kinds of truth. Many implications are contained in the above, and we shall be obliged to outline them only sketchily. The first is that different kinds of truth emerge in a sense which we could call that of 'great categorical distinctions' which include 'descriptive truth', 'hermeneutic truth', 'deontic truth', and perhaps others. Within each of these great categories we may indicate some paradigmatic examples, such as e.g., science in the case of descriptive truth, text interpretation in the case of hermeneutic,

and ethics in the case of deontic. However, besides these paradigmatic examples many other members are included in each class, as we have seen, and members which belong to a certain class may also play complementary roles in other classes. A direct consequence of this is that qualitatively different truth-criteria have to be envisaged for these different kinds of truth, depending on the respective 'intention' which defines the class; and this explains why these truths are almost *incomparable*.

However something similar happens within the single classes, where the different members of a class are also distinct, partly because of different intentions, and partly because of other conditions, so that the truth-criteria are to be different not only for, e.g., art and science, but also for the different arts and the different sciences.

As a consequence of the foregoing analysis we may rehabilitate a certain measured and cautious use of the 'substantival' conception of truth even outside its strict 'property-meaning'. This appears to be advisable the more we depart from the purely descriptive sentential context. In other words, while it seems extremely commendable to consider truth as a pure property of single propositions when they aim at describing reality, this seems less obvious when we speak of the truth, e.g., of a theory which is a structured set of sentences whose aim is that of describing or capturing a kind of *Gestalt* or organization of reality which is not univocally imposed by the mere description of isolated items. However, we can still claim that here the basic intention remains that of describing 'how things are' and, for that reason, truth may be seen, also in the case of theories, as a property which they may or may not possess according to their ability to say (possibly in a broader sense) how things are.

But as soon as we leave the plane of descriptive truth and move to that of hermeneutic truth, the *intention* is not primarily that of telling how things are, but rather of capturing 'what they mean', which certainly involves as a presupposition the inclusion of some adequate descriptive moment, but which has to go beyond it. Here two questions must be considered. The first concerns the entity of which we say that it is true; the second concerns the entities 'about which' we say that it is true. Now what should be the entity to which we might attribute (or deny) the property of being 'true'? This entity, as we have said, is an *interpretation*, which is not at all easy to define clearly, for it consists neither of isolated propositions nor of a purely descriptive grouping of propositions, but rather of something *implicit* in a whole construction of propositions, which should be able to reveal the *meaning* of a given complex of things. Only if the interpretation has been able to capture this meaning, do we

say that this interpretation is true. And we are entitled to say that it may be true (or perhaps false), since an interpretation is expressed through *declarative* propositions (though not through *descriptive* propositions).

But now the second problem emerges, since meaning is not something that could be attributed to material things such as colour, mass, length, charge, spin. Meaning is normally thought of as belonging to discourse, to speech, to something which is supposed to express some kind of message. Hence the hermeneutic truth may be more or less difficult to understand and to admit depending on the kind of 'things' we consider it to be 'about'. For instance, it is not problematic to speak of an interpretation of written texts or fragments, whose proper intention is that of *saying* something and, in particular, of communicating a meaning from one person to others. A little less obvious is the attaching of an interpretation to non-verbal human productions, such as paintings, musical works, rites, ceremonies, and so on: these may in fact possess a meaning, but in order to capture it we have to be able to uncover their *intention* as well. In the case of musical compositions the meaning may be very difficult to determine, quite apart from the question whether this potential meaning is irrelevant when we judge the aesthetic value of the composition (according, e.g., to Hanslick's musical aesthetics or similar ones). If it already proves so problematic to speak of truth as a property of interpretations in the case of the supposed meaning of works of art, it appears much more difficult (and actually implies a very different sense) to speak of an interpretation (let alone of a true interpretation) which should try to provide the meaning of such 'things' as, e.g., human history, natural history, cosmic events, cosmic structure, or nature in general.

Why does the issue become more and more complicated? Because the *truth-criteria* for attributing truth to an interpretation become more and more difficult to make explicit. If we have to do with a purely descriptive text, we are in the limiting case where something like the principle of verification could provide us with a good criterion (establishing the meaning may be seen as knowing how to discover the reference). In the case of an imaginary description that we find in a novel, the problem is only slightly more complicated: capturing the meaning might simply amount to indicating a convincing 'possibility of referring' (be it to a landscape, a concrete situation, the articulation of a feeling). In other more complicated cases capturing the meaning could imply understanding the 'expression' of a feeling, the 'imposition' of a norm or command, the 'asking' of a question, the 'prescription' of some handling procedures, and so on.

It would be arbitrary to say that in many fields where the human activity of interpretation occurs, people do not rely upon good criteria for

objectively defending the truth of their interpretations, i.e., criteria for establishing 'what the meaning is', and this is why it is not seriously objectionable that 'hermeneutic truth' has a precise sense. Of course, it would be too ambitious if we should pretend to provide a list of such criteria here, but on the other hand nobody could seriously contest that historians, jurists, philosophers, scholars in the fields of literature, etc., actually have such criteria at their disposal, and the reliability which may be attached to the 'truth' of their interpretations does not seem essentially weaker than the reliability which may be attributed to the 'probabilistic' truth of which Ayer speaks concerning scientific propositions. On the other hand, it seems legitimate to be skeptical about the possibility of speaking of a true interpretation in those cases in which such criteria do not exist (like, e.g., in the case of certain works of art or even more in the case of the 'interpretation' of history or of nature mentioned above).

9. THE DEONTIC TRUTH

As we have said, hermeneutic truth has still to do, in a way, with saying 'how things are', 'things' being, in this case, meanings. Let us briefly consider now the case of 'deontic truth'. Here the *intention* is to determine 'how things ought to be' and it has been recognized for a long time that a descriptive account is far from being sufficient for reaching this goal (as also Ayer correctly stresses, descriptive accounts are almost immaterial to the very issue). Is hermeneutic truth relevant in this case? Yes, but only partially. An hermeneutic work may be necessary, e.g., for establishing the exact meaning of a 'norm', but the problem envisaged here is not that of understanding correctly a norm, but that of saying whether what the norm prescribes is 'good' or 'bad' (or something similar), i.e., whether it is how 'it ought to be'. This is why we are speaking here of 'deontic' and not of 'normative' truth. Similarly, when we try to express an ethical evaluation of a concrete human action, it may be relevant to recognize the 'intention' of the agent, and here again a work of interpretation is clearly needed.

The examples just given already indicate that *actions* are the most appropriate kind of 'things' to be explored at this level, and this is tantamount to saying that deontic truth is 'truth about actions' (and not about facts or meanings, as in the preceding cases). But what must be 'true' about a given type of action? Not its description, nor its correct interpretation (though these truths may be necessary prerequisites for the deontic judgment). What is expected to be true is the 'deontic judgment', whose paradigmatic example is the moral judgment, but which may be

extended to several other kinds of 'value judgments', that is, to all judgments whose *intention* is that of objectively determining an ought-to-be of a certain kind.

And now we are confronted with the decisive difficulty: that of proposing 'truth-criteria' for the value-judgments. My opinion is that this situation is not radically different from that which is involved in the application of the principle of verification: we must and can rely upon a particular kind of *experience*, though different from sense experience. In other words, ethics is (at least to some extent) an 'empirical' discipline. The experience which I am hinting at here is that of the moral values, which every man possesses within what is often called his 'moral conscience'. Evidence of the existence of such an experience is given by the fact that there are many kinds of action which are universally judged to be morally wrong (like killing, stealing, telling lies, betraying), and others morally right (like being charitable, forgiving, fulfilling promises, promoting justice). It is true that in several concrete cases it may be difficult to find a consensus in the evaluation of a given action, but this depends on the complexity of the situation (i.e., of the *context*) in which many such values may appear to be conflicting, or not clearly applicable. But this situation is not essentially different from that correctly mentioned by Ayer himself in the case of scientific hypotheses, which sometimes are not abandoned in spite of being in conflict with some negative outcomes of experiments, when there are sufficient *reasons* (coming from the general context) for still keeping them. Or when the degree of accuracy with which a hypothesis can actually be tested is not very high. In other words: ethical truth is not expected to be less 'probabilistic' than the truth of the empirical sciences. Moreover, as in the empirical sciences we have hypotheses of different levels of generality, so we have in ethics moral principles of different levels of generality. But there is even more than that: in order to be a good scientist, one must undergo a not superficial training in experimental and mathematical skill. In a similar way we must expect that accurate and reliable moral evaluations presuppose a refinement of the moral experience, a capability of reflection, an accuracy in performing arguments which are perhaps not very common, but certainly not less common than a good mastery of scientific practice.

An indirect, but significant, confirmation of the above reasoning comes from the consideration of the so-called 'ethical paradoxes' of deontic logic. They are not logical contradictions, but rather correct consequences derived from the axioms of a certain system of deontic logic, which nevertheless are patently in opposition to the most obvious moral intuition. They are something like 'counterexamples' which in-

duce people to modify the axioms, not because they are against certain 'feelings', but because they are incompatible with what we objectively mean when exploring the mutual relationships between what is 'obligatory', 'permitted', 'prohibited' (or some other similar concepts which make explicit our intellectual understanding of the ought-to be).

10. Conclusion

In conclusion we might suggest that these kinds of truth may be seen as something more than mere properties of statements or systems of statements, but rather as achievements in the discovery and deepening of complex aspects of reality and existence, which are not as concrete as sensible things, but are probably of an even greater importance to man, who decides according to them the fundamental directions of his life. What we say amounts to claiming that value judgments may be no less *true* (or false) than judgments aiming at telling how things are. The risk to be avoided is that of endowing these values with a kind of substantialistic ontology in an extreme Platonistic sense; but we certainly cannot discuss this point here. Truth is really many-sided and multifaced, and there is no point in trying to restrict it to one or to very few of its different kinds. Man strives towards truth in many fields, and this is one of the fundamental features of his being a *rational* being. Far from putting restrictions on this search for truth, the interest of mankind points in the direction of broadening this effort, for, after all, the opposite tendency would lead to a restriction of rationality, which would by no means be desirable.

Evandro Agazzi

University of Fribourg, Switzerland
University of Genoa, Italy
June 1989

NOTES

1. Cf. *Language, Truth and Logic*, 2nd ed. (London: Victor Gollancz, 1946), pp. 15–16.
2. Op. cit., p. 33.
3. Op. cit., p. 90.
4. Op. cit., p. 105.
5. Op. cit., p. 108.

6. Op. cit., p. 112.
7. Op. cit., p. 107.
8. Op. cit., p. 104.
9. Op. cit., p. 91.
10. Op. cit., p. 35.
11. Op. cit., p. 97.
12. Op. cit., p. 99.
13. For a rather detailed account on this issue I refer to a paper "On the Different Kinds of Truth" that I have presented at the 1985 meeting of the International Institute of Philosophy in Palermo, and which has been published in the proceedings of this meeting: N. Incardona, ed., *Les formes actuelles du vrai* (Palermo: Enchiridion, 1988), pp. 11–38. Some parts of that paper are now being included in the present work.
14. They are given in the already quoted paper of mine "On the Different Kinds of Truth".
15. In order to avoid giving too many details here, I allow myself to refer to other publications of mine in which I have developed this discourse at length. A rather detailed presentation of these ideas may be found in several publications which have appeared in Italian, including the last chapter of my book, *Temi e problemi di filosofia della fisica*, 2nd ed. (Rome: Abete, 1974); the essay "L'epistemologia contemporanea: il concetto attuale di scienza", in *Scienza e filosofia oggi* (Milan: Massimo, 1980), pp. 7–20, and "Proposta di una nuova caratterizzazione dell'oggettività scientifica", in *Itinerari* (1979) nn. 1–2, pp. 113–43. In other languages, see my: "Les critères sémantiques pour la constitution de l'objet scientifique', in *La sémantique dans les sciences* (Brussels: Office International de Librairie, 1978), pp. 13–29; "The Concept of Empirical Data. Proposal for an Intensional Semantics of Empirical Theories" in M. Przelecki et al., eds., *Formal Methods in the Methodology of Empirical Sciences* (Dordrecht: Reidel, 1976), pp. 143–57; "Subjectivity, Objectivity and Ontological Commitment in the Empirical Sciences", in R.E. Butts and J. Hintikka, eds., *Historical and Philosophical Dimensions of Logic, Methodology and Philosophy of Science*, (Dordrecht: Reidel, 1977), pp. 159–71; "Eine Deutung der wissenschaftlichen Objektivität", in *Allgemeine Zeitschrift für Philosophie* 3 (1978), pp. 20–47; and "Realism v Nauke i Istoriceskaja Priroda Naukovo Posnanija", in *Voprosi Filosofii* 6 (1980), pp. 136–44.
16. It is interesting to note that Ayer, in spite of having been an advocate of a 'linguistic' view of theories, does not subscribe to the above sketched features of the 'statement view'. Indeed in his book there are several very interesting points where he anticipates certain correct criticisms that have been addressed to this view in most recent times, and introduces in the problem of evaluating scientific hypothesis a useful perspective of intellectual pragmaticism (see in particular pp. 93–100).
17. I have been hesitant, when I have developed this view in my writings, whether I should better call this dimension *iconic*, but I preferred to use the term "hermeneutic" since "iconic" could have given the impression that this *Gestalt* corresponds essentially to a process of 'visualization', which is not necessarily the case. In addition, resorting to the idea of interpretation better accounts for the multitude of conceptual elements which produce the said *Gestalt*. For additional details I may refer to a couple of papers of mine, such as "Do Experiments Depend on Theories or Theories on Experiments?", in D. Batens and J.P.

van Bendegem, eds., *Theory and Experiment* (Dordrecht: Reidel, 1988), pp. 3–13; or "The Role of Experience in Science", in E. Scheibe, ed., *The Role of Experience in Science* (Berlin: De Gruyter, 1988), pp. 190–200; or "La funzione del modello nella scienza", in *Il quadrante scolastico* 31 (1986), pp. 52–62.

18. In a recent paper: "Historicité de la science et de sa philosophie", which appeared in *Diogène* 132 (1985), pp. 61–83, I analyzed this analogy to a greater extent and also hinted at its limitations.

2

James Campbell

AYER AND PRAGMATISM

One cannot hope to offer a complete study of the writings of A.J. Ayer on Pragmatism and related themes[1] in a few pages. My plan here is far more modest; but I hope it will prove satisfactory. I have divided this essay into five main sections. In Parts I to III, I explore some of the aspects of Ayer's discussion of Pragmatism, with a focus on William James's understanding of truth. In the next section, I explore a major aspect of Pragmatism that Ayer does not consider: its attempt to integrate facts and values. In Part V, I attempt to show the root of this omission in different senses of the nature of the philosophic endeavor. In this way I hope to offer an account of Ayer's writings on Pragmatism that furthers the understanding of both Ayer and Pragmatism.

I

In the first three sections I wish to consider some of the aspects of Ayer's discussion of Pragmatism by focussing on his account of James's understanding of truth. I begin with a few relevant remarks on truth in Charles Sanders Peirce.[2] One central element in Peirce's account of truth is the need for commitment from inquirers to explore as long as is necessary to find answers, a commitment that moves easily from "sufficient inquiry" to "fifty generations of arduous experimentation" to "endless investigation" (CP 5.494, 5.60, 5.565). Peirce can offer such a causal continuum because of his realism: there is some correct answer to be found. Facts are, for Peirce, "hard things which do not consist in my thinking so and so, but stand unmoved by whatever you or I or any man or generations of men may opine about them" (CP 2.173; cf. 5.565). This combination of a realistic account of the independence of facts with

limitless inquiry leads to his belief that, with the proper method, there
will be eventual agreement among all inquirers. "The opinion which is
fated to be ultimately agreed to by all who investigate," he writes, "is
what we mean by the truth . . ." (CP 5.407; cf.5.384, 5.494, 5.553).

Although James[3] admits that Peirce is right about the long term—that
"[t]he 'absolutely' true, meaning what no farther experience will ever
alter, is that ideal vanishing-point towards which we imagine that all our
temporary truths will some day converge"—he recognized that, in a
fundamental sense, we do not live in the long term. In the meantime, "we
have to live to-day by what truth we can get to-day, and be ready
to-morrow to call it falsehood" (PMT 106–7; cf. 309–10). Peirce's
similar comments about "matters of real practical concern" (CP 5.60)
suggest that he and James do not so much differ over the nature of truth
as over what truths are most important. For Peirce, these are the generic
truths, the laws of various sorts, the unchanging, while James's focus
remains upon the individual living his or her life, searching for particular
meaning or value. From this perspective, individuals do not lead lives of
infinite inquiry: we choose spouses and careers, we accept or reject
religious dogmas and political programs. With this shift in emphasis to
finite and grounded human living, James suggests the need for a shift to a
sense of success rooted within the range of the present experience of a
single person who is attempting to settle some matter with which he or
she is deeply involved.

It is worthwhile to point immediately to two possibly problematic
areas in James's account of truth. The first is the question of his broad
use of the term 'true' as, for example, "*whatever proves itself to be good in
the way of belief . . .*" (PMT 42). This broad usage allows James to
discuss ideas and beliefs as being "truer" and "truest" (Cf. e.g. PMT 120,
36) in senses roughly parallel to 'better' and 'best.' Although this is
certainly an unusually broad sense of the term 'true,' careful readers
should not find it to be problematic. There is a second area, however, that
I take to be legitimately problematic: James's willingness to allow the use
of 'true' too soon. If an idea or belief yields *any* measure of verification or
success, we find James saying that it is "true for just so much, true in so
far forth . . ." (PMT 34; cf. 36, 40–41). The problem here is that there
are many ideas and beliefs that, in the common usage, 'contain a little
truth.' Superstitions, hasty generalizations, and prejudices all seem to be
able to demonstrate at least some tortured evidence for themselves. A
particular view, for example, need not have amassed much solid evi-
dence to appear "true for *me*" (SPP 113). Moreover, since what James
calls "unverified truths"—that is, ideas and beliefs whose truth simply
has not yet been called into question—"form the overwhelmingly large

number of the truths we live by," and since "[t]ruth lives, in fact, for the most part on a credit system" (PMT 99–100), being satisfied with casual success can lead to serious trouble. Such defective ideas and beliefs will often function adequately until and unless they are subjected to systematic examination.

Lost in James's easy use of 'true' are two valuable points that Peirce emphasizes (and that Ayer duly notes). The first is an ongoing emphasis upon the distinction between what a person might have some evidence for and what is true; the second, the belief that social agreement about what is true is important (Cf. OP 12–15, 25–29). All too often, Peirce writes, "as soon as a firm belief is reached we are entirely satisfied, whether the belief be true or false" (CP 5.375). And, without careful investigation, such errors may perpetuate themselves. More serious still is the problem of the deliberate fostering of marginally attractive falsehoods like racist political programs. As Bernard Shaw noted in 1915: "the weakness of Pragmatism is that most theories will work if you put your back into making them work. . . ."[4] James clearly realized, at least sometimes, the need for the social testing of beliefs; and, as his well-known attempts to counteract America's late nineteenth-century surge of imperialism will attest,[5] James could be a good fighter against the proponents of such fantasies. In such cases, it is necessary to enter into public controversy to attempt to prove that the positions in question are false. Here, pressure for social agreement is the most valuable means for forcing some serious consideration of questionable views.

Ayer writes that James was uninterested "in arriving at a formal definition of truth" beyond "agreement . . . with reality" since such a formal definition, although not incorrect, was "uninformative" (OP 189; cf. PMT 96, 257, 283). James's interest was rather in how we are to decide "whether a proposition agrees with reality or not. . . ." The answer, Ayer continues, is "if and only if it works" (OP 189). In attempting to explicate what his sense of 'working' means, James's discussions of truth are most interesting. One of his formulations runs as follows: true ideas are those "upon which we can ride" (PMT 34). Elsewhere he writes that true ideas are those "*that we can assimilate, validate, corroborate and verify*" (PMT 97; cf. 283–88). Underlying these and other formulations is James's overpowering concern, not with all of the truth question, but with truth as "an affair of leading" (PMT 103).

Our understanding of the incompleteness of James's writings on truth grows with the recognition that, as he wrote to A.O. Lovejoy in 1907, *Pragmatism* "was never meant for a treatise, but for a sketch. . . ."[6] James was, as he wrote, intent upon "dealing in broad strokes, and avoiding minute controversy" (PMT 5). He was interested initially in

exploring and building a consensus for this new philosophy of his, rather than in driving out as heretics all who might be in less than total agreement with him (Cf. PMT 32). Now, as Ayer points out, James's writings in general "left room for some uncertainty, perhaps in his own mind as in the minds of his critics, as to the precise implications of the theories that he held" (PMT ix). To ask whether James would have been better off writing more defensively in general—as Ayer puts it, "to safeguard his theories from minute criticism" (PTC 69; cf. OP 175)—may be to ask whether James would have been better off not writing like himself. However, the topic of truth was, as James himself admits, "[t]he pivotal part" of *Pragmatism* (PMT 169); and, as such, we could have expected more precision and more completeness there and in *The Meaning of Truth*.

II

In an attempt to explicate the core of James's position on truth, I will not consider here the whole variety of possible truth cases. Rather, I will consider, initially at least, just two. The first general class of such cases is based upon the recognition that, as James writes, "in our dealings with objective nature we obviously are recorders, not makers, of the truth . . ." (WB 26). These are cases like whether or not it will rain today, when the swallows will return, "[t]he future movements of the stars or the facts of past history . . ." (WB 80; cf. PMT 220). The individual involved in such cases must face, James writes, "the whole body of funded truths squeezed from the past and the coercions of the world of sense about him . . ." (PMT 111–12). "Woe to him whose beliefs play fast and loose with the order which realities follow in his experience," James writes. The same is true with regard to what James calls "abstract relations . . . [like] . . . the ratio of the circumference to its diameter. . . ." Both realities must be given their due. "Between the coercions of the sensible order and those of the ideal order, our mind is thus wedged tightly" (PMT 99, 101; cf. 211–12, 225–26; WB 15–16). In such cases, to decide the outcome without waiting for the situation to resolve itself, or to offer our report without sufficient inquiry into the historical evidence or the abstract relation, "would be wholly out of place" (WB 26). What is required is that we do the necessary work and then offer our report.

Although this class of recording cases is frequently the most emphasized by individuals concerned with the topic of truth, for James this class is not of vital philosophic importance. He indicates that there is "a

reality independent of . . . us, taken from ordinary social experience, [that] lies at the base of the pragmatist definition of truth" (PMT 283; cf. 272). In recording cases we report this reality; and, for such cases, James was quite satisfied with a stringent code of belief ethics: "*we must avoid error . . .*" (WB 24). Beliefs must follow the facts. With regard to these cases, James even quotes approvingly from W.K. Clifford's "Ethics of Belief": "It is wrong always, everywhere, and for anyone, to believe anything upon insufficient evidence" (WB 18). This having been said, James is ready to move on to a second class of truth cases that he sees as philosophically more important.

Those who take this first class of truth cases to be more important than James does are less interested in moving on quite so quickly. Many have found fault with some of James's specific formulations. Ayer, for example, presses him on the relationship between the truth of a proposition and its verification, as in James's comment that the truth of an idea is the process "of its verifying itself, its veri-*fication*" (PMT 97; cf. 104). "When we verify a proposition we discover it to be true," Ayer replies, "but we do not confer truth upon it. Its truth or falsehood belongs to it quite independently of our knowledge . . ." (OP 194; cf. 188; PTC 80). For example, no one knows "how many fish there are in the North Sea at this moment, or how many human beings have been born and died in the last four thousand years, but certainly there is in fact a definite number in each case." Ayer's point is simply that "[f]or a proposition to be true it is not necessary that any one should believe, or even consider, it: there are countless facts that never will be known" (MCS 92). Even though Ayer admits that these are "humdrum questions" (OP 27), a full consideration of truth must deal with them adequately and James, he believes, does not.

In response to Ayer, it is important to remind ourselves of two Jamesian points. The first of these is that, unlike Ayer, James was leery of propositions as philosophical tools, seeing them as "mongrel curs that have no real place between realities on the one hand and beliefs on the other" (MT 305). Consequently, James's use of the term 'idea' is best rendered as 'belief' rather than 'proposition.' Using 'proposition' as an equivalent to 'idea,' although it may feed more easily into contemporary discussions, will not yield James's position. Secondly, for James the realities themselves, the facts, "are not *true*. They simply *are*. Truth is the function of the beliefs that start and terminate among them" (PMT 108; cf. 36, 272). Consequently, James is quite willing to allow that "[t]here have been innumerable events in the history of our planet of which nobody ever has been or ever will be able to give an account, yet of which it can already be said abstractly that only one sort of possible account can

ever be true" (PMT 321; cf. 323). The important point for James, however, is whether or not such an account will ever come into human consciousness as a belief.

Facts have a kind of eternal character that persists, as Ayer notes, even when the facts themselves remain unknown. A certain number of people, for example, have lived and died. Beliefs, what James is considering, can have no such eternal existence, no life outside of particular believers. He tells us that "in any concrete account of what is denoted by 'truth' in human life, the word can only be used relatively to some particular trower" (PMT 313). So, while it may be a timeless fact that 'the causal process behind Alzheimer's disease is x' or that 'the future of the Milky Way is y,' James's focus is not upon the facts themselves but upon the beliefs that we are developing in our attempts to come to know the facts. We hypothesize and test, revise and refine; we sharpen and modify our ideas about a particular phenomenon of experience until we feel justified to give our report. In a very real sense then, "[t]he truth of an idea [i.e., a belief] is not a stagnant property inherent in it. Truth *happens* to an idea. It *becomes* true, is *made* true by events" (PMT 97). In recording cases, the facts stay what they are while our beliefs, our ideas, are made true by our efforts.

We now turn to the second class of truth cases, the class that James thought *was* philosophically important. These are the contributory situations, situations in which reality "*is still in the making, and awaits part of its complexion from the future.*" We cannot believe, James writes, that "*reality is ready-made and complete from all eternity . . .*" (PMT 123). Rather, it is fluid, developing. Most importantly, reality is modifiable. These are the cases "*where faith in a fact can help create the fact . . .*" (WB 29; cf. 80–81, 88). Examples of contributory cases would include: Can this marriage be made to work? Will the victims of this shipwreck all be saved? For James, these are the philosophically important truth cases because their favorable resolutions contain human goods that will not be attained without our efforts to shape facts to our benefit, to *make* our idea of a better future reality true.

There are severe restrictions, as James recognized, over these contributory cases. The most fundamental is the coercion of the funded part of the situation. A troubled marriage is a specific marriage; a ship is wrecked, and a rescue attempted, under specific circumstances. The situation moreover must present us with a choice that is momentous rather than trivial, forced rather than avoidable, and living rather than dead (Cf. WB 14–15). When the lives of the shipwrecked are at stake, the situation is significant and irreversible. When a marriage is in trouble, the couple is forced into a choice between attempting to save it or letting it end. And in both of these cases those involved must have the means to

act and confidence in at least the possibility of success. Of course, they may turn out to be mistaken. The marriage may fail despite the best of efforts; the drowning of the shipwrecked may turn out to have been unpreventable. However, when some contribution on our part is necessary to make possible an anticipated good that cannot be achieved in any other way, being wrong is not so bad: "Our errors are surely not such awfully solemn things" (WB 25). In these contributory cases, we can see most clearly the power of James's remark that "[t]ruth is *made . . .* in the course of experience" (PMT 104).

III

To offer James's position on truth in this way is to simplify it somewhat and to leave out some of his more troublesome formulations. But I think that this presentation, at least as far as it goes, accurately reflects James's fundamental viewpoint.[7] Let us now consider what may be a third kind of truth case: the difficult matter of questions of religious faith. Given only our two classes of recording cases and contributory cases, can cases of the truth or falsity of religious hypotheses be categorized adequately? Or is some third class of truth cases necessary? A common approach to this matter is to see it as properly a simple recording case; and individuals of this mind are often found to be critical of the low level of evidence demanded by believers. One such critic is Bertrand Russell, who writes that James believed that "although there is no evidence in favour of religion, we ought nevertheless to believe it if we find satisfaction in so doing." Russell continues, moreover, that according to Pragmatism it is not worth the effort "to trouble our heads about what really is true; what is *thought* to be true is all that need concern us." Consequently, Russell writes, James's view "simply omits as unimportant the question whether God really is in His heaven. . . . "[8]

We thus see in Russell's view the position that the question of the justification of religious faith is to be treated as fundamentally a recording case to be decided by gathering the appropriate empirical evidence, with no response to be offered until and unless that evidence is decisive. From Russell's point of view, then, James simply avoids the central question of the evidence for the existence of God and believes whatever makes him happy. James's response is to reject the claim that cases of religious faith are properly characterized as recording cases. For James, at least some element of our contribution is essential. Critics, he writes, "accuse me of summoning people to say 'God exists,' *even when he doesn't exist,* because forsooth in my philosophy the 'truth' of the saying doesn't really mean that he exists in any shape whatever, but only

that to say so feels good" (PMT 172; cf. 111, 292–93). This interpretation of his understanding of the religious hypothesis James characterized as "the usual slander" (PMT 313).

Ayer, for his part, repeatedly rejects as an adequate account of James's view the position Russell articulates that would subsume these religious cases under recording cases (Cf. OP 188; PMT xxx; PTC 82). The key to Ayer's approach is his position that "true beliefs are not treated by [James] as being all of a pattern. They all work, but they work in different ways" to satisfy the "different needs" of human believers, needs which are satisfied by "different kinds of propositions" (OP 191, 186). Ayer distinguishes in James's work three areas within the topic of truth, of which the first two—"truth in relation to matters of fact" and "*apriori* truths" (OP 192–98; cf. PMT xix-xxi)—as straightforward recording cases need not detain us here. Ayer's third area covers that range of human life that he variously describes as "moral and aesthetic judgments," "moral and religious questions," and "spiritual and moral needs" (OP 198–202; PTC 72; PMT xxx). Here, an approach different from that appropriate to the recording cases is necessary. I am reluctant, however, to equate Ayer's third area within the topic of truth with what I am calling the class of contributory cases for two reasons. The first is that Ayer's distinction is based upon the assumption of different *kinds* of beliefs, not, as mine is, upon how belief operates in different situations. Secondly, James's contributory cases, as we have seen, are tightly bound by the coercions of reality whereas Ayer's third group, as we shall see, seems to operate with far greater independence.

Keeping this pair of caveats in mind, James's analysis does run generally parallel to the lines of Ayer's three-part approach. "*Our passional nature,*" he writes, must "*decide an option between propositions, whenever it is a genuine option that cannot by its nature be decided on intellectual grounds . . .*" (WB 20). James continues that "all three departments of the mind alike have a vote" in determining the rationality of ideas and that "no conception will pass muster which violates any of their essential modes of activity. . . ." Each must satisfy what we take to be "the facts of nature," "the theoretic and defining department" of the mind, and our "fundamental active and emotional powers." For an idea to fail to satisfy any one of these three "is fatal to its complete success" (WB 100; cf. OP 186). Using James's approach, we might thus begin by considering the empirical and logical aspects of a potential belief. If these are not decisive either way, and if we are not dealing with a recording case, we may go on to consider the other aspects of the belief. We can now see why Russell's claim that James is maintaining that a position could be factually false but emotionally useful and consequently true—for exam-

ple, "'Santa Claus exists' is true, although Santa Claus does not exist"[9]—is the "slander" James thought it was. For James, an hypothesis is emotionally entertainable at all only when it is not a recording case and when it is thought to be at least initially factually and logically indeterminate. Simple satisfaction of an emotional, moral, or aesthetic sort is "insufficient unless reality be also incidentally led to." Or, as he put it elsewhere with regard to the religious hypothesis, "[t]he truth of 'God' has to run the gauntlet of all our other truths" (PMT 272, 56; cf. VRE 341–42).

Returning now to Ayer's analysis, there is a question of whether or not Ayer thinks James is offering here a single complex test of truth or a set of three simple tests, one for each area of truth. At times, Ayer suggests the former approach, for example in the following passage: "any adequate system of beliefs must satisfy our moral requirements, *as well as* agreeing with the facts of sensory experience *and* maintaining logically correct relations between its constituent ideas . . ." (OP 186, emphasis added). Under this version of James's view, when Ayer writes that sometimes questions are "not decidable on purely intellectual grounds" (OP 184), he would mean that the "moral" test is to be used *in conjunction with* the other two. But Ayer also offers a second version of the relationship among these three factors that I think better displays his sense of James's view.

In this second version the three tests are used independently because, with regard to value questions, there is no evidence of a factual or logical sort. It is one position to suggest, as Ayer occasionally does sounding like the first version, that there are certain important human questions "that cannot be decided on purely intellectual grounds" (PMT viii; cf. OP 208). It is a very different claim to suggest that James's "equation of what is true with what one finds it satisfying to believe" applies properly "to questions of faith or morals, with regard to which there are no ascertainable facts," or that "the criteria by which James wishes to determine whether [religious and moral beliefs] are acceptable come down to being purely subjective," or that when faced with a choice between theism and atheism "there is no evidence either way," or that the position "that truth is a matter of convenience" was held by James "in the domain of morals and theology" (OP 213, 184, 323–24). The significant problem with Ayer's second version of James's view is that it cuts facts off from values. Using this second version, with regard to at least some truth claims, the consideration of factual or logical evidence would be irrelevant. Beliefs from this third group would then be true, independent of the coercions of reality, if only they are pleasing to believers. Thus it seems that Ayer is offering us as James's view not one complex test for truth but rather three simple tests, each to be used independently

depending on the type of question under consideration. This is not Russell's view, of course, because Russell accuses James of using his emotions to decide factual cases. But, I believe, it is not James's view either.

Ayer seems to be driven to this position of three independent tests of truth because of his reluctance to attribute to James the intellectual holding of views, especially views related to religious hypotheses, that he thinks are factually or logically mistaken. He suggests, rather, that for James these beliefs are non-factual and subjective, without "intellectual content." Hence they cannot be mistaken: "I doubt if James really regarded his religious hypothesis as being open to falsification by experience" (OP 212). Let us consider two specific examples where Ayer seems to believe that James is factually wrong, yet he tempers his criticism with the suggestion that, for James, these are not factual matters. The first of these is the question of the possible nature of God. James offers the view that there is a God who is finite and who, because of a reliance upon our contributory efforts, "may draw vital strength and increase of very being from our fidelity" (WB 55). Beyond this, however, James's account of the nature of God and of our contribution to this divine partnership is sketchy and relies on our indulgence of his hunch that over time answers will emerge (Cf. PMT 139–44; WB 106–7; PU 141; VRE 406–8). This is all quite troublesome. Ayer, I think quite rightly, complains for example that "before the proposition that any such being exists can even become a candidate for faith, our intellect must first be satisfied that the predicates by which it is defined are neither meaningless nor inconsistent" (OP 184; cf. 209–11). Still, Ayer concedes, this is ultimately not a factual matter but a matter of "our moral experience" (OP 185). A second example is the role of the religious hypothesis in life. "The notion of God," James writes, "guarantees an ideal order that shall be permanently preserved" (PMT 55). In a world that is destined to grow cold as the sun dims, " 'God or no God?' means 'promise or no promise?' " (PMT 172). It means, James continues, "the letting loose of hope" (PMT 55), the liberation of which will enable us to build more meaningful lives. Ayer, again quite rightly I think, sees no justification for such hope. Nor does he require meaning of a divine sort. "Life," he writes, "has the meaning that we succeed in giving it" (WIB 15; cf. CQP 233–35; MCS 8). But here too it seems that we are dealing with subjective matters.

Rather than calling James to task for empirical or logical problems in these areas, Ayer suggests that James saw them as questions of personal taste. Differences over matters of religious belief are instances where there are "no ascertainable facts." Such beliefs are "purely subjective."

From this point of view, Ayer can assert that James "takes the statement that God exists to mean no more than that men have spiritual requirements which religious belief may be found to satisfy" and that "the pragmatic content of the belief in God's existence consists merely in the feeling of optimism which it induces" (PTC 82; PMT xx–xxi; cf. xxx; CQP 234–35; OP 212). But it seems to me that when James writes that "if the hypothesis of God works satisfactorily in the widest sense of the word, it is true" (PMT 143), he means by this a good deal more than Ayer would allow.

I think that we should hold James to be doing exactly what he says he is doing; and I think that this can be done without falling into the "[a]gnostic positivism" and "scientific materialism" that he frequently warns us against (WB 50; PMT 54). Our beliefs must satisfy, as we have seen above, "the facts of nature," and "the theoretic and defining department" of the mind and our "fundamental active and emotional powers." Thus, when James writes that "we have the right to believe at our own risk any hypothesis that is live enough to tempt our will" (WB 32; cf. 52), we must assume that he intends us to consider each hypothesis according to his three-part test. Similarly, when James writes that the philosopher's temperament "loads the evidence for him one way or the other . . ." (PMT 11), we must assume that this bias can be overcome and that calling our attention to it aids in the process. And when James writes that he denies "the right of any pretended logic to veto my own faith" (PMT 142), he surely does not expect that this would free him of all constraints. We have the right to expect at least that he will ground his faith according to the criteria that he has set up. Maybe religious faith would survive under these restrictions. I suspect that it would not; James thinks that it would. He takes religious faith seriously to be evaluated as an essential element of a full human life and asks us to do the same. Classifying religious faith as "purely subjective" is not taking it seriously.

The questions of the truth or falsity of religious hypotheses and of whether matters of religious faith can be classified adequately within the limitations of the two classes I introduced above have not been answered. But I believe that these questions have done the job that I introduced them to do. Examination of them has indicated, I believe, a fundamental difference between James's view on truth and Ayer's presentation of it. Under James's analysis, when considering a potential belief it is possible to say that the empirical and logical aspects of the matter have been answered as well as they can be answered yet the resolution of the matter is still in doubt. Thus, for James, it is conceivable that two conflicting views of the universe could be in all empirical and logical aspects "equal"

and, if they were, we would be justified in choosing between them based upon which one better satisfies "some vital human need" (PMT 171; cf. 104; WB 66; CP 5.598). For Ayer's James, on the other hand, the situation is different. His James faces factual questions and logical questions and value questions; but, since they are fundamentally different kinds of questions, they must be considered independently. This analysis cuts the final group of beliefs off from consideration of other sorts of evidence, ultimately leaving James's values without grounding beyond subjective preference.

IV

In the first three parts of this essay, I have addressed aspects of Pragmatism as presented by Ayer, with a focus upon James's understanding of truth. I wish to turn now to aspects of Pragmatism that Ayer does not consider. My general claims here will be that a presentation of Pragmatism without a central consideration of its attempts to integrate facts and values will be inadequate and that such a consideration is impossible without an examination of the thought of John Dewey. Despite Ayer's reconsideration of Dewey's role in Pragmatism from being merely a publicist of the movement to being a leading Pragmatist (Cf. OP 3-4; PMT xiv), Dewey plays no role in any of Ayer's discussions of Pragmatism. The exclusion of some figures in a discussion of Pragmatism—Chauncey Wright or Schiller or Papini or Tufts or Mead, Lewis or Goodman or Quine—may be open to debate; but any discussion of Pragmatism that hopes to reach its core must include the trio of Peirce, James, and Dewey. Dewey is an especially important figure if we wish to follow up on the theme of the relationship between facts and values, a theme that is essential to a consideration of Pragmatism.

Historically, Pragmatism was a philosophy that saw as its ideals an intimate connection between thought and social practice and the integration of facts and values. Consider in this regard the following comment by C.I. Lewis:[10]

> Pragmatism is an activistic, an instrumentalist conception; it could be characterized as the doctrine that all problems are at bottom problems of conduct, that all judgments are, implicitly, judgments of value, and that, as there can be ultimately no valid distinction of theoretical from practical, so there can be no final separation of questions of truth of any kind from questions of the justifiable ends of action.

Knowledge is attained and employed in practice; evaluation is a fundamental aspect of human life. Dewey writes that these Pragmatic themes

resulted from the intellectual impact of the work of Charles Darwin. "The influence of Darwin upon philosophy," he notes, "resides in his having conquered the phenomena of life for the principle of transition, and thereby freed the new logic for application to mind and morals and life." In these applications we discover and create new knowledge, knowledge that brings with it responsibility: "if insight into specific conditions of value and into specific consequences of ideas is possible, philosophy must in time become a method of locating and interpreting the more serious of the conflicts that occur in life, and a method of projecting ways for dealing with them. . . ."[11] In the attempts to make use of the methods and results of science in their various evaluations, James and Peirce and Dewey emphasize the integration of facts and values.

To begin with James, we see repeatedly his desire for the unification of life through the integration of its various aspects. Though at times he seems cool to science, James's real opponent is scientific hegemonism. Our present dilemma in philosophy is that our "scientific loyalty to facts" pulls us in the direction of "inhumanism and irreligion," while our "old confidence in human values" holds us "out of all definite touch with concrete facts and joys and sorrows" (PMT 17). We face the choice between "an empirical philosophy that is not religious enough, and a religious philosophy that is not empirical enough . . ." (PMT 15). Pragmatism was what James proposed "as a philosophy that can satisfy both kinds of demand" (PMT 23), a philosophy that uses the various aspects of a full human life—the empirical, the logical, and the valuational—in our attempts to understand our existence. Whatever criticisms we might offer of how James carried out this program, his aim was the integration of these aspects. Turning to Peirce, we find a figure who also was attempting to integrate facts and values. His aim for the long-term scientific inquiry that we considered earlier was not career-building or industrial advance but reaching a correct understanding of the meaning of natural existence and the place of human life within it. Hence Peirce's emphasis upon the long-run pursuit of answers, his attempts to eliminate conceptual confusions and advance communication, his stress upon fallibilism—the admission that our efforts to attain the truth are always tinged with error—and his claim that we should integrate our understanding of logic, ethics, and aesthetics (Cf. CP 2.196–2.200; 5.110–5.114), are all fundamentally moral considerations. His quest for the ideal of truth is a quest for a community of inquirers who would ultimately pursue with him a picture of existence grounded in evolutionary love (Cf. CP 6.287–6.317). Thirdly, it is with Dewey that the consideration of Pragmatism as the attempt to integrate facts and

values culminates. "The problem of restoring integration and coopera-
tion between man's beliefs about the world in which he lives and his
beliefs about the values and purposes that should direct his conduct," he
writes, "is the deepest problem of modern life."[12] For him, it is the
dualistic standpoint itself, the standpoint that would separate moral and
scientific inquiry, the evaluational and the factual, that must be over-
come.

Dewey's starting point is the universally admitted existence of
valuings in living; but, rather than attempting to prove that the objects of
some valuings are themselves absolutely true, Dewey's goal is more
limited. He begins with the recognitions that life involves reconstruction
in problematic situations and that in such situations choices among
possible goods are made with great frequency by all of us. We select aims
for our lives, priorities for our societies, programs for our schools. Dewey
then considers how some of these valuings might be better than others.
"The fact that something is desired," he writes, "only raises the *question*
of its desirability. . . ."[13] The fact that something is taken initially to be a
good thus must make way for a judgment whether it is or is not really a
good, a judgment that is defensible only if we can propose a defensible
criterion. The criterion that Dewey offers is the impact of the various
proposals on the long-term common good. We attempt to determine
which of the competing proposals will function to minimize over the long
run a problem like drug abuse; and, if one course of action appears
distinctly promising, we *should* follow it because our evidence suggests
that it is the most adequate solution that we have. Or, we attempt to
determine which of the competing policies to adopt in order to improve
our society's economic situation. Again, if our criterion of the long-term
social good yields from among the many candidates a set of policies that
are distinctly promising, this set of policies *should* be adopted. The
'should' that Dewey is deriving here, rooted as it is in the elimination of
suffering and the fostering of human growth, is intended as a moral
'should.'

This sort of social inquiry attempts to integrate facts and values. It is
valuational because the problems it attempts to solve are moral prob-
lems, problems of justice and liberty, of right and wrong. As Dewey
writes, "any inquiry into what is deeply and inclusively human enters
perforce into the specific area of morals."[14] Social inquiry is factual
because it uses the best information available, often information that it
itself generates. The problem of the isolation of social inquiry from the
benefits of science results, Dewey writes, at least in part from the narrow
conception of what is often counted as 'science,' especially in the use of
the natural sciences as the model. "The question is not whether the

subject-matter of human relations is or can ever become a science in the sense in which physics is now a science," Dewey writes, "but whether it is such as to permit of the development of methods which, as far as they go, satisfy the logical conditions that have to be satisfied in other branches of inquiry."[15] These logical conditions, adumbrated by Peirce in "The Fixation of Belief" (CP 5.358–5.387), are that the habits of thinking that are adopted aid us in bringing our ideas into conformity with the reality with which we are presented. Following this lead, Dewey considers science to consist in systematic methods of inquiry which, when brought to bear on a topic or problem enable us to understand and control it better. Science, in this broad sense, would be, he writes, "the supreme means of the valid determination of all valuations in all aspects of human and social life"; and a moral science, as "physical, biological and historic knowledge placed in a human context where it will illuminate and guide the activities of men," would thus be a possibility.[16] Social inquiry based in this conception of science could offer a kind of situationally objective status for its evaluations, transcending the subjective level without at the same time aspiring to or needing the absolute level.

V

There is a legitimate question about the likely success of Dewey's aim of social inquiry. The key issue, it seems to me, is whether or not we will be able, as he believes we will, to overcome the problems inherent in the limitations of human partiality and the complexities of social interaction. But regardless of our conclusion on this matter, it remains undeniable that Pragmatism contains as an essential element of its program the attempt to integrate facts and values. This is an element, however, that does not come through in Ayer's presentation of Pragmatism; and some explanation of this omission would seem to be worth pursuing. One factor might be that Ayer came to Pragmatism through Logical Positivism and has never fully distinguished the two streams of thought. Another possible factor is that, as Ayer indicates in his preface to *The Origins of Pragmatism*, his initial interest was more in examining what he saw as "the main stream of American philosophy from Peirce and James to Quine and Goodman" (OP vii) than Pragmatism per se. Other factors no doubt play a role as well. The possible factor that I wish to consider is based on the difficulty found in presenting a view with which the presenter is not in agreement. There is no doubt that for Ayer there are serious problems involved in philosophical attempts to integrate facts and values, science and a full human life. Pragmatism's efforts

aimed to do exactly that by using the tools of science to develop social goods appropriate to the emerging world from among our past experience and present possibilities. Given these two very different conceptions of philosophy, is it possible that Ayer offered the presentation of Pragmatism that he did because it is more compatible with his own understanding of what philosophy is?

In comparison to Pragmatism's *reconstructive* goals, Ayer's goals are more modest; and, if the term had not another contemporary meaning, I would say that Ayer's goals were *deconstructive*. He wants to undermine unjustified moral claims, to deflate pretensions parading as expertise, to expose confusions in social discourse, to foster "the study of evidence" (PTC 18). His philosopher is "an intellectual trouble-maker" and a protester (MCS 18, 260); but he or she is not essentially a rebuilder. Ayer writes favorably of the banishment of merely edifying social and political thinking that he describes as "woolly uplift" (FM 177). He writes as well that it is a mistake to believe that "it is the business of the philosopher to tell men how they ought to live," because "he has no professional advantage over anyone else" (PTC 15; cf. MCS 6; FM 19). The philosophers' understandings of social issues and their answers to social problems are not necessarily better than those of others. The kind of moral knowledge that would seem to be necessary as the basis for scientific evaluation is simply not present. What is present in social discourse is subjective choice and emotional preference traveling under the banner of objective truth. And Ayer, unlike Dewey, does not believe that we will be able to escape these personal constraints. Social reform is consequentially, for Ayer, hardly a field where philosophy is likely either to contribute to favorable social reconstruction or to benefit itself.

Philosophers' efforts are better placed elsewhere. Instead of offering an external criterion of advance, Ayer's understanding of philosophic progress is based upon one that he sees as internal. Philosophic progress consists in "a change in the fashion in which the problems are posed, and an increasing measure of agreement concerning the character of their solution" (PTC 13–14). Allowing room for some consideration of the history of philosophy, Ayer's understanding of philosophy relates it more centrally than the Pragmatists' does to conceptual analysis—a most important activity that can only be denigrated by those who would advocate sloppiness and guess-work. A large part of this analytic effort will be the "descriptive analysis" of how various concepts are used. But there is more: "The philosopher's work is also critical; even our fundamental concepts are not sacrosanct: we can propose ways in which they should be revised." Moreover, "by refashioning the structure of language," Ayer continues, "philosophy can change the world" (MCS 93; cf.

CQP 235). This understanding of philosophy finds itself closely focussed in our contemporary world upon the concepts and the various intellectual problems of the natural sciences. Ayer, of course, does not equate philosophy with science, nor even with the philosophy of science (Cf. MCS 92, 84); but his understanding of philosophy is one that continually drifts, I think not unconsciously, into the realm of the natural sciences, especially in its understanding of their type of knowledge as the paradigm for knowledge.

Using the term descriptively, we can consider Ayer's conception of philosophy to be a 'narrow' one, one suitable perhaps to an age which finds its knowledge in the natural sciences. Ayer at times suggests additionally that concern with social and political issues will be seen as "extra-curricular" to the philosopher in a society that views itself as being stable and "ideologically homogeneous" (MCS 240, 259). Whether or not we are adequately served by an understanding of knowledge that is modelled on the natural sciences, and whether or not our respective societies are sufficiently stable and homogeneous to forgo philosophical inquiry into social issues—two positions that Dewey strongly rejects—are questions that I will not address here. What I do wish to consider is the justification for an understanding of philosophy, whether it be broad or narrow. What *would* constitute an adequate justification for an understanding of philosophy is an interesting question. History, etymology, theology, sociology, and others have offered standards. But, regardless of the justificatory standard used, it is important that we remind ourselves that the understanding adopted is always a choice from among a set of various competing views of what philosophy is, and that this choice needs to be justified.

I do not mean to imply that for Ayer the philosopher is not also a moral agent and a citizen with social concerns. He writes, for example:

> Even though he can claim no special expertise, there is no reason why a moral philosopher should not advance, let us say, a novel theory of justice, if he thinks it worthy of general acceptance. There is equally no reason why he should not apply his intelligence to the solution of concrete moral problems such as the question when, if ever, men have the right to kill. (PTC 16; cf. MCS 6–7)

This is, of course, provided that the philosopher recognizes that "there is no foundation for morality." We have no moral knowledge. Our values are always based upon "some unproved moral assumption" that we find adequate and that "we are prepared to stand by" (MCS 6). Ayer grants that his own support for a broad-based social humanism is without ultimate foundation (Cf. MCS 259–60; WIB 15–17). Our values are our own. We cannot escape, he writes, "the responsibility of deciding what

ends we are to regard as worth pursuing and what principles we are prepared to stand by . . ." (WIB 15). But these evaluative activities play no essential role in the activities of the philosopher who can just as well fulfill his or her calling without them. As Ayer writes, "[w]hether those who embark on such topics should be said to be engaging in philosophy is a verbal question of very little interest" (PTC 16; cf. MCS 7; CQP 235).

For the Pragmatists, especially Dewey, on the other hand, the role of philosophy in society is a much 'broader' one. It includes considerations of the history of philosophy and of conceptual analysis, but it also requires the consideration of broader social issues. As Dewey writes, "philosophy is inherently criticism" and its efforts should aim at attempting "to clarify men's ideas as to the social and moral strifes of their own day." In this way, philosophers should work with other citizens "to clarify, liberate and extend the goods which inhere in the naturally generated functions of experience."[17] This pragmatic conception of philosophy is one in which the role of evaluation is primary, and ethics and social philosophy are central. Wisdom, for the Pragmatist, is a moral notion; and the search for wisdom that is philosophy is a moral search, aided by the contributions of the various social sciences. The questions of the social realm cluster around how we are to live well together. Working with others to attempt to answer these social questions requires the criticism of our political realm and attempts to move toward the creation of a state where such a fulfilling life is possible.

Two particular points of Ayer's position are worth consideration here. The first is related to his claim that there is no moral knowledge, just "unproved moral assumption." On this question, of course, Ayer and the Pragmatists disagree fundamentally. They do agree, however, in rejection of, in Ayer's words, moral claims based in authority, tradition, natural law, etc.: "there is nothing external to morality on which it could logically be founded" (MCS 6). Ayer also rejects attempts to see moral beliefs as "arbitrary" or "just a matter of taste" (MCS 6; WIB 15). Yet, he will not recognize moral 'knowledge.' The Pragmatists, on the other hand, accept the existence of such knowledge and focus their attention on increasing it. The advocacy of reform that we find especially in Dewey is not based upon the claim that we already have the necessary knowledge to carry out the reconstructions that we will need. Rather it is based upon the claim that we now have some knowledge and that further knowledge is discoverable through social inquiry. As Dewey writes,[18]

> it is a complete error to suppose that efforts at social control depend upon the prior existence of a social science. The reverse is the case. The building up of social science, that is, of a body of knowledge in which facts are

ascertained in their significant relations, is dependent upon putting social planning into effect.

If we heed Peirce's advice that we need not consider inquiry along the analogy of a chain—where our attention would wrongly be focussed upon the "weakest link"—but rather along the analogy of a cable—where even slender threads yield great strength "provided they are sufficiently numerous and intimately connected" (CP 5.265; cf. PMT 238)—the Pragmatists suggest that we can develop a model of inquiry that places the search for moral knowledge in the center of our social lives.

A second particular point in Ayer's analysis that should be considered is that the Pragmatic advocacy of involvement in social reform does not contain the claim that philosophers should "tell men how they ought to live." Their role is rather that of advancing policies and challenging, with others, the various traditional and proposed policies for attaining the social good to justify themselves in practice. Choosing social goods, evaluating public policies, developing educational programs—all of these require discussion. The aim here, Dewey writes, is to foster "the participation of every mature human being in formation of the values that regulate the living of men together. . . ."[19] In this call to work together to generate the requisite social knowledge, domination by philosophers, or by any other group, would be deleterious.

Ayer has a sense of the nature of philosophy and its role in culture that is profoundly different from the Pragmatists. He tells us that, under his conception of philosophy, "very often" philosophical questions are "academic" and make "no difference to our practical beliefs" (MCS 88), whereas James writes: "The whole function of philosophy ought to be to find out what definite difference it will make to you and me, at definite instants of our life, if this world-formula or that world-formula be the true one" (PMT 30; cf. P 260). Ayer tells us that there is no guarantee that we will succeed in our attempts at bettering society; but this is hardly discouraging to followers of the ever-fallibilist Peirce who reminds us that "the first step toward *finding out* is to acknowledge you do not satisfactorily know already" (CP 1.13). To find out if our plans will work, the Pragmatists tell us it is necessary to try them out. Ayer tells us, as we have seen, that there is no reason why a moral philosopher should not advance a theory of justice, a position that is at best a very weak endorsement of the sort of activity that Dewey says is essential to philosophy. And Ayer admits that in his society "political life draws very little inspiration from political philosophy" while at the same time social betterment depends upon finding "a more effective means of putting into

operation the principles that most of us already profess to have" (MCS 247, 260); yet these two admissions do not draw from him a call, as they would from Dewey, for philosophical efforts to advance social life through the integration of political thought and practice.

Fundamental differences over the nature of philosophy are to be expected. Without them, philosophic life would be deadening in its monotony. Such fundamental differences, however, can be problematic when we are attempting to move from one understanding of philosophy to another. This problem is especially acute when we are attempting to present the work of historical figures and schools. Ayer indicates, in a suggestive trio of sentences in the introduction to the Peirce portion of *The Origins of Pragmatism*, that we must "always" keep in mind that Pragmatism is a "dynamic philosophy" and that the Pragmatist views himself as "an enquirer adapting himself to and helping to modify a changing world" (OP 5–6). But this spirit—the spirit of Darwin, of evaluation and reconstruction—does not pervade Ayer's own discussions of Pragmatism. My point here is not that the Pragmatic understanding of philosophy is better (or worse) than the understanding of philosophy that Ayer offers; nor is it that criticism from another perspective is to be discounted. It is simply that to be fully and accurately presented particular understandings of philosophy must be presented, initially at least, from within their own understanding of what philosophy is. Ayer, on the contrary, presents us with a picture of Pragmatism without its evaluative core, a picture of Pragmatism that does not struggle to integrate facts and values, thought and practice, a picture of Pragmatism based on his own sense of the nature of philosophy.

VI

In a volume of this sort it is legitimate, and probably necessary, to discuss the nature of philosophy in unusually fine detail. With this in mind, I have attempted to gather together Ayer's ideas on some very general questions related to the nature of philosophy. I hope that I have presented his views with some degree of accuracy; I have no doubt that he will improve on my efforts.

My main focus, however, has been Ayer's encounter with Pragmatism. Although this paper has been largely critical, anyone who examines seriously his work on Pragmatism will be convinced of the sincerity and diligence of his attempts to understand what the Pragmatists were saying. Moreover, even though I am not always in complete agreement with his views, there is much to be learned from Ayer's examination of Pragma-

tism that I have not been able to discuss here: his consideration of Peirce's logic, metaphysics, and philosophy of science, his consideration of James's work on free will, identity, and radical empiricism, and his considerations of Lewis, Quine, and Goodman.

JAMES CAMPBELL

DEPARTMENT OF PHILOSOPHY
UNIVERSITY OF TOLEDO
SEPTEMBER 1986

NOTES

1. In this essay I will be drawing from the following texts: "What I Believe" [WIB], in *What I Believe*, ed. George Unwin (NY: George Allen & Unwin, 1966), pp. 13–17; *The Origins of Pragmatism* [OP] (San Francisco: Freeman, Cooper, 1968), *Metaphysics and Common Sense* [MCS] (San Francisco: Freeman, Cooper, 1970); *The Central Questions of Philosophy* [CQP] (London: Weidenfeld and Nicolson, 1973); "Introduction" to William James's *Pragmatism* and *The Meaning of Truth* [PMT] (Cambridge and London: Harvard University Press, 1978), pp. vii–xxx; *Philosophy in the Twentieth Century* [PTC] (NY: Random House, 1982); *Freedom and Morality and Other Essays* [FM] (Oxford: Clarendon Press, 1984).
2. *The Collected Papers of Charles Sanders Peirce* [CP], ed. Charles Hartshorne, Paul Weiss, and Arthur W. Burks (Cambridge and London: Harvard University Press, 1931–1958), 8 volumes.
3. *The Works of William James*, ed. Frederick H. Burkhardt (Cambridge and London: Harvard University Press, 1975–). In this essay I have drawn from the following: *Pragmatism* [P] (1975); *The Meaning of Truth* [MT] (1975); *A Pluralistic Universe* [PU] (1977); *Pragmatism* and *The Meaning of Truth* [PMT] (1978); *Some Problems of Philosophy* [SPP] (1979); *The Will to Believe* [WB] (1979); *Essays in Religion and Morality* [ERM] (1982); *The Varieties of Religious Experience* [VRE] (1985).
4. "Preface on the Prospects of Christianity" to *Androcles and the Lion* in *The Bodley Head Bernard Shaw*, vol. 4 (London: Max Reinhardt, The Bodley Head, 1972), p. 549.
5. Cf. ERM 120–23, 162–73; *The Thought and Character of William James*, vol. 2, ed. R.B. Perry (Boston: Little, Brown, 1935), pp. 300–322.
6. *The Thought and Character of William James*, vol. 2, p. 480.
7. For a different attempt to explicate James's understanding of truth, cf. H.S. Thayer's introductions to *Pragmatism* and to *The Meaning of Truth* (cited in n. 3) and his *Meaning and Action: A Critical History of Pragmatism*, rev. ed. (Indianapolis: Hackett, 1981).
8. "Pragmatism" [1909], in *Philosophical Essays* (NY: Simon & Schuster, 1966), pp. 83, 105; *A History of Western Philosophy* (NY: Simon & Schuster, [1945] 1967), p. 818; cf. "William James's Conception of Truth" [1908], in *Philosophical Essays*, p. 124.

9. *A History of Western Philosophy*, p. 818.

10. "Logical Positivism and Pragmatism" [1941], in *Collected Papers of C.I. Lewis*, ed. J.D. Goheen and J.L. Mothershead, Jr. (Stanford: Stanford University Press, 1970), p. 108.

11. "The Influence of Darwinism on Philosophy" [1909], in *The Middle Works of John Dewey, 1899–1924*, 15 vols., ed. Jo Ann Boydston (Carbondale: Southern Illinois University Press, 1976–1983), vol. 4, pp. 7–8, 13; cf. Philip P. Wiener, *Evolution and the Founders of Pragmatism* (Cambridge: Harvard University Press, 1949).

12. *The Quest for Certainty* [1929], in *The Later Works of John Dewey, 1925–1953*, 17 vols., ed. Jo Ann Boydston (Carbondale: Southern Illinois University Press, 1981-), vol. 4, p. 204.

13. *The Quest for Certainty*, p. 208; cf. *Experience and Nature* [1925], in *The Later Works*, vol. 1, pp. 301–4.

14. "Introduction" [1948], to *Reconstruction in Philosophy* [1920], in *The Middle Works*, vol. 12, p. 268.

15. *Logic: The Theory of Inquiry* [1938], in *The Later Works*, vol. 12, p. 481.

16. *Theory of Valuation* [1939], in *The Later Works*, vol. 13, p. 250. *Human Nature and Conduct* [1922] in *The Middle Works*, vol. 14, pp. 204–5.

17. *Experience and Nature*, p. 298; *Reconstruction in Philosophy*, p. 94; *Experience and Nature*, p. 305.

18. "Social Science and Social Control" [1931], in *The Later Works*, vol. 6, pp. 65–66.

19. "Democracy and Educational Administration" [1937], in *The Later Works*, vol. 11, p. 217.

REPLY TO JAMES CAMPBELL

At one point in his essay, Professor Campbell puts the question 'Is it possible that Ayer offered the presentation of Pragmatism that he did because it is more compatible with his own understanding of what philosophy is?'. The answer to this is that Campbell has hit upon the truth. I found a great deal in the work of Peirce, James, and C.I. Lewis, which was not only consistent with my own views, but also, especially in the case of Peirce, contributed to their development, and I turned a blind eye to passages in their writings which I could not assimilate. Again, this applies especially to Peirce. The omission of any attempt to expound his metaphysics would have been dishonest if I had thought that it had any bearing upon the core of his pragmatism which I was trying to penetrate. But I did and do not think that it had. This may, indeed, be due to my failure to understand it. I have yet to discover what he meant by 'evolutionary love'.

I admit also that Campbell has some reason to object to my choosing 'The Origins of Pragmatism' as the title of a book in which I totally ignore the work of John Dewey. It is true that Dewey was later on the scene than Peirce and William James, but he is commonly ranked alongside them in histories of philosophy. My reason for ignoring him was not only that he wrote very badly, a charge which could also be brought against Peirce, but that apart from his suggestion that the concept of 'warranted assertibility' should replace that of 'truth', the motive for which was derived from Peirce, it did not strike me that he had anything interesting to say. His attack on formal logic seemed to me misguided, his concentration on the process of enquiry is inherited from Peirce and James, his doctrine of fallibilism echoes that of Peirce; for the rest, his work was a venture into sociology, a subject beyond my purview.

No doubt Campbell would reply that my disdain for Dewey confirms his charge that I miss what he takes to be the main point of pragmatism,

its integration of fact with value. Here I think that he is right to the extent that I disregarded the importance that the early pragmatists attached to values. On the other hand I believe that he goes too far in his talk of integration. Even in Dewey's case, it appears to me that he took a set of humane values for granted and concentrated, notably in his work on education, on the factual question how they could best be translated into general practice. C.I. Lewis did, indeed, aim at integration, but in his case it took the form of a reduction of value to fact. He assimilated the moral to the other senses and applied his phenomenalism to it also. Perhaps I am wrong in saying that Peirce contributed nothing of interest to moral theory, but if he did I have failed to discover it in his writings. As for moral practice, I do not deny that he resembled other philosophers in attaching a value to the proper assessment of evidence and to what he conceived as the pursuit of truth. When it comes to William James, my contention is that while there are passages in his works which favour the view that he regarded values as encroaching upon facts, his theory of truth demands their separation.

It is on this point that Campbell and I most seriously disagree. Since each of us can support his position by a judicious winnowing of the texts, I shall be content to claim that it is only if it is given my interpretation that James's theory of truth acquires any plausibility. Otherwise it is exposed to Russell's objection that the theory allows us to hold it to be true that God exists, even if God does not exist, so long as the belief in his existence gives us satisfaction: an objection which Campbell reports James's dismissing as 'the usual slander'. But it would not be a slander at all if James were treating the question of God's existence as a matter of fact, for which we did not have and could not acquire empirical evidence. I allow that the statement that God exists is regarded by James as an intelligible hypothesis, so that I might be willing to concede to Campbell that 'the moral test' was never taken by James to be sufficient on its own. The intellectual examination had also to be passed. If I hesitate even here it is because I am not entirely convinced that James would not have been prepared to accept the freedom of the will on emotional grounds, even if the concept had been shown to be incoherent. But let that pass. What I am concerned to assert is that in the case of the truth of God's existence, or indeed any purely theological or moral question, the third factor, that of empirical warrant, simply is not brought into play, because James realizes that they do not fall under its domain.

I believe that Campbell makes far too much both of James's mistrust of the concept of a proposition and of his conception of truth as 'an affair of leading' or something that is '*made* in the course of experience'. It is, indeed, significant that James follows Peirce in treating the question

'What is true?' as practically equivalent to 'What am I to believe?', but neither of them maintains that our beliefs become even provisionally true through the steps that we take in verifying them, as opposed to the matters of fact that we discover. Obviously, there are many states of affairs that are brought about by human action but I am not convinced by Campbell that James was primarily concerned with them or that the cases to which James refers in *The Will to Believe* as those 'where faith in a fact can help create the fact' were of the mundane character of Campbell's examples.

I concede to Campbell that James would not have regarded our emotional needs a sufficient ground for accepting religious and moral hypotheses, if he had thought these hypotheses to be contradictory; neither did I suggest that he would. Perhaps I did not sufficiently stress the fact that James believed, in my view mistakenly, that there was an equality of empirical evidence for and against some religious hypothesis, and I may have been mistaken, though I doubt if I was, in attributing to him the view that moral judgements were not 'intellectually' decidable. But in whatever way James's other requirements are taken to be neutralized, I adhere to my view that the only positive reason that he offers for our acceptance of religious hypotheses or judgements of value is the presumption that they satisfy emotional needs.

A.J.A.

3

David S. Clarke, Jr.

ON JUDGING SUFFICIENCY OF EVIDENCE

For a person X to know a proposition p, Professor Ayer tells us, it is both necessary and sufficient for p to be true, for X to be "sure" of p, and for X to have the "right to be sure" that p is true.[1] Current discussions of epistemology have tended to cite this as a statement of the classical definition of knowledge as justified true belief prior to turning to Gettier-type counterexamples purporting to show its inadequacy. The difficulties experienced in formulating further conditions which in conjunction with Ayer's are sufficient for knowledge should make us wonder whether this project has a hope of being carried out, whether the verb 'to know' does not have such a wide variety of uses in different contexts as to make impossible any list of conditions applicable to them all. But whatever our views on this issue, we must acknowledge that Ayer in his discussions of the "right to be sure" as his third condition has successfully formulated the central problem of epistemology. And while I think he would steadfastly resist what in my view is its correct solution, he has with that admirable clarity and honesty that marks all his writings made substantial concessions to those proposing this solution.

Ayer distinguishes between a person's "being sure" or being convinced of a proposition and his or her experiencing a feeling of conviction or certainty. To "be sure" is not to experience a characteristic feeling but to accept as true:

> . . . to be convinced of something . . . does not seem to consist in any special mental occurrence. It is rather a matter of accepting the fact in question and of not being at all disposed to doubt it than of contemplating it with a conscious feeling of conviction.[2]

X tells me that $Y's$ house has burned down. I trust X as a reliable informant; I accept what he says as true. Am I then certain that the house burned down? Surely Ayer is correct in holding that there may be no feeling of certainty which I can report as being present. If to be certain is to be willing to stake everything on its truth, this dispositional state may also be absent. I may accept X's report but be unwilling to bet a substantial sum on it, even at favorable odds. I accept it only in the sense that I am willing to use it as the basis of action, e.g. prepare to help Y, without entertaining a doubt that would lead to first seeking an independent check on the report.

The relationship between acceptance and belief as a psychological state is more difficult to state. Certainly for a person to accept proposition p as true is sufficient for him to believe that p. But acceptance does not itself seem to be a kind of belief. Most obviously, the acceptance of p can be dated, while beliefs have an indefinite duration. Also, belief admits of degrees, while acceptance is an all-or-nothing affair. Finally, acceptance is within a person's control, and hence is subject to evaluation as justified or unjustified, rational or irrational. In contrast, strong reasons have been given by some philosophers against beliefs being voluntarily held. I don't choose to now believe that the sky is blue or that the paper in front of me is white. Such beliefs have been regarded by some as causal effects of the states of affairs they are about, registering environmental conditions much as a thermostat registers a room's temperature. If so, we have reasons for thinking that evaluative terms such as 'justified' or 'rational' have no place. A thermostat is either accurate or defective, depending on whether it registers in a manner sufficiently similar to that of a standard instrument. There is no sense to our saying that a defective instrument "ought not" register in the way that it does, though we may criticize in these terms its maker. Similarly, we cannot say of a person that he ought not hold a belief if that belief is simply the effect of a causal process initiated by the state of affairs it is about. In contrast, we do say of a person that he ought not to have accepted a certain proposition, that this acceptance was irrational or unjustified. This evaluation seems to imply that the acceptance was at least in part governed by normative rules and was not simply the effect of a series of causes.

The central problem of epistemology is then correctly formulated by Ayer as one of specifying the criteria we employ in justifying the acceptance of a proposition, for

> to ask how a statement is known to be true is to ask what grounds there are for accepting it. The question is satisfactorily answered if the grounds

themselves are solid and if they provide the statement with adequate support.[3]

Alternatively, we can state the problem as determining how we justify both the assent to a sentence expressing the proposition (or statement) and the assertion of the proposition on a given occasion.

Ayer's solution is stated in very general terms. To be justified, he says, acceptance must follow "one of the accredited routes to knowledge."[4] Which "accredited route" is to be followed will depend on the kind of proposition asserted or accepted, whether a perceptual report such as 'This paper is white', a memory report, a claim based on the testimony of others, or a generalization based on singular observation reports. These latter may be uniform generalizations of the form 'All As are B' ('All crows are black') based on observation of individual As that are without exception B or statistical generalizations of the form 'The probability of an A being a B is r', where r is some rational number between 0 and 1. The reliability of a rule or procedure, its tendency to produce conclusions which are confirmed in later experience, seems to be the test Ayer employs to determine accreditation. He distinguishes, however, between success as such, which may be due to luck or accident, from success due to following an accepted rule or method, even though this rule may not be capable of being explicitly formulated.[5] The expert chicken sexer can be said to be justified in his identifications, for his success is not due to luck but use of perceptual clues which even he may not be able to state. Perhaps what we should say is that success can be regarded as a justification so far as it indicates that a rule for which there is an established practice is being followed. As for the rules, Ayer is surely correct in rejecting the possibility of justifying them. Once established in practice they set the standards for rationality; there are no higher standards in terms of which they themselves can be evaluated.

Ayer's condition seems indistinguishable from that central to the epistemological theory known as "reliabilism." We can formulate it as the following

> *Reliability Condition:* a person X is justified in accepting a proposition p only if X concludes that p on the basis of reliable rules, that is, rules which have established themselves in practice as the norms governing the type of inquiry in which p is formulated.

Ayer's reliabilism is one version of the general philosophical theory I shall label *cognitivism* following Isaac Levi.[6] According to it, the criteria for justifying acceptance, assent, and assertion must be stated in purely

epistemic terms which specify the relation between the proposition a person accepts and either the state of affairs it is about, the person's experiences, or other propositions reporting evidence for it. In the latter case the relation is a logical one and canons of inductive logic are applied. The empiricists' search for "rules of acceptance" is an attempt to specify the exact nature of this logical relation. Such a rule Ayer attempts to state. It is rational, he says, "to accept a generalization when it has acquired a high degree of instance-confirmation, without meeting any counter-instances,"[7] implying that a degree of confirmation (or Carnap's degree of "credibility") can somehow be determined for specific generalizations. For a statistical generalization, he tells us, we require for confirmation and acceptance that "the observed percentage coincides nearly enough with the prescribed percentage."[8] These relations between evidence and generalizations are logical relations that presumably can be determined apart from the subjective states of the person deciding to accept the generalizations. The alternative to cognitivism we shall label *pragmatism*. According to it no specification of a relation between a proposition p and either states of affairs, experiences, or supporting evidence is in itself sufficient to justify the acceptance of p. In addition, justification must also make reference to the purposes and interests of the person accepting p and perhaps also the community of inquirers of which he is a part.

A difficulty presented by a quite obvious feature of all inquiry makes plausible, I think, the pragmatist alternative. Prior to the acceptance or rejection of a proposition there is usually a process of gathering information on which to base this decision. For empirical generalizations this is the process of accumulating instances which confirm them. For testimony of others the process can be one of checking on an informant's reliability or corroborating his report. Even a direct perceptual report is often preceded by a process of eye scanning and inspection which can be more or less carefully carried out. In all such cases to finally accept the proposition is also to decide to terminate this information search. To justify this acceptance is to endorse this judgment as itself justified. Usually to acquire further information is to eliminate anticipated potential defeaters of the proposition under consideration. Though the paper may look white to me now, I know that there may be conditions present which have caused it to appear differently than it normally does. I may then attempt to establish that no such abnormal conditions exist prior to asserting that it is white.

Now it seems clear that how much information or evidence is judged sufficient will depend on the person's interests and purposes and how much he has at stake if the proposition were to prove mistaken. Suppose I

am the owner of a small store in which Jones is employed. Smith tells me that he saw Jones fleeing from a recent robbery. Should I accept the proposition that Jones was involved in the robbery, or should I search for further available evidence? Clearly, the answer will depend on my estimate of the cost of a mistake should I prove mistaken and fire Jones on the basis of false testimony, whether Jones is a valued employee, whether he is easily replaced, perhaps also whether there are moral obligations of loyalty because of his long service. A high cost would seem to warrant a further search for evidence, e.g. a check of police files, contacting other possible witnesses, etc. The problem whether to accept now or postpone after a further search can also be illustrated by perceptual reports. I may justifiably assert 'This paper is white' only after a quick glance, for nothing is at stake. But a mountain climber preparing an ascent would be irrational to accept 'This rope will support two hundred pounds' unless he first tested the rope he depends on for safety, thoroughly examines it for signs of fraying, etc.

The problem is even more clearly illustrated in the testing of hypotheses that are empirical generalizations relative to instances that are derived from them. Methodological rules of inductive logic such as Mill's methods of agreement and difference prescribe to the investigator ways of avoiding possible sources of error. For a generalization of the form 'All As are B' the rule may be that of selecting the As of the sample from the total population by means of a random sampling procedure or varying the other attributes of the sampled As relevant to their being B. But the rule will not itself specify how large the sample must be or how many relevant attributes must be varied before deciding that the evidence accumulated is sufficient and accepting the hypothesis as true. Introductory logic texts standardly include among the basic fallacies that of "hasty generalization." But there is no such fallacy, at least not of a logical kind, for inductive rules do not themselves specify what is a "reasonable" precaution against error, and what is "reasonable" will vary with the importance of avoiding a mistake. A generalization such as 'All adult swallows have a wing span of at least four inches' might be accepted on the basis of a relatively limited number of confirming instances. In contrast, 'Drug Z has no injurious side effects' would be accepted only after the most extensive testing because of the costs of a mistake in the form of the distribution of a drug lethal to certain types of persons.

In his discussion of Carnap's principle of total evidence Ayer shows an appreciation of this problem of assessing sufficiency. For Carnap the total evidence on which our assessment of a hypothesis is based is that actually possessed at the time of the assessment. Such a principle, Ayer

claims, is open to the "fatal objection" that "if one has acquired even a single piece of evidence which is relevant to the hypothesis which one is trying to evaluate, there is no reason why one should bother to look for any more."[9] His solution is to extend the total evidence to that which is not yet possessed but is available if searched for. In general, he says, "we should always try to maximize the relevant evidence," that is, bring into our possession all the evidence which is available. But he notes that in actual practice

> this could be taken too far. There are times when it is rational to act on evidence which one knows to be incomplete: a general who refused to launch an attack until he has ascertained the position of every enemy soldier would not be very successful. There may also be moral as well as practical limitations. If I am trying to pick a winner on a race-course, the principle of maximizing evidence may be held to fall short of requiring me to attempt to bribe the stableboys. But, subject to such provisos, the principle is in accord with common sense.[10]

But it is misleading in the extreme to suggest that it is only on certain occasions when there is the exigency of a pressing action or a moral prohibition against acquiring evidence that there are exceptions to maximizing evidence. The available evidence for even the most obvious propositions, evidence which could be obtained if a search were to be continued without limit, will be indefinitely large. Even 'This paper is white' can be mistaken in indefinitely many ways: there could be abnormal lighting, my visual mechanisms impaired in countless ways. For empirical generalizations the available members of the population will typically be larger than any possible sample. In such cases there will *always* be a gap between possessed and available evidence, and acceptance will *always* involve a decision to terminate a search for what is available and could be obtained by further effort and expenditure of resources over an indefinitely long time span. Without such a termination our questions would never be answered. Moreover, since this is a pervasive feature of acceptance, its justification can never be adequately given by citing only conformity to rules which prescribe "accredited routes to knowledge."

It would not be correct to say that our purposes are alone employed in limiting evidence search. Background information about the variability of members within a given population relative to certain kinds of attributes can help to determine, for example, how large a sample to select as a basis for a generalization about kinds of objects. Thus, our knowledge of human variability will help dictate a larger sample on which to base a generalization about the behavioral traits of male Swedes than for a generalization about the melting point of a certain metal. Background knowledge will also serve to exclude some attributes as

irrelevant to that being ascribed and order others in terms of their relevancy. Nevertheless, this background knowledge will not itself prescribe the amount of evidence to provide a basis, and will still leave indefinitely many attributes as at least potentially relevant. A given proposition about male Swedes may thus be based on a larger or smaller sample selected by varying more or less relevant attributes, depending on the risks that attend accepting a false generalization.

Though it is easy enough to state in this general, vague way that the evaluation of a person's acceptance of a proposition must make reference to interests and purposes, it is much more difficult to state specific criteria for this evaluation. One attempt might take the form of comparing the costs that would be incurred if the proposition should prove false to the costs of continuing to accumulate relevant evidence. We could then say that acceptance of a proposition p is justified only if the costs of a further search for available evidence, including the opportunity costs of foregoing or delaying immediate benefits, are higher than the costs that would be incurred if p were later to be rejected as false. By a "cost" I mean a state of affairs towards which there is an aversion. Thus, for one cost to be higher than another, is for there to be a greater aversion towards one state of affairs than towards another.

Such a condition seems applicable to the examples we have cited. The employer is justified in accepting the proposition that Jones committed the robbery only if the costs of obtaining further evidence outweigh the costs of a mistaken assessment of blame and the needless firing of a valued employee and perhaps other moral costs. The reason why 'All adult swallows have a wing span of at least four inches' is accepted on the basis of scantier evidence than 'Drug Z has no injurious side effects' seems obviously due to the negligible costs of a mistake for the former as compared to the latter. For the drug the costs outweigh the costs of further testing; for the swallows they do not. Ayer uses the example of a gambler preparing to bet on a horse race and deciding how much evidence to gather and at what cost. Here the proposition to be accepted has the form 'Horse X has a probability r of winning', with the odds the rational gambler should be willing to accept being a function of the probability r. Again, it seems obvious that the amount of evidence that should be gathered, e.g. histories of past races, the present condition of the horses, the abilities of the jockeys, will be a function of the size of the bet and potential loss. Thus, suppose there are two gamblers accepting the proposition that X will win with a given degree of probability on the basis of a hearsay report. If the first gambler were to place a two dollar bet while the second places a thousand, we would probably judge the first to be justified in accepting this proposition and criticize the second for accepting the same proposition without a further search to confirm the

report. For the second the cost of this search would probably be less than what he stands to lose, even discounting the greater thrill of risk-taking that may be experienced when more is at stake.

Though intuitively plausible as applied to such examples, others pose a serious problem for our pragmatic justification condition. I accept now the proposition that it is highly probable that the ceiling above me is safe, that it will not collapse suddenly on top of me. I accept this without bothering to check by going into the attic to inspect for structural soundness. Surely the cost of my being mistaken far outweighs the effort to make this additional check. Yet we would say that my acceptance is fully justified, that it would be irrational, even neurotic, to check the ceiling of every room I enter on the basis of the pragmatic justification condition. There are countless other examples: the irrationality of checking the steering wheel whose malfunction could cause a disastrous accident, of chemically testing food which could be lethally poisoned, etc.[11] Obviously, what must be compared to the cost of an evidence search is not the cost of error *per se*, but instead the *expected* cost of error as determined by the probability of the "bad" state of affairs coming about, the ceiling collapsing, the steering wheel malfunctioning, etc. The acceptance of a proposition is a decision to terminate a search, and this decision is to be evaluated by the norms of decision theory where the action whose outcome has the highest "expected utility" should be chosen, and this utility is calculated with reference to the probabilities of outcomes. Since we judge the ceiling's collapse highly improbable, the expected cost or disutility of this occurring is far less than that of the check for structural soundness.

But how do we determine the probabilities used in determining expected costs? It is, after all, the acceptance of the proposition that it is highly unlikely that the ceiling will collapse that we are attempting to justify. We cannot consistently accept this proposition, use it to assess the cost of a mistake, and then use this assessment to justify the original acceptance of the proposition. Obviously, the original acceptance must have had to be justified; otherwise, our estimate of expected cost would not have had a rational basis. This precludes using subjective probabilities or degrees of belief in the estimations of expected cost, since we can believe strongly in a proposition without any rational support for the belief. But then we must have employed criteria for the original acceptance which did not include cost comparisons, that is, criteria restricted in the way advocated by cognitivism.

The solution to this problem, I think, lies in recognizing that a person imports into his estimate of costs a background of accepted propositions, a portion of his knowledge corpus, which include the proposition under

consideration. My acceptance of the safety of *this* ceiling currently above me may be based on a cursory look at it plus knowing that it has never collapsed in the past. But my estimate of an expected cost of error may be based on background knowledge about structural conditions of houses with ceilings of the kind I am under. There is thus no circular use in assessing costs of the proposition whose acceptance is to be justified. Accordingly, we have the following

> *Pragmatic Condition:* A person is justified in accepting proposition *p* only if the estimated cost of a search for additional available evidence is greater than the expected cost of *p* being false as estimated relative to background knowledge.

Notice that the nature of the costs being compared is left indefinite in this formulation. An individual investigator may be motivated by a desire for quick publication and financial gain. For him the costs of searching for additional data with which to test a hypothesis may include frustrating these desires, while the cost for him of a mistake may only be a relatively minor public embarrassment. Obviously, we would not use these personal considerations in evaluating whether his termination of evidence search was justified. It is instead the *social* costs of continued search and error that would be weighed. In other situations, e.g. the rock climber deciding on the strength of his rope, evaluation may be based only on the individual's own cost comparisons.

At this stage defenders of cognitivism can attempt to introduce a distinction which they would regard as crucial to their position. Some questions are asked, they would concede, in order that their answers provide the basis for deciding whether or not to perform actions that have been specified in advance. The decision to accept a given answer then becomes a decision to commit oneself to a specific action whose consequences will be potentially harmful if the answer should later prove mistaken. Thus, if we must decide whether to inoculate a population with drug *Z*, the answer to the question 'Does drug *Z* have harmful side effects?' will provide the basis for the answer. To accept an affirmative answer is, in effect, to decide not to inoculate. For propositions that are such answers, the cognitivist may admit, acceptance can be evaluated by the Pragmatic Condition as justified or unjustified relative to consequences of actions based on them. Most of the propositions of daily life and applied science are of this nature. It is examples from both that are appealed to in formulations of the pragmatist alternative. But the cognitivist will contend that in "theoretical" as contrasted to "practical" inquiry the goal of the scientist is to gain truth for its own sake independently of any potential practical applications. Questions in this

inquiry are posed solely out of curiosity, and answers designed only to satisfy this curiosity. A hypothesis being tested in this mode of inquiry will invariably have an indefinite number of potential applications in action, some of which may be in the remote future. It will then be impossible to assess the cost of a mistake as we could for the employer who loses a valued employee, the climber whose rope breaks, the gambler who loses a bet, etc. With truth the only relevant goal, the only condition for justified acceptance remains conformity to "accredited routes to knowledge," to rules established in scientific practice.[12]

The skeptic has his own special uses for the theoretical-practical distinction used to derive this conclusion. He argues that in theoretical inquiry acceptance will never be justified. For him to accept a proposition p as true is to be "absolutely" certain that p. He will concede that we have a right to be "practically" certain that p is the case when p occurs within the context of a practical inference and a decision to perform some specific action must be made. To be "practically" certain here is simply to commit oneself to performing this action. But outside such contexts acceptance must conform to the theoretical ideal of ruling out the possibility of error, and this we are never entitled to do. Instead, we can at best assign a certain degree of probability to p depending on the support it receives from some set of evidence.

Ayer correctly rejects this skeptical view as inconsistent with actual scientific practice. In fact, the scientific community does at some stage terminate further inquiry relative to certain hypotheses, accept them as true, and accord the empirical generalizations among them the status of "laws of nature." If an error is later detected, then revisions are in turn accepted, usually in the form of restricting the scope of reference, as Newton's laws of motion are restricted to bodies of relatively large mass traveling at relatively low velocities in the face of falsifying instances. For Ayer one has the "right to be sure" that p is true, i.e. accept p

> when one is judged to have taken every reasonable step toward making sure: but this is still logically consistent with one's being in error. The discovery of error refutes the claim to knowledge; but it does not prove that the claim was not, in the circumstances, legitimately made.[13]

He criticizes Russell's view that no proposition, not even 'There is a table in front of me', can be more than "highly probable." This, he says, would admit "that there could be further evidence which could alter this probability, and I am setting no limit to its possible extent."[14] In fact, there is a point at which doubt is no longer reasonable, and we judge that further evidence would be irrelevant to the conclusion we are prepared to unqualifiedly accept. This occurs in theoretical science just as consistently as in the judgments of everyday life, though for science the temporal

interval over which evidence continues to be acquired is normally very much longer and there may be many intermediate revisions prior to final acceptance.

But given the cognitivist framework that Ayer seems to accept for propositions as objects of theoretical inquiry, it is unreasonable to expect that the skeptic will be satisfied with this answer. For how do we determine that we have taken "every reasonable step towards making sure" and that further evidence search is not required? As we have seen, the rules of inductive logic plus background knowledge do not themselves allow us to determine sufficiency of evidence and hence the stage in testing when acceptance is justified. For practical inquiry related to specific actions—the general estimating enemy strength, the gambler estimating the probability of a horse winning—Ayer appeals, as we have seen, to "practical and moral limitations" to evidence search, though even here he implies these limitations apply only in special circumstances. But for theoretical inquiry where no specific action is contemplated he cannot make a similar appeal. Here the total evidence on which to base acceptance would seem to be equivalent to all available evidence no matter how difficult to acquire. He thus has no answer to the skeptic who recommends a never-ending search for additional evidence and suspension of judgment.

An answer to the skeptic can be given by noting examples of theoretical inquiry where scientific practice distinguishes between requirements for extent of evidence. Suppose a botanist preparing a classification of the wild flowers of a certain region for which there are minimal practical applications. In order to accomplish this she must describe the height, coloration, geographical location, and shape of a certain species of columbine. It seems obvious that a very limited sample would be justified as a basis for accepting a certain description and then asserting it to others in the form of a published monograph. It would be unlikely that the published results would be checked by other investigators. But suppose now a microbiologist describing the mechanisms of cell division in plants, a description with no specific practical application at present. Then it would seem that for her to accept any theory and assert it to others would require first extensive testing. The published formulation of the theory would then be subject to independent testing in order to provide either corroboration or falsification and possible revision.

We seem to be able to give pragmatic reasons for distinguishing requirements for evidence sufficiency in these two cases. Despite the fact that for neither description are there specific practical applications, we can in fact distinguish between the costs of error in the case of the columbine description from those of the cell division description. For the

former the cost is minimal. If the description is mistaken, the classification of the flower on which it is based may have to be revised, but beyond this virtually nothing is at stake. In contrast, for the scientific community to accept the cell division theory is for it to commit itself to an extensive program of research based on this theory. Acceptance of it becomes a basis for actions of a special sort, actions such as developing new instruments and techniques for answering new questions which the theory helps to formulate, developing new observational techniques which presuppose the theory, etc. If the theory is later rejected as false, much of the time and resources expended on such actions would have been wasted. In addition, there seem to be differences in the estimates of another kind of cost. There are many potential applications we could anticipate an improved or more detailed theory of cell division to have; a mistake here could thus be expected to delay or force us to forego altogether the practical benefits these applications may bring in areas such as plant hybridization, improved crop production, pest control, etc. The justification for extended evidence search can be at least in part given by citing such indefinite costs, costs admittedly not easily calculable. Without comparable potential costs of this kind limitations of evidence become more easily justified when testing the columbine description. In general, the *centrality* of the scientific discipline within which a hypothesis is formulated will determine these kinds of costs, both those of wasted research effort and foregoing anticipated benefits. Microbiology is more central than botany as a classificatory science in that its results have an effect on conclusions reached in botany, while a botanical classification will rarely have an effect on a theory of microbiology. Similarly, chemistry is more central than microbiology, while physics is in turn more central than chemistry. It is thus to be expected, and seems to be borne out in practice, that physics, chemistry, microbiology, and classificatory botany as theoretical sciences will have in this order decreasing demands on what is justified as sufficient evidence and on the resources that can be justifiably committed to the search for additional evidence.

The cognitivist cannot therefore employ the distinction between practical and theoretical inquiry in order to dismiss our Pragmatic Condition as having relevance only for action-oriented propositions. For all inquiry there are comparisons between the costs of acquiring additional evidence and those of a mistake. The only difference lies in the nature of the costs of a mistake: for theoretical inquiry they may be either those of frustrating a program of research or indefinite and not easily calculable opportunity costs.

In *The Origins of Pragmatism* Ayer dismisses quickly the general

pragmatic theory which "equates a true proposition with one which we find it useful to believe,"[15] noting that such a theory was not held by Peirce and by James only for metaphysical propositions. He is more sympathetic, however, with the pragmatists' link between the truth of a proposition and its acceptance as true. We cannot, he points out, claim that the truth of a proposition consists in a person's accepting it, for what one person accepts as true may be rejected by another as false. Nor can we say that truth consists in general community acceptance or consensus, since what is generally accepted as true at one time may be later rejected, and the same proposition cannot both be true and false. Anyone holding the attitude of fallibilism towards empirical propositions must therefore reject this equation. But while this equation of truth with acceptance fails, Ayer finds plausible Peirce's view that "the distinction between what is true and we believe [or accept] to be true is one which we cannot ourselves give any practical effect."[16] Similar approval is given to the view of James that the "cash value of the question 'What is truth?' is 'How can I decide what propositions to accept?' "[17] Thus, suppose our botanist to be asking the question 'What is the period during the year at which species X of columbine blooms?' and considering the answer 'X blooms from May to June'. Her only problem is to decide whether or not to accept this proposition relative to the available evidence. The further problem of deciding whether this proposition is true in the sense of corresponding to the facts reduces itself to the first, that is, to solve it is to decide whether or not to accept. Similarly, a person may be justified or warranted in asserting a proposition p and p later be rejected as false. In this sense, truth cannot be identified with warranted assertion, contrary to what Dewey maintains. Nevertheless, the problem facing an investigator is that of deciding whether he should assert to others in the form of publication the results of his studies. For him the question whether a given proposition is true is equivalent to questioning whether to assert it, and the "cash value" of truth, that aspect which is in our power to determine, is thus that of justified assertion.

Ayer is then correct in endorsing this pragmatic conclusion. But if our defense of the Pragmatic Condition has been sound, it follows that it is possible to reformulate a weakened version of the slogan "the true is the useful" which avoids the criticisms that have been directed against it. For the Pragmatic Condition formulated above relates the justification of acceptance and assertion to utility considerations, and our argument has been that such justification must be given for a person deciding to endorse a proposition as true. Certainly we do not want to claim that this condition is a sufficient condition for justified acceptance. Were this so, we could justify accepting a proposition relative to no evidence provided

the cost of acquiring additional evidence were less than that of a mistake. Acceptance could also be justified in the face of obvious violations of standard methodological rules, as would occur if a generalization of the form 'All As are B' were based on an obviously biased sample of the total population of As. The Pragmatic Condition cannot therefore replace Ayer's Reliability Condition requiring that acceptance be based on evidence in accordance with "accredited routes to knowledge." The fulfilling of both is a necessary condition for justified acceptance, with the role of the Pragmatic Condition that of supplementing the Reliability Condition in order to specify in given cases what constitutes sufficiency of evidence.

The "true as useful" view attributed to the early pragmatists sought, in effect, to justify our acceptance of a proposition in terms of the consequences of actions for which it serves as a basis. Our Pragmatic Condition is at least partly consistent with this intent. Where it differs is in its characterizing the search for evidence as itself a series of actions and the decision to accept a proposition as a decision to forbear from these actions. Provided the Reliability Condition has been satisfied, the decision to accept then becomes based on preferences between the costs of the search-actions and the costs of the consequences of the proposition based actions. The "true as useful" view, in contrast, not only seemed to restrict its pragmatic condition to proposition-based actions, but also made this condition both necessary and sufficient for justified acceptance. It becomes then subject to well-known counterexamples to which Ayer appeals in his dismissal of it, examples of true propositions which prove to have harmful consequences when acted upon and of false propositions with beneficial consequences. Clearly, no such difficulties can be raised against our more restricted Pragmatic Condition.

A more extensive consideration than can be carried out here would show, I think, that our condition provides the only link between social and individual purposes or "values" and the truth of what is accepted or asserted on a given occasion. Certainly such purposes influence what questions inquirers ask, but to say that questions are selected because of the purposes to which their answers will be put is not to say that the truth of a particular answer will be dependent on these purposes. It is also true that what a person wants to believe will often determine how much evidence is either acquired or overlooked. But this we regard as introducing an element of irrational bias that is at cross purposes with the use of accepted rules of scientific practice. Consideration of other attempts to claim a dependence between the truth of what a person says and his purposes would show, I think, similar confusions.

What remains, then, is the Pragmatic Condition as it has been

formulated here. Ayer suggests such a condition in his identification of "being sure" with acceptance, his endorsement of the pragmatists' claim that justified acceptance is the "cash value" of truth, and his acknowledgement that limitations on evidence search may in some cases be imposed by personal and social preferences. It is testimony to the hold of the cognitivist tradition on twentieth-century philosophy that despite these concessions he fails finally to recognize the extent of practical limitations on acquiring evidence and the effect of this on our justification of acceptance.

DAVID S. CLARKE, JR.

DEPARTMENT OF PHILOSOPHY
SOUTHERN ILLINOIS UNIVERSITY AT CARBONDALE
MAY 1986

NOTES

1. *The Problem of Knowledge* (Baltimore: Penguin Books, 1956), p. 35; also published in hardback by Macmillan in 1956. I use the Penguin edition with its differing page numbers because of its greater accessibility.

2. Ibid., pp. 16, 17. The misleading psychological associations of "being sure" Ayer later avoids in *Probability and Evidence* (New York: Columbia, 1972). Here he consistently employs in its place the term 'acceptance'.

3. *The Problem of Knowledge*, p. 70. In *Probability and Evidence* Ayer discusses another key problem, that of deciding between hypotheses which are both equally confirmed by the same set of evidence. This is irrelevant to our purposes.

4. Ibid., p. 33.

5. Ibid., p. 34. Whether success in itself can justify is also said by him to be a "decision" about what is to count as knowledge.

6. In *Gambling with Truth* (New York: Knopf, 1967), p. 17. See also Levi's "Must the Scientist Make Value Judgments" in *Decisions and Revisions* (Cambridge: Cambridge University Press, 1984).

7. *Probability and Evidence*, p. 87.

8. Ibid., p. 20.

9. Ibid., p. 56. It is perhaps more accurate to say that Carnap usually assumes the evidence constitutes a "random sample" representative of the entire population, and that this is an assumption which will always beg the question of how much evidence is sufficient. Ayer also discusses the problem of total evidence in "Two Notes on Probability" in *The Concept of Person* (New York: St. Martin's Press, 1963). There he suggests that the totality of evidence should be "defined by reference not to the results of all relevant observations that one happens to have made, but to those of all the relevant observations that one could make if one chose" (p. 194). He concedes that there is no rule for determining total available evidence in this sense and that "we can never be sure of having all the requisite

evidence." By acquiring more evidence, however, "we bring our estimates of probability nearer to the truth" (p. 196). He thus neatly side-steps the problem of justifying acceptance by switching discussion to the assignment to propositions of logical probabilities.

10. Ibid., p. 57.

11. Such examples were brought to my attention by Richard Fumerton in response to an earlier attempt to state a pragmatic condition for acceptance.

12. The argument of this paragraph has been stated by Richard Jeffrey in "Valuation and Acceptance of Scientific Hypotheses," *Philosophy of Science* 23 (1956): 237–46 and by Isaac Levi in "Must the Scientist Make Value Judgments?" in *Decisions and Revisions*. Both are arguing against versions of the pragmatic theory formulated in Richard Rudner's "The Scientist *Qua* Scientist Makes Value Judgments," *Philosophy of Science* 20 (1953): 1–6 and Richard Braithwaite's *Scientific Explanation* (Cambridge: Cambridge University Press, 1953), Chapter VIII.

13. *The Problem of Knowledge*, p. 44.

14. *Probability and Evidence*, p. 59.

15. *The Origins of Pragmatism* (San Francisco: Freeman and Cooper, 1968), p. 8.

16. Ibid., p. 16.

17. Ibid., p. 189.

REPLY TO DAVID S. CLARKE, JR.

Professor Clarke's friendly and perceptive essay raises a number of issues which I shall do my best to disentangle. In particular I shall try to show that the concessions which I have made to pragmatism are not incompatible with what Clarke calls my cognitivism.

Let me begin with my cognitivism of which Clarke gives a full and mostly fair account. He assumes, correctly, that I still uphold the analysis of knowledge, according to which one can properly be said to know that p when the following conditions are satisfied: that p is true, that one is sure of its truth and that one has the right to be sure. I used the expression 'the right to be sure' rather than some such expression as 'having very good reason to believe that p', in order to leave no doubt that I intended to cover such cases as that of the chicken sexer who is unable to formulate his evidence, but I did and do consider having very good evidence in favour of p as giving one the right to be sure of its truth. Since this form of analysis is widely thought to have been refuted by Gettier I shall say something about his counter-examples, even though Clarke makes no more than a passing reference to them in his opening paragraph. Gettier appears to make the two generally false assumptions that if one believes a proposition p one believes everything that it entails and that if one has good reason for believing p one has good reason for believing anything that p entails, but it is sufficient for his purpose that these assumptions are sometimes satisfied. Consider his example that a person A has good reason to believe that his friend B is spending his holiday in France and that A admits that this gives him good reason to believe that B is spending his holiday in either France or Italy. In fact B is spending his holiday in Italy. Gettier argues, rightly, that it would be incorrect to say that A knew the disjunctive proposition to be true. But it seems to me that all one needs to do here is enter the caveat that if one believes a

proposition *q* because it is entailed by a proposition *p* which one has good reason to believe, one's belief that *q* does not amount to knowledge if it is validated by a state of affairs which does not figure at all or figures only insufficiently in one's evidence for *p*. I add this last proviso because it might be argued that one does not know that one's cousin drives a motor-car if one believes falsely but with very good reason that she drives a Ford, whereas the fact that she drives a Peugeot, since it entails that she drives a motor-car, does give some indirect but insufficient support to the proposition that she drives a Ford.

Having, as I hope, disposed of Gettier, I return to Clarke. I agree with some, but not all, of his reasons for distinguishing acceptance from belief. In particular, I cannot see that there is any difference between them with regard to choice. Whatever grounds there are for concluding that one's beliefs are causally determined apply equally to acceptance. Again, if one's acceptance of a proposition can be rational or irrational so can one's beliefs. A question which I shall be discussing at greater length in my replies to the essays of Professors Hollis and O'Connor is whether the evaluation of one's beliefs as rational or justified is inconsistent with their being causally determined. Clarke thinks that it is and it is only because he assumes, it would appear quite arbitrarily, that acceptances are not causally determined that he considers them to be subject to those evaluations. My own view is that there is no such inconsistency. This seems to me to be borne out by the example of a computer. The moves of a chess computer have physical causes but they can be assessed as rational or irrational according to the same criteria as those that we use in judging the performance of a human player. A computer which has been programmed to do mathematics may be physically caused to produce the proof that there is no greatest prime number. Since the proof is valid, and a computer can intelligibly be said to accept what it prints, I see no reason to deny that its acceptance of the conclusion is justified.

Clarke is seriously mistaken in saddling me with the view that there is a logical relation running from *p* to *q*, when *p* is evidence for *q*, without entailing it. On the contrary, if he re-reads the first of my "Two Notes on Probability", he will discover that it contains what I still regard as a decisive argument against the conception of probability as a logical relation. I show that if it is assumed, as it invariably is by those who take this view of probability, both that to say of an event that it is probable can be only a way of saying, perhaps elliptically, that it is made probable to such and such a degree by such and such evidence, and that such statements are necessarily true, if they are true at all, it follows that different assessments of the probability of a given event, correctly based on different amounts of evidence, are all equally valid. So long as there is

nothing wrong with the calculations, it is not possible within theories of this kind, even to attach any meaning to the statement that an assessment of probability which is based on a greater amount or a greater variety of evidence is more reliable than one that is based on less. The advocates of such theories take it for granted that probabilities should be assessed in relation to the total available evidence, but I was able to show both that their theories allow no room for any such assumption and that it is very far from clear what 'the total available evidence' is supposed to comprise.

In my book *Probability and Evidence*, to which Clarke refers, I do say that it is rational to accept a generalization where it has acquired a high degree of instance-confirmation, without meeting any counter-instance, or, if the generalization is statistical, where the observed percentage coincides nearly enough with the prescribed percentage, but he is again entirely at fault in supposing that these relations between evidence and generalizations are logical relations, or that I take them to be so. There is indeed a relation of entailment between a generalization of the first sort and its instance, since a counter-instance refutes it, but the converse relation does not hold, and in the case of an open statistical generalization there is no relation of entailment either way, since however much the observed percentage has deviated from that which the generalization prescribes, it remains possible that the balance will eventually be redressed. What makes it rational, in the pursuit of truth, to adopt the principles in question is that in our past experience, which is all that we have to go by, reliance upon them has afforded us a large measure of success in predicting what will happen. The same applies to the principle of maximizing evidence. I should have hoped that Hume had demonstrated, once for all, that the fact that these principles have served us well in the past is no guarantee that they will do so in the future.

In this context, it surprises me to find Clarke burdening the sceptic with the requirement that 'to accept a proposition p as true is to be "absolutely" certain that p'. Surely it is common ground by now that with the possible exception of records of one's current sense-experience, all our assertions are fallible. What makes the sceptic's arguments of abiding philosophical interest is that they purport to prove not, for example, that our reasons for attributing consciousness to others fail to attain certainty but that they carry no weight at all; in this and in similar cases where a gap exists between evidence and conclusion the sceptic's contention is that there is no way of closing or even reducing it. I thought that I had made this point sufficiently clear in *The Problem of Knowledge*.

Perhaps it is at least partly my fault that Clarke has failed to understand that my references to rationality and to the justification of beliefs have always been restricted to the domain of truth. Although I

value the pursuit of knowledge for its own sake, at least in many instances, I have never asserted and do not believe that knowledge should always be pursued at all costs. This is, indeed, denied in statements of mine which Clarke himself quotes. Without wholly subscribing to Pope's maxim 'Where ignorance is bliss, tis folly to be wise', I have no difficulty in conceiving of many situations in which one would be better off without holding a true belief which it would be within one's power to acquire.

It is not clear to me what Clarke has in mind when he says that when it comes to theoretical enquiry I have no answer to his idiosyncratic sceptic 'who recommends a never-ending search for additional evidence and suspension of judgement.' What grounds would there be for such a recommendation? I have acknowledged that every empirical theory is open to refutation. Consequently there is no such thing as making certain that it is true. One may indeed rationally increase one's confidence in a theory by acquiring further evidence in its favour. Here, as Clarke notes, the scope of the theory comes into play. Also, since scientific theories are for the most part mutually dependent, it is rational to test a given theory in circumstances where other accepted theories put it most at risk. When one has completed this procedure, to the best of one's knowledge, there is no reason to repeat one's experiments unless one has some special reason for thinking that they will yield a different result. One retains the theory so long as it survives intact. If it does come to grief one formulates a new theory which accounts for the evidence which destroyed its predecessor.

The recommendation that one should suspend judgement needs to be backed by argument, for instance an argument that what we take to be a good reason for holding such and such a belief is really not so. As I said earlier, there are such sceptical arguments, not mentioned by Clarke, and I have tried to show elsewhere how they might be met.

This is not to deny that one may have motives, other than the desire for knowledge, for engaging in research, or that one may have motives, such as lack of money, moral scruples, a loss of confidence in one's own abilities, the lure of other pleasures, for discontinuing it. What I fail to see is that there is anything to be gained by confounding such motives with evidential reasons for belief. At the same time I am quite willing to admit that when the question at issue is how one should act in a given situation, a motive which is at odds with the further pursuit of some item of knowledge should sometimes be given the greater weight.

I conclude therefore that apart from some misunderstandings of my views, on which I have commented, Professor Clarke's position is much closer to my own than a casual reading of his essay might lead one to suppose.

A.J.A.

4

Michael Dummett

THE METAPHYSICS OF
VERIFICATIONISM

I

The title of this essay may seem perverse, inasmuch as one of the aims of verificationism, at least in the logical positivist version adopted, in the early phase of his career, by Sir Alfred Ayer, was to demonstrate that there is no such subject as metaphysics: if there were, its propositions would be incapable of verification, and hence without sense. Since what went for the purported propositions of metaphysics went also, to the delight of the positivists, for those of religion, and, further, to their slight embarrassment, for ethical propositions as well, logical positivism appeared a threat to many: to a few recalcitrant metaphysicians, to many more who adhered to some religious faith, and to yet more who wished to construe their ethical principles as substantial and objective truths. Notoriously, those who felt threatened eagerly adopted what they imagined to be a knock-down riposte to the logical positivist: "How do you verify the principle of verification?".

This counter-attack may not seem very powerful: Ayer and his colleagues surely had a simple reply to it. After all, neither he nor other positivists ever maintained that *all* meaningful propositions are verifiable or falsifiable by sense-experience: only that this held for synthetic propositions. They regarded analytic propositions, including those of logic and mathematics, as being meaningful in a different way, or, rather, as having an altogether different kind of meaning; or, perhaps better still, as having meaning in an altogether different sense of the word "meaning". The propositions of philosophy are not attained by empirical investigation: they could not, therefore, masquerade as synthetic propo-

sitions, and hence, if true, must be analytic and, accordingly, meaningful only in the second sense of the word "meaningful". The verification principle did not, therefore, purport to apply to itself: it was an analytic consequence of the meaning of the word "meaning" and of the other words contained in it.

This rebuttal would, indeed, have appeared stronger if the positivists had had a plausible explanation, such as Frege offered, of how it is that, as Frege insisted, analytic judgements can advance our knowledge. Neither the first axiom of logical positivism, that the meaning of a proposition is the method of its verification, nor the second, that all verification consists of sense-experience, is at all obvious, either at first hearing or after considerable reflection: so one who claims them to be analytic truths ought to be prepared with an explanation of how there can be unobvious analytic truths. The same, of course, holds for anyone who claims, as Ayer and the other positivists did, that all mathematical truths are analytic, since most of them are very far from obvious. They were not in possession of any very convincing explanation, however: indeed, they tended to make observations about analytic truths, to the effect that they tell us nothing about the world, which suggested that they would deny that analytic judgements can advance our knowledge. It is, of course, no more than a suggestion: one can insist that an analytic proposition tells us nothing *about the world* (in that it would hold true whatever the world were like), while resisting the suggestion that it simply tells us nothing. It remains that, on the one hand, Ayer and his school believed themselves to be in possession of a principle, not arrived at by empirical investigation, by means of which they could demonstrate the senselessness of a great range of propositions which many people took to be true—or, at worst, false; and, on the other, that they had no plausible explanation of how they had achieved this feat.

This, however, though it mattered, was not fatal. *Any* comprehensive philosophy must either both show (1) that there are not really any philosophical propositions, and (2) that there are not really any mathematical propositions, or explain how propositions not arrived at by empirical investigation (whatever their precise status) can advance our knowledge and allow of surprising applications. If Ayer was unwilling to undertake the former task, and did not know exactly how to carry out the second, this was a weakness of his philosophy: but it might well still be that this weakness could be remedied without damage to his other philosophical views, and then he could reply, to their complete discomfiture, to those who asked triumphantly, "How do you verify the verification principle?".

Those who asked it were, however, wiser than they knew. Tarski had

charged natural languages with inconsistency on the score than they contained their own semantics, which no consistent language could do. The argument appears incontestable: it follows that no semantic theory governing a language can be formulated in that language itself, on pain of inconsistency. Any attempt to state such a theory must therefore lead to contradiction.

It is undoubtedly true that natural languages contain semantic terms, such as "true", "false", "means", and so on, which purport to be applicable to those very languages. Moreover, these are not technical terms reserved to philosophers or linguists: they are instruments of everyday discourse. Perhaps most of their uses, in everyday discourse, can be defended on the ground that their application is strictly local: we can therefore feign that the entire natural language is serving as a metalanguage in which to say something about some small fragment of that language, temporarily constituting the object-language. But no such defence can be offered for the enunciation of grand all-embracing semantic theses such as the principle of verification. They must therefore be doomed to lead to inconsistency; very frequently by violating themselves. This is, indeed, a familiar phenomenon. It has repeatedly been remarked that Russell's statements of the theory of types run counter to the theory of types; and the same holds good for much that Frege says concerning the different logical types of expressions and the corresponding types of referents. When, for example, he lays down that it is senseless to say of a concept what can meaningfully be said of an object, he is, in that very statement, violating his own principle, since, in talking about saying of a concept what can be said of an object, he *is* saying of a concept what can be said of an object, namely that something is said of it which can be said of an object.

Conceptual relativism is the doctrine that we cannot escape this predicament: we are trapped inside our language, or our conceptual scheme, and cannot survey it as from the outside. The weakness of this view is that, if it were correct, it is hard to see how we could so much as be aware of our entrapment: not only could we not step outside what encloses us, but we could not so much as form the conception that it had an exterior. It is this that gives rise to the incoherence to which every form of relativism appears doomed: it is yet another self-refuting doctrine, to state which is to violate the prohibition it embodies. For all that, the predicament which it declares inescapable is a genuine one: it is that which Wittgenstein faced in the *Tractatus*. For him, it is not merely that the functioning of our language—which of course involves its relation to the world—cannot be expressed within that language: it cannot be expressed at all, since we are concerned, not with what is

peculiar to some one language as contrasted with others, but with what is essential to language as such. To say that it is inexpressible, however, is quite different from saying that there is nothing to be expressed. His solution was therefore not the defeatist conclusion of the relativist: rather, he thought it possible to make believe that we have the means to express the inexpressible. When we do so, what we say is strictly senseless: we may nevertheless succeed, by this means, in apprehending that which defies expression, but which we must apprehend if we are to see the world aright.

It is difficult to refute this view; but its paradoxical character renders it highly uncomfortable to adopt. I have never felt sure of understanding with what alternative view Wittgenstein later sought to replace it. On one reading, it is the view that there really *is* nothing to be expressed: not only can we give no account of how our language functions—no theory of meaning for it—but there is, as it were, no way in which it functions of which we are unable to give an account. But, if this genuinely was his view, it appears inadequately supported, and, furthermore, inherently incredible. It may, of course, be that any such account would be exceedingly complex, in a manner that ruled out all such grand simplicities as the verification principle; or even that it would be so complex that we are incapable of attempting so much as a rough sketch of its structure (although that seems unlikely): but this is quite different from saying that there is nothing of which to give an account.

The proper response to the predicament depends upon its proper diagnosis. If, as I think, Tarski's diagnosis is essentially correct, Wittgenstein's response in the *Tractatus* is altogether too drastic. The difficulty does not arise, on this diagnosis, from the intrinsic ineffability of the functioning of our language, nor from the fact that, as philosophers, we are primarily interested in features of our language that it shares with all other natural languages. It arises, rather, from our attempting to include that part of the language which embodies the conceptual apparatus by means of which we attempt to describe its functioning in the language whose functioning we are describing. If, therefore, we conceive ourselves as giving a description of the functioning only of that fragment of our language which does not contain the expressions that serve as theoretical terms in that description, we shall escape the predicament. We shall say nothing either self-contradictory or senseless: we shall merely construct a theory that cannot be applied to the statements of that theory itself.

If this is the correct response to the predicament, it follows that no one had the right to ask how the verification principle was to be verified: properly understood, it did not purport to apply to itself. It was not to be

considered either as a synthetic statement, meaningful only if verifiable, or as an analytic statement, consequent upon conventions governing the use of words: it fell altogether outside the scope of the dichotomy. Rather, it was part of a *theory* explaining how the rest of the language worked: not only the everyday part of the language, but the specialised and scientific parts of the language—all of it save that part serving solely to construct the theory. Of course, "meaning" and "verification" belong to the English language, but, for the present purpose, they would figure solely as theoretical terms. Either the theory would have to be construed as applying only to a fragment of English not containing them, or their use within the theory would not be responsible to their use within that part of English to which the theory applied: in either case, they would gain what meaning they had in the statements of the theory—including the verification principle itself—solely from their role in that theory.

Such, as I see it, would have been the only correct answer for the positivists to give to the challenge issued by their opponents: but it would have drawn the teeth of the verification principle as a hound with which to hunt down metaphysical statements. They, too, would have had to be allowed to fall outside its scope. This claim may seem to rest upon a confusion between metaphysical statements and those belonging to semantic theory: but the distinction is more one of style than of content. Metaphysics attempts to describe the most general structural features of reality, but to do so as the outcome of pure reflection, unaided by empirical investigation. It can do this only by extrapolating from the most general structural features of our thought, or of our language: more exactly, by expressing the structural features of our thought or of our language as structural features of the world about which we think and talk. More particularly, a semantic theory will tell us what, in general, makes a statement of one or another kind true, if it is true: in virtue of what it is capable of being true. At least, in view of the intimate connection between the concepts of truth and of meaning, it must tell us this unless it eschews the notion of truth altogether. Viewed in one way, a thesis about what, in general, makes a statement of a given kind true is a semantic thesis, determining the type of content attaching to statements of that kind. Viewed in another way, it is a metaphysical thesis, telling us what is the substance of a certain sector of reality: what kinds of thing, or, better, what facts, constitute that reality.

It makes no difference whether language is taken to be prior to thought in the order of philosophical explanation, or thought to be prior to language. The former is the order of priority traditional in analytical philosophy, indeed, until quite recently, a common mark of analytical philosophy: and no version of analytical philosophy was more firmly

committed to that tradition than logical positivism. A philosophy accepting the explanatory priority of language over thought cannot but have a metaphysical component if it has a theory of meaning: not in the full-fledged sense of a detailed theory of meaning for an entire language, but in the broad sense of having a conception of the general form that such a detailed theory would take. Even if it has no explicit theory of meaning in this broad sense, it is likely that one will be implicit in its methodology: for what one takes to be an adequate analysis of particular expressions will tend to show in what one takes the meaning of an expression, in general, to consist. None of this would be affected, however, by a reversal of the order of explanatory priority: for the notion of truth is as applicable to thoughts as to statements, and the concept of a true thought is as intimately connected with that of the content of a thought as is the concept of a true statement with that of the meaning of a statement. (The word "proposition" creates a convenient ambiguity between a thought and its verbal expression in a sentence, which is why it ought to be treated as philosophically disreputable.)

II

What, then, were the metaphysical consequences of Ayer's verificationism? The best known is the phenomenalist conception of physical reality. According to phenomenalism, sense-data form the substance of the material universe; this is so, the verificationist adds, because it is only by means of sense-data that a statement concerning the material universe can be verified.

We are concerned with a certain large class of statements. These statements are usually characterised as 'statements about material objects': but that seems in one respect too restrictive. Not all matter goes to compose an object, in the ordinary sense of that term, nor, when it does, is a statement about it always about the object in question. We do not normally think of the air, for instance as being part of any object: it is, of course, an integral part of the planet, but we can talk about it, or some portion of it, without talking about the planet. It would be an improvement, therefore, to characterise the relevant class as consisting of statements about matter: but even this may be too restrictive, as excluding statements about radiation. On the other hand, it may in another respect be too inclusive: we do not wish to become entangled with special problems concerning statements in the past tense, or, more precisely, those relating to theoretically inaccessible regions of space-time, but to confine ourselves to statements about present, accessible

physical reality. We do not, however, for present purposes need to be completely clear which class of statements is intended, or how to characterise it: leaving the question to some extent unresolved, therefore, let us call the statements in question 'M-statements'.

It might be thought that the verification principle could be derived for M-statements without appeal to any general thesis about meaning, but simply from reflection on the concepts of matter and radiation, on the ground that it is intrinsic to those concepts that the presence of matter and the emission of radiation is capable of affecting something—other matter or radiation; the argument would be that, if it affects something, it must be detectable, ultimately by its remote effects on our sense-organs. Such an argument fails of cogency: undetectable matter might affect only other undetectable matter, or might render otherwise detectable matter undetectable. To rule out the possibility of undetectable matter, the verification principle must be invoked.

This need not worry us, however. For our purposes, the verification principle is to be considered as already in place: our question is whether phenomenalism is genuinely a consequence of it. In seeking an answer to this question, we shall find it very delicate, and are liable to go through various phases. The starting point is that an M-statement can be verified only by suitable sense-data. Many doubts can, of course, be raised about the concept of a sense-datum, but here we may set them aside: but what does "suitable" mean here? The second axiom of logical positivism states that all verification takes the form of experiencing sequences of sense-data. According to positivism, therefore, it is true of any meaningful statement whatever that it can be verified only by means of suitable sense-data. The relation between an M-statement and a sequence of sense-data that serves to verify it is, however, thought to be less oblique than that between, say, a statement about someone's motives, or the inflationary effects of a rise in oil prices, and a sequence of sense-data that would verify *it*.

The obvious explanation is that many M-statements—though very far from all—can serve as reports of observation, whereas individual motives, economic consequences, and the like are not, in that sense, observable. When an M-statement is observed to hold, we may say that it has been verified *directly*: but a statement may be conclusively verified, even though indirectly. A simple example is this. The word "page", as applied to the pages of a book, has two senses: the older sense, in which a page has two sides; and the usual modern sense, in which it has only one. Let us distinguish them by capitalising the word when used in the older sense. Then the most direct verification that a certain book has 284 pages consists in counting the pages, and arriving at the number 284; but a

simpler way, equally certain though indirect, will be to count the PAGES, arriving at the number 142, and multiply by 2.

A large subclass of M-statements—we might call them O-statements —are capable of serving as reports of observation; an O-statement may be said to have been verified directly *only* when it has been observed to hold good. We often know an O-statement to be true only indirectly: for instance when a star is deduced to have a massive dark companion from its being in an orbit revealed by a succession of blue and red shifts in the spectrum of its light. An observer suitably placed would be able to witness the transit of the companion star across the face of the luminous one, and so actually receive the sense-data which would provide a direct verification of its existence; since no observer is present, the only relevant sense-data are those attending inspection of its spectrum.

The concept of direct verification ought not, however, to be restricted in such a way that only O-statements are capable of being directly verified. If a statement, whether an M-statement or otherwise, is not capable of being used as a report of observation, there is nevertheless a distinction between a verification of it by the most direct possible means, and one which involves a detour or a short cut. That is illustrated, sufficiently well for present purposes, by the example of the number of pages, since it would be stretching the term "observation" to include under it the determination of a number by counting: counting is not bare observation, but an empirical *process*. What we should reckon as being a direct verification of a statement of course depends on the character of the statement: it is what must be recognised as a means of verifying the statement simply in virtue of an understanding of that statement. To be recognised as a means of verifying it, an indirect verification demands something more, if only reflection or even the ability to reason in accordance with familiar deductive principles. One cannot know what it means to say that a book has 284 pages unless one knows what counting is: but one could know what it meant without being acquainted with multiplication, even by 2. It is in no way intrinsic to M-statements that they can serve as reports of observation: certain physical substances, and certain physical properties of others, may reveal themselves otherwise than by acting on our sense-organs. We may nevertheless apply the distinction between direct and indirect verification to such M-statements also, even if in accordance with a criterion somewhat less sharp than for O-statements: for there is likely to be a characteristic test for the possession of any physical property, and a characteristic set of properties defining any given substance.

One of the great defects of positivism was that it paid little attention to the distinction between direct and indirect verification. Ayer, inter-

ested in wielding the verification principle as a weapon against theological and metaphysical statements, felt that he could afford to interpret the term "verification" very broadly, since the target statements would not come out as capable of verification, however broadly understood: in particular, therefore, he need not demand of meaningful statements that they be capable of more than *indirect* verification. But, when we examine the logical connection between the verification principle and phenomenalism, the distinction between direct and indirect verification assumes a critical importance.

Phenomenalism is a doctrine about that in virtue of which M-statements are true, when they are true: crudely stated, it maintains that an M-statement can be true only in virtue of the occurrence of ('suitable') sense-data. Not even the most radical phenomenalist can be found to assert that an M-statement can be true only if sense-data actually occur of such a kind as to verify the statement directly: for O-statements in particular, this would be to say that they could not be true unless they had been observed to be so. There are two possible ways to soften the claim. One would be to hold that an M-statement will be true just in case sense-data actually occur of such a kind as to verify the statement, whether directly or indirectly. This would still be a very strong claim: it would amount to saying that no M-statement is true unless we have conclusive evidence for its truth. Phenomenalists have therefore chosen an alternative modification, most easily stated for O-statements, according to which the actual occurrence of suitable sense-data is not required for the truth of such a statement. Rather, an O-statement will be true if and only if sense-data of a kind that would directly verify the statement would have occurred had there been an observer appropriately situated to experience them. This thesis can plainly be construed as covering all M-statements, if "observer" is understood to include one who carries out the relevant tests; and, for convenience, the term will here henceforward be used in this generalised sense. According to this (the most usual) version of phenomenalism, therefore, what renders an M-statement true is the hypothetical, but not, in general, actual, occurrence of sense-data directly verifying it. The truth of an M-statement is constituted by the truth of a certain conditional which we may call 'the ideal conditional', to the effect that, if an observer had been suitably placed, he would have experienced certain sense-data.

Is there, then, a valid transition from the verification principle, which is a thesis about what must hold good for a statement to be meaningful, to a doctrine such as phenomenalism, about what must hold good for it to be true? It is natural to suppose that there is: but some care is needed to make this out. A preliminary attempt to provide such a transition

might consist in the following argument, which we may call 'argument A'. Suppose that it is something other than sense-data, actual or hypothetical, that renders a given M-statement true: let us label whatever renders it true "gross matter". Then there can be, at best, a natural necessity that gross matter will, for a suitably placed observer (in the generalised sense of 'observer'), give rise in him to appropriate sense-data. It follows that the state of affairs is thinkable in which (contrary to the laws of nature) the gross matter is present, but no such sense-data either actually occur or would occur even were there a suitably placed observer. In such a state of affairs, the M-statement would, by hypothesis, be true. But since an M-statement can be verified only by means of sense-data, this M-statement would, in such a case, be unverifiable, contrary to the principle of verification. Hence there can be no gross matter. In other words, if, for an M-statement to be meaningful, certain sense-data must be *possible*, then, for that statement to be true, it must hold good that those sense-data either actually occur, or at least *would* occur in favourable circumstances (namely when there is a suitably placed observer).

Argument (A) is in several respects too crude. Its salient crudity is an uncritical deployment of the term "unverifiable". After all, if a statement is false, it will be incapable of verification: but the verification principle was obviously not intended to imply that only true statements can be meaningful. We may say that there is a 'genuine possibility' of an M-statement's being verified if it holds good that, were there a suitably placed observer who carried out the appropriate tests, it would be verified. Now, plainly, when it is said that, to be meaningful, a statement must be capable of being verified, it is not meant that, given the way things are, there need be any genuine possibility of its being verified, in this sense, but only that the supposition that there should occur a sequence of sense-data constituting a verification of it involves, in itself, no contradiction. This indeed entails that there can be no meaningful statement whose content requires, for it to be true, that no such sense-data should occur.

It may, then, be objected to argument (A) that this is *all* that the principle of verification entails, even for a true statement. In particular, it does *not* entail, as argument (A) contends, that, if the statement in question is true, the appropriate sense-data really *would* occur in favourable circumstances. It is enough, on this objector's view, that, were they to occur, we should recognise them as verifying the statement; the statement may nevertheless be unverifiable in the stronger sense that, as things are, no sense-data would disclose its truth to us.

This objection may be rejected as resting on too weak an interpretation of the verification principle. On that interpretation, the possibility of verifying a statement, if it is true, will not, in general, be an intrinsic consequence of the meaning of that statement, but of that together with certain natural laws or other empirical connections we believe to hold. However palatable such a view may appear in a philosophical climate, like the present one, favourable to holism, it is implausible as an interpretation of the highly atomistic doctrines of the logical positivists. Rather, we must take it as implicit in the verification principle, as the positivists understood it, that the possibility of verifying a meaningful statement follows solely from its meaning: and that entails that, if it is true, then there must be a genuine possibility of its being verified, just as argument (A) concluded.

Thus argument (A) did establish that the verificationist must hold that an M-statement of itself entails what we earlier called the 'ideal conditional' associated with it, namely the conditional stating that a suitably placed observer would experience the appropriate sense-data. Nevertheless, it did *not* succeed in demonstrating that the verification principle implies phenomenalism. How can this be? We have rejected the idea that a positivist could consistently hold that the ideal conditional is not implied by the truth of the M-statement alone, but by that together with other empirical truths: what room, then, is left for him to deny that it is in virtue of the truth of the ideal conditional that the M-statement holds good? The room is provided by the character of such conditionals, which are judged correct or incorrect only against tacit background assumptions to the effect that all is hypothesised to remain as it in fact is save as required for the truth of the antecedent. It is this which would make it consistent for the positivist to regard the fact that things affect our sense-organs as they do, giving rise in us to sense-data of a particular kind, as a contingent feature of the world: the truth of the ideal conditional would then consist in the fact that, given that our sense-experiences are as they are, a suitably placed observer would have experienced certain specific sense-data. If the positivist were to take this view, he would then be compelled to take something independent of the actual or hypothetical occurrence of sense-data of a particular kind to be that which renders a given M-statement true, and so to reject phenomenalism.

To this it may well be replied that the position thus envisaged tacitly admits a distinction between two kinds of necessity, metaphysical and linguistic, and is therefore irreconcilable with positivism, which insisted that there is only linguistic necessity. The truth of an M-statement will,

on such a view, imply that of the corresponding ideal conditional by linguistic necessity: for our understanding of the M-statement depends upon our knowledge that the occurrence of the associated sense-data constitutes the canonical ground on which we may recognise it as true. But the thesis that it is a contingent feature of our make-up that the state of affairs reported by the M-statement will give rise in us to just those sense-data requires the term "contingent" to be construed in a different, metaphysical, sense. Namely, it demands that, by reflecting on what makes the M-statement true, if it is true, we can see that *it* might yet hold good, even if our sense-data were quite different: and *this* notion of contingency is not linguistic, but metaphysical, turning not on how we recognise our statements as true, but on what makes them true or false.

The distinction is real enough, but it is wrongly drawn: it ignores the tight conceptual connection between truth and meaning. It makes sense to ask what sort of thing makes a statement of a given kind true, when it is true, only when this amounts to asking what we *understand* as rendering statements of that kind true. If the answer is then held to be significantly distinct from the answer to the question by what means we recognise those statements as true, the meaning of such a statement is being taken to comprise two distinguishable components: the basis on which it is recognised as true; and our conception of what makes it true, when it is. This will, indeed, give rise to two types of necessity: but both will be equally entitled to be deemed to be linguistic in origin, as arising from the meanings we attach to our sentences. Such a distinction between types of necessity is indeed akin to, but definitely not identical with, Kripke's distinction between epistemic and metaphysical necessity. It can arise only in so far as we are prepared to acknowledge a merely contingent connection between something and the effects by means of which we recognise it. This of course depends on how those effects are described: a description in terms of a supposed sense-datum language offers an exceptionally plausible example for regarding the connection as no more than contingent.

Two versions of the verification principle were current among the logical positivists. The stronger version is their original slogan:

(V1) The meaning of a statement is the method of its verification.

Ayer was principally concerned to maintain a version plainly implied by (V1), but not, in itself, implying it:

(V2) A statement is meaningful if and only if it is verifiable.

(V2) is, obviously, simply a test for meaningfulness. (V1) is something much more comprehensive, the core of a theory of meaning: it makes a

proposal for what should be taken as determining the content of a sentence.

Why, then, should anyone believe (V2)? A strong reason for believing it would be that one found (V1) convincing. Crudely stated, (V1) claims that what we learn, when we learn to use a sentence, is what is to be recognised as verifying a statement made by uttering it. More exactly stated, it claims that the use which we learn to make of each sentence can be represented as systematically derivable from whatever is required to verify such a statement. Stated more exactly yet, it claims that the understanding we acquire of the words of our language consists in a mastery of the contributions they severally make to determining what shall count as verifying a statement made by uttering any sentence composed of them, together with a mastery of other features of the use of such a sentence as are systematically derivable from those verification-conditions. That is what it is to propound the core principle of a theory of meaning. So regarded, (V1) has considerable plausibility: it is not my purpose here to discuss its strengths and weaknesses.

(V2) certainly does not imply (V1); but (V1) provides (V2) with a rationale. Some such rationale is required. One could hardly believe oneself to possess a criterion for deciding whether or not apparently meaningful sentences really have a meaning in the absence of any general idea about what constitutes the meaning of a sentence. (V1) does not supply the only possible ground for believing (V2), however: a weaker principle, (V3), would serve the same purpose equally well:

> (V3) The method of verifying a statement is an essential component of its meaning.

(V3) is consistent with the view sketched above, that the meaning of a sentence has two distinct components: what is required to verify a statement made by uttering it; and our conception of what would render such a statement true. This 'composite' view must be held by a verificationist who rejects phenomenalism, at least if he accepts the second axiom of logical positivism, that an empirical statement (and in particular an M-statement) can be verified only by the occurrence of suitable sense-data. Since he holds that an M-statement is rendered true by something other than actual or hypothetical sense-data, he cannot accept the unvarnished (V1). Since he is a verificationist, and adheres to (V2), he cannot adopt a pure truth-conditional theory of meaning according to which the meaning of a sentence simply consists in what is required to render a statement made by uttering it true: he has no choice but to adopt a composite theory. Adherents of (V1), on the other hand, must be phenomenalists. It is plain that, historically, the positivists

accepted (V1), not the weaker (V3): even Ayer, who did not overtly advocate (V1), must be thought of as having based (V2) on (V1) and not on any composite conception of meaning.

Divergent proposals about what should be regarded as determining the content of an utterance, or, in other words, about the core principle of a theory of meaning, arise because of the diversity of features possessed by a sentence and dependent solely upon its meaning: it then becomes natural to seize on some one of these, and propose that it be regarded as primarily embodying the meaning. Such a proposal is always program-matic: it remains to be seen whether it is possible to devise a plausible theory of meaning around the proposed core principle. One of the conditions such a theory must satisfy is to display the connection between what has been taken to constitute the meaning of any given sentence and the various other features that intuitively depend on its meaning. If the meaning of a sentence is taken as consisting in the method of verifying a statement made by means of it, then there must be a uniform means of determining, from the meaning considered as so given, what is required for such a statement to be true. There must likewise be an account, in terms of the verification-conditions of the statements involved, of the relation of entailment of one statement by finitely many others; an account also of what someone commits himself to by accepting a statement as true. Conversely, if the meaning of a sentence is taken as constituted by the condition that must hold for a statement made by means of it to be true, there must be a means of deriving, from those truth-conditions, what we shall take as verifying the statement. Only if the theory of meaning can display everything that we take to depend solely on the meaning of a sentence as derivable from what, according to the core principle of the theory, has been taken as constitutive of that meaning, will the proposal to adopt that core principle have been vindicated.

The task of thus vindicating any proposed unitary core principle is daunting enough: but harder yet is that of defending a composite principle. The difficulty lies in explaining the relation between the two (or more) components. It is in no case plausible that they are wholly unconnected: one could not suppose, for example, that, once it has been fixed what is to count as verifying a certain statement, we are completely free to fasten on anything we choose as rendering it true. At the same time, the connection cannot be rigid. It must not be possible systemati-cally to derive either component from the other, for a more elegant theory would then result from taking the latter component by itself as constitutive of meaning, and so adopting a unitary principle in place of a composite one.

III

So far, not a single plausible proposal exists to show how two putative basic components of meaning could be displayed as connected, but sufficiently loosely connected to make it essential to require both as fundamental. But the prospect for unitary theories is not yet a great deal brighter. On the one side are the resolute adherents of truth-conditional theories, which take, as the single core component of meaning, that which renders a statement true, and hence, as the single core component of understanding, the conception of what, in general, is required for it to be true. On the other are the heirs of positivism, who continue to explore the possibility of treating what is required for a statement to be recognised as true as the single core component. It was Quine who first perceived where the fatal error of positivism had lain. It had not lain in the very idea of treating the type of verification demanded of a statement as the core component of meaning; in the famous article in which Quine diagnosed the error of positivism, he himself sketched as verificationist a picture of language as any positivist's. It had lain, rather, in its crude conception of what constituted the verification of an empirical, that is, of a non-mathematical, statement, and, in particular, in the atomistic character of this conception. On such an atomistic conception, the meaning of any one sentence might, in principle, be grasped by someone ignorant of the rest of the language, and could, in principle, be characterised without reference to the use of any other sentences or expressions. This atomistic conception can be replaced by a more holistic one—one that allows that the understanding of a sentence will, in general, depend upon a background understanding of at least some fragment of the language—only by broadening our notion of what a verification of a statement comprises to include procedures in which we actually engage, procedures that will normally involve linguistic operations: in this way, we can eliminate the positivists' dichotomy between the type of meaning possessed by empirical statements and that possessed by mathematical ones. This diagnosis contains no refutation of the fundamental idea of a verificationist theory of meaning: it leaves us free to explore that possibility, so long as we admit a sufficiently generous conception of what, in general, may constitute a verification. Such a theory, because it is unitary, must either jettison the notion of truth altogether, or seek to explain it in terms of the core notion of verification. To jettison the notion of truth is not, of course, to declare the word "true" senseless, but to reject the notion of truth as having any role to play within the theory of meaning: its role, on such a view, is purely internal to the language, and, as such, is sufficiently explained by

Ramsey's redundancy theory, or, perhaps, by a Tarski-style truth-definition.[1] There is, on this view, no deep or illuminating connection between truth and meaning.

Now there are formidable difficulties facing any such theory, of which its proponents are well aware, and which its opponents press. It is of little value to press them, however, unless a parallel effort is made to show that a unitary truth-conditional theory can meet the demands laid on all theories of meaning. Such a theory faces two problems: first, to explain in what a speaker's grasp of the condition for the truth of a statement consists; and, secondly, to show how other features of the uses of sentences, intuitively dependent on their meanings, can be derived from what is taken by the theory to be its meaning as characterised by the core notion. A solution to the second problem requires an account of how the condition for the truth of a statement determines what we shall count as establishing its truth; in other words, how what, in general, makes it true determines what serves for us as a means of recognising it as true. For the most part, defenders of truth-conditional theories of meaning simply fail to perceive that they need to solve these problems if they are to vindicate the adequacy of their theories: they are especially blind to their obligation to solve the second of them. They appear to think that there is no problem to be solved: but the more strongly it is insisted that our conception of what renders certain statements true comes apart from our means of recognising them as such, the more pressing the need to explain the connection between them. The two problems are not, indeed, independent. A truth-conditional theorist must explain our grasp of the meaning of a predicate as consisting in a knowledge of what it is for it to hold good of an arbitrary object; and when he undertakes to explain what constitutes possession of such knowledge, he must surely begin with the simplest cases, namely those in which we can directly verify the application of the predicate by observation or some effective procedure. It could hardly be maintained that our conception of what it is for something to be, say, smooth has nothing to do with our ability to say whether it is smooth to the touch, or that our conception of what it is for a container to hold twelve tennis balls is independent of our knowledge how to count. At this fundamental level, the truth-conditional and the verificationist conceptions of meaning virtually coincide: the task of the truth-conditional theorist is to explain what forces them apart at higher levels; that is, how our conception of what makes our statements true comes apart from our ability to recognise them as true, and yet determines what is to count as so recognising them.

For anyone who still accepts the conceptual priority of language over thought, a theory of meaning provides the only viable route to the

philosophical analysis of thought; and even one who rejects it has to construct a theory of thought that will, of necessity, at many places mirror a corresponding theory of meaning. In particular, theories of thought may be either verificationist or truth-conditional in a sense exactly analogous to that in which these terms apply to theories of meaning. Theories of either kind, to be coherent, must observe the restriction that they cannot be self-applicable: they must purport to apply only to a part of language or a range of thought that does not include such theorising. Of their very nature, they will have metaphysical consequences. For any theory of meaning or of thought, whether verificationist or truth-conditional, must either jettison the notion of truth, in the sense explained, or explain what makes statements or thoughts of various types true when they are true. As already observed, that was what phenomenalism attempted to do for M-statements: and that is what makes phenomenalism a metaphysical theory. The ambition to abolish metaphysics was positivism's greatest illusion. Metaphysics can be abolished only if philosophy is abolished: and that was an ambition the positivists never entertained.

IV

What, then, will be the metaphysics of a generalised verificationism, one generalised by replacing the atomism of the positivists, not indeed by full-blooded holism, but by a conception according with Wittgenstein's dictum that to understand a sentence is to understand a language? No precise answer can, of course, be given, since "generalised verificationism" names only a type of meaning-theory, within which there may be many variations. We may say at once, however, that such a verificationism will not, of itself, dictate any thesis about what forms the substance of the world, or even of material reality, such as the phenomenalist thesis that its substance consists of sense-data. To choose some notion of verification, or, more generally, of evidence, as the core notion for the theory of meaning determines that the notion of truth is somehow to be explained in terms of it, but by no means determines the precise form of that explanation; it certainly need not take the radical form of holding a statement to be true only if it is in fact verified. But, however exactly truth is to be explained within a verificationist theory of meaning, there can be no justification for an assumption of bivalence for every meaningful statement; such an assumption rests strictly upon the belief that our grasp of its meaning consists in knowing what it would be for it to be true, and that this yields us simultaneously a knowledge of what it

would be for it not to be true. It follows that any verificationist theory of meaning will involve that there are gaps in reality; that is to say, that there are meaningful statements, which we can understand and whose truth or falsity we can therefore conceive of establishing, but for which, nevertheless, the question whether they are true or false has no answer; they concern a region of reality that is simply indeterminate.

Such a conception goes against the grain of our whole way of thinking, just as it goes against the grain of our way of thinking to suppose, in particular, that there is no answer to a counterfactual question about what would have happened if we had made some crucial decision the other way; but that intuitive repugnance is no ground for rejecting it. It is sometimes suggested that it is inconsistent with theism (which Ayer has lost few opportunities to repudiate, but to which I happen to subscribe). The ground is that God knows all that is to be known, and that his faculties for knowledge are uncircumscribed; but, of course, to say that God knows all that is to be known is simply to say that he knows the truth of every true statement or thought, and does not, of itself, tell us anything about which, or how many, statements or thoughts *are* true. The appeal to God's omniscience has, indeed, some cogency against arguments for indeterminacy based on the finitude of the human mind. In mathematics, the platonist argues that, given that each of some denumerable set of statements is determinately true or false, it must also be determinate whether any of them is true. The constructivist argues that, even if, for each statement in the set, we have an effective means of deciding whether it is true or false, we still cannot have applied this decision-method to all but finitely many of them, and that therefore we have no warrant to assume that either all of them are false or that at least one is true. But God must surely know, for each of them, whether it is true or false; and then he must surely also know whether or not he knows, of any of them, that it is true. Similar considerations may also apply to arguments for indeterminacy based on the inaccessibility in principle of certain regions of space-time. These, however, are not the only sources of indeterminacy: not the only features of intelligible statements which open a gap between a verificationist and a realist conception of truth; and, in other cases, the appeal to God's omniscience fails to bridge that gap. There is no reason why, when we have no access to the truth of some matter, we should assume that God has such an access: there may simply *be* no truth of the matter. A verificationist may remain sufficient of an idealist to believe that the world as God created it is the world as we apprehend it, or, rather, as it is apprehended by whatever rational creatures it contains.

But surely, it may be said, God could have created a universe devoid of rational creatures. Well, we can reason about how *our* universe would

have been if it had contained no rational creatures; but to suppose that God might have created such a universe is to entertain a phantasm: there would be no difference between creating a universe devoid of rational creatures and not creating anything. What follows from the fact that the world was created by God is that it is *one* world. I do not mean that theism is the only refuge from solipsism, because I hold that there cannot be a rational creature that does not belong to a community of rational creatures. (If it were legitimate to substitute "beings" for "creatures" here, we should have the beginning of what Aquinas said was impossible, a rational deduction of the doctrine of the Trinity.) I think, further, that solipsism is incoherent on this ground alone; but certainly, even on this planet, not to speak of what there may be elsewhere in the universe, not all creatures inhabit the same world. Admittedly, we are not sure that any inhabitants of this planet save ourselves are rational; but, in speaking of the world a creature inhabits, I do not want to lay excessive stress on its rationality, because we cannot say that the rationality we claim but deny to gorillas, for example, is a condition for having a picture of the world, and hence for inhabiting a world. One of my grandsons, at the age of six, came rushing in from the garden one day, having been studying the ants and other small creatures that he found in it, and said excitedly, "There's a world of worlds out there!". This is absolutely right. Other creatures share this planet with us: but we can describe them as living in the same world only to the extent, very often non-existent, that we can communicate with them.

Without a belief in God, we must conclude that that to which we can attribute truth holds only of *our* world. We know confusedly that there are other worlds; but, not only do we know nothing of them, but we cannot really speak intelligibly of them. If all creatures are truly creatures, however, that is, the work of one Creator, then, and only then, there must be a single world of which all their worlds are aspects. This certainly implies that that single world is a great deal richer than our world; but it does nothing to guarantee that it is free from indeterminacy or from gaps. Gaps occur in the single world whenever there are thoughts that some creatures can entertain, but whose truth-value no creature can in principle determine; gaps occur in our world when there are thoughts that we can entertain, but whose truth-value we cannot in principle determine. Since our world is only an aspect of the single world, many of the gaps in our world may be illusory; but there is still no ground for holding that the single world is a metaphysical plenum, that is, wholly free from indeterminacy.

These last remarks are, of course, highly speculative, and I feel quite unsure whether they are right; but I console myself with the thought that

nothing that I have written is as wild as some of the things that Ayer asserted during his positivist phase.

MICHAEL DUMMETT

NEW COLLEGE
UNIVERSITY OF OXFORD
JANUARY 1989

NOTE

1. It may seem odd to think of a Tarskian truth-definition as characterising the use of "true" *within* the language, because Tarski demonstrated that it cannot apply to the language in which it is framed. But it can apply to part of that language, and, if no use is made of the defined notion in the semantic theory, it serves only to characterise such applications, which can be made within the language as a whole.

REPLY TO MICHAEL DUMMETT

I am very grateful to my friend and former colleague, Michael Dummett, for his thorough, fair, and perceptive criticisms of the views that I advanced in *Language, Truth and Logic*. Though I find myself in agreement with much of what he says there are a number of points which I shall find it necessary to elucidate. I shall also have something to say about the speculations on which Dummett embarks in the concluding section of his paper.

I can begin by saying that I entirely agree with Dummett's account of the status of the principle of verification. I was never tempted to claim that the principle was synthetic. As an account of the way in which English speakers actually talk of meaning, it would too obviously be false. Nor was I hoping to maintain that it was analytic for, while analytic statements are not descriptive of linguistic usage, they are validated by the ways in which signs are used. Happily not everything that the verification principle failed to license was cast by me on the pyre of metaphysics. In my treatment of ethics, I had made provision for prescriptive statements. If I did not allow them to be true or false, I did not brand them as nonsensical. Accordingly, in the preface to the second edition of *Language, Truth and Logic*, I treated the verification principle as a prescriptive definition. But why should the prescription be obeyed? I evaded this awkward question by defying my critics to come up with anything better.

Dummett's way of dealing with this problem is an improvement on my own. I should have dismissed the objection that the verification principle does not satisfy itself as an *ignoratio elenchi*. The verification principle encapsulates a general theory of meaning and a general theory of meaning should not be expected to satisfy itself.

I have also to concede to Dummett that when the verification

principle is viewed in this way its cutting edge is blunted, at least as an instrument for executing metaphysics. I agree that in so far as metaphysics constitutes a set of semantic theories, the verification principle passes it by. I doubt, however, whether this is true of metaphysics in general. It applies to the metaphysics of Plato, Leibniz, and Spinoza but not, in my view, to the utterances of Heidegger or Derrida, the greater part of which I should still dismiss as nonsensical, nor to the neo-Hegelian systems of Bradley and McTaggart, which are valuable not because of their conclusions but because of the arguments, leading to those conclusions, which put the concepts of matter, space, time, and motion in question. I have elaborated this point in my essay "Metaphysics and Common Sense", which gave its title to a volume of essays that I published in 1969.

To the question how analytic propositions or, as Dummett prefers to put it, "propositions not arrived at by empirical investigation", can then bring us fresh knowledge, I am satisfied with the answer which I gave in *Language, Truth and Logic*. It is due to the limitations of our insight. I defend this explanation at length in my reply to Professor Miró Quesada's essay in this volume.

I accept Dummett's characterization of 'M- and O-statements' and his attribution to me, as a Logical Positivist, of the view that verification consisted in the occurrence of sense-data, with the consequence that 'what renders an M-statement true is the hypothetical, but not, in general, actual occurrence of sense-data directly verifying it'. When I wrote *Language, Truth and Logic*, I was inclined to think that the conditional statements, into which M-statements were to be resolved, had to refer to possible sense-data of one's own. This led me to give an implausible analysis of statements about the past, and an inconsistent account of statements about one's own and other persons' minds. I therefore fell back on what Dummett calls 'the ideal conditional', invoking not necessarily oneself but the best placed observer.

Dummett raises the question whether acceptance of the verification principle commits one to phenomenalism. I thought that it did, and defended phenomenalism not only in *Language, Truth and Logic* but also in my second book *The Foundations of Empirical Knowledge*, which was published in 1940. When I returned to philosophy after the war, having been engaged for five and a half years on military duties, I decided that phenomenalism was not tenable. I gave my reasons for this change of view in an article entitled 'Phenomenalism', which first appeared in the *Proceedings of the Aristotelian Society* for 1947–48 and was reprinted in my *Philosophical Essays*. I continued to hold that the occurrence of the appropriate sense-data entailed the truth of the corresponding M-

statement, with the important reservation that since the potentially relevant data are infinite in number their tally could never be completed. On the other hand, I realized that the truth of an M-statement did not entail the truth of any of the sense-datum statements which would verify it; for the sense-datum statements might be falsified for reasons which were unconnected with the truth of the M-statement which it was equipped to verify. The observer might be inattentive or he might be suffering from some physical or physiological disorder. We might try to guard against this by having the observer hypothetically tested by a competent scientist, but the same doubt could then be raised about the scientist in his turn and so *ad infinitum.*

This rejection of phenomenalism did not and does not commit me to a belief in undetectible matter. The existence of the material objects in our environment is directly verifiable, in Dummett's sense. While I do not take such objects to be 'constructed' out of sense-data, in the way that phenomenalism requires, I do treat them as theoretical 'constructs' on the basis of sensory qualities or, as I now prefer to call them, 'qualia'. As I explain in *The Central Questions of Philosophy*, the phenomenal properties with which they are endowed are the properties of the 'standardized percepts' which are derived in their turn from families of qualia that are similarly located in various sense-fields. I rely here, as Hume did, for a rather different purpose, on the relations of constancy and coherence which predominantly obtain in our sense-experience.

I am less troubled than Dummett believes that I should be by the holism which the positivists were accused by Quine of having overlooked, thereby committing a 'fatal error'. In fact, I already paid my respects to holism in *Language, Truth and Logic*, with an acknowledgement to Henri Poincaré. I admitted that, in the case of scientific theories at least, to accept a hypothesis as verified involved letting other constituents of the theory pass as being true. I did, however, fail to remark that this diminished the role of the verification principle in determining the meaning of a hypothesis. The requirement that theories as a whole be empirically testable is comparatively weak, even if we are in possession of a method of expunging from the theory any statement that in no way contributes to its testability. Because of this I am willing to concede that the meaning of this or that ingredient in a theory is not detachable from the meaning of its associates, inasmuch as it depends on the way that they too are interpreted. Furthermore, these interpretations allow for some latitude. For instance, as Poincaré pointed out, it is in our power to decide whether the rules governing the concept of force in classical mechanics are to be treated as conventions or as empirical hypotheses. The same might be thought to apply to the Uncertainty Principle in

quantum mechanics, though here the impossibility of carrying out the observations which would assign definite values to the position and momentum of an elementary particle at a given instant should cause the principle to be treated by verificationists not as an empirical hypothesis but rather as a rule of meaning. No sense is to be attached to saying that a particle has a definite position and momentum at any given time.

In this matter, I remain a verificationist. More generally, I am still prepared to equate the meaning of a theory with the totality of the observations that would verify it. I should, however, again make it clear that this does not commit me to my old view that the theory could be rewritten as a conjunction of O-statements of a purely sensory type. Not only do I maintain the objections to this view which I have already stated but I hold that the possibilities of verification are not circumscribed. To that extent, the meaning of abstract scientific concepts like 'meson' or 'quark' is indeterminate.

My residual attachment to phenomenalism does not, in my view, commit me to an ontology of sense-data, or even debar me from upholding a form of physical realism. In *The Central Questions of Philosophy* I tried to show that priority in the order of knowledge did not have to coincide with priority in the order of being. All our empirical knowledge, apart from our knowledge of our own states of consciousness, was shown to be founded on our percepts, but the physical objects, which were represented as theoretical constructions on the basis of those percepts, were what there was primarily taken to be. The percepts were reinterpreted into the theory as states of the persons whom they had served to 'construct'. I am still in some doubt as to the status of the unobservable particles of modern physics but I am inclined to revert to Locke's view that they are unobservable, not in principle, but only for the reason that they are so minute. If this is correct, I can regard them as being literally parts of the physical objects of common sense. The chief argument in favour of this interpretation is that they are supposed to occupy the same regions of physical space.

The result is that of the different renderings which Dummett gives of the verification principle. I opt for V1 rather than V3. The choice of V3 would be more prudent but I cannot accept the implication that an M-statement is made true, even in part, by states of affairs which are not even indirectly verifiable. However, I do not agree with Dummett that acceptance of V1 commits me to phenomenalism, at least in the strong form in which I once defended it. From the fact that an M-statement can be made true by nothing other than the actual or possible occurrence of percepts, it does not follow that an M-statement must be translatable into a set of 'ideal conditionals' which refer exclusively to percepts. This is

not because the M-statement entails the existence of anything that lies outside the domain of percepts, but rather, as I have explained, because one or more of the conditionals may fail to be true for reasons which are independent of the truth of the M-statement, and also because the range of the sensory possibilities is neither finite nor bounded.

This subordination of the concept of truth to the concept of verifiability in our account of meaning does not entail, as Dummett recognizes but fails to make entirely clear, that the concept of truth needs to be explained in terms of the concept of verification. Tarski's formula, 'S is true in L if and only if P', is misleadingly exemplified by ' "Snow is white" is a true English sentence if and only if snow is white', since the example obscures the fact that the meta-language need not be extracted from the same natural language as L, so that a better example would be 'The French sentence "La neige est blanche" is true if and only if snow is white'. Even so, the formula, however illustrated, serves as an adequate control upon any proposed definition of truth. That it gives no control over meaning is shown by the fact that any piece of nonsense can be slotted into it : so, for example 'La phrase anglaise "The Absolute is lazy" est vrai si et seulement si l'Absolu est parasseux'. It is not necessary even that the nonsense has its equivalent in another natural language. Since L and the meta-language can be homophonic, the less satisfactory example 'The English sentence "The Absolute is lazy" is true if and only if the Absolute is lazy' serves our purpose just as well.

I think that Dummett goes too far in saying that we are hereby rejecting the equation of the meaning of a declarative sentence with the truth-condition of the statement which it is understood to express. The objectons to the truth-conditional theory of meaning are first, that in the case of O-statements and most everyday M-statements the affirmation of their truth-conditions coincides with the affirmation of the statements themselves, so that the theory is useless, and secondly, that, in the case of more abstract statements, where it should be useful, the truth-conditions of a given statement cannot be separated from those of the other empirical constituents of the scientific corpus of which it is an ingredient, and that the truth-conditions of the whole corpus are not fully specifiable. On the other hand, the advantage of interposing its truth-conditions between the meaning of a statement and the possibilities of its verification is that it brings out the point that while the dependence of the meaning of an M-statement upon its truth-conditions may sometimes be exhibited as a translation, this never applies to any account that we can give of the possibilities of its verification in terms of which its meaning is ultimately 'cashed'. And I am inclined to think that this advantage outweighs the objections.

Having accepted Dummett's offer of 'a generalised verificationism', I address myself to the metaphysics with which he links it. There are two points on which I agree with him. Though I should not myself choose to talk of 'an indeterminate region of reality' I agree with him that there are intelligible statements which do not have a truth-value. All professed examples of this type are controversial, but probably the least controversial is the one that Dummett has chosen, namely, that of counterfactual conditionals. I am not sure whether Dummett would go so far as I do in denying truth-value to all counterfactuals, while allowing that those that are backed by established generalisations like the counterfactual 'If I had jumped out of the window a moment ago I should have been injured' are more acceptable than their negations. I assume, however, that he would deny truth-value to such an example as 'If I had taken a coin out of my pocket a moment ago it would have emerged heads uppermost' where it is not only plausible to say that there is no fact of the matter but also no reason for accepting the counterfactual rather than rejecting it.

I agree also with Dummett that if there were a God, his being unable to assign a truth-value to such counterfactuals would not detract from his omniscience. Even a God can not be expected to know facts where there are no facts to be known. The assumption that there is a God, whether omniscient or not, is one that I do frequently repudiate, but I shall forbear to do so on this occasion.

On the other hand, I cannot let Dummett's 'wilder' speculations pass without objecting to them. So far as I can make his reasoning out, he takes it for granted that there is a Creator of 'our world' and then argues that this world, qua something that a God has created, necessarily contains a community of rational creatures who share their conception of it at least to the extent of being able to communicate with one another; necessarily, because 'there would be no difference between creating a universe devoid of rational creatures and not creating anything'. Dummett offers no reason in support of this last statement and I shall argue in a moment that it is simply untrue.

Dummett offers no reason either in support of another statement, which I believe to be untrue, that it is only to the extent that we can communicate with other creatures that we can describe them as living in the same world. Presumably he does not mean that I have to conceive of monolingual speakers of languages like Finnish and Arabic, which I myself do not speak, as living in a different world from mine, nor even that I inhabit a different world from that of English speakers with whom I can hardly communicate because we have next to no common interests. This could be said figuratively but it would not be a point worth making. Dummett may think that there is more point in saying that my cat and I

inhabit different worlds, but even here I cannot see how he can possibly hold this to be true except in a figurative sense.

I do not understand, either, why Dummett supposes that the existence of a Creator is necessary for there being only one world. He says that 'Without a belief in God we must conclude that that to which we can attribute truth holds only of *our* world' as though this were a disadvantage. It might be a disadvantage if Dummett were entitled to say 'We know confusedly that there are other worlds', but he is not so entitled if the plural covers me. I do not claim to know even confusedly the truth of what I believe to be false. I am therefore quite happy with the thought that I attribute truth only to 'our' world, the only world that there actually is.

In speaking of 'our' world, I am implying that the world contains persons like myself, but not that it was bound to contain such persons, or even sentient beings of any sort. Dummett appears to concede this point when he says that 'we can reason about how *our* universe would have been if it had contained no rational creatures' for this implies that a universe resembling our own except for the absence in it of rational creatures is at least a possibility. Perhaps I am handicapped by an inability to share Dummett's assumption of a Creator, let alone his ability to believe in such a being, so that I do not regard it as possible that the world was created at all. But, if for the sake of our argument, I allow that it could have been created, then I am bound to say that I still find no difficulty in conceiving it to have been devoid of rational creatures.

This is not inconsistent with my verificationism. My acceptance of Dummett's ideal conditionals does not commit me to holding that their protases are actually satisfied. I can intelligibly speculate about the theoretically observable scenes which would confirm hypotheses about the absence of any actual percipients.

When I first read the final section of Dummett's paper I suspected that he had fallen into the same error as Bishop Berkeley who allowed Philonous to convince Hylas that a thing like a tree could not exist without being thought of, on the ground that Hylas himself was thinking of it when he gave it as an example. Similarly I suspected that Dummett might have been deceived into thinking that since it required a rational being to describe our world he could intelligibly describe it as devoid of rational beings. Evidently this would have been a *non sequitur* just as it was a *non sequitur* for Philonous to argue that because Hylas could not think of a particular tree without thinking of it he could not suppose that there were trees that were unthought of, or even that the tree in question might have been one of them. Later I realized that while Dummett had once or twice provided food for this suspicion he had also said things

which were inconsistent with it. Besides, I regard him as too acute a thinker to make such a mistake. Unfortunately, this leaves me with no clue whatever to the processes of reasoning which led him to what I regard as his untenable conclusions.

In these circumstances I do not feel entitled to comment on his claim to have written nothing so wild as some of the things that I asserted during my positivist phase.

A.J.A.

5

Elizabeth R. Eames

A.J. AYER'S PHILOSOPHICAL METHOD

Since 1935 Ayer's writings on philosophical topics have represented a clarity of expression, a sense of the history of contemporary problems, and an awareness of current philosophical alternatives which are rare in the literature of analytic philosophy in the last half century. In particular he has been attentive to the problem of the function and method appropriate to philosophy in a time when science seems to have left no subject matter as the domain of philosophy. His own work exemplifies an awareness of a variety of methodologies from the classical analysis of the logical positivism of *Language, Truth and Logic* to the epistemological analysis applied to current problems of essays in *The Concept of a Person and Other Essays* of 1963, *Metaphysics and Common Sense* of 1967, and the summation of *The Central Questions of Philosophy* of 1973.[1] Ayer has examined, borrowed, and adapted from the different analytic methodologies as they emerged during his philosophical career. The outcome is a volume of analytic work marked by change, development, and interesting and surprising turns. These changes raise some questions: How do these different methodologies fit together in Ayer's work? Is there an ultimate synthesis? Does a later replace an earlier methodology? How are philosophical arguments to be constructed and philosophical hypotheses assessed? And are the methods Ayer advocates and uses suitable to carry out the task of philosophy as he sees it?

Ayer's early discussion of the nature and scope of philosophy in *Language, Truth and Logic*, in 1935, represented the high tide of the influence of the Vienna Circle on his thinking. There is no specific subject matter which is philosophical, and philosophical method is the logical analysis of scientific concepts and propositions. Matters of fact are the domain of science itself, and most of what has been considered

the subject matter of philosophy in the past meets the criteria of neither the factual nor the syntactical, and thus fails to have cognitive significance.[2] Even the second edition of this book, in 1946, although acknowledging serious problems within logical positivism with verifiability and analyticity, concedes only that it might do no harm to allow the propositions in the book itself to be called philosophical, if it were understood that they were purely linguistic in nature.[3]

The Foundations of Empirical Knowledge of 1940 was devoted primarily to a phenomenalist analysis of the empirical basis of our knowledge. While phenomenalism is presented as a linguistic choice and is thus still within the framework of Ayer's logical positivism, the concern with finding a secure basis for the reconstruction of the beliefs of common sense and of science emerges as an important epistemological theme. In *Philosophical Essays* of 1953 and *The Problem of Knowledge* of 1956[4] the epistemological problem seems a step further from positivism. In the latter book Ayer begins with a description of philosophical method:

> It is by its methods rather than its subject-matter that philosophy is to be distinguished from other arts or sciences. Philosophers make statements which are intended to be true, and they commonly rely on argument both to support their own theories and to refute the theories of others; but the arguments which they use are of a peculiar character. The proof of a philosophical statement is not, or only very seldom, like the proof of a mathematical statement; it does not normally consist in formal demonstration. Neither is it like the proof of a statement in any of the descriptive sciences. Philosophical theories are not tested by observations. They are neutral with respect to particular matters of fact.[5]

Thus, neither specific factual investigations nor lexicographical inquiries are appropriate methods for the philosopher. No question can be raised of how a specific occurrence happens; rather the question is, How can anything that happens be described? There is no question of cataloging the usage meanings of a given term, but of asking how those meanings are to be analyzed. It is also noteworthy that the philosopher aims at truth. Ayer chooses examples of the kind of questions raised by philosophers concerning knowledge such as "Does knowing make a difference to what is known?" or "Is it necessary to distinguish between the sorts of things that can be known directly and those that can be known only indirectly?"[6] These and other questions require the philosopher to seek for the common features of knowledge. Ayer considers a number of proposals for definitions of 'knowledge', and a number of objections raised against them in philosophical literature, and offers arguments for and against these historical claims. He ends his introductory chapter with a tentative

definition of knowledge, and with a statement of the challenge of the philosophical skeptic to any proposed criteria for knowledge, and to the proposed means for evaluating claims that certain kinds of knowledge meet those criteria. This sets the framework for the traditional epistemological problem of answering the philosophical skeptic and the traditional method of definition and criticism of a definition, of proposed proposition and offered counter-example as a form of argument.

More recently Ayer addresses the description of the subject matter and method of philosophical analysis in the third chapter of *The Central Questions of Philosophy* (the Gifford Lectures of 1973). Here he shows an appreciation of the different kinds of analysis which have developed in the period following the second world war. Ayer offers a classification of five types of philosophical analysis.

The first is formal analysis which is usually a definition and a critical evaluation of concepts important in science or everyday life. The hope for this kind of philosophical activity is quoted from F.P. Ramsey. "In philosophy we take the propositions we make in science and everyday life, and try to exhibit them in a logical system with primitive terms and definitions etc."[7] But Ayer indicates that much less has been accomplished than was hoped for by Ramsey. The second kind of analysis is that of logical grammar which is an attempt to "explain distinctions which lay claim to belong to the architecture of our language." The works of Willard Van Orman Quine and Rudolf Carnap exemplify this kind of analysis. The third type of analysis is that of ordinary usage, an informal analysis of the usage of ordinary educated speakers of English with the intent of eliciting philosophical insights from this study. A representative of this kind of analysis is J.L. Austin. A fourth type of analysis Ayer terms "looking at the facts," and refers to Gilbert Ryle and Ludwig Wittgenstein as practitioners of the analysis described by Wittgenstein as that in which "problems are solved, not by giving new information, but by arranging what we have always known."[8] The fifth type of analysis is termed "theory of knowledge" and turns out to be the work of answering the challenge of the philosophical skeptic.[9] What is of interest here is that the other four kinds of analysis are distinguished from theory of knowledge, which Ayer also calls "an exercise in philosophical analysis." Yet it is difficult to distinguish this fifth kind of analysis from the others. Logical analysis is not so much rejected as a tool of theory of knowledge as it is regarded as difficult to use extensively, and, in fact, elements of logical symbolism appear at junctures in Ayer's work. With respect to logical grammar, this has its philosophical uses, as Ayer acknowledges, and ordinary usage analysis and "looking at the facts" seem to be involved at every stage of the discussion of theory of knowledge in the

proposing and criticizing of what we think we know and how we justify it.[10]

Beyond the general direction of philosophical analysis toward meaning, language, and theory of knowledge, how is an actual philosophical analysis to be carried out? In several passages Ayer provides guidelines for philosophical argumentation. In "Philosophy and Language" he reviews the different forms of contemporary analytic philosophy with a critical eye. He concludes that in the case of both Ryle and Wittgenstein their analyses are not entirely linguistic but are also directed to the phenomena, the circumstances under which the words and sentences are used. These meanings have a bearing on what he calls "a range of facts."[11] Ayer wonders whether the procedures of these philosophers can be evaluated, since the criteria of evaluation would be the same as those used in obtaining the results to be evaluated. But such a begging of the question seems unavoidable, he says. "Thus, so long as it is free from inner contradiction, it is hard to see how any philosophical thesis can be refuted, and equally hard to see how it can ever be proved."[12]

Ayer goes on in this essay to imagine an argument between a defender and an opponent of the thesis of physicalism, that all so-called mental processes can be translated into terms of physical processes. The opponent of physicalism produces a counter-example of something said of someone's thought which is independent of a physical correlate. But the physicalist will say this example can be interpreted in physicalist terms. The antiphysicalist can only make the consequences of the physicalist's interpretation "appear so strained that the assumptions on which they rest become discredited." In such a case, Ayer says, the only proof of a thesis must rest on the absence of any refutation, that is, of any "convincing counter-example."[13] He argues that

> most philosophical arguments are linguistic; for they mainly consist in stating that one proposition does, or does not, follow from another; and whether or not one proposition follows from another depends entirely on the meaning of the sentences by which they are expressed. The trouble is that very often when these alleged entailments are of philosophical interest, their validity is in dispute. . . . If one proposition does not entail the other, it should be possible to find, or at any rate to imagine, some state of affairs in which one proposition would be true and the other false. In short, it is once more a question of searching for a counter-example.[14]

The discussion in "Philosophy and Language" and Ayer's remarks in *The Problem of Knowledge* and *The Central Questions of Philosophy* give rise to questions concerning Ayer's specific recommendation for philosophical methodology. In the five-part classification referred to above, and in his critical consideration of contemporary schools of analysis,

Ayer appears to be questioning the efficacy of their methods, yet it appears that he had no choice but to adopt these methods, at least in part.

With respect to formal analysis, which he had said is seldom used in philosophy, Ayer remarks in several passages that the program of the Vienna Circle for the systematic reduction of physical and common sense language to that of phenomenalism and the attempt to construct a perfected logical schema for science on the model of *Principia Mathematica* have failed. But, he says, these efforts failed because the project was very difficult and the vocabulary lacking, not, perhaps, because it was impossible.[15] He also comments that many philosophers such as Carnap thought it necessary to restrict their consideration to sentences; they produced valuable semantic and syntactic theories, but failed to realize that language cannot be separated from the world that is referred to by language.[16]

If formal analysis is too difficult and the work of logical linguists and grammarians insufficiently empirical, what can the philosopher do? Given that the realm of logic is unfruitful and the realm of facts is the domain of science, what philosophical task and what philosophical methodology are available? The task is the epistemological one of answering the skeptic, and the method recommended is another kind of logical argument. In place of the kind of formal logical analysis proposed by the logical positivists Ayer recommends a form of argument which is logical and deductive but not formal. This is the consideration of logical possibility. If one's definition of 'knowledge', for example, involves a contradiction, it is to be rejected as logically impossible. This means that an already accepted rule of language excludes this as a possible definition. On the other hand, a given philosophical proposition can be established by being shown to be logically necessary. This means that the denial of such a proposition involves a self-contradiction. Such a logical demonstration of proof or disproof is not achieved by a formal decision procedure but by appeals to an accepted principle of logic.

> Although we have not been in any way concerned with setting up a formal system, the argument has also been developed by means of deductive logic. Thus the proof that no cognitive state of mind could be infallible depends upon the logical truism that if two states of affairs are distinct a statement which refers to only one of them does not entail anything about the other. If the statement that someone is apprehending, or intuiting, something is to be regarded purely as a description of his state of mind it cannot follow from it that what he apprehends is true.[17]

The proof depends on the recognition of the tautology that what is distinct is distinct, and this may "seem too trivial to be worth making." Ayer draws our attention to the importance of explaining how such an

error can occur, of uncovering hidden and suspect assumptions. It is also the case that the contradiction depends on a tacit linguistic rule, that "to know" involves two distinct elements, of psychological conviction and of objective correspondence with an external fact. If this rule is denied, no contradiction would follow.

The informal deductive method is carried out in a context of questioning "What one would say if . . ." and "looking at the facts . . .". The recognition of a necessary truth may lead us to insights on other philosophical topics.

> This distinction which we are required to draw between the past and the future is based on the principle that cause cannot succeed effect. And I do not think that we can deny that this principle is true. The use of the word 'cause' is such that if one event is said to be the cause of another, it is implied that it precedes, or at any rate does not succeed, the event which is said to be the effect. But while the propriety of this usage cannot be contested, it is difficult to account for. It is hard to see why one should insist on making it impossible for a later to cause an earlier event.[18]

Ayer continues the discussion to uncover the consequences of this necessary truth in terms of the treatment of time, and the testimony of memory.

In the context of a technical or invented term such as 'sense datum' Ayer points out that the inventor must specify its meaning since there are no "accepted rules of usage." Hence, Ayer criticizes G.E. Moore for asking as a question of fact whether a sense datum could exist without being sensed. The question requires a stipulation of how the term is to be used, not an empirical inquiry.[19] In the case of a complex philosophical argument reflection may detect a contradiction within the argument that was not initially apparent. Ayer cites such a discovery of a contradiction in his own earlier work when, in *Language, Truth and Logic* he defended both a mentalist view of the proposition and the thesis of physicalism:

> The contradiction arises because the mentalistic analysis is supposed to hold good not only for me when I talk about myself but for anyone who refers to his own experiences. But if the only sense that I can attach to saying that any other person has experiences is that he behaves or is disposed to behave in such and such a fashion, then I cannot consistently allow that he means anything different from this when he attributes experiences to himself.[20]

Ayer says that one could avoid this contradiction only by concluding either that one is the only being who has experiences, or that one's own experiences must be treated behavioristically. He chooses to reject physicalism, referring to Ogden and Richards having pointed out that physicalism requires one "to feign anaesthesia." Here the example shows which of his two inconsistent theses is to be rejected. On other occasions,

the choice of which of two inconsistent theses is to be adopted is settled on the grounds of the convenience of one language over another. An example is the argument for a choice of a phenomenalist description of experience over a physical object description as set forth in *The Foundations of Empirical Knowledge.*[21] Here it is not put as a refutation but a pragmatic choice; it is noteworthy that Ayer later rejected the language of phenomenalism, also on pragmatic grounds.[22]

If, *per impossibile*, all philosophical arguments could take the form of proofs or disproofs which depend on logic or linguistic rules requiring no further justification, it would be an easy matter to satisfy the philosophical skeptic against whose doubts the arguments of both *The Problem of Knowledge* and *The Central Questions of Philosophy* are directed. Failing that, the analysis of theory of knowledge seeks for elements of incorrigibility, or relative incorrigibility, within experience on which to build a defense of our claim to know the past, the external world, and the thoughts of others. Empirical knowledge of science or common sense is notoriously fallible, but we might find in uninterpreted experience elements that are as direct, and as incontestable, as humans are able to acquire. These are the sensory aspects of experience, and Ayer has devoted much patient attention, ingenuity, and analysis to the identifying, describing, and uncovering of these elements, and in exchanges of philosophical argument with the defenders and opponents of sense-data.[23] An additional concern is the justification of the inferences from which we pass from the given sense qualia to the propositions describing them, to propositions referring to remembered sense qualia, to inferences of induction reaching to the world, the past, and other persons. The problem, of course, is not that of justifying specific perceptual judgments or specific scientific empirical generalizations, but of justifying the possibility of knowledge of these kinds. The conclusion reached with increasing modesty is that there can be no satisfactory answer to a philosophical skeptic who asks for certainty, or conclusive proof or disproof, or a justification of belief which cannot be challenged. But it is possible to say that the skeptic asks for too much, and that we can be satisfied that empirical knowledge of some degree of probability can be shown to be possible, even though no absolute guarantees are available in specific cases.[24]

As Ayer's philosophy has developed we have seen it settle into the concern with answering the philosophical skeptic and we have seen that different analytic techniques are acknowledged. The attempts at a formal logical analysis and at a phenomenally formulated empirical foundation are increasingly replaced by informal deductive arguments which, while they have reference to the world of facts and of experience, are not

directly verified or disconfirmed empirically. The onus of philosophical methodology is thus concentrated on such informal logical arguments.

As we saw earlier this domain of philosophical argumentation depends on the testing of philosophical theses, whether one's own or another's, through the presentation of persuasive counter-examples. This has been a staple of philosophical argument since Plato, and it has recently been practiced with great ingenuity by many analytic philosophers. In Ayer's methodology counter-examples enter in the area of the shifting of the philosophical argument back and forth across the line that divides the empirical from the logical. In an essay "One's Knowledge of Other Minds" of 1953 Ayer comments on the difficulty:

> It is the crossing and recrossing of the line between the empirical and the logical that makes this a text-book problem in the theory of knowledge. The undoubted fact that one sometimes does not know what other people are thinking and feeling gives rise to the suspicion that one never really does know; the next step is to pass from saying that one never in fact knows what goes on in another person's mind to saying that one never can know, and interpreting this statement in such a way that it is necessarily true. But this appears to concede too much to skepticism, and so a move is made in the reverse direction. It is suggested that even if we never do in fact know what goes on in the minds of others, there might be circumstances in which we should. The assertion of our ignorance is thus reconstructed as empirical but, like an alien without a valid passport, it is constantly liable to deportation. As soon as an attempt is made to treat it seriously as an empirical statement, it tends to change back into a necessary truth. At this point it is tempting to lose one's patience with the problem. It is simply, one may say, a matter of what one chooses to understand by knowledge.[25]

Ayer does not give up, however, and concludes that, unless we yield to the temptation to make the matter one of necessary truth, we can put knowing what other people are thinking on the same basis as any other inductive inquiry. But what is of interest with respect to the use of counter-examples, is that, at the stage of the argument where the philosopher is retreating from seeing the impossibility of knowing the mind of another as a necessary truth, he invokes the possibility that two individuals might be co-conscious, and the fact that this has not happened, as far as we know, does not prohibit it from being a logical possibility. Since co-consciousness would enable one to know another's mind, and since it is a logical possibility, the impossibility of knowing another's mind is not a necessary truth.

Another context in which Ayer makes an interesting use of counter-examples is in his analysis of the private language argument. The significance for him of the claims of Wittgenstein and others that the concept of a private language is logically impossible is that, for Ayer's theory of knowledge, part of the building up of empirical knowledge

from sense qualia involves these qualia presented to an individual and recognized and identified by him prior to the appearance of communication and the interaction of different observers. Ayer, accordingly, analyzes the private language argument, attacking two assumptions he regards as essential to the denial of the possibility of a private language. These are: first, that it is "logically impossible to understand a sign unless one can either observe the object which it signifies, or at least observe something with which this object is naturally associated," and second, "that for a person to be able to attach meaning to a sign it is necessary that other people be capable of understanding it too."[26] In order to attack these assumptions, and especially that latter, Ayer constructs a story of an infant Robinson Crusoe somehow surviving in solitude, not only developing his own symbols for the things around him and his own feelings, but eventually making his private language public by teaching it to Friday. Since this is an intelligible story, the Robinson Crusoe story is a logical possibility; it shows that the denial of the possibility of a private language is not logically necessary. Ayer even imagines the possibility of each individual having a private world and a private language, and yet a language by which these different persons and worlds could be identified.[27] In a footnote to the republished 1959 article, "Can There Be a Private Language?" Ayer takes back this last proposal:

> Having tried to construct a language of this kind, I have come to doubt whether it is feasible. I am now inclined to think that in any language which allows reference to individuals there must be criteria of identity which make it possible for different speakers to refer to the same individual. This would not prevent the language from containing private sectors, but it would mean that my idea that these private sectors could be made to absorb the public sectors was not tenable.[28]

A slightly different use of imagined circumstances is introduced by Ayer in a discussion of the relation of mind and body. He has been arguing against mental substance and raises the question of whether a belief in the immortality of the soul could survive the denial of mental substance. This would reflect the possibility that memory or bodily continuity alone could suffice for personal identity.

> The question that I now wish to consider is not so much whether there is any good reason to hold any of these beliefs as whether the situations which would be required to verify them are logically possible.[29]

As a test of the idea of a disembodied mind, Ayer imagines various possibilities of brain transplantation, of the halves of an individual's brain into two separate bodies. He also imagines having all the experiences he does have but having no body. His conclusion is that none of these science fiction scenarios are logically impossible, and hence that

there is no logical necessity in persons being embodied, and that the objections to the existence of disembodied spirits are thus empirical and not logical.[30] In fact, there is no limit to the kinds of imaginings, or science fictions, which can be entertained by an ingenious mind; therefore, the logical necessity which might be claimed for some philosophical arguments is undermined. Would there remain a possibility that some examples would support the claim of logical necessity, if no negative counter-examples could be found? For instance, suppose one tried to produce counter-examples to the "logical necessary truth" that a cause must precede its effect. We could imagine a situation in which the rising of smoke from the chimney was invariably followed by the lighting of the fire, or the rolling of the stone down the hill was invariably followed by the movement of the rock on which it has rested. Would one then refuse the denomination of this as a case of cause and effect? Or would one admit that the causes preceding their effects was an empirical generalization and not a necessary truth? By a similar argument could one choose to regard the brain transplant as just not a case of personal identity? or the case of the precocious Robinson Crusoe as not a case of language? It would seem that these options would be open, and that the choice as to whether a given counter-example is to count as a proposal for an emendation of the linguistic rule in question might well be a pragmatic one.

In order to evaluate the various elements of Ayer's concept of the subject matter and method of philosophy which are under discussion, it is important to see how they are integrated into the total argument. As an example of such an argument we will consider "One's Knowledge of Other Minds." Ayer begins by propounding six propositions which are in dispute concerning the topic; he then runs through the opinions of different philosophers concerning these propositions.[31]

In the third stage of the argument Ayer explores the possible answers to the questions posed in the first step. Some are shown to be answered on the basis of a definition and, therefore, to claim a necessary truth. He brings up a counter-example: Would telepathy be a way of having direct knowledge of another's mind, and hence refuting the claim that it is necessarily true that one cannot know the mind of another? No, because if telepathy were the case, the knowledge of the other's mind would be known by experience and then one would be in the same position as the person who makes the ordinary claim of empirical knowledge of the mind of another.[32] As we have seen, co-consciousness is brought up as a counter-case to the impossibility of knowing another's mind, and the problem of the argument shifting back between the logical and the empirical is exposed. Ayer says that it is too simple a solution to say that it is a matter of how one defines 'knowledge'; it is a problem of the kind

of justification that can be offered for the claim to know another's mind.[33] Considerable discussion of what kind of knowledge this can be and whether one is ever in a position to claim such knowledge on the basis of privileged access follows. At a further stage of the argument the beginning of the solution to the problems posed is in sight. If we mean by 'knowing' being in the best position to have information, then we are not in this position with respect to the mind of another, and hence it is logically necessary that we really cannot know it. Ayer adds, however, that although this is the case, we can in imagination overcome this obstacle. We could conceivably be in a position to have this knowledge, and, in cases where we conceive it to be possible to be in a privileged position with respect to something we cannot in fact know, we often are willing to trust whatever indirect and inductive empirical evidence may be available for what is inaccessible to our observation.[34] The next phase of the discussion turns on whether, if I were someone other than who I am, I might then be in a position to have access to the knowledge which, being the person I am, I necessarily lack. This extended argument hinges on the logical conceivability or inconceivability involved with one's personal identity being other than it is.

> What is asserted, then, by a statement which in fact refers to the experience of someone other than myself is that the experience in question is the experience of someone who satisfies a certain description: a description which, as a matter of fact, I do not satisfy. And then the question arises whether it is logically conceivable that I should satisfy it. But the difficulty here is that there are no fixed rules for determining what properties are essential to a person's being the person that he is.[35]

Ayer's argument continues, and he argues that

> nothing is described by his being the person that he is except the possession of certain properties. If, *per impossibile*, we could test for all the properties that he possesses, and found that they did not produce a counter-example to our general hypothesis about the conditions in which pain is felt, our knowledge would be in this respect as good as his: there would be nothing further left for us to discover.[36]

The final conclusion answers the question by saying that it is necessarily true that I am I, that I can not conceivably satisfy the description of some other person and remain a distinct person, but that there is no logical reason why I should not test the degree of the connection of a given property (having a headache) with other properties (someone else having a headache). This is a matter of an inductive inference and is on the same ground as any other empirical and inductive inference. If the skeptic insists on proof, or the most secure and privileged knowledge of the mind of another, his challenge cannot be

met. But this demand is too strict, and he and we must be satisfied with ordinary and less than proven empirical knowledge.[37]

It can certainly be claimed that this brief review does not do justice to the subtlety and complexity of Ayer's argument. It is also possible that he would wish to amend some parts of it if it were to be offered today. But for the purpose of raising questions about his method, it is an excellent example.

Much that is obscure and troublesome in Ayer's practice of philosophy centers around his use of counter-examples as in the arguments we have been considering. There seem to be several ways in which counter-examples function to reflect on the cogency of a philosophical thesis. A philosophical thesis may be supported by examples. For instance, Ayer argues,

> Thus the proof that one can know an object, in the sense of being able to recognize it, without making any conscious judgment about it, is that it is possible to find examples of such recognition where there is no evidence that any judgment is made. The proof that knowing how to do something need not include the ability to give an account of the way in which it is done is just that there are many things which people know how to do without their being able to give any such accounts. . . . In such cases we show that what might be thought to be a necessary factor in a given type of situation is really not necessary, by finding examples in which it does not occur. This is essentially a method of disproof . . .[38]

On some occasions counter-examples may be decisive in showing a logical contradiction between one proposition and another accepted proposition of a theory, as in the case of Ayer's criticism of his former physicalism cited above. At other times the counter-example may show that the thesis is a logically necessary proposition, or that it is a logical contradiction based on the meaning given to a term, and on an accepted principle of logic, as in the case of the definition of 'knowledge', and of 'cause' cited above. In some cases the counter-example is used to show that a given thesis is only logically possible rather than logically necessary, as in the cases of the private language argument and knowledge of the minds of others which we have been considering. It is in this latter context that the nature of the counter-example raises serious questions.

What kinds of counter-examples do we find Ayer using? One obvious kind of counter-example is one that shows that a case attested to by experience is not taken account of in the thesis under discussion, as in the cases quoted above. Ayer mentions that a physicalist thesis might be combated by producing the example of mental function not accompanied by a physical correlate. However, he points out that the physicalist may reinterpret this counter-example so as to avoid refutation. In a

similar vein we see Ayer quoting against physicalism the consequences that as a physicalist one would have to "feign anaesthesia." In one interesting case, as we saw, Ayer cites his own experiment with trying to invent a private language without publicly shared referents as a reason to abandon as not feasible part of his own counter-example in opposition to the denial of the possibility of a private language. In an extended sense, we might say that "the range of facts" which forms the empirical background of philosophical argument for Ayer tacitly provides a controlling context of possible counter-examples, so that the philosopher draws back from any thesis which is perceived as disconfirmed by what is known empirically. This is evident, for instance, in the treatment of perception. This kind of counter-example is useful and, as Ayer claims, close to the method of science.[39]

Sometimes logical principles are the prominent feature of counter-examples. For instance, Ayer, in criticizing the view that knowledge consists in a certain state of mind, argues that this violates the logical principle that if two things are distinct, they are distinct. Or, in discussing knowledge of the past, he cites the necessary truth that the cause must precede the effect, and this has a controlling effect on the argument concerning the past and the role of memory, ruling out a thesis that in remembering, the past remembered is present. Certainly logical contradictions are not to be sanctioned and thus such counter-examples are frequently helpful.

But the most problematic counter-examples, in my critique of Ayer's method, are those that are designed to show that a given thesis is "logically possible," or that an opposing thesis is not "logically necessary." Here we often have the use of imagined, invented cases, or, as Ayer calls them, "science fictions." A good example to show the difficulty of a counter-example is the infant Robinson Crusoe imagined by Ayer to be under the age of learning language, and somehow surviving in solitude on a desert island, and inventing his own symbols for the things around him, and for his own feelings. In the first place, a child who has not yet learned any language, either understood or spoken, must be at least under a year of age, and totally incapable of survival alone. Ayer suggests that he might be raised by animals like Romulus and Remus—but of course this is fantasy, and if one wanders into such fantasy one might as well infer that he learned an animal language like Mowgli. Admittedly, this scenario is one which we know to be factually and physically impossible; how does it reflect on the impossibility of a private language? Are not the opponents of a private language talking about real, cultural communication? After all, the background of the discussion is the relation of one individual's experience to that of others, and how does the mythical

precocious Robinson Crusoe help us understand this? In fact, Ayer's acknowledgement that he no longer argues a counter-example of a model of language in which each individual has private symbols not only for his own feelings but for the objects of the world around him is due to his experimental failure to invent such a language. If we are dealing with fantasies, what would it matter that the language was not "feasible"? Are we talking about real experienced possibilities of private languages or fantasized "logical possibilities" of private language?

Similar considerations apply to Ayer's discussion of our knowledge of other minds, where the arguments concerning the basis of personal identity involve the logical possibility of brain division, brain transplants, telepathy, reincarnation, and other contrary-to-fact circumstances. Is it really necessary for us to rule out such "conceivable" situations before we can form any positive view of the relation of body and mind? At times the range of conceivability sounds like the old arguments against infinite regress; it seems a matter of how tolerant of fantasies one may be. Why is it possible to imagine that one's mind might inhabit another body than one's present body, but not possible to conceive that two persons would have every property in common and yet be distinct persons? How could it be conceivable that one would have no body but have all the experiences of "a spectator" which, as we know, are causally dependent on the body's sense organs and nervous system?[40]

The most vital question seems to be what are the limits of counter-examples? Ayer indicates that it does not matter whether the counter-examples are actual or imaginary. "In either case we describe a situation in order to see how it should be classified." [41] However he goes on to link the linguistic and the factual aspects of the inquiry; "the inquiry into the use of words can equally be regarded as an inquiry into the nature of the facts which they describe."[42] If there are no limits to the kinds of counter-examples that may be cited, if they can be contrary to fact, and even impinge on accepted rules of language, then it seems that they cannot serve to eliminate any philosophical thesis, since every thesis is equally vulnerable to such counter-examples. If the principles of identity, contradiction, or excluded middle are the only limits to acceptable counter-examples, the whole world of possibilities is open to us. We point out that the application of those formal logical principles take as their premises accepted linguistic rules which are open to change, and that the principles themselves have been known to be challenged. For instance, some philosophers would object to a two-valued logic applied to every proposition in cases where no means of determining its truth or falsity exist.

The extended discussion of Ayer's use of informal logical arguments, and in particular of his use of counter-examples, suggests that the attempt to use logical arguments of this kind to establish, or more often combat, philosophical theses such as those concerning private languages, other minds, and Ayer's own problem with answering the philosophical skeptic, may not serve to establish, controvert, or even render more or less plausible the theses in question. If this is so, one wonders about the need for the prior logical argument which seems to have left everything as it was. Perhaps the problem stems from what Ayer calls the tendency of philosophical arguments to shift back and forth across the line dividing the logical from the factual. The slipperiness of these arguments and the troublesome unlimited nature of counter-examples may account for the different outcomes of Ayer's consideration of philosophical topics from one period of his career to another. The most famous example may be the defense and then abandonment of phenomenalism. Since phenomenalism could not be proven, but only pragmatically justified as a choice of linguistic rules, it is not surprising that neither could it be disproven, but only rejected as too difficult and cumbersome for its intended purpose. A refreshing candor leads Ayer to many remarks such as "I formerly accepted" or "I no longer hold," in referring to changes in his views. The increasing problems which have emerged in the method of philosophical argument employed and discussed by Ayer points to one area of his thought which has shown an interesting change in a different direction. We noted that when the philosophical arguments of a deductive kind run aground, and result in a standoff, Ayer concludes that in the absence of either proof or disproof concerning the question at issue, for instance, the existence of other minds, one is justified in employing ordinary induction, that the philosophical skeptic has asked for more than he can get, and that there is sufficient empirical basis for a judgment of probability. This kind of conclusion, which appears throughout his work from *The Problem of Knowledge* on, foreshadows an increasing interest in the criteria of empirical knowledge, as in his *Probability and Evidence*. He has also, to his surprise, found much of value in the work of C.S. Peirce and William James.[43] If this is the general tenor of his thought it would be reasonable to expect that the line between the linguistic and logical on one hand, and the empirical and factual on the other, would create tension in his thought. It seems that he is moving toward seeing philosophy in relation to empirical knowledge in general, and hence that the possibilities of "proof" and "disproof" are receding. The present criticism suggests that this might well be accompanied by the abandonment of the kind of counter-example which trades on conceivability and

contrary to fact possibilities. Could Ayer not conclude that, in the absence of contradiction, all hypotheses are logically possible, and that our interest is properly centered on those which are sustained by our present empirical and factual knowledge?

To return to the questions concerning the development, consistency, and success of Ayer's methods of analysis with which we began, it now appears that in the course of the development of his philosophy Ayer has evaluated different analytic methodologies, including those of Moore, Russell, Carnap, Quine, Ryle, Wittgenstein, and Austin. Although he has offered specific criticisms of some aspects of each, he has neither accepted nor rejected them wholeheartedly. From the logical positivism of the 1940s, and the linguistic phenomenalism of the 1950s, Ayer has used whatever technique seemed applicable in the service of a concept of the task of philosophy as the epistemological justification of common sense and scientific knowledge. This task has occupied him since 1940 and has oriented him philosophically as closer to Russell and to Moore than to later analysts. In seeking to defend his answer to the skeptic and to meet the arguments advanced by Ryle against the substantive mind, by Wittgenstein against the concept of a private language, by Austin against the concept of sense-data, Ayer relied increasingly in recent years on the informal deductive reasoning by definition and counter-example which we have been examining. The inconclusiveness and difficulties of these arguments make them neither a suitable answer to the skeptic nor a vindication or disproof of hypotheses concerning other minds, private languages, or the existence of minds separate from bodies. These difficulties might be thought to support the claim of Ayer's critics that his concepts of the task of philosophy are no longer valid.[44] But, given his search for the empirical foundation of knowledge, his analysis of perception, his appeal to logical laws and to accepted meanings, the reliance on informal argumentation of his later work often led him to the conclusion that, in the end, in the absence of conclusive proof or disproof, our claim to knowledge was a matter of "ordinary induction." Does falling back on "ordinary induction" render epistemological analysis otiose by banishing the philosophical skeptic? Or does Ayer's recent work on probability and evidence and his recent interest in pragmatism provide a more appropriate task and a more promising methodology than his earlier positivist and post-positivist philosophy?

ELIZABETH R. EAMES

DEPARTMENT OF PHILOSOPHY
SOUTHERN ILLINOIS UNIVERSITY AT CARBONDALE
OCTOBER 1987

NOTES

1. Alfred Jules Ayer, *Language, Truth and Logic* (London: Victor Gollancz Ltd., 1935); Alfred J. Ayer, *The Foundation of Empirical Knowledge* (New York: The Macmillan Company, 1940); A.J. Ayer, *The Concept of a Person and Other Essays* (London: Macmillan & Co., Ltd., 1964); A.J. Ayer, *The Central Questions of Philosophy* (Harmondsworth: Penguin Books, Ltd., 1973).

2. Ayer, *Language, Truth and Logic*, Chapters I, II.

3. Ayer, *Language, Truth and Logic* (New York: Dover Publications, 1946), Introduction to the second edition.

4. A.J. Ayer, *The Foundations of Empirical Knowledge* (New York: Macmillan Company, 1940); A.J. Ayer, *Philosophical Essays* (London: Macmillan & Co., 1954); A.J. Ayer, *The Problem of Knowledge* (Baltimore: Penguin Books, 1956).

5. Ibid., p. 7.

6. Ibid., pp. 9–10.

7. A.J. Ayer, *The Central Questions of Philosophy*, p. 44.

8. Ibid., p. 53.

9. Ibid., Chapter III, "Philosophical Analysis," pp. 58–67.

10. Ibid. For instance in the chapter on "Body and Mind" Ayer uses logical and factual considerations to argue against other philosophical theories and uncriticized views of common sense.

11. A.J. Ayer, "Philosophy and Language," in *The Concept of a Person and Other Essays*, pp. 3–26.

12. Ibid., p. 27.

13. Ibid.

14. Ibid., pp. 30–31.

15. Ibid., pp. 12–15.

16. A.J. Ayer, "Truth," *Concept of a Person*, pp. 179–80. See also A.J. Ayer, "The Errors of Formalism," *The Foundations of Empirical Knowledge*, pp. 84–91.

17. Ayer, *Problem of Knowledge*, p. 29.

18. Ibid., pp. 170–71.

19. A.J. Ayer, "The Terminology of Sense-Data," *Philosophical Essays*, p. 76.

20. Ayer, *The Central Questions*, p. 127.

21. Ayer, *The Foundations of Empirical Knowledge*, p. 48–56.

22. Ayer, *Central Questions*, pp. 90–91, p. 107.

23. For the discussion of Ayer's sense-data theory see: J.L. Austin, *Sense and Sensibilia* (Oxford: Oxford University Press, 1962); A.J. Ayer, "Has Austin Refuted the Sense-Datum Theory?" *Synthese* 17 (June, 1967), reprinted in *Metaphysics and Common Sense*; Charles Taylor, "Sense Data Revisited," in *Perception and Identity* (Ithaca, NY: Cornell University Press, 1979); David Pears, "A Comparison Between Ayer's Views about the Privileges of Sense-Datum Statements and the Views of Russell and Austin," ibid.; A.J. Ayer, "Replies," ibid.

24. This kind of response to the philosophical skeptic is given in the following presentations of Ayer's theory of knowledge: *Foundations of Empirical Knowledge*, pp. 45–46; *The Problem of Knowledge*, pp. 80–81; *Philosophical Essays*, pp. 170–90; *The Central Questions*, pp. 63–67.

25. A.J. Ayer, "One's Knowledge of Other Minds," *Philosophical Essays*, pp. 197–98.

26. A.J. Ayer, "Can There Be a Private Language?," *Concept of a Person*, p. 44.

27. Ibid., pp. 77–78.

28. Ibid., footnote on p. 78.

29. Ayer, *Central Questions*, p. 121.

30. Ibid., pp. 121–25.

31. Ayer, *Philosophical Essays*, pp. 191–92.

32. Ibid., pp. 193–96.

33. Ibid., p. 200.

34. Ibid., pp. 207–8.

35. Ibid., p. 211.

36. Ibid., p. 214.

37. Ibid.

38. Ayer, *Problem of Knowledge*, p. 27.

39. Ayer, *Problem of Knowledge*, p. 28; Ayer, *Concept of a Person*, p. 27.

40. Ayer, *Central Questions*, p. 124.

41. Ayer, *Problem of Knowledge*, p. 28.

42. Ibid., p. 29.

43. A.J. Ayer, *Probability and Evidence* (New York: Columbia University Press, 1972); A.J. Ayer, *The Origins of Pragmatism* (San Francisco: Freeman, Cooper & Company, 1968).

44. For instance, see the criticism in Hilary Putnam's "After Empiricism," in *Post-Analytic Philosophy* (New York: Columbia University Press, 1985).

REPLY TO ELIZABETH R. EAMES

Professor Eames has given a sympathetic account of my philosophical development. She is right in saying that I have remained closer to Russell and Moore than to later analysts, though I have argued against the theory of perception which Russell eventually adopted and exposed the limitations of Moore's defence of common sense. She is right also in saying that I have found much of value in the work of C.S. Peirce and William James though I do not know why she thinks that this came to me as a surprise. For some time, indeed, my respect for Peirce was no more than second-hand, arising from the attention paid to him by F.P. Ramsey in the fragments appearing in *Foundations of Mathematics*, but I had read and enjoyed James's *Pragmatism* as an undergraduate, and among the various influences of which my *Language, Truth and Logic* was the product, one of the strongest was the pragmatic C.I. Lewis's *Mind and the World Order*.

There are, however, several quite important points upon which Eames misunderstands me. One of them is my treatment of the question of privacy. In the lecture on 'Privacy' which I delivered to the British Academy I attacked the view that objects or events are intrinsically public or private. I suggested that the reason why tables and trees are held to be public objects is that we attach a sense to saying that two different persons perceive the same tree or the same table. On the other hand, we do not attach a sense to saying that two different persons feel numerically the same headache, and for this reason headaches are deemed to be private. I then argued that the grounds for this distinction were empirical. It is normally the case that when one person in a given environment claims to perceive what is counted as a public object, other persons in what is roughly the same environment make the same claim. This is not, in general, true of headaches. Nevertheless, it is easy to conceive of

circumstances in which it would be. There might be regions which under certain conditions were disposed to be 'headachey' in the way that London was once disposed in November to be foggy, and in that case headaches might well have been accorded the same publicity as fog was. With sufficient ingenuity, one could envisage a set of circumstances in which people's thoughts and feelings coincided to the same extent as their perceptions of physical objects are supposed to do, as it is. In that case the empirical ground for contrasting private feelings with public objects or events, including public behaviour, would have been removed. Everything would be publicized.

It occurred to me that sense-datum theorists play the same game in reverse. The perception of public objects can be more or less completely resolved into the sensing of sense-data or particularized qualia which, if not initially introduced as private objects, acquire privacy at some stage through the fact that the possibility of two persons sensing numerically the same sense-data is not admitted. I then encountered the disanalogy that not everything could be privatized. The reason for this was not, as Eames seems to suggest, that I was not clever or patient enough to bring it off, but that I met with the logical obstacle that my analysis of the concepts of privacy and publicity required that the language contained terms which one person could interpret as designating another, as opposed to some object that was accessible only to himself.

I may remark in passing that I am admitting no more than that the conception of persons as public objects is a necessary condition for the division of the contents or objects of our experience into private and public sectors. I am not taking it to be an indispensable feature of any adequate account of what there is. I do not know how much of what one might want to assert can be expressed in the phenomenal language which Nelson Goodman developed in his *Structure of Appearance*, but it contains no reference to persons. They figure in Quine's ontology only as the features of world lines extended in the four-dimensional manifold of space-time.

None of this has very much to do with my objection to Wittgenstein's so-called private language argument. Having naively annexed the concept of publicity, without elucidation, Wittgenstein relies on his slogan that an inner process stands in need of outward criteria. He and his followers also make the mistake of assuming that the reference of a term is indissolubly bound to the conditions under which it was learned. He is consequently led to maintain, not that we do not have private experiences, but that our references to them would not be intelligible, even to ourselves, unless they were made in accordance with linguistic rules the conformity to which was publicly testable. Against this, I maintain that

all use of language, whether it serves to refer to what are counted as private experiences, or what are counted as public objects, is ultimately 'private', in the sense that its interpretation, including the interpretation of 'public' tests, depends on what I call acts of primary recognition. The point of my Robinson Crusoe fantasy was that there is no logical reason why he should not register his performance of such acts. The low probability of such a creature's being able to survive and record his experiences is irrelevant. I am not denying that the use of language is in fact a social phenomenon, though the proposition that language must always be learned, and never invented, makes it hard to account for its original appearance.

Eames is again mistaken in saying that I rejected the language of phenomenalism on pragmatic grounds. I rejected the classical thesis of phenomenalism that all statements about physical objects can be translated into statements about actual and possible sense-data on the logical ground that any serious attempt to carry out such a translation would fall foul of an infinite regress. I have had to be content with the weaker thesis that our conception of the physical world can be exhibited as a theory with respect to a basis of sense-qualia.

I abstain from commenting on Eames's remarks concerning my erratic treatment of the Problem of Other Minds since I have dealt with this question to the best of my ability in my answer to Professor Sprigge.

Finally, I come to the question of the use by philosophers of what scientists call thought-experiments. I agree that like all good science fiction, for instance that of H.G. Wells and Jules Verne, the possibilities which they envisage should not be excessively improbable in relation to the current state of science. If this condition is observed, I think that such thought-experiments can be philosophically very fruitful. One of the primary concerns of philosophy is to elucidate concepts, and for this purpose it is useful to discover how closely their application is tied to existing circumstances which might conceivably be otherwise or become so. An excellent example of this is the pressure to which the concept of identity is subjected in Derek Parfit's *Reasons and Persons*.

A.J.A.

6

John Foster

THE CONSTRUCTION OF THE PHYSICAL WORLD

I want to examine Ayer's account of our knowledge of the physical world as set out in his book *The Central Questions of Philosophy* (CQ).[1] The core of this account, as well as its most interesting and imaginative part, is the chapter entitled 'Construction of the Physical World', and it is on this that I shall mainly focus. But as the theory which Ayer develops there is prompted by, and offered as an answer to, a certain kind of radical scepticism, I shall start by considering his characterization of this scepticism and of the possible ways in which it might be met. My own discussion throughout will be largely expository: I shall be more concerned to present and to clarify Ayer's views and arguments than to evaluate them.[2]

1. THE SCEPTIC'S ARGUMENT

The sceptic claims that our belief in the existence of a physical world is wholly unwarranted. Following the lines of his earlier discussion in *The Problem of Knowledge* (PK), Ayer represents the sceptic as defending this claim by an argument in four steps.[3] The sceptic begins by insisting that, in a certain sense, our epistemological access to the physical world is indirect: our physical beliefs are warranted only to the extent that they are supported by our sensory evidence and this evidence consists exclusively in information about the intrinsic character of our sense-experiences, without any reference to the physical items which we supposedly perceive by means of them. His next step is to insist that however much information we possess about the sensory domain (and this may include not only information accorded by current introspection

and memory, but also more general information built up inductively from previous experiences), there is no deductive route from this information to conclusions about the physical world. His point here is simply that the physical world, if it exists at all, is external to the realm of sense-experience, and that, consequently, its existence does not logically follow from any set of sensory facts, however comprehensive. His third step is to insist that the logical gap between our sensory evidence and our physical beliefs cannot be bridged by inductive reasoning. The thought here is that while induction might serve to justify inferences within the sensory domain—for example, inferences from past sensory regularities to their future continuance—it cannot help to justify inferences from sensory premises to physical conclusions, since, with no initial information about how experiences and physical items have been correlated in the past, there are no data here on which induction could be put to work. His final step is to derive his sceptical conclusion from these three claims. Thus since our physical beliefs are warranted only to the extent that they are supported by our sensory evidence and since inferences from sensory to physical propositions cannot be justified either deductively or inductively, the sceptic concludes that the beliefs are wholly unwarranted and that we have no rational grounds for accepting the existence of a physical world. The underlying assumption here is that deduction and induction are the only valid forms of reasoning.

Corresponding to these four steps in the sceptic's argument, Ayer sees four ways in which one might try to defeat it, each way involving the rejection of a particular step. First, we have the response of the 'naive realist', who denies the sceptic's initial premise. Thus while the sceptic claims that our epistemological access to the physical world is (in the relevant sense) indirect, the naive realist insists that, in favorable circumstances, physical facts are directly revealed to us, so that we can be justifiably sure of the physical propositions in question without any need of further evidence. Next we have the response of the 'reductionist' who, while accepting the first step of the sceptic's argument, rejects the second, claiming that we can move from our sensory information to certain physical conclusions by deduction alone. The basis of this claim is his acceptance of a phenomenalistic account of the physical world—an account which, as Ayer represents it, involves saying that statements about physical objects turn out, on analysis, to be logically equivalent to statements about sense-experience. Thirdly, we have what Ayer calls the 'scientific approach'. The claim here is that, while the sceptic is right in his first two steps, we can bridge the gap between our sensory premises and our physical conclusions by an explanatory inference. As Ayer puts it, 'the existence of physical objects . . . is represented . . . as a probable

hypothesis which one is justified in accepting because of the way in which it accounts for one's experiences' (CQ, 66). Since he classifies this sort of inference as a form of induction (one might call it 'explanatory' as opposed to 'extrapolative' induction), Ayer sees the scientific approach as rejecting the sceptic's argument in its third step. Finally, there is the response of those who accept all three premises in the argument, but deny its conclusion. They concede that our physical beliefs are only warranted to the extent that they are supported by our sensory evidence and that the inferences from sensory facts to physical conclusions cannot be justified either deductively or inductively, but insist that such inferences are, in certain cases, legitimate: they are legitimate, not because they are covered by more general canons of reasoning which can be applied to any subject matter, but because they exemplify a *sui generis* (sensory–physical) form of reasoning which is valid in its own right. In PK, Ayer calls this fourth response the 'method of descriptive analysis', because those who adopt it claim that the inferential procedures in question can at least be systematically described.

Ayer's own response to the sceptic has varied over the years, this variation reflecting a gradual weakening and final abandonment of his initial phenomenalism.[4] One element which has remained constant, however, is his rejection of naive realism, at least in its epistemological aspects. It is to this that we must now turn.

2. NAIVE REALISM

The naive realist claims that our epistemological access to the physical world is direct: that, in favorable circumstances, physical facts are directly revealed to us. It is important that we give this claim a sufficiently strong interpretation. The naive realist is not merely claiming that, in the relevant circumstances, we acquire true physical beliefs *non-inferentially* and by a type of causal process which is *truth-reliable* (a type which ensures or makes it very likely that a belief thus acquired is true).[5] He is claiming, in addition, that, in these circumstances, our direct access to the physical facts is such as to provide, from our own standpoint, a rational warrant for the corresponding beliefs—a warrant sufficiently strong to put the physical propositions in question beyond the scope of any reasonable doubt. He is claiming that, in the relevant circumstances, the physical facts are manifest in a way which makes it impossible for the sceptic's argument to get started. Obviously, the mere non-inferential and truth-reliable acquisition of physical beliefs would not destroy the sceptical argument in this way. For if the truth-reliability is only an objective feature of the situation—something to be discerned

from a God's-eye view—the sceptic can still insist that we have no grounds for supposing that it obtains and so no rational warrant for holding the beliefs. To show that we have acquired the beliefs truth-reliably, we should need to have some independent access to the physical facts, whereby we could establish that they have controlled our acquisition of the beliefs in the appropriate way.

But granted that we give the naive realist's claim a sufficiently strong interpretation—sufficient to prevent the sceptic from getting a foothold —why does the realist think that he is entitled to make it? If the physical world is external to the realm of sense-experience, how could he suppose that our epistemological access to it is, in the relevant sense, direct? As Ayer notes, the claim is based on a certain view of the nature of sense-perception.[6] Whereas the traditional empiricist view is that the immediate objects of our perceptual awareness are sensory items in our own minds and that we only make perceptual contact with physical items in so far as these sensory items 'represent' them, the naive realist holds that it is the physical items themselves which we directly perceive. And it is because he credits us with this direct perceptual access to the physical world that he takes our epistemological access to be direct as well. He thinks that each sense-perception directly displays some portion of the physical world and that the percipient only has to take note of the features of this displayed portion to acquire an epistemological datum which is secure from sceptical challenge.

The naive realist's view of perception is intuitively appealing, since it reflects the way in which we interpret our perceptual experiences in the course of everyday life. We do not ordinarily think of our perceptions as separated from their physical targets by an internal screen of sensory items. Rather, we construe the qualities and quality-patterns of which we are immediately aware as elements of the physical environment and think of the awareness as reaching out, like a spotlight, to illuminate them. None the less, a number of philosophical objections have been brought against this view, most of them falling under the so-called argument from illusion. Ayer finds these objections inconclusive; indeed, he thinks that there is *no* way of proving that the naive view is mistaken.[7] At the same time, he thinks that there is no way of establishing its correctness either. His conclusion is that, as it is traditionally conceived, the issue of perceptual immediacy is spurious. We have the option of saying that our perceptual access to physical objects is direct and we have the option of saying that it is mediated by the presentation of sensory items. Neither position can be said to be objectively true or false: each can be legitimately employed as a conceptual framework in which to describe the empirical facts. Which framework it is best to employ becomes, then, a matter of philosophical convenience rather than of

empirical or metaphysical inquiry. On this point, I find myself in disagreement with Ayer, though, as the issue is complex and one which I have discussed in detail in my book about him, I shall not pursue it any further here.[8]

Where Ayer takes issue with naive realism is over its epistemological claims. For he takes it to be clear that, however we care to describe our perceptual access to the physical world, the epistemological datum (the item of skepticism-proof knowledge) furnished by each perceptual experience in isolation falls short of any physical judgment, however weak, which the experience might induce us to make.[9] In this I am sure that he is right. He focuses on the example of someone's making the judgment 'I am seeing a table' on the basis of a single visual experience, and draws our attention to a range of propositions which the judgment entails (that the item seen is accessible to more than one sense and to different observers, that it is capable of existing unperceived, that it is endowed with certain causal properties and designed for certain purposes) but which go beyond anything which the experience itself could be said to reveal in the naive realist's sense. Nor would naive realism fare better if we focused on the weaker perceptual judgment 'I am seeing something physical'. For even this, which entails that the item seen is accessible to different observers and capable of existing unperceived, goes beyond what is validated by the experience. After all, the subject could have an experience of exactly the same subjective character while suffering a total hallucination.

Because the naive realist has got things wrong epistemologically, Ayer now finds a reason for avoiding his account of perception.[10] It is not that this account is objectively false, it is rather that, in the context of our epistemological concerns, the sensory-item account is better suited to our philosophical purposes. It is better suited in two related ways. In the first place, it enables us to formulate, in the most convenient fashion, the unit of sensory evidence which each experience in isolation supplies—the unit of information which simply records the content of the experience without carrying any implications about the physical world. And secondly, by confining the immediate objects of perceptual awareness to the mind, so that we no longer count physical items as things which we can directly observe, it brings out more clearly the full extent of the sceptical problem—the extent of the epistemological distance which we have to cover in passing from our basic information to any physical conclusions. So Ayer comes to the conclusion that, while the naive view of perception cannot be regarded as erroneous, the sensory-item account should be adopted for reasons of philosophical expediency, as the framework in which we can most clearly represent our epistemological situation and most effectively pursue our epistemological inquiry.

The version of this account which Ayer adopts in CQ is one which construes the basic sensory items as universals, each item being something purely qualitative, which can be presentationally realized in any number of minds and (even for a given mind) on any number of occasions.[11] In this respect, he is following in the footsteps of Nelson Goodman in *The Structure of Appearance*,[12] and, like him, he calls his sensory universals 'qualia'. But whereas Goodman confined his ontology of qualia to relatively simple items and construed quality-complexes and concreta as qualia-aggregates whose parts stand in certain phenomenal relations, Ayer helps himself at the outset to qualia of any complexity, so long as each is capable of occurring within the scope of a single presentation in a single sense-realm. Thus his domain of basic visual qualia includes complex patterns, to which, borrowing from the vocabulary we use in our physical interpretation of them, he assigns such convenient names as 'visual chair-pattern' and 'visual leaf-pattern'. One reason why Ayer is prepared to recognize these patterns as ontologically basic is that his present concern is not with the details of phenomenal structure, but only with the epistemological route from sensory evidence to conclusions about the physical world. A further reason, and one which shows him to be actually opposed to Goodman's approach, is that, by making 'it necessary for anything to be an appearance that it be something of which the observer at least implicitly takes notice', he sets a limit on the degree to which his complex qualia can be resolved into simpler phenomenal elements. It is also worth noting that, while he accepts that qualia can be presented in certain spatial and temporal relations (relations such as *being visually to the left of* and *being phenomenally earlier than*), he shows no inclination to recognize, as genuine individuals, Goodman's visual-field places and phenomenal times, though this is not an issue which he discusses.

The normal practice among those who adopt the sensory-item account is to employ, at the outset, an ontology of sensory particulars, so that each sensory item is confined in its occurrence to a single mind on a single occasion. Since this was Ayer's own practice prior to *The Origins of Pragmatism*, one may wonder why he opts for qualia in his later work. On this point, Ayer is not very explicit. But the point seems to be that, while there is nothing wrong with an ontology of sensory particulars, our epistemological access to them depends on our prior access to qualia, together with a certain step of ontological invention by which the latter get 'particularized'.[13] More precisely, he seems to think that our capacity to construe a presented item as particular depends on our capacity to identify both the relevant quale and its presentational occurrence, and then to form the notion of something—the particularized quale—which combines the qualitative content of the one with the particularity of the

other. This would make the choice of an initial ontology of qualia a matter of securing the right epistemological perspective. As for the method by which we identify presentational occurrences, this has to be, in the first instance, demonstrative—the recording of the occurrence as 'this' or as 'here-now'—though Ayer allows that, with enough information about the total empirical arrangement of qualia (information which may well have to include facts about their physical as well as their experiential arrangement), a purely descriptive method would be in principle available.

3. From Experience to Theory

Because Ayer rejects the epistemological claims of naive realism, he has to take the sceptical argument seriously: he has to concede that our physical beliefs are only warranted if they are adequately supported by our sensory evidence. His aim now is to find some way of defeating the argument by showing that such adequate support obtains.

At this point, we might expect Ayer to address himself quite directly to the epistemological issue—to examine in more detail the remaining steps in the sceptic's argument and the possible responses which can be made to them. Instead, we find him embarking on a project which, on the face of it, is more concerned with psychology than with epistemology. The project is to set out the steps by which, without any prior physical concepts and without anyone to teach him the physical language, a human subject, with normal rational, sensory, and recollective capacities, might acquire a system of physical beliefs—a 'physical theory'—on the basis of his sensory data. Because the subject starts out with no physical concepts and because there is no one who prompts him to interpret his experiences in a certain way, the process by which he arrives at this system of beliefs is a highly creative one, involving radical steps of ontological and descriptive invention. Ayer speaks of it as a 'construction of the physical world'. The term 'construction', however, must not be misconstrued. There is nothing here akin to the programme of *logical* construction pursued by the phenomenalists, in which physical facts are reduced to sensory facts. The subject in Ayer's story is not merely inventing the physical terminology as a convenient way of recording the salient features of the sensory realm: he is postulating a genuinely new realm of entities and facts, which transcend all that exists and obtains at the sensory level. How Ayer's account of this constructive process is intended to serve his epistemological purposes is something we shall consider presently. But first I must give an outline of the account itself.

As I have indicated, Ayer envisages his fictional subject—his

'Robinson Crusoe'—as arriving at his physical theory by a series of steps. The initial steps are taken within the confines of the sensory realm: they are merely ways of reorganizing the ontology or regimenting the facts at the sensory level. The subsequent steps involve an expansion of the subject's ontological and factual commitments beyond the sensory realm and exhibit the gradual development of the physical theory from its embryonic form to the mature version which matches our ordinary beliefs. In this second phase, each step is prompted by some aspect of the empirical organization discernible in the theoretical framework prior to that step, and has the effect of increasing the uniformity and nomological simplicity of the organization discernible in the new perspective it creates. There is here, as Ayer himself acknowledges, more than an echo of the imaginative process described by Hume, in which, allegedly, we come to credit our perceptions, or perceptual data, with a continued and distinct existence in response to, and as a way of augmenting, their relations of 'constancy and coherence'.[14]

The subject's first step is to particularize his qualia in the way we have already envisaged; that is, he introduces an ontology of sensory items which combine the qualitative content of qualia with the particularity of their presentational occurrences.[15] Following Russell, Ayer calls these sensory particulars 'percepts'. He goes on to stress that, from the standpoint of the subject, this step of particularization is only in respect of time, not in respect of minds.[16] The subject conceives of percepts as momentary, or at least unrepeatable, but does not characterize them as private. Nor, for that matter, does he characterize them as public, either in the sense of being able to occur in different minds or in the sense of being perceptually accessible to different observers. The point is that, at this stage, before the subject has acquired a conception of himself as a subject or drawn any distinction between inner experiences and external objects, the question of what is private and what is public does not arise. Of course, *we* can see that his percepts are private; but this is because we are viewing the constructive process from a theoretical standpoint to which the subject himself has not yet attained.

The introduction of percepts, though only an ontological adjustment within the sensory realm, greatly increases the subject's descriptive resources. For it enables him to specify complex arrangements of qualia in terms of simple relations (relations he applies to percepts)—a facility which, with no way of indicating sameness or difference of presentational occurrence, would not be available in an exclusive ontology of qualia.[17] In particular, it prepares the way for the subject's next two steps, in which, for each sense-realm, he comes to think of his percepts as grouped into sense-fields (the largest aggregates of co-presented percepts) and as ordered in time.[18] This latter step depends on a number of factors: his

ostensive grasp of the relation of phenomenal precedence holding between co-presented percepts; an awareness of the overlap between neighbouring sense-fields in the same sense-realm; a capacity to use the relationships of phenomenal precedence and overlap to group sense-fields into temporally ordered streams; and some way in which memory, as well as furnishing information about their contents, arranges the streams in a single time-dimension. As Ayer summarizes it: 'sense-fields overlap in their contents, and . . . this makes it natural for the relation of temporal precedence, which is originally given as holding between the members of a single sense-field, to be projected on to its neighbours on either side. If this relation is then conceived to hold between the members of these sense-fields and members of their neighbours, and if the exercise of memory endows it also with the power to bridge gaps in consciousness, one can come to conceive of the domain of temporal relations as being, if not infinitely, at least indefinitely extended' (CQ, 99).

Having thus regimented the sensory facts, the subject is now ready to take his first step beyond them.[19] Confining his attention, for the present, to the visual realm, he notices that, while his percepts are fleeting, they are (by and large) collectively organized as if they were, or displayed, the elements of a more stable arrangement. It is as if there were a relatively stable arrangement of colours in an enduring three-dimensional visual space and as if each stream of visual fields constituted a sequence of presentations of portions of that arrangement from a spatially continuous series of viewpoints. The way in which the subject comes to discern this quasi-spatial organization of his visual phenomena is a complex story, and Ayer only focuses on certain aspects of it, such as the 'reversibility' of sensory routes. But the important point is that, on the basis of this discernment, the subject comes to believe that things are as the organization suggests—that his successive visual fields really do afford successive and appropriately related views of a relatively stable colour-arrangement in a three-dimensional visual space. His postulation of this visual space does not amount to a postulation of physical space, as we ordinarily conceive it, since, at this stage, the only items he locates in it, or regards as capable of location, are patches of colour (it is this which makes the space distinctively visual). At the same time, this postulation does involve a substantial leap beyond the ontology and facts in the strictly sensory realm and towards the fully mature physical theory. The visual space has the same dimensionality as physical space, and the colour-patches and colour-patterns located in it can exist at times when they are not perceived.

Now that this space has been introduced, the next few steps in the constructive process are relatively straightforward.[20] Noticing that there

are a very large number of cases in which the same colour-pattern
remains in the same region of space over a considerable period of time
and still further cases whose only difference from these is that there is,
over the relevant period, either a slight and gradual change in the
character of the pattern or a continuous change in its position or both
(and, of course, it is the predominance of such cases which gives the
overall colour-arrangement its relative stability), the subject comes to
recognize a domain of mobile visual continuants, which persist through
time, are capable of movement through space, and can preserve their
identity through some degree of qualitative change. At this point, he
turns his attention to the sensory data furnished by his other senses. By
correlating his tactual and his visual percepts in the framework of the
already constructed visual world, he comes to endow his visual continu-
ants with additional tactual properties, and in this new framework, he
accords to one of these visuo-tactual continuants (the one which *we*
would describe as the subject's own body) a special significance, as both
exceptionally pervasive through the changes in his experience and as
occupying the spatial viewpoint from which the world is perceived. He
also comes to incorporate 'sounds and smells and tastes into his
world-picture by tracing them to their apparent sources' (CQ, 103).

The next phase of the story sees the subject becoming conscious of
himself as a subject and drawing a sharp distinction between his own
internal and private experiences and the external and publicly accessible
things they present.[21] Ayer assumes that these further developments
require the subject to make contact with other observers (or at least with
a 'Man Friday'). The subject initially identifies these observers merely as
visuo-tactual continuants, of the same kind as the 'central body' from
whose viewpoint the world is perceived; but, finding himself able to
interpret their vocal sounds as signs and construe them as making
predominantly true assertions about the constructed world, he comes to
think of them as observers in their own right, with perceptual access to
this same world from different sequences of viewpoints. This enables
him to form a conception of himself as an embodied observer of the same
general kind, with the same kind of access to the common world via a
series of experiences which are uniquely his.

Finally, the subject comes to regard the constructed world as enjoying
an ontological independence from, and primacy over, its sensory ori-
gins.[22] The external objects, though still characterized in sensible terms,
are held to be capable of existing without ever being perceived and
without there even being observers equipped to perceive them, and they
are also held to be causally responsible for the experiences by which they
are perceived. In contrast, 'the percepts out of which the theory grew are

re-interpreted into it, and given a subordinate status', being now 'denied any independent existence, and treated merely as states of the observer' (CQ, 105). By achieving this independence and primacy, the constructed world has now become the fully fledged physical world of common sense. There is still, of course, room for further theoretical development from the outlook of common sense to that of physics, but this is something which, for the time being, Ayer is happy to leave on one side.

4. The Justification of Our Physical Beliefs

Ayer's story is not, and is not meant to be, a record of how we actually acquire our physical beliefs. 'Young children, who very quickly assume the theory, do not elaborate it on their own; they are taught a language which already embodies it' (CQ, 106). He continues: 'I have told a fictitious story, the purpose of which has been to highlight the general features of our experience that make it possible for each of us to employ the theory successfully.' The point is that, while in practice we follow a shorter route to theoretical competence, such competence is only attainable at all because our experience is such as to invite, to be conspicuously amenable to, physical interpretation. Ayer's story is then designed to exhibit the form of this invitation.

Ayer's ultimate aim, of course, is to provide an answer to the sceptic. So we may wonder how the fictitious story is intended to serve that purpose. In fact, he seems to think that the story itself constitutes the answer, and that, by revealing the way in which experience invites physical interpretation, he has shown that our physical beliefs are adequately supported by our sensory evidence. It is in this respect that he sees his account of the constructive process as differing from Hume's. 'Whereas he found in the relations of "constancy and coherence", which our perceptions exhibit, a means of explaining how we are deceived into treating them as persistent objects, I have represented these relations not as accounting for a deception but as justifying an acceptable theory' (CQ, 106).

This last remark is a little puzzling. For even if the relations of constancy and coherence, and the other organizational factors which his story highlights, do justify the acceptance of the theory, it is not clear in what sense Ayer thinks that he has, so far, *represented* them as doing so. There is, admittedly, at the very end of the story, a passage where he not only describes a constructive step but also endorses it. The step in question is that in which the subject comes to accept the physical theory as ontologically dominant; and Ayer, projecting himself and us into the

story, comments: ' . . . once the theory of the physical world has been developed, . . . we are entitled to let it take command, in the sense that it determines what there is. The fact that in doing so it downgrades its starting-point . . . is not a logical objection to this procedure' (CQ, 105–6). But in general Ayer describes the constructive process from the standpoint of a neutral commentator, without commitment to its epistemological validity.

The crucial question, however, is not whether Ayer has already represented his story as providing a defence against scepticism, but what kind of defence he has in mind. As things presently stand, the answer is unclear. After all, as Ayer represents him, the sceptic is not denying that our experiences are organized in a way which renders them conspicuously amenable to physical interpretation. His claim is simply that we have no rational warrant for supposing that such interpretations are correct. So exactly how does Ayer see this claim as undermined by the facts he has cited?

This question, of course, would have a straightforward answer if Ayer were still a phenomenalist and thought that statements about the physical world were logically equivalent to statements about experience. For he could then say that the sensory organization itself logically ensures the truth of the physical theory it invites us to accept. But Ayer makes it clear that he has abandoned phenomenalism for 'a sophisticated form of realism' (CQ, 108). The story itself represents the subject as coming to believe in the existence of a world which is logically independent of the realm of sense-experience, and it is in this realist form that Ayer takes the physical theory to be justified by the sensory evidence.

There is only one short passage where Ayer says anything explicit about the kind of justification he envisages. Referring back to his list of the different ways in which one might try to meet the sceptic's argument, he claims to have been pursuing 'a variant of . . . the scientific approach' (CQ, 108)—the approach which he earlier characterized as that in which 'the existence of physical objects . . . is represented . . . as a probable hypothesis which one is justified in accepting because of the way in which it accounts for one's experiences' (CQ, 66). He goes on to concede that to speak of the existence of physical objects as a probable hypothesis would be somewhat misleading, 'since this description would ordinarily be taken to apply to propositions that lie within the framework of our general theory, rather than to the principles of the theory itself' (CQ, 108). But he regards the difference in status between the specific propositions and the general principles as only one of degree: 'The theory is vindicated not indeed by any special set of observations but by the general features of our experience on which it is founded, and since these features are contingent, it could conceivably be falsified in the sense that

our experiences might in general be such that it failed to account for them' (CQ, 108).

Ayer is claiming, then, that we are justified in accepting the physical theory because of the way in which it accounts for our experiences. But it is still not clear exactly what he has in mind. Suppose the sceptic were to say: 'Of course, if the physical theory were true, it would account for our experiences. But there are no good grounds for thinking that the theory is true.' How exactly does Ayer want to answer this? How does he see the explanatory role of the theory as justifying its acceptance?

Although Ayer does not tell us any more about the nature of the envisaged justification, it might seem that we can work things out. At first sight, it seems that if the physical theory is to be justified by its explanatory role, then there must be something about our experiences which calls for explanation and which is best explained by that theory. Given this, and given the content of his fictitious story, it is natural to assume that his argument would run as follows:

(1) Our experiences are organized in a way which renders them conspicuously amenable to physical interpretation.

(2) This organization calls for explanation.

(3) It is best explained by the physical theory.

Therefore,

(4) We are justified in accepting the theory.

His story could then be seen as drawing attention to the thing which calls for explanation and as showing how it can be explained in physical terms.

Although, on the evidence we have so far considered, this would be a natural interpretation of his position, I think it is incorrect. My reasons for rejecting it are exclusively concerned with premise (2). But before I focus on this premise, I want to say something about the sense in which Ayer thinks of our experiences as having an *organization* and the sense in which he thinks of this organization as *explained by* the physical theory.

Ayer is an empiricist philosopher in the tradition of Hume. In particular, he takes a Humean view of causality and natural law. Thus he assumes that causal relations between particulars are to be construed as law-like correlations between their types, and he takes these law-like correlations to be nothing more than factual regularities, which are only distinguished from 'accidental' regularities by our nomological attitude towards them (roughly, we are prepared to believe in these regularities on the basis of a limited sample of their instances and are willing to project them on to hypothetical cases).[23] Crucially, he does not recognize, nor think we can even make sense of, any kind of objective causal agency, whereby one event is literally responsible for bringing about another, or any kind of objective natural necessity by which the course of events is

constrained. This has an important bearing on the way we should interpret the argument formulated above, if we envisage it as representing Ayer's position. There is no doubt that, suitably interpreted, Ayer would accept premise (1); but he would take the sensory organization to be wholly constituted by certain factual regularities, which obtain solely in virtue of the sorts of experiences which occur in various minds at various times. Likewise, there is no doubt that, suitably interpreted, he would accept premise (3); but he would see the explanatory role of the physical theory as consisting in the fact that, by adopting the theory, we can represent the sensory regularities as logically ensured by the structure of the external realm and the much simpler regularities which pertain to it (both physical regularities characterizing events in this realm and psychophysical regularities characterizing its links with human experience). In neither the specification of the sensory organization nor the provision of its physical explanation, would Ayer acknowledge any sense in which things *have to* happen or are *made to* happen in a certain way, apart from the trivial sense in which some facts may be the logical consequences of others.

Bearing this in mind, let us now look at premise (2). If (2) is to serve its purpose in the argument, the sense in which it claims that the sensory organization *calls for* explanation must be stronger than the sense in which the organization is said 'to invite' (to be conspicuously amenable to) physical interpretation. The thought must be that it is *rational* to seek an explanation of the organization, that it would be in some way surprising or puzzling if the organization obtained without there being something else (something other than the sensory facts which constitute it) which accounts for it. Now it seems to me that, taken in this sense, the premise is one which Ayer would reject, and that, consequently, we should not think of the argument as representing his true position.

How might Ayer come to think that the organization calls for explanation in the relevant sense? One thing is already clear. He could not reason as follows: 'The organization involves a substantial departure from a merely random distribution of qualia over minds and times. So it would be implausible to suppose that it obtains by chance.' For since he rejects objective causal agency and objective natural necessity, he himself has to settle for unexplained regularity, and hence unexplained non-randomness, at the level of the physical theory, which forms his explanatory terminus. Indeed, if the call to explain the sensory organization depended merely on its non-random character, there would be a still more urgent call to explain the physical and psychophysical organization, whose non-randomness is greater.

It might be suggested that what stands in need of explanation is not

the non-random character of the organization, but its amenability to physical interpretation. The reasoning would then run: 'Our experiences are organized exactly as if there were an external sensible realm in which we are located and to which we have perceptual access. Even if there is no problem with unexplained regularity as such, it would be very implausible to suppose that there is nothing which accounts for an organization with this special character.' But, here again, I do not see how this reasoning could be acceptable to Ayer. For on what grounds could he find the relevant supposition implausible? Obviously, it could not be on empirical grounds, since, at this stage of the argument, his empirical knowledge is confined to the sensory realm. So the grounds would have to be a priori. He would have to think that we can know a priori that, had the sensory realm been left to its own devices, the likelihood of such an organization obtaining would (compared with the other possibilities) have been distinctively low. But all such thoughts are quite alien to Ayer's empiricist outlook. For, as well as endorsing a Humean view of causality and natural law, he rejects any form of a priori probability, other than what is reducible to mathematical truisms: he is adamant in holding that, for any type of contingent state of affairs, the likelihood or unlikelihood of its obtaining can only be assessed empirically. Thus, in arguing against the claim that the orderly behaviour of atoms is evidence of divine creation, he insists that, antecedently to experience, we have no reason to expect atoms to behave in one way rather than another: 'So long as we remain in the realm of purely a priori possibilities, we can make no inference at all about what is actually likely to happen' (CQ, 165–66). And in all his writings on probability, he makes the same empiricist point.[24] So the suggestion that we can establish premise (2) on the basis of an a priori assessment of the probabilities is one which Ayer would regard as wholly misconceived.

As far as I can see, there is no way in which Ayer could endorse claim (2) as a premise in the anti-sceptical argument. He might, indeed, be willing to say that the sensory organization calls for explanation. But if he did, it would be in consequence of thinking that the physical theory gains credibility from its explanatory success, rather than because he recognized some antecedent need for explanation in the character of the organization itself. This, of course, brings us back to the crucial question. Exactly why does he think that we can derive a justification for the physical theory from its explanatory success? If there is no antecedent call for explanation, how can he see us as justified in going beyond the sensory realm?

The answer, I think, is that Ayer would regard the justification as essentially pragmatic. He would appeal to the fact that, as well as fitting

our experiential data, the physical theory allows us to absorb the complex and limited regularities which obtain at the sensory level into the much simpler and more extensive regularities which characterize the enlarged domain, so that the sensory organization becomes an aspect of a more uniform and orderly system. And while he would deny that we can make any a priori inference from the character of an envisaged system to the likelihood of its occurrence, he would still insist that, by adopting the physical theory and taking advantage of the gain in uniformity and orderliness, we obtain the best account of reality for practical purposes, not only because it increases our powers of prediction, but also because it is only in the perspective of the physical theory that we can achieve a proper understanding of the sensory organization itself. This last point is a consequence of the fact that, while certain aspects of the organization can be specified in purely sensory terms, the organization as a whole can only be fully and exactly specified as that which would obtain if the physical theory were true.

But now we face a new problem. For if Ayer is offering a merely pragmatic justification of our physical beliefs, how can he see it as an answer to the sceptical challenge? It seems that we are only being given a practical reason for employing the physical theory rather than any theoretical grounds for believing it to be true. And if this is so, it seems that the sceptic's argument has been evaded rather than met.

The solution emerges when we look at the final section of his book *The Origins of Pragmatism* (OP), which was published five years earlier.[25] In this section, which is entitled 'On What There Is', and which immediately follows an account of the construction of the physical world similar to that in *Central Questions*, Ayer draws a distinction between two kinds of ontological question. On the one hand, there are those questions which are raised within the framework of some theoretical system and which can be settled by employing the verification procedures which this system assumes. For example, such questions as 'Is there a greatest prime number?' and 'Are there abominable snowmen?' are of this type. On the other hand, there are those higher-order questions which concern the ontological correctness of some theoretical system and which seem to call for a metaphysical inquiry into how things ultimately are. Examples of such questions are 'Do numbers really exist?' and 'Are there really physical objects?'. It is Ayer's attitude to the higher-order questions which is of interest. He thinks that it is sometimes possible to settle such questions objectively, though always negatively, by showing that the relevant ontology is either logically incoherent or eliminable by reductive analysis. But, and this is what is crucial, he also insists that where an ontology cannot be disposed of in either of these ways, the

ontological question should be construed as a question for decision, not a question of fact. He illustrates the point by focussing on the rival ontologies of common sense and science. 'Is what is really there before me the solid continuous coloured table of common-sense or a set of discrete colourless physical particles?' (OP, 333). Each answer can be seen as objectively correct within the framework of its own theoretical system. But if we are raising the higher-order question of which of these systems provides the right ontological picture of the world, then there is no objective answer. We simply 'have to opt for one view or the other' (OP, 333). Of course, the feeling that there must be an objective answer dies hard. 'One is tempted to say: Never mind how we choose to regard the world. How is it in itself? What is *really* there, the table or the particles? What does God see? But this is to forget that we have not supplied any criteria for determining what there really is, in this sense. We are no longer raising a question which can be settled by a recognized experimental procedure. Given two different orders of discourse, we are asking which of them we want to reify. This is not a purely arbitrary question. One can give reasons for going one way or the other. But they are not compelling reasons. In the end it comes down to a matter of choice. The word 'really', in this special usage, calls for the expression of an ontological decision' (OP, 333–34).

So Ayer would insist that the pragmatic justification of the physical theory is the only one we need. Given that the theory squares with experience, there is nothing left in virtue of which it could be objectively mistaken; and given that it scores the highest marks for utility, there is no rival ontological theory which could be deemed preferable. Beyond the considerations of empirical accuracy and practical convenience, there is no further issue to be raised—no question of what ultimately exists, of what is real from a God's-eye view. This does not mean that Ayer sees the physical theory as immune from challenge altogether. For it is conceivable that a better theory will emerge in the light of future experience. But the crucial point is that, if there is no transcendental issue of truth or falsity, no question of how things are *sub specie aeternitatis*, then he can legitimately represent the physical theory as *adequately supported* by the currently available evidence. And it is in this sense that he wants to maintain that we are justified in accepting the theory because of the way in which it accounts for our experiences.

It might be thought that if this is Ayer's position, he is, in effect, endorsing a form of idealism, in which the existence of the physical world is held to be nothing over and above the sensory organization together with those aspects of human psychology which give the physical account of this organization its practical value. But such an interpretation would

be wholly mistaken. There are two ways in which the nothing-over-and-above claim might be taken. On the one hand, it might be taken to mean that statements about the physical world are really statements about the sensory organization and human psychology in verbal disguise, so that even the physical theory itself (properly understood) does not represent the physical world as mind-independent. On the other hand, it might be taken to mean that although physical statements themselves should be construed 'realistically', as making claims about how things are in some mind-independent realm, the physical reality which they characterize is not metaphysically ultimate; that from a God's-eye view it would be seen as something sustained and wholly constituted by the relevant sensory and psychological facts. But, whatever their merits (and I myself would endorse the second[26]), Ayer is not subscribing to either of these positions. He construes the physical theory realistically; and, in adopting it as his 'primary system', he rejects any metaphysical framework in which the reality of the physical world is downgraded. The only sense in which he is tying the physical reality to human experience and psychology is that he does not acknowledge any issue of how things ultimately are except in empirical and pragmatic terms. It is not that he is pursuing a phenomenalist analysis of physical concepts; much less that he is endorsing some form of transcendental idealism. It is simply that, construing the physical theory realistically, he refuses to recognize any framework in which the question of its truth can be raised other than one which is tied to the perspective of our empirical viewpoint and our practical concerns.

This refusal to recognize a transcendental issue of truth is a further aspect of Ayer's empiricism, and seems to reflect a residual allegiance to the verificationist doctrines of his early work.[27] His thought seems to be that if there were an issue of how things are from a God's-eye view, it would be wholly undecidable, and that, because it would be wholly undecidable, we should dismiss it as spurious. On both counts, of course, his position is open to challenge: many philosophers would claim to have made progress on the transcendental issue, and still more would be unwilling to fix the limits of significance in a verificationist way. But if we grant Ayer his philosophical presuppositions, we are likely to find his account of our physical knowledge compelling.[28] And it is a tribute to his resourcefulness, and to the power and elegance of his writing, that the presuppositions themselves seem more compelling when viewed in the perspective of what he develops in their framework.

<div align="right">JOHN FOSTER</div>

BRASENOSE COLLEGE, OXFORD
JULY 1986

NOTES

1. (Harmondsworth: Pelican Books, 1973).

2. On many of the philosophical issues, I have set out my own position in *The Case for Idealism* (London: Routledge & Kegan Paul, 1982) and *Ayer* (London: Routledge & Kegan Paul, 1985). The present discussion fills a gap in my book on Ayer, where I did not have space to examine his CQ account in the detail which it merits.

3. CQ, 65–67. The earlier discussion is in PK (Harmondsworth: Pelican Books, 1956), 75–83.

4. On this, see my *Ayer*, Part II, section 11.

5. On this notion of truth-reliability, see my *Ayer*, Part II, section 3.

6. CQ, 65.

7. For Ayer's discussion of these objections and his assessment of the naive-realist view of perception, see CQ, ch. IV and PK, ch. 3, (i)–(v).

8. For my discussion, see *Ayer*, Part II, sections 9–10.

9. CQ, 80–81.

10. CQ, 81–82. *Cf.* PK, 97–98.

11. CQ, 89–93.

12. 2nd ed. (New York: Bobbs-Merrill, 1966). However, for the purposes of his constructional system, Goodman adopts the methodological assumption that there is only one mind.

13. CQ, 92–93.

14. See Hume, *Treatise of Human Nature,* Book 1, Part 4, Section 2. Ayer's acknowledgement comes at CQ, 106.

15. Strictly speaking, this step has been taken *prior to* the constructive process which Ayer's fictitious story describes.

16. CQ, 93–94.

17. Goodman's 'problem of concretion' *(The Structure of Appearance*, ch. VI, section 4) is a special case of this difficulty. However, given his choice of qualia (in particular, his recognition of visual-field places and phenomenal times) and his methodological assumption that there is only one mind, he was able to solve the problem very easily and without the introduction of percepts.

18. CQ, 99.

19. CQ, 99–100.

20. CQ, 101–4.

21. CQ, 104–5.

22. CQ, 105–6.

23. See CQ, 147–55 and 179–83.

24. See especially his *Probability and Evidence* (New York: Macmillan, 1972), 27–43.

25. (New York: Macmillan, 1968).

26. See my book *The Case for Idealism* (London: Routledge & Kegan Paul, 1982), Parts III and IV.

27. In particular, *Language, Truth and Logic*, 2nd ed. (London: Victor Gollancz, 1946).

28. Admittedly, there would still be the problem of whether we can have access to sufficient sensory evidence without relying on the truth of our physical beliefs. See my *Ayer*, Part II, section 12.

REPLY TO JOHN FOSTER

I f I write little in reply to Mr Foster's paper, it is not because I think little of it. On the contrary, I think very highly of it indeed. The reason why my reply will be short, is that Foster, as he says, has been concerned to expound my views rather than evaluate them, and his exposition is impeccable. When it comes to the crucial point of my handling of the question what there really is, his account of my approach is more lucid and probably more persuasive than anything that I have been able to achieve myself. I shall confine my comments to one or two details.

With regard to one point on which Foster says that he finds himself in disagreement with me, I am now inclined to give way to him. It concerns naive realism. In my books *The Foundations of Empirical Knowledge* and *The Problem of Knowledge* and less explicitly in *The Central Questions of Philosophy*, I propounded the view that the naive realist's account of perception could not be proved to be mistaken. The insistence on the part of philosophers from Descartes, through Locke, Berkeley, Hume, and Mill, to Russell, Moore, Broad, and Price that our perception of physical objects was mediated by what in my own time was most commonly known as the sensing of sense-data, was not, I maintained, the expression of a factual discovery, but rather the advocacy of a special terminology. If I chose to adopt such a terminology it was only because it supplied a more convenient instrument for the philosophical analysis that I proposed to undertake.

I still adhere to this position in so far as I am not disposed to say that the plain man's belief that he sees and touches flowers and trees and chairs and tables is actually false. His position may be unsophisticated, but his interpretation of such words as 'see' and 'touch' accords with ordinary English usage, for what that is worth. On the other hand, the naive realist philosopher is not representing himself as a plain man, whether or not he be one. His claim that we *directly* perceive physical

objects is a venture into epistemology; it is intended to deny the legitimacy of the interposition of anything of the order of sense-data; and when it is so construed, Foster and I agree in maintaining that his view is wrong. The argument that every perceptual judgement which implies the existence of a physical object claims more than is vouchsafed by the sense-experience on which it is based is surely irrefutable; and indeed no attempt has been made to refute it even by philosophers like Ryle and Austin who have made the most strenuous efforts to banish sense-data from the philosophical scene.

Among my books I confess to a preference for *The Problem of Knowledge* over the much more celebrated *Language, Truth and Logic*, partly because of its greater originality and partly because I am vain enough to consider its treatment of scepticism, which Foster admirably summarizes, a valuable contribution to the theory of knowledge. Its main defect, which Foster kindly overlooks, is that it ends by defrauding the sceptic. By disqualifying him on the ground that his standards of justification are set so high that they cannot possibly be met, it arbitrarily turns his victory into a defeat.

It was this injustice that I attempted to redeem first in *The Origins of Pragmatism* and then in *The Central Questions of Philosophy*, not by surrendering to the sceptic, but by finding an acceptable way of meeting, or perhaps I should say, circumventing his challenge. Unfortunately, as I am grateful to Foster for remarking, I did myself an injustice by stating or implying at several points in *The Central Questions* that my 'construction' of the physical world was a vindication of the method of countering the sceptic's argument by pursuing what in *The Problem of Knowledge* I had called the scientific approach; in sum, that it represented the existence of physical objects as 'a probable hypothesis which one is justified in accepting because of the way in which it accounts for one's experiences'. Of course it does not achieve this and I hope that I did not delude myself into thinking that it did. Of the four propositions which would be required to certify this achievement, as Foster formulates them: (1) that our experiences are organized in a way which renders them conspicuously amenable to physical interpretation; (2) that this organization calls for explanation; (3) that it is best explained by the physical theory; (4) that we are therefore justified in accepting the theory, Foster is quite right in saying that I am not in a position to accept the second. The most that I can claim is that the way in which our experiences happen to be organized favours the theory which I develop out of them, and that that theory is such that our adoption of it is pragmatically advantageous to us. But from this, as Foster notes, it does not follow that the objects which figure in the theory are what there really is.

Nor do I pretend that it does. The clue to my position, as Foster has perceived, is to be found in the final section of my book *The Origins of Pragmatism*, where I borrow from Carnap the distinction between internal and external questions. As Foster explains, with the help of examples, internal questions are those that can be settled within the framework of some theory. External questions bear on the status of the theory itself. For instance, they ask whether the theory describes what there really is in some absolute sense. I hold, as Carnap did, that while there may be a negative answer to an external question, if the theory can be shown to be vacuous, or incoherent, or amenable to a reductive translation, a positive answer can only take the form of a decision, since our flight into metaphysics has removed us from any question of fact.

I should perhaps emphasize, what Foster also explains very well, that this is not an endorsement of idealism. On the contrary, one of the features of *The Central Questions* to which I attach most importance is its dissociation of primacy in the order of knowledge from primacy in the order of being. The percepts out of which the theory is developed are interpreted into it and thereby become subordinate to persons. It is my choice of a theory which shows what I take there to be, and my chosen theory is realistic.

I wish to end by commenting briefly on Foster's final footnote where he raises the question 'whether we can have access to sufficient sensory evidence without relying on the truth of our physical beliefs'. I have never sought to deny that my descriptions of qualia are tailored to the use that I intend to put on them but believe that I have also succeeded in showing that there is no logical objection to this procedure and I hope that I always adduce enough sensory evidence to sustain the posits that I make. Finally, if I may descend to the level of a *tu quoque* in reply to someone who has treated me so generously, surely a phenomenalist like Foster is committed to allowing that there is a sufficient supply of sensory material to satisfy my more modest demands.

 A.J.A.

Paul Gochet

ON SIR ALFRED AYER'S THEORY
OF TRUTH

In his writings, Sir Alfred Ayer has discussed the main traditional theories of truth: the coherence theory, the pragmatic theory, and the correspondence theory. To each of them he has made new and forceful objections. In the first part of this essay I shall expound and assess his most significant criticisms. In the second part, I shall examine Ayer's own theory of truth, i.e., the redundancy theory, and show that it cannot be made to work unless some elements of the correspondence theory are retained. In a third and final part, I shall defend a version of the latter theory amended and revised in the light of Ayer's objections.

Coherence theories of truth are open to a well known objection: several systems might be mutually incompatible and yet internally consistent but clearly only one of them can be true. How can we know which one? Logical Positivists provided a new answer to this classical problem: ". . . the true system is that which is based upon true protocol propositions" (Ayer 1937, 143), and which, in turn, is characterized by "the historical fact that it is actually adopted by the scientists of our culture circle" (Ayer 1937, 144).

What does this amount to? If we take this requirement in its ordinary sense, i.e., if we mean "that only one of these systems was accepted by the scientists *in fact*" (Ayer 1963, 180) we breach the coherence theory of truth and tacitly appeal to the correspondence theory.

To remain consistent with coherentism, one should insist that the self-referential statement "This system was accepted by the scientists of

I wish to thank Prof. H. Hubien, Mrs Van Parijs and MM. F. Beets, Ph. Miller and J. Riche for their helpful comments.

our culture" be included in the system. But this self-referential statement itself might occur in *all* the competing systems. If this happens, we have to find out which of these self-referential statements are true *in fact* and this means that once again we surreptitiously reintroduce the classical sense of truth as correspondence with facts.

A similar objection can be levelled against the pragmatist theory of truth, even in its most sophisticated versions. This theory identifies "the truth of a proposition with its being firmly believed, whether by oneself, or by most people, or even by everybody who ever considers it" (Ayer 1968, 22). What account shall we give, Ayer asks, "of the truth of the proposition which states that some proposition *is* firmly believed by the persons in question?" (Ayer 1968, 22). Shall we say, for instance, that the proposition "it is firmly believed that the sun is spherical" is true if the belief in the sphericity of the sun exists *in fact*? But here again, by appealing to facts, "we shall be making an exception to the theory" (Ayer 1968, 22).

If, however, we take up the other branch of the dilemma and equate "it is true that it is firmly believed that *p*" with "it is firmly believed that it is firmly believed that *p*", then, as Ayer observes, "we are launched upon an infinite regress" (Ayer 1968, 22). The source of the trouble lies in the occurrence of the schematic letter "*p*" which can be filled by any proposition whatsoever.

At this stage one may wonder whether Tarski's Convention T, which formulates the condition of material adequacy for the theory of truth, is not threatened by the same regress. In the schema "*S* is true if and only if *p*" where "*S*" is a name or a structural description of the sentence which occurs *in use* on the right-hand side of the biconditional, nothing prevents our substituting the sentence " 'snow is white' is true" for *p* and the name of that sentence for *S*. Hence having agreed that "snow is white" is true if snow is white, we are led to also agree that " 'snow is white' is true" is true if "snow is white" is true and so on *ad infinitum*.

Ayer circumvents this objection and shows that the second regress is harmless: "The propositions which we should successively reach [by entering the regress] would be technically different from one another but the material content of each member of the series would be exactly the same as that of its predecessors; to be told that it is true that *p* is true is to be told no more than that *p* is true" (Ayer 1968, 23).

To show that Ayer's contrast is correct and illuminating, let us apply to the pragmatist's truth definition schema the same sort of substitution as the one Ayer tried on the T-convention. Let us start with the schema: "It is true that *p* iff it is firmly believed (by the ideal scientific community) that *p*" and substitute "it is firmly believed that *p*" for "*p*" in

that schema. We shall obtain: "It is true that it is firmly believed that p iff it is firmly believed that it is firmly believed that p".

This exercise brings out an important distinction between Convention T and the pragmatic definition of truth, and reveals another weakness in the latter. Whereas in the case of Convention T, the sentence "it is true that it is true that snow is white" says no more about the world than "it is true that snow is white", the sentence "it is believed by x that it is believed by x that the snow is white" says something more about the world than "it is believed by x that snow is white". In other words, "it is believed that it is believed that p" does not amount to "it is believed that p". To claim the opposite would be to assume that an agent cannot have false or incomplete beliefs about his own beliefs, and this is a highly controversial assumption which epistemic logicians refrain from making. Konolige explicitly avoids it (Konolige 1985, 385). On the contrary, Convention T which Ayer employed to reduce "It is true that it is true that p" to "It is true that p" is uncontroversial if one is concerned with the truth-conditions, as opposed to the conditions of use, of the phrase "it is true that".

In Ayer's eyes, the correspondence theory of truth fares no better than its rivals. According to the correspondence theory, a proposition is true iff it corresponds to facts. Ayer has important things to say about each of the three notions which occur in this standard version of the theory. I shall successively examine his criticism of the notion of proposition, his attack on the notion of correspondence and his objections to facts conceived as truth makers.

If one considers a sentence such as, e.g. "There is a stove in my room", one might ask what it expresses or means. The first answer which comes to mind is that it expresses an empirical fact. This apparently trivial answer, however, raises a problem, whose solution seems to require the introduction of the concept of proposition. As Ayer writes, "if the meaning of a sentence is the same, whether what it expresses is true or false, and if in the case where it expresses a falsehood it cannot mean an empirical fact, then it does not mean an empirical fact even when it happens to express what is true. . . . The course that is favoured by most philosophers . . . is to invent a class of would-be facts, which they call 'propositions' " (Ayer 1940, 96).

Ayer takes exception not only to the answer, but more radically, to the very question which has prompted it. It is legitimate, he says, to "seek to know the meaning of a particular symbol", i.e. of a particular sentence, but one "cannot deal in the same way in the general case, for the simple reason that there is no general usage to explain" (Ayer 1940, 97–98). If the proponents of the propositions have moved from the premiss that all

meaningful sentences mean something to the conclusion that there is something which all meaningful sentences mean, as Ayer seems to suggest, they have unquestionably made a trivial fallacy. There is, however, another way of introducing propositions as sentential meanings which is not open to Ayer's criticism. One can divide the set of meaningful sentences by the relation of synonymy, which is an equivalence relation. Each equivalence class obtained in this way can be said to be a distinct proposition. Here, however, an essential use is made of the dubious notion of synonymy.

Propositions have also been introduced as objects of intentional mental states such as belief. With this particular use of the notion of proposition, Ayer is dissatisfied for another reason: because appeal to propositions lacks explanatory power: "... to say that people ... believe propositions is no more informative than to say they love their beloved ... or eat food" (Ayer 1940, 100). One can concede to Ayer that internal accusatives convey a very small amount of information, but it would be rash to go further and say that they convey no information at all. The phrase "singing a song", for instance, gives more information than the verb "singing". It implies that the song existed before the act of singing. In the same way, talk of people believing propositions might be a way of conveying the idea that these propositions existed before being believed, like Bolzano's *Satz an sich*. But the question remains: is it illuminating to see belief as a dyadic relation whose relatum is an abstract object, i.e., a proposition?

We have considered propositions as bearers of meaning and as second terms of the alleged dyadic relation of believing. Our main concern here, however, is the role of propositions as truth bearers. Ayer can be credited with an important insight on this problem. He has seen that the role of propositions as objects of belief is not only *different* from but *inconsistent* with their role as subject of the predicate "true". Speaking of propositions he writes: "To treat them as objects, onto which beliefs are directed, is to make it impossible to explain how anything comes to be true or false. Since an object, in this sense, does not refer beyond itself, the propositions simply cut off the beliefs from the actual course of events by which they are verified or falsified" (Ayer 1967, 193).

Ayer has hit on something very important here. Philosophers such as Quine and Husserl who are very divergent have sensed the problem and tried to offer a solution. Quine did so by explicit regimentation. He forged the predicate "x believes-true S" whose second argument-place takes sentences as values and names of sentences as substituends just as the "S" in Tarski's Convention T (Gochet 1986). This seems to solve Ayer's problem but the solution is illusory. Since "believes-true" is an atomic predicate, we are not allowed to recognize "true" in it. Quine's

regimentation, which, to be fair, was not made for the purpose of solving Ayer's problem, nevertheless shows that a problem does exist.

In a note to his translation of Husserl's *Ideen*, Ricoeur stresses that the latter was fully aware of the problem: "Husserl . . . declares that the most intimate part of intentionality has not been accounted for if, in the 'sense' aimed at, by the consciousness, one does not discern in addition an arrow which goes through the sense and indicates the direction towards . . . or the claim to . . . reality [objectivité]" (Husserl 1950, 431–32).

Hence for both Husserl and Ayer, propositions are not self-sufficient. They point to something outside, they are used to "act", to quote Ayer again, "as a bridge" rather than "as a barrier between words and things" (Ayer 1967, 193).

We have devoted enough time to propositions. Let us now examine what Ayer has to say about correspondence.

The relation of correspondence has been used in both the theory of meaning and the theory of truth. Neither of these uses is accepted by Ayer. Commenting on the correspondence theory of meaning, he writes, ". . . the notion of correspondence, or portrayal, does not provide us with an adequate model for the relationship of meaning" (Ayer 1967, 32). The correspondence theory of truth is criticized with equal vigor: ". . . we must make it clear that by 'agreement' [with reality] we do not mean '*resemblance*' " (Ayer 1935, 29) and "The classical model [of the theory of truth] is the metaphor of reflection; it was thought that the truth of a statement consisted in its faithfully mirroring some fact. But apart from other difficulties, the metaphor could simply not be cashed" (Ayer 1967, 17).

If we carefully scrutinize Ayer's arguments against the correspondence theory of truth, we discover to our surprise that they are the very same arguments as those which he formulated against the correspondence theory of meaning. This suggests that there is something wrong somewhere. You cannot aim at two different targets with the same gun at the same time.

To prove that the metaphor which assimilates truth to mirroring is wrong, Ayer says that "Most languages are not ideographic" and that "there is no particular virtue in a pictorial symbolism" (Ayer 1967, 17). But surely Ayer's argument runs against the picture theory of meaning and not against the correspondence theory of truth. What is refuted here is the allegedly iconic character of language or symbolism, but language and symbolism are not the sort of things to which truth or falsity can be ascribed; they rather are the sort of things which can be said to be meaningful or meaningless.

Elsewhere we observe that Ayer expects the theory of truth to provide

an answer to a query which, in fact, relates to the theory of meaning. He challenges the proponent of the correspondence theory of truth to answer the following question: "What do sentences which express false propositions resemble?" (Ayer 1940, 108). But clearly this question arises only if we are offering an account of the *meaning* of false propositions, not, of course, an account of their truth since *ex hypothesi* they are false.

As a third and last example of this conflation of these two distinct but related issues—the problem of explaining what sentences mean when they are meaningful and the problem of saying what they correspond to when they are true—is given by the following criticism addressed to the relational theory of meaning: "To see how inadequate this conception is we have only to consider the cases where . . . a sentence is used to state what is false" (Ayer 1967, 32). But clearly, the relational theory of meaning which posits propositions as correlates of sentences is not endangered by falsity unless it also purports to account for sentences *qua* true as opposed to sentences *qua* meaningful. If what is at stake is a theory which explains what false sentences *mean,* the proponent of the relational theory of meaning can reply that both true and false sentences are correlated to propositions or that "a statement . . . designates . . . a set of situation types" (Barwise and Perry 1981, 390).

We should refrain from concluding that Ayer has failed to disentangle the issue of truth from that of meaning. In the above mentioned passages he is putting himself in the position of the proponent of the correspondence theory of truth in order to disclose from the inside the confusions of which the latter is guilty. According to Ayer's reconstruction, the correspondence theory of truth draws all its appeal from the picture theory of meaning in which it is rooted: "In its traditional form, [the correspondence theory of truth] mistakes a cardinal feature of a certain type of symbolism for an essential feature of all symbolism, and then confuses a key to the interpretation of these symbols, a clue for deciding in this special type of case what it is that they state, with a criterion for deciding whether what they state is satisfied. In this way a defective theory of meaning is turned into a defective theory of truth" (Ayer 1963, 185).

I shall try to reinstate the correspondence theory of truth and show that it can be spelt out in a way which makes it immune to the objections which Ayer levelled against the standard version of the theory. Before starting this defence, I have to examine a third ingredient of the correspondence theory of truth, i.e., facts, which Ayer says, we have "to be able to characterize . . . not as linguistic entities of any kind, but somehow as objective states of affairs" (Ayer 1963, 173).

We have learned from Wittgenstein that there are expressions in

language which do not designate: logical constants, for instance. The indeterminacy produced by the disjunctive sign "or" in the sentence "Mars is red or the sun shines" is a feature of our description of the world, not a feature of the world. We therefore have some grounds for denying that disjunctive statements are good clues for reaching objective states of affairs. Atomic states of affairs are undoubtedly better candidates.

Atomic empirical statements fail to secure full specificity. Consider, for instance, the two statements (a) "Mars is red" and (b) "Mars is coloured". Clearly (a) is more specific than (b) in so far as (b) entails (a) while (a) does not entail (b). To reach full specificity, we should be able to sort out absolutely specific statements, a notion which can only be defined with respect to a language. A statement is said to be "absolutely specific with respect to a given language L" if and only if "there is no statement expressible in L by which it is entailed and which it does not entail" (Ayer 1963, 176).

Having reached these apparently fundamental statements, we can still make them more specific by conjoining them and by adding a new constraint, i.e., the requirement that none of the statements which have passed the specificity test be compounds of simpler ones. The statements which fulfil these conditions can be said to be correlated with facts.

This way of isolating a certain category of facts which are to be regarded as "truth-makers" is open to a fatal objection: " . . . we are turning in a circle. We set out to explain the truth of statements in terms of their relation to facts, but we have ended by explaining what facts are in terms of the truth of a certain class of statements" (Ayer 1963, 177). Hence we have fallen into the trap of circularity.

How does Ayer solve the formidable problem he has set himself? His reply is that "the circle is broken by observation and by action" (Ayer 1963, 180). "There is," he says, "nothing mysterious about our ability to compare statements with facts, . . . We break the circle by using our senses. . . . The problem is a practical one and in practice often quite easily solved" (Ayer 1983, 185–86).

In his review of the book from which this passage has been quoted, V.C. Chappell accused Ayer of committing the fallacy known as *ignoratio elenchi*: "This is like saying that Zeno's problem is solved by staging an actual race and observing that Achilles does indeed pass the tortoise. For there is a theoretical problem here, a problem which Ayer himself has stated quite nicely, and it now looks as if he is simply dodging it" (1968, 241).

I shall try to dispose of Chappell's objection by arguing that statements and facts dialectically shape one another. To see that this is neither a verbal nor an ad hoc solution, we have to go deeper into the matter.

In his attempt at isolating facts, Ayer was right to concentrate on sentences which are logically simple, i.e., which contain neither connectives nor quantifiers. He was also right to say that the atomic character of the sentence does not guarantee that the state of affairs which it describes is ontologically simple. The new method he introduced at that stage in order to increase the specificity of the statements designed to capture the "facts", is also unquestionably welcome. The trouble is that it does not suffice.

Ayer paid much attention to the *linguistic* side of the undertaking. He observes that atomic statements such as "This is coloured" which are analytically entailed by other statements such as "This is red" are not specific enough to capture facts. But one should not overlook the *empirical* side of the undertaking.

Not very long ago, it was not known that there are two sorts of viral hepatitis: A-hepatitis and B-hepatitis. Hence if we are confronted with the statement "Cyril has hepatitis" (borrowing the example of Mulligan et al.), we know that it has at least two truth-makers: i.e., Cyril being infected by A-hepatitis and Cyril being infected by B-hepatitis. But this lack of specificity of the atomic statement "Cyril has hepatitis" is definitely not something which can be discovered by examining the entailment relations between sentences along Ayer's lines. It is, on the contrary, a pure matter of empirical research. The complex fact that poor Cyril has been infected by the two kinds of hepatitis at the same time is something which could be expressed by a conjunctive statement but which cannot be extracted from the logical form of the initial atomic statement: "Cyril has hepatitis". To express Cyril's physical condition we shall have to split the statement "Cyril has hepatitis" into "Cyril has A-hepatitis and B-hepatitis" under the pressure of the facts. To say that our initial statement was covertly ambiguous in three ways would clearly be sophistical.

Ayer recognizes that language shapes facts: ". . . the content and structure of the facts is determined by the content and structure of the propositions which they verify" (1967, 92), but he also admits that facts shape language: ". . . we can raise the question whether one conceptual system is not more adequate than another. . . . We may be able to show that one system is richer than another, or that in certain respects it permits us to discriminate more finely" (Ayer 1967, 92).

To refute Chappell's objection, however, one should stress the *dialectical* character of the interplay between language and (empirical) facts. The question "does fact come first or language come first?" should be given the same answer as the question "does theory or observation come first?". Gonseth's reply was: neither. We go back and forth from the one

to the other (See his theory of the '*doctrine préalable*' [Gochet, 1986b]). Ayer's views on the subject are congenial to Gonseth's (See: Ayer 1984, 136, 137).

Up to now we have shown that one can make sense of the concept of fact if the concept is essential for working out a version of the correspondence theory of truth which is immune to the objection of circularity. We have not yet established, however, whether such a theory is needed at all. In order to do so, we shall examine Ayer's alternative, the redundancy theory of truth, and show that it cannot be made to work unless we covertly assume something like the correspondence theory of truth. The redundancy theory invented by Ramsey was considerably improved by Ayer. Thanks to his refinements it can withstand objections which were fatal to the earlier version. If I am right, the redundancy theory illuminates some aspects of the use of the predicate "true" but it cannot be regarded as a substitute for the correspondence theory of truth.

From 1936 onwards, Ayer subscribed to the redundancy theory. Having observed that "When, . . . one says, that the proposition 'Queen Anne is dead' is true, all that one is saying is that Queen Anne is dead" (Ayer 1936, 117, 18), he concluded that "the terms 'true' and 'false' connote nothing, but function in the sentence simply as marks of assertion and denial" (Ayer 1936, 118). And he adds that we should not be misled by the "sentence whose grammatical forms suggest that the word 'true' does stand for a genuine quality or relation" (Ayer 1936, 118).

In his later essay on Truth, Ayer restated his early position and came to grips with the more serious objections raised against it. Some philosophers had argued that the redundancy theory fails to account for the cases where 'true' and 'false' "do appear to function as predicates" (Ayer 1963, 165). For instance, if I say "I forget what I told you, but I know that I would not lie to you: so whatever I said, I am sure that it was true", I am not repeating or reaffirming my statement, since I have forgotten it. But even in this case, the redundancy theory can be upheld: "What happens . . . is that one makes what could technically be called a variable assertion. The use of the expression 'is true' in conjunction with a descriptive phrase [here 'what I told you'] is a way of according one's assent to any statement which satisfies the description" (Ayer 1963, 166). If a statement satisfies the description to which I ascribe the predicate 'true' or 'false', then I am implicitly asserting, or denying it, . . . even though I may not know what the statement is. . . . Even when they do function as predicates, "the rôle which these terms ["true", "false"] essentially fulfil is that of assertion or negation signs" (Ayer 1963, 166).

Ayer says that the predicate "true" and the predicate "false" are *used* as assertion and denial signs respectively. The question arises, however,

as to whether one could go one step further and claim that the notion of truth could be *defined* in terms of assertion, and that of falsity in terms of denial, or more precisely in terms of the speech acts of asserting and denying.

Holdcroft discussed this question: "*Prima facie* the two concepts [assertion and truth] are much too closely linked for this to be possible, since to assert that p is to assert that p is true" (Holdcroft 1978, 11). If we adopt Dummett's theory of assertion and regard the latter as a speech act which has to obey the convention of truth telling, "it is clearly not possible . . . to produce a classical analysis in which the *definiendum* is the notion of truth and the *definiens* involves that of assertion" (Holdcroft 1978, 11, 12).

Searle also appeals to the notions of truth and correspondence (matching) in his account of the speech act of assertion: "The members of the assertive class of speech acts—statements, descriptions, assertions, etc.—are supposed in some way to match an independently existing world; and to the extent that they do or fail to do that we say they are true or false" (Searle 1983, 7).

If we regard assertion as the expression of a belief and if belief can be explained without reference to truth, "then", Holdcroft writes, "it might very well be possible to explain truth non-circularly in terms of assertion" (Holdcroft 1978, 12). Holdcroft himself denies that the condition is fulfilled: we cannot suppose "a creature to have a concept of belief (as well as particular beliefs), who does not have a concept of truth" (Holdcroft 1978, 12). Admittedly, Ayer has offered a behaviourist account of belief which is independent of the concept of truth: "*A* believes that *p* if and only if *A* is disposed to behave in a way that is appropriate if and only if" (Ayer 1967, 45). Unfortunately this account seems to be open to a decisive objection from Church (Church 1958, 77–81).

While the concept of truth cannot be *defined* in terms of assertion it can be *illuminated* by a careful study of assertion. An elaborate study of this speech act has recently been offered by Searle and Van der Veken. They subsumed assertion under the Austinian notion of illocutionary acts. These acts have a point. The "point" of the illocutionary act of assertion is given by the following definition in extension: "The *assertive* point is to say how things are. More cumbersomely but more accurately: in utterances with the assertive point the speaker presents a proposition as representing an actual state of affairs in the world of utterance" (Searle and Van der Veken 1985, 37).

The old ontological notion of state of affairs crops up once again. What is new with regard to the standard correspondence theory of truth

is the shift from the notion of a sentence *corresponding* to the facts to the notion of a sentence *representing* the facts. The two relations are obviously different. The former is symmetric, the latter is not. The distinction between the two is not that correspondence is iconic and that representation is not—both can be either—but that representing is an *action* accomplished with a purpose whereas corresponding is a *state*. In other words, "to represent" is a verb of action, "to correspond" is a state verb.

The communicative purpose of representing is often that of indicating to a receiver something which the speaker knows or perceives but which the hearer does not know or perceive. I may assert that I am wounded for the purpose of conveying a piece of information which one would not get simply by looking at me. Attal adds: "there is no fundamental difference between pointing with one's finger to a piece of reality and making the statement which corresponds to this reality through linguistic conventions" (Attal 1976, 10). It is worth noting that Attal resorts to the notion of correspondence to give an account of assertion. We shall try later on to offer an answer to these two questions. Let us now return to Ayer's conflation of the theory of meaning and the theory of truth. By unravelling the two issues, we shall find a way of dissipating the obscurity which mars Attal's insight.

According to Ayer we do not need a *separate* theory of truth to explain how we compare statements with facts. The theory of meaning already does that for us: "If one understands a sentence, then one already knows how to compare it, or the statement which it expresses, with a fact" (Ayer 1963, 185). How do I compare the English sentence "It is a fine day" with the facts? Ayer replies that ". . . My understanding the sentence, my attaching the right meaning to it, the meaning that it conventionally has in English, just *is* among other things my being willing to accept or reject it in these various conditions" (Ayer 1963, 186) and he concludes ". . . there is no separate problem of truth" (187).

I shall question this statement and argue that although there is no truth without meaning, there can be meaning without truth. My starting point will be a passage from Waismann's posthumous book in which he neatly distinguishes linguistic mistakes from factual mistakes. Waismann describes two games (a) and (b): (a) "In the room where A sits there is a lamp which lights up red or green at irregular intervals. A is to watch the lamp and say which colour he sees" (Waismann 1965, 286). We have here an exercise in the application of colour names. The subject who errs here can only make a linguistic error. (b) "The antithesis could occur in a game in which A is to guess which colour will come next" (Waismann 1965, 286). Here the subject can make a factual error.

Let us now complicate Waismann's game a little bit by giving the player of the second game the possibility of correcting himself when he has made a wrong guess and to repeat himself when he has made a right one. Suppose he guesses red and the green light lights up. If he repeats "red", we shall be inclined to say that he made a good guess but misdescribed it by using the colour word in a linguistically incorrect way. If he says "green", we shall be inclined to say that he had made a good guess and that he uses the English language correctly. Other interpretations are possible but less plausible. This last game reveals that we need to dissociate factual mistakes from semantic ones and correlatively to dissociate the problem of truth from the problem of meaning.

Think also of the doctor who tells his blind patient waiting outside that the door to his office *is* on the left. Two distinct misuses of "is" are possible: a *factual* misuse which occurs if the doctor is ill-informed about the topography of his house and a *linguistic* misuse if—a very unlikely possibility—he attaches to "is" the meaning normally attached to "is not" and vice versa. That these two mistakes can occur at the same time and can cancel one another out clearly shows that they have to be distinguished.

Most of the time, the assertion game of language is not used to *describe* a perceptible event which both the hearer and the speaker are contemplating, but rather to *inform* the hearer about something which the speaker knows but which the listener does not know. This is implicit in the Maxims of Conversation spelt out by Grice: "Make your contribution as informative as is required. . . . Do not say what you believe is false, do not say that for which you lack adequate evidence" (Grice 1975, 45–46). That the hearer b_i "does not know that P at time t_i in w" (Searle and Van der Veken 1985, 66) is also part of the special "preparatory conditions" of the speech act of informing.

As a first step towards a defence of the correspondence theory of truth, we have to consider two objections recently raised about the very notion of fact and about the correspondence theory of truth underlying Tarski's T schema. Davidson claims that as soon as one tries to identify facts without resorting to the *contour* given to facts by sentences, one is led to an unforeseen conclusion: there is only one fact left, the great fact, to which all true sentences correspond. This conclusion is clearly untenable. The great fact to which all sentences are supposed to correspond cannot be distinguished from the truth value Truth. Once again the difference between truth and fact collapses.

Davidson's argument, which Barwise and Perry called the "slingshot argument," runs as follows: "The statement that Naples is farther north

than Red Bluff corresponds to the fact that Naples is farther north than Red Bluff, but also, it would seem, to the fact that Red Bluff is farther south than Naples (perhaps they are the same fact). Also to the fact that Red Bluff is farther south than the largest Italian city within thirty miles of Ischia. When we reflect that Naples is the city that satisfies the following description: it is the largest city within thirty miles of Ischia, and such that London is in England, then we begin to suspect that if a statement corresponds to one fact, it corresponds to all" (Davidson 1985a, 41–42). Whoever is willing to defend the correspondence theory of truth has to face this objection.

An analogous problem to the one diagnosed by Davidson arises in connection with Tarski's T schema and shows that any attempt to extract a correspondence theory of truth from this schema is doomed to failure. As M. Devitt observes, the alleged relation to facts introduced by Tarski's schema "is an uninteresting correspondence because the sentence is just as much related to indefinitely many other 'facts'. Thus *each* truth-scheme for English assigns a 'fact' to the sentence 'snow is white'; one scheme assigns *snow is white*, another *grass is green*, another *blood is red*, and so on" (Devitt 1984, 30–31).

Colin McGinn tried to overcome this difficulty. Rejecting material equivalence as too weak a criterion of identification for facts and synonymy as too strong a criterion, he suggests "that an acceptable intermediate constraint is afforded by the condition of 'extensional isomorphism': the sentence mentioned and the sentence used in the theorems of the truth-theory [i.e. in the T-schemas] should be composed of semantic primitives bearing the same extension in the same logical structure" (Colin McGinn 1982, 233).

The criterion of extensional isomorphism used by Colin McGinn as a criterion of identification of facts has been foreshadowed by Lemmon who used a version of the former as a criterion for identifying statements (Lemmon 1966; see also Mleziva 1969). This two-fold use of the criterion reveals how difficult it is for facts to part company with statements. As it stands McGinn's criterion thwarts the slingshot argument—I myself have used the criterion for the same purpose (Gochet 1980, 141)—but it is too weak to individuate either facts or statements. To establish this point I shall have to digress a little and say a few words about identity criteria for belief contents.

Searle claims that the content of a belief as opposed to the reporting of the content of a belief is purely extensional: "The report that John believes that King Arthur killed Sir Lancelot is indeed an intensional-with-an-s report, but John's belief itself is not intensional. It is complete-

ly extensional: It is true iff there is an unique x such that $x =$ King Arthur, and there is an unique y such that $y =$ Sir Lancelot and x killed y. That is as extensional as anything can get" (Searle 1983, 24).

Searle draws a parallel between intentional states and speech acts. An intentional state, such as belief or desire has both a representative content and a psychological mode. A speech act such as statement, question, or command has both a propositional content and an illocutionary force. In view of this parallelism, Searle is committed to saying that the propositional content of an asserted statement as opposed to that of a reported statement is just as extensional as the belief content which it expresses. Searle's claim, however, is open to the following objection.

Suppose the chief of police in Brighton—I am adapting Hodges's example to my purpose—orders the policemen over whom he has authority to "arrest all the Brighton bombers". Let us suppose that the class of Brighton bombers has the same members as the class of Brighton tuba players and that Brighton policemen are maniacs who compulsively arrest anyone who plays the tuba. Moreover, Brighton policemen are quite undisciplined. They do not care one bit about arresting those whom they have been ordered to arrest. They are not even aware that the predicate "Brighton tuba player" has the same extension as "Brighton bomber". Consider now what happens if they succeed in arresting the Brighton tuba players. Shall we say that they have obeyed the order issued by the chief of police? This is counter-intuitive, but it seems that Searle is committed to saying just that.

An analogous counter-example could be given for questions. The chief of police might have simply asked his men to list the names of the Brighton bombers and have been given in return the list of Brighton tuba players who, unknown to him and to the policemen, happened to be the same people. This surely would not count as an answer. The same holds, *mutatis mutandis,* for statements. This seems to me to show that Searle's thesis cannot be defended.

Independently of Mulligan et al., Hodges also uses the useful phrase "makes true". It is in this direction that our search for a solution to the puzzle just produced should go. Clearly, in my example, it is true that the Brighton bombers have been arrested and that the Brighton tuba players have been arrested, but what *makes* it true that the Brighton bombers have been arrested is definitely not what *makes* it true that the Brighton tuba players have been arrested. Here again, what we are after, is a method allowing us to dissociate two truth-makers which are instantiated at the same time.

Considering the statement "All the Brighton bombers have been

arrested" which can be regimented in the semi-formal sentence "($\forall x$) (x is a Brighton bomber $\supset x$ has been arrested)," Hodges observes that the assignment of people or things to the variable x is not what matters. "By contrast," he writes, "the assignment of the class B to the phrase 'Brighton bombers' and of the class A to the phrase 'have been arrested' are crucial for determining whether the sentence is true or not" (Hodges 1986, 146).

One might fear that we are once again falling into the trap of the principle of extensionality (two classes are identical iff they share the same members). But what Hodges says next provides a way out: ". . . let us understand the *structure* of a time and place to be whatever features of the time and place determine whether certain sentences are true or false. Then the structure includes constant assignments to English noun and verb phrases, but not assignment to free variables" (Hodges 1986, 146).

If I understand Hodges correctly, the important word here is "constant". By "constant assignment" Hodges presumably means an assignment of extension which remains constant across language, just as the assignment of an extension to the primitive terms of an axiom system is to be kept constant across the axioms and all the theorems derived.

As Davidson pointed out (Davidson 1985, 17–36), if we want to build a theory of meaning, we have to take into account the fact that the same words recur in different phrases and sentences. There is a connection between the various contributions these recurring words make to the truth conditions of the sentences in which they occur. He mentions "good" which occurs in "is a good actress" but also in "is a good mother". If we take into account the fact that "player" occurs not only in the compound "tuba player", but also in the compound "violin player", we begin to see that the predicate "Brighton tuba player" corresponds to a different feature in the world than the predicate "Brighton bomber" even though the class of Brighton tuba players is the same class as that of Brighton bombers.

This is a familiar story, which Davidson taught us long ago. What I want to stress is the special use to which Hodges has put it. Hodges uses the constraint of constancy of predicates not to capture meaning via truth as Davidson did but to capture truth itself or truth-makers.

Admittedly, Searle also speaks of "features". He says that a belief or a statement represents their conditions of satisfaction (Searle 1983, 12) and he suggests that we should "think of conditions of satisfaction as the features of the world that satisfy or would satisfy an intentional state . . ." (Searle 1983, 24), i.e., as the features of the world which would make the intentional state true in the case in which it is a belief. What is missing in Searle's account is a way of reconciling two conflicting claims:

the claim that beliefs represent *features* of the world and the claim that beliefs and the statements which express them are *extensional*. Hodges provides the missing link and removes the risk of inconsistency by ascribing to the predicate the role of standing for *recurrent* features. He thus parts company both with those who ascribe predicates the role of referring to classes ("Fido"-Fido theory) and with those who shy away from naive Platonism and say that predicates are satisfied by—or related by multiple denotation to—the individuals of which they are predicated.

S. Haack brought out that "Tarski's definition of satisfaction, if not of truth, bears some analogy to correspondence theories: the clauses for atomic open sentences to Austin's, the clauses for molecular open sentences to Russell's and Wittgenstein's version" (Haack 1978, 114). In the spirit of Logical Atomism, one could go further and argue that the arrangement of individual variables in n-place predicates corresponds to the arrangement of the n-first individuals of the sequences which satisfy them. I shall go one step further again and say that the recurrence of predicates corresponds to a recurrence of features in the outside world.

One could object that the recurrence of the predicate in the above-mentioned example is nothing but an *accidental* feature of linguistic notation. The sentence "Tuba players have been arrested and violin players have been arrested" is logically equivalent to "Tuba or violin players have been arrested" in which the predicate "have been arrested" occurs only once.

I would reply that the latter statement, though logically equivalent to the former, is *less perspicuous* and *less primitive* in so far as it contains the connective "or". The initial statement, on the contrary, can be seen as a sequence of *elementary* statements. The connective "and" which joins them together causes no serious problem since it can be dropped and replaced by a comma without loss of information.

My opponent might retort that the conditional sign in the sentence "$(\forall x)$ (x is a Brighton bomber \supset x has been arrested)" fares no better than the connective "or". I would reply that the conditional is more a copula than a connective here. By this I mean that the conditional, the recurrent individual variable and the quantifier together make up the mechanism of predication. This matches Quine's contention that the positing of enduring individual objects through bound variables is a device for "tightening" the antecedent and the consequent which "were too loosely connected by the mere truth-functional" (Quine 1985).

The view defended here bears some resemblance to Küng's version of the correspondence theory of meaning. According to this theory, the recurrence of the singular term "Albert", in, e.g. "Albert is intelligent and Albert is touchy" indicates numerical identity, whereas the recur-

rence of the predicate "intelligent" in "Albert is intelligent and Bruno is intelligent" expresses the qualitative equality holding between Albert's intelligence and Bruno's intelligence. The latter are independent of one another: ". . . there are happenings which affect the intelligence of Albert but not the intelligence of Bruno, and vice versa" (Küng 1967, 166).

Küng's appeal to concrete properties, which play the role of Hodges's features, fills a gap in Tarski's account. It explains why a predicate is satisfied by such and such a sequence and not by others. But something is still missing in Küng's theory. Küng nicely explains the semantic contribution of singular terms and general terms, but fails to give an account of what is expressed by the very act of *combining* singular terms (bound variables or constants) with general terms into closed sentences. Here Tarski takes us further than Küng. He tells us that closed sentences are satisfied by all sequences of individuals if they are true and by none if they are false.

Tarski's account implies that the combination of "Snow" with "is white" does not have the same effect as the combination of "Snow" with "is green". In the first case, the combination results in a sentence satisfied by all sequences, in the second it results in a sentence satisfied by none. No equivocation on the role of combination of general terms with singular terms—or on the meaning of the copula "is"—is involved here. We are faced with the familiar case of an operation delivering different values for different arguments.

Tarski's account of the semantic role of predication viewed as the combination of general terms with singular terms fails, however, to do justice to the following asymmetry: satisfaction by all sequences, i.e., truth, is something to which we aspire, satisfaction by no sequence, i.e., falsity, is not. A complete account of truth should mention that the verb "is" is correctly used in "Snow is white", whereas it is *misused* in "Snow is green".

This possibility of factual misuse is built into language. It is part and parcel of the assertive game. It is the price we have to pay to be able to communicate and receive information about which we have only incomplete evidence. To study this mechanism we have to go beyond semantics, i.e., to move up to the level of communication theory. As long as we remain within the confines of semantics, we are incapable of describing this machinery. At this level, there is no separate problem of truth.

To sum up my position, I claim that Ayer has vindicated Ramsey's redundancy theory. The latter theory is needed to answer the question formulated in the formal mode of speech "under what conditions can we *say* 'the sentence x is true'?". The correspondence theory fulfils another task. It answers the question formulated in the material mode of speech

"under what conditions is it the case that *p*?". The correspondence theory explains what it is for a sentence to *be* true as opposed to being *said* to be true. Admittedly the correspondence theory I defended is mainly a *correspondence theory of meaning* which has been extended to cover predication, but it becomes a *correspondence theory of truth* as soon as the notion of factual as opposed to linguistic misuse of the copula is brought to bear on the matter.

I borrowed the notion of features from Hodges. Ayer, however, addressed a warning to those who make use of the terms "properties" and "attributes", and no doubt this warning applies to features too: "There is no reason indeed why we should not draw on all these forms of vocabulary but it is neither necessary nor profitable to reify all the entities which figure in them" (Ayer 1969, 201).

The version of the correspondence theory defended here does not reify features. It does not require that features exist independently of the individual in which they are instantiated nor does it require that features that we perceive be independent of our perceptual apparatus, i.e., of the innate sense of similarity, to use Quine's word. The latter can, by the way, help solve Goodman's puzzle of imperfect community (Panaccio 1989). I do not dispute the fact that at a more advanced level, features cease to be perceived and are discovered indirectly through theoretical construction. The correspondence theory I advocate does not commit me to naive realism.

<div align="right">PAUL GOCHET</div>

SEMINARY OF LOGIC AND EPISTEMOLOGY
UNIVERSITY OF LIÈGE
FEBRUARY 1987

REFERENCES

Attal, P. 1976. "L'acte d'assertion". *Semantikos* 1, no. 3, pp. 1–12.
Ayer, A.J. 1935. "The Criterion of Truth". *Analysis* 3, no. 1–2, pp. 28–32.
_____. 1937. "Verification and Experience". *Proceedings of the Aristotelian Society, 1936–1937*, pp. 137–55.
_____. 1940. *The Foundations of Empirical Knowledge*. London: Macmillan.
_____. 1963. "Truth". *Revue Internationale de Philosophie*, 1953. Reprinted in *The Concept of a Person and Other Essays*. London: Macmillan, pp. 162–87.
_____. 1967. *Metaphysics and Common Sense*. London: Macmillan.
_____. 1968. *The Origins of Pragmatism*. London: Macmillan.
_____. 1984. *The Central Questions of Philosophy*. New York: Penguin Books (1st ed. 1973).

Barwise, J. and J. Perry. 1981. "Semantic Innocence and Uncompromising Situations". *Midwest Studies in Philosophy VI, 1981*, ed. P. French, Th. E. Uehling and H.K. Wettstein, pp. 387–403.

Chappell, V.C. 1968. Review of A.J. Ayer, *The Concept of a Person and Other Essays*. *Philosophical Review* 77, pp. 235–42.

Church, A. 1958. "The Criterion of Ontological Commitment". *Journal of Philosophy* 55, pp. 1008–1014.

Davidson, D. 1985a. "True to Facts". *Journal of Philosophy*, 1969. Reprinted in *Truth and Interpretation*. Oxford: Blackwell, pp. 37–54.

———. 1985b. "Truth and Meaning". *Synthese*, 1967. Reprinted in *Truth and Interpretation*. Oxford: Blackwell, pp. 17–36.

Devitt, M. 1984. *Realism and Truth*. Oxford: Blackwell.

Gochet, P. 1980. *Outline of a Nominalist Theory of Propositions*. Dordrecht: Reidel.

———. 1986a. *Ascent to Truth*. Munich: Philosophia Verlag.

———. 1986b. "Les contributions de Guy Hirsch à la philosophie des sciences". *Bulletin de la Société Mathématique de Belgique*, pp. 9–32.

Gonseth, F. 1972. *Time and Method*. Springfield: Charles Thomas.

Grice, P. 1975. "Logic and Conversation". *Speech Acts. Syntax and Semantics*, Vol. 3, ed. P. Cole and J.L. Morgan. London: Academic Press, pp. 41–58.

Haack, S. 1978. *Philosophy of Logics*. Cambridge University Press.

Hodges, W. 1986. "Truth in a Structure". *Proceedings of the Aristotelian Society, 1985-1986*, pp. 135–59.

Holdcroft, D. 1978. *Words and Deeds*. Oxford: Clarendon Press.

Husserl, E. 1950. *Idées directrices pour une phénoménologie*. Trans. P. Ricoeur. Paris: Gallimard.

Konolige, K. 1985. "Belief and Incompleteness". In *Formal Theories of the Commonsense World*, ed. J.R. Hobbs and R.C. Moore. Norwood, N.J.: Ablex Publishing Co., pp. 359–403.

Lemmon, E.J. 1966. "Sentences, Statements and Propositions". *British Analytical Philosophy*, ed. B. Williams and A. Montefiore. London: Routledge and Kegan Paul.

McGinn, C. 1982. "The Structure of Content". *Thought and Object*. Oxford: Clarendon Press, pp. 207–58.

Mleziva, M. 1969. "Problema fakt U logicke Semantice". *Teorie a Metoda*. Prague.

Mulligan, K., P. Simons, B. Smith. 1984. "Truth-Makers". *Philosophy and Phenomenological Research* XLIV, no. 3, pp. 287–321.

Panaccio, C. 1989. "La question du Nominalisme". *Encyclopédie philosophique*, Tome I. Presses Universitaires de France. Forthcoming.

Perry, J., see J. Barwise.

Quine, W.V.O. 1985. *Meaning, Truth and Reference*. Unpublished.

Searle, J. 1983. *Intentionality*. Cambridge University Press.

Searle, J. and D. Van der Veken. 1985. *Foundations of Illocutionary Logic*. Cambridge University Press.

Simons, P., see K. Mulligan.

Smith, B., see K. Mulligan.

Waismann, F. 1965. *The Principles of Linguistic Philosophy*, ed. H.R. Harré. London: Macmillan.

REPLY TO PAUL GOCHET

I find Professor Gochet's paper both very interesting and rather difficult. Let me begin with the points on which we are in agreement. He accepts my arguments which seek to show that the coherence theory is not a tenable theory of truth. He also agrees with me that the pragmatic substitution of 'it is firmly believed that p' for 'it is true that p' leads to a vicious infinite regress in a way that Tarski's convention does not. However, he overlooks C.S. Peirce's opinion that the concept of truth acquires significance only through its association with belief. Peirce's argument was that taking a proposition to be true is equivalent to believing it. This is, indeed, the case with regard to one's own current beliefs. Nevertheless the proof that there is no general equivalence in this case is that one often looks upon the beliefs of other persons or one's own past beliefs as being false. Peirce was too good a philosopher to fall into this trap. Like all pragmatists, he started by putting himself into the position of an enquirer and the question which he asked was not What is truth? but What is true? and then it is plausible to equate this with the question What am I to believe? The trouble with this, however, is that it is not always in one's interest to accept the evidence which favours a particular belief. I doubt if it is possible simply to decide to give up a belief because it is unpalatable; but if one's motives for discarding the belief are strong enough one may be able to bring oneself to disregard the evidence on which it depends. One may indeed rephrase Peirce's question, in the way that Dewey did, as What am I warranted in believing? but this still carries the implication that in assessing the warrant only evidential factors count. Consequently, there still remains a covert reference to truth. What does emerge from pragmatism is that the notion of objective truth is of no interest to us except as a target for belief.

Gochet's attitude to what he calls the redundancy theory of truth

appears to be ambivalent. In his opening paragraph he says that he proposes to show that this theory 'cannot be made to work unless some elements of the correspondence theory are retained'. On the other hand, when he sums up his position towards the end of his essay he claims that I have vindicated Ramsey's redundancy theory. As it turns out, Gochet is guilty of nothing worse than overstating his case against the theory in his opening paragraph. He should have said not that it could not be made to work but only that it was insufficient. For his view is that it does work as an answer to the question 'Under what conditions can we say "the sentence x is true"?', whereas the correspondence theory explains what it is for a sentence to *be* true as opposed to being *said* to be true. It should, perhaps, be remarked that Gochet's assessment of the redundancy theory is badly formulated since one can presumably *say* that a given sentence is true whenever one pleases. I take it that what he means is that the redundancy theory gives a correct account of what we are doing when we say that a sentence is true. We are, implicitly or explicitly, asserting it.

I originally followed Ramsey in thinking that the words 'true' and 'false' were straightforwardly redundant, inasmuch as they could easily be eliminated. I now see that this is not so easy as I formerly thought. There is, indeed, no problem when the sentence to which truth or falsehood is ascribed is actually mentioned. 'It is true that Queen Anne is dead' tells us no more or less than that Queen Anne is dead; 'It is false that Queen Anne is dead' no more or less than that she is not dead. The trouble arises only when the sentence to which or the negation of which we implicitly assert is only described. Consider the sentence 'Everything that he told you is true'. Ramsey proposed to translate this into 'For all p, if he asserted "p" to you, then p', but this formula is defective, since the variable does not cover the expression between quotation marks. What is needed is something like 'For all s and p, if p is a proposition and s denotes p, and s was what he told you, then p'. I follow Ramsey here in taking sentences to be the vehicles and propositions the contents of assertions. If propositions, for the reasons which Gochet quotes me as having given, are regarded as causing more trouble than they are worth, the formula can easily be adapted to the ascription of truth to sentences. As it happens I still find it convenient to talk of propositions, having anticipated Gochet's proposals to treat them as classes of equivalent sentences. I realize that this exposes me to Quine's objections to the use of the concept of synonymity, but I have yet to be convinced that they are decisive.

What emerges from this discussion, if anything like my formula is defensible, is that the redundancy theory, in so far as it does not merely describe a functioning of the truth predicate, but affords a means of

eliminating it, is surprisingly on a par with Tarski's convention T. In both cases the problem is to give a satisfactory account of meaning, or at the very least of denotation. Putting it in Tarski's terms, the only difference is that in my formula it is stated that the expression which is mentioned names the sentence which is used. In Tarski's convention this is presupposed. It needs to be presupposed because, as many critics have pointed out, the relation of material implication is too weak for Tarski's purpose. I agree with Gochet's criticisms of McGinn's proposal to substitute a relation of extensional isomorphism, in this context, though if Gochet is right in thinking, as it seems to me that he is, that it blocks Davidson's 'slingshot argument', it does perform a very valuable service.

Gochet reproaches me for using the same arguments to attack the pictorial theory of meaning and the correspondence theory of truth. If he thinks it absurd that one and the same bullet should hit different targets, he should read the report of the Warren Committee on the assassination of President Kennedy. Not that I am unsceptical of the report, but it does set out a possibility. However, that is by the way. What I find strange is that Gochet almost immediately withdraws his charge. He fully understands why I hold that the two theories stand or fall together, actually quoting the passage in which I explain how 'a defective theory of meaning is turned into a defective theory of truth.'

Does it follow that I was right in accepting Ramsey's conclusion that once the concept of assertion is clarified, an undertaking which chiefly consists in giving a satisfactory account of meaning, no separate problem of truth remains? Yes, inasmuch as we are confronted only with a single problem. To understand the meaning of an indicative sentence, used assertorically, is to know what are its truth-conditions, or, if one prefers to put it a different way, the truth-conditions of what the sentence is used to express. At this point one can go either way. One can capture the truth-conditions by making it clear exactly what the sentence is used to assert, or one can pin down the assertion by minutely specifying the truth-conditions. In the second case, one will, indeed, be stating what makes the assertion, or what the sentence expresses, true.

It is no objection to this, as Gochet claims, that there is a difference between semantic and factual mistakes. If someone is imperfectly acquainted with the French language he may use a French sentence to assert something different from what a competent French speaker would understand by it. Consequently, the correct answers to the questions What assertion did the speaker intend to make? and What assertion did he make?, if his words are given their standard interpretation, will themselves be different. Even so, in both cases, the answers can be viewed as stating truth-conditions.

While we are on the subject, I should add that I take exception to Gochet's saying that 'the verb "is" is correctly used in "Snow is white" whereas it is *misused* in "Snow is green".' He goes on to explain that what he has in mind is a factual rather than a semantic error, so that it is at best highly misleading to speak in such an instance of there being any misuse of *language* at all. Moreover there seems to be no reason to pick on the copula rather than on the word 'snow' or 'green'. Indeed, one might go further and maintain that it is the one element in the sentence that is not being misused. It is performing its proper function of conjoining the designations of two features of the world. What is amiss is that the two features do not actually go together. Putting it in this way enables me to see that Gochet is fastening on to the mistake of conjoining two signs in language the designations of which are not conjoined in fact, but his suggestion that a mistake of this kind is even quasi-linguistic seems to me unfortunate. His statement that 'the possibility of factual misuse is built into language' is surely a curious way of formulating the platitude that sentences can be used to assert what is false.

The fact that a sentence, to adopt Tarski's usage, is made true by the fulfilment of its truth-conditions, is hardly enough to sustain a correspondence theory of truth, if only because different sentences have different truth-conditions. I think that the term 'correspondence' should anyhow be avoided because of its pictorial association, but since it has gained currency as applying to any theory which accounts for the truth of sentences in terms of the states of affairs that make them true, I shall not press this objection. It remains the case that if we are to be justified in speaking of a correspondence theory, we have to be able to give a general account of these states of affairs. Following Gochet's example, and anyhow not wishing at this point to embark on a discussion of logic or an assessment of the analytic-synthetic distinction, I shall confine myself to sentences which express what I was brought up to call empirical propositions. Is it possible to formulate anything that is not a wholly trivial theory of their truth-conditions?

I think that it may be, but only at a price that most realists would not be prepared to pay. We shall need to hold that the truth-conditions of even the most abstract scientific theories consist in the presence of certain 'features' at such and such spatio-temporal positions. For my own part, I should want to add the requirement that these features be of an observable sort, but I do not append this as a restriction on theories of truth. I also agree with G.E. Moore's too little known exposition of a correspondence theory, in his reply to Ramsey's more famous essay on 'Facts and Propositions',[1] in requiring that the description of these features be as specific as the language in question permits, without,

however, accepting Moore's conjecture that what he terms the non-general facts which fulfil the function of being the bedrock makers of truth may not be expressible in language. The difficulty, as I see it, is to give an adequate definition of specificity. My own attempt, which Gochet quotes, seems to me to suffer from its reliance on the undefined concept of a 'simple' sentence. Gochet seems to have been aware of this defect, but I have failed to understand how he proposes to remedy it.

As for Chappell's criticism, I now think that the circle is unavoidable but agree this time with Gochet that it need not be regarded as vicious. Obviously, we have to use statements in order to say what the statements are the fulfilment of whose truth-conditions render them makers of truth. The point of the exercise, if there is one, lies in the selection of the statements that perform this office. I see no harm either in my having said that actual observation of what is asserted is a way of escape from the circle. What I overlooked was that if one avoids tying verification to the identity of the observer and the position which he occupies in space and time, the number of relevant observations which he will in fact be able to carry out will be relatively small.

What then does the correspondence theory amount to? According to Gochet, it supplements the redundancy theory by explaining what it is for a sentence to be true, instead of being content to give an account of what it is for a sentence to have truth attributed to it. Clearly, the two questions are different, but if the difference consists in no more than that the first is answered in any particular case by making the assertion which figures in the second, the correspondence theory either lacks the generality which Gochet claims for it, or turns out to be trivial, telling us no more than that what makes a sentence true is that what it is used to assert is so. I have argued that the theory would acquire more interest if it were legitimate to pick out a special class of assertion as 'presenting' those states of affairs which are truth-makers, and have indeed suggested what they might be. However, not only is my suggestion open to dispute, but it still may be accused of begging the question; for it has to be presumed that the privileged states of affairs actually obtain.

<div align="right">A.J.A</div>

NOTE

1. *Vide Supplementary Proceedings of the Aristotelian Society, 1927.*

8

Martin Hollis

MAN AS A SUBJECT FOR SOCIAL SCIENCE

In the introduction to *A Treatise of Human Nature* Hume set out his ambitions for a science of man. All sciences have a relation to human nature, he said, because 'they lie under the cognisance of men, and are judged by their powers of faculties'. This relation is evident for sciences like Logic, Morals, Criticism, and Politics. It is less plain but just as important for Mathematics, Natural Philosophy, and Natural Religion. 'In pretending, therefore, to explain the principles of human nature, we in effect propose a complete system of the sciences'. The method to follow would be the one which had served the natural sciences so notably. This, Hume believed, was to begin with 'experience and observation' and thence advance to universal generalisations which explained 'all effects from the simplest and fewest causes'. His recommended strategy was to observe 'men's behaviour in company, in affairs and in their pleasures'. Explanation was to be in accordance with his analysis of causation as (principally) regular sequence in given conditions.

That is a grand challenge and a clear way to tackle it. Yet the science of man has neither caught the others up nor ushered in a complete system of the sciences. It has yielded neither theories of commanding power, like Relativity, nor discoveries, like the steam engine, light bulb, laser, or nuclear fission, which brook no argument about their genuineness. Twenty years ago A.J. Ayer cast a quizzical, Humean eye over this discrepancy. The result was a marvellous essay, "Man as a Subject for Science", the Auguste Comte memorial lecture for 1964.[1] Since it arrested my attention at the time and has stayed at my elbow since, I am glad of this chance to come to terms with it. Although it has been almost his only direct foray into the social sciences, its message is continuous

with his work on other fronts and has been reaffirmed very recently in his introduction to J.S. Mill's *A System of Logic: Book VI* (Duckworth, 1986). So I am not conjuring my topic out of thin air, so to speak. Meanwhile it is a pleasure to record my large debt to a thinker, whose elegance is a delight, and to an inspiring teacher, whose virtues stay green in my memory. He would not wish for servile applause, however, and I do not intend to offer it.

The social sciences do, of course, have large achievements. There are grand theories, like Talcott Parsons's, as bold as Newton's, influential sources of policy, like Keynes's ideas on unemployment, and practical results, like effective welfare systems. But nothing is definitive. For every theory there seems to be an equal and opposite theory, with no practical results as indisputably illuminating as, for instance, the light bulb. The broad picture is one of contested concepts, partial explanations, and contentious social recipes. Hume's descendants are naturally disappointed. Yet it cannot be said that social scientists of Humean persuasion —associationists, utilitarians, or Positive economists, for example— have fared notably better than Marxians, Durkheimians, Freudians, or others who would quarrel with Hume. Whereas the *Treatise* bids us work from the individual agent, from the mind and from observed regularities, there remains an opposing case for looking to the group, to the rules of social life or to underlying structures and forces which shape the social world.

Such large and cloudy issues need a sharp focus. Ayer provides one by taking the question which most concerned British philosophers at the time of writing and by stating a neat, sharp-edged Humean case for applying his general empiricism to social life. The question is whether motives for action are causes of action. Here is his agenda for dealing with it:

> Exactly how do explanations in terms of purpose operate and in what way are they explanatory? In particular how do they significantly differ from explanations in terms of causal laws? What kind of understanding of an action do we acquire when we are able to fit it into social context, or see it as fulfilling a social norm? In what sense, again, is this an explanation of the action? And finally, even if a reason can be found for saying that explanations of these types are not, or not wholly, scientific, does it follow that the actions which they explain cannot also be explained in a way which does conform to the scientific model? Assuming that we do have to deal here with two or more radically different sorts of explanations, are we bound to conclude that they are mutually exclusive?

In what follows I shall work briskly through his own answers and then stand back in order to raise what is sometimes called the problem of *verstehen*. That is the philosophically charged question of whether social

action is different enough from the behaviour of natural objects to require a method of understanding (*verstehen*) distinct from that of explaining (*erklären*), which suffices for natural science. In effect, Ayer allows a certain amount of *verstehen* as a short cut or heuristic device but insists that warranted explanation can only be in a Humean, causal mode. In disputing this, I shall be encouraged by the thought that his essay certainly raises one puzzle larger than any it settles. If a Humean approach is commandingly right, why has it not achieved enough to make Ayer's defense of it unnecessary? Twenty years on, this puzzle remains just as tantalising.

The positive theme of "Man as a Subject for Science" is one connecting action, human nature, explanation, and the character of science. Action is behaviour caused by desire and belief, with desire supplying the motor. To explain action, we must first interpret the behaviour by reference to its goal and then account for the agent's choice of means to the goal. The account will involve specific occasioning elements but will also rely on explicit or implicit generalisations. That is the proper form of all scientific explanation and hence what it means to make man a subject for science. But such a science is not aggressively deterministic and human beings emerge, in Humean compatibilist spirit, as free agents, capable of conscious, civilised behaviour, when they understand themselves. That is the broad message, which takes shape as doubts are raised and rejected.

How do explanations in terms of purpose operate? Ayer has no truck with the idea that human teleology is peculiar because 'motives operate *a fronte*, whereas causes operate *a tergo*'. Clearly the explanation of why someone embarked on an action does not require that the goal be achieved. Since a goal-state which does not occur cannot be a determinant, it must be the desire for the goal which motivates. But desires operate *a tergo*. Yet this need not be to think of desires as distinct states or impulses which act as propellants, rather as when one billiard ball knocks another forward. Often enough what is identified as a motivating desire is simply a feature of the description of the action, which licences the interpretation of the behaviour as the specific action in question.

I find two points to pause for in this opening manoeuvre. One is the suggestion that desire operates at a level of interpretation, rather than at the level of what Hume calls 'real existences'. Despite Ayer's neat footwork, one can notice a distinction between behaviour and action. The former is a physical change in a physical world and an independent referent of our concepts in the way in which, say, planetary movements are. Action is an interpretation, a reading of what the behaviour means. It is not, for instance, the coupling of a psychological cause with a

physical effect. We have, on the one hand, a language of behaviour with physical referents and, on the other, a language of action with (presumably) the same referents but a different rhythm. That raises a question about the agent's access to his own motives, which I shall return to.

Secondly there is a point to note about Ayer's way of making desire an element in the interpretation. He does it as part of a general move to let causal explanation range not over separate events but over facts, 'where "fact" is understood in the wide sense in which time propositions of any form can be taken as expressing facts'. This involves no sacrifice, he remarks, since statements about facts can, when appropriate, still be translated into statements about events; 'it merely extends the field of causal relations a little more widely'. Here he seems to give with one hand and then take away with the other. On the one hand he comes close to making the object-level of any form of discourse mind-dependent or shot through with interpretation. In that case actions are no longer special, because *all* events or states of the world cease to be brute. On the other hand events are then restored as referents 'where it is appropriate'. What, one wonders, are the referents in other cases? A teasing question is left about the referents of true propositions concerning the agent's dispositions, beliefs, desires, and other internal paraphernalia. It will recur when we reach the fleeting remarks about physiology at the end.

At any rate, by letting causal laws range over facts Ayer clears the way for his next question, whether there really are causal laws connecting motives to actions. After some elegant discussion, he opts for the strong claim that 'whenever an agent can properly be said to have acted exclusively from a given motive, the circumstances must be such that in any situation of this kind, indispensably including the presence of such a motive, an action of this kind invariably follows'. The claim would be trivial, however, if so much were packed into the description of the circumstances that the action becomes unique. So Ayer suggests two propositions which he deems 'not quite' tautologies. One is that if a person ranks no state above state S and believes that he can bring S about only by performing action A, he will perform A, unless prevented. The other is that, if he can bring about S by performing A or A' and prefers what he expects to be the other consequences of A to those of A', then he will perform A, unless prevented. Such generalisations, he admits, have neither the precision nor the strength of those governing natural phenomena. But this is only a matter of degree. 'There is nothing about human conduct that would entitle us to conclude *a priori* that it was in any way less lawlike than any other sort of natural process'.

I am not myself persuaded that these propositions are empirical generalisations.[2] They seem to me to be implications of describing an agent as rational, in the sense of 'rational' which is standard for

micro-economics and related theories. They state conditions of application for the theory of marginal utility. If so, it is clearer simply to subsume them under the general claim that human beings are truly the rational economic agents of the micro-economic textbooks. This is not an easy claim to assess. It should definitely not be construed as a claim that everyone always act selfishly—an empirical enough proposition but a false one. But, if it is construed more blandly to mean that every agent always aims to maximise the satisfaction of his current desires in the light of his current beliefs, then it is immune to refutation, because subjective expected utilities can always be adjusted so as to preserve it. A good way to get at it, I think, is to try out an alternative. One alternative is the Wittgensteinian contention that we are rule-followers rather than utility-maximisers. Ayer next disposes of this idea.

Even granting that we do follow rules much of the time, he says, there is no threat to the scope of causal explanation. 'The only reason why it is possible to account for the performance of an action by relating it to a rule is that the recognition of the requirements of the rule is a factor in the agent's motivation'. The same applies more generally to any appeal to social context as an explanatory element. For 'the only way in which the social context enters the reckoning is through its influence on the agent'. In other words, the thesis that action is the result of desire plus belief, with desire supplying the motor, is not touched by the fact that some desires and beliefs have social causes. Indeed 'that human behaviour has a point or meaning, in this sense, is not even an argument against the materialist thesis that it is all physiologically determined'.

Here too Ayer's Humean instincts seem to me impeccable. That is just what the spirit of the *Treatise* calls for. Nonetheless I think it more disputable than he makes it look. The Wittgensteinian starting point is that an action language reduces neither to a language which recognizes psychological causes for physical behaviour nor to a language of physical behaviour alone. Ayer came within a whisker of agreeing, when letting causal explanations range over facts, and, as I noted at that stage, his reason for holding back was unclear. Perhaps the trouble lies in what might follow from this starting point. For instance Peter Winch in *The Idea of a Social Science*, published in 1959, had argued that, since the identity of an action depended on the rule it instanced, there could be no actions outside some social institution or form of life. To explain an action was to understand the institution to which it belonged. Intention, in other words, was to be identified by citing a specific rule being followed, and motive by locating the rule in its institutional set.

That appears to yield a picture of human beings as social actors who are creatures of institutions. Winch would deny it on the grounds that 'creature' is a causal notion, whereas actors are hooked up to institutions

by internal relations of meaning and not by external ones of cause and effect. But I cannot myself see that internal relations need make us any the less creatures of institutions. Does a Winchean actor have any personal space for deciding whether to follow the rules? Can roles be played with distance? If, as Winch claims, *all* meaningful behaviour is *eo ipso* rule-governed, personal space would need to be rule-governed too.This is the upshot of Winch's reading of Wittgenstein's anti-private-language argument. Conversely Ayer's reflections on Robinson Crusoe[3] (which Winch had picked out for attack) assert a robust individualism, which distances actors from institutions. This individualism also marks his portrait of agents as utility-maximisers elsewhere. Ayer has always had a traditional empiricist's strong sense that the individual is prior to the social in all matters from epistemology to ethics.

Yet one can (I hope) reject an oversocialised picture of human beings without making motives into law-governed, causal antecedents of action. The large question on the horizon is what to make of the hermeneutic or interpretative tradition, which insists on internalising social relations, in contrast to the positivist tradition (in a loose sense of 'positivist') which works with external causal relations. The guiding precept of the hermeneutic tradition is that social action can be understood only from within. But the precept is ambivalent between two claimants to be the primary methodological concept. One claimant is Meaning, and Ayer's essay gives good reason not to rely on it to ground a distinctive philosophy of social science. To put the snags summarily, if Meaning refers to the subjective meanings which individuals attach to their experiences, then it is too unsystematic to yield solid explanations without the aid of psychological (or finally perhaps physiological) laws. If Meaning refers to the intersubjective meanings embodied in social rules, then we run into the matters just discussed *à propos* of Winch. Although games, especially 'language-games', have the tempting feature that the rules are external to each player without being external to all players, to make them primary is to absorb the player into the game. Hence, prompted by Ayer, we see that we either lose the individual altogether or need a supporting Humean causal framework.

There is a second claimant, however: Rationality. If Meaning is primary, then Rationality is to be construed (as Winch does) as consistency in following rules and itself governed by rules which can vary from one 'form of life' to another. But if Rationality is primary, the emphasis shifts from the game to the player. To bring out why I do not think that Ayer disposes of this way of marking out a hermeneutic tradition, against a positivist one, here is an example from an ordinary, unmetaphorical game.

Suppose that Kasparov wins the decisive game in the next world chess championship by playing *45 P-K5*. He plays it because it uncovers a mating threat, which Karpov can block only by a move which costs him the game in some other way. This is the explanation but it does not settle the philosophical question of why the explanation explains. According to Ayer, it does so because the circumstances are such that in any situation of this kind an action of this kind invariably follows. It strikes me that this gets the order of particular and general precisely the wrong way round. Granted that Kasparov is performing an action *A*, whose outcome he ranks above all others and with no move *A'* available, whose other consequences he prefers, does the (somewhat suspect) generalisation do anything to explain *45 P-K5*? To my mind it is just a clumsy way of saying that Kasparov made a rational choice. A good reason for him to play *45 P-K5* is *eo ipso* a good reason for anyone so placed. The general does not explain the particular here; indeed, the particular reason explains why such moves are played in such situations.

On the other hand this example does support what Ayer says about the need for motivating factors to be distinct from the requirements of the rules of chess. References to kinds of situation and to kinds of action depend on (as Winch puts it) rules for sameness and difference, in the sense that *45 P-K5* is a *move*, which could equally be made with a pawn of wood or ivory, with a pencil on paper or by telex, rather than a displacement of matter. But, while that might be awkward for a behaviourist, Ayer allows for it by introducing an action language, in which it remains a *further* question why Kasparov did what the rules of chess merely make possible. In other words motive needs to be the player's own contribution and not just an extended implication of following the rules. For, as Ayer remarks, 'if the assignment of the motive did not refer to something other than the action, . . . it is hard to see how it could have any explanatory force'.

Motive thus links behaviour to 'something beyond it'. Two grand old philosophical problems now crop up. One is Other Minds, arising because motive is not written on the face of behaviour, even when the behaviour is read in an intensional language of action. The other is Free Will, arising because Ayer's actors have freedom of action in his account of social science. He tackles both, consistently with what he says elsewhere,[4] by regarding motive as primarily dispositional. This addresses the Other Minds problem by ascribing to agents an orderly character and hence a general regularity in similar conditions. It connects neatly with his compatibilist views on free will, since free actions become typically those where the agent acts in character so as to satisfy a dispositional desire.

Here I part company. Kasparov's reason for playing *45 P-K5* is not a dispositional desire. It is the tactical or strategic advantage gained by the move. Dispositions come in, if at all, only at the stage when we need to be sure that he wanted to win. Similarly, if a wife poisons her husband because of his infidelities, we may need to establish that she is of jealous disposition before being sure that his carryings on were truly her reason; but the disposition certifies an explanation rather than provides one. Furthermore character is not a stopping point, if one believes that people are responsible for their dispositions or have some choice about whether to act on them. J.S. Mill, for instance, heading off fatalists and Owenites on grounds like Ayer's, insists that we shape our own character in part—'we are exactly as capable of making our own character, *if we will*, as others are of making it for us'. (*A System of Logic IV*, chapter 2, his italics). Since freedom involves acquiring the dispositions which we would ideally wish to have, he adds, 'none but a person of confirmed virtue is completely free'.

Ayer may be reluctant to allow choice of character or choice of whether to act on it. He often uses the argument that the only alternative to causality is chance and hence that actions can be explained only if they have causes. That is why motives must be causes and why fervent believers in free will 'stand by a concept of self-determination to which no sense can be attached'.[5] But, I submit, chance is not the only alternative to the Humean causality which Ayer advocates. Granted that *45 P-K5* is played neither at random nor because some covering law holds, there is a third option in citing the agent's good reasons. One familiar version has its origin in Kant, who also provides for choice of character and for choice of whether to act on existing dispositions by assigning to agents an active power of judging the merit of reasons. Crossing from explanation to ethics, Kant would agree with Mill that none but a person of confirmed virtue is completely free; but he would insist that free action is motivated by belief and is not a matter of conforming to regularities.

I cannot argue for this third option in any depth here (although I cannot resist pointing out *ad hominem* that kleptomaniacs, whose disposition to steal is regularly instanced in action, seem to be free agents on Ayer's account, despite his claim to the contrary.) But I can use it to sharpen the questions which Ayer raises for the philosophy of social science. For Other Minds it opens the way to a method of rational reconstruction of the sort recommended by Max Weber in proposing the use of 'ideal types' of rational action or by R.G. Collingwood in *The Idea of History*. The guiding thought is that the identification and explanation of action depends on knowing what it would have been rational to do and

why. Fully rational action is its own explanation and, for the rest, the question is why the agent departed from the ideal. Ayer would object, I fancy, in parallel to what he says about rule-governed explanations, that rational reconstruction offers a merely possible motivation. To turn it into an explanation one needs to know about the agent's particular psychology. Whether the cap fits is one thing and whether the agent was actually wearing it another. That brings us to the question of where explanation stops.

In both "Man as a Subject for Science" and the Introduction to *A System of Logic: Book VI*, Ayer makes it clear that explanation by desires and purposes is second best. A truly scientific explanation of action and motive would be in terms of 'the succession of states of the central nervous system, and a set of well-supported hypotheses serving to correlate these states with states of consciousness' (Introduction). But, lacking the physiology, we do passably well with desires and purposes. This view, together with his similar reflections *à propos* of free will, yields an account of human nature and, if I may oversimplify, reveals us as complex natural animals predictable on the same basis as all others. Whatever its merits when (or if) the physiological boat comes in, I fear that it allows only an attenuated kind of social science in the meantime.

My example of the rational chess player has the snag that the rules of chess are explicit and complete, even if the rules of good chess strategy are not. The rules of social life are usually open-textured and the roles which social actors play are underdefined. The players are distanced from the game by the open and shifting character of the game itself, quite apart from the distancing involved in their own psychology. This psychology seems to me very imperfectly captured by an economic-man egoism, which makes them utility-maximisers, even in the muted version, where the good Samaritan maximises the satisfaction of his altruistic desires. Hence uncertainty in social life is more than the physicist's uncertainty about what will happen next. It is also an uncertainty about one's own reasons (both positive and normative) stemming from the obscurities of the social system and one's own psychology. The players of the social game are not transparent even to themselves.

A Humean comment on such uncertainties is that they stem from lack of information. Human beings have dispositions, natural or acquired, which prompt them to act in whatever way they calculate as likeliest to bring satisfaction. Uncertainty about what will happen next would be removed if we only had psychological generalisations about the varieties of sentiments and about the processing of information. But this seems to me to underrate the importance of decision, as opposed to prediction, in determining what happens next. If one thinks of social

roles as underscripted and of social actors as monitors of their own performances, then actions are not just the predictable inking in of a dotted line which projects from the inked line of the past. Implications are dramatic as soon as one notices that each actor's rational decisions usually depend on what he expects other actors to do. If he must allow for the underscripted character of decisions by people who are allowing for the underscripted character of his decisions, then there obtrudes a creative uncertainty quite alien to physics.

This line of thought challenges two deep assumptions of Ayer's account. One is that only desires can motivate. I suggest that 'desire' needs to be a far broader category than the Humean one of sentiment or disposition, if due influence is to be granted to the expectations (both normative and rational) which enter into decisions. For many purposes 'belief' is the more appealing label for the motivating reason. The other assumption is that any social outcome is the sum of individual decisions. Here I suggest that the direction of analysis is more puzzling. The social outcome is a joint product of decisions guided by expectations on the part of actors whose reasons belong to the joint enterprise in which they are individual participants. The circularity is deliberate—I confess to being simply puzzled about communal character of social action.

Ayer's retort will presumably be to repeat that the social fabric can bear on action only as a psychological component of the agent's preferences and information. But I think that he owes us a further move. Humean psychology, even when backed by Ayer's across-the-board empiricism, seems to me unconvincing on its own, once the social aspects of expectation obtrude. The language of action becomes too different from a language of events, even when 'events' are replaced by 'facts' as noted earlier. To preserve the Humean case, he will need to bet his shirt on a unifying physiology after all. Yet it is, as he concedes, a very distant prospect. Without it, however, I prefer to settle for what we have—explanations particular to the agents' own good reasons, agents who reflect on their own performances in the light of their expectations and historically specific contexts where history is made partly behind men's backs.

That leads me to a final remark about *verstehen* and *erklären*. Max Weber called for explanations to be adequate both at the level of meaning and at the causal level. By the latter he intended something statistical, in keeping with what he termed 'average' (as opposed to 'ideal') types, to ensure that a typical regularity was involved. Ayer's demand is similar, being also wedded to the idea that the causal level is one of regularities. Recent philosophy of science has put this idea of causal explanation in need of defence, however, although without arriving at any agreed

alternative. So the question of how to relate *verstehen* to *erklären* is much complicated by not knowing how to construe *erklären*. A unifying physiology to serve as the causal level would by-pass that difficulty by delivering the missing goods. Short of it, however, I doubt if Ayer can attach a clear and distinct sense to 'the causal level' in social science.

At the level of meaning the two most promising keys to *verstehen* are 'rule' and 'reason'. I share his grounds for distancing the agent from the rules governing social intercourse and hence his preference for an action language which assigns reasons to individuals. Also I believe that, in conceiving people as rational agents, one gains a promising *entré* to the Other Minds problem. That leaves a dispute about whether 'reasons' are to be construed on a Humean model of dispositions and utility-maximising or on a Kantian model of judgement, which I cannot pursue further here. But it allows scope to *verstehen* as a method of rational reconstruction. How deep a difference does this then set between social and natural sciences? Ayer's answer will presumably remain that a rational reconstruction is only a hypothesis, whose success depends on there being a suitable causal law to cover the case. My summarising question to him is what more we could need to know than we know already, before we can explain Kasparov's choice of a winning move.

I hope to have said enough to show why Ayer is a thought-provoking obstacle to anyone who is inclined, as I am, to take the hermeneutic tradition seriously. Yet there is still the puzzle of why the social sciences have not fared better with his own sort of account of explanation. My suggestion is that the players of the social game combine to change the rules of the game from time to time (not always consciously) and that, when the game changes, the stock of reasons for action changes too. That makes social life radically unlike a game with nature and in ways which should baffle a Humean. If so *verstehen* is more than a heuristic device. No doubt Ayer will refuse to be baffled. He can play for a draw by repeating a hedge-hog defence of causal regularity as the only alternative to chance, coupled with an act of faith in the future of physiology. But this line offers no more than a draw, in my view, through its denial of epistemological problems peculiar to the understanding of social action. Moved by warm respect for his commanding range elsewhere, I wish that he would turn his skilled hand to the social sciences more often. Perhaps he would care to open up the game and try for a win?

MARTIN HOLLIS

SCHOOL OF ECONOMIC AND SOCIAL STUDIES
UNIVERSITY OF EAST ANGLIA
APRIL 1986

NOTES

1. Reprinted in A.J. Ayer's *Metaphysics and Commonsense* (London: Macmillan, 1969), pp. 219–39.

2. Nor perhaps is Ayer himself altogether sure what they are, to judge from his essay on "The Principle of Utility" in *Philosophical Essays* (London: Macmillan, 1963), pp. 250–70, especially p. 266.

3. "Can there be a Private Language?" in *The Concept of a Person and Other Essays* (London: Macmillan, 1968), pp. 36–51.

4. E.g. in "Freedom and Necessity", in his *Philosophical Essays* (London: Macmillan, 1963), pp. 271–84.

5. Introduction to J.S. Mill's: *A System of Logic: Book VI.*

REPLY TO MARTIN HOLLIS

The title of my essay "Man as a Subject for Science", which provides Professor Hollis, whom I thank for his kind remarks about me, with nearly all the material for his criticism of my treatment of the social sciences, could lead to misunderstanding. I purloined it from Thomas Love Peacock's *Crotchet Castle*, mainly because of my admiration for the book, and as I admitted in my essay, the science to which the phrase refers was, in the context, that of anatomy. I do not suppose that Hollis is disposed to deny that human anatomy is a less suitable subject for science than any other department of biology.

A part of human anatomy is the human brain and here too I do not suppose that Hollis would wish to set anything but practical limits to the scientific exploration of the human brain, neither do I think that he would regard it as impossible that these practical limits should be overcome. On the other hand I believe that he is doubtful of the proposition, which Professor O'Connor takes for granted, that every facet of human consciousness is causally dependent upon the state of the subject's central nervous system. In my reply to O'Connor, I let his assumption of this form of determinism pass, because our common interest lay in deciding what room it left, if any, for a conception of free will. I referred only briefly to my own view that, while there is a very strong case for holding that the state of a person's central nervous system is a necessary condition for his being in any given state of consciousness, the claim that it is also a sufficient condition is more open to question. I also made the point that the thesis of determinism is vacuous, unless it is supported in every instance by an operative theory which accounts for the phenomena under consideration.

I wanted to get this question of determinism out of the way because it turns out, perhaps surprisingly, to have next to no bearing on the points

at issue between Hollis and myself. This can be illustrated by Hollis's own example of a move in a game of chess. He attributes the move to Kasparov but there is nothing in his description of the move which excludes its being made by a computer. Let us assume that it is made by a computer. In that case we are, I think, entitled to assume that the move can be accounted for in purely physical terms. I am lamentably ignorant of both the structure and functioning of computers, but I assume that the computer's repeated selection of the 'best' move among those which it surveyed in a given stretch of time would be systematically correlated with a series of its physical states. Nevertheless, if one were asked why the computer had advanced the king's pawn it would be not only laborious but perverse to couch the answer in physical terms. Assigning to the computer the 'motive' of winning the game, and assuming that it had been trained to abide by the rules of chess, one would couch one's answer in terms of the relative positions of the pieces on the board, the responses that this would leave available to the other player, the choice that it seemed most likely that he would make among them, the computer's 'best' reaction to this choice, and so on perhaps for a move or two further until one's power even of estimating probabilities gave out.

What I have just said of the computer applies equally to Kasparov. The hypothesis, about which I keep an open mind, that every move that a chess player makes could be explained, or at any rate could come to be explained, in purely physiological terms, does not even threaten, let alone invalidate an explanation which is couched in terms of a player's desire to win the game, his beliefs about his opponent's intentions, and the strategy and tactics which he accordingly pursues. Not only that, but it is only an explanation of this second type that is ever in fact available to us. In the normal conduct of our lives we are not in a position to inspect one another's brains and even if we were, we do not possess a manual for correlating patterns of neurons with particular mental phenomena. So, for the purposes of the discussion, we can leave physiology alone.

But if that is the case, what are we talking about? What was the point of the essay which Hollis is principally criticizing? The answer is that I was trying to show the two forms of explanation fitted into the same mould. In each case it was a matter of making the item to be explained the consequent, given the relevant antecedents, of a projectible generalization.

This comes out in a passage which Hollis quotes: 'Whenever an agent can properly be said to have acted exclusively from a given motive, the circumstances must be such that in any situation of this kind, including the presence of such a motive, an action of this kind invariably follows.'

I have to say that it now seems to me both that this claim is too strong and that Hollis is justified in objecting that it 'gets the order of particular and general precisely the wrong way round', at least in so far as the generalizations which I still look upon as sustaining the explanation are reached through consideration of particular circumstances. My example, to illustrate this point, is taken from the game of Association Football. Consider a striker in a situation where his operative motive is that his side should score a goal. He has to decide whether to shoot straightaway, whether to advance a little further and then shoot, whether to try to pass the ball to another member of his own side, and in that case when and to whom, whether, if he is in the penalty area, to provoke an opponent into fouling him, or causing the referee, perhaps wrongly, to adjudge that he has been fouled. A merit of this example is that the player may or may not deliberate between these alternatives, since even if his choice is immediately manifested in his behaviour, as in the case of his shooting straightaway, the two are still distinguishable.

What action the player takes will depend upon many factors, his own character, more or less typically exemplified in his current mood, the relative positions of the players involved on either side, his estimate of their speed and skill, his appreciation of the referee, the state of the game, which may make it more or less important for the fulfillment of his over-riding desire for his team to be victorious that it should then score a goal, and others that I could imagine if I wished to complicate the examples: but I judge that so far as that goes I have said enough.

Where then do the generalizations come into the picture? The answer is that the various factors owe their status to their being supported, not indeed by universal generalizations, but by generalizations of tendency. If the striker is a selfish player, or he has a special motive for adding to his personal tally of goals, then more often than not he will attempt a shot, even though one of his colleagues is better placed to score. This will be more frequently the case when his side has already done so well that his failure in this instance would not endanger its victory. If the opposing goalkeeper has shown himself to be fallible in the air, and the striker finds himself on the wing in possession of the ball, then more often than not he will try to deliver a high centre to whichever of his colleagues appears to him best placed and most capable of collecting the ball and scoring before it is intercepted. Once more I could multiply examples.

Does the fact that these actions owe their point to generalizations of tendency, rather than universal generalizations, justify our characterizing them as motivated by reasons, in a sense which opposes reasons to causes? I do not think so. Many of the operative generalizations which provide the backing for our assignment of causes in the purely physical

domain are no more than generalizations of tendency. An obvious example is the science of meteorology. Let it not be said that the vagaries of the weather are subject to Laplacean natural laws, only we do not know enough to make any practical use of them. Once again, my rejoinder would be that such claims are vacuous unless the laws in question are specified. Moreover if we knew still more, so that we could actually operate at the microscopic level, we should find ourselves dealing in frequencies anyway.

I had not reached this view of causality when I formulated the two generalizations, quoted by Hollis, of which I wrote that they were not quite tautologies. I now think that, so far from being tautologies, they are not universally true. I believe that if preferences are measured independently of the actions in which they may or may not be realized, as the generalizations require that they should be, it is not always the case that given a choice of actions people attempt to perform the one which they believe will have the consequences that they most prefer. For my own part, I quite often find myself failing to do what I most want, owing to weakness of will or a moral scruple to which I subscribe with an ill grace, or simply to inertia. Nevertheless, I think that a great deal of human conduct does conform to the pattern which my generalizations outline.

In particular, I believe this to be true of Hollis's example of Kasparov. I cannot agree with Hollis that Kasparov's reason for advancing his pawn 'is the tactical or strategic advantage gained by the move', if only because there may in fact be no such advantage. Grand masters are not immune from making errors when they play chess. At most, Kasparov's reason for making the move will be his belief that it will bring him an advantage, and when this belief is coupled with his desire to win the match, I can see no good reason for denying that they jointly caused his action. I concede to Hollis that the desire need not be dispositional. A player like Kasparov is generally disposed to want to win his matches, otherwise he would not have become a champion; but there may be occasions, even in his case, say, when he is trying out a new variation, when it does not much matter to him whether he wins or loses, and this may quite often be true of mediocre players, though it is unlikely that they would seriously embark upon a game without doing their best to win it. I say no more than 'unlikely' because even a good player, wishing above all to lose plausibly to a child whose confidence he hopes to increase might make the move with the intention of its proving disadvantageous to him. He could also be making an advantageous move, inadvertently, if the child overlooked what his instructor had regarded as the obvious response.

It was the frequency with which failures of this sort are causally operative that led me to demur to treating causality as a relation between

events, since, to put it shortly I thought it awkward to count a non-event as an event. I now see that my substitution of 'facts' for 'events' was not felicitous since, in a case where one makes a false causal ascription, the particular antecedent of the underlying generalization may not be a fact. When I said that there were many cases where it did not matter whether one spoke of facts or events I had nothing more in mind than that one could equally well represent the fact that Brutus and his fellow conspirators stabbed Caesar as being causally conjoined with the fact that Caesar died or represent the event of the stabbings as being causally conjoined with the event of Caesar's death. In either case the causality would be sustained by the *de facto* generalization that persons who are stabbed in that fashion very seldom survive it. I regret that Hollis was misled into attaching too much importance to my choice of terminology.

I agree with Hollis's observation that 'the players of the social game are not transparent even to themselves' and also that 'each actor's rational decisions usually depend upon what he expects other actors to do', if he means no more by 'rational' than 'purposive'. I cannot understand, however, why he is led in this context to speak of 'dramatic implications' or why he thinks that in the dependence of a person's actions not only on the actions of others but also on his beliefs about what he and they are likely to do, 'there obtrudes a creative uncertainty quite alien to physics.' There is no doubt that the behaviour of physical particles is interdependent and when it comes to microphysics in some degree uncertain. I should not call it 'creative' but then I am not sure what Hollis means by this term when he applies it to human agency. If it implies 'unpredictable' then I take it as marking only a difference, albeit a considerable difference, of degree; the far greater prevalence in physics of deterministic and well-established statistical laws.

I think that the result of this discussion cannot, in Hollis's terms, be better than a draw, as I do retain the view 'that the social fabric can bear on action only as a psychological component of the agent's preferences and information' and I have not divined what further move he thinks that I owe him. I am perhaps a little more hospitable than he is to the idea of a 'unifying physiology' but I also see no serious prospect of our actually employing it as a tool of explanation in dealing with human, or indeed animal behaviour. I credit my cat with desires and beliefs and do not need to inspect her brain in order to account for her presence in the glow of my table-lamp in terms of her desire for warmth and the belief, engendered by her past experience, that this is a place where she will find it.

Does that imply that I stand in a relation of '*verstehen*' to the cat? Presumably not. It is not a difficult problem to work out in my Humean

terms. But is there any essential difference in my understanding of human behaviour? Admittedly, I very often think myself capable of grasping what some other person, especially someone I know well, is thinking or feeling without going through any conscious process of drawing an inference from his demeanour. And sometimes I am right, at least in the sense that my appraisal is confirmed by what he tells me or what he proceeds to do. But if this is what *'verstehen'* comes to, I should not consider it a special form of knowledge. Not only is it far from being infallible, but I am not persuaded that it applies only to human reactions. It seems to me that some people have the same 'intuitive' understanding of, and indeed sympathy with, machines. In both instances the claims which the exercise of *'verstehen'* leads one to make need to be verified. If they pass the test, what we will have achieved is the taking of a short-cut through the extrapolation of our past experience.

To sum up, Hollis has not persuaded me that there is a difference of kind in the resources we bring to the explanation of the social and the natural sciences. There is, however, a very great difference of degree, and it is to this that I attribute the disparity in their achievement.

A.J.A.

9

Ted Honderich

CAUSATION: ONE THING JUST HAPPENS AFTER ANOTHER

A yer is to me and to others the exemplar of a philosopher of clarity. He is this for the reason among several that no other philosopher of the twentieth century has so defended the indubitably necessary constraints put on philosophy by Hume, and, better, so carried philosophy forward in accordance with them. A significant part of this has had to do with causation. In this essay his reflection on causation is examined, in something like the critical spirit which is his own.

He distinguishes four main types of causes: gravitation and other subjects of our theories, the composition or structure of a thing, dispositions like ambition, and events or states of affairs such as one billiard ball's striking another. He might have added ordinary things and stuff, such as paving stones or tables and wine. However, as he asks, is there one general category into which all causes fall? "[W]e could perhaps say that the terms of the causal relation were facts, so long as we made it clear that all we meant by this was that every causal statement could be represented as offering an explanation of the truth of one proposition in terms of the truth of another." (1972, p. 134)

That is not so much to answer the category question as to burke it, as may indeed be implied. We are at most told that a cause is whatever makes true a certain proposition, say that the match was struck, which thing explains whatever makes true another proposition, say that the match lit. The question, however, is whether the initial truth-makers fall into a further specifiable category, say facts in some more determinate sense, events in some sense, or whatever. We are not given a reason to think that anything stands in the way of their doing so.

Elsewhere it is said that "since every causal statement can be

represented as offering an explanation of the truth of one proposition by reference to the truth of another, it would seem better either to give up thinking of causality as a relation or, if this is asking too much, to conceive of its terms as consisting in facts rather than events." (1973, p. 182) Leaving aside the first and surely too audacious proposal, to which Ayer himself does not conform in his thought about causation, I do not see how causal statements' being explanatory can support the proposal that causes are facts—facts, as it here seems, conceived more narrowly than just as truth-makers of whatever kind. Perhaps what mediates the proposal is something like the thought that the explanatory proposition, like any proposition, needs a verb for its expression, but that thought does not entail or otherwise recommend the proposal that a cause is a peculiarly verb-eliciting entity, which a fact, something's being such-and-such, seems to be. Still, causes may be such facts.

What *is* a fact in this sense? Not a true proposition, an abstract object wholly out of space and time. Objects out of space and time cannot possibly be causes, however we may speak, and however tempting it may be for formal semantics or other theoretical purposes to identify propositions and causes. (Pollock, 1976, p. 157) A fact in the relevant sense is as well labelled as a state of affairs, a situation, or indeed as an event, although admittedly not as an event in a narrow sense where the "negative cause" which is someone's not having put up the sun awning over the table is not an event. (1972, pp. 132–34; 1973, p. 148f., pp. 179–81)

To repeat, what is such a fact, state of affairs, or event? Secondly, are all causes such things? Ayer does not pause to consider the first question, although in another connection he does in a way delimit the class of facts (1963b, p. 172f.), and so is ill-prepared for the second. Can we get help elsewhere?

One philosopher's events are introduced as items referred to by such gerundive nominalizations of sentences as "this match's being struck". (Kim, 1973) For such an event of a simple sort to exist, it is said, is for an ordinary thing to have a general property or relation at or for a time. A simple sort of such an event is *the exemplification of a general property by an object at a time*. This, it is said, is a complex consisting of constitutive property, constitutive object, and constitutive time, a complex which falls under a description of the form [(x, t) P]. Is each cause such an event? That depends on what such an event is, which, despite what is said, is not clear. There are two possibilities, each with disabilities.

(i) Is such an event a compound of three parts or elements, or at any rate of two, these being an ordinary thing and a general property? If so, given a certain intuitive and theory-guiding idea about causes, causes are

not such events. The idea, nearly as dependable as any in this neighbour-hood, is that a cause is typically or anyway often a *particular* or an *individual* of some kind, which thing is not necessarily a pair of things, let alone a trio, of whatever kind or kinds, with each making a contribution to the effect. It is at least in accord with this idea that I can so naturally say it was the colour of the sky that caught my attention, the slope of the vineyard that led to my downfall. We also have a second and very dependable idea, already noted. It is that a cause is a wholly *spatio-temporal* individual. But what we have in the philosophical picture of an event under consideration is not such. One constituent of the complex is a general property, say being of a certain weight, what traditionally has been called a universal. A universal, whatever it is, is not such a spatio-temporal individual.

(ii) According to the other possibility, a simple event is not an entity made up of parts, but rather an ordinary thing's *having* of a property at a time. It is, for example, the match's *possession* of the general property of being struck. It is an elusive *relationship* between an ordinary thing and a general property or relation. Certainly we do not get a clear idea of that relationship, as puzzling to us as the ancients, by being offered a canonical form for descriptions taken as specifying it—[(x, t) P]. But anyway the claim that causes are such things conflicts with a third dependable idea, not quite so inexact as to preclude it from constraining our theory. A cause has a certain *reality*. It is the opaqueness or the weight of a thing that is causing something else, not the thing's *having weight* or *having opaqueness*, where we take the latter words to pick out something other than the very opaqueness or the very weight.

Another philosopher's idea of an event is of an entity like an ordinary thing in that it may have an indefinitely large number of general properties or relations. (Davidson, 1980) An event here, although the idea is unclear, is certainly such that we ordinarily do not come near to specifying all the properties and relations of one when we refer to it in an ordinary way—as, say, "the striking of the match". The latter event was intended by Nicholas, of a match of a certain length, in the square at Le Beausset, and so on.

Is a cause such an event? It is at least careless to think so. In giving the cause of the match's lighting I do not implicitly give more than its being struck. I do not give Nicholas's intention and so on. A cause, to come to a fourth dependable idea, is *no more than enough* to secure its effect—which securing will have some attention in due course. If it is possible so to categorize the local part of reality that the striking enters into a larger entity, an indeterminately extensive event, it remains true that we refer only to the striking when we rightly take that to be the cause.

Ayer elsewhere speaks of a cause not as a fact, state of affairs, situation, or event, but as a *property*. (1963a, pp. 215, 219, 232) There, to my mind, he is moving in the right direction, one at least suggested by a plain truth about our thought and usage. It is that if we give careful or precise answers to the question of what caused something, what we give are items like the temperature of something, or its sunniness, weakness, silence, location, distance, speed, age, colour, pitch, positive charge, nucleoprotein content, molecular structure, absorption spectrum, bending moment, conduction band, radioactivity, or spin. In short, we give a *property* or *relation* of something, or sets of such. It isn't all of the copy of *Language, Truth and Logic* that I take to be flattening the postage stamp under it, or the book's being mine, or any other property or relation of the book but one, which roughly speaking is its distributed weight of ten ounces. I might conceivably have singled out something else from a certain set of things as the cause of the flattening, but still a property or relation.

That is not to say that causes are *general* properties or relations. What is flattening the stamp is not the general property of weighing ten ounces, which the book is said to share with many other things. What is flattening the stamp is not a universal. General properties or universals are of course the subject of a persistent philosophical problem of great difficulty. (Armstrong, 1978; Loux, 1976) The way of their existence is obscure and disputed, but it is at least arguable that the general property of weighing ten ounces would have persisted exactly as it is if the book did not have its new introduction and so did not weigh ten ounces. But if that had happened, the cause as we have it would not exist. Therefore the cause cannot be the general property. If it is maintained that the general property would *not* have persisted exactly as it is if the book were lighter, there is another reason for not identifying cause and general property. It is *not* all of the general property, including that part or whatever that is involved in the ten-ounce wine bottle on another table in the square, that is flattening the stamp—the cause is no more than enough to secure the flattening. The points, incidentally, pertain as much to the first conception of cause as event noticed above.

What is suggested by our precise answers to the question of what caused something is therefore *an individual property or relation*. What is flattening the stamp is the weight of this book and of nothing else. Such properties and relations are no new invention. (Armstrong, 1978, pp.77–87) They are sometimes taken as suspect for the use to which they have been put in connection with the problem of universals. But who can deny what is needed in the present enterprise, which is that they exist and

can be individuated? Who can deny that this book's weight, where it is and as long as it exists and with its own effects, is something, and that it is not identical with the weight of the wine bottle? "Some philosophers, no doubt, have made too much of the category of particularized qualities. But we need not therefore deny that we acknowledge them." (Strawson, 1959, p. 169; cf. Campbell, 1981)

If careful or precise answers to the question of what caused something lead us to causes as individual properties and relations, or of course sets of them, we are also led there, so to speak, by theory—by the four dependable ideas. Causes, we have it, are particulars or individuals, spatio-temporal, real, and no more than enough to secure their effects. The second and fourth of these ideas, above all, lead us to individual properties.

We can leave aside further questions about individual properties and relations, in particular the unclear question of *how* they exist, and the question of their relation to ordinary things. In different ways the existence they have is a dependent one, dependent on ordinary things. Related and quite as severe metaphysical questions arise about general properties and hence other proposals, including Ayer's seeming proposal about facts in the narrower sense, as to the ontological category of causes. What remains to be said here is that our conclusion is not in conflict with our ordinary ways of speaking. Certainly we speak of ordinary things, events, and other items as causes. So too do we speak of the town hall being on fire when only part of it is. We speak of the whole and intend the part. With causes we also ordinarily speak of some whole and intend a part, or intend what is in a related relation to a whole. We intend an individual property or relation. In what follows, incidentally, I shall proceed in this ordinary way, consistently with the careful truth that causes—and effects, since effects *are* also causes—are individual properties and relations or sets of them.

What is the relation between cause and effect, and, more fundamentally, the relation between a cause together with certain other conditions and the effect, between what here will be called a *causal circumstance* and the effect? The latter is the largest philosophical question about causation. Certain answers to the questions issue partly from the common desire to establish or explain the rationality of inferences from causal circumstance to effect, the most common inductive inferences. These answers, typically obscured by metaphysics or run together with a separable set of answers to which we are coming, can be said to have as their burden that the causal relation is logical.

When these Logical Connection answers are clarified, as they must be,

into the proposition that a statement of the occurrence of a causal circumstance or cause entails a statement of the occurrence of the effect, their falsehood is evident. The denial of such a statement is not self-contradictory. One of Hume's great contributions was to see his way through to the fact. One of Ayer's has been to defend that perception against certain irrelevant truths, and philosophers who have depended on them. The irrelevant truths at bottom are that types of events may indeed be defined causally, which is to say in terms of their effects, and hence that *if* something is such an event, it logically necessarily has some effect. The latter fact, to be brief, does not make the causal relation logical. (1961, p. 199f.; 1963a, p. 213f.; 1972, p. 4f.)

To move towards the second set of answers to the question of the nature of the causal relation, those having to do with Natural Necessity, it is in a way uncontroversial that things have powers. That means, among many other things, that tables are able to support glasses. To say that something does in this sense have a power to do something, further, is not just to make a conditional statement about it that if such-and-such is the case so will something else be the case. To say that the table has a power to support glasses, now when there is nothing on it, is indeed to say truly that it has an actual quality now.

It is typically but not necessarily to say, a bit more precisely, that it has an individual property whose conjunction with certain individual properties of other things—notably glasses of less than a certain weight —would constitute a causal circumstance for the effect of supported glasses. The power in question is now as real as any other quality of the table whatever. Furthermore, to recall Hume's famous demand that we produce a perception or impression for (almost) any idea, it is clear that powers in the given sense satisfy the demand as fully as other properties. To take a simple case, I *see* the size and shape of this table, in virtue of which it *can* be got in through the door of the café.

Powers in this plain and satisfactory sense do not satisfy all philosophers, partly for a reason to which we shall come. (p. 261) The fundamental doctrine of Natural Necessity is that things have powers in some quite different sense, and that a satisfactory account of the causal relations into which things enter will fundamentally have to do with these other powers. They are spoken of by piling on such mere synonyms as "potentiality" and "real tendency". They are spoken of merely metaphorically by way of talk of a linkage or tie which binds effect to cause. Thirdly, they are so characterized as to suggest an ascription of commanding, willing, trying, or striving to causal circumstances. Finally, the causal relation is characterized yet more animistically in such a way as to suggest compulsion, which involves desire on the causal side and

frustrated desire on the effect side. It is against such hopeless talk of powers that Hume so rightly inveighed. It is against the persistence of such talk that Ayer as rightly inveighs. (1961, p. 18f.; 1973, p. 147f.)

Both Hume and Ayer go further than denying Logical Connection and Natural Necessity doctrines of the causal relation. Hume, in dismissing "necessary connection", dismisses any account of the causal relation but his own, in terms of constant conjunction and habits of mind. Ayer too speaks against "necessary connection" generally, any non-demonstrative or non-logical relation of necessity between events. Causal circumstances do not "necessitate" their effects, effects are not made "inevitable" by their causal circumstances; there is no acceptable sense in which they "must" happen. What this comes to is a denial of any account of the causal relation except his own, an advance on Hume's to which we are coming. To speak differently, it is a denial of objective necessity. (1946, pp. 54–55, 96; 1980, p. 63; 1971, p. 113; 1961, pp. 186, 194; 1963, p. 211; 1971, p. 113; 1973, pp. 138–39; 1984, p. 61)

It is one of my purposes in this essay to ask whether the grounds on which Ayer rightly rejects Natural Necessity and also Logical Connection, and advances his own account, are such as to justify his rejection of another account of the causal relation different from and inconsistent with his own and Hume's. This account, I think, cannot conceivably be seen as defending anything like Natural Necessity or Logical Connection, but certainly it does give sense to talk of necessary connections, necessitation, and inevitable effects. It gives a more substantial or non-artificial sense than the accounts of Ayer and Hume. *Every* arguable account, of course, must in fact, despite dismissals and denials, give *some* sense to the talk.

In one of his principal discussions of the causal relation, Ayer has it that causal judgements are "partly factual", which is to say in part true or false, and in part something else. The "factual content" of a singular causal statement, to treat of it first, may consist "in an assertion of the existence, in such and such a spatio-temporal relation, of the states of affairs which it conjoins, together with whatever generalization is the basis for the conditional that one of these states of affairs would not in the circumstances have occurred without the other". (1972, p. 132, cf. p. 115; 1973, p. 152)

What is the spatio-temporal relation which a singular causal statement, we are told, asserts to hold between the events or whatever which it asserts to exist? Ayer says in this connection that the cause did not succeed the effect in time, and that a preceding cause must be temporally contiguous or very nearly so with the effect, or that cause and effect are linked by temporally contiguous items. As for spatial contiguity, that is

not necessary, although at least typically there is such contiguity, or a linkage of spatially contiguous items.

It is fairly clear that Ayer's view is that a given singular causal statement asserts *specific* spatio-temporal relations between the given cause and effect, as distinct from just that the given cause, like any other, occurred *some time or other* before the effect or was simultaneous with it, and that the given cause and effect, like any others, were *in some way or other* related by spatial contiguities. (1972, pp. 11–12, 134–35) That is to say "Striking the match caused it to light" and "Firing their shotguns up into the trees was what brought down the leaves" *assert*, and do not merely have evidential bases in, *different* spatio-temporal relations. This seems to me unlikely, mainly because it does not contribute to a univocal account of causal statements, but let us not linger over the matter.

More important, what is thought to be the relation of the singular causal statement, say that event c caused event e, to the generalization about events of the types of c and e? Or, since we are concerned with the factual side of things, and the generalization is said to be both factual and non-factual, what is the relation of the singular statement to the generalization taken as factual?

The quoted passage has it, in line with Hume, that the singular statement *is* in part an assertion of the general. So too, on this view, the singular causal statement that the circumstance cc caused e, whatever else is to be said of that, *is* in part the assertion of a generalization about all circumstances of the type of cc and all events of the type of e. On other pages of the work in question, however, Ayer's usages suggest something less or indeed greatly less than that a singular statement actually asserts a general. "Exactly what . . . we are saying is not easy to specify, except that the answer has to do with the fact that the use of causal expressions brings in an element of . . . generality." We in some way imply that the c–e sequence is typical. (1972, pp. 11–12) The singular statement needs the "backing" of the general; singular statements are made "on the basis of" or "warranted by" the general. (1972, pp. 136, 138; cf. 1973, p. 181; 1980, pp. 67, 68)

In another work it is said that a particular causal statement rests on and "invokes" a generalization. (1973, p. 144) And, however this is to be taken, it is said that every singular causal judgement "carries an implicit reference to some generalization of a lawlike character" and that "even if the implicit generalization is not believed by the person who makes a causal judgement, its validity is still required for the judgement to be true . . .". (1973, p. 180)

It must seem wholly unlikely, if one eschews a kind of automatic Humeanism, that the singular causal statement that c caused e, about a

cause rather than a causal circumstance, not only states that c and e were related in a certain way but also states that all e-type events are so related to c-type events, or are so when the c-type events occur with certain accompaniments. That claim goes against the useful principle that generally a statement is what it says it is about, and would also give us the surely rebarbative conclusion that the singular causal statement contains within itself the ground or premise for another part of itself. There remain two other options, both of which are suggested by the noticed usages.

One is no more than that such singular causal statements, whatever they state, are indeed conclusions drawn from general statements. But that clear proposition makes singular causal statements in themselves *in no way* general. They are not left, to use one summation of Ayer's usages, "implicitly general". (Foster, 1985, p. 240f.) The other option, to which we are driven, is that such singular causal statements in themselves or of their own nature do indeed somehow involve generalization, that somehow they are implicitly general. But it is notable that no account is given of this supposed fact of generalization.

There are similar options with singular causal statements about circumstances, such as that a circumstance cc caused an event e—or that cc was such that e had to happen or was the only possibility. The first option, again, would carry a rebarbative conclusion, and the second leaves the statement itself with no element of generality. With respect to the third, it *is* persuasive to take such a statement as "implicitly general", more so than with a statement about just a cause, but no account is given of this fact.

What we have, so far, about the statement that c caused e, is that it states the existence of c and e, and their being in a certain spatio-temporal relation, and of its own nature somehow involves a generalization which is in part factual. Does the original passage (1972, p. 132) quoted above convey that the statement is in part a conditional statement: that in the circumstances if c had not occurred, neither would e—or, as we can say to avoid a certain ambiguity, since I have appropriated "circumstance" for a particular use, that *in the situation* if c had not occurred, neither would e? Using C for the statement that c occurred, and so on, does the statement that c caused e in part convey that in the situation if not-C, then not-E? That we are to suppose so, although the matter is in several ways complicated, is subsequently made clear enough. We are to take it, as often is said, that causes are what are called necessary conditions of effects. (1972, pp. 137–38; 1973, p. 180; cf. 1956, p. 171, pp. 281–82; 1984, p. 62)

One question which arises here is whether that is the only conditional

statement made by the statement that c caused e. Ayer does allow that on certain assumptions it will be true that if or since there occurred a certain causal circumstance, including the cause, then there occurred the effect —if CC, then E. (1972, pp. 133–34) However, to stick to the statement that c caused e, and to take c as being less than a complete causal circumstance, perhaps just the striking of a match, he does not allow, or at any rate does not state or imply, that the given statement is in part also the conditional that if C then E. In this he agrees with several like-minded philosophers and many others. But is this right? It needs noticing that it is only *in the situation as it was* that if not-C then not-E. It is only in the absence of this match's being held in the flame of another one that if the match hadn't been struck it wouldn't have lit. Might a like reflection lead us to affirm that, *in the situation as it was*, if C then E?

A second and larger question is that of what is to be said of the conditional "If not-C then not-E" and any other conditional involved. The analysis of conditionals generally is itself a problem. Ayer's view, in part, is that a conditional insofar as it does *state* anything, which is to say insofar as it has a truth-value, is the so-called material conditional. That is, "If not-C then not-E" states that either C or not-E. (1972, pp. 115–16; 1973, p. 152) More needs to be said, as he does and must allow. A conditional which is part of the content of a singular causal statement is not adequately understood as conveying only that its antecedent is false or its consequent true, and hence that it is true just in virtue of having a false antecedent. There are, as he notes, coercive reasons for this judge-ment. (1972, p. 116)

It is at this point that we need to return to what was said originally of a singular causal statement, that it is part factual or statemental but in part something else. The additional thing is in one respect a matter of the contained conditional. The future conditional, that if the match is not struck then it will not light, may be *acceptable to us*, in a way that it is not acceptable that, say, if the match is not struck then it will slowly turn into St. Eloi. In elucidation of this acceptability, it is said that we may be willing to bet on the first conditional but not the second. With respect to my assertion of a past-tense and unfulfilled conditional, such as "If the match hadn't been struck, it wouldn't have lit", where a bet is out of the question, "I put myself imaginatively at an earlier time than that of the hypothetical event", but the force of my assertion somehow remains the same. (1972, p. 122)

Ayer remarks that we do, indeed, predicate truth of just those statements that we accept, but goes on to say that on the other hand "we also have the idea that a true statement should be one that corresponds to a fact" and that such a statement as the statement that if the match

hadn't been struck it wouldn't have lit "does not correspond to any fact". (1972, pp. 122–23) The reason that such a statement as the one about St. Eloi is unacceptable, it is also remarked, is that it "conflicts with our method of arranging facts". It does not fit in with our conception of the way things work." (1972, p. 124)

There is a further respect in which the singular causal statement, that striking the match caused it to light, is non-factual. This is a matter of the character of the generalizations we have been considering. Any generalization involved in the causal statement, if it makes only a certain claim of fact, may also be such that we have a certain attitude to it.

Consider the causal generalization that all matches which light in a certain situation, where all other possible causes are absent, are matches which are struck. It can be compared with the generalization that all the matches struck by Nicholas today are struck in Provence. The first is rightly called a generalization of law, the second a generalization of fact. What each *states*, however, according to Ayer, is no more than an invariable connection, a *de facto* connection: there is no match which in a certain situation lights but has not been struck, and there is no match struck by Nicholas today which is not struck in Provence. More needs to be said of the first generalization, however, since it seems to carry or entail the idea that if any match *were* to light in a certain situation it would have been struck, while the second generalization does not carry or entail the idea of any match that if it were to have been struck by Nicholas today then it would have been struck in Provence. He might have travelled elsewhere. The first has to do with all possible lightings in a certain situation, while the second does not have to do with all possible strikings by Nicholas today.

Ayer writes that he takes the distinction between the generalizations, having to do with possibilities, as a genuine difference, and not to be equated with a difference in our attitudes to them. But, he continues, ". . . I propose to explain the distinction between generalizations of law and generalizations of fact . . . by the indirect method of analysing the distinction between treating a generalization as a statement of law and treating it as a statement of fact. If someone accepts a statement of the form '(x)(ϕx \supset ψx)' as a true generalization of fact, . . . there will be various properties X, X_1 . . . such that if he were to learn, with respect to any value a of x, that a had one or more of these properties as well as ϕ, it would destroy or seriously weaken his belief that a had ψ." (1963, pp. 230–31) In contrast, what is centrally true if someone is treating "(x) (ϕx \supset ψx)" as a generalization of law is that "his belief that something which has ϕ has ψ is not liable to be weakened by the discovery that the object in question also has some other property X, provided (a) that X does not

logically entail not-ψ, (b) that X is not a manifestation of not-ψ, (c) that the discovery that something had X would not in itself seriously weaken his belief that it had ϕ". (1963, p. 233; cf. 1956, p. 171) If this has in it something very close to what seems to me the central truth about causation, it also has in it a great deal more.

To sum up again, what we have is that the statement that c caused e (i) states the existence of c and e and (ii) their being in a certain spatio-temporal relation, (iii) expresses the conditional that if not-C then not-E, and (iv) on certain assumptions somehow involves in itself a generalization that no e-type events occur in the absence of c-type events, which conditional and generalization (v) make certain limited claims of fact about invariable or *de facto* connections and (vi) only convey a certain attitude or acceptance with respect to possible as against actual cases. A similar view is taken of the statement that circumstance cc caused e.

With respect to (v) and (vi), which is to say the matter of claims of fact and expressions of attitude, the doctrine on hand is surprising. To revert again to the statement that striking the match caused it to light, it does not *state*—it is not true of—any *connection* between cause and effect. Insofar as it has to do with such a thing, which somehow comes into view by way of possible rather than actual cases, it has no more than "some title to acceptance". (1972, p. 122) The generalization that in a certain situation all matches that light were struck, taken as a generalization of law, similarly asserts no fact of connection. It expresses the attitude, to be brief, that certain additional suppositions about any lighted match in a given situation will not weaken the belief that it was struck.

Some of what has been said so far will be puzzling, partly because it has been said quickly, but I shall now propose something with which it can be compared, an alternative view of causation. Or rather, I shall propose an alternative view of *standard causal claims*, which is to say claims where the effect is other than a choice, decision, judgement or the like of a person. For the clear reason that feelings having to do with Free Will, moral responsibility and a good deal more intrude on our talk of choices and the like, our use of causal language here is non-standard. My subject matter is not made much different from Ayer's by this restriction.

The alternative view includes, first, a simpler and more uniform account of singular statements about cause and effect. As it seems to me, this relative simplicity and uniformity is itself a recommendation. Can it really be that "Striking the match made it light" asserts or otherwise conveys the mixed bundle of items supposed by Ayer's view as lately summarized?

On the alternative view, if I state that (s) the striking of the match

caused (l) its lighting, then I state that both events occurred and, if the situation was an ordinary one not involving over-determination, that if or since not-S then not-L—or, as we can say in abbreviation, s was *required for l*. That belief depends on certain others, of course. It depends on the belief that in the situation as it was, there did not exist another or an additional cause or causal circumstance for l, say this match's being held in the flame of another. However, my causal belief does not include the others on which it depends. Taking the variable x to cover any event or condition, or set of them, which did not occur, my conditional belief is simply that if s hadn't occurred, neither would l, and not that even if x had occurred, if s hadn't occurred neither would l.

There is more, along the same lines, to my statement that s caused l, since it evidently is not merely the belief that given the occurrence of s, it *might* have been the case that l happened. I do believe, if I believe that s caused l, that in some sense or other l had to happen. That s was required for l, however, is consistent with s's having existed without l. It is in fact consistent with l's having been, although it could not have occurred without s, a random event. As anticipated earlier, what I additionally believe and state, more specifically, although it is not all that gives sense to my claim that l had to happen, is the further conditional that if S then L. The occurrence of s, by way of abbreviation, *required* that of l. This belief depends on others, such as the belief that the match was dry, but does not include them. Again it is not the belief that whatever else had been true, if or since the match was struck then it lit.

Clearly enough, what leads Ayer to reject or pass by the second of these two *dependent nomic conditionals*, as we can call them, is exactly the fact that s might have happened without l. The struck match would not have lit if it were wet, or if any other part of the causal circumstance for l had been missing. But this dependency of l on other than s has a counterpart with the first conditional. The absence of s, if it had been accompanied by a second match's being alight and in the right place, would not have been followed by the absence of l. It seems to me that there is quite as much ground for the inclusion of the second conditional as the first in the analysis of the causal statement.

If Ayer does not allow or at any rate offer the second conditional in analysis of the given singular statement about a cause, he does of course offer something else, about generalization. On the present and different view, singular statements about causes do *not* assert any generalization, and they do not in some other way, in themselves, involve generalization —they are not "implicitly general". Admittedly, as will be shown, they do follow from or presuppose certain generalizations. The fact may have contributed to the mistake that *they* are general. In particular, the statement that c caused e derives from a fact of generalization which, so

to speak, is more closely related to it than the generalization, say, that all
e-like events in a certain situation are preceded by c-like events. It derives
from a certain conditional to which we are coming about just the *causal
circumstance* in question, which conditional is in a way general.

Still, what we have at the moment is properly if quickly stated as the
conclusion that the statement that c caused e is not *about* anything other
than, or does not *designate* anything other than, c and e. "It was the curve
that caused the car crash" refers to no more than the curve and the car
crash. This conclusion seems to me wholly satisfactory. It is a proposi-
tion which should *guide* further reflection in the philosophy of language
rather than be tested by it. I leave unconsidered, by the way, the issue of
what a singular statement of standard cause and effect can be taken to
assert about spatio-temporal relations, and leave unconsidered for a time
what the statement conveys of what is called causal asymmetry.

To turn now to the relation between causal circumstance and effect, it
is well approached by way of Ayer's view. That view is that the statement,
or, as it would be better to say, the utterance, that cc caused e insofar as it
in itself involves general *statements*, involves only the general statement
that all actual cc-like circumstances stand in a certain spatio-temporal
relation to e-like events. All actual cc-like circumstances are followed or
accompanied by e-like events. There is no more stated than this
invariable or *de facto* connection.

There is the upshot that this view, insofar as its statemental side is
concerned, and to revert to Reid's famous counter-argument against
Hume, does not effectively exclude yesterday from counting as having
been the causal circumstance for last night. If we think, as I do, that a
proper view of what we *state* in saying a circumstance caused an effect
must not allow the consequence that we say yesterday caused last night,
the view is unacceptable. (Cf. 1972, p. 136; 1973, pp. 179, 182)

Yesterday and last night did indeed constitute an instance of a
constant conjunction, as good a constant conjunction as any other. The
true causal circumstance for last night, however, consisted in what we can
call *the solar conditions*, thereby naming a spatio-temporal particular
rather than a type. These conditions included the orientation with
respect to the sun of a part of the earth's surface, the absence of a light
source alternative to the sun, and so on. The solar conditions and last
night also constituted an instance of a constant conjunction. The
fundamental philosophical question about causation, at any rate given a
certain philosophical commitment, is the statemental difference we make
between our two instances of constant conjunctions.

Something close to the correct answer, in my view, is suggested in
some of Ayer's doctrine noticed earlier. (p. 253f) The correct answer is

that it is not true that the occurrence of yesterday, together with certain conceivable changes in the universe, would still have been followed by last night, and it *is* true that the solar conditions, together with certain conceivable changes in the universe, would nonetheless have been followed by or accompanied by last night. The occurrence of yesterday, together with what would have been logically consistent with it, the arrival of a new light source alternative to the sun, would not have been followed by last night. The occurrence of the solar conditions, together with a change or changes consistent with them, would nonetheless have been followed or accompanied by last night.

More generally, let *cc* be a circumstance or set of conditions or events, and let *e* be an event. Let the variable *x* designate any condition or event which did not occur, any conceivable change in the universe. To say that *cc* caused *e* is to say, fundamentally, that if or since *cc* occurred, then even if there had also occurred any change *x* that was logically consistent with the occurrence of *cc* and *e*, *e* would still have occurred—or, *cc* began and *e* ended a sequence of events or whatever, such that it is true of each one and its immediate successor that if or since the first occurred, even if there also occurred any change *x* logically consistent with both, then the second also occurred. References to conditions, events and so on are to be understood as references to individual properties.

It is to be noticed that this account of the statement that *cc* caused *e*, which certainly makes it "implicitly general", differs from Ayer's in two ways. The account's idea of what a generalization states is not that of mere invariable or *de facto* connection. Secondly, the general class of circumstances like *cc* and events like *e* are no part of the statement. What we have is the class of conceivable changes logically consistent with *cc*, *e*, and any links between them. That Ayer has in mind the other mentioned classes is clear. (1972, pp. 132, 136–37; 1973, pp. 152, 181)

The given connection between a causal circumstance and its effect is stated by what can be called an *independent nomic conditional* statement. Such statements, of the form "If *A* even if *X* still *B*", with the variable constrained in the given way, are what we refer to as lawlike statements or laws. It is to be noticed, then, that the given account of the connection between causal circumstance and effect does not depend on any unanalysed reference to lawlike statements or laws. Independent nomic conditional statements are different in kind from what were noticed earlier, dependent nomic conditionals. The latter, as remarked, depend for their truth on other things. This is not the case, although more might be said, with independent nomic conditionals.

We can say, in abbreviation of the fact about causal circumstances and effects stated by the given independent nomic conditional, that

causal circumstances *necessitate* their effects. It is to be noted, as with dependent conditionals, that independent nomic conditionals are not logically necessary, and so do not bring the present view into company with doctrines of Logical Connection.

What we have so far are these conditionals: (1) If not-C then not-E, (2) If C then E, both of which are stated by the claim that c caused e, and (3) If CC then even if X still E. Causation standardly understood, on my view, consists at bottom in a web of connections stated by conditionals of the two kinds. Four other conditionals, like (3) in having to do with causal circumstances rather than causes, are to be noted.

One, stated by a dependent conditional, is that a causal circumstance, like a cause, *required* its effect—the statement that cc caused e does assert that (4) if CC then E, although that by itself is certainly not logically sufficient for the truth that cc caused e.

A further conditional has to do with the widely accepted fact that there is some *set* of types of causal circumstances for a particular type of effect. A match's lighting, as we have noted, can be owed to circumstances of different types. Suppose, then, that cc was a causal circumstance for e, and that only cc' or cc'' or . . . , if any of these had existed, would also have caused e. Given this, (5) if not-CC, not-CC', not-CC'' . . . , then, even if X, still not-E. By way of abbreviation, one of certain circumstances was *necessary for e*.

As has so far not been remarked, both dependent and independent conditionals have equivalent contrapositive forms. In connection with a subject to be considered below, causal asymmetry, it is to be noted that what we have in the case of (5) can also be stated as this: If or since E then, even if X, at least either CC or CC' or CC'' or. . . . The occurrence of e, we can say, did not necessitate cc but rather necessitated cc or cc' or cc''. . . .

Finally, and differently from anything said so far about generalization, there is a generalization about circumstances of the type of cc. If cc caused e, then, to state the generalization quickly, (6) if any circumstance of the type of cc occurs, even if there also occur changes consistent with it and with an e-type event, there still occurs the e-type event.

Let me now set out, very quickly and informally, a speculation as to a main part of the structure or sequence of causal argument in its main character, which is to say in its being a structure or sequence of conditional statements. More particularly, let us glance at the sequence which issues finally in the conditional that if (S) the match was struck then (L) it lit, taken as asserted by the singular causal statement that striking the match made it light.

That sequence may be supposed to begin with certain observations or

findings in *some number* of *different* situations. In each of these situations, despite their differences, there occurs a circumstance of a given type and a subsequent lighting of a match. This primary experience or evidence issues in a first inductive step, which is taking as true, of a *particular* circumstance of the given type, that if the particular situation in which it occurs were in many respects different, a lighting would nonetheless still occur. That is, an independent conditional like (3) is taken as true. A second inductive step takes us to a generalization like (6), in fact another independent conditional, about all instances of the type of circumstance. There follows, logically, an independent conditional concerning the particular circumstance which includes our *s*, again a conditional like (3). Finally, I think via a dependent conditional like (4), and a belief in the existence of conditions or events additional to *s*—the match was dry and so on—we come to the conditional that if or since *S* then *L*.

What is to be said of the nature of dependent and independent nomic conditional statements? To concentrate on dependent conditionals, they can be identified, as they have been here, as typified by the "if"-statements which we accept in connection with our standard beliefs that one thing caused another. They are not thereby elucidated, of course. Rather, causal statements are to be elucidated by way of them. As we have seen, they are not logically necessary. Secondly, they are unlike a mixed bag of other "if"-statements, including "If you give him a full account of the affair, he will judge differently", "If you want them, there are biscuits on the sideboard", and so on. (Cf. Mackie, 1973) Thirdly, they state more than is stated by material conditionals. They state a connection. About that proposition, despite the views of Ayer and some others to the contrary, there is a general agreement. (Anderson and Belnap, 1962; Bradley and Swartz, 1983, pp. 226–29)

This latter distinction, between dependent nomic conditionals and material conditionals, comes into focus in a somewhat unexpected way. Dependent nomic conditionals are at least typically stated by sentences of the form "If *P*, *then Q*", and there is a difference, although not a wholly uniform one, between these and sentences of the form "If *P*, *Q*", which at least naturally state material conditionals. (Davis, 1983)

Suppose that someone has removed the firing pins from one of the shotguns to be used for shooting the trees. It makes sense to say, and in a certain ordinary situation it will be in a way true, that (i) *If a trigger isn't pulled, the gun will not go off.* We can say as truly in this way, of course, that if a trigger is pulled, the gun will not go off. But what of (ii) *If a trigger isn't pulled*, then *the gun will not go off?* Surely it is false. It is false, presumably, because it asserts a connection between two things

(the gun's not going off being connected with the trigger's not being pulled as against its being pulled), and, as things stand, there is no such connection. This fact about (ii) marks a difference between it, together with dependent nomic conditionals generally, and, on the other hand, material conditionals.

Dependent nomic conditionals, further, can be characterized in terms of their logical properties narrowly conceived. They are, as already noted, equivalent to their contrapositives. Dependent nomic conditionals, although it has sometimes been supposed otherwise, are also transitive—*If P then Q* and *If Q then R*, if they are such conditionals, entail *If P then R*. This fact about them, of course, is consonant with the transitivity of causal statements. As for their grammatical properties, as Ayer rightly notes, they are not to be identified with either subjunctive or counterfactual statements. (1972, pp. 116–17)

Leaving aside what seem to me inadequate or mistaken doctrines about dependent conditionals (Goodman, 1965; Lewis, 1973; Stalnaker, 1975), and a curious tendency to confuse the question of their elucidation with the question of their grounds or premises, a tendency perhaps perceivable in Ayer's writing (1972, pp. 118–20), and also a want of a settled and clear intent with respect to analysing or reforming our understanding of them, what remains to be said of their elucidation has to do with the central fact that they assert what I have spoken of as *connection*. To speak in this way is not to engage in the metaphor or metaphorical suggestiveness of some proponents of Natural Necessity.

Nor, however, is it to speak in a way which is open to analytical definition, which is to say reductive analysis. One gets no more than synonym, certainly, by rendering "If *P* then *Q*" as "On the assumption that *P* is true, so is *Q*" or "In the possible world where *P* is true, so is *Q*". To say that a certain statement asserts connection of the given kind between the two things is not to say anything more specific than is said by asserting the statement in the standard way—by asserting, for example, that if the match is struck it will light. Dependent conditionals, then, are primitive conceptions, of the kind which are taken by all to occur at the base of all logical systems and discourses, certainly including those which utilize only the material conditional. No doubt that truth is not as pleasing as an analysis would be, and it is open to retort, but I see no way around it.

To take dependent conditionals as primitive, certainly, is not to come near conceding that no general account can he given of what is properly called their meaning. Their sense can be distinguished from that of other "if"-statements, as we have seen, and, although the point is not wholly separate, their logical properties can be described. I am also strongly

tempted to an unclear idea, that they can be elucidated by reference to their positions and roles in the structure or sequence of causal argument set out above.

I have been speaking of dependent nomic conditionals, but nearly all of what has been said, as will be anticipated, applies as well to the independent ones. Their difference from dependent conditionals, which is the fact of their generality, needs no further attention. Their being the conclusions of inductive inferences, in the way indicated in the speculation as to the structure or sequence of causal argument, does of course bring them into the subject-matter of the traditional problem of induction. It is a problem to which Ayer's kind of response, essentially that induction is by definition rational, can at moments seem promising. (1956, p. 75; 1972, p. 88)

More is to be said of these various contentions in comparison with Ayer's, but it will be best to turn first to a final issue about standard causal claims. It has to do with the asymmetry we recognize between causes and causal circumstances, on the one hand, and, on the other, effects. This asymmetry or priority or direction, whatever it is, issues in the linguistic facts that we say causes and causal circumstances—causal items, as we can call them—(i) *make their effects happen* and (ii) *explain them*, and effects do neither of these things with respect to causal items. We also speak of effects as (iii) *depending on* causal items, but not of causal items depending on their effects.

Of the various accounts of this asymmetry, none is less useful than the claim of advocates of Natural Necessity that causal items, but not effects, have a mysterious power. Can we do better by way of the clear idea of a thing's power given above? (p. 248) It seems that we cannot, for the reason among others that in the given sense, effects also possess such a power. For a thing m to have a power to give rise to event l is centrally for a certain conditional to be true—one whose antecedent mentions a property of m and also other properties, and whose consequent specifies l. However, there is a like conditional whose antecedent mentions l and other items, and whose consequent specifies the property of m. By way of a quick example, if the match lit, and it was dry and so on, and there existed no extraordinary circumstance for its lighting, then it was struck.

Another account seeks to explain causal asymmetry by the fact that causal items are our means to our ends, our ends being certain effects. (Mellor, 1987) One considerable difficulty for the account is that not all causal items are means of anyone. A fundamental objection is that causal asymmetry is surely a fact about causal relations, a fact about the natural world to which we give expression, but not a fact about *us*, and more particularly, our desires. There is the related objection that causal

asymmetry is not a fact which is vulnerable, so to speak, to our changing attitudes to causal items. Causal items become or cease to be means with the alteration of our desires, but causal asymmetry does not vary with this alteration.

An arguable account, to my mind, is in one of two parts owed to a thought about the usages mentioned above: causal items explain and make happen their effects, which effects are dependent upon them. One thing suggested by these usages—a kind of summation of them—is that a causal item *fixes or secures the occurrence of just one thing.* But, as others have noticed, we already have just such an asymmetry in the fact noticed earlier that causal circumstances necessitate exactly their effects, and effects do no more than necessitate, so to speak, a disjunction. (p. 258) This is a matter of the conditionals (3) and (5). To speak differently, as I shall hereafter, there is a many-one relation between the causal side and the effect side.

A second thought about the usages, certainly including the usage that causal items explain their effects, is that causal items *bring into existence* their effects. It is given clear content by the proposition, unconsidered until now, that causal items precede their effects in time. Despite seeming counter-examples that need to be dealt with, this has been the contention of many philosophers. It is to be admitted that the proposition can be said to be a matter not only of conceptual analysis but also of decision or stipulation. It appears to me that if our ordinary thinking about causation and time is unsettled, as surely it is, it does include the strong tendency to take causal items as temporally prior to effects. I propose that causal items and effects be distinguished from nomically-connected items generally—from, fundamentally, items whose relation is given by independent nomic conditionals—partly by the stipulation that causal items are earlier than their effects. The proposal seems less audacious when it is seen that it does not subtract certain nomic connections from the world, those not allowed as causal, but merely assigns them to another category.

There is a bit more to be said of this conclusion about asymmetry, that it is owed to the many-one and the temporal considerations, neither sufficing by itself. Notice now, however, that we could come to a full characterization of a causal circumstance. (Cf. Honderich, 1988, Ch. 1) To give something less, such a circumstance consists, most importantly, in no more than a set of individual properties which necessitates the event which is their effect. (The term "causal circumstance" has been used rather than "causally sufficient condition", by the way, since the latter term has often been used to pick out something different, a lesser thing which does not in itself necessitate an effect.) A causal circumstance

does not include, certainly, all of what is required for the effect. The set, further, precedes the effect, which effect does no more than necessitate either the given circumstance or another one of a certain set.

Such a characterization, to glance back to the first part of this essay, makes possible a close elucidation of what was said earlier, that a *cause* is no more than enough to secure its effect. What is to be understood by that is that if any part of the cause were missing, we would not have a causal circumstance and hence not have necessitation of an event. With cause as with causal circumstance, nothing is redundant.

Ayer in one place (1956, p. 170f.) considers the question of causal asymmetry in the context of the question of why an effect logically cannot precede its cause in time. His supposition, I take it, is that the consideration of asymmetry, whatever it is, will or may in a sense explain the logical truth. The consideration of asymmetry, he conjectures, has to do with human action, since, as he also conjectures, our notion of causality is derived from our being agents, from our experience of our actions. He is not satisfied, however, with the thought alone that we speak of causation in the asymmetrical way because in our actions we try to bring about future but not past events. He is not satisfied since this restriction to future events puzzles him: the notion of bringing something about is at bottom that of there being a sufficient condition for it, and there are present sufficient conditions not only of future but of past events. His idea of a sufficient condition is of course the idea of something given in the antecedent of some or other conditional statement.

He comes to a different view, but one still based on the conjecture that our conception of causation is somehow derived from our conception of action and agents, and that we try to bring about only future and not past events. His different view depends on the proposition that our actions and our conception of action are bound up with a degree of uncertainty as to upshot. Normally, when we try to do something, we do not know for certain that it will happen. This fact is taken as distinct from the fact that the upshot is in the future. If we now add in the proposition that we are *more* uncertain about future than past events, we are said to have an explanation of why action is conceived, so to speak, as forward-moving, and, in turn, an explanation of why causation is such.

To speak differently, if I have it right, we associate action with the future because of the action-uncertainty tie and the uncertainty-future tie, and, having been directed to the future with actions we are also directed to the future with causation generally—with the final upshot of our having our conception of causal asymmetry. In sum again, as Ayer writes, "the reason . . . why we do not allow ourselves to conceive of our

actions as affecting past events is, I suggest, not merely that the earlier events already exist but that they are, for the most part, already *known* to exist. Since the same does not apply to the future, we come to think of human action as essentially forward-moving: and this rule is then extended to all other cases of causality." (1956, p. 175) The proposal, he says subsequently, is not one that he finds entirely satisfactory. (1971, p. 116)

Elsewhere, after an acute discussion of other philosophers' doctrines of causal asymmetry, Ayer again offers a view of his own. (1984) It is not the previous proposal, but like it. That we explain effects by causal items, and not the other way around, is again taken to be owed to no fact external to us, no fact of the natural world. Our explanatory practice is said to be owed in part to ideas or images of Natural Necessity, but these ideas and images represent no facts in the world. Our practice is also owed to the fact, and what follows from it, that our explanatory endeavours are bound up with the desire to extend our knowledge. That of which we know less, or take ourselves to know less, is the future rather than the past. Of the two domains of past and future, we know less of the second. Hence explanation is largely of the future. It consists largely in forecasts, in correlating present or past with future events. "Consequently, when we find it convenient to correlate an element of the less well-known domain with one of the better known we treat it as a junior partner. We conceive of what is later and so less likely to be revealed before it occurs as being dependent on what is earlier and so relatively more likely to have been ascertained, and we then generalize this tendency and project it upon nature." (1984, pp. 61–62)

Both of Ayer's proposals seem to me to involve rather too loose conceptual connections, and to be open to several more particular objections. With the first, it seems to me quite uncertain, although the idea has a popularity in some quarters, that our notion of causality *is* significantly derived from our being agents. Ayer himself, subsequently, is at least unsure. (1984, p. 60) There seems to me no clear obstacle at all to thinking of an inactive spectator of nature—a perceiving non-agent—coming to have our own conception of causation.

The second proposal is also open to that objection, and perhaps others, but I should like to revert to what may be a fundamental ground of opposition to both. There seems to be no good reason for subtracting causal asymmetry from the natural world, which is done by both proposals. To say causal items make happen and explain effects, and have effects dependent on them, seems, as much as any other claim about causality, and many other claims, to be about the world as distinct from

us. One could have a good reason for this Humean looking-away from the world if it really offered no facts to which our practice could be owed.

Such facts, to my mind, are available. They are the facts of which we know, the many-one relation between the causal side and the effect side, together with the existence of non-simultaneous nomically-connected items. Ayer does not consider that two-part proposal, but does say something of each part taken as sufficient in itself for symmetry. Given what he says of agreeing with another philosopher (Mackie, 1974, p. 160f.) about time-order, it may be that he will suppose that an effect's being later than a causal item does not contribute to our saying that the causal item *explains* the effect. (1984, p. 52) I would not accept that. The causal circumstance, we now have it, *exists before and necessitates* the effect.

As for the first part of the proposal, taken independently, Ayer appears to agree with a rejection of it partly on the grounds that the causal side stands to the effect side not only in many-one relations but also (i) many-many and (ii) one-one. (Mackie, 1974, p. 166f.) With respect to (i), there seems no difficulty in denying that many-many relations between two sets of events *are* in themselves standard causal relations, and with respect to (ii), it is at least possible to deny that one-one relations are causal. With the latter and more difficult case, it is to be recalled again that there is room for stipulation in distinguishing causal connection from other nomic connection.

Ayer also appears to agree with another and a remarkable idea which, if acceptable, would cut against my preferred proposal about asymmetry. It is the idea having to do with a randomizing or quantum mechanical slot-machine, that some *effects* are not necessitated, and hence that here we have *one-many* causation. (Mackie, 1974, p. 40f.) He remarks that if causal direction really were many-one direction, we would here have direction from effect to cause. To my mind what is to be said of this, in brief, is that random events, unnecessitated events, are simply not standard effects. (Honderich, 1988, Ch. 1) We have no case at all of one-many direction between causal items and effect, and hence no problem for the view of asymmetry that has been advanced.

I turn now to a further comparison between what were set out earlier, the parts of Ayer's view of causal statements and my own that do not concern asymmetry. The comparison, which should make possible a final appraisal, will follow roughly the previous order of exposition.

(1) Ayer like Hume, as we know, engages in a kind of general disparaging of philosophers' and indeed others' talk of necessary connection, the necessitating of effects by causal circumstances, and so on. (p.

249) Insofar as this has to do only with doctrines of Natural Necessity and Logical Connection, there is no disagreement. In particular, as might have been said before of the doctrine of Natural Necessity, it appears to add to the universe a set of something like *entities*, over and above ordinary things, individual qualities, and the rest of what we ordinarily recognize. These "powers" are indeed fictions, and are not required in analysis of our conception of causation.

However, as will be clear, it can be maintained that we do have a conception of a causal circumstance which is not merely abbreviated but well characterized as something that necessitates a certain event. This is to claim not just that we recognize that there occur certain invariable or *de facto* connections, but that our conception is of something which stands in that particular connection to the event which is stated by a certain independent conditional statement. It seems exactly proper to characterize such a relation as one of necessitation, or of course connection. In saying that *a* necessitated *b* what I convey is, roughly speaking, that *a* was all that mattered with respect to the occurrence of *b*, which *is* the proposition that everything else might have been different.

However, this claim that we take causes as necessitating in the given sense subsumes a good deal: a view of conditional statements, of generalization, and so on. These need some further attention.

(2) Consider two conditionals which were in view earlier. (i) "If the match hadn't been struck, it wouldn't have lit." (ii) "If the match hadn't been struck, it would have slowly turned into St. Eloi." Ayer takes it that insofar as they can properly be regarded as true or false, which is to say when they are regarded as material conditionals, both are true, since they have false antecedents. My contrary view shared with a great majority of philosophers and indeed the rest of the world—which agreement is perhaps not wholly irrelevant in what is fundamentally a matter of conceptual analysis—is that the first may in a certain situation properly be regarded as true in another way, and the second regarded as false. It seems to me that such facts are axiomatic, that they should govern inquiry into such conditionals. That is, any philosophical theory inconsistent with the given view of the two conditionals should be rejected rather than depended on to resist the view, More needs to be said, however.

Ayer allows that the first conditional may be acceptable, or have a title to acceptance, and that this is not the case with the second. That is to say, at least in part, that we have attitudes to them such that we might earlier have bet on a future-tense counterpart of the first conditional but not the second. I find it difficult to conceive of how this attitude, of which not very much is said, could be elucidated without recourse to ideas of truth

and falsehood, perhaps by way of ideas of probability. It seems evident that the behavioural criteria of taking something as true or of having a certain probability of truth and of taking it as acceptable in the given sense are likely to be identical. What can be concluded more safely is that Ayer has not concisely distinguished between a statement's being true and its being acceptable. I must allow, however, that he does refer to a good deal of general theory on levels of discourse, partly owed to Peirce and James. (1972, p. 113f.; 1968) Pursuing this theory, alluded to earlier and also describable as having to do with facts and their arrangement, would have made this essay very long indeed.

In a kind of summation of some of this theory, as noticed earlier, Ayer remarks against our conviction that the first conditional may be true, when taken as other than a material conditional, that "it does not correspond to any fact", which something should do if it is true. Certainly we can take it, as the conditional implies, that there was no fact of the match's being struck. I am puzzled, however, as to how he moves from this truth to the conclusion that the conditional lacks the truth-value we think it has.

It is not as if Ayer has persisted in what might have been an idea of very early Logical Positivism, that only utterances which stand in the closest possible relation to empirical fact can be statements, which is to say true or false. It is rather the case, to speak quickly, that the class of statements has for good reason been conceived as including utterances which stand in less close and indeed distant relation to empirical fact. (Foster, 1985, Part 1)

The account given earlier of the structure or sequence of causal argument, in fact the structure or sequence of argument which issues in certain dependent conditionals, does explicitly connect such a conditional as the one we are considering with empirical fact. Moreover, it connects it with empirical fact of a kind eminently acceptable to anyone of a strong empiricist commitment—a commitment, incidentally, to which I too am inclined. That is, the conditional is connected to observed plain conjunctions: conjunctions each of which consists in a circumstance of a certain type and an event of a certain type. (Cf. 1963b, p. 172; 1972, p. 121; 1980, p. 32)

Does it matter much whether conditionals are taken as capable of truth or only of acceptability? There is a consequence of some importance. Ayer, as noted, goes beyond denying Natural Necessity and Logical Connection to the point of denying what can be called *objective necessity*, relations of necessity in the natural world. This denial must have as perhaps its most important content the denial of significant truth-value to the conditional content of causal statements. The defence of objective

necessity properly conceived certainly requires the defence of conditionals as having significant truth-values—other than material-conditional truth-values—and as not being crucially a matter of our attitudes.

(3) To return to the matter of generalization, we have it that Ayer mistakenly somehow inserts generalization into the statement that c caused e (p. 250f., p. 255f.), and mistakenly inserts an additional fact of generalization into the statement that cc caused e. (p. 257) The one fact involved has to do with a class of possible accompaniments of cc and e, and not with cc-type circumstances and e-type events.

A more fundamental difference between us, however, has to do with the character rather than the location or specific content of the generalizations involved in our conception of causation. On my view they *state* more than constant conjunction, while on his view, it seems, they state only constant conjunction but express an attitude which goes beyond that. I have depended on my view in order to object to his account of the relation between causal circumstance and effect and to introduce my own. (p. 256)

Consider for simplicity just the generalization (6) that any circumstance of the type of cc, even if there also occur changes consistent with it and an e-type event, is followed by an e-type event. The generalization *states* roughly that. We have assumed that on Ayer's view the involved generalization *states*, roughly, only that cc-like circumstances are followed by e-like events, and conveys as an *acceptance*, with respect to any such circumstance, that it would still be followed by an e-like event even if that particular circumstance had certain further properties. Clearly the same idea turns up in what I take to be true and what he takes to be a matter of attitude.

It needs to be remarked, however, that some doubt attaches to what has just been said of the difference between the two views. As partly quoted earlier, Ayer writes as follows of generalizations of law, with which we are now concerned, and generalizations of fact: "My suggestion is that the difference . . . lies not so much on the side of the facts which make them true or false, as in the attitude of those who put them forward." Generalizations of law involve an attitude as to possibilities, he remarks, and then continues: "Now I do not wish to say that a difference in regard to mere possibilities is not a genuine difference, or that it is to be equated with a difference in attitude. . . . But I do think it can be elucidated by referring to such differences of attitude." (1963, p. 230)

It is not easy to say what this comes to. If there *is* a genuine difference between generalizations of law and fact, what else could it be but that the former *state* something about possibilities? If this is what is intended,

there is no real difference between Ayer's view of the character of generalizations of law and the alternative view that has been proposed here. However, virtually all of what is said in what follows and elsewhere is that a generalization of law, insofar as it goes beyond stating a constant conjunction, does not *state* anything but only expresses an attitude. That view, of course, is more or less required by what is said of conditional statements.

What is to be said of the attitudinal view of generalizations of law is more or less what was said of the attitudinal view of conditionals. Certainly these generalizations are almost universally taken to be true or probable in a significant way. Can the acceptability of these generalizations be distinguished from their truth? Can there be any good reason, deriving from a principle of empiricism, for excluding these generalizations, in part of what they convey, from being true or false? The answers to the questions—mine will be obvious—are fundamental to the issue of whether there exists objective necessity.

(4) Ayer ends one of his discussions of causality with this: "What then does *propter hoc* add to *post hoc*? At the factual level, nothing at all, so long as the conjunction is constant in either case. . . . In nature one thing just happens after another." (1973, p. 183)

As I have struggled to establish, it is not the case that our conception of causation, taken as consisting in what is true or false, is simply of instances of constant conjunction, cases where one item is simply followed by another. Causation is not a matter just of *post hoc*. Our conception of causation, rather, is such that one item is connected with another. Causation *is* also a matter of *propter hoc*.

Is our conception of causation such that we take it that in nature one thing just happens after another? That, at least in one very important understanding, seems to me true. We do not in fact assign more to nature than the things of which Ayer speaks. We do not, in making causal statements, impose entity-like powers on nature, or suppose that things are logically connected. It seems to me that the view of causal statements proposed in this essay is as true as Ayer's to this idea that *in nature one thing just happens after another.* They do, certainly, happen in certain ways—the ways described by certain conditional statements—but that, it seems, is not to claim that nature has more in it than a decently Humean philosopher supposes.

TED HONDERICH

DEPARTMENT OF PHILOSOPHY
UNIVERSITY COLLEGE LONDON
SEPTEMBER 1987

REFERENCES

(Original publication dates given in parentheses)

Anderson, A.R. and N.D. Belnap. 1962. "The Pure Calculus of Entailment". *Journal of Symbolic Logic.*

Armstrong, D.M. 1978. *A Theory of Universals.* Cambridge University Press.

Ayer, A.J. 1946 (1936). *Language, Truth and Logic.* 2nd ed. New York: Dover.

———. 1956. *The Problem of Knowledge.* Harmondsworth: Penguin.

———. 1961 (1940). *The Foundations of Empirical Knowledge.* London: Macmillan.

———. 1963. *The Concept of a Person and Other Essays.* London: Macmillan.

———. 1963a. "What Is a Law of Nature?". In 1963.

———. 1963b. "Truth". In 1963.

———. 1968. *The Origins of Pragmatism.* London: Macmillan.

———. 1971. *Russell and Moore: The Analytical Heritage.* London: Macmillan.

———. 1972. *Probability and Evidence.* London: Macmillan.

———. 1973. *The Central Questions of Philosophy.* Harmondsworth: Penguin.

———. 1980. *Hume.* Oxford University Press.

———. 1984. "On Causal Priority". In *Freedom and Morality and Other Essays.* Oxford University Press.

Bradley, R. and N. Swartz. 1983. *Possible Worlds: An Introduction to Logic and its Philosophy.* Oxford: Blackwell.

Campbell, K. 1981. "The Metaphysics of Abstract Particulars". In P.A. French et al., *Midwest Studies in Philosophy* VI: *The Foundations of Analytic Philosophy.*

Davidson, D. 1980. *Essays on Actions and Events.* Oxford University Press.

Davis, W.A. 1983. "Weak and Strong Conditionals". *Pacific Philosophical Quarterly.*

Foster, J. 1985. *Ayer.* London: Routledge & Kegan Paul.

Goodman, N. 1965 (1954). *Fact, Fiction and Forecast.* London: Routledge & Kegan Paul.

Honderich, T. 1988. *A Theory of Determinism: The Mind, Neuroscience, and Life-Hopes.* Oxford University Press.

Kim, J. 1973. "Causation, Nomic Subsumption, and the Concept of Event". *Journal of Philosophy.*

Lewis, D. 1973. *Counterfactuals.* Oxford: Blackwell.

Loux, M.J., ed. 1970. *Universals and Particulars: Readings in Ontology.* Notre Dame University Press.

Mackie, J. 1973. "Conditionals". In *Truth, Probability and Paradox.* Oxford University Press.

———. 1974. *The Cement of the Universe: A Study of Causation.* Oxford University Press.

Mellor, H. 1987. "Fixed Past, Unfixed Future". In B. Taylor, ed., *Michael Dummett: Contributions to Philosophy.* The Hague: Martinus Nijhoff.

Pollock, J. L. 1976. *Subjunctive Reasoning.* Dordrecht: Reidel.

Stalnaker, R. 1975. "A Theory of Conditionals". In E. Sosa, ed., *Causation and Conditionals.* Oxford University Press.

Strawson, P. F. 1959. *Individuals: An Essay in Descriptive Metaphysics.* London: Methuen.

REPLY TO TED HONDERICH

Professor Honderich's essay raises a number of interesting and difficult questions, which I do not feel competent to summarize. I shall therefore try to follow the course of his argument, commenting on any points that seem to me contentious or at least in need of further elucidation.

It seems to me that Honderich attaches too much importance to my suggestion that, in what may be the most common use of the word 'cause', in which it can pardonably be supposed to stand for a relation, the terms of the relation should be characterized as facts rather than events. My main motive was that omissions of various sorts, both in the domain of human action and in that of physical occurrences, frequently figure as causes, and it seemed to me incorrect to describe them as events. At the same time, I did not and do not at this stage wish to be drawn into a discussion of the ontological status of facts. To avoid this, I shall resort to Wittgenstein's device in the *Tractatus* of referring to what is or is not the case. Thus, my first approach to an analysis of our use of the word 'cause', in this sense, assumes the form: 'its being the case that p is conjoined in a law-like fashion with its being the case that q'. For instance, to borrow Honderich's chief example, its being the case that Nicholas struck a match at the place and time at which he did is conjoined in a law-like fashion with its being the case that the match was lit there and then. An advantage of this formula is that it accommodates omissions. For instance, its being the case that the driver did not know how to switch on the car's headlights is conjoined in a law-like fashion with its being the case that the car scraped along the wall at the edge of the terrace. Evidently, in all such examples, the 'is' is tenseless. I shall need to explain later on what I take to be covered by the expression 'is conjoined in a law-like fashion.'

Returning to Honderich, I am surprised that he considers it to be at all a 'dependable idea' that a cause 'is typically or anyway often a *particular* or an *individual* of some kind', or more specifically 'a wholly *spatio-temporal* individual', or that it is 'an individual property or relation'. Let us consider a few examples. 'Yesterday's rain caused me to buy an umbrella.' 'General Browning's failure to take Brian Urquhart's advice caused the disaster at Arnhem.' 'My decision to give up smoking has caused my health to improve.' 'The return of Mrs. Thatcher to power was caused by our anomalous electoral system.' Is yesterday's rain an individual? Is Browning's failure to be guided by his chief intelligence officer an individual property? Only if anything that is true of Browning is counted as such. If my decision to give up smoking is allowed, in the same generous spirit, to be called a property of mine, is it a spatio-temporal property? Temporal, indeed, insofar as it was a decision taken, if not at a precise moment in time, at least over a certain period, but spatial? I do not think that the thesis of psycho-physical identity has yet been firmly established. Finally, is the English electoral system correctly described either as an individual, let alone a spatio-temporal individual, or as an individual property?

In fact, I am not persuaded that Honderich's use of the expression 'individual property' is justified. Having referred to a book and a wine bottle each of which weighs ten ounces, in a situation where the book is so placed that it presses on a particular postage stamp while the wine bottle does not, he defies anyone to deny 'that this book's weight, where it is and so long as it exists and with its own effects, is something, and that it is not identical with the weight of the wine bottle'. I, for one, do deny it. The book and the wine bottle are in different places. One has a stamp underneath it, the other not. As the example has been devised, it can truly be said that the book flattens the stamp in virtue of its weight and that the bottle does not. However, this in no way differentiates the weight of the book from the weight of the bottle. Since both objects weigh the same, if one is going to single out the weight of the book as causing the flattening of the stamp, the same will be true of the weight of the bottle or of any other object which weighs the same as the book. Obviously this does not imply that its being the case that the book weighs ten ounces is logically or factually connected with its being the case that the bottle weighs ten ounces, or that the causal consequences of these two facts, in any sanitized usage of the term, are to any extent the same. But this has no bearing upon the identity of the weights.

I confess that I do not understand what Honderich means by saying that the weight of the book is something, unless it is just a way of saying that the book possesses a weight, and possibly also that its weight which it

may or may not share with other things is a permissible object of reference.

I am puzzled also by Honderich's insistence that a cause 'is *no more than enough* to secure its effect'. Possibly, he means only that many features of the striking, its taking place at Le Beausset rather than Le Castellet, its being performed by a young man rather than a woman, its serving the purpose of smoking a cigarette, and much else besides, are causally irrelevant to its being the case that the match ignites; and so much is evidently correct. All the same, there remains the question why the striking should be picked out as the cause rather than some other 'causal circumstance', in Honderich's phrasing, such as the presence of oxygen, the match's being dry, its not having been previously struck and replaced in the box, and so forth. The most plausible answer seems to me to be that the striking of the match, in the particular way in which it was struck, was what Henry Price called a differential condition. It constituted the change in the existing situation which had to be conjoined with the other factors, regarded as relatively stable, to bring about the ignition.

Having agreed with me in rejecting the devices by which it is made to appear that causality is a logical relation and having also rejected the concept of natural necessity, though we shall see later on that it is not clear how far he genuinely does so, Honderich raises the crucial question of the generality which I have claimed to be implicit in every causal statement. I agree with him that the responses to this question which I have so far given have tended to be evasive. In my recent writings I have most frequently been content to say that particular causal statements are implicitly general. I have already made this somewhat more precise by speaking of such statements as implying that causes are linked in their effects in a law-like fashion. I shall now try to say exactly what I take this to mean.

Let its being the case that p be understood as pinpointing a particular cause, whether the cause be an event, an omission, the possession by some object of a property at a particular place and time, or whatever, and let its being the case that q similarly pinpoints the effect of the cause in question. Let its being the case that r summarize the set of attendant circumstances which are causally relevant in this instance. Let P and Q and R be descriptions of situations which p, q, and r typify in the sense that other propositions which typify them are isomorphous with p, q, and r. For instance, if p pinpoints the striking of the match in Honderich's example, its isomorphs will comprise the similar striking of matches in the same causal circumstances by the same or other persons at different places and times. Finally let H be a projected generalization which may take a strong or weak form. In its strong form it not only affirms that it is

never the case that *P* and *R* are actually typified whereas *Q* is not, but also assents to there being instances of *Q* in any situation in which *P* and *R* were typified, whether or not the situation is actual. In its weak form the generalization asserts no more than that instances of *P*, given instances of *R*, are frequently conjoined with instances of *Q*, but it is preferred to other weak generalizations which have instances of *Q* for their consequents, as being the only or the dominant candidate which appears on the particular scene. It would be simpler if we could confine ourselves to strong generalizations, but we do in fact commonly rely on weak generalizations for the explanation of human actions. A favourite example of mine is that of a child crying because it has been denied some pleasure. Not all children cry in these circumstances, nor does this one; it is not the only way in which children's crying comes about. It is, however, the only candidate on show. When other candidates are in contention, dominance may be decided by the spatio-temporal proximity of one antecedent to its consequent, or by the possession of a stronger frequency.

Having armed myself with this elaborate apparatus, I can now define 'C causes E', as its being the case that *p* and *r* and *q*, the temporal reference of *q* being not later than those of *p* and *r*, together with the obtaining of *H*, at some theoretical level. As I formulated *H* this represents the cause as a sufficient condition. I could also have represented it as a necessary condition by reversing the positions in the formula of *Q* and *R*. In both cases, it is required that the actual composition of *r* is not varied. If we allow the possibility that the match is doused simultaneously with its being struck the sufficiency vanishes; so does the necessity if we are permitted to suppose that the match is otherwise ignited in the very brief interval between its being struck on the box and the appearance on it of the flame.

The purpose of my qualifying *H* by adding 'at some theoretical level' is to cover the case where *Q* is realized not by a single event but by a sequence such as that of night and day and *P* and *R* are realized at a higher level of theory. A similar case is that of the ebb and flow of tides, where the conjunction is not itself considered to be causal but the process is causally attributed to the moon as it figures in the system of Newtonian mechanics.

To this extent my position is more flexible than Hume's. I profit by his fundamental insight that there is never anything more to the causal relation than *de facto* conjunction but do not maintain either that all such conjunctions are constant, since *H* may be a wholly projected generalization with only one actual instance or even none, or, as we have just seen, that every constant conjunction instantiates a causal relation.

I refrain from entering fully into the question why we pick out one from a set of causal circumstances and choose to call it the cause. I have already endorsed Price's suggestion that very often the favoured item is a differential conditional and I agree with Collingwood that we often denominate as a cause something resulting from an action or omission on the part of an agent; as he put it, 'something that we can produce or prevent'. Thus we may say that its having run out of petrol causes the car to come to a stop. Honderich's example 'It was the curve that caused the car crash' does not fit into either of these slots, but it is in any case a dubious example, at least to the extent that picking out the curve of the road as the cause of the accident appears quite arbitrary. There was just as good a ground for saying that the crash was caused by the speed at which the car was being driven.

In passing, I may say that I have some reservations about Honderich's claim that his example 'refers to no more than the curve and the crash'. It does not imply the existence or occurrence of anything else, but I think that it does imply the obtaining of the weak generalization that cars frequently come to grief at curves in the road. Otherwise I do not see what the statement that the curve caused the crash adds to the bare statement that the car, subsequently crashing, went off the road at the curve.

Honderich at this point resorts to conditionals, using capital letters C and E to express the statements that particular cs and es occurred as causes and effects. Altogether he lists six. (1) 'In the situation as it was, if C then E; (2) if not C then not E; (3) if CC then E, where "CC" stands for the totality of causal circumstances; (4) if CC, then, even if X, still E; (5) since E, then, even if X, at least either CC or CC' or CC'' or . . . (6) if cc caused e, then, if any circumstance of the type of cc occurs, even if there also occur changes consistent with it and with an e-type event, there still occurs the e-type event'. To achieve greater clarity in my review of these propositions I have reversed the numbering of 1 and 2 and of 3 and 4 in Honderich's text.

I take the qualification 'In the situation as it was' to be attached to both the first two propositions. Without it they are simply false: or, as I should prefer to put it, unacceptable. Having no more information than that the road was curved and the car crashed, we have no warrant for attributing the crash to the curve, or for asserting that if there had been no curve, there would have been no crash: the speed at which the car was driven might have led to a crash on a straight road, and without the qualification, we are not even excluding non-actual events. But now what is to be understood by 'In the situation as it was'? If it commits us to no more than there being a curve in the road and an accident, together with

the speed at which the car was being driven, the physical condition of the driver and so forth as causal circumstances, the first conditional is still not entailed. The car might have crashed before it reached the curve. If 'the situation being as it was' is understood to comprise the car's leaving the road at the curve, there is not yet an entailment. It might have come to a stop harmlessly in a field. If the car's coming to pieces is included in the situation, we do obtain the entailment but only by trivializing the conditional.

The same applies to the second conditional. If we include in the 'situation' the car's not coming to grief before it reaches the curve, its leaving the road at the curve and then its falling to pieces, we give ourselves the right to infer that in these circumstances the car would not have crashed if there had been no curve, but we have also made the inference trivial.

My difficulty with the third proposition is that of interpreting CC. I have taken it to comprise the totality of causal circumstances, not seeing what else could be intended. I am also assuming that Honderich is still taking the situation to be as it was. But the trouble there is that his proposition then becomes analytic. If everything that combines to cause such and such an effect on a given occasion obtains, and nothing to prevent it, it follows logically that the effect occurs.

On the other hand I think that Honderich's fourth conditional is too strong. I take as an example a person infected with malaria. If X can be any counter-factual circumstances we can introduce a hitherto unknown particle into his blood stream which immunizes him against the bite of the anopheles mosquito, even if he has failed to take any of the recognized prophylactics. The presence of X is not logically inconsistent with CC and its postulated inconsistency with E is not logical but only causal.

On the same grounds I reject Honderich's fifth and sixth conditionals. The sixth is, indeed, only a generalization of the fourth and open to the same objection. As for the fifth, it is surely possible to conceive of a possible set of circumstances which cause an attack of malaria, even in the absence of all the actual causal conditions, without the two sets being logically incompatible.

I am not sure that I have correctly understood what Honderich means by dependent nomic conditionals, but if they include counter-factuals, I have a counter-example to his claim that they are transitive. From the propositions that if I had not been born my parents would never have met, and that if my parents had never met they would never have married, it unfortunately does not follow that if I had not been born my parents would never have married. Admittedly, my parents' meeting

would not ordinarily be said to be the cause of my being born, but it was undoubtably among the causal circumstances, indeed a necessary condition.

I disagree also with Honderich's treatment of his example of the men firing into the trees, though here the disagreement may be no more than verbal. He takes the statement 'If a trigger is not pulled, then the gun will not go off' to be equivalent to 'The gun's not going off would be the effect of a trigger's not being pulled' and he takes this to be false because in the absence of the firing pin, which he has postulated, the gun would not go off even if a trigger were pulled. I doubt if the two sentences would ordinarily be regarded as equivalent, but do not insist upon this point. I demur to his saying that the conditional would be false, because even if the absence of the firing pin is justifiably selected as the cause of the gun's failure to go off, failure to pull the trigger is not thereby deprived of its status as a causal circumstance.

While I have said that our disagreement on this point may be no more than verbal, the example does at least hint at a deep disagreement. Honderich's reference to a 'connection' here and elsewhere, in a sense which amounts to more than *de facto* conjunction, together with his speaking in other contexts of the occurrence of one event being 'required' for that of another and his saying that in a given set of circumstances, a particular effect 'had to happen', all indicate, what he finally admits, his belief that there is such a thing as non-logical objective necessity. I regret to say that I find nothing in his essay that goes any way towards justifying this belief.

I take it to be a slip on Honderich's part to maintain that causal circumstances invariably precede their effects. He has overlooked the fact that they can also be simultaneous, as in Kant's example of a weight pressing on a cushion and indeed his own example of the book and the stamp. What still puzzles me is our reason for making it a conceptual truth that causes do not succeed their effects, and I admit that I am not wholly satisfied with my theory that it is simply a consequence of our knowing so much less about the future than we do about the past. It looks as if Honderich believes that his concept of necessitation carries temporal priority with it, but I see no good reason why it should.

It seems to me also that Honderich is less troubled than he should be by Mackie's example of one-many causation. Surely the insertion of the coin into the slot-machine does cause the emergence of a piece of chocolate or chewing gum or whatever it may be, even if it is a matter of chance which of them comes out. Neither are effects of this sort so uncommon as Honderich assumes. Even in the heyday of classical mechanics the observations which were regarded as confirming a hypoth-

esis seldom yielded results which exactly matched the predicted values. The customary scatter was attributed to 'errors of observation', without there being any independent evidence that any error had been made. I prefer to follow C.S. Peirce in attributing these deviations to chance.

Since Honderich makes no issue of it, I shall pass over my other debt to Peirce in respect of the distinction which I draw between facts and our arrangement of them. I attach importance to this distinction, inasmuch as it incorporates the difference between what is actual and what is no more than possible, though I admit that there is an arbitrary element both in my drawing of the boundaries of fact and in my confining the extention of the terms 'true' and 'false' to the domain of fact, thereby bestowing truth on all conditionals whose antecedents are unsatisfied, but counting them as acceptable or unacceptable according to our evaluation of their consequents. I, therefore, have no strong objection to Honderich's preference for turning my 'acceptability' into a criterion of truth. For what it is worth, he is probably right in saying that his proposal is more in accordance with common usage.

Having found so much to criticize in Honderich's essay I wish nevertheless to end by expressing my gratitude to him for making me face so many of the implications of my own standpoint, and above all for obliging me to give some precision to the sense in which I conceive of particular causal statements as being implicitly general.

A.J.A.

10

Tscha Hung
AYER AND THE VIENNA CIRCLE

I

With the publication of his book *Language, Truth and Logic* Ayer became one of the outstanding representatives of the logical positivism of the Vienna Circle founded by Moritz Schlick, Hans Hahn, Otto Neurath, and Rudolf Carnap. Afterwards he published several articles on the same subject in various periodicals and compiled an anthology of *Logical Positivism* (1959) with a long introduction. Even in his new book *Philosophy in the Twentieth Century* (1982) he devoted two chapters to this school of thought. Although it was published fifty years ago, the book is still widely read. Bryan Magee said of it in his interview with Ayer: "The person who introduced Logical Positivism into England was A.J. Ayer, and his is the name that has been chiefly associated with it ever since. He did so in a still famous and widely read book called *Language, Truth and Logic*. It is very much a young man's book, explosively written, and still the best short guide to the central doctrines of Logical Positivism."[1]

In his *Language, Truth and Logic* (1936) Ayer was trying, on the one hand, to represent the essential doctrines of the logical positivism of the Vienna Circle, and on the other hand, to conjoin this with the Cambridge School of Analysis founded by Bertrand Russell and G.E. Moore and inspired by Hume, whose empiricism is the real key to Ayer's interpretations. Ayer dealt with this problem so skillfully that many were led to believe that British Analysis and Logical Positivism were actually identical. In fact, however, the logical positivists had no interest in the historical epistemological problems upon which British analysts from the beginning concentrated. These for their part, in contrast to the logical positivists, paid very little attention to the problem of the structure of scientific theories and to the mathematical-logical methodology and its

application to philosophy. Although British analysts and logical positivists are both empirical in tendency and both anti-metaphysical, still their conceptions of the task of philosophy stand poles apart. Some of the logical positivists were trying to set up a scientific philosophy and therefore proposed to replace the concept *philosophy* by that of the "logic of science" or "physicalism", whereas for the British analysts the real function of philosophy consists merely in so-called "linguistic analysis", which was the function that Locke, Berkeley, and Hume essentially fulfilled.

The Vienna Circle took the verification principle of Ludwig Wittgenstein as the criterion determining the meaning of a proposition and made it the starting point of their philosophizing. Thus some have called the philosophy of the Vienna Circle "verificationism". What does the verification principle actually mean? To this question Schlick answered: "The meaning of a proposition is the method of its verification" and "the question what a sentence means is identical with the question: How is this question verified?"[2] As for the impossibility of verification Schlick distinguished empirical impossibility, according to which a proposition is not verifiable merely for lack of technical means for deciding its truth or falsity, and a logical impossibility, according to which a proposition is in principle in no way whatever empirically decidable. Schlick called a proposition whose verifiability is logically impossible a proposition without actual meaning, in other words, a "pseudo-proposition" or metaphysical proposition.

Inspiring as Schlick's exploration of the concept of the verification principle was in many respects, his approach provoked a critical reaction inside and outside the Vienna Circle.[3] The first to raise objections to Schlick's thesis mentioned above were Carnap and Ayer. According to Carnap Schlick's formulation and requirement of verifiability are "not quite correct", for by its simplification it led to a narrow restriction of scientific language, excluding not only metaphysical sentences but also certain scientific sentences having factual meaning. Carnap expressed his view in the introduction to "Testability and Meaning" (1935) as follows: "If by verification is meant a definitive and final establishment of truth, then no (synthetic) sentence is ever verifiable. . . . We can only confirm a sentence more and more. Therefore we shall speak of the problem of *confirmation* rather than of the problem of verification. We distinguish the *testing* of a sentence from its confirmation, thereby understanding a procedure—e.g., the carrying out of certain experiments—which lead to a confirmation in some degree either of the sentence itself or its negation."[4] In a word, "confirmation instead of verification".

In "Wahrheit und Bewährung" Carnap distinguished between two different kinds of synthetic sentences, viz., those that are directly testable

and those that are merely indirectly testable. By a directly testable sentence he means one for which, under imaginable conditions, on the basis of one or a few observations, we can with confidence regard it either as so strongly confirmed that we accept it or as so strongly disconfirmed that we reject it. Indirect testing of a sentence consists in directly testing other sentences which have a certain relation to it.[5] The most important testing operations here are confrontation of the sentence with sentences that have been previously recognized. Indeed, the former operations are the more important, for in their absence there is no confirmation at all, while the latter are merely auxiliary operations which mostly serve to rule out unsuitable sentences from the system of the sentences in question.

In his view of the verifiability principle Ayer took over a great deal from Carnap's theory of confirmation, and indeed in the preface to his first edition of *Language, Truth and Logic* he says, "I owe most to Rudolf Carnap." He did not, however, accept Carnap's assertion: "Confirmation instead of verification". Ayer's contribution resides in the reformulation of the conception and requirements of the verifiability principle as framed by Schlick and Friedrich Waismann. Ayer, like Carnap, maintained that if we adopt conclusive verifiability as our criterion of significance, as some positivists have proposed, "our argument will prove too much". The expression "too much" should mean that if we adopt conclusive verifiability as our criterion of significance we are logically obliged to treat the general propositions of natural law and of ordinary language, which have actual meaning, in the same way as we treat the statements of the metaphysician.[6]

For this reason Ayer was intent on providing a new way of testing the meaning of a synthetic proposition without the use of conclusive verification. He also distinguished two kinds of verification principle as Carnap distinguished between direct and indirect testing; namely, a strong verification principle asserting that a proposition is meaningful, if and only if experience can conclusively establish its truth, and a weak verification principle which requires only that some observations be "relevant" to the determination of a proposition's truth or falsity. Ayer accepts the verification principle only in its weak sense for the reason that the principle in this form is quite sufficient to destroy metaphysical propositions such as Bradley's proposition, "Reality is absolute" or Heidegger's statement that "The nothing nothings", for no metaphysical statement needs any reference in principle to empirical observation.

Having introduced the contrast between strong and weak verification, Ayer went on to claim that no propositions are verifiable in the strong sense. He wrote: "no proposition is capable, even in principle, of being

verified conclusively, but only at best of being rendered highly probable, the positivist criterion, so far from making a distinction between literal sense and nonsense, as it is intended to do, makes every utterance nonsensical. And therefore, . . . it is necessary to adopt a weakened form of the positivist verification principle, as a criterion of literal significance, and to allow a proposition to be genuinely factual if any empirical observations would be relevant to its truth or falsehood."[7]

After the first appearance of *Language, Truth and Logic* Morris Lazerowitz objected to Ayer's distinction between strong and weak verification. He argued, if strong verification is impossible "even in principle", then Ayer has not succeeded in giving sense to this notion; nor has he given sense to the contrast between weak and strong, in terms of which the essential "weak sense" was supposed to be expounded.[8] In the introduction to the second edition of *Language, Truth and Logic* Ayer, however, noticed this question and added that there is a class of empirical propositions which can be verified conclusively. He called such propositions "basic propositions", which refer merely to the content of a single experience. Examples of such propositions would be "I am in pain" and "this is green", which are used to designate the sense-content being experienced at the time of speaking.[9] He asserted that such propositions are verifiable in the strong sense.

Ayer defined "basic propositions" in quite the same way as Schlick did affirmations (*Konstatierungen*) by which Schlick meant a sort of observation proposition that was beyond all doubt and absolutely certain. He maintained that such propositions as "Here black borders on white" or "Here and now pain" involve immediately the recognition of whether it is true or false, and do not need in principle any verification for discerning their truth or falsehood, i.e., their meaning. In other words, such propositions presuppose the impossibility of any doubt about them, whereas the verification principle, in contrast to them, presupposes a possibility of doubt. To verify a proposition or an event means properly to find out whether it is true or false. If it makes no sense to speak of a possibility of doubt, then it makes no sense to speak of verification either. In that case, as Schlick said, "my own observation propositions would always be the final criterion. I would proclaim . . . : 'What I see, I see!' "[10]

There are further difficulties in the operation of Ayer's weak sense of verification. It is a matter of fact that Ayer defined its operation in terms of so-called "strict deduction". In his view there was no such deduction from observation propositions to a proposition to be tested. That is why he rejected the use of conclusive verifiability as the criterion of the meaning of scientific propositions or those of common language. But can there be "a strict deduction" the other way around? In what sense are

observation propositions deducible from "certain other premises"? In his *Language, Truth and Logic* Ayer took the sentence "This is white" as an example for the performance of that operation. But this led him against his wish to strange results. He wrote "the statements 'the Absolute is lazy' and 'if the Absolute is lazy' and 'if the Absolute is lazy, this is white' jointly entail the observation-statement 'this is white,' and since 'this is white' does not follow from either of these premises, taken by itself, both of them satisfy my criterion of meaning."[11] To prevent some difficulties in this formulation of the testability criterion Ayer later made a modification of his criterion stipulating that the "certain other premises" must themselves be observation propositions, thinking that thereby he would be able to avoid such propositions as "The Absolute is lazy" appearing among the premises and meeting the demands of "strict deduction".

But C.G. Hempel rejected Ayer's measures, arguing that they could not prevent the criterion from producing strange results still. He said: "it can readily be shown that this new criterion, like the requirement of complete falsifiability, allows empirical significance to any conjunction S.N, where S satisfies Ayer's criterion, while N is a sentence such as 'The Absolute is perfect,' which is to be disqualified by that criterion. Indeed: whatever consequences can be deduced from S with the help of permissible subsidiary hypotheses can also be deduced from S.N by means of the same subsidiary hypotheses, and as Ayer's new criterion is formulated essentially in terms of the deducibility of a certain type of consequence from the given sentence, it countenances S.N together with S."[12]

Another difficulty of that criterion of meaning has been pointed out by Professor Alonzo Church. He has shown that if there are any three observation sentences none of which alone entails any of the others, then it follows, for any sentence S whatsoever that either it or its denial has empirical import according to Ayer's revised criterion.[13] To Church's criticism Ayer replied: "We still don't have a watertight formal theory of confirmation, with the result that the verifiability principle never got itself satisfactorily formalized. I made a valiant attempt to bring it off in the second edition of my *Language, Truth and Logic*" but Alonzo Church torpedoed me".[14]

II

Although all members of the Vienna Circle accepted the verification principle of Wittgenstein, they used it in different ways and interpreted it in different senses. These differences were found not only in the controversy concerning the formulation and requirement of the princi-

ple, as shown in the previous part, but also in the question of the elimination of metaphysics. In consequence Schlick, Carnap, and Ayer came to represent different trends within the logical positivism of the Vienna Circle.

Under the influence of Carnap and Wittgenstein, Schlick's position of the transcendence problem was changed in some respects; i.e., he moved from his early critical realism to a positivist and empirical realism. On the ground of the verification principle Schlick asserted that the whole dispute between the philosophers of immanence and transcendence rests on a pseudo-problem. All answers to the question whether "the external world is real or merely a logical construction", or the question, "does an external world exist, or is the world only my sensation?" are in the same way without any cognitive meaning and therefore metaphysical. For it is impossible in principle that such answers should either be confirmed or refuted empirically. For this reason Schlick held the quarrel between transcendent realism and immanent idealism, phenomenalism and solipsism, to be nothing more than a senseless quarrel about some metaphysical pseudo-propositions.

Here the question arises: does Schlick's positivism coincide with Auguste Comte's, John Stuart Mill's, and Ernst Mach's? As to this question, Ayer asserted that by the time he published the second edition of his *Allgemeine Erkenntnislehre* (1925) "Schlick had been converted to a view of science which was substantially the same as Mach's".[15] But my own opinion is that although Schlick's way of thinking in some respects stands near to Mach's, he is distinguished from Mach substantially by his position in regard to sensation. Schlick held the thesis of Mach that "the physical world resolves into complexes of sensation" to be absurd, as Ludwig Boltzmann and Max Planck also asserted. But Schlick adopts another entirely different standpoint. Instead of a positivist resolution of real physical objects he gets involved in inquiry into the meaning of statements about such objects. It meant that an examination of linguistic usage first allows us to recognize whether and to what extent there exists a connection between statements about body and statements about perception. It turns out that Mach's thesis does not represent the factual meaning of scientific statements and even distorts and misconstrues that meaning.[16]

Thus for Schlick the expression "positivist" should be taken to indicate nothing but an endeavor to eliminate metaphysical pseudo-propositions and to confine inquiry to the empirical scrutiny of propositions. Although Schlick was not against the designation "logical positivism" as applied to the Vienna Circle, he preferred to call his own philosophical standpoint "consistent empiricism", saying: "the term

'logical' or 'logistic positivism' is often used; otherwise the expression 'consistent empiricism' has seemed to me appropriate."[17]

One of the cardinal points in Schlick's philosophy is the clear distinction between experience (*Erleben*) and cognition (*Erkennen*) and the distinction between their tasks and their goals. All cognition without exception has its being in the realm of formal relations: it sets things in order and it calculates. Its function is to convey to us objective knowledge of the external world. Experience, on the other hand, can only enable us to enter into a direct relation with the external world and the internal world. It stimulates and enriches our inner life but is of no service in communicating to others the experiential content of that life; thus cognition is always essentially intersubjective, while experience remains forever private. The metaphysicians, however, had not only arbitrarily neglected both distinctions, but also tried realizing their ideas by metaphysics, thereby inevitably giving rise to a lot of senseless quarrels in philosophy mentioned above, and likely to continue ad infinitum.

On this point Schlick wrote: "If the metaphysician was striving only for experience, his demand could be fulfilled, through poetry and art and life itself. . . . But in that he absolutely demands to experience the *transcendent*, he confuses living and knowing. . . . We can see the precise sense in which there is truth in the oft-expressed opinion that metaphysical philosophemes are conceptual poems: in the totality of culture they play . . . a role similar to that of poetry; they serve to enrich life, not knowledge."[18]

As to these points of Schlick's, Ayer objected that it is impossible for Schlick to draw a sharp distinction between structure and content, the reason lying in a fundamental difficulty in his view, which "inconsistently puts the 'private worlds' of other people on a level with one's own", thus resulting in a strange and contradictory theory of multiple solipsism.[19] Accordingly, Ayer asserted that it does not matter to one what the content of another's experience is like so long as there is a structural correspondence between their respective worlds and one can rely on the information the other provides and can make sense in one's own experience of the other's reactions to one's statements. Nevertheless Ayer wrote in 1982: "I once thought that this distinction between structure and content could not be so sharply drawn but I am now more inclined to think that there is a good deal in this idea."[20] But what does Ayer mean by the phrase "a good deal in this idea"? Would he hold that to replace Schlick's form-content theory by "structural correspondence" would still not enable us to escape from "multiple solipsism"?

Ayer also criticized Schlick's view of the value of metaphysics by saying that to reckon the metaphysician among the poets rests on the assumption that both talk nonsense. But according to Ayer, this assumption is not true at all, for in many cases the sentences produced by poets do have actual meaning. The difference between poets and scientists lies in the difference between the task and goal of a work of art and a work of science. The metaphysician on the other hand, does not intend to write nonsense, he lapses into it through being deceived by grammar; thus Ayer rightly showed that "it is not the mark of a poet simply to make mistakes of this sort."[21]

As for Carnap's view of the verifiability principle, Ayer accepted a good number of ideas from him, but in some other points he stands in opposition to Carnap. For instance, Ayer does not regard either the account of philosophical propositions as syntactical propositions, nor the distinction between the material and formal modes of speech, as sufficient arguments in the elimination of metaphysical propositions. Here Ayer wrote: "the attempt to make syntax do the work of semantics failed and so did the construal of philosophical propositions, where they were not metaphysical, as syntactical statements masquerading as statements of fact (this was the nub of Carnap's celebrated distinction between formal and material modes of speech). Whatever else they were, philosophical propositions were not syntactical."[22]

In his *Logische Syntax den Sprache* (1934) Carnap realized his idea by two kinds of speech: material mode of speech and formal mode of speech. Hereby he distinguished three sorts of sentences: "objective sentences" such as "The rose is red", syntactical sentences such as "The word rose is a thing word", and pseudo-object sentences like "The rose is a thing". The third sentence has the same grammatical subject as the first and thus appears to deal with the thing, rose, but there is a fundamental difference between them. The first really asserts some quality of the rose, but by the third we can learn nothing at all, neither its quality nor anything else. Thus Carnap insisted on calling sentences pseudo-object sentences of the material mode of speech, while assigning syntactical sentences to the formal mode of speech. Besides Carnap put forward the so-called "relativity of philosophical thesis" in regard to language, that is, the need for reference to one or more language-systems. In his view many philosophical controversies arise only through some incompleteness of theses which is concealed by the use of the material mode of speech. When translated into the formal mode the want of reference to a language is noticed immediately. In this case we do not need to refer to other language-systems in order to make the two theses compatible with each other.[23]

In Ayer's view the fruitfulness of Carnap's distinction between the

material and formal modes of speech lay in that it directed us to pay attention to the fact that many philosophical statements are "disguised statements about language". Where Carnap went wrong for the most part was in asserting that such statements are syntactical. For what statements are concerned with is not their form or their order, or their system, but their use, or more exactly speaking, in how they would be used. In Carnap's examples we could not find any trace of their importance in using the language. The ground was, according to Ayer, that Carnap "illicitly smuggles semantics into syntax."[24] For instance: " 'The only primitive data are relations between experiences' was equivalent to 'Only two-or-more-termed predicates whose arguments belong to the genus of experience-expressions occur as descriptive primitive symbols' ".[25]

As described above, Ayer held that an expression such as "experience-expression" which appeared in the sentence just mentioned is not a syntactical term at all. For what makes an expression an experience-expression is not its having any particular form but its being used to refer to an experience. Thus the question what is to count as an experience becomes important. However it cannot be settled by an arbitrary decision. In his latter works Carnap recognized the importance of semantics in logical analysis and allowed the right to speak of the reference of words to things, and he even allowed almost any type of word to denote its special sort of object. So some members of the Vienna Circle greeted his change of view with indignation as a retreat from positivism into realism.

Carnap also asserted that pseudo-object sentences are quasi-syntactical, because they are synthetical sentences masquerading as object-sentences. If we translate such quasi-syntactical sentences of the material mode of speech into the formal mode of speech, it replaces them by syntactical equipollents. In Ayer's opinion Carnap is right in not maintaining that all discourse is only talk about words, as some critics have supposed, but on the other hand, he is most wrong in overlooking the existence of a further category, that of pseudo-syntactical sentences which are "object-sentences masquerading as syntactical sentences".[26] As a result Carnap fell into the error of treating these sentences as if they were syntactical, and from this he was led to deal with philosophical problems and to draw the conclusion that philosophy should be replaced by the logic of science, that is to say, by the logical analysis of the concepts and sentences of science, for the logic of science is nothing but the logical syntax of the language of science.

With this criticism of Carnap's theory of syntax, I think that Ayer made a great contribution to the further development of the logical empiricism of the Vienna Circle by his strict analysis of Carnap's logical theory of language and its relation to conventionalism and empiricism.

As a matter of fact, Ayer's view was not only confirmed by the further development of that school of thought at that time, but in my opinion, also by the development of Carnap's own philosophical thought.

III

In the third decade of the twentieth century there were many controversies between the so-called "right wing" (Schlick and Waismann) and the "left wing" (Neurath and Carnap) inside the Vienna Circle. At that time the main problems consisted in what the foundation of empirical knowledge should be, the affirmation (*Konstatierung*) statement or the protocol proposition and accordingly whether to accept the coherence theory of truth or the contrasting theory of correspondence. Ayer joined the dispute, and his opinion attracted attention from both Schlick himself and other members of the Vienna Circle.

Schlick held the view that protocol statements, which Neurath and Carnap maintained to be the foundation of empirical knowledge, do stand as the gates of cognition and its origin but that they are not on this account its foundation. That distinction belongs to statements that represent a completed cognition. Such statements about what is now perceived as protocol propositions cannot be this. Rather we need statements about what is now experienced at the moment of experience, and these are our affirmations.

By an affirmation Schlick meant a sort of observation statement. It was expressed always in the form: "Here black borders white" or "Here and now pain"; in short, "Here is 'such' and 'such'", when "such" and "such" mean nothing more than what is designated by a present sensation. It could be seen from this that the understanding of such propositions also and immediately involves the recognition of whether they are true or false. This is so because in all other synthetic propositions, determination of sense and determination of truth are two distinct processes. The two processes coincide in the case of affirmation, as they do in that of analytic judgments. The difference is that an analytic proposition has no factual content whereas observation propositions provide us not only with genuine knowledge of reality but with the very foundation of empirical cognition.

As opposed to Schlick, Ayer expressed his view that in the propositional system of our science there is no such special class of synthetic propositions as would be constituted by affirmation in this sense. For such propositions would have to be, on the one hand, composed entirely of ostensive symbols and, on the other hand, completely comprehensible.

It is obvious that if a proposition makes a statement, it cannot merely name a state of affairs or cannot simply make a note of sense-content but must in some way or other classify it. But this is enough to transport us away from the immediately given into the realm of what is not immediately given. Affirmation, however, is possible only when reference is made solely to what is immediately given. Since the conditions are impossible to meet, an affirmation cannot be a genuine statement in the logical sense; and, what is more, no synthetic statement can lay claim to absolute certainty in Schlick's sense.[27]

On the other hand, as mentioned above, Ayer affirms a class of empirical propositions which are in his view verifiable conclusively, namely, the so-called "basic propositions" like "I am in pain" and "This is green". Although Ayer defined the "basic propositions" in a similar manner to Schlick's affirmations, he does not agree with Schlick that propositions which record direct observations are absolutely objectively certain without any reference to our subjective attitude toward these propositions. Here Ayer put forward the question: What should these propositions actually mean? In this case Schlick would reply that at the moment at which I am actually having a sensation of pain or "of green", the propositions "This is green" or "I am in pain" which I might use to describe my immediate sensations would be "absolutely, objectively certain". To this Ayer argued that we have in this case first to distinguish their truth value. Only on this ground can we say that it is "objectively certain" that when "I am feeling pain", then "I am indeed feeling pain". For this is to say no more than that it is objectively certain that p implies p. But it is false to say that when "I am feeling pain", then the proposition that "I am feeling pain" is "objectively certain". For this is a special case of the proposition: p implies that p is objectively certain. And this proposition is false when, as is the case here, p is a synthetic proposition. Thus Ayer held Schlick has been "guilty of confusing these two propositions and has come to believe the second only because he mistook it for the first".[28]

As regards the problem of the foundation of empirical knowledge Schlick asserted that it is in the end not distinct from the question of the criterion of truth. About this question there was a long lasting dispute inside the Vienna Circle, to which Schlick and Waismann were on one side and Carnap and Neurath on the other. According to the latter the criterion of truth in science could be certainly established by singling out protocol propositions, by whose truth it should then be possible to measure, as if by a yardstick, the truth of all other statements. To this Schlick, however, put the question: "What do we have left if we accept certain specific protocol propositions as the criterion of truth?" Since we

are not to have it that all statements of science are to accord with a specific set of protocol propositions but rather that all propositions are to accord with all others, where each is regarded as in principle corrigible by any other, the truth can consist only in the mutual agreement of the propositions with one another. Here Schlick was criticizing Neurath's idea that the empirical character of protocol propositions could be supported by the coherence theory of truth. He asserted that to take mutual agreement between empirical propositions simply amounts to a completely arbitrary determination of what is empirically valid and what is not, with the result that we should be forced back on conventionalism and empiricism would have to be abandoned.

Further, Schlick maintained that the truth of the system of scientific propositions does not consist merely in the freedom of the system from self-contradiction, but rather in its "agreement with reality". It should long since have been generally recognized that non-contradiction and truth can be identical only in the propositions of a tautological character, i.e., in the sentences of mathematics and logic. But in propositions of that sort all connections with reality are severed; they are only formulae within an established calculus. On the other hand, if someone desires to describe the truth of synthetic propositions by means of the concept of non-contradiction with other propositions, this can be done by saying that they may not stand in contradiction to certain specific statements which record facts of immediate observation. In other words, it is not consistency with just any kind of propositions that can serve as a criterion of truth; what is required is conformity with certain particular statements which can by no means be chosen at will. Thus Schlick wrote that for this consistency with very special statements of a peculiar kind "there is nothing to prevent . . . our employment of the good old phrase 'agreement with reality' ".[29]

But Neurath and Carnap found Schlick's criterion of truth to be unacceptable. They thought that talk of comparing empirical sentences with reality was without any doubt metaphysical and that empirical sentences in science could be compared only with sentences. They were therefore driven to holding a coherence theory of truth in contrast to Schlick's correspondence theory. As Neurath expressed it, "the verification of certain content statements consists in examining whether they conform to certain protocol statements; therefore we reject the expression that a statement is compared with 'reality', and the more so since for us 'reality' is replaced by several totalities of statements that are consistent in themselves but not with each other." Further, "Within radical physicalism statements dealing with 'unsayable' things and events, prove to be typical pseudo-statements."[30]

In the dispute about the criterion of truth Ayer substantially accepted Schlick's correspondence theory but added that the criterion was only then useful if it could give "a suitable interpretation" to the phrase "agreement with reality". He really has given a very suitable interpretation to this phrase in his "The Criterion of Truth" (in *Analysis*, vol. 3, no. 2, 1935) but he overlooked the fact that Schlick had already done it in his "Positivism and Realism". Schlick said in that paper, "If we say of some event or object—which must be marked out by description—that it is *real*, this means . . . there is a quite specific connection between perceptions or other experiences, that under given circumstances certain data are presented."[31] Accordingly, when Schlick says of a proposition that it agrees with reality all that he means in this usage is that the specific connection between perceptions and other experiences are what the proposition in question said they would be. In this way Schlick used the phrase "agreement with reality" and clarified the misunderstanding of this phrase as "metaphysical" by Neurath and Carnap as well as more or less, by Ayer himself.

Although Ayer agrees with Schlick's view that people will accept a synthetic proposition as valid only if it conforms to their experience, in the sense indicated above, he nonetheless urges us to pay attention that the result of an observation depends more or less on the mental states of the people during the substantiating of one of their hypotheses and that we cannot entirely avoid contingent elements playing some role in this procedure of substantiation. On this assumption Ayer suggested to us that, while we may accept what Schlick says as an accurate account of the procedure which we actually employ in the validation of synthetic propositions, we must not assume that no other procedure is possible.[32] As regards Ayer's suggestion, it seems to me that as between him and Schlick it is not that they have different understandings of synthetic propositions but rather that they represent different trends within logical empiricism; namely, Schlick held firmly his "consistent empiricism", whereas Ayer passed over from logical empiricism to the traditional British scepticism, and the difference between these two marks the main difference between logical empiricism and British empiricism up to the present day.[33]

In regard to the Neurath-Carnap coherence theory of truth Ayer stands essentially on Schlick's side and deals with this problem in a similar way. To begin with, he put forward the question: "Why should it be assumed that only one completely coherent system of propositions is conceivable?" However many empirical propositions we succeed in combining into an apparently self-consistent system we seem always able to construct a rival system which is equally extensive, appears equally

free from contradiction, and yet is incompatible with the first. Compare Schlick: "Anyone who takes coherence seriously as the sole criterion of truth must consider any fabricated tale to be no less true than a historical report or the propositions in a chemistry text-book, so long as the tale is well enough fashioned to harbor no contradictions anywhere."[34] And what Schlick said was recognized by Carnap and Hempel as well. They admit the possibility of inventing fictitious sciences and historical reports just as comprehensive and free from contradiction as those in which we actually believe. "But how then do they propose to distinguish the true systems from the false?"[35]

Carnap answered the question by saying that the selection of the true system does not depend upon any internal relation, but it can be carried out within the realm of descriptive syntax. This is to say that "the true system is that which is based upon true protocol propositions; and that true protocol propositions are those which are produced by accredited observers, including notably the scientists of our era."[36] This answer in Ayer's view does not remove the difficulty. The question is how are we to determine that a particular system is accepted by contemporary scientists except by appealing to the facts of experience. But once it is conceded that such an appeal is possible there is no longer need to bring in the contemporary scientists. For, as Ayer rightly said, "however great our admiration for the achievements of the scientists of our era we can hardly maintain that it is only with reference to their behaviour that the notion of agreement with reality has any meaning."[37]

Hempel has tried to avoid the difficulties of saying that the system of protocol statements which we call true may only be characterized by the historical fact that it is actually adopted by the scientists of our culture circle by asserting that we ought to express ourselves "formally" and say that a given statement is sufficiently confirmed by the protocol statements adopted in our science.[38] But Ayer said this does not remove the difficulty either. For we must ask in this case: how is it determined that the protocol statements which support the statements in question really are adopted in our science? If Hempel is really speaking "formally", then the phrase "adopted in our science" must be regarded merely as an arbitrary syntactical designation of a certain set of sentences but it cannot convey any information that the sentences expressed by these sentences actually are adopted. Putting an end to this controversy Ayer said, "the attempt to lay down a criterion for determining the truth of empirical propositions which does not contain any reference to 'facts' or 'reality' or experience has not proved successful. It seems plausible only when it involves a tacit introduction of that principle of agreement with reality which it is designed to obviate."[39]

IV

Schlick's analysis of the mental and physical is certainly very significant for the resolution of the mind-body problem in philosophy. In his subtle article "On the Relation between Psychological and Physical Concepts", he clarified the concept of physical space and the resultant distinction of psychological from physical space.[40] According to him the traditional view of the nature of the physical consists in a mixture of intuitive and conceptual elements which causes some paradoxes in the mind-body problem. Schlick pointed out that such paradoxes have been long acknowledged in the psycho-physical problem. For instance, there are contradictions in the localization of the mental states of affairs. It is well known that we do not localize extended color-patches, neither in an objective way outside us nor in the observer's brain. For in the context of physics both places are already occupied by unintuitable material processes. By this reasoning Schlick maintained that Descartes's dualism of mind and body is just metaphysical, like such other traditional forms of metaphysics as materialism or spiritualism.

Feigl designated Schlick's theory of mind and body as "psycho-neural identity theory" and remarked that it considers here one and the same real that is at one time immediately given and thereupon described in the qualitative and introspective language of acquaintance-psychology, and at another is, through indirect observation, characterized in the quantitative language of behaviorist psychology. Thus "brain-processes" of certain kinds and "occurrences of feeling" are not two realities, but merely two modes of designation for the same mental processes just as in dynamics molecular and kinetic terminology can be translated into macrophysical terminology. But that translatability is not a logical one, it depends solely on certain conditions of the real world. According to Schlick, the contradictions of the mind-body problem disappear if we avoid a mixture between the two languages, i.e., a mixture between intuitive and conceptual language. In this sense Schlick anticipated the essentials of the later physicalism of Neurath and Carnap in his early article "Ideality of Space, Introjection and the Psycho-Physical Problem" and in his 1925 *General Theory of Knowledge*.[41]

The basic ideas of physicalism of Neurath and Carnap were that statements which ostensively refer to experience of mental states of any kind whether one's own or anybody else's must be all equivalent to physical statements. As Carnap declared, or, as Neurath put it, a hypothesis expressed in mentalistic terms makes empirical assertions only if it can be translated into the language of physics. Thus, in his view, if a psychological or sociological hypothesis is expressible in the language

of physics, then it is accessible to objective scientific testing just like the physical statements. Yet how such translations are to be performed and how one is to determine whether a proposed physicalistic translation is correct were not elaborated in precise and explicit terms by Neurath, but only later by Carnap. Indeed, Carnap modified his version of physicalism gradually, and this led him to views which were less narrow than those of some of the other members of the Vienna Circle at that time.

Further, Neurath and Carnap maintained that physical language is "the basic language of all sciences", that it is a "universal language" comprehending the content of all other scientific language. In other words every sentence of any branch of scientific language is equivalent to some sentence of physical language and can therefore be translated, into the physical language without changing its meaning. Carnap has defined the concept of physical language as those sentences which attribute to a certain series of values of time-space coordinates a certain value of some definite physical function. Insofar as the rules are known for unique translation of sentences of qualitative characteristics into sentences of quantitative characteristics, there is nothing to prevent the physical language from containing characteristics of the former kind.[42]

As described above, there is no essential difference between Schlick and the physicalism of Neurath and Carnap. But we find such a difference in Ayer, once again difference which pulls him back from logical empiricism into traditional British empiricism. According to him sentences about physical objects as well as about everyday life are best formulated in such a way that they can be translated into sentences which refer exclusively to sense-content in the form that if I were to do such and such, I should experience such and such sense content. But it is well known that no set of statements about sense experience is equivalent to a statement about a physical object. Ayer concedes this absence of equivalence, but he asserts that it does not follow that the physical-object statements are about something other than sense contents. We can nonetheless in Hume's manner point to those relations between sense contents which induce us to construct out of our experience assertions about physical objects. Ayer wrote: "when we distinguish a given mental object from a given physical object, or a mental object from another mental object, or a physical object from another physical object, we are in every case distinguishing between different logical constructions whose elements cannot themselves be said to be either mental or physical."[43] It is very interesting to see that in his attempt to reinstate Hume, Ayer falls back essentially into Mach's doctrine of elements and Russell's theory of construction.

As for Carnap's physicalism, Ayer said, "I think he is mistaken", for in Ayer's view "statements about the experience of others cannot be

logically equivalent to statements about their overt behavior; while to maintain that the statements which one makes about one's own experiences are equivalent to statements about the publicly observable condition of one's body is, as Ramsey put it, to feign anaesthesia."[44] But Ayer thought that the difficulties which the thesis of physicalism was designed to meet remain and that it is not easy to see how else they can be evaded. He suggested, however, that "much of the trouble may arise from the acceptance of two false assumptions, the first being that for a language to be public it must refer to public objects, and the second that in making an empirical statement one is always referring to one's own experiences." As against these views, he held that "empirical statements must refer to experiences, in the sense that they must be verifiable; but the reference need not be to the experiences of any one person, as opposed to any other."[45]

In this context I wonder whether Ayer has noticed that his claim that empirical statements must refer to experiences in the sense that they must be verifiable but that the reference need not be to any experience of any one person, as opposed to any other, is in fact just what physicalists such as Neurath and Carnap have suggested. This is why they tried, on the one hand, to avoid empirical propositions either referring to public objects or to one's own experience, and confined themselves to protocol sentences, and on the other hand to use the expression "intersubjective" instead of "objective" and to employ the coherence theory of truth instead of the correspondence theory. But such views in any form would lead to conventionalism, and empiricism would have to be given up.

Feigl also called Schlick's solution of the mind-body problem a "two language theory". To construct it Schlick took the practical and logical operation of testing physical propositions as the key-point without regard to the intuitive notion of their meaning. Therefore, the question for him is not what sort of ideas we have in mind when speaking of the physical, but rather what sort of practical operation we undertake when testing physical propositions for their validity. According to him we can only by operation acknowledge the physical world, physical space, and the objective continuum. By the method of coincidences we form these concepts objectively and establish them as a basic conceptual system. The physical is thus not a part or perspective of reality, but rather merely a conceptual system of language well fitted for the systematic designation of states of affairs.[46]

Because physical language is so well adapted to description of inorganic nature, the physical is usually identified with the inorganic, thereby contrasting it dualistically with the organic. This paradox, however, in Schlick's view, would disappear if we paid enough attention, first, to not confusing the intuitive concept of the idea of the body with

the non-intuitive concept of a four-dimensional order and, secondly, to not neglecting the special operations involved in testing these propositions. Schlick as well as P.W. Bridgman maintained that all propositions are tested with respect to their truth or falsity by the performance of certain operations, and giving an account of the meaning of the propositions consists in specifying these operations.[47] Bridgman was the first who said precisely that this coordination consists in the description of physical operations, and that a theory which does not contain the operational definition of its abstract terms is meaningless.[48] In this sense he arrived at the concept of meaning and "meaninglessness" that was similar to the concept advanced by Carnap and the Vienna Circle.

A similar "psycho-neural identity" has been advanced by S.C. Pepper in his *Concept and Quality* (1966). This view was influenced by Feigl's theory of mental and physical, and by J.J. Smart and D.M. Armstrong. Even Pepper's formulation of his resolution of the mind-body problem in some respects resembles Schlick's earlier position. But the material identity theory of Smart and Armstrong in many respects does not agree with Schlick's psycho-neural identity theory. Ayer, however, in his *The Central Questions of Philosophy* (1973) criticized Smart's theory together with the psycho-neural theory as a whole without any distinction between them.[49] But the matter is too complex for description here.

<center>V</center>

Now I will deal briefly with some problems of ethics or philosophy of value. It is well known that the Vienna Circle as a whole was not much interested in this field, except for Schlick and Kraft. Carnap said in his *Philosophy and Logical Syntax* (1935) that "value judgements have no theoretical sense, therefore we assign them to the realm of metaphysics" (p. 26). Schlick disputed this view sharply in his *Fragen der Ethik* (1930), and seven years later Kraft's book *Die Grundlagen einer wissenschaftlichen Wertlehre* (1937) appeared. In it Kraft also dissented from Carnap's concept of value judgments and clearly pointed out: "In my theory of value I showed that there is present in value concepts not only the characteristic of value but also a factual content. . . . it is possible, making use of their connection with other judgements, to establish value judgements as valid."[50]

As for Schlick's view of Carnap's concept of value judgments, he wrote at the very beginning of his *Problems of Ethics* (an English translation by David Rynin was published in 1939): "If there are ethical

questions which have meaning, and are therefore capable of being answered, then ethics is a science." Schlick's position on ethics was not that of the majority of the Vienna Circle; some members even were directly opposed to him, for example, Carnap and Ayer. They did not regard ethics as part of science or ethical statements as having cognitive meaning. They held that such statements are not expressions of knowledge, but of a person's feelings or attitudes. And they distinguished between language that is descriptive and language that is prescriptive, imperative or emotive. On this view ethical statements are not subject to verification, and it makes no sense to speak of verifying an ethical statement, any more than to speak of verifying a poem or a prayer.

Although both Schlick and Kraft took utilitarianism as the basis of their philosophy of ethics and both refused to accept the emotive theory of values of Carnap and Ayer, still in their conception of the positive role of ethics they stand poles apart. According to Schlick ethics as a theoretical discipline can only be concerned with knowledge, not with positing a norm. What good is can only be found by reference to specific norms. Therefore, the so-called highest norms cannot themselves be justified; they must be accepted as facts of human life, and as such are only accessible to psychological and sociological investigation. Kraft, on the other hand, asserted: "Value judgements can take on objective validity, demanding universal acknowledgement, if the relevant attitude is made into a norm—if it becomes established, in a universally valid manner, what attitude *ought* to be adopted. . . . Hence these norms, and likewise the norms of knowledge, must be acknowledged by all who wish to achieve the ends in question. Value is determined by conformity or nonconformity to these ends."[51]

Ayer's theory of values or value judgments stands substantially near to Carnap, but sharply in contrast to Schlick and Kraft. He has distinguished four classes of ethical philosophy. "There are, first of all, propositions which express definitions of ethical terms, or judgements about the legitimacy of certain definitions. Secondly, there are propositions describing the phenomena of moral experience, and their causes.Thirdly, there are exhortations to moral virtue. And lastly, there are actual ethical judgements."[52] According to Ayer the whole of ethical philosophy consists in the first of the four classes, namely that which comprises the ethical propositions relating to the definitions of ethical terms. Ayer was not, however, as is usual in ethical philosophy, concerned to find a term which is to be taken as fundamental; what he was interested in was the possibility of reducing the whole sphere of ethical terms to non-ethical terms, i.e., in the question whether statements of ethical value can be translated into statements of empirical fact.

Ayer rejected utilitarianism, including that of Schlick and Kraft, subjectivism, absolutism, and naturalism as well because in his view their attempts to reduce either the whole sphere of ethical terms to non-ethical terms or non-ethical statements into ethical statements have without exception failed. For, in his view, what philosophers do not notice is that the presence of any ethical term in a proposition adds nothing to its factual content but only shows that it expresses certain moral feelings about certain actions or attitudes. In other words, in every case commonly the use of an ethical expression or moral judgment is to express feeling or sentiment about certain objects, not to make any assertion about them, it is merely emotive, not descriptive. Ayer maintained that the fundamental ethical concepts are unanalyzable inasmuch as there is no criterion by which one can test the validity of the judgments in which they occur. Ayer even said that on this point, he here agrees with the absolutists; their differences lie only in that he can explain why the fundamental concepts cannot be analyzed, whereas the absolutists cannot do this. In my opinion, however, Ayer's assertion is entirely senseless, for the absolutists as well as the intuitionists do not want any explanation at all for their assertions; otherwise, how could they become absolutists or intuitionists? For it is well known that everything for them is an affair of self-evidence.

In his later article on "Analysis of Moral Judgements" Ayer wrote near the beginning that "the view which I still wish to hold, that what are called ethical statements are not really statements at all, that they are not descriptive of anything, that they cannot be either true or false, is in an obvious sense incorrect. For, as the English language is currently used . . . it is by no means improper to refer to ethical utterances as statements. . . ." Nevertheless, continued Ayer, "when one considers how these ethical statements are actually used, it may be found that they function so very differently from other types of statement that it is advisable to put them into a separate category altogether. . . . [Yet, after all,] if someone still wishes to say that ethical statements are statements of fact, only it is a queer sort of fact, he is welcome to do so."[53] Ayer has done his best to demonstrate the queerness of moral facts in his paper, so that the reader will also believe that there are no really ethical facts at all and that moral judgments are not really statements at all. But, in my opinion, Ayer's arguments do not constitute a sufficient reason for his assertion.

TSCHA HUNG

PEKING UNIVERSITY
SEPTEMBER 1987

NOTES

1. Bryan Magee, *Men of Ideas* (London: British Broadcasting Corporation, 1978), p. 118.

2. Moritz Schlick, *Philosophical Papers*, ed. Henk L. Mulder and Barbara F. B. van de Velde-Schlick, Vienna Circle Collection, no. 11, 2 vols. (Dordrecht, Holland; Boston, U.S.A.; London, England: D. Reidel, 1979), 2:131.

3. Schlick, *Philosophical Papers*, 2:361–69, 370–87.

4. Rudolf Carnap, "Testability and Meaning," *Philosophy of Science* 3, no. 4 (October 1936) 420 and 4, no. 1 (January 1937).

5. Carnap, *Actes du Congrés international de philosophie scientifique, Sorbonne, Paris 1935* (Paris: Hermann & Cie., 1936), 4:19.

6. Alfred Jules Ayer, *Language, Truth and Logic* (London: V. Gollancz, 1936, 1946; reprint, New York: Dover Publications, 1952), p. 37.

7. Ayer, *Language, Truth and Logic*, pp. 135–36.

8. Morris Lazerowitz, "Strong and Weak Verification," *Mind* 48 (April 1939): 202–13.

9. Ayer, *Language, Truth and Logic*, pp. 10–11. Cf. "Verification and Experience," *Proceedings of the Aristotelian Society* 37 (1937): 137–56 and *The Foundations of Empirical Knowledge* (London: Macmillan, 1940, 1964), pp. 80–84.

10. Schlick, *Philosophical Papers* 2:380.

11. Ayer, *Language, Truth and Logic*, pp. 11–12.

12. Carl G. Hempel, "The Empiricist Criterion of Meaning" in A.J. Ayer, ed., *Logical Positivism*, Library of Philosophical Movements, edited by Paul Edwards, no. 2 (Glencoe, Ill.: Free Press, 1959), pp. 115–16.

13. Alonzo Church, Review of *Language, Truth and Logic* in *Journal of Symbolic Logic* 14 (1949): 52–57.

14. Alfred J. Ayer, "The Vienna Circle" in Eugene T. Gadol, ed., *Rationality and Science* (New York, Vienna: Springer, 1982), p. 50.

15. Ayer, "The Vienna Circle," p. 40.

16. Schlick, *Philosophical Papers*, 2:263–67.

17. Schlick, *Philosophical Papers*, 2:283.

18. Schlick, *Philosophical Papers*, 2:110–11.

19. Ayer, *Logical Positivism*, p. 19.

20. Ayer, "The Vienna Circle," p. 51.

21. Ayer, *Language, Truth and Logic*, p. 45.

22. Ayer, "The Vienna Circle," p. 52.

23. Rudolf Carnap, *Philosophy and Logical Syntax*, Psyche Miniatures, General Series, no. 70 (London: Kegan Paul, Trench, Trubner & Co., 1935), pp. 18–22.

24. Ayer, *Logical Positivism*, p. 26.

25. Ayer, *Logical Positivism*, p. 25. Quoted from Carnap's *Logische Syntax der Sprache* (Vienna: Springer, 1934), p. 233.

26. Ayer, *Logical Positivism*, p. 25.

27. Ayer, *Language, Truth and Logic*, pp. 90–92.

28. Ayer, "The Criterion of Truth," *Analysis* 3, no. 2 (1935).

29. Schlick, *Philosophical Papers*, 2:374–79.

30. Otto Neurath, *Philosophical Papers 1913–1946*, edited and translated by Robert S. Cohen and Marie Neurath, with the editorial assistance of Carolyn R.

Fawcett, Vienna Circle Collection, no. 16 (Dordrecht, Boston, Lancaster: D. Reidel, 1983) p. 102.

31. Schlick, *Philosophical Papers*, 2:273.

32. Ayer, "The Criterion of Truth," *Analysis* 3, no. 2 (1935):28–32.

33. Ayer, *The Problem of Knowledge* (London: Macmillan; New York: St. Martin's Press, 1956), pp. 34–43, 52–57.

34. Schlick, *Philosophical Papers*, 2:376.

35. Ayer, *Logical Positivism*, p. 233.

36. Ibid.

37. Ayer, *Logical Positivism*, p. 234.

38. Carl G. Hempel, "Some Remarks on Empiricism," *Analysis* 3, no. 3 (January 1936):39–40.

39. Ayer, *Logical Positivism*, pp. 234–35.

40. Schlick, *Philosophical Papers*, 2:420–31.

41. Schlick, "Ideality of Space, Introjection and the Psycho-Physical Problem" in *Vierteljahrsschrift für wissenschaftliche Philosophie und Soziologie* 40 (1916); English translation by Peter Heath in Schlick, *Philosophical Papers*, 1:190–206. Schlick, *Allgemeine Erkenntnislehre*, 1925. *General Theory of Knowledge*, Library of Exact Philosophy, no. 11, translated by Albert E. Blumberg (Vienna and New York: Springer, 1974), p. 293. Cf. Herbert Feigl, "The 'Mental' and the 'Physical' " in Herbert Feigl, Michael Scriven, and Grover Maxwell, eds., in *Concepts, Theories, and the Mind-Body Problem*, Minnesota Studies in the Philosophy of Science, vol 2 (Minneapolis: University of Minnesota Press, 1958), pp. 370–87.

42. Rudolf Carnap, "Die physikalische Sprache als Universalsprache der Wissenschaft," *Erkenntnis* 2:441–42.

43. Ayer, *Language, Truth and Logic*, p. 123. Cf. *Foundation of Empirical Knowledge*, p. 78–84.

44. Ayer, *Logical Positivism*, p. 21.

45. Ibid.

46. Schlick, *Philosophical Papers*, 2:426–32.

47. Schlick, *Philosophical Papers*, 2:424.

48. P.W. Bridgman, *The Logic of Modern Physics* (1927; new impression, New York: Macmillan, 1960), pp. 3–7.

49. Ayer, *The Central Questions of Philosophy*, Gifford Lectures at the University of St. Andrews in 1972–1973 (London: Weidenfeld and Nicolson, 1973), pp. 126–30.

50. Victor Kraft, *Foundations for a Scientific Analysis of Value*, edited by Henk L. Mulder, translated by Elizabeth Hughes Schneewind, with an introduction by Ernest Topitsch, Vienna Circle Collection, no. 15 (Dordrecht, Holland; Boston; London: D. Reidel, 1981), p. xv.

51. Kraft, *Foundations for a Scientific Analysis of Value*, p. 186.

52. Ayer, *Language, Truth and Logic*, p. 103.

53. Ayer, *Philosophical Essays* (London, Melbourne, Toronto: Macmillan; New York: St. Martin's Press, 1969), pp. 231–33.

REPLY TO TSCHA HUNG

Professor Tscha Hung has given a very thorough and fair account of the positions taken by prominent 'logical positivists', such as Schlick, Carnap, Neurath, and Hempel, in the 1930s, and of my own views as expressed in my *Language, Truth and Logic* and elsewhere, including some of my later writings. He is right in saying that even at the time I wrote *Language, Truth and Logic*, my philosophical outlook was closer to that of 'The Cambridge School of Analysis' than to that of The Vienna Circle, even though the relatively short period in which I attended meetings of the Circle and my study of its publications made a deep impression on me. As he remarks, my greater fidelity to the tradition of British empiricism was displayed by my paying more attention to the theory of knowledge than to what Carnap called the logic of science, and this has been increasingly the case in the course of my career. Not that I have abandoned my view that the best prospect for philosophy lies in its integration with science but my own lack of a scientific background has debarred me from pursuing this end. On the other hand, an intensive education in the Classics can be an asset in wrestling with the traditional problems of philosophy.

Tscha Hung writes that 'The Vienna Circle took the verification principle of Ludwig Wittgenstein as the criterion determining the meaning of a proposition and made it the starting point of their philosophizing'. This is true to the extent that the Circle's elimination of metaphysics did depend upon a principle of verification and its leaders and adherents, including myself, believed that our principle emanated from Wittgenstein. When one looks carefully, however, at the *Tractatus*, one sees that we were animated more by what we took to be Wittgenstein's spirit than by the actual text. Wittgenstein was very far from making it clear that his primitive 'objects' were required to be

observable, still less that they were of the order of sense-data: the most that can be claimed is that he did not rule these conditions out. Moreover, if he was a verificationist, his insistence that all molecular propositions were truth-functions of the atomic propositions committed him to what I called the strong version of the principle: there was no room in his system for the weak version which Carnap and I adopted. In sum, it can rightly be said that Wittgenstein followed Frege in equating the meaning of a statement with its truth-conditions. Whether he went on to equate such truth-conditions with 'methods of verification' is much more dubious.

It was the need to give precision to the weaker concept of confirmation that underlay my unsuccessful attempts to formalize a principle of verification. Carnap was later to show in his work on inductive logic that a concept of confirmation can be formalized in an artificial language. He did not try to formalize the concept of confirmation that we ordinarily employ when we speak of a series of observation statements as confirming a scientific hypothesis or a scientific theory. The continual failure of attempts to formalize this concept in such a way as to find a middle ground between the over-strict requirement of complete reducibility to observation and the over-indulgent licensing of gibberish does not oblige us to discard the concept or even to stop using it as a scientific touchstone. Even so, the need remains for it to be suitably defined. Throughout the years various proposals have been made to revise my principle of verification in such a way as to make it invulnerable to the objections which Church and Hempel brought against it. The problem has been to find an additional clause which will block the introduction of the 'irrelevant' statements that figure in their counter-examples. This is a technical problem which has, I believe, at last been solved by Professor Crispin Wright in his contribution to *Fact, Science and Morality*, a collection of essays by eleven different authors, appearing in 1986 to mark the fiftieth anniversary of the original publication of *Language, Truth and Logic*. His solution is too complex for me to set it down here. Unfortunately, as he himself points out, it has the consequence that every theoretical term in a fully verifiable theory must be analytically dependent, even if only ancestrally, on what we have selected as our observational vocabulary. This is weaker than the requirement of complete reducibility but it is still a stronger requirement than the more abstract scientific theories, currently in vogue, may be thought to satisfy.

The principle of verification, as I endeavoured to formulate it, served only to set out the conditions which a sentence needed to satisfy in order to be literally meaningful; it did not provide a means of determining

what literal meaning such sentences had. In Schlick's formula this further step was taken, but not very firmly. The formula fails to specify in what verification is held to consist, thereby leaving room for the dispute, of which Tscha Hung gives a good account, between the physicalists in the Circle and those, like Schlick, who carried the process down to the deliverances of immediate sense-experience. I have commented on my own vacillations concerning the status of these 'experiential' statements in my answers to Professors Park and Pears.

A serious defect in Schlick's formulation, on which I have remarked in my answer to Professor Dummett and elsewhere, is that one is left unclear whether the possibility of verification is relativized to the identity of the speaker, or auditor, with all the limitations that this would impose, or whether we can invoke the actual or notional aid of the best-placed observer. In *Language, Truth and Logic*, I took the former course, with the result that I provided an implausible analysis of statements about the past and an incoherent analysis of statements about the experiences of oneself and others. Consequently, I now prefer the more liberal option, while admitting that it raises difficulties of its own.

Tscha Hung quotes Schlick as maintaining that 'All answers to the question whether "the external world is real or only a logical construction", or the question "does an external world exist, or is the world only my sensation?" are . . . without any cognitive meaning and therefore metaphysical'. I agree that these are not empirical questions, but they need not be cast aside as metaphysical. They can and should be construed as questions of analysis. Thus in giving up the relativisation of Schlick's criterion of meaning to the identity of the speaker one is also relieved from the temptation to hold that statements about physical objects are equivalent to statements about 'my' actual or possible sensations. The phenomenalist thesis that 'the external world' is a logical construction out of sense-data is a consequence of the neutral monism, which Tscha Hung attributes to me. As I have pointed out in several of my replies, I long ago found reason to conclude that phenomenalism is not tenable in its classical form. Mr J.A. Foster's essay in this volume contains an excellent account of the sense in which I now hold that our picture of the external world is 'constructed' out of our sense-experiences. Another important question of analysis, which should not be dismissed as metaphysical, is that of the relation between our everyday statements which attribute phenomenal properties to physical objects and the very different set of statements that figure in high level scientific theories.

What did I mean by saying that there was 'a good deal' in Schlick's idea of distinguishing structure from content? What I had in mind was

that one does not need to vex oneself with the question whether the sensations and perceptions of other persons are of the same intrinsic character as one's own. If their behaviour bears out the expectations which I form on the basis of their utterances, I can safely interpret these utterances in terms of my own experiences. Now one way of putting this would be to say that so long as the structure of another person's 'world' is similar to that of my 'world', it would not matter if they were radically different in content. Here I am deliberately avoiding the question whether the very possibility of such a difference does not depend upon there being some means of detecting it.

Nevertheless I remain wary of Schlick's distinction between structure and content, mainly because it props up another distinction which I still regard as seriously mistaken. This is the dichotomy between cognition, which is supposed to convey 'objective knowledge' of the external world, and experience which is 'forever private' and therefore incommunicable. There must be a mistake here if only because we have no way of apprehending structure except through content. Moreover, if the verification of a statement ultimately consists, as Schlick rightly held, in the occurrence of the appropriate experiences, the experiences must be cognitive: the statements which record them purport to be true. Neither does the privacy of one's experiences prevent them from being communicable. I understand another person's description of his sensations just as well as I understand his description of his perceptions. If it is less easy to discover what another person is thinking or feeling than it is to discover what he is observing, the difference is only a difference of degree. The prevalent assumption that references to 'public' objects are unproblematic, as distinct from references to 'private' experiences, is based on a superficial treatment of the private-public distinction. I made this point in my reply to Professor Sprigge and elsewhere.

I do think that the resort to structural correspondence is insufficient on its own to ward off 'multiple solipsism'. Multiple solipsism, which is patently incoherent, is the fruit of an ill-starred attempt to avoid the absurdity of simple solipsism, the conclusion that I alone am conscious, or the skeptical position that I have no good reason to believe that anyone is conscious apart from myself. While I remain loyal to sense-datum theory, I do not believe that a sense-datum theorist can parry the onslaught of scepticism, if nothing worse, so long as he starts with a conception of sense-data as private entities. For not only does this rule out the possibility of translating statements about physical objects into statements about sense-data, but it prevents one even from 'positing' physical objects on the basis of sense experience. I now think that this weaker course is the one to adopt, but for that too it is essential that the

items with which one starts should be sensory particulars, or preferably universals, qualia, the occurrence of which is not restricted to the sense-fields of any one person. At a later stage when a theory of the physical world has been constructed it can be allowed to cannibalize its origins, so that then and only then the scrutiny of a sense-field can be treated as a private experience. I have outlined this procedure in my books *The Origins of Pragmatism* and *The Central Questions of Philosophy*.

Tscha Hung suggests that my insistence on the neutrality of the qualia which are my primitive items in the order of knowledge aligns my position with that taken by Neurath and Carnap in the nineteen thirties. This is not correct, as I do not believe that such neutrality commits me, as they believed that it committed them, to making my basic statements refer to physical objects. This became a mistake only when it led them to their coherence theory of truth, but from the outset it left them open to the charge described by Bertrand Russell as that of preferring the advantages of theft over honest toil.

I am pleased that Tscha Hung credits me with having refuted the version of the coherence theory of truth which Neurath foisted on Carnap and Hempel, and that he has been convinced by my argument that Carnap's transposition of philosophical statements into the formal node requires that they be construed as semantic statements and not as syntactical statements in the way that Carnap originally supposed.

Tscha Hung appears to agree with me that no set of physical statements can be logically equivalent to a mental statement, which debars him from accepting a two-language solution of the mind-body problem, at least in its strongest form. Since he refrains from discussing the currently fashionable view that mental states are contingently identical with states of the brain I shall be content to say that the attribution of such diverse properties to one and the same event might be defended on grounds of economy if we were able to correlate mental and physical phenomena at the level of the types which they instantiated, but, as it is, I do not see any justification for claiming anything more than the causal dependence of mental states upon the states of the subject's brain. Indeed, it is not clear to me what is being claimed when it is said that they are identical as tokens, without there being a one-to-one relation of their types.

I had not realized that Schlick had anticipated Bridgman's operationalism. Tscha Hung does not state his views of operationalism with which it would be convenient for me to agree were it not that I fail to see how complex scientific theories can simply be equated with a description of the observations that would confirm them. For one thing the range of

these observations is not sharply delineated; and for another the road from theory to observation can be very long and winding. However, when the terms of a theory are related only very indirectly to possible observations, it is tempting to regard the theory as a means of accounting for and generating observations, rather than as something which is literally descriptive of what there really is.

When it comes to moral philosophy, I think that it would now be generally agreed that utilitarianism should not be regarded as offering a definition of ethical terms but rather as recommending a moral code. We are to do what will most probably result in bringing the most satisfaction to those whom our actions affect, where satisfaction is measured in terms of the fulfillment of desires. This frees the theory from Bentham's and Mill's false assumption that only pleasure can be desired and thereby increases its attraction. To a large extent I am in favour of the policy which it recommends but I cannot get over the objection that some predominant desires, such as the desire of most members of a given society to persecute some minority within it, should not be fulfilled, and that the theory countenances the condemnation of an innocent man, if this can be shown to serve the interests of the community. In short, I attach an independent value to justice and to the maintenance of certain human rights.

It is misleading for Tscha Hung to say that in adopting my emotive theory I held that the fundamental ethical concepts were unanalysable. I did hold that they were not descriptive but I regarded my account of their function, in expressing the author's moral sentiments and encouraging others to share them, as a way of analyzing them. I should now say that the best reason for preferring an emotive or prescriptive theory of ethics to a subjective theory which analyses moral judgements in terms of what meets with the moral approval of the speaker or of the prevailing moral sentiments in the society to which he belongs, is that it seems obvious that in making a moral judgement one is not actually mentioning oneself or one's society. For this reason, a non-cognitive theory is an improvement on traditional subjectivism.

I now think that my use of the word 'emotive', which I borrowed from Ogden's and Richard's *The Meaning of Meaning*, was not a felicitous way of characterizing the expression of moral sentiments, and I also think that I did not lay enough stress on the prescriptive element in our moral judgements. A more serious defect in my original handling of the topic was my overlooking the fact that the majority of our everyday moral judgements turn out to be descriptive, inasmuch as they presuppose the acceptance of a set of moral standards and state that some person or action or course of conduct, or situation, measures or fails to measure up

to them. It is to be noted that this allies the moral with the non-moral uses of the word 'good'; for instance, a good athlete is one whose performances come up to standard or even set a new mark. It is only when our moral standards themselves are put in question, as they sometimes are, that the emotive account of ethical terms, as I am still calling it, comes into the picture.

Tscha Hung remarks that my arguments have not supplied a sufficient reason for my denying truth-values to moral judgements, when they are not put forward under the presupposition of some set of moral standards, but he does not give any grounds for holding them to be deficient; and he does not attempt to justify his own preference for speaking of ethical facts.

A.J.A.

11

Peter Kivy

"OH BOY! YOU TOO!": AESTHETIC EMOTIVISM REEXAMINED

On the subject of aesthetics Sir Alfred Ayer has had but little to say; and it is surely a mark of the esteem in which he is held as a philosopher that even so small a contribution should be thought important enough to merit discussion in a volume devoted to his work. Perhaps, too, the inclusion of an essay on aesthetics in this collection is a mark of the philosophical respectability that that discipline has so recently attained: it would have been quite unthinkable twenty years ago.

My task, however, is a formidable one. For in a lifetime devoted to philosophy, Ayer has, so far as I know, written scarcely a word about aesthetics, and, indeed, confesses that, at least up to the ninteen-forties, he had little enthusiasm for it.[1] So the subject of Ayer's aesthetics seems almost as close to being a non-subject as the physiology of unicorns. Nevertheless, the emotive theory of ethics, to which Ayer still (as of 1985) more or less subscribes, has always been claimed by its devotees, Ayer included, to be applicable, *pari passu*, to aesthetics as well. It is this claim that I take as license for "constructing," partly by implication and partly, I am afraid, by imagination, an emotivist aesthetics that Ayer might recognize, if not adopt. And it is this claim that, I want to argue, is misguided: not that the emotive theory of ethics is wrong, or even that its aesthetic counterpart is, but, merely, that there are some reasons, not necessarily conclusive ones, for thinking that we cannot go as easily as ethical emotivists seem to assume we can, from the one to the other; that, indeed, a certain part of the plausibility of emotivism as an ethical doctrine is absent when it is transferred to an aesthetic context. I have argued this before;[2] and will have to repeat some of that argument again here. But as few people read my earlier essay, and none of those few, I

suspect, will be reading the present one, this will not be a problem. In any case, my earlier venture into aesthetic emotivism dealt exclusively, so far as Ayer was concerned, with *Language, Truth and Logic*. I now want to bring the argument up to date by looking at what implications for aesthetic emotivism Ayer's later essays on ethics might have. But: first things first; and so, I am afraid, *Language, Truth and Logic* once again.

I

The fullest statement that Ayer has ever given (so far as I know) of the passage from ethical to aesthetic emotivism occurs in Chapter VI of *Language, Truth and Logic:* "Critique of Ethics and Theology." I will quote it in full (from the second edition). Ayer writes:[3]

> our conclusions about the nature of ethics apply to aesthetics also. Aesthetic terms are used in exactly the same way as ethical terms. Such aesthetic words as 'beautiful' and 'hideous' are employed, as ethical words are employed, not to make statements of fact, but simply to express certain feelings and evoke a certain response. It follows, as in ethics, that there is no sense in attributing objective validity to aesthetic judgements, and no possibility of arguing about questions of fact. A scientific treatment of aesthetics would show us what in general were the causes of aesthetic feeling, why various societies produced and admired the works of art they did, why taste varies as it does, within a given society, and so forth. And these are ordinary psychological or sociological questions. They have, of course, little or nothing to do with aesthetic criticism as we understand it. But that is because the purpose of aesthetic criticism is not so much to give knowledge as to communicate emotion. The critic, by calling attention to certain features of the work under review, and expressing his own feelings about them, endeavours to make us share his attitude towards the work as a whole. The only relevant propositions that he formulates are propositions describing the nature of the work. And these are plain records of fact. We conclude, therefore, that there is nothing in aesthetics, any more than in ethics, to justify the view that it embodies a unique type of knowledge.

Four points, to be mentioned straightaway, are crucial for the discussion to follow.

(1) What we would describe as aesthetic terms of an evaluative kind, for which Ayer uses the examples, "beautiful," and (its opposite) "hideous," are used exactly the same way as evaluative words are employed in ethics.

(2) These evaluative aesthetic terms do not refer to objective matters of fact but, rather, express certain feelings, either pro or con; and

(3) evoke certain responses, presumably as part of their "meaning," or, in any event, as part of their normal "function," which is to say that

the purpose of aesthetic criticism is not to give knowledge but to communicate emotion.

(4) The only propositions, as opposed to expressions of emotion cum exhortations, that play a part in aesthetic criticism are descriptions of the nature of works of art, which are plain matters of fact.

Given these premisses concerning aesthetic evaluation, which, I hope, will become somewhat more refined as we progress, the questions that will principally occupy us in the rest of this essay will center on the matter of critical "argument." That is to say, we will want to enquire whether these four premisses, taken together, can give us a plausible account of how critics try to get their attitudes shared by others, and, a more perplexing matter, *why* they should do so. To anticipate, my conclusion will be that there are serious problems in these regards. Whether they are insurmountable I will not venture to say. I merely suggest that they are in need of a solution if aesthetic emotivism is to gain credence as a viable account of critical activity. We must begin, however, by looking at the way moral disputation is generally represented by Ayer; for as ethical emotivism is supposed to transfer, point for point, to aesthetic contexts, that will have to be where we find a model for what critics do when they "argue."

Two questions would quite naturally come to mind in this regard. *Why* do we take part in ethical disputes? And *how* do we convince our opponents?

The direct purpose of ethical argumentation is implied in the exhortative moment of moral value terms: what the late Charles L. Stevenson called their "quasi-imperative" part. These terms evince our approval; but they also urge our attitudes upon others. "I approve; do so as well," was Stevenson's rough analysis of "good," and Ayer already anticipated this kind of analysis in *Ethics and Language*. And if it is asked, further, what the indirect purpose of moral discourse is—*why*, that is, one should want to urge one's attitudes upon others—the answer, clearly, is to motivate them to action. For our attitudes towards states of affairs will, of course, determine, in part, whether or not we will take steps to bring them about, or take steps to prevent them. As Ayer says:[4]

It is worthy of mentioning that ethical terms do not serve only to express feeling. They are calculated also to arouse feeling, and so to stimulate action.

Now whatever else, for or against, may be said about the emotive theory of ethics, it does pay its dues to the connection we suppose there to be between moral discourse and moral behavior. For my "winning" a moral argument—"convincing" my opponent of the rightness of my

ethical views—is finally, according to the emotivist, getting him or her to have my emotional attitude towards some person, or state of affairs, or whatever, and, hence *ipso facto*, getting him or her to have a motive for behaving in one way or another.

The question of *how* I bring my opponent to share my emotive attitude is bound up with the question of what we are really disagreeing *about*, besides disagreeing in attitude towards someone or something. On Ayer's view, in *Language, Truth and Logic*, we are usually disagreeing about factual matters which, if they are straightened out, will lead to attitudinal agreement as well.

> When someone disagrees with us about the moral value of a certain action or type of action, we do admittedly resort to argument in order to win him over to our way of thinking. But we do not attempt to show by our arguments that he has the 'wrong' ethical feeling towards a situation whose nature he has correctly apprehended. What we attempt to show is that he is mistaken about the facts of the case. We argue that he has misconceived the agent's motive: or that he has misjudged the effects of the action, or its probable effects in view of the agent's knowledge; or that he has failed to take into account the special circumstances in which the agent was placed. Or else we employ more general arguments about the effects which actions of a certain type tend to produce, or the qualities which are usually manifested in their performance. We do this in the hope that we have only to get our opponent to agree with us about the nature of the empirical facts for him to adopt the same moral attitude towards them as we do.[5]

We may say, then, that the emotive theory of ethics provides a two-faceted account of what goes on in ethical argumentation. It provides, in the quasi-imperative, a motive, or, if you will, a rational explanation for why we do not just express our preferences and aversions, and leave it at that, the way people frequently express their preferences or aversions in respect to foods, or amusements, or trivial pursuits of various kinds, without a thought of persuading others to their tastes. It is bound up, of course, with the whole fabric of morality: its purpose of directing and controlling human action. We not only express our moral "preferences" and "aversions," but say "do so as well!"—because getting others to share them will be a step towards getting them to *behave* in the ways that we think optimal.

It provides, also, ample field, not just for persuasive rhetoric but for "rational argumentation," to the extent that ethical disagreement is the result of disagreement about factual matters. Because these factual matters are complicated, and seldom easy to make out, there is a good deal of room, in moral discourse, for what, on any philosopher's view, would be questions of "truth" or "falsity."

I shall not be concerned, in the present paper, except in a tangential way, with the question of whether there is a very direct analogue, in

aesthetics, for the "factual" matters that ethical disputes so obviously involve. I do believe there are problems here, and I raised some of them in my earlier paper on emotivism in aesthetics;[6] but I do not wish to pursue that topic any further here. Rather, I want to concentrate on the quasi-imperative aspect.

Basically, as I see it, the problem is this. If ethical emotivism were offered without its imperative part, analyzing "good" as merely an expression of approval, as (say) it might be analyzed in "tastes good," it would certainly fail to capture a very fundamental aspect of moral discourse: its disputatious character; the very clear function that it has, which mere expressions of taste do not, of *convincing* others. But aesthetic discourse *also* has that function; the amount of time and energy devoted to discussion of the arts, informally and in print, quite convincingly attests to that. Aesthetics has its "You too!" as well as its "Oh boy!," as mere expressions of culinary approval do not. "The judgement of [aesthetic] taste," Kant observed, "exacts agreement from everyone; and a person who describes something as beautiful insists that everyone *ought* to give the object in question his approval and follow suit in describing it as beautiful."[7] However, we are at somewhat of a loss to explain *why* aesthetic discourse should have this imperative part, and its disputatious, other-directed character, if aesthetic value judgments were, besides being quasi-imperatives, merely expressions of aesthetic approval and nothing more. The analogy with moral discourse here seems to break down. We can quite understand why the expression of moral approval should, at the same time, be an exhortation to agreement. My end, in expressing my moral attitude, is to get others to act in certain ways; for it lies close to the heart of the whole institution of morality that it protect various interests, prevent injury, promote human welfare, insure fair treatment, and so on. Where is the analogue in aesthetics, to explain the existence of "aesthetic imperatives"? Why should I be the least bit interested in exhorting others to share my aesthetic tastes and attitudes, when no interest of mine or anyone else's depends upon it; where no course of action, of any concern to anyone involved, would be seen to be motivated by it? That is the question that I want to examine more fully here. And I can begin to further that examination by looking at Ayer's later statements of ethical emotivism.

II

That the disputatious character of *all* ethical discourse could be accounted for, in any obvious way, by its action guiding function came early into doubt, and this was frequently made capital of by critics of

ethical emotivism. The criticism basically was this. It may be the case, for instance, that I intend to influence actions by saying to a prospective cannibal, in Flanders and Swan's immortal words, "Eating people is wrong," and trying to get him to share my attitude by ethical "argument," the point being that if he comes to share my attitude, this will, *ipso facto*, at least partially motivate him not to make me part of the table d'hote. But what possible action am I trying to initiate or prevent by making a moral judgment on an event or personage in the distant past, and attempting to *convince* someone to share my moral attitude? I cannot prevent an action that took place in ancient Rome, or hope to reform the dead. Yet my moral pronouncements, in such contexts, do not fail to be argued for.

In reaffirming his commitment to ethical *and* aesthetic emotivism, in 1949, Ayer attempted to answer such objections. Still defending the position "that moral judgements are emotive rather than descriptive, that they are persuasive expressions of attitudes . . . ,"[8] he wrote:[9]

> Of course there are many cases in which one applies an ethical term without there being any question of one's having to act oneself, or even persuade others to act, in any present situation. Moral judgements passed upon the behaviour of historical or fictitious characters provide obvious examples. But an action or a situation is morally evaluated always as an action or a situation of a certain kind. What is approved or disapproved is something repeatable. In saying that Brutus or Raskolnikov acted rightly, I am giving myself and others leave to imitate them should similar circumstances arise. I show myself to be favourably disposed in either case to actions of that type. Similarly, in saying that they acted wrongly, I express a resolution not to imitate them, and endeavour also to discourage others.

Whatever the merits of this as a reply to the objection that moral judgments upon fictitious or historical figures and events cannot be action provoking in the way required by ethical emotivism, it clearly will be nothing to the purpose as regards a similar objection brought against aesthetic value judgments: that is to say, the objection that aesthetic judgments are not action guiding. For it relies upon reducing moral judgments that do not seem action guiding to ones that are; whereas it does not seem to make sense to say that *any* aesthetic value judgments are action guiding (except for very trivial cases). Perhaps I am obliquely recommending political assassination as a morally justifiable policy by calling Brutus a good man, but it is hard to see what action I am endorsing by calling *Julius Caesar* a good play. There are, of course, circumstances that can be thought up where one might locate such an action: uttered to a producer, a director might be urging its mounting; uttered by a playwright, it might be taken as a recommendation of how to write plays. But I doubt such cases, multiplied within reason, could

sustain the imperative nature of aesthetic value judgments; for where action is absolutely central to the institution of morality, it is, at most, peripheral to the institution of aesthetic criticism.

Perhaps, then, we should simply drop the imperative moment of the aesthetic analysis altogether, and render "beautiful" or "aesthetically valuable" merely as "I approve." But then aesthetic value judgments just collapse into judgments of taste *simpliciter*—likes and dislikes—and the disputatious character of aesthetic discourse is left to dangle uselessly, without a reason, or even an explanation for being. (I shall return to this later on.) So let us try a different tack.

III

In another place in the 1949 essay on ethics, Ayer writes:[10]

> To say, as I once did, that these moral judgements are merely expressive of certain feelings, feelings of approval or disapproval, is an over-simplification. The fact is rather that what may be described as moral attitudes consist in certain patterns of behaviour, and that the expression of a moral judgement is an element in the pattern. The moral judgement expresses the attitude in the sense that it contributes to defining it.

Now it might be thought that this passage is really quite damning of aesthetic emotivism, for it brings out, in a new and quite vivid way the intimate relation between emotive language and human action, not merely, as in the earlier version in *Language, Truth and Logic*, representing moral attitudes as motives to action but as themselves "patterns of behaviour." But if moral attitudes are supposed to have their analogues in aesthetic attitudes, then, I suppose, aesthetic attitudes are also to be seen as "patterns of behaviour." Does this make sense? Do people who have a positive attitude towards Bach's music tend to behave differently from those who have a negative one? Well, in a way they do: they buy phonograph records of Bach, they play them a lot, they go to concerts where Bach's music is performed, and so on. But why in the world should anyone have a stake in influencing such attitudes, such "patterns of behaviour"? (I put aside the trivial case in which someone might profit, for example, from the sale of records or musical scores.) Why should critics waste their time trying to "argue" that Bach's music is good? Moral persuasion is vigorously engaged in because the kinds of actions it is addressed to profoundly affect our lives and well being. Aesthetic persuasion is also vigorously engaged in. However, it is hardly plausible to argue that this can be explained in the same way. Whatever patterns of aesthetic behavior may be implied by our aesthetic attitudes, they hardly

seem to penetrate very deeply into the human condition or, therefore, warrant all the fuss and feathers of aesthetic disputation.

But perhaps we have moved too quickly to trivial examples of "aesthetic behavior" when more profound ones might be available. Might it not be that taste in the arts has deeper implications for human character and behavior than what records we listen to, or what museums we visit? Might it not be the case that a taste for the sublime sense of order, structure, and craftsmanship in Bach's music would contribute to the forming of a more steady, reliable character than taste for the Romantic excesses of Wagner would do? Or, perhaps more plausibly, wouldn't reading the *Divine Comedy* or *Paradise Lost* be more morally uplifting than reading the *Fleur du mal?*

Well, merely stating the conjecture seems enough to refute it. There is, as we know perfectly well, absolutely no evidence of a connection between taste and morality. To be told that someone prefers Bach to Wagner, or Milton to Baudelaire, is to tell us absolutely nothing about whether this person would be a more trustworthy friend, or a more upright citizen than someone with the opposite preference. But, more to the point—since the question is not whether aesthetic disputes are based on plausible reasoning, or any reasoning at all, but whether emotivism can give us a plausible account of what is going on when critics "argue"—there is absolutely no evidence to show that the kinds of moral considerations I have been talking about play a major role in critical disputes. And "modern" criticism tends to reject them, when they do obtrude, as "aesthetically irrelevant." Surely there is not enough substance here to support the institution of critical discourse. It is clear what kind of behavior moral discourse is intended to promote or discourage, and how important a goal that is. There is no such plausible connection either between aesthetic discourse and "aesthetic behavior," or between it and moral behavior.

Of course, this is not to say that there are no "schools" of moral criticism, Platonic for one, Marxist for another, that endorse critical arguments basically directed towards the moral (or immoral) aspects of art works, and, hence, plausibly thought of as action directed, at least obliquely: i.e. recommending certain kinds of behavior by recommending certain works that put such behavior in a good light. But it is far different to have isolated pockets of critical argument that might be thought of, or thought by some, to be action guiding, and to have a whole institution, moral discourse, agreed upon by all hands to have action guiding as one supremely important function. And it is the latter kind of thing that one needs, if the quasi-imperative aspect of evaluative discourse is to provide a plausible base for the existence of evaluative "argument."

But, to take a final stab at it, perhaps, in becoming fixated on the action directed character of moral discourse, we have missed another important aspect. R.M. Hare, in *Freedom and Reason*, makes a distinction between the kind of moral arguments, basically utilitarian, that would evaluate two possible future states of affairs in terms of comparative utilities, and the kind that would evaluate two possible future states of affairs as what he calls "moral ideals." In the latter case, there is nothing to choose, between two states of affairs, as regards total sum of happiness, welfare, or whatever. One merely has a preference; one envisions them imaginatively, and is drawn to one or to the other. Here, by way of example, is what Hare has in mind.[11]

> The leader of a Himalayan expedition has the choice of either leading the final assault on the mountain himself, or staying behind at the last camp and giving another member of his party the opportunity. Here it is obvious that different ideals will conflict; yet it is easy to suppose that no argument concerned with the interests of the parties will settle the question—for the interests may be very precisely balanced. The questions that arise are likely to be concerned, not with the interests of the parties, but with ideals of what a man should *be*. Is it better to be the sort of man who, in face of great obstacles and dangers, gets to the top of the *n*th highest mountain in the world; or the sort of man who uses his position of authority to give a friend this opportunity instead of claiming it for himself? These questions are very like aesthetic ones. It is as if a man were regarding his own life and character as a work of art, and asking how it should best be completed.

Now, mightn't it be that when I praise Bach's music I am, among other things, envisioning a state of affairs in which men and women generally are of the sort that admire Bach, comparing it (say) to one in which, rather, people generally admire punk rock and advertising jingles, and saying of the former, "*This* is the way men and women ought to be!" Aesthetic evaluations might be taken, then, to be expressions of moral ideals (broadly speaking); and although I prescribe no action in expressing them, they are in some sense or other imperatives: I do not merely say "I approve of men and women admiring Bach!" but "Let there be such men and women!" as well. I am not sure I quite understand why an expression of approval of a moral ideal such as this should be an imperative as well, inasmuch as neither my interest, nor the interest of anyone else is, by hypothesis, involved at all; but it does seem intuitively obvious to me that such expressions are imperatives, and I will have to leave it at that.

Further, it *does* seem to me that there *is* some element of this in aesthetically evaluative discourse. I *do* think something like what Hare calls "moral ideals" are sometimes implicitly at stake in aesthetic criticism. And to that extent I think we now have uncovered a genuinely convincing example of aesthetically persuasive language. I am not by any

means convinced, however, that it can sustain the whole institution of criticism and aesthetic argumentation. At least appearances are against its being the whole ball of wax. If it were, a large part of what critics do would be pointless. Perhaps it is pointless; but if it is, the theory of valuation that implies it at least owes us an account, in the form of an explanation, of *why* a pointless "language game" should have arisen and endured. And this takes us in a new direction worth exploring.

IV

In his most recent consideration of ethics, "Freedom and Morality"— his 1983 Whidden lectures at McMaster University—Ayer considers the objection to emotivist ethics that it is quite at variance, as an analysis of moral discourse, with what people take themselves to be doing when they engage in it. As Ayer puts the objection,[12] it is that

> the emotive theory of ethics was put forward as an account of the way in which ethical terms are ordinarily used . . . and that most people do not believe that when they make moral judgements of the kind envisaged by the emotive theory, they are merely expressing their moral sentiments and encouraging others to share them. What most people believe, it is alleged, is that such judgements are genuinely assertions. They are ascriptions of absolute values. If true, they are made true by objective ethical facts.

What I should like to bring out here, for present purposes, is the underlying distinction between what we are "really" doing when we engage in moral discourse, when we use ethically evaluative terms, and what we think we are doing. What it might mean to tell us what we are "really" doing as opposed to what we think we are doing in using language is, obviously, a very sticky point. What Ayer thought he meant is summed up this way:[13]

> I was satisfied if the theory fitted the circumstances in which ethical terms were actually used, when they were employed in what might be called an absolute fashion. Whether most people believed that their linguistic habits conformed to my theory was a question that did not greatly trouble me.

In any event, I will leave that question alone. What interests me is the distinction itself, and, particularly, the notion that (according to the opponents of emotivism) what we believe we are doing when we engage in moral discourse is describing "objective" moral values. Perhaps the same is true for evaluative aesthetic discourse: that is to say, perhaps what people who evaluate things aesthetically *think* they are doing is describing "objective" aesthetic values; predicating beauty of things in

the belief that beauty is an "intrinsic" property of the world. And if that were the case, might it not explain, although not justify the persuasive, disputatious aspect of aesthetic criticism? The argument would go something like this. When I say "X is good," in a moral context, it can be analyzed, on the emotive theory, into (very roughly) "Oh boy! You too!," where the plausibility of the quasi-imperative, the "You too!," devolves on the practical interests we have in altering the attitudes and (hence) the actions of other people. When I say "X is beautiful," the emotivist also wants to render it "Oh boy! You too!"; but here the action guiding function is not present to make the "You too!," and hence aesthetic argumentation, clearly aimed at altering people's aesthetic attitudes, understandable as a linguistic institution. So here we resort to the mistaken belief people are supposed to have about what they are "really" doing when they say things are beautiful, hideous, and so forth. Since they mistakenly believe not that they are merely expressing their attitudes but actually describing objective states of affairs, they naturally try to convince other people, feel justified in doing so, just the way they would if they were expressing their scientific opinions, or their opinions about ordinary "matters of fact."

Three questions are quite naturally going to arise with regard to this argument. One, clearly, is going to be whether, in fact, people really do think they are predicating "objective" properties of things when they call them "beautiful" and the like. Hume thought that "common sense," as he called it, was divided on the issue, one "species" of it acquiescing in the aesthetic subjectivism of *de gustibus non disputandum est*, another inclining towards the notion that, as Hume put it, "Whoever would assert an equality of genius and elegance between Ogilby and Milton, or Bunyan and Addison, would be thought to defend no less an extravagance than if he had maintained a mole-hill to be as high as Teneriffe, or a pond as extensive as the ocean."[14] But this is, I suppose, as Ayer suggests the analogous question with regard to moral language is, a sociological one,[15] and I am not going to bother about it. I will merely assume, for the sake of argument, that many people do in fact think they are ascribing real properties to things when they "describe" them aesthetically.

The second question that must naturally arise is whether, in fact, people are mistaken in believing that aesthetic properties are "objective," intrinsic properties of the world. And the third is whether the true or false belief that they are will in fact provide a plausible explanation for why people try to persuade other people to acquiesce in their aesthetic attitudes. These two questions I do want to examine.

V

We owe to the late J.L. Mackie, as Ayer acknowledges, the calling to our attention the importance of carefully keeping linguistic questions of what ethical language means apart from what he calls the metaphysical question of whether or not ethical values are "objective," a question he answers in the negative. Ayer finds his "reasoning persuasive" on this regard.[16]

Mackie, like Ayer, is committed to the view that questions of an ethical kind do not concern matters of fact; and, like Ayer, he thinks that the ethical analysis will transfer to aesthetic properties in a trouble free manner. Thus, he writes:[17]

> The claim that values are not objective, are not part of the fabric of the world, is meant to include not only moral goodness, which might be most naturally equated with moral value, but also other things that could be more loosely called moral values or disvalues—rightness and wrongness, duty, obligation, an action's being rotten and contemptible, and so on. It also includes non-moral values, notably aesthetic ones, beauty and various kinds of artistic merit. I shall not discuss these explicitly, but clearly much the same considerations apply to aesthetic and to moral values, and there would be at least some initial implausibility in a view that gave the one a different status from the other.

Mackie uses two arguments to try to establish that ethical values are "subjective." They are the familiar "argument from relativity," and what he calls the "argument from queerness." I take it as an implication of the passage quoted above that both arguments establish also, on Mackie's view, the thesis of aesthetic "subjectivity." And I am not going to deny that they do. Rather, I want just to suggest that here, as elsewhere, we cannot simply assume, as if it were trivially true, that the arguments transfer point for point, from ethics to aesthetics. That, it seems to me, has to be argued for; and I do not think that what Mackie says about the relativity and "queerness" of ethical "properties" has nearly the same initial plausibility for aesthetic ones.

Mackie's version of the "argument from relativity" goes like this. There are, both within a single culture, and cross-culturally, disagreements about moral codes. There are, of course, disagreements about scientific, historical, and other objective, non-relativistic questions as well: disagreement alone proves nothing.

> But such scientific disagreement results from speculative inferences or explanatory hypotheses based on inadequate evidence, and it is hardly plausible to interpret moral disagreement in the same way. Disagreement about moral codes seems to reflect people's adherence to and participation in different ways of life.[18]

In other words, "the argument from relativity has some force simply because the actual variations in the moral codes are more readily explained by the hypothesis that they reflect ways of life than by the hypothesis that they express perceptions, most of them seriously inadequate and badly distorted, of objective values."[19]

Now without carrying the argument from relativity any further, let me suggest that at this stage, at least, it is far less plausible as a case against the objectivity of aesthetic values than it is as a case against the objectivity of ethical ones. That, quite simply, is because it is a much more plausible hypothesis that actual variation in aesthetic judgments, at least certain kinds of the cross-cultural ones, *are* the result of seriously inadequate and badly distorted perceptions of objective aesthetic qualities than the hypothesis that they are reflections of dramatically opposed ways of life. When a Western musician finds Indian ragas a meaningless jangle, and his Indian counterpart judges likewise of Beethoven, it is surely much more like my being unable to read an X-ray than like my failure to share another's way of life or moral ideal; and it is surely more plausible to say that the Western musician is failing to perceive things in the ragas that are "really" there, and that the Indian musician does perceive, and likewise for the Indian's failure with Beethoven. And just as I can learn to read an X-ray, I can learn to "read" a raga, and an Indian to "read" the *Eroica* (they have—and to conduct it as well).

The point is not that arguments from relativity are impotent against aesthetic absolutes: it is that *this* argument from relativity is, and it is a mistake to merely assume that it will do, without more working out. It is a mistake that ethicists continually repeat when they claim, without any further considerations at all, that this ethical argument, or that one, will apply, *pari passu*, to the aesthetic counterparts. It is a kind of philosophical put down, all too familiar, and seldom borne out by a close scrutiny of the relevant facts.

The same, although perhaps somewhat less forcefully, can be said for the "argument from queerness." According to this argument, there is something, so to say, prima facie strange about the kinds of qualities moral values would have to be if they were "objective," and likewise the kind of faculty that would have to be postulated to perceive them.

> If there were objective values, then they would be of a very strange sort, utterly different from anything else in the universe. Correspondingly, if we were aware of them, it would have to be by some special faculty of moral perception or intuition, utterly different from our ordinary ways of knowing everything else.[20]

Now to the extent that the argument from queerness is simply an appeal to our reactions, upon inspection, to the concepts of "moral

quality" and "moral intuition or perception," it might be countered, on behalf of aesthetics, that the concept of "aesthetic quality" comes off somewhat better when the same test is performed, and even that it might not be necessary to invoke the concept of a special aesthetic faculty at all. For if my perceiving of the musical coherence of the *Eroica*—which is to say, merely perceiving it, on a not necessarily expert level, as a piece of music—is something like my orthopedist's perceiving in my X-ray the thinning of the disc between my third and fourth lumbar vertabrae, and if my failing to perceive the musical coherence of Indian ragas is something like my failing to see what my orthopedist sees, then it doesn't seem that the argument from queerness is going to have the same force here. For the "quality" of coherence in music is no more mysterious than the "quality" of the X-ray; and the answer to the question, What "faculty" perceives these "qualities"?, in the case of X-rays, is not "intuition," but "eyes, mind, talent, training," and the answer, in the case of the *Eroica*, is "ears, mind, talent, training."

Of course, if we press the analogy, and pursue the argument from queerness further, we may perhaps find ourselves in similar difficulties in aesthetics to the ones in ethics. And if that proved to be the case, we would perhaps have to acquiesce in Mackie's judgment (with the terms appropriately changed): "How much simpler and more comprehensible the situation would be if we could replace the moral quality with some sort of subjective response which could be causally related to the detection of the natural features on which the supposed quality is said to be consequential."[21]

But whether a case for the objectiveness of aesthetic qualities can be made out that avoids the pitfalls of "queerness" is not something that can be determined here. And so I want to press on to the question of what the belief, true or not, of the objectivity of aesthetic qualities, can do for us, in our attempt to understand aesthetic persuasion and "argument."

VI

As is perfectly clear, not everyone who applies aesthetic predicates labors under the assumption that they refer to "objective" properties of the world. For one thing, anyone who has a theory to the contrary does not believe it. For another, there certainly is a pre-systematic belief abroad to the effect that "beauty is in the eye of the beholder." But, just as clearly, there are lots of people, with theories and without, who do believe that when they describe the world aesthetically, they are describing, in an "objective" sense, the way the world is. Aesthetic discourse, then, among

both the lettered and the unwashed, is probably not uniform in this regard, as Hume's "two species of common sense" are meant to reflect. Granted this, let us concentrate on the kind of person who believes that aesthetic terms like "beautiful" do name objective properties of things, and ask ourselves whether, true or not, the presence of this belief would adequately explain the persuasive, argumentative character of much critical discourse. The question would seem to answer itself. What better explanation, after all, could there be for my wanting to persuade you that something is the case, and thinking it possible to do so by rational argument, than my belief that it is the case in an objective, factual sense of "is"? The matter, though, is not quite so simple.

A very strong motive for wanting to convince others that what you believe is true is, quite clearly, a practical one; for most of our ordinary beliefs, and many of our theoretical ones, have direct or indirect implications for action, and consequences affecting our welfare. There is a great deal in it for me, and for those whose fortunes (or misfortunes) I am concerned about, that they see the world as it really is, which is to say, the way I think it to be. And this is true whether I am trying to persuade a friend that the M5 bus does not stop on Beagle Street, or whether I am trying to persuade the president of the United States that nuclear fission is possible. And it is just such practical significance that, we have seen right from the start, aesthetic beliefs or attitudes do not have. So one very considerable motive for persuasion, where one believes the questions to be matters of fact, namely, the motive of influencing the actions of others, is lacking, where the "facts" in question are aesthetic ones. We seem to be right back where we started.

But, after all, there are theoretical questions at the cutting edge of scientific research that do not now, and perhaps never will have practical implications for anyone. And I think we are forced to admit that strongly held factual beliefs in such contexts survive even the complete absence of practical consequences. Why, I do not know: perhaps it is the fear of being "abnormal," which disagreement arouses, on both sides, and agreement subdues. However that may be, I do think we must grant that believing aesthetic values to be "objective" ones is an at least partially adequate explanation for why those who hold it engage in aesthetic argument and persuasion, although the additional, and very influential motive of practical interest, present in the ethical cases, will be entirely lacking. And perhaps the fact that there are no practical consequences, where aesthetic questions are concerned, helps explain the additional fact, if indeed it is one, that, as Mackie and others seem to believe, aesthetic disputants do not quite have the doggedness and energy of their ethical counterparts.[22]

But what of those who are convinced that aesthetic values are not "objective"? Would not this belief result, among those who held it, in the withering away of critical argument and persuasion? Yet if Ayer himself is any indication, this does not seem to be the case. For the pages of his autobiography contain many insightful characterizations and evalua- tions of works of art that, on his own emotivist views, are not merely expressions of his aesthetic attitudes but exhortations to others to share them. But given the complete lack of motive or purpose in so exhorting his readers, the exercise seems no less pointless than a solipsist writing letters to *The Times*.

VII

On this inconclusive note I will leave off my rather rambling argument, and try, as briefly as possible, to draw what conclusions I can from it.

I began by considering the very plausible connection that ethical emotivists draw between moral "argument," moral attitudes, and human action. Evaluative ethical terms not only express attitudes but urge them upon others. The explanation for this is clear: we have a very high stake in how others behave, towards ourselves, and towards each other, and moral persuasion is meant, at least in part, to influence attitudes for the purpose of motivating desired actions, discouraging undesired ones. This plausibility, I suggested, aesthetic emotivism lacks; yet ethical emotivists, seemingly unmindful of this, rather perfunctorily assert that the emotive analysis of ethical terms, without any sweat at all, can make do for aesthetic ones as well.

I have gone through various possible strategies for either justifying, or at least explaining the persuasive character of aesthetic discourse: some palpable non-starters, others at least partially successful. There is no need (or time) to run through them again. What conclusions I can draw are these. Certainly, nothing that I have said here has been a refutation of aesthetic emotivism, or intended to be. What I do hope to have shown is that the unexamined assumption of a direct analogue between ethical and aesthetic emotivism is rash. What might, with justice, be described as an emotive theory of evaluative aesthetic terms is certainly worth considering seriously. But in various, non-trivial respects, it will, I think, differ quite markedly from its ethical counterpart. No one, surprisingly, has tried to work the thing out, in the "mature" period of emotivist ethics (which I date from the publication, in 1945, of Stevenson's *Ethics and Language*). And until that is done, I, for one, will be quite skeptical of the bland, unadorned assertion that what does for ethics will do for aesthetics as well. At the present moment, then, my attitude towards

aesthetic emotivism must be "I (more or less) disapprove! Do so as well—or deliver the goods!"

PETER KIVY

DEPARTMENT OF PHILOSOPHY
RUTGERS UNIVERSITY, NEW BRUNSWICK
MAY 1986

NOTES

1. A.J. Ayer, *Part of My Life* (Oxford: Oxford University Press, 1978), p. 244.
2. Peter Kivy, "A Failure of Aesthetic Emotivism," *Philosophical Studies* 38 (1980).
3. A.J. Ayer, *Language, Truth and Logic* (2nd ed.; London: Victor Gollancz, 1948), pp. 113–14.
4. Ibid., p. 108.
5. Ibid., pp. 110–11.
6. "A Failure of Aesthetic Emotivism," pp. 360–62.
7. Immanuel Kant, *Critique of Aesthetic Judgement*, trans. James Creed Meredith (Oxford: Clarendon Press, 1911), p. 82.
8. A.J. Ayer, "On the Analysis of Moral Judgements," *Horizon* 20 (1949), reprinted in *Philosophical Essays* (London: Macmillan, 1954), p. 246.
9. Ibid., pp. 237–38.
10. Ibid., p. 238.
11. R.M. Hare, *Freedom and Reason* (Oxford: Oxford University Press, 1963), p. 150.
12. A.J. Ayer, *Freedom and Morality and Other Essays* (Oxford: Clarendon Press, 1984), p. 30.
13. Ibid., p. 31.
14. David Hume, "Of the Standard of Taste," *Essays: Moral, Political and Literary* (Oxford: Oxford University Press, 1963), p. 237.
15. Ayer, *Freedom and Morality*, p. 30. "So far as I know, this allegation is not the result of any systematic piece of social research."
16. Ibid., p. 33.
17. J.L. Mackie, *Ethics: Inventing Right and Wrong* (Harmondsworth: Penguin Books, 1977), p. 15.
18. Ibid., p. 36.
19. Ibid., p. 37.
20. Ibid., p. 38.
21. Ibid., p. 41.
22. Ibid., p. 43. "Aesthetic values are logically in the same position as moral ones; much the same metaphysical and epistemological considerations apply to them. But aesthetic values are less strongly objectified than moral ones; their subjective status, and an 'error theory' with regard to such claims to objectivity as are incorporated in aesthetic judgements, will be more readily accepted, just because the motives for their objectivication are less compelling."

REPLY TO PETER KIVY

The fact that Professor Kivy has chosen to write on a topic to which I have devoted less than a paragraph in the whole of my philosophical work releases me from any obligation to reply to him at length. Not that I find his essay devoid of interest. I think that he makes good his contention that the emotive theory of ethics should not simply be carried over into aesthetics without further comment, if only for the reason, which he gives, that what one might call the missionary aspect of moral discourse does not apply to aesthetics, or at any rate not in the same way.

What then is the point of engaging in aesthetics? I shall concentrate mainly on literary criticism, partly because I have practised it to a greater extent than I have any other kind of aesthetics though I have worked as a film critic and also written about cricket and Association football, if these are counted as forms of art, partly because I know more about literature than I do about painting or music, partly because aesthetic criticism in these latter domains is chiefly factual. Art criticism, insofar as it does not devolve into art history, consists for the most part in descriptions of the use of symbols in particular paintings, the way in which the placing of one colour sets off that of another, the distribution of masses, and so forth. When it is well done, work of this sort can be enjoyable and instructive but it raises no questions of philosophical importance. Musical criticism of a factual kind has, in my view, less to commend it. I do not believe that the boredom from which I suffer when I read the programme notes for concerts is due only to my being better informed about painting, other than 'pop art', than I am about classical music.

I must now confess that I cannot find anything of much interest to say even about literary criticism. My purpose in engaging in it, apart from

the fact that I enjoy writing, find it easier than philosophy, and do not object to getting paid, is, I think, mainly to communicate to others and indeed induce them to share the pleasure which the works in question have given me. Very often indeed, I am satisfied simply to recommend books, especially unfashionable works like W.H. Mallock's *The New Republic* or R.L. Stevenson's and Lloyd Osbourne's *The Wrong Box*, without comment, hoping that those whom I persuade to read them will discover in them the same qualities as I do, whether it be subtle and pungent satire or infectious high-spirits.

If I am addicted to reading literary criticism, as indeed I am, it is because a first-rate critic, like V.S. Pritchett, draws my attention to aspects, which have escaped my notice, even in books that I thought I knew thoroughly well. He illuminates them for me, and thereby increases the understanding of human nature and the overall sensibility which I have gained from the books themselves. The interesting question, to which I should be grateful for an answer, is why one has the feeling that Macbeth's 'Tomorrow and Tomorrow' speech conveys so much more than the factual information that men are mortal and the less common-place reflection that life has no intrinsic meaning. Is it just that it conveys these facts more impressively?

I take little stock in the question whether there are objective aesthetic properties. I confess that given the choice between good performances of a Rossini opera and a Bach concert, I should choose the Rossini, and might even prefer a revival of Noel Coward's *This Year of Grace*. I should not be more abashed by being told that I was displaying ignorance of a feature of reality, than that my taste in music tended towards frivolity, rather less indeed, since I should acknowledge the second proposition, whereas I should be philosophically suspicious of the first. If you think it out, you will have to admit that the simple projection of ethical and aesthetic values on to the world adds nothing to emotivism except a display of arrogance.

If, like Neurath, I were to compile a philosophical index, on the Roman Catholic model, I think that I should put the word 'beauty' on it, not only because the almost exclusive attention paid to its meaning by philosophers writing about aesthetics has fostered the subordination of aesthetics to ethics, of which Kivy rightly complains, but also because it has made their work boring. There are interesting problems in the domain of aesthetics, more perhaps than there are in ethics. For instance, what do we mean by saying that a picture or a poem is sentimental and why is this a condemnation? What justifies us in saying that Tolstoy's novels are more profound than Jane Austen's? And many others of that

sort. But so far from being answered these questions are not even posed. The best philosophical work on aesthetics—I am tempted to say the only good one—that has come my way is Nelson Goodman's *Languages of Art* but its main subject is denotation.

<div align="right">A.J.A.</div>

12

Arne Naess

AYER ON METAPHYSICS, A CRITICAL COMMENTARY BY A KIND OF METAPHYSICIAN

What Sir Alfred Ayer has found it worthwhile to publish about metaphysics is, as one could expect, carefully formulated. He may have an integrated, highly consistent view about metaphysics in one or two senses of the vague and ambiguous term 'metaphysics', but I shall not offer a condensed exposition of it. I do not think I am able to. I shall offer some comments which mainly refer to central quotations from his article "Metaphysics and Common Sense".[1]

The way I shall organize my comments is to concentrate on a fairly small number of quotes.

Quotation 1:

> If we go by appearances, it can hardly be disputed that metaphysics is nearly always in conflict with common sense. This is most obvious in the case of the metaphysician who professes to find a logical flaw, a contradiction or a vicious infinite regress, in one or other of the ways in which we commonly describe the world, and so comes to such startling conclusions as that time and space are unreal, or that nothing really moves, or that there are not many things in the Universe but only one, or that nothing which we perceive through our senses is real or wholly real.[2]

The slogans or key sentences of most metaphysicians are, and are presumably meant to be, shocking, to most people.

But *read in context* I think the somewhat shaky statistical hypothesis breaks down. Most people get bored or frustrated feeling they don't understand and perhaps ought to understand. From the context they presumably understand that a sentence like "nothing really moves" is not to be interpreted as synonymous to "nothing moves". People who

read a little history of philosophy understand that "exist" in Gorgias's slogan "nothing exists" is not used in quite the same way as in "some rhinoceroses still exist". The shock is milder or disappears.

"Nothing exists" in the phraseology of Gorgias is a formulation taken out of context that elucidates what is *referred to* through the shocking slogan. It is a question of that branch of empirical communication research to approach an understanding of the context and its relation to the slogan. We probably agree that it has to do with conception and perception of timelessness, unchangingness, permanence. I suspect that there are ways, W1–W10, of experiencing and conceptualizing the world or 'everything' that make it tempting to say something like 'what is real is unchanging'. As analytical, academic philosophers we may, and personally I think we must, try to find ways of expressing at least one of the Ws; in a way more understandable and connectible (von Mises) with our scientific ways of talking. The crucial point for me in the case of Gorgias and hundreds of other metaphysical key slogans is that *always something remains* unexpressed and often the 'analyses' of the key slogans are felt by their constructors to be inadequate. The metaphysical key slogans are not to be eliminated; there is no complete substitutability.

Suppose non-academic people hear this uttered: "matter tells space how to curve, and space tells matter how to move". Non-sense? Shocking misuse of terms? Literally false? Or perhaps something profound? Told that it is a quotation from a physicist (J.A. Wheeler) and inspired by Einstein, people may dismiss it as un-understandable, and sometimes with a feeling of awe. There is an interpretation of the quotation making it an elegant popularization of acceptable physical theory, and *nothing else*. Nothing remains. What I hint at is that many metaphysical sentences may be 'precised' in various ways, some of them scientific, but not restless, like the quotation from Wheeler. For me questions of common sense do not enter.

It is tempting to use Neurath's term *'Ballungen'* about metaphysical key slogans. They are 'slimy' in the sense that you cannot neatly separate individual components of their meanings or uses, and some of them are 'deep'—using a very different metaphor. That is, they touch basic attitudes, value-priorities, concepts.

Let us return to the key sentence attributed to the sophist Gorgias: "Nothing exists." Diogenes's strategy as a listener would be to say, for instance, "What about you, Gorgias? Are you there? Did I hear you say something?" Another way of tackling the situation—in the absence of any existing writings of Gorgias—is to guess what he intended to convey

by uttering what he did. One guess is that he opposed a view attributed to Parmenides that only the unchangeable can be counted as really existing. Neglecting the difficult adverb "really", Gorgias might have meant, among other things, to convey that if the absolutely unchangeable deserves the predicate 'existing', *then* nothing exists, because nothing is absolutely unchangeable. A Parmenidian then asks for proofs that movement is possible, which he rejects. I suppose we today are able to tackle the paradoxes of Achilles and the Tortoise, in part through a kind of mathematics Gorgias could not know. But there seems still to be an open question whether change is ever adequately conceptualized. Maybe it is, I ought not to wonder. Anyhow, I appreciate the Diogenes strategy, but not in a discussion of adequate conceptual frameworks. I assume Ayer would agree "the victory [over metaphysics] has been won on the wrong terrain."[3] Metaphysicians treat external questions; Moore's "technique"[4] presumes they are internal. More about that later.

Quotation 2:

> G.E. Moore "looked at metaphysics with the devastating simplicity and candour of the child in the Andersen story of the Emperor's Clothes. His technique was to take metaphysical assertions at their face value and show how extraordinary their implications were."[5]

One may fully appreciate Moore's uproar against the domination of the Hegelians and their way of metaphysical communication. The way the strategy of Moore is described in the quotation presents, however, a generalization of that of Zeno. He cannot be said to take in a non-selective way "metaphysical assertions at their face value". He picked out some, and isolated them from contexts. A slogan like "time is unreal!" he treated as synonymous with "time does not exist". But even if this very implausible interpretation is valid, one may from a rigorous point of view question the validity of the consequences. Birth may be constructed to precede death without letting any definite *concept* of time enter our conceptual frame of reference. This is not important, however. What is important is the strategy to avoid contexts which may be held to only confuse the issue, but which certainly must be discussed in order to get nearer to the intended message of the sender of the dark utterance. What was a valuable "new departure in the history of philosophy" in the first year of our century is not a new departure now. And I think Ayer does not really (?) think that Moore offered a philosophically acceptable way of handling the metaphysical discussions.

Discussions about 'the nature of time' are as lively today as in the time of Bradley, and if a participant only says "time is unreal" within a

prolonged discussion it may only provoke laughter. But not as a title of a book, or as a slogan. Like "the will is free", "existence precedes essence", "God is but does not exist".

The use of the word "real" is of course often frustrating in metaphysicians, including Spinoza, but non-academic people use it in senses very near, or even identical with those of metaphysicians. Example A: To me Mr B does not appear *real*. C: Yes, there is something lacking in him. To me he is less real than any other I know. They do not talk of the existence of Mr B. It has to do to a certain extent with genuineness, authenticity as a personality. On the whole I find so-called ordinary people rather often talking metaphysics. This is one of my obstacles when trying to get a clear conception of what Ayer means by 'common sense'. It seems to have little to do with how people ignorant of academic philosophy talk and reason. It seems to relate to what I might consider a rather implicit metaphysical frame of reference; I shall refer to it as 'the common sense of science'.

Quotation 3:

> The important question for the plain man is whether the statements that are made within his conceptual framework are true: the same applies to the scientist at his level of discourse. The important questions for the philosopher are how these different sorts of statement are related, and what are the criteria by which their truth or falsehood is determined. Once these questions are satisfactorily answered, it does not very greatly matter how the ontological medals are bestowed.[6]

The task of the philosopher as depicted above seems to me more like that of a low level administrator. Not the philosopher, but unspecifiable others create conceptual systems and erect conceptual frameworks. These others find themselves having visions of the world, pictures of the world, ways of looking at the world. (Ayer uses such expressions.) And others struggle to verbalise and clarify these ways of looking at the world. They struggle to get from vague and ambiguous, perhaps "dark" spontaneous utterances to more clear and precise ones, even utilize scientific conceptualizings. They struggle to investigate possibilities of testing rival views—and they freely wonder.

Very late in the show the philosopher arrives on the scene inspecting already formulated conceptual frameworks and making clear how different sorts of statement are related. Inspiring?

I do not see that the tasks of philosophy today are much different from what they were at the time of Aristotle and Spinoza.

The study of Spinoza makes me conclude that his system in a way 'colours' the conception of the whole existence, the conception of 'everything', not only every thing. The hundreds of conceptual interrela-

tions postulated by Spinoza through his definitions and propositions, contribute to the impression of a metaphysics that affects every aspect of our existence. I take the written exposition of Spinoza's system in his *Ethics*—whether it is intended to be conceptual or nominalistic—to present a verbalisation of what Ayer calls a vision of the world. This vision concerns me as an 'existential' and academic philosopher because I think my vision is somehow of a similar kind, and because his power of thinking and intensity of vision is greater than mine.

How would the Spinozist vision most effectively be verbalised today? This is a grave question. Very few sentences of the *Ethics* might be retained. The question is philosophical *and* empirical. The kind of theory of communication needed concerns empirically given texts of his and our century. But there is no science of communication of much use for us as philosophers. Philosophical inquiry is as much empirical as logical; to concentrate on logic is a blind alley.

The use of the term 'real' in metaphysics I agree with Ayer is largely a dismal story. I am glad to say that it plays a minor role in the *Ethics*. It does not occur a single time in propositions, proofs, or definitions. But 'reality' and 'to have realness (reality)' occur a few times, seven in all. 'To have realness' is an adjective capable of degrees, as it is capable of in the Latin and English vernacular. In a contemporary exposition of the *Ethics* one may without great mistakes eliminate the term 'reality' through the use of conceptual near-synonyms, 'equivalences', for instance through definition 6 in Part 2: "By reality (*realitas*) and perfectedness (*perfectio*) I understand the same". In term the Spinozist 'perfectedness', the Latin *per-facere* may here approach the meaning of 'carry through', may be elucidated by referring to other equivalences.

This is necessary in order to understand a 'definition' close to my vision of the world, "Gladness is man's transition from a smaller to a greater perfectedness" (second definition of affections, Part 3). Here again we must patiently try to find out what 'definition' and 'gladness' stand for in the system. (Berkeley's complaint about Spinoza is well-founded!) Equivalences are helpful in these matters of interpretation, and I have an easily available list of 243.

In short, in order to understand what a metaphysician tries more or less imperfectly to convey, and to verbalise this understanding with some interpersonal preciseness, requires a lot of patience. For good reasons some philosophers do not find it rewarding. But Spinoza is to me always rewarding.

Visions of the world and their conceptualization is a central task of philosophers. On the other hand, life-long study of philosophy on the highest academic level contributes to philosophical culture whether the

participants feel they are philosophers in the sense I use the term, or not. Today I feel we need more philosophers, but not less academic philosophy. It is my suspicion that Ayer is more of a philosopher than one might think reading his *Metaphysics and Common Sense.*

Quotation 4:

> As we have seen, it is not an arbitrary judgement. One can give reasons for going one way or the other. But they are not compelling reasons. Whether we opt for naive realism, or physical realism, or phenomenalism, or whatever, there are going to be some consequences which make us feel intellectually uncomfortable. If most of us feel least uncomfortable with naive realism, it is mainly, I suppose, because it is the picture of the world with which we are most familiar, having lived with it since our childhood, and also because it occupies a safe, or comparatively safe, middle position, the phenomenalist picture being too fragmentary and the physical realist one too abstract.
>
> My second point is that the question whether or how this decision is taken does not seem to me to be of any great importance.[7]

After this fragment of the text, quotation 3 follows, presenting the last lines of Ayer's article "What Must There Be?".

It is, I think, pertinent to distinguish pictures of, or ways of looking at, the world from conceptual frameworks. The three "pictures" referred to by Ayer I would class as three kinds of ontological fragments of a total conceptual framework tentatively adapted to present in words fragments of a way of looking at the world (or, more in my terminology, a total view).

Speaking of consequences, I agree that more or less logically derived consequences of basic ontological conceptualizations may make us in various ways uncomfortable. We may try to change some of the links in our derivation—in ways suggested by Quine, or we may radically change parts of the basic ontological conceptualization, or even get to experience the world differently. The philosopher with a systematic bent finds himself or herself in the middle of questions and queries which engage all human capacities. Feelings, passions, attitudes, inclinations—logic.

Quotations 5 and 6:

> Thus if a philosopher is to succeed not merely in involving us in logical or semantic or epistemological puzzles but in altering or sharpening our vision of the world, he cannot leave common sense too far behind him.[8]
>
> In philosophy, nothing should be absolutely sacrosanct: not even common sense.[9]

In quotation 5 it seems that Ayer agrees with my view that a philosopher may involve "us" in altering "our" vision. And in the context

of quotation 6, and others, it seems that a philosopher may legitimately as a philosopher, engage in creating, discussing, and changing not only conceptual frameworks, but also refer them to visions of the world, including his own. To me it seems that it is not easy to make these quotations legitimizing and defending what I would call metaphysical undertakings with quotation 3. Possibility: I have misinterpreted that quotation.

In attempts to explicate a total view, the expressions 'felt' to be the most adequate at least at the first stages of the work are likely to be heavily metaphysical and formed in short sentences. At later stages some but scarcely all these expressions are eliminated. I see no general reason to eliminate them, but strong reasons to comment upon them and their function. 'Intuition' is here a central slogan. Unhappily, there has been a tendency to stress the kind of methodical features of a vision of the world. That is perhaps one of the reasons why at graduate philosophical seminars (at some universities) expressions of such kinds are frowned upon. Without methodical tolerance, efforts to explicate total views soon grind to a halt.

To catch the attention metaphysicians have often to leave common sense, as the expression is used by Ayer, *far* behind. Thus, in the metaphysical mass communication of Gandhi he would say such things as "God is the hungry millions". Short sentences with great power. Sometimes he engaged in conceptual clarifications, but from a statistical point of view, very rarely.

After years of intense interest in the so-called common sense view of truth I don't think there is anything deserving that name. There is not much to be found, I think, to contrast a conceptual framework of "the plain man" (see quotation 3) with those of metaphysics. Very prolonged interviews with bright school-children who never have read a line of professional philosophy tend to make them approach professional status! They exhibit 'embryonic' systems and they are able to criticize, not totally incompetently, quotations from philosophers. And if one does not by 'common sense' refer to so-called ordinary people, but to my ideally reasonable world view, I cannot see much difference from calling it '*my* view'.

Quotation 7:

The recognition of the autonomy of morals on the one hand, and on the other the continued adherence to a well-established set of moral values, have led to a certain narrowing of the scope of moral philosophy. It concerns itself less with the question what our duties are and more with the question what our talk about our duties means. The promulgation of moral judgements has given way to their analysis.[10]

Statistically Ayer may be right.

From the point of view of articulation of total views this tendency is to be regretted. In trying to set up priorities of action, consideration of priorities of duties and articulation of sets of duties and their logical relations are important undertakings. And philosophical training may be of help. Terminology is secondary; like many others I do not often use the term 'duty', but rather expressions like 'what we ought to do'.

When students raise questions on morals, the shift from substance to meaning is pernicious if done in a way that suggests philosophy is more about meaning than direct answers to questions of ethics. But I would join Ayer in holding that the direct propaganda for particular moral opinions or systems cannot be a function of academic teachers.

The "question what our talk about duties means" is understood by Ayer in accordance with his own demand for a frame of reference as a question within what he takes to be 'common sense'. This is the nearest I come to a conclusion about how to suggest a frame. Suppose a student accepts what Ayer considers "what our talk about duties means", is this a considerable plus, or a minus for him and for us as fellow citizens? A pragmatic question, I admit. If the student has metaphysical views, like I have, I answer negatively, but of course a tentative, open answer.

Let me mention a field of metaphysical thinking among nonphilosophers. About 125 people were interviewed about the rights of animals and plants, and the acceptability of exterminating dangerous and poisonous ones. A very frequent argument among these people for rejecting extinction is that they all have a place to fill and that they are part of the whole. Discussion of such sayings reveals that they function often as ultimate normative points of view.

As superbly stated already by Aristotle one cannot prove every assertion or norm. There are some which always, however deep we are digging, are taken as ultimates. This is one of the reasons that I do not find grounds for rejecting the validity of the above ultimates. Another reason is that I essentially share them myself.

As philosophers we may find it necessary to try to interpret the statements, for instance, trying to transform them into psychological statements, or otherwise making them testable. Very good! But so far there are no good 'analyses', and even if there were, I doubt they would be restlessly brought out of metaphysical realms.

Among my own statements within ecophilosophy there are hundreds which need further clarification, but this does not imply that I ought to stop accepting them before I (five hundred years old?) have found analyses satisfactory to myself. I cannot see any good reasons for giving analytic work generally higher priority than synthetic. For instance why

stop using the term 'intrinsic value' because of lack of satisfactory analyses? Or 'truth'? To fight confusion is one thing, to invariably search for clarifications of certain particular kinds quite another.

Quotation 8:

> For Heidegger there remains one metaphysical question: Why is there anything at all and not rather nothing? Perhaps this should be treated in Collingwood's way as the senseless querying of an absolute presupposition. At least, if it is treated as a question, there is no way of answering it. If the 'Why' is construed as a request for a cause, then even if an answer is forthcoming, it merely relates one existent item to all the others, or leaves us with a theory for which we have no more general explanation. If it is construed as a request for a reason, then not only are we making the unwarranted assumption that the totality of what there is has been designed, but we are still committed to the being of the designer.[11]

Heidegger's sentence ending with a question mark is today spontaneously experienced as a genuine question by many people, including myself. I am ready, but not eager, to incorporate it in my (somewhat fictional) system as a philosophical question. More often, but not always! I wonder *that* there is something rather than nothing, and sometimes, perhaps not less often, I wonder that I wonder that there is something. But I do not, for instance, wonder that I wonder that I wonder that there is something, because I take this wondering as natural for some philosophers like me.

The way Ayer treats the strange question strikes me as impatient. Too fast! It is as if we ought to be in a haste to find a piece of analysis which can stop our wonder, if there was any. What I wonder about is, for instance, why so little in our publications as academic philosophers reflects the frequent state of wonder which I suspect (and hope) my colleagues experience. To publish a book favourable to epistemological scepticism, as I have done, is not of much help here. It is too argumentative. It scarcely reflects pervasive wondering. I shall end my comments with a sentence put forth in wonder as well as in regret:

> It is a weakness of our situation as academic teachers of philosophy that it intensively favours learning arguments and learning conclusions at the expense of relaxed wondering.

Quotations 9 and 10:

> But why put things in a portentous way when they can be put in a simple way? Why not say that as you grow older you come to comprehend more things; your knowledge perhaps increases, and then after a certain point, I'm afraid, diminishes again. But up to a point it increases. Perhaps your range of sympathy is greater; perhaps you *identify* with more things and sometimes again with less.[12]

When one has a fairly precise method, a precise way of describing all these facts, why does one have to make such portentous statements about one's self expanding and including everything. It sounds romantic, but it's quite superfluous.[13]

The written account of the television debate in 1971 between Ayer and myself carries the excellent subtitle "an empiricist versus a total view". As a philosopher I find it inevitable to pretend in a mild way to 'have' a total view. Not only a vision, but a practice more or less logically connected with a verbalisation of the vision. One of the crucial points in the discussion is the following remark: "I think I believe *in the ultimate unity of all living beings.*" This is a very vague and ambiguous phrase, but I have to rely on it. *It is a task for analytical philosophy to suggest more precise formulations.* Because I have such principles, I also have a programme of action, the main outline of which is part of my philosophy.[14] One of Ayer's reactions to this, the only one I find inadequate, is to say that I am "simply false", "in any literal sense just false", "not only I and a mosquito, but even you and I are not one".[15] This is to me playing the Diogenes card. Obviously to me, and also to Ayer, "ultimate unity" must be interpreted differently from "identity" in a certain trivial sense. And he soon in a constructive way proposes a substitute for my metaphysical phraseology—quotation 9!

My use of "identification" is related to the one we can meet in description of employees who strongly identify with their big corporation. The essential point is not that they consciously plan their vacations and place of living in accordance with the requirements of the corporation, but that their tastes, choice of friends, emotional stability, sense of achievement are such as are good for the corporation. This has all to do with what William James terms their social self, as something wider than their ego.

The main thing is that I do not find any single less "portentous" set of sentences which completely covers what I intend by the metaphysical sentences. I try out psychological, or more general, social science terminology, and try out many for what I call 'precisations' (analyses of a certain kind), but it always turns out that something might still be lacking. Therefore I do not easily discard a metaphysical sentence which clearly has deep relations to basic attitudes towards reality as I conceive it. I do not use the 'unity of life' formulation any more, but retain metaphysical use of the terms 'identification' and 'self-realization'. It is easier to trace practical applications this way.

In asking for a less portentous, more simple way of expressing a philosophical point, Ayer exhibits a characteristic British trait from which European philosophers have profited immeasurably through the

centuries. And Ayer has in his writings contributed significantly to this tradition which may be as important in the future as it is today. But whereas a metaphysical terminology like mine may tend towards the portentous and romantic, Ayer's way of expression may occasionally trivialize or amputate. There may be too fast transition from the vague and ambiguous but deeply spontaneous and inspiring, to the particular and rational in a narrow sense. And to wonder is not to be confused. Contemplating and using certain carefully selected metaphysical key terms and sentences need not confuse us. Not if we retain our wonder when employing them. Exactly what does the expression "living beings" cover? The vision or intuition does not cover viruses. Mosquitoes, yes. Obviously the 'depth of intention' from the point of view of zoology and botany is small. But this is not confusing. It exemplifies a kind of unavoidable limitation.

One of the most repulsive characteristics of the metaphysical style of writing is the seemingly utter neglect of the distinction between descriptive and ascriptive or normative. A description of 'the authentic life' has clearly a normative function, 'you ought to live like that!' The sentence 'ultimately all life is one' is obviously intended to have a normative function. Why not transform it into a kind of moral precept about treating non-human life forms decently? Because moral precepts are weak, whereas a changed way of conceiving reality is potentially very strong in its motivational force. If you tend to 'see yourself' in all living beings, decent treatment is quite natural (provided your relation to yourself is good).

In trying to untangle normative and non-normative ingredients one has to be patient otherwise too much potential insight is lost. The metaphysical primordial soup of normative and descriptive ingredients does not imply confusion. In everyday life we function well with some of this soup. Perhaps some of us shall have to search for expressions of our vision of reality which does not immediately and basically introduce that distinction. As Ayer puts it, common sense is not sacrosanct and the same holds of any distinction introduced by philosophers.

Summing up, what I try to convey is that philosophy, even as a field of inquiry at the university level, gains by accepting metaphysical ways of expressing visions or intuitions of reality as genuine sources of insight. Efforts to try to find equivalent non-metaphysical expressions are central, but need not pretend to exhaust the potential insights. And the metaphysical versions may, even after partly successful analytical work turn out to be the simplest way of expressing a vision or intuition. I think Ayer might agree with this, but continue rejecting the dogmatism and the obscure and portentous style of much metaphysics. And perhaps more

than anything else, fight the tendency to rest content with abstract metaphysical pronouncements without clarifying their relations to concrete problems we all understand or to problems of scientific research.

ARNE NAESS
COUNCIL FOR ENVIRONMENTAL STUDIES
UNIVERSITY OF OSLO
SEPTEMBER 1987

NOTES

1. "Metaphysics and Common Sense" in *Metaphysics and Common Sense* (San Francisco: Freeman, Cooper & Company, 1970), pp. 64–81.
2. Ibid., p. 64.
3. *Metaphysics and Common Sense*, p. 71.
4. Ibid., p. 71.
5. Ibid., p. 64.
6. Ibid., p. 63.
7. Ibid., p. 63.
8. Ibid., p. 81.
9. Ibid., p. 81.
10. Ibid., p. 7.
11. "Phenomenology and Existentialism" in *Philosophy in the Twentieth Century* (New York: Random House, 1982), p. 229.
12. Fons Elders, ed., *Reflexive Water: The Basic Concerns of Mankind* (London: Souvenir Press, 1974), p. 35.
13. Ibid., p. 36.
14. Ibid., p. 29.
15. Ibid., p. 32.

REPLY TO ARNE NAESS

I am happy to be reminded by Professor Naess of the debate in which we engaged on Dutch Television in 1971. We had both moved a considerable distance from the positions that we had occupied under the influence of the Vienna Circle in the 1930s. If I remember rightly, he did not even then embrace their views so whole-heartedly as I did. I doubt if he ever committed himself to the 'Elimination of Metaphysics' on which I embarked in *Language, Truth and Logic*. Nevertheless I remember being surprised by our failure to find more common ground in the course of our debate. Looking back on it I now think that this failure was in some degree artificial. Appearing on this occasion officially as antagonists, we tended, or at any rate I tended, to exaggerate the differences between us rather than explore the possibilities of a common understanding.

This is brought out in his quotation from *Reflexive Water*, the published version of the set of debates which included ours, of my reaction to one of his expressions of his 'total view'. It must have been obvious to me that when he said that he was inclined to believe in the ultimate unity of all living beings he was not owning to a disposition to regard two different human beings, let alone a man and a mosquito, as literally identical. To pretend that he was committed to this absurdity was indeed to make a cheap debating point. I made some amends in another passage that Naess quotes from our discussion by speaking of the possibility of one's acquiring 'a greater range of sympathy', of one's coming to 'identify with "more things" '; and Naess says that he now uses the terms 'identification' and 'self-realization' metaphysically in preference to talking about 'the unity of life'.

But what is it to use such terms metaphysically and what is to be gained by it? Towards the end of his essay Naess provides a clue to the

way in which he would answer these questions, when he says that 'the sentence "ultimately all life is one" is obviously intended to have a normative function' and then asks 'Why not transform it into a kind of moral precept about treating non-human life forms decently?' His answer is that moral precepts lack the requisite strength. People will be more apt to treat all living beings decently if they can be induced to see themselves in them. This may well be true; at any rate let us assume that it is. What still puzzles me is why Naess supposes that the best way to induce people to see themselves in other living beings is to secure their assent to the metaphysical pronouncement that they are identical with them. There is, indeed, the suggestion that they obtain more from this metaphysical pronouncement than a reinforcement of the moral precept. We are not, however, told in what this 'more' consists. I suspect that, whatever it may be, its function is to associate the moral precept with what Naess would call an insight into the nature of things. Again, we are not given even any hint as to what this insight amounts to, but I should not now say that this was a sufficient reason for denying its existence. For instance, it might be analogous to the insight we are said to obtain from works of art, which also defy translation into plain narrative terms.

In this connection I was interested in Naess's example of what he calls 'a field of metaphysical thinking among non-philosophers'. He does not say what proportion of the 125 or so people interviewed were against exterminating dangerous and poisonous animals and plants on the ground that 'they all have a place to fill and that they are part of the whole' but I assume that he would not have used the example unless the proportion was quite high. I have to say that I find this astonishing. It is possible of course that the people in question had been influenced by stories such as that of the ecological damage caused by the overabundant use of certain insecticides, and that they rashly drew the conclusion that any interference with natural processes would do more harm than good. But can they really have been so ignorant of, or indifferent to, the progress of medicine? In any case Naess characterizes them not as misguided biologists but as metaphysicians. It looks therefore as if they had succumbed to a version of Leibniz's proposition that this is the best of all possible worlds. If I had been the interviewer, I should have advised them to read Voltaire's *Candide*.

In fairness to Naess, I should say at once that his reason for introducing this example was to show that the distinction between Metaphysics and Common Sense was not nearly so sharp as my essay with that title, on which he was chiefly commenting, originally made it out to be. And here I confess that he was right. In composing that essay, I

failed to make it clear that it was closely related to G.E. Moore's celebrated 'Defence of Common Sense' and Moore's account of what he called the common-sense view of the world was not the outcome of any sociological research into what 'the man in the street' actually believed. For instance, it is likely that in the nineteen twenties when Moore's article was written, most Englishmen, let alone Americans or Spaniards, held some form of religious belief but Moore refused to include religious belief in his summation of common sense, effectively though not explicitly, because the principal theme of his essay was that he knew the common-sense view of the world to be wholly true, and he himself held there to be no good reason to believe in the existence of a God.

Moore's need to uphold the common-sense view led him to restrict it to four propositions: the existence of physical objects, the existence of acts of consciousness, the reality of space and that of time. As Naess has noticed, Moore was declaring war on the neo-Hegelians who threatened to dominate British philosophy at the start of his career and he took it for granted both that the man in the street shared his knowledge of the truth of the propositions in question, and that his metaphysical adversaries denied it. What else the man in the street believed, how far he had been infected with what Naess would count as metaphysics, were questions which Moore ignored. Even if he had been provided with evidence that neo-Hegelian slogans were frequently employed in the conversation of persons who were not philosophers, he would still have insisted that these persons knew the truth of such propositions as that they possessed hands and feet, that they had memories and feelings, that a book-case stood a short distance to the right of the table at which they were seated, that the events of today were later than those of yesterday and earlier than those of tomorrow.

On this last point, I am on Moore's side, though I continue to hold that his defence of common sense, even on his own terms, is very much weakened by his extreme openmindedness with regard to the analysis of the propositions of which he claims that we all know the truth. I shall not, however, pursue the issue here. What I wish to discuss is Moore's other assumption that his metaphysical adversaries seriously denied the reality of matter, space, and time, in such a way as to fall victims to his assumption of the role of the child in Hans Andersen's story of the Emperor's clothes.

There is some evidence that they did. Thus, in a conversation with John Wisdom, Moore was able to cite a passage in McTaggart's works where McTaggart claims to have proved matter to be as mythical as Gorgons. Moreover the conclusions which those philosophers reached were, in my judgement, not at all illuminating. I frankly have no idea

what Bradley thought he meant by the Absolute. McTaggart's theory that what we misperceive as chairs surrounding a table were really selves standing in emotional relations to one another strikes me as simply ridiculous.

Nevertheless I think it unlikely that when McTaggart denied the reality of time what he had in mind could be refuted by such commonplaces as that Moore had his breakfast before he had his lunch. Suppose that McTaggart had been content to deny the passage of time. In that case he would have had the support of many scientists and philosophers who represent the universe as a four-dimensional continuum. Time enters into it only as an enduring relation which makes the whole picture static; for the fact that one event precedes or succeeds or is simultaneous with another is not itself subject to change.

In fact McTaggart did not take this view. He opted for the passage of time, taking the concepts of past, present, and future as primordial, and attempting to show that their use was incoherent. His attempt did not succeed because it depended on his misconstruing demonstratives as descriptions. Nevertheless it did illuminate the concept of time just as the paradoxes of Zeno, who would surely not have betted against Achilles in any actual race, illuminated the concepts of time and space and motion and infinity. I am sorry that Naess did not pay more attention to my view that to appreciate metaphysicians one should look primarily, if not exclusively, at their arguments.

I think that Naess may have been slightly unfair to me in the passage in which he says that I depict the task of the philosopher as being like that of a low level administrator. The quotation on which he delivers this verdict occurs in the book to which my essay "Metaphysics and Common Sense" lends its title, but it is not part of that essay. It is the conclusion of an essay entitled "What Must There Be?" which ends with the questions whether we should give preference to what I called the plain man's conception of physical objects, one that endows them with properties corresponding to Locke's ideas of secondary as well as primary qualities, or to the electrons, neutrons, and so forth which embody what I called physical realism. It was the relation between these views that I left it to the philosopher to elucidate, with the rider if he was able to make the relation clear it did not much matter how he cast his vote. My remark was tailored to this context, and I was not implying that philosophy had no other function to fulfil.

At the same time I do maintain, perhaps in opposition to Naess, that in terms of C.D. Broad's serviceable distinction between speculative and critical philosophy, a philosophical enquiry into what there is should only be critical. It still seems to me that metaphysicians go astray when

they try to usurp the scientists' practice of devising theories and testing them by observation. How in the end can one tell what the world contains except by examining it?

Here Spinoza, whom Naess so greatly prizes, provides a good example. He is a philosopher to whom I admit that I have paid much less attention than he surely deserves, but I am able to recognize that he does throw light on particular philosophical problems, such as that of determinism, and that a sympathetic study of him can deeply affect one's attitude to life. Nevertheless I draw the line at what anyhow appears to be his attempt to incorporate the world in a deductive system. The system appears to be based on his definition of substance as something that contains in itself the reason for its own existence, where what he means by a reason is a logical ground. But then he encounters the fatal objection that his definition cannot be satisfied. Nothing that exists concretely is such that its existence can be deduced merely from a description of its character. I repeat that this does not imply a rejection of everything that Spinoza then goes on to assert.

Concerning Heidegger, however, I am unrepentant. I do think that there is nothing more of interest to be said about his metaphysical question than is contained in the eighth of Naess's quotations. If a question is posed to which it is so easily shown that there can be no answer, I cannot admit that a lengthy answer is called for. Naess values the question as the expression of wonder at the existence of the universe, but here it seems to me that someone like Wordsworth achieves more with his poetry. Perhaps I should end with the admission that I am not temperamentally a pantheist. I do not know whether it has been more of an advantage or a handicap to me as a philosopher that I am entirely devoid of any religious feeling.

A.J.A.

13

D.J. O'Connor
AYER ON FREE WILL AND DETERMINISM

The problems of free will and determinism have not been one of Sir Alfred Ayer's central interests. But he has written four influential papers on these matters.[1] And at various points in his writings, he has discussed topics that are closely relevant to them.[2]

I will spend the first part of this paper on some critical remarks on Ayer's methods and approach to his problems. In the second part, I will examine and criticise the form of 'soft determinism' which he defends. And in the third part, I will consider some new points of view which he has introduced in his last two papers. I shall not consider his arguments against fatalism. I am more impressed than he is by the case for fatalism, but it is clear to me that the arguments for fatalism involve some difficult issues in philosophical logic which there is no room to discuss here.

I

Ayer starts his discussion in "Freedom and Necessity" by linking the concepts of free action and responsibility. And throughout his discussion, he continues to link them, going so far as to say that one concept implies the other or presupposes it or is entailed by it. I shall have some remarks to make on this point later. In "Freedom and Necessity", he goes on to highlight the apparent conflict between two common assumptions: (a) that in the sense of "free action" which is a necessary condition for moral responsibility, human beings are sometimes capable of free action; and (b) that "human behaviour is entirely governed by causal laws".[3] This apparent conflict can be resolved in various ways. We could reject (a) by showing that in the required sense of 'free action' there is no such

action open to us. Alternatively, we could reject (b) by producing counter-examples to the proposition that human behaviour is entirely law-governed. Or lastly, we could try to show that (a) and (b) are in fact consistent and that the 'apparent conflict' is apparent only. It is this third course that Ayer adopts. In view of the difficulty of proving or refuting (a) or (b), this choice is, tactically, a sensible one and it has very respectable precedents in the history of philosophy. But does it, in fact, do the trick? That is the chief question with which I shall be concerned in this paper.

Ayer gives the determinist less than his due by confining his discussion of causality in human behaviour to psychological causes. Moreover, he takes a view of psychology which has not been supported by its history. "The science of psychology is still in its infancy and, as it is developed, not only will more human actions be explained but the explanations will go into greater detail."[4] In the thirty years since his paper was written, the science of psychology has, indeed, made a good deal of progress. But it has, in general, not succeeded in or even aimed at the explanation of human actions. Psychologists have rather concentrated their efforts on the detailed study of the mechanisms underlying and constituting human experience and behaviour—sensation, perception, memory, language and the rest. Indeed, it is not clear exactly what the explanation of human actions would amount to.

He gives two concrete but hypothetical examples of such an explanation given by a psychoanalyst.[5] When "Freedom and Necessity" was written in 1946, psychoanalysis, if not a respectable branch of science or even of psychology, was still a flourishing intellectual fashion. But since the work of Sir Karl Popper and Hans Eysenck, we may surely say of psychoanalysis as Pope Leo X is alleged to have said of Christianity: "It is a profitable fable".

In order to be able to make more acute the "apparent conflict" between determinism and free choice I would like first to set out a stronger version of determinism than the one Ayer was content to use in "Freedom and Necessity". Instead of talking of "psychological causes" (whatever these may be) I want to talk of physical causes of a type which have been well studied and whose existence is well known to any educated person. And to avoid having to talk of predictions based on psychological laws, I want to make a distinction between scientific determinism and metaphysical determinism. The former is dependent on the nature and extent of human knowledge which varies from age to age and from subject to subject.

There are three main criticisms to be made of scientific determinism.

1. It is always stated with question-begging provisos: "if we knew enough", "if our mathematical techniques were sufficiently powerful" and so on. The first authoritative statement of the theory by Laplace in the eighteenth century supposes an "intelligence" who could "comprehend the actions of the largest bodies in the world and those of the lightest atoms in one single formula provided that his intellect were sufficiently powerful".[6] The commonest way in which such hidden tautologies are introduced is via the phrase "predictable in principle". (Ayer himself uses this turn of phrase: "It is possible, in principle, to deduce it from a particular set of facts about the past."[7]) Such phrases merely disguise the gap between what we do know and what we could know under hypothetically favourable conditions. If we knew *enough,* we could, of course, know everything. But such tautologies are quite uninformative.[8]

2. Any scientific prediction requires measurements. And measurements can only be made within certain specifiable limits of accuracy. Thus any measurement of a continuous quantity is a description of a potentially indefinite number of states or events. So to say that an event is determined is not to say that it is precisely predictable.

3. The third (and most damaging) criticism of scientific determinism was made in 1951 in a classic paper by Sir Karl Popper.[9] Popper uses three very ingenious arguments to show that certain deterministic predictions even in classical physics, are essentially incompletable. The consequence of this is that it is logically impossible to achieve a complete deterministic theory of the future of the world.

But if we reject scientific determinism, what is the alternative? Let us consider the theory of metaphysical determinism. The form in which I wish to examine this theory can be put simply as follows:

Every macroscopic physical event has a cause.

All human actions are macroscopic physical events.

Therefore: All human actions are caused. (The insertion of the term 'macroscopic' into the argument is simply to avoid the objection that there is good evidence that some physical events [namely, certain sub-atomic happenings] are uncaused. This can be shown to be irrelevant to the issue of free will, but I do not want to complicate the argument here.) This version of determinism can be called *metaphysical* or *ontological.* Unlike scientific determinism, it makes a statement about the world without any reference to human knowledge or to human (or superhuman) capacities for inference and prediction.

There is, of course, a close connection between these two versions of determinism. The evidence for our belief in metaphysical determinism,

if we believe it, is very largely the success of natural science in explaining, predicting and controlling the natural world. But it goes far beyond the scientific evidence. The first premise of the argument clearly stands in need of some justification. When Ayer considers this point he writes: "But why should it be supposed that every event has a cause? The contrary is not unthinkable. Nor is the law of universal causation a necessary presupposition of scientific thought."[10]

There are notorious difficulties in offering any persuasive justification of the principle that every event has a cause. It is not a generalisation like "all metals expand when heated" or "all green plants need sunlight". Such simple generalisations are (a) refutable by contrary instances and (b) are linked together with other generalisations to give an explanatory scientific background. But "every event has a cause" is not subject to such controls. Why then do we accept it?

At a commonsense level, the answer seems to be that it serves to make sense of our fragmentary experiences. Just as memory and imagination fill out our immediate physical environment which is evidenced only by scanty and irregular percepts, so causal explanations, tacitly under-pinned by an animal belief in the causal principle, give us a stable, orderly world of events and processes which goes far beyond our immediate experience. So we all have a pragmatic belief in the principle.

For the present, I want to point to a feature of Ayer's treatment of the free will problem which is common both to his earlier essays, to his Auguste Comte lecture "Man as a Subject for Science" and to his recent Whidden Lectures.[11] He discusses the problem entirely in terms of the surface phenomena of motives, intentions, and actions and the causal connections (or lack of causal connections) between them. But to a serious determinist these are, so to speak, merely the froth on the surface of human behaviour. There is a strong case for believing that the machinery of human action which is open to observation or introspec-tion (motives, intentions, emotions and so on) can be nothing more than the end products of causes of which we are unconscious. I mean, of course, not the hypothetical mechanisms of what used to be called 'depth psychology' but to the genuine and well established physico-chemical mechanisms studied by physiologists.

To be a determinist is to take the scientific picture of the world seriously. That picture shows that human beings like any other animal are individual energy systems in which there is a perfect balance between input of food and oxygen and output of energy in heat, movement, chemical and physical reactions, and waste products. This balance has been well established by experiment. Furthermore, all bodily processes such as digestion, respiration, growth, movement, and the rest can be shown to be based on physical and chemical reactions which we share

with the rest of nature. Most important of all, for the problem in question, human actions together with consciousness in all its forms have been shown to depend very closely on the physical processes of our brains and nervous systems. I add the cautious proviso "very closely" simply because no physiologist would claim that a perfect point for point parallel has yet been established between states of nervous tissue and states of consciousness. It may well be that there are good reasons why this never could be established. However, the more that is learned about neurophysiology, the more detailed does this parallel become. And even if the parallel were far less well evidenced than it is, it would still constitute a far stronger case for metaphysical determinism than considering the relations between motives, intentions, and actions. For whether or not motives can ever be the *causes* of anything, they are certainly the *effects* of bodily processes. Let us consider in what sense this is so.

All the varieties of human consciousness can be shown to have certain states of the central nervous system as a necessary condition of their existence. For example, the activity of the reticular formation in the brain stem is a precondition for any kind of conscious experience. And in an intact nervous system, certain particular states can be shown to be sufficient conditions for appropriate varieties of consciousness, given that the standing necessary conditions are present. For example, if I raise my right hand, there are various complex electrical and chemical events in my brain, nerves, and muscles which are immediate necessary preconditions of even so simple an event. And without these unconscious preliminaries, the event does not take place. Now antecedent necessary and sufficient conditions, suitably specified, are a plausible analysis of the concept of cause. So there is good reason to believe that the causes of all conscious states (including motives and intentions) and all bodily movements (including human actions) are complex physico-chemical processes in our nerves and muscles of which we are unaware. As one of the great neuro-physiologists of the century has written: "Our own picture of the universe is clearly not the whole truth but it has been too useful to be far from it and it can always be adapted to include fresh evidence."[12]

This is a far more formidable version of determinism than Ayer's. And if we are to consider the impact of determinism on our common-sense thinking about free action, it is well to state it in its strongest available form. It is a stronger version of determinism than the psychological version which Ayer considers because it is more precise and because it bypasses questions that he wants to discuss but which are matters whose decision procedures are ill-determined in the extreme. "Do motives cause actions?" is a vague question at best. And if we accept physiological determinism as our favoured version we have a

reputably established scientific story which assures us that there are antecedent necessary and sufficient conditions in our nervous systems which account for all the facets of consciousness including our wants, motives, intentions, and our actions as well.

But before we look in detail at Ayer's views on free will it is well to raise the question: "Suppose that metaphysical determinism were false, what would that do to support a belief in human free choice?" Ayer tends to offer a blunt either/or in his approach to the problem. "Either it is an accident that I choose to act as I do or it is not. If it is an accident, then it is merely a matter of chance that I did not choose otherwise."[13] But what is it to say that some event or other is "merely a matter of chance"?

In his essay on chance,[14] Ayer distinguishes no fewer than seven senses of the word 'chance' only a few of which are relevant to the problem in hand. There are chance events that we know to be caused but recognise that the causes at work are too complex for us to be able to take account of them. The simplest example of this would be tossing a coin. The fall of a coin, heads or tails, is ordinarily taken as a standard example of a random or chance event. But we know that the amount of force applied in the toss and its point of application together with a number of other factors like distance of fall, air resistance, and so on jointly determine whether the coin falls heads or tails. And the case is similar, *mutatis mutandis*, for all other instances of this sort of chance (dice throwing, roulette, the dealing of cards, and so on.) There is no contrast in such cases between cause and chance (even though we can construct series of 'random numbers' by throwing dice.) Nor is there in the occasion in which I meet a friend "by chance". Here the events leading to our meeting can be traced separately in the journeys of my friend and myself. The qualification "by chance" indicates only that the intersection of the two causal chains was not intended or foreseen. To say that something happens "by chance" without an *assignable* cause is not to say that it happens without any cause at all. Indeed, it is very hard to imagine a situation relevant to the issue of free will and determinism in which cause and chance can be contrasted in any plausible way so that one excludes the other. So there are perfectly good senses of 'chance' in which chance events are not uncaused. To sketch a scenario for a genuinely uncaused event, we have to outline something analogous to the case of Schrödinger's cat[15] where a macroscopic event (the death of the cat) may be brought about by a random and presumably uncaused event, the emission of a particle from a radioactive source. Genuinely random events are hard to find in nature and they can be identified and put to use only by rather sophisticated technology. And they can in any case, have little bearing on the problem of free will, as Ayer recognises.[16] His only other sense of "random" is one which he cites from the writing of C.S.

Peirce.[17] "Try to verify any law of nature, and you will find that the more precise your observations, the more certain they will be to show irregular departures from the law. . . . For an element of pure spontaneity or lawless originality mingles, or at least must be supposed to mingle, with law everywhere." This "looseness of fit" between law and observation can be attributed (though not indubitably) to the natural variability of events exceeding our powers of observation and the limits of our measurements. But this random variability in nature, if indeed it cannot be explained by the built-in limitations of our techniques of measurement, referred to above, can give no comfort to the libertarian unless he can explain how randomness can be incorporated in the concept of free choice. The attempts in this direction by Eddington, Eccles, and others have not met with any general acceptance.[18]

It is clear that what is needed, as a first step, if the libertarian is to meet the "cause or chance" dilemma offered by Ayer is a positive and detailed account of what free choice amounts to. We can look at some points which arise in giving this account when we have assessed Ayer's own answer to the question: How can we be said to be free if all human actions are the outcome of antecedent necessary and sufficient conditions? The libertarian can not be encouraged by the question: But what if determinism were false? For his case would not be any stronger if it were false, in the absence of a clear statement of what his own position amounts to.

Ayer's own version of determinism is a weak one on two counts: (a) it is a version of scientific determinism and so subject to the weaknesses of that variety of determinism that we have discussed above: (b) it depends on hypothetical laws of psychology which have not in fact been established. To put Ayer's case in its strongest form, I have suggested that we deal with metaphysical determinism rather than with scientific and concentrate on that particular form known as physiological determinism. This enables us to bypass psychological terms like motives, wants, intentions, and actions on the ground that these are events and processes which have necessary and sufficient antecedent conditions in the workings of the central nervous system.

II

Ayer's favoured solution to the problem under discussion is based on a proposed analysis of the concept of free action which has a long history. "A man's liberty", said Thomas Hobbes, "consisteth in this that he finds no stop to doing what he finds the will, desire or inclination to do."[19] And this in no way conflicts with the fact that "every act of man's will and

every desire or inclination proceedeth from some cause and that from another cause in a continual chain."[20] Hobbes did not elaborate his account and subsequent philosophers from Locke to Ayer himself have attempted to do so. Without development in detail, Hobbes's suggestion is merely a programme. And it is putting detail into this account that raises problems.

Ayer locates some of the difficulties of the debate between determinists and their opponents in a mistaken starting point. "We began with the assumption that freedom is contrasted with causality: so that a man cannot be said to be acting freely if his action is causally determined. But this assumption has led us into difficulties and I now wish to suggest that it is mistaken. For it is not, I think, causality that freedom is to be contrasted with but constraint."[21] In other words, he claims that all human actions are caused but only some of them are constrained or coerced. Constraint is a type of causality which operates in human actions (and, perhaps, though he does not consider the point, in some animal actions as well). And when it does operate, the action is unfree. But no other cases of causes effective in producing and directing human actions make an action unfree. Clearly, there are a number of questions to be asked about the relations between ordinary causes and constraining causes. But let us first look at the argument as Ayer puts it. He is claiming that "from the fact that my action is causally determined, it does not necessarily follow that I am constrained to do it: and this is equivalent to saying that it does not necessarily follow that I am not free."[22]

The strong point in favour of this 'consistency hypothesis' as it is sometimes called is that social judgments on human actions are very commonly made in accordance with it. We praise and blame and assign responsibility to those agents whose actions are plainly free from constraint or coercion. Why do we do this? It is not easy to give a convincing answer to this question. It is of no use to say that praise and blame and punishments and assignments of responsibility are measures of social control which are found to be effective in regulating freely chosen acts and ineffective in controlling the actions of psychopaths, kleptomaniacs, and the like. Though this remark is roughly true as a statement of fact, it cannot be consistently invoked by those who accept Ayer's account of human freedom. He admits that unconstrained acts are free and constrained acts are not. Let us take as an example two criminal acts of a similar description—say, holding up a small bank at gunpoint and stealing £50,000. One of these acts is committed by a psychopath, A, who has been certified by psychiatrists to be indifferent to the outcome of his criminal acts because of his psychological compulsions. The other is committed by a resolute and determined criminal, B, who has none of the traits of a psychopath. Threats of legal punishment have deterred

neither of them. So both of their acts were uncoerced by the usual social restraints. Yet we call B's act free (and so responsible) because it was unconstrained and A's act is counted as unfree because there is deemed to be evidence of inner psychological constraints which override the normal force of social and legal pressures. (We may suppose, perhaps charitably, that the psychiatrists have independent evidence for their assessment other than A's anti-social behaviour.)

Now consider the cases of C, D, E, . . . who read in their newspapers about the exploits of A and B. Each of them would very much like to have £50,000 and would gladly emulate A and B but for the fear of imprisonment and social disgrace. In other words, *they have been constrained* by the very forces which failed to constrain A and B. Must we not on Ayer's theory count these law-abiding citizens as unfree in respect of their law-abiding conduct? This is surely an unacceptable consequence of the theory.

I think that this criticism calls for an elaboration of Ayer's theory rather than its outright rejection at this stage. It is obvious that the notion of constraint or coercion as ordinarily used is too vague a concept to do the task assigned to it. The examples of constraining forces which Ayer himself gives are physical threats (such as having a gun put to one's head) and psychological forces of various kinds (such as kleptomania, compulsion neurosis, and the habitual ascendency of one person over another.)[23] These examples could be multiplied. What is obvious about them is that they are "forces" of very different natures and, indeed, of very varying degrees of efficacy. What they are presumed to have in common for the purposes of the argument is that all of them are, or can be, *causes*. Now this raises a special difficulty for anyone, like Ayer, who wants to hold a regularity theory of causation. In criticising the notion that all causes "equally necessitate", he writes "we tend to form an imaginative picture of an unhappy effect trying vainly to escape from the clutches of an overmastering cause. But, I repeat, the fact is simply that when an event of one type occurs an event of another type occurs also, in a certain temporal or spatio-temporal relation to the first. The rest is only metaphor."[24] So on the regularity account of causation, no causes constrain or compel. But on the hypothesis that freedom is consistent with determinism some causes must constrain or compel. Otherwise, all acts would be free and there would be no problem of "the freedom of the will". So there seems to be a conflict between Ayer's theory of free will and his theory of causality.

Thus the consistency hypothesis seems to require that there are two radically different kinds of cause at work in producing human actions. There is, first, the continuous physico-chemical working of the central nervous system; secondly, there are the various constraints and impedi-

ments, some physical, some mental, which impede or deflect the natural outcome of the body's physical processes, including the actions of the individual. How are these two types of cause to be distinguished? And what is the relation between them supposed to be? Clearly, the principal difference between them is that we are ordinarily made aware of the workings of one type of cause and not of the other. Indeed, this does seem to be a necessary condition for certain types of constraints to have any coercive power. If I am being threatened by a robber or a blackmailer to make me do something that I would not otherwise do, I must be conscious of the threat for it to have any power over me. All parties to the argument would agree that in such cases my action is, *prima facie*, unfree. (I add "*prima facie*" in anticipation of a case to be considered below.)

Let us then look at the consequences of accepting the following generalisation: If I am aware of being compelled to do X, then I am not free in doing X. This clearly would not satisfy Ayer. It is equivalent to: If I am free in doing X, then I am not aware of being compelled to do it. And it is easy to find counter-examples to this. Many young men in the United Kingdom were anxious to join the armed services in World War II, even though the conscription laws left them no choice in the matter. They joined the services "of their own free will" in the sense that they would have done so anyway even if there had been no conscription. It is no doubt in this sense that religious persons do willingly what they have to do anyway and call it accepting God's will. Indeed, it is easy to multiply counter-examples to this maxim which is an essential feature of the consistency hypothesis.

Nor is the situation any more favourable to the hypothesis if we start from the principle: If I am not conscious of being compelled to do X, then I am free in doing it. This certainly seems to cover an important part of the consistency theorist's case. Our ordinarily supposedly free acts fall conveniently under this rule. But it will not serve Ayer's purpose. Indeed, he admits that "the fact that someone feels free to do, or not to do, a certain action does not prove that he really is so. It may prove that the agent does not himself know what it is that makes him act in one way rather than another: but from the fact that a man is unaware of the causes of his action, it does not follow that no such causes exist."[25] Certainly, it is not difficult to produce counter-examples to this principle also. As Spinoza points out,[26] we are often conscious in dreams of performing "dream actions" with no sense of compulsion and often with the same feeling of freedom that accompanies our real life choices. Yet no one doubts that such dream sequences are programmed completely by the contemporary physical states of his brain. And there are well authenticated cases of illusory cases of free choice which have been induced

experimentally by post-hypnotic suggestion. (In another context, Ayer considers this case himself.[27]) Moreover, the second principle is equivalent to: If I am not free in doing X, then I am conscious of being compelled to do it. Here we may cite the case of the kleptomaniac which Ayer himself quotes.[28] Kleptomaniacs, if indeed genuine cases of the species exist, are presumably neither free in their specialist activities nor, ordinarily, conscious of the compulsion which drives them. So it is possible to produce clear counter-instances to any clear-cut statements of the consistency hypothesis as set out above.

But it may be objected that these "principles" are too clear-cut in that the lines between constraint and its opposite and between awareness and the lack of it cannot be clearly drawn. In his later paper on fatalism Ayer raises this point and recognises that a main objection to his theory is "that the boundaries of constraint are not at all easy to draw with any precision."[29] But the consequences of admitting that the boundaries both of constraint and of our awareness of it are imprecise do undermine the radical simplicity of the consistency hypothesis. And this is part of its strong attraction. It has the air, at first sight, of being a "no nonsense" theory, well in accordance with common sense, which sweeps away a great deal of ineffective metaphysical subtleties.

But once we recognise the areas of imprecision involved in its basic concepts, the problem changes. Instead of dividing actions exhaustively into free and unfree, we must now grade them as more or less free. And the degree of their freedom will be proportionate to, among other factors, the power of the constraints involved and the agent's awareness of this power. We then face the probably insoluble problem of measuring degrees of awareness and degrees of constraint. Such matters are both personal and private and relative to the strength of character and resolution of the agent. One man may be intimidated by mere verbal threats; another will not be moved by torture. If we make distinctions between degrees of freedom in such cases, what kind of objective basis can we claim for them?

Let us look at Ayer's original summary of his position and then ask how it fares against the type of determinism outlined above. To say that I could have acted otherwise is to say: "First, that I should have acted otherwise if I had so chosen; secondly, that my action was voluntary in the sense in which the actions of the kleptomaniac, say, are not; and thirdly, that no one compelled me to choose as I did."[30]

Consider these conditions from the point of view of a metaphysical determinist. In respect of the first condition, the obvious question arises: But could I have so chosen? In his 1946 paper, Ayer does not look at this question in any detail. But Dr. Anthony Kenny, writing from the point of

view of a believer in the consistency hypothesis, tries to square the hypothesis with physiological determinism. He discusses the question whether physiological determinism does not run counter to common sense by denying this proposition: If I am in a physical position to do X but do not do it owing to the current state of my central nervous system, I must be said not even really to have the opportunity to do X. "Physiological determinism need in no way involve the theory that wants do not affect actions: if it did, it could be excluded straight off as entailing an obvious falsehood."[31] And he goes on to say that any plausible version of physiological determinism must allow us to claim that whatever may be the case about the current state of my central nervous system, that state would be different from what it is, if I had wanted to do something different from what I am actually going to do.

We may certainly concede to Kenny that wants affect actions, though we must bear in mind that on the theory that we are considering, wants are themselves the by-product of physical states. We may also concede the hypothetical statement that if the current state of my central nervous system were different in certain appropriate ways, then I would want to do an action which I do not now want to do. But I do not think that we need also grant that having the opportunity to do these currently unwanted actions is equivalent to conceding this hypothetical. "If the current state of my central nervous system were different from what it is, then I would want to do X" is just like any other contrary to fact conditional statement. Its truth does not give me the opportunity to do X any more than the truth of "If I were now in Moscow, I could visit the Kremlin" gives me the opportunity to visit the Kremlin.

Physiological determinism "makes room for", in Kenny's phrase, the fact that if I wanted to do X, I would do it by emphasising that my wants affect my actions only because the state of my central nervous system affects my wants. The latter are causes of my actions only in the weak sense that they are an intermediate link in the causal chain between states of nervous tissue and my actions. My actions would indeed be different if my wants were different. But on the hypothesis that we are considering my wants can have no independent source for their existence and nature other than the current state of my central nervous system. So physiological determinism is a much more restrictive theory than Kenny has conceded. He concludes that "whatever my present state is, it is not a state such that" if I wanted to do X, I could not. "The libertarians have been right to insist against the determinists", says Kenny, "that there can be no genuine freedom in the absence of the power to do otherwise".[32] Whether this is a justifiable claim depends on how we read the phrase "the power to do otherwise". If we mean "an unconditional power to do

otherwise", the claim is false. But if we mean "a power to do otherwise conditional upon the presence of the appropriate state of our nervous systems", it is true. But this is an unsatisfactory concession to a clear-headed libertarian. Having a different state of the central nervous system is a necessary condition not only for my doing something that I do not want to do but also for my wanting to do it. And if that necessary condition is not present, I cannot be said to have the opportunity to do it. So I do not think that scientific determinism (in the physiological form in which it is most relevant to the problem of free will) can be interpreted in the innocuous way that Dr. Kenny proposes. If the theory is true (and, of course, I agree with Dr. Kenny that we have no conclusive proof of this) it is a very serious objection not only to commonsense views about human choice but also to more sophisticated views like the version of the consistency hypothesis that Ayer holds and which we are now considering. So to say that "if I had so chosen, I would have acted otherwise" is no guarantee that I would or, indeed, could have acted otherwise. The opportunity to act otherwise is contingent upon the ability to have so chosen. And if choices, like any other state of consciousness are the outcome of states of the brain, then I had no such ability. So physiological determinism, if true, is a formidable obstacle to the satisfaction of Ayer's first condition. And if it is not true, we seem to be left with the alternative that human actions and choices arise "by chance" in the extreme non-causal sense of that phrase.

The second condition says that my action has to be voluntary in the sense in which the actions of a kleptomaniac are not. We may presume that this means that I am not driven by psychological forces of which I am not conscious or, if I am conscious of them, find them too strong to resist. But psychological forces, on the hypothesis of physiological determinism have their appropriate counterparts in the current state of the kleptomaniac's central nervous system. And now the question arises: how do these physiological states which mirror the hypothetical psychological forces differ from any other physiological states which mirror other states of mind?

This question is relevant also to Ayer's third criterion: Nobody compelled me to act as I did. It is an essential feature of the consistency hypothesis that we distinguish between two types of cause which are operative in human behaviour, the scientifically established regularities of the physiologist and the coercions and constraints which are held to nullify free action. And how these psychological constraints arise is irrelevant to the theory. Whether they are the psychic undercurrents of the kleptomaniac or the threats, overpersuasions or psychological ascendency of some second party is beside the point. So Ayer's second and

third conditions merge together. On the materialist hypothesis that we are considering, they are both equally embodied in the physico-chemical states of the central nervous system. There is no way in which we can distinguish these two types of causation in their physical embodiments. Of course, it may be that physiologists of the future will be able to detect subtle differences of nature and origin between the physical states that represent the various causal influences on human experience and behaviour. But in the present state of knowledge, this is not so.

So Ayer's three conditions cannot give us a satisfactory distinction between free and unfree actions, if physiological determinism is an approximately true picture of the causation of human experience and behaviour. And if it is not a true picture, the believer in free will is not in any better position. He has to admit with Ayer himself that "if it is a matter of pure chance that a man should act in one way rather than another, he may be free but he can hardly be responsible."[33] Perhaps the way out of this uncomfortable dilemma would be to show that cause and chance are neither mutually exclusive nor jointly exhaustive concepts. This has been done, in another field of endeavour, by the theory of natural selection. But it is not obvious how we start to do it for free will.

There is one further feature of Ayer's earlier treatment of 'soft determinism' which deserves comment. To tie the concept of freedom to that of responsibility centres the dispute on moral and social issues so that we are led to disregard actions occurring in non-moral situations. But very many of our most important actions, particularly those which are the outcome of rational calculation, may have little or no bearing on moral questions. Consider, for example, making a move in a game of chess or choosing between alternative scientific hypotheses or giving a verdict as a member of a jury or making a choice between alternative careers. These are all rational choices, and it can hardly be denied that they are one important kind of free choice. They have an interesting common feature in that the more evidence we have favouring one course of action, the less free (because the more constrained by rational considerations) our choice appears to be. And at the other end of the rational spectrum, we have cases of the "Buridan's ass" type—say, selecting an apple from a dish of identical-seeming apples. Here our choice may be 'random' in the sense of minimally motivated, but it can hardly be said to be unfree. The virtue of considering non-moral cases of this sort is that we can throw some much needed light on the concept of free choice and give it some positive content. So long as this is merely a negative concept (for example, "unimpeded by constraints") it is a threadbare notion. And this makes it difficult to work with.

A second reason for not making this link is that the concept of

responsibility is a strange one. It is not clear whether it is a straight descriptive predicate, as it seems to be when Ayer talks of responsibility presupposing freedom or freedom entailing responsibility.[34] This surely implies that the two concepts are of logically similar types (like 'coloured' and 'extended' or 'temporal' and 'ordered'). But it has, of course, been persuasively argued[35] that 'responsible' is an ascription rather than a description, a status to which we assign actions and persons in virtue of certain properties. But if that is so, it is hard to see how invoking the notion of responsibility throws any light on the problem of free will.

There is a dilemma here. Either the concepts 'free' and 'responsible' have the same cognitive content or they do not. If they have the same content, then one of them cannot be explicated by referring to the other. If they do not, then either 'free' has some content which 'responsible' does not or vice versa or they are concepts sharing an overlap of cognitive content like 'fish' and 'reptile'. In all these cases we must ask: What is the shared and the unshared content? If we are not told that, the supposed link between freedom and responsibility is too uncertain to sustain any argument.

III

In a recent paper,[36] Ayer takes the argument further, recognising some defects in his former treatment. He still talks in terms of scientific determinism and of psychological explanation. And he still uses 'free' and 'responsible' as related by some sort of mutual entailment. Moreover, he still holds to the basic principle of the consistency hypothesis that there need be no conflict between freedom and causality. So far then, much of my previous criticisms, if valid, are still applicable.

The classical defenders of soft determinism (Ayer takes Locke as an example) had concentrated on the question: Can I put my choices into action? If the answer to this question is Yes, then I am deemed to be free. But Locke (and most of his numerous successors in this tradition) do not ordinarily raise the question: Do I have the power to make what *choices* I want? That is to say, do I have freedom of choice as well as of action? Locke regarded this question as "unintelligible"[37] on the ground that only agents are free and that it makes no sense to talk of human *powers* being free or otherwise. It seems to me that Locke disposed of this question in a rather cavalier fashion, relying on his own rather uncritical categorisation of experience.

But the question Ayer raises is an important one. It makes a bid to throw some light on a controversial suggestion by G.E. Moore that "I

could have chosen otherwise" can be read as equivalent to, or at least as entailing "I would have done otherwise if I had so chosen". This purported entailment raises the obvious question: But could I have so chosen? Ayer himself does not accept Moore's suggestion and produces some elaborate counter-examples to show that it will not work. But he does accept that the question "Can choices be free?" is worth investigating, and may not be dismissed out of hand in the manner of Locke. His method of attacking the problem of the limitations on an agent's freedom is to sketch a whole spectrum of such restrictions from the logically or physically impossible at one end through various awkward conjunctions of impeding circumstances to violable rules of morals, social conventions and even good taste. Any of these circumstances place restrictions of varying degrees of severity not only on the actions within our power but also on the corresponding range of choices. For example, no one (or at least no rational person) can even choose to be in two places at once. If some apprentice warlock were to cast a spell with such an outcome in mind, we would regard him as seriously deranged. And if we found an inventor working on the design for a perpetual motion machine, we would judge him, at best, to lack a basic knowledge of physics.

If we accept Ayer's picture, we have at least to recognise that we are impeded in choosing only those courses of action which we *know*[38] to be impossible or difficult. If my arm has been recently paralysed and I do not yet realise that fact, I am not precluded from choosing to raise it. And for much the same sort of reason, Thomas Hobbes was not prevented from choosing to waste his time in trying to square the circle. But given a reasonable degree of knowledge and rationality, Ayer can claim that it is "a great merit of the foregoing approach that it covers not only freedom of action but freedom of choice."[39]

Why should this be a "merit"? Presumably the reason is that the concept of freedom of choice is not only clearly distinguishable from the concept of freedom of action but also essential to it so that, at least in some important cases, if choices were not free, actions would not be so either. It is worth looking more closely at this assumption. "Free" in this context means "unimpeded" or "unconstrained" by any of the factors which Ayer has put into his spectrum. So the type of freedom here in question can be no more than that of the soft determinist that we have examined earlier.

There are many actions in which it is not possible to distinguish choosing from acting or deciding from implementing the decision. It often happens that a decision and its implementation are so intricately tied together that the distinction cannot be made. Consider, for example, making a stroke at cricket or tennis or performing some impulsive but

not involuntary action in self-defence, say, or to assist another person. The choice and the act are simultaneous and cannot usefully be disentangled. But there certainly are decisions made after cool reflection where the choice is made and the corresponding action follows perhaps after some necessary interval.

In such cases we would require that a "free" (that is, unconstrained) action would be preceded by a similarly unconstrained decision. A choice which was the outcome of a post-hypnotic suggestion would taint the ensuing act, however "unconstrained" it might appear to the agent.

But what is this choice? To pre-analytic common sense, it is a mental rehearsal of, and self-committal to the action which is envisaged. But such rehearsals and self-committals can be of very varying degrees of explicitness from detailed to vestigial. There are well-known difficulties in determining the nature and indeed even the existence of such mental episodes. Their introspectible features, if they can be clearly delineated, seem to bear little relation to the status of the episodes as genuine choices. Ayer does not discuss these questions. He wishes to single out as important only the disabling factors of our choices, those which will disqualify a choice as having been freely made. As he says, "the emphasis falls on the denial of freedom."[40] And he makes our assessment of the status of choices dependent, as it must be on his account, on the present state of knowledge. Perhaps future scientific developments would disqualify all choices from the status of "free" so that any present assessment we make must be provisional. We can never give a "not guilty" verdict: it has always to be "not proven".

"The awkward question is", he says, "how much this would matter."[41] He concludes that "we could still fall back on the Lockean conception of a free agent as one who is not prevented from doing what he chooses."[42] I do not think that we could do this. Ayer's treatment of freedom of choice and freedom of action as separable problems does not explain the relation between the two. And that relation is important. For unless we explain how they are related, it is unclear why the freedom of one should bear upon the freedom of the other. It seems to me that the relation between choice and action, between a decision and its execution may be something like that described by Aquinas in his discussion of free will.[43] A choice exemplifies what was later called 'liberty of specification' where we make a selection between alternatives; we execute the choice by 'liberty of exercise'. And both 'liberties' are required to explain the working of the will. Choice gives content to the act; exercise carries it out. Of course, this distinction does nothing to support or weaken determinism; but it makes a point which is relevant to Ayer's discussion. Choice is the more important feature since it determines the content of an action.

And once the selection of the content of an action has been decided, how can the execution be free, even in the restricted sense of 'unimpeded'? The impedance has already occurred in determining the unique direction to be taken. Freedom of exercise consists only in selecting the occasion for putting the choice into action.

I am sure therefore that Ayer was correct in emphasising the problem of free choice as important in its own right. But I am not sure that I understand why he did so, given the general tenor of his account. He has been rightly influenced by Sir Peter Strawson's treatment of the topic in his British Academy lecture "Freedom and Resentment"[44] where Strawson showed how the whole basis of our social attitudes and emotions would be destroyed, or at least, radically altered if once we took determinism seriously. Not only would the *raison d'être* of punishment and reward be abolished. We would no longer have rational grounds for pride, remorse, resentment, gratitude, and a host of other responses which Strawson collects under the general title of 'reactive attitudes'. Strawson's own attitude to this position is ambiguous. But on the whole, he seems to want to avert the eye of reason from clinching evidence in favour of determinism, supposing that the future growth of knowledge were to present it to us. (After all, the past growth of knowledge from Newton to the present, has gone a long way to make determinism plausible.) "It would not necessarily be rational", he says, "to choose to be more purely rational than we are."[45] Ayer himself endorses this sentiment, though with understandable misgivings. Both wish to preserve the comforts of what they believe to be an illusion, if determinism is true. "Like Strawson, I am disposed to see the outcome as an impoverishment of human life."[46]

This reaction is quaintly reminiscent of those churchmen who lost their faith in the cold wind of Victorian rationalism and afterwards complained that life had been drained of its colour and its meaning. It has the virtue of taking determinism more seriously than it is usually taken and the defect of not taking it seriously enough. Many philosophers have made this error in the past. Aquinas thought that determinism "removes the basis of merit and demerit in human acts".[47] And even Russell, in an unguarded moment in a popular essay[48] made the same error: "If when a man writes a poem or commits a murder, the bodily movements involved in his act result solely from physical causes, it would seem absurd to put up a statue to him in the one case and to hang him in the other." But a philosopher who takes determinism seriously will simply point out that, if determinism is true, the erection of the statue and the execution of the murderer were as much the result of previous causes as the writing of the poem or the murder. The "absurdi-

ty" is just the outcome of intellectual tunnel vision. This fairly obvious point was made in ancient times by Chrysippus,[49] but subsequent philosophers have not always taken his remarks to heart. The fact is that determinism is an all-inclusive theory. If it is true (and we certainly have no *conclusive* reason to believe that it is so), we cannot stand outside the system and take the stance of impartial critics. For we ourselves are then part of the system. This all-inclusiveness is, perhaps, in part, a weakness. But at least it cannot be said of it, as has been said of other metaphysical theories, that it leaves everything as it is. On the evidence of Ayer and Strawson, a belief in determinism can deeply alter our way of looking at what is for most people the most interesting part of the world, ourselves and our fellow humans. At least, that may be so, if we are rational and intelligent people. But it is known that the proportion of intelligent persons to the rest of the populace, let alone that of rational persons, is quite small. So perhaps the universal impoverishment of our social emotions would need more than the establishment of determinism to bring it about.

D.J. O'CONNOR

DEPARTMENT OF PHILOSOPHY
UNIVERSITY OF EXETER
APRIL 1987

NOTES

1. "Freedom and Necessity" in *Philosophical Essays* (London: Macmillan, 1954), pp. 271–84; "Fatalism" in *The Concept of a Person* (London: Macmillan, 1963), pp. 235–68; "Free Will and Rationality" in *Philosophical Subjects*, edited by Zak van Straaten (Oxford: Clarendon, 1980), pp. 1–13; "The Concept of Freedom" in *Freedom and Morality* (Oxford: Clarendon, 1984), pp. 1–16.
2. E.g. in "Man as a Subject for Science" in *Metaphysics and Common Sense* (London: Macmillan, 1967), pp. 219–39 and at other relevant points in his writings.
3. *Philosophical Essays*, p. 271.
4. Op. cit., p. 273.
5. Op. cit., p. 282 and *The Concept of a Person*, p. 263.
6. *Analytic Theory of Probability* (Paris, 1820).
7. *Philosophical Essays*, p. 284.
8. As Ayer himself recognises in a later essay (*Freedom and Morality*, p. 3).
9. *British Journal for the Philosophy of Science*, 1950–51.
10. *Philosophical Essays*, p. 272.
11. In "The Concept of Freedom".
12. Lord Adrian in *Brain and Consciousness* edited by J.C. Eccles (Vatican City, 1966).

13. *Philosophical Essays*, p. 275.

14. *Metaphysics and Common Sense*, pp. 94–114.

15. *Naturwissenschaften*, Vol. 23 (1925), p. 812. Schrödinger's fantasy was not, of course, elaborated with reference to free will. It had a serious purpose in the interpretation of quantum mechanics.

16. *Philosophical Essays*, p. 275.

17. *The Origins of Pragmatism* (London, 1968), p. 105.

18. For a criticism, see: D.J. O'Connor: *Free Will* (London and New York: Macmillan, 1971), pp. 57–59.

19. *Leviathan*, Chapter 21.

20. Ibid.

21. *Philosophical Essays*, p. 278.

22. Ibid.

23. Op. cit., pp. 279–80.

24. Op. cit., p. 283.

25. Op cit., p. 272.

26. *Ethics*, III, 2. Scholium.

27. "The Concept of Freedom" in *Freedom and Morality*, p. 8.

28. *Philosophical Essays*, p. 280.

29. *The Concept of a Person*, p. 257.

30. *Philosophical Essays*, p. 282.

31. *Free Will and Responsibility* (London: Routledge and Kegan Paul, 1978), pp. 31–32.

32. Op. cit., p. 29.

33. *Philosophical Essays*, p. 275.

34. E.g., *Freedom and Morality*, p. 2 and *The Central Questions of Philosophy* (London: Weidenfeld and Nicolson, 1973), p. 233.

35. H.L.A. Hart: "The Ascription of Responsibility and Rights", *Proceedings of the Aristotelian Society*, 1948–49.

36. "The Concept of Freedom" in *Freedom and Morality*, pp. 1–16.

37. *Essay Concerning Human Understanding*, II, xxi, Section 14.

38. In introducing this point, Ayer makes what seems to me (though not, I think, to him) a significant concession. "This is not to repudiate my earlier view that there need be no conflict between freedom and causality so *long as the causality is taken no further back than the operation of the agent's motive.*" ("The Concept of Freedom", p. 13) (My italics.) But he has not explained how a motive can be a new and independent source of causality.

39. "The Concept of Freedom", p. 13.

40. Op. cit., p. 12.

41. Op. cit., p. 15.

42. Ibid.

43. E.g., at *Summa Theologiae*, I, ii, Q.10.2 and Q13.6.

44. *Proceedings of the British Academy*, 1962.

45. Op. cit. p. 199.

46. 'Free Will and Rationality' in *Philosophical Subjects*, p. 13.

47. *De Malo*, 6.1.

48. *Why I am not a Christian* (London: Allen and Unwin, 1957), p. 36.

49. Cicero, *de Fato*, Chapter 13.

REPLY TO D.J. O'CONNOR

Professor O'Connor has delivered such a powerful attack upon my series of attempts to cope with the problem of free will that I am not at all confident of my ability to parry it. I am, however, content to follow the argument wherever it seems to me that it leads us. Even if I have to give way to him on all the principal issues, some philosophical progress will have been made.

I shall not spend much time over the opening pages of his paper. My reasons for this are that the distinction which he draws between scientific and metaphysical determinism, though interesting in itself, has no bearing upon our principal topic, and the metaphysical proposition that every macroscopic event has a cause appears to me vacuous, since I hold the view that the assignment of a cause requires the backing of a generalization, even if it be only a generalization of tendency, and every event can be subsumed under some generalization or other. For the proposition that every macroscopic event has a cause to acquire content, it must be understood as implying that every such event is covered by an operative generalization, a proviso which excludes generalizations which are introduced *ex post facto* and therefore not intended to apply to further instances.

O'Connor may disagree with me on this point, but it does not affect his argument, since he proceeds to satisfy my condition. He takes his stand on the view that 'we have a reputably established scientific story which assures us that there are antecedent necessary and sufficient conditions in our nervous systems which account for all the facets of consciousness including our wants, motives, intentions, and our actions as well'. I do not dispute the proposition that we have strong enough grounds for concluding that processes in our nervous systems are necessary conditions of all the facets of our consciousness. I do not

regard it as so well established that they are also sufficient conditions, and it is surely not yet the case that all the phenomena of consciousness can actually be explained in physiological terms. I do not, however, venture to deny that it ever will be the case, and I am not disposed to ally myself with libertarians who depend upon a rejection of O'Connor's view.

Since O'Connor and I are agreed that it is not in the interest of the libertarian to ascribe human choices and actions to chance, I shall not dwell upon his remarks concerning the extent of the antithesis between chance and causality. I concede his point that events, like the results of tossing a coin, which are ascribed to chance, in the sense that they tend to conform to the a priori calculus of chances, are also due to a combination of physical causes of the sort that he describes. At the same time, I follow Peirce in holding that, even at the macroscopic level, there may well be random events, in the sense that they can never be shown to be governed by operative laws. I refrain, however, from pressing the point that if macroscopic events find their explanation at the microscopic level, and the generalizations to which microscopic events are subject are irreducibly statistical, there is a sense in which everything that happens contains an element of chance.

Though I have long been dissatisfied with the essay "Freedom and Necessity" which I first published over forty years ago, its attempt to reconcile free will with determinism by distinguishing causality from constraint has attracted sufficient notice to make it worth while considering whether O'Connor has wholly succeeded in refuting it. His first argument is that all my examples of constraint are causes, but according to the regularity theory of causation, which I do indeed hold, no causes constrain or compel. O'Connor says politely that 'there seems to be a conflict between Ayer's theory of free will and his theory of causality'. The truth is that if his argument is valid, my position was inconsistent.

I do not believe that his argument is valid. I grant that in my view causes as such do not constrain or compel. This applies to his own hypothesis that all the phenomena of consciousness are physiologically determined. All that it amounts to is that there is dependable concomitance between one's mental states or processes and states or processes of one's central nervous system. So far as that goes, the mental items might be the causes and the physical items the effects. If we order it the other way round, it is, I believe, because the physical items fit into a wider explanatory pattern.

What I have granted is that causes do not constrain or compel *qua* causes. If some of them are to be regarded as constraints, it must be

because of other features which they possess, features which do not modify their causal status. Thus, even if these features could be adequately identified, which remains in doubt, my use of the word 'constraints' was infelicitous, in so far as it carries the suggestion of a mysterious increase in causal efficacity.

In "Freedom and Necessity" I seem to have interpreted 'constraint' in such a way that an agent was said to be constrained to do what he did when the circumstances were such that he could not have acted otherwise. Seeing that it was not at all obvious what this implied, I transposed the question by asking what were the circumstances in which I could have acted otherwise than as I did. I laid down three conditions, of which only the first need be considered, since the others were subordinate to it. Following Moore, I suggested that 'I could have acted otherwise' entailed that I should have acted otherwise if I had so chosen. Since this is consistent with my having made no choice at all, it needs to be added that I did make one, and then it seems natural to ask whether I could have chosen otherwise; but I shall come to that question later on.

O'Connor pays little attention to Moore's formula as it stands, and indeed at one point misrepresents it as a rendering of 'I could have chosen otherwise' instead of 'I could have acted otherwise', whereas as an analysis of 'I could have chosen otherwise', Moore offers 'I should have chosen otherwise if I had chosen so to choose' and it was with regard to both formulae that in *Freedom and Morality*, I devised the elaborate counter-examples to which O'Connor refers. An attempt to rebut Moore's analysis is, however, to be found in O'Connor's example of the volunteer and the conscript and I think that it succeeds. At least it frustrates the translation of 'I joined the army of my own free will' into 'If I had not chosen to join the army, I should not have done so'. Whether I had volunteered or been conscripted, it is possible that I should have joined the same regiment in the same capacity and been lodged in the same barrack-room at the same time. It might be objected that it would not have been exactly the same action because my mood would have been different, but part of this difference would consist in my feeling free in the one case and not in another, and it is not in dispute that one's feeling free to do something is not sufficient for one's really being so.

Where then does the difference lie? A plausible answer, at first sight, is that in the case of the volunteer only does the agent's choice function as a causal factor, by which I mean that it is, in the circumstances, an indispensable part of a sufficient though not a necessary condition of the ensuing action. I shall need to consider in my reply to Professor Honderich how far a statement of this kind can be fitted into the general view which I have taken of causality.

In any case, this answer would not satisfy O'Connor. It raises the question whether the volunteer could have chosen differently, and O'Connor has no hesitation in saying that he could not, since his choice would have been causally dependent on the state of his brain. There are, indeed, contemporary philosophers who go so far as to identify choices, or indeed mental events of any kind, with states of the brain, but for O'Connor causal dependence is enough. We can avoid digressing into a discussion of the identity theory by counting choice as a causal factor, under the appropriate conditions, if it is experienced as such by the agent whether it is identical with or no more than causally dependent on some current state of his brain.

So what sense can we attach to the statement that a person could have chosen otherwise, and is it ever true? My latest suggestion, set out in my lecture entitled "The Concept of Freedom" delivered in 1983 and reprinted in my book *Freedom and Morality* is that the statement is always relative to our current state of knowledge. We say that a person could have acted otherwise when we are not in possession of a body of information such that in conjunction with our stock of accredited generalizations we could, antecedently to his action, have deduced that he was going to act as he did. By this I do not mean that his action has to have been predictable. We may only subsequently come into the possession of information in the light of which we are entitled to assert retrospectively that the person could not have acted otherwise. My qualification 'antecedently to his action' is intended only to avoid trivializing the thesis, in a negative direction, by allowing the information to include descriptions of the action itself.

As I explained in my lecture, I arrived at this suggestion, which I advance only tentatively, by asking myself what was ordinarily thought to prevent persons from making such and such a choice and coming up with the answer it was our having or believing that we had good theoretical grounds for excluding it as a possibility. Thus, a person who claims to have made a free choice can be seen as issuing a challenge to all of us to account for his having chosen as he did: and here it is important for me to stress that a merely general assumption of the causal dependence of consciousness upon the central nervous system, however well warranted, would not be acceptable as an answer: to meet the challenge one must produce the specific theory and the particular facts which conjointly rule out any alternatives to the choice.

Pace O'Connor, I still consider it a strong point in favour of this approach that it covers freedom of action as well as freedom of choice, so that if we were to be content with Locke's conception of a free agent as one who is not prevented from doing what he chooses we should be in a

position to say what constitutes prevention. O'Connor's objection that there are very many instances in which no sharp line can be drawn between choice and action seems to me to have little force even against Locke, who could have adapted his thesis to Aquinas's terminology by identifying freedom of the will with 'liberty of exercise'. In my own case, it tells if anything in my favour since my analysis is meant to apply only to intentional actions, not to those performed inadvertently, if they deserve the name. On the other hand, I concede to O'Connor that the most I ever seek to obtain for those whose beliefs would appear to be put on trial by an acceptance of determinism is a verdict not of not-guilty but of non-proven.

How does this affect the other issues that he raises? Let us begin with the relation between the concepts of freedom and moral responsibility. I insert the epithet 'moral', which O'Connor tends to omit, because one is often, in ordinary usage, said to be responsible for much that is not the consequence of any intentional action of one's own. There are, indeed, cases in which one is accounted morally responsible for the results of unintended actions, for instance, if one is held to have behaved negligently, or acted under the influence of drink or drugs, where one's being in that state is a consequence of the fulfilment of previous intentions, but I think that we may be permitted to disregard the complications which they introduce. In the case where one is held to have behaved negligently, it is assumed that we could have taken the proper care. This illustrates the general point, which I do maintain, that one is accounted morally responsible only for the consequences of actions which were done either directly of one's own free will, in a sense which implies freedom of choice, or were such that they could be characterized as having been avoidable. This is not to say that I take the concepts of freedom and moral responsibility to be equivalent. I do not reject Hart's distinction between descriptive and ascriptive terms and am content to place 'free' in the first class and 'morally responsible' in the second. I think it likely that we can sometimes be said to choose or act freely in circumstances where no question of moral responsibility arises. O'Connor's example of selecting an apple at random, if we make such provisos as that the apples have not been stolen, would be a case in point. The question which we need to discuss is whether we can hit upon a descriptive account of freedom which is not only satisfied by persons who would commonly be said to be doing things of their own free will but is also such as to warrant the ascription to those persons of moral responsibility for what they do.

In this connection, I am sure that O'Connor would agree with me in interpreting moral responsibility in such a way that it sustains not only the bestowal of rewards and punishments but also the responses which

Strawson collects under the general title of 'reactive attitudes'. This may not be strictly in accord with ordinary usage, but that is unimportant. The point is that moral responsibility, as a basis for reward or punishment implies desert. Whatever utilitarians may say, it is a common assumption that people ought not to be rewarded or punished unless they deserve to be, and their desert in its turn is thought to presuppose an ability to have acted otherwise. Now the point which Strawson made was that the same applies to his collection of reactive attitudes. When we feel pride or remorse, or resentment or gratitude, it is always on account of actions which we suppose to have been freely performed.

My most recent account of the concept of free will does allow this condition to be satisfied, but perhaps not in such a way as to meet the requirements of the popular notion of desert. There is no formal inconsistency in attaching praise or blame or engaging in a reactive attitude to the performance of an action of which an essential feature is that we lack the knowledge which would have enabled us to deduce that it would be done, but it may well be doubted whether this is a rational ground for conceiving of the agent as deserving anything whatsoever, whether for good or ill. In fact, I am strongly inclined to say that it is not, indeed to go further to the point of maintaining that the popular notion of desert is incoherent.

This is a conclusion which Strawson himself apparently accepts, but is also content to disregard. Whatever may be his view, about rewards and punishments, he is resolved not to abandon reactive attitudes. In a passage which O'Connor quotes, and I endorsed, he relies on the proposition that 'it would not necessarily be rational to choose to be more purely rational than we are.'

I am no longer willing to subscribe to this epigram. I do not think it probable that I shall succeed in divesting myself of my reactive attitudes, nor do I altogether wish to, but I may manage to provide them with a different basis. I may succeed in taking not so much what Strawson calls an objective view of the behaviour which evokes them, since seeing it in a scientific light, even if that were possible, would not serve the purpose, but rather what one might call an aesthetic view; I should feel grateful for some act of kindness, not because I ascribed any merit to the agent but because I regarded the act itself as meritorious. I should feel remorse for a display of bad temper not because I considered myself to blame for it but because it was in itself an unseemly act. The fact that I would leave the field clear for a utilitarian rationale of both rewards and punishments would be quite widely regarded as a point in its favour, even by those, like myself, who are not willing to commit themselves to everything that passes for utilitarian theory.[1]

I am not worried by the argument that the maintenance or indeed the renunciation, if I could achieve it, of my reactive attitudes might itself be determined. My aesthetic responses to various forms of behaviour, or even their arousal of my moral sentiments, so long as these were not infected by an incoherent notion of desert, would not, so far as I can see, be rendered irrational merely by their being systematically correlated with states of my central nervous system.

What does rather worry me is that advances in the fields of psychology and still more of physiology tend to strengthen the hands of those who exercise power over others and indeed to favour the emergence of societies like Skinner's *Walden II* or Aldous Huxley's *Brave New World*. Since the members of these societies are represented as being happy, it is not quite clear why I should find the idea of them repulsive but the fact is that I do. But just as O'Connor seeks to reassure Strawson and my previous self with the remark that comparatively few persons are rational, so I now reassure myself with the thought that, when it comes to predicting human behaviour, the gap between theory and practice, though narrowing, is still wide and is likely to remain so.

A.J.A

NOTE

1. See my *Freedom and Morality*, 1A.

Désirée Park

AYERIAN *QUALIA* AND THE EMPIRICIST HERITAGE

The statement that Professor Ayer is the heir of Hume is obviously true, but not trivially so. The importance of the Humean tradition is perhaps best seen in the terms in which empirical information is presented for analysis. No one would deny that other influences, including Russell and the Vienna Circle, contributed to the range of philosophical concepts that Ayer early transformed for his own use. Readers of the Preface to the first edition of *Language, Truth and Logic* are reminded of the main lines of Ayer's thought at the time, and subsequent volumes, from *The Foundations of Empirical Knowledge* in 1940 down to the present, have continued to be mostly concerned with contemporary issues in epistemology and logic. Nevertheless, a great many of the distinctively Ayerian claims reveal the identifiable influence of Hume and the special interests of the classical British empiricists. This bias in favor of empiricism is, I shall argue, a good thing; though one which would have been even better if Hume and his partisans had given more attention to some few though telling details.

Ayer's taste for Hume's description of sensory experience is seen clearly in the role assigned to *sense-data*, now known as *sense qualia*. The concept of a private language is tangential to the historical Hume, but is firmly rooted in Ayer's account of sense qualia. These two related topics in Ayer's work will guide the following discussion.

SENSE QUALIA

The Humean ancestry of sense qualia is to be found in Hume's account of ideas and objects in his *Inquiry concerning Human Understanding*.

There it will be recalled, Hume's discussion of *matters of fact* has to do with those ideas which can be related by *resemblance, contiguity*, and *cause* and *effect*. Resemblance is the concept that is important here, and it is very curiously described by Hume. When we see the portrait of a friend, Hume tells us, then we are inclined to think of that friend because of the resemblance between the friend and the portrait. As the discussion is developed, it becomes clear that we can have Humean ideas of objects, including friends, that resemble the objects. This is not, of course, to say that our ideas can depict a complete object in three-dimensional space, but the link between ideas and objects is such that one can:

(1) Have an idea of an object that is like that object; and
(2) Reasonably suppose that an object of which one can have ideas, continues much the same whether anyone thinks about it or not; with the result that,
(3) Unperceived objects are just like perceived objects, except that the former are not perceived. One is thus led to suppose that unperceived objects are lurking off-stage, fully made-up and simply awaiting their cue.

Sense qualia display a similar independence of perceivers; and equally, as percepts, can signal the presence of an object. The discussion begins with appearances.

In *The Central Questions of Philosophy* we read:

There are two reasons why I shall follow a different procedure [from that followed by Goodman in *The Structure of Appearance*]. In the first place, I am mainly concerned not to organize appearances into a system but rather to show how they are capable of sustaining the interpretations which we put upon them. Secondly, I propose to make it necessary for anything to be an appearance that it be something of which the observer at least implicitly takes notice, and this induces me to treat as primitive a number of concepts which, from a purely logical point of view, it might be thought preferable to construct. Beginning also with the visual field, I add to the qualia of colour, not only qualia of size and shape, but also a set of patterns of which the description may be borrowed from that of the physical objects with which they come to be identified. Thus I shall speak of a visual chair-pattern, a visual leaf-pattern, a visual cat-pattern, and so forth, and I shall construe these terms as applying to any members of the range of visual patterns which would typically lead the observer to think that he was seeing the corresponding physical object. This is not to say that the character of the visual pattern is wholly determined by the identity of the physical object which it actually presents. . . . Neither is it to say that the observer characterizes these patterns *as* patterns. He notices them implicitly, in the sense that it is his registering of them that governs his identification of the physical objects which he thinks he sees. They provide the main visual clues on which our everyday judgements of perception are based.[1]

Qualia and percepts are then distinguished.

> When qualia are turned into particulars, whether by being located demonstratively or descriptively, I shall usually refer to them as percepts. In this I follow Russell. . . . There is, however, one important point in which I differ from Russell. Unlike him, I do not characterize percepts from the outset as private entities. It is obvious that qualia are not private entities, since they are universals which can be exemplified in anyone's experience. It might, however, be thought that privacy accrued to them when they were turned into percepts, in as much as their particularization had been made to depend on their location in sense-fields which are presented to a single observer. But the answer to this is that while the reference to a particular observer may occur in our explanation of the way that percepts come into being, it does not, and indeed cannot, occur in the primitive designation of percepts themselves. As I have tried to make clear, this is simply a matter of recording the presence of a set of patterns. Since persons do not yet come into the picture, there is no implication that the patterns occur in the experience of any particular observer, nor, therefore, that their concretion into percepts gives any one person a monopoly of them.[2]

We shall return to persons and particular observers in the second section. The point to be made here is that the Ayerian qualia enjoy that elusive state that sometimes allows them to resemble fairly complex objects, and sometimes reveals them to be indistinguishable from simple objects. For their part, the objects, as signalled by percepts, are independent in that they do not belong to any particular observer. Furthermore, a cat pattern may resemble a cat or be perceived as being where a cat is said to be, and no one need be mentioned in this account of things.

All empiricists agree that there is nothing mere about appearances, since only appearances can indicate that anything is going on at all. Ayer's treatment of the appearances of things shows a characteristically Humean approach to sensory information. Whereas Hume seized on resemblance as one means of associating ideas with objects, and thereby neatly provided himself with the possibility of having ideas of objects, Ayer endows qualia with the function of signalling objects. Percepts are qualia which are actually entertained and objects can be identified in terms of this familiar sensory information. In both analyses, appearances count, and one's ideas about them form a link with whatever objects there may turn out to be. Things are exactly what they seem, though other things may be found to be associated with them. The question is how to describe each kind of thing; that is, the things that seem, and their supposed accompaniment if any.

The passages quoted from *The Central Questions of Philosophy* began with Ayer's statement that he is mainly concerned to show how appear-

ances "are capable of sustaining the interpretations which we put upon them."[3] To this end, the designation of sense qualia as universals repeatable and available to all has clear advantages. Presented with a bird-pattern, say, one can seek out its owner, or notice the pattern in order to remember it for the purpose of judging future sightings. A percept that can correctly be called a bird-pattern offers good grounds for supposing that a bird is in one's view. In these respects, sense qualia organize appearances admirably, and do so by exploiting the working units of natural language. Patterned qualia and repeatable simple qualia effectively bridge the gap between the most elementary sensory information and physical objects. But now a problem emerges.

If the great virtue of sense qualia is to provide a means of generalizing sensory information, it is well to be clear about the information on which all subsequent claims must rest. What precisely are these elements of perception with which sentient beings are obliged to begin when describing the world?

The reply is first that they are elements in the strong sense, in that they cannot be in any way transformed; and second that they are proper elements because they literally provide the foundations of empirical claims.

Put briefly, the most interesting elements of perception have long been those of sight, touch, and hearing. The visual elements are particular colors, including both the spectral and non-spectral colors, as well as the blacks, grays, and whites. For our purposes, 'color' should be understood as 'hue'; and a color is that which is detected by sight exclusively. An example is *this blue* that I see now. Auditory elements are pitches, whether definite or indefinite. An example of the former is the F# that I hear now; of the latter, the siren that I am hearing. The tactile elements which concern us here are continuous or discontinuous surfaces.

A marble slab is tangibly continuous; a terry cloth towel is discontinuous. Equally, the edge of a rectangular table is tangibly discontinuous at the corners, whereas the edge of a circular table is continuous. Each example mentioned is an element as and when it is perceived and has no hidden aspects. To complete the description, an element of perception, of whichever sense one pleases, is confined to the moment that it is perceived and cannot recur, although it can be succeeded by a qualitatively identical perception. Essentially the elements of perception are, of course, strictly interpreted Berkeleyan *ideas* and none the worse for that.

The limitations of these perceptual elements make them particularly useful in analyzing appearances. Because such elements are restricted to the moment that they are perceived and cannot recur, they bring to light

the chief differences between reports of appearances and judgments about objects. Elements have no hidden features, hence only that which is perceived is to be considered. When therefore one is presented with the misleading appearances in the Müller-Lyer illusion, the systematic ambiguities woven into the case can be unravelled and the issues clarified.

This is of particular interest to Ayer in his campaign to collapse the gratuitous distinction between "the actual character of one's sense experience" and "the character one believes it to have".[4] As recently as his reply to David Pears in *Perception and Identity*, Ayer has noted the kind of exception provoked by ambiguous figures. Earlier indeed he had argued that the problem with the Müller-Lyer illusion does not arise from uncertainties about language, but from doubts concerning the appearance of the two lines. In *The Problem of Knowledge* he set out the essential issues as follows:

> Suppose that two lines of approximately the same length are drawn so that they both come within my field of vision and I am then asked to say whether either of them looks to me to be the longer, and if so which. I think I might very well be uncertain how to answer. But it seems very strange to say that what, in such a case, I should be uncertain about would be the meaning of the English expression 'looks longer than'. . . . I know quite well how the words 'looks longer than' are used in English. It is just that in the present instance I am not sure whether, as a matter of fact, either of the lines does look to me to be longer than the other.[5]

The first requirement is to identify and so dismiss irrelevant information, especially the psychological point made by the very existence of the illusion. For it is now well known that the textbook illustrations of the Müller-Lyer example show parallel lines of equal length. This done, the question turns to recurrence, and to the fact that the Ayerian qualia permit a second look and therefore the possibility of a revised opinion when one examines the lines again. The advantages conferred by an analysis based on perceptual elements are as follows:

First, the colors of figure and ground must be seen, but they need not be named. Second, the lines are colored shapes, which as these particular colors *will never be seen again*. Third, lines similar to these may be seen, but the colors on which all depends are confined by definition to their moment. It follows that only one look can count, and a second look cannot have the same colors as subjects, and therefore cannot be a look at the same lines. For as perceived, the lines are simply and entirely colors. We can, of course, say that the lines seen on a second occasion are to be understood as the same lines, and for most purposes we do this. But this practice remains an elision of color with colored figure, hence a literal

confusion of a transient perceptual element and a repeatable and comparatively stable object.

The Müller-Lyer illusion can therefore be unhinged by insisting on its terms. To the question which line looks to be the longer one, the answer is to be framed with reference to how the lines look here and now. A second viewing is literally of successor colors, and a different opinion about the shapes or figures so colored may be given without contradiction.

This option is not available when one is judging in terms of Ayerian percepts and qualia. For if the lines are qualia associated with a comparatively stable figure like a drawing, there is no way to evade the claims arising from a second viewing of the same figure. The problem is that percepts resemble objects in their stability, and a second percept can be incompatible with its predecessor; leaving one then to choose between a single figure with inconsistent properties, or a mistaken judgment.

It has been objected that the special case of the Müller-Lyer illusion is not so much concerned with a second viewing as with genuine uncertainty about whether one line looks longer than the other. This challenge brings out a crucial difference between the Ayerian qualia and perceptual elements. The elements are transient, and each element must be judged at this moment or not at all. Qualia, by contrast, reflect the customary beliefs entrenched in natural language. Thus the visible lines of our example are attenuated colored shapes which not only are thought to persist from moment to moment, but whose lengths are best judged by measuring them. I should argue therefore that Ayer's professed hesitation about the length of the lines in the passage quoted rests on the unspoken conviction that the lines could be measured, and that the result of this exercise would give a true answer to the question. It is after all by systematic measurement that we determine lengths most accurately. Hence it is not unreasonable to resist experiments that are known to be less reliable than our time-honored methods. I should think too that if the question were explicitly about the colors one perceives when viewing the lines, Ayer would be quite prepared to say whether they all looked to be the same color. For then the look of the colors would be the only information that could possibly count.

I conclude then that the 'actual character of one's sense experience' is indeed 'the character one believes it to have', provided that one's sense experience is accurately described. Moreover Ayer could sustain this good empiricist claim intact, if he were to concede to the elements of perception their place at the level of fundamental sensory information. This is not to deny that habitual usage readily conforms with the Ayerian qualia, and that empirically indubitable elements are rarely mentioned. But then it has been noted that from the beginning qualia were intended

to reflect the divisions of natural language. That they obviously do so is a mark of their success and is not disputed. Still, elements, as their name suggests, continue to abide in sensory experience even when they are not explicitly recorded.

Ever since Hume, apparently perceivers have been engaged in suspect relations with ideas while remaining systematically invisible. Ayer's reluctance to admit perceivers to his scheme of things is seen in his account of qualia and percepts, but I do not see how something like a perceiver can be successfully avoided. Certainly perceptual elements can be balanced only by a perceiver or sensible perspective, which is a point I judge to be in their favor.

The advantages conferred by perceivers are clear. There is first the concept of *presence,* which empiricists have used freely at least since Locke defined an idea as whatever is present to the mind. Then there is *direction,* which is concerned not just with a measured distance increased or diminished between two points, but rather with progress from point to point. Again, in a world of three-dimensional objects, the near and far sides of objects require an implicit perspective. Whether one is an empiricist or not, a working perceiver has the inestimable value of focussing privileged information, including all sensory information and the indispensable judgments that we make without using words. If your appearances are not my appearances, and how could they be, how does anyone come to recognize anything and then talk about it?

PRIVATE LANGUAGE

The percipients or observers in Ayer's articulation of the physical world lead to the public/private distinction eventually, but not immediately. He is first concerned to avoid skepticism by evading the classic perceiver and the inevitable problems attendant on an individual point of view. To this end one is warned:

> These difficulties [arising from the assumption that percepts require a percipient to whom the percepts are exclusively attributed] are avoided by making percepts neutral, which is not to be confused with making them common. I shall, indeed, represent the theory out of which the physical world is constituted as being developed by a single observer. This Robinson Crusoe approach is not meant to be historical, but only to do justice to the fact that any knowledge of the world which anyone acquires is bound to be based upon his own experiences. It might seem, at first sight, as if this is to take the idealist position which I have just been condemning, but there are two vital points of difference. The first and most important is that the observer is not permitted to conceive of the data with which he works as

private to himself. We shall see that this is eventually possible, but only when the theory has been developed and is allowed to transform its own origins. The second is that the observer is not identified either with myself or with any other person. If I am asked who is then supposed to carry out the construction, my answer is that we can think of it as being carried out by anyone who disposes of the necessary percepts.[6]

It is not perfectly obvious that Ayerian percepts can be as neutral as Ayer says that they are. The problem is that this ruled neutrality leaves the concept of presence adrift, and presence is not so easily governed by *fiat*. We have been told that "reference to a particular observer . . . does not, and indeed cannot, occur in the primitive designation of percepts themselves. As I have tried to make clear, this is simply a matter of recording the presence of a set of patterns."[7]

It seems to me highly implausible to talk about the presence of some appearance without admitting that the appearance takes place *now* from some percipient's point of view. Moreover it is the very neutrality of percepts which removes from them the usual and more fruitful connotations of 'presence'. At this juncture the elements of perception, with their necessary perceivers and perforce the accompanying perspective, make a better case for a private language than do percepts themselves. And perceptual elements do this in terms that Ayer otherwise supports.

The privileged information of a perceiver has been much talked against of late, but always in terms of descriptive systems that exclude perceivers from the outset. That I, or anyone else, can be possessed of information quite independently of whether this is articulated by me, or described in other terms by some observer, is a claim I take to be among the few certainties about the world. One form in which this privileged information occurs is that of a private language, one sometimes associated with the elements of perception and their recognition.

In defending private language Ayer has recently repeated his view that "anyone's significant use of language must depend sooner or later on his performing what I call an act of primary recognition."[8] This is elucidated by noticing that the process of checking the evidence of one's senses and one's memory must come to an end. In developing his account of recognition Ayer remarks:

> The point I am stressing is not the trivial one that the series of checks cannot continue indefinitely in practice, even if there is no limit to them in theory, but rather that unless it is brought to a close at some stage the whole series counts for nothing. Everything hangs in the air unless there is at least one item that is straightforwardly identified.[9]

Essentially private language is the language of recognition; discourse follows from it and must be taught. Ayer makes this point when he remarks that, "Wittgenstein's well-known dictum, 'An "inner process"

stands in need of outward criteria', is pedagogically true."[10] What then is to be recognized in acts of primary recognition?

From the evidence available so far, the subject matter of an act of primary recognition is an Ayerian percept. Certainly a percept is a good candidate for the 'one item that is straightforwardly identified' when one engages in checking one's memory about one's sensory experience. But if this is so, then again it can be argued that the elements of perception are the more secure in their identification, and therefore to be preferred, because they eliminate ambiguities that percepts tolerate. As the analysis of the Müller-Lyer example showed, perceptual elements isolate sensory information by sharply distinguishing it from the descriptions and predictions in which it can figure. It is true that if elements are to be used, then a perceiver, or sensible perspective, must be admitted to the account and the neutrality of Ayerian percepts abandoned. But this price is not, I believe, unreasonably high because perceptual elements still march well with Ayerian qualia when the external world is described in natural language. Moreover, we have already noticed that a good many benefits follow from admitting that sensory information is always governed by a perspective. Not least was the fact that concepts like *near side, far side,* and *direction* made rather better sense if observations were thought to be made from here, now.

One way of showing the operation of acts of primary recognition in private language is to consider what 'sameness' can mean in different contexts. It is obvious that the grounds for saying that one thing is like another, or that two things are the same, are in part determined by the kinds of things under discussion, and how they are said to be known.

Of two colors, it has been noted that they must be perceived together; that is, at the same moment in order for their likeness to be judged. As visual elements, *this green* and *this green* are to be compared now or not at all. If they are the same, they will exhibit the 'perfect likeness' of like ideas, in the Berkeleyan sense of *idea*. Their qualitative indistinguishability, and hence their identity as colors, is inevitably confined to the single moment when they are perceived.

This concept of 'the same' clearly is different from that used in comparing two ordinary physical objects. First, unlike perceptual elements, two such objects usually are supposed to be comparatively stable. Second, the sameness of physical objects can include tangible features as well as visible ones. Third, two objects can be measured, struck, weighed, chemically analyzed, and rearranged in innumerable ways in the search for properties which as objects they both exhibit. Moreover, these several properties can be distinguished from the sensory evidence for them, and given a systematic description. Plainly then, the sameness of colors is unlike the sameness of objects. Hence to judge that two colors are the

same is quite different from judging that two objects are the same. Only another transient *this green* can be indistinguishable from *this green*, and therefore the same as it; whereas many continuous rectangular figures are of the same size as this page, including the other pages in this volume. Furthermore no one needs to measure the pages to discover whether or not this is the case, since the test of perceptual congruency is a commonplace use of Ayerian qualia.

In discussing private language Ayer has called attention to the fact that a private language is not the code of a psychological secret society which has only limited interest. One is told quite explicitly:

> I think it very important to note that it makes no difference to my present argument [about memory and current sensation] whether it is applied to the use of signs to refer to what are counted as public objects or to their use to refer to so-called private experiences.[11]

This lends support to the earlier-mentioned claim that private language is the language of recognition; and in recognition Ayerian qualia come into their own. One notices similarities that need not be articulated, that frequently, indeed, have neither names nor standard descriptions. The familiar pattern of movement that a friend's silhouette exhibits when apparently walking at some considerable distance is a common instance of non-verbal recognition known to innumerable near-sighted observers. There is too the dissimilarity, again nameless apart from being noted as 'different', which can be seen in selected adjacent water-marks in a reference work on the subject. Anyone who undertakes to identify a water-mark based, say, on the letter 'P', is confronted with hundreds of slightly differing figures whose differences have no concise standard description, but which are readily apparent.[12] In neither case of recognition is there any need to give a definite name to the similarities and differences that are noted, even if it could be done. As experience teaches, it is sufficient to recognize the patterns which are displayed, and these are precisely the Ayerian qualia.

To sum up, it would seem that the special advantages of qualia would be enhanced if the elements of perception were acknowledged to provide the foundations of empirical claims. Perceptual elements, because they are indubitable, put an end to redescriptions of empirical information, and either they are noticed or they are nothing. A registered element like 'this green' is an obvious candidate for the part of the ultimate subject in an act of primary recognition. To register an element is not of course to make an assertion, but the analysis of elements reveals their happy limitations and consequent usefulness.

It is clear from the passages quoted that a registered 'this green' usually is insufficient for Ayer's purposes, and that the more elaborate

patterned qualia are required to serve as subjects for most acts of primary recognition. This causes no problems; patterned qualia, like a squirrel in a tree, are suitable subjects for primary recognition, although there subsequently may be doubts about the identity of the squirrel or the tree. Even then however it will still be true that the subject, as registered, consisted in colored shapes that once looked like a squirrel in a tree. The elements of that percept attach it firmly to its moment, and it does not matter that the apparent squirrel of the first viewing is later said to be a curiously shaped branch when seen from a different perspective or in a better light. Empirical claims are always subject to revision. It remains the case that it is the perceptual elements which signal that something is going on now, and that any further account of what is happening is traceable to their successive appearances.

Finally, there is no denying that the elements of perception bring with them a perceiver of the sort that all Humean tradition has endeavored to exclude. And yet quite how it is proposed to deal with presence, perspective, and even acts of primary recognition without introducing something rather like a perceiver is not altogether clear. If Ayer is right about private language, as I think he is, some points about perceivers and judges need elucidation. How, for example, is the concept of presence to be developed in company with the Ayerian qualia; and how can the neutrality of percepts be balanced with the demands of sensory experience? More generally, what would Ayer now say about the tacit perspective that governs empirical claims, and of which he has made such liberal use?

DÉSIRÉE PARK

DEPARTMENT OF PHILOSOPHY
CONCORDIA UNIVERSITY
LOYOLA CAMPUS, MONTRÉAL
SEPTEMBER 1986

NOTES

1. A.J. Ayer, *The Central Questions of Philosophy* (London: Weidenfeld & Nicolson, 1973), p. 91.
2. Ibid., pp. 93–94.
3. Ibid., p. 91.
4. G.F. Macdonald, *Perception and Identity, Essays Presented to A.J. Ayer with his Replies to them* (London: Macmillan, 1979), p. 288.
5. A.J. Ayer, *The Problem of Knowledge* (London: Macmillan, 1956), p. 65.
6. *Central Questions*, pp. 98–99.

7. Ibid., p. 94.
8. A.J. Ayer, *Wittgenstein* (London: Weidenfeld & Nicolson, 1985), p. 76.
9. Ibid.
10. Ibid., p. 77.
11. Ibid., p. 76.
12. Cf. *Wasserzeichen Buchstabe P—Teil 2*, ed. Gerhard Piccard, Stuttgart, 1977, Section VII, Nos. 194 and 195, and ff. For further instances of Ayerian *qualia* and their special advantages see my *Elements and Problems of Perception* (Oxford: Alden, 1983), pp. 84–88.

REPLY TO DÉSIRÉE PARK

Professor Park's paper raises several interesting points. It does, however, contain a misunderstanding, for which no doubt I carry some responsibility through failing to make my position sufficiently clear. It is true that my 'construction' of the physical world begins with the transformation of what I call percepts into visuo-tactile continuants, and true also that my descriptions of the qualia which are embedded in percepts are chosen with this end in view. Nevertheless, percepts themselves, as I conceive them, do not in themselves differ from Park's 'elements'. As she rightly says, I chose to begin with qualia because they carry no suggestion of privacy; they are not tied to my own or any other person's sense-experience, to the exclusion of any one else's. They are, however, particularized by being instantiated in just one sense-field. This is what produces percepts, and percepts do eventually turn out to be private when the construction has reached a level where the concept of privacy can find a home: until then it has no application.

This point is recognized by Park, which is not to say that she accepts it. Where she misunderstands me is in supposing that I take percepts, in their original form to be repeatable, though I admit that there are one or two earlier passages in *The Central Questions of Philosophy* from which this conclusion might be drawn. It should, however, be clear, that the very fact that percepts owe their existence to the particularization of qualia entails that they occur only once. The positioning of the same quale in a different sense-field produces a different percept; its positioning in a different part of the same field may render it a segment of the same percept; but it will be a different segment and neither segment of the percept or the percept as a whole can re-occur. It is in this respect that my percepts coincide with Park's elements which, in spite of Berkeley's speaking of sensible qualities, she may, as an authority on Berkeley, be justified in identifying with Berkeleyan ideas.

Without attaching great importance to the question, I demur to
Park's saying that 'these ideas,' in what she takes to be Berkeley's sense of
the term, 'literally provide the foundations of empirical claims'. I regard
it rather as a matter of convenience whether one starts with what were
recently known as sense-data or with sense-qualia which are then
particularized. If there is any question of fact involved, it is presumably
psychological. And here I believe that children recognize patterns before
they discriminate particulars. This is not, however, a point on which I
want to insist.

What I am more concerned to question is Park's assumption that 'the
actual character of one's sense-experience' cannot fail to be 'the character
one believes it to have'. She may be right, but the only reason which she
advances in favour of her view, namely that 'ideas' occur once for all,
does not seem to me sufficient. Let us consider her example of the
Müller-Lyer illusion. She is mistaken in thinking that I believe that my
doubt whether one line really looks longer than the other on a given
occasion can be settled by taking a second look, still less by measuring the
physical lines. In my discussion of the question in *The Problem of
Knowledge*, which Park quotes, I allow it to be possible that I should be
unsure, when simply confronted with what I now call percepts of the two
lines, exactly how they look to me, and I am still inclined to maintain this
position. This would apply also to Park's example of two patches of
colour in the same visual field; one might be uncertain whether they were
identical in hue. Neither does the fact that these items do not recur
appear to me to exclude the possibility of coming to a decision retrospec-
tively in the light of further evidence; in doubtful cases further evidence
might even lead one to revise one's verdict. On the other hand, if I am in
no doubt, in the presence of the sense-field, that the two patches of
colour, for example, are of identical hue, or that one of the two lines does
look longer than the other, then I take my judgement to be authoritative:
I make no provision for its being over-ridden.

I have changed my mind more than once concerning this question of
'incorrigibility' and one of the reasons for my vacillation has been an
uncertainty about the logical consequences of my commitment to the
view that the ingredients of a sense-field are 'given' as being of such and
such a hue, such and such a pitch or whatever it may be. This does not
entail that they are so labelled, if only because sense-fields are presented,
and their contents in some degree recognized, by animals and children
who have not acquired the capacity to label them. Those who do have the
capacity are seldom content to exercise it on its own. The common-sense
theory of the physical world is built into the language which they
originally learn. They speak not of green patches but of green leaves, not

of a sound of or such and such a pitch, but of the mewing of a cat. The notice taken of the data is implicit in such judgements, but as a rule these are not two separate episodes, though this may be the case when for one reason or another the physical object in question is hard to identify.

Where then is there opportunity for error? Obviously, at the physical level. One can be mistaken not only about the identity of the physical object in whose presence the character of a percept has led one to believe, but also about its qualities. The colour which it looks to have on a given occasion may differ from the 'red' colour which is ascribed to it on the basis of further information. But what about the sensory level? It is not denied that one can make a verbal mistake, whether owing to a slip of the tongue, or through ignorance of the correct use of the words that stand for colours or sounds or tastes or tactile or olfactory qualities. I have no doubt that it is the greater richness of our vocabulary for describing colours, owing to the leading part played by sight, except for the few who do not possess it, in the formation of our beliefs, that accounts for the predominance of visual examples in discussions of this sort. But this itself could be misleading. The English language does contain a fairly rich vocabulary for describing the 'auditory elements' which Park, I am sure for good reasons, would have us designate as 'pitches'. It is, however, a vocabulary of which I, for one, can take only a very small advantage. I can distinguish 'loud' from 'soft' and 'bass' from 'tenor' but not even 'sharp' from 'flat'. Suppose now that I pursue my musical education to the point where I confidently but erroneously greet an auditory element as 'C# '. Am I entitled to say that it sounded C# to me? I do not think that I am. The tautology that it sounded as it did does not sustain whatever more informative description one chooses, however honestly, to give. But how does this accord with my earlier claim, when dealing with the examples of the colour patches and the Müller-Lyer illusion, that, if it was no way hesitant, my verdict was authoritative? The underlying assumption, which was justified in those cases, was that I was using my words correctly. It would seem to follow that my misdescription of the sound has to be counted as a sort of linguistic mistake. And the same would apply to many such examples, taken from any of the sensory domains. Factual error would be excluded.

I am not entirely happy with this conclusion, but perhaps it matters less than my wrestling with the problem would suggest. What is important for my general position is first, that percepts and only percepts serve as springboards for our everyday discourse about physical objects and secondly, that any explicit characterization of these percepts, whether it

be corrigible or not, and whether or not it ventures beyond them, is a part of the total experience to which the percept in question belongs. In short, I follow Hume, William James, and Russell, at all but the start of his career, in rejecting any act-object account of sensation and identifying minds with series of mental states.

This brings me to the principal point of disagreement between me and Park. Perceivers enter into my scheme of things but only at a very late stage, after the prominence of a particular set of percepts has led to the promotion of one visuo-tactual continuant to the status of what Peirce called 'the central body', after other continuants have been distinguished as bodies of persons by their association with the emergence of signs, and after percepts have been re-interpreted into the theory which they have served to build as states of the persons who are conceived as 'owning' the various bodies, in a sense of ownership of which I confess that I have not yet been able to give an adequate account. One great advantage of this elaborate procedure is its preservation of neutrality. The title to the central body can accrue to anyone whose constitution includes the requisite percepts.

Park, on the other hand, does not believe that one can manage with only Berkeleyan ideas as primitive elements; there has also to be a percipient, a percipient who, as Park forgets to point out, can be no other than herself. But what can this percipient be? Nothing but what Berkeley himself took it to be: a spiritual substance. But this alone gives rise to my first objection. I do not find the notion of a spiritual substance intelligible. What could be the criteria for its identity?

My second objection, like the first, is one that applies equally to Berkeley. In neither case, so it seems to me, is any provision made for avoiding solipsism. As Park has acknowledged, in her scholarly examination of Berkeley's philosophy, he simply makes himself a present of the notions of the Deity and of other spirits. But even if he be allowed this latitude, there remains the objection that he has no warrant for crediting these other percipients with counterparts of his ideas. He does make rather a perfunctory effort to use an argument from analogy, but how can this possibly lead him ever to acquire the concept of alien ideas, if his only resources are the notion of a company of spirits and a set of ideas earmarked as his own? With this inheritance I cannot see that Park is in any better position.

Of course, if one is greedier than Berkeley, and makes oneself a present of embodied minds, one can still develop a theory of perception, without having even to entertain any thought of the menace of solipsism. But this would be simply to abandon the philosophical enterprise, to which Park and I are alike devoted, of discovering a basis in experience

for our beliefs in the existence and character of an external world, and examining how, on this basis, such beliefs could be justified. Contemporary fashion in philosophy has, indeed, tended to turn away from the theory of knowledge. Its followers are content to enjoy what Russell once called the advantages of theft over honest toil.

Having said why I am unable to accept Park's premature introduction of a perceiver, I need to deal with her reasons for taking this course. They are that they give her two advantages, to which she thinks that I am unable to lay claim. The advantages consist in the command of two concepts: the concept of 'presence' and that of 'direction'. It should be stressed that these concepts cannot, in her case, have the physical applications that they commonly carry. Presence is not the occupation of a spatial region more or less adjacent to that which is currently occupied by one's body. It is simply what is currently given to a mind; and here I am waiving the fatal objection that the mind can only be Park's own. As for direction, all that she says about it indicates that she is tacitly assigning it a physical function. For example, she says that it 'is concerned not just with a measured distance increased or diminished between two points but rather with progress from point to point'; it caters for 'the implicit perspective' involved in distinguishing the near and far sides of objects in a three-dimensional world: it joins with presence in supplying appearances with 'a point of view'. I am unable to see how these operations are facilitated by the introduction at the outset of a disembodied perceiver, still less why it should be thought necessary for their performance.

On both counts my own position is quite simple. The presence of a quale just consists in its actual instantiation. I am doubtful whether the use of demonstratives is necessary for locating it explicitly, but I do not deny that they can be used, and if they are used they enter into the narrative which forms part of the total experience in which the percepts which they designate occur. The benefits which Park claims to derive from her concept of direction accrue to me through my following William James in taking visual and tactual fields to be intrinsically three-dimensional. My reason for preferring this view to Berkeley's conception of the visual field as initially two-dimensional is that Berkeley derives his argument from the science of optics, on which he is not in a position to draw, whereas James is reporting the way things actually seem. My adherence to James on this point undoubtedly makes it easier for me to develop my construction, but I think that it might be possible for me to accept Berkeley's conception of the visual field, if I had any good reason for doing so, and reach the same end by associating visual with tactual percepts at an earlier stage. This would also bring me more

quickly to the identification of the central body, which does indeed supply the perceiver with his 'point of view' at the physical level, but is itself constructed in part out of percepts which fulfil the same function at the sensory level. The introduction of a perceiver as a primitive factor is accordingly shown to be superfluous, even if it were legitimate.

A.J.A.

15

David F. Pears

AYER'S VIEWS ON MEANING-RULES

How ought we to represent the commerce between mind and world? Is there a series of separate contacts, each one-to-one? Or is it really more holistic than that? This is a question too vague to be answered as it stands, but it may serve to identify a line on which philosophers can be roughly placed. Ayer's position has always been as far as he could push it towards separatism. But how far did he think that this tendency could go? And how far can it actually go?

I shall not try to deal with all the manifestations of this tendency in his *oeuvre*. One of them was discussed in an article by me in the collection presented to him to mark his retirement in 1978 from the chair which he had held at Oxford University for nineteen years[1] and in the comments that he made on my article. The question at issue there was whether someone can make a mistake in his report of a sense-datum that he is having at the moment and, if so, what kind of mistake it might be. Here I want to examine Ayer's views on another, related matter, meaning-rules.

The two topics are connected in many ways, and the clue that I shall be following is the effect on Ayer's treatment of each of them that is produced by his tendency to separatism. A philosopher who is apt to underestimate the consequences of the way in which even knowledge of a sense-datum spreads beyond the particular situation, may well underestimate the diffuseness of the basis of a meaning-rule. I am not sure how far he really does underestimate these two things, but I am sure that his drive towards separatism is a clue that is worth following.

Before I start, I should make the familiar point that the name "meaning-rule" represents the topic as a simpler one than it really is. For it suggests that a regularity in our linguistic reactions can be checked in the same way as any other kind of rule-governed behaviour: we merely look up the rule in a book to see if what we are doing conforms to it.

However, that way of checking a regularity presupposes, and therefore can not establish, a regularity in the use of the words in which the rule is formulated. Naturally, this is not felt as a deficiency when the rule is a practical one, like a rule of a game: we take the meanings of the words as given and we check whether our practice conforms to the rule in whose formulation they occur. However, it may be felt as a deficiency when the rule governs a linguistic reaction. For in such a case it is supposed to gear our use of a word to the world and it can do that only by specifying in further words what in the world would make that particular word appropriate.

Wittgenstein generalized this obvious point. According to him, it is not only when we look in dictionaries for the complete specification of the meaning of a word that we find ourselves launched on an infinite regress. The fact is that there are no fixed landmarks of any kind from which the meaning of a word could possibly be plotted definitively. Neither an image nor anything else in anyone's mind could conceivably serve this purpose. Anything on the signifying side of this elusive relationship will leave room for interpretation, because it will be too static to determine something as fluid and dynamic as the correct use of the word. Only the actual practice can do that.

I have rehearsed these ideas of Wittgenstein's because, whatever view is taken of them, they constitute today the inevitable background to any discussion of meaning-rules. They pose a challenge, but though Ayer rejects the response attributed to Wittgenstein by Kripke,[2] that in default of anything firmer, we rely on agreement in judgements with other people using the same word, it is not clear what his own response is. I shall return later to this point.

Meanwhile, a brief recapitulation of our earlier discussion of mistaken reports of sense-data may serve as an approach to the more difficult topic of meaning-rules. Ayer finds it implausible to suppose that someone might misidentify the type of his own sense-datum in the same way that he might misidentify the make of a momentarily glimpsed car. His general reason for finding this implausible is that the sense-datum is all there, so that everything that it has to show for itself can be taken in immediately. However, he admits that this is not a sufficient reason by itself, because a word still has to be found for it, and if there were no possibility of choosing a wrong word, the right one would hardly be informative. It is at this point that the topic becomes difficult, because it is tempting to say that, if he chose the wrong word for the make of car, that might be because he was genuinely misled, whereas his choice of the wrong word for the type of his sense-datum could only be a verbal mistake.[3]

However, if there is going to be a difference between making a verbal mistake and being genuinely misled, it looks as if it ought to turn on the answer to the question, whether the speaker really knew the right answer but, unfortunately, made a mistake when he tried to put it into words, or whether there was no truth in him. There are, of course, ways of testing this. So let us suppose that someone fails the tests and is judged to have been completely misled. Is there then some *further* sense in which the phrase "verbal mistake" could still be applied to his error?

There is a well known argument for an affirmative answer to this question. Learning the meaning of a word in a sensory vocabulary is merely a matter of acquiring proficiency in applying it to the right sensations. Consequently, if someone misapplies such a word, that will indicate that he has not learned its meaning and so that he has made a verbal mistake, even if he turns out to be unable to retrieve it. Wittgenstein uses this argument in the case of pain. However, pain is a very simple case and the argument does not look so convincing when it is extended to a case where the range of possible descriptions is much greater—for example, when someone is reporting fine differences between his taste-sensations.[4]

I think that Ayer believes that there really is such a *further* sense of the phrase "verbal mistake": in simple sensory cases, even if the speaker is unable to retrieve his mistake, because there is no truth in him, his mistake is still verbal, because it shows that he has not yet learned the meaning of the word that he used. However, he is inclined to concede that a similar mistake made in more complicated cases, like the discrimination of taste-sensations, need not be verbal in this sense. But that, he says, presents a problem. What is the criterion for distinguishing between verbal mistakes in this further sense and non-verbal mistakes?

Our earlier discussion of this topic ended with his challenge to produce a criterion which would distinguish this further type of verbal mistake from the correlated kind of non-verbal mistake. I would now evade it by suggesting that what we have at this point may not be two coordinate types of mistake at all. That was the situation earlier, when the question was whether the speaker merely chose the wrong word to express his knowledge of the type of his sense-datum or whether there was no truth in him. But it may not be the situation now. For the explanation of the difference between Austin's example and Wittgenstein's may merely lie in the relative difficulty of carrying out the same task, matching words to things. In the easy case any fault will be attributed to lack of proficiency in using the word, while in a difficult case it will be attributed to lack of discrimination of the things. However,

there will not be any fundamental difference between the two kinds of case. Indeed, there could not be, if knowledge is not only expressed but also constituted by some reaction in the subject. If that is what knowledge is, the claim that there ought to be some fundamental difference between the two cases, marked by a definite criterion, must be a relic of the mistaken idea that this kind of knowledge is *au fond* a one-to-one relation.

Ayer has certainly moved some distance from the separatist account of reports of sense-data that he gave in the first edition of *Language, Truth and Logic*.[5] But where does he stand on meaning-rules? A short answer would be that he shows a certain ambivalence. On the one hand he concedes Wittgenstein's claim that someone who is setting up a sensory language needs a criterion to tell him when he is actually using a word consistently instead of merely being under the impression that he is using it consistently. On the other hand, he rejects Wittgenstein's claim that he could not get such a criterion unless he exploited the resources of the physical world. According to him, the beginner could perfectly well rely on the "primary recognition" of a sense-datum.[6]

"Primary recognition" sounds like a very extreme example of one-to-one contact. It suggests that either there is no generality in the recognition of the sense-datum, or, perhaps, that, though there is some generality, it does not raise the usual question, "Am I using this word consistently?" But that question surely must arise for a beginner who is trying to set up a sensory language. So we have to review Ayer's criticism of Wittgenstein's Private Language Argument in order to discover how he gets into this puzzling position.

Wittgenstein uses his argument against the thesis that in the original position described by Cartesians it would be possible to set up a sensory language. He argues that it would not be possible, because nobody could establish a consistent use for a word without a criterion to tell him when his practice really was consistent, and no such criterion would be available without the resources of the physical world.

Ayer concedes the need for the criterion, and that is surely right. Speaking a language is an acquired skill and the beginner must know what he is trying to do with a word and when he is succeeding in doing it. This is true of all intentional actions, but it is especially important in the early stages of acquiring a skill.

What Ayer denies is that the necessary criterion would be available only if the beginner could use the resources of the physical world. He argues that, if Wittgenstein allows that we can set up a sensory vocabulary when our sensory types occur in regular physical contexts, then he ought also to allow that the vocabulary can be set up when they occur in

regular phenomenal contexts. If the phenomenalist's picture represents the enterprise as impossible, then so too does the realist's picture. Wittgenstein's reasons for refusing to treat the two descriptions of enterprises in this even-handed way are complex. Ayer picks out one of his lines of argument and tries to block it by introducing the concept of "primary recognition". Wittgenstein makes the point that it is not enough that someone should think that he remembers the name for the type of his sensation—'he must produce a memory which is actually *correct*'.[7] Otherwise he would be like a man who sought to confirm his memory of the time of departure of a train by calling up a mental image of the page in the time-table on which he had seen it recorded.

Ayer sees that this point, if it were valid, would count against his own suggestion that the beginner can rely on the phenomenal context of a problematic sense-datum. For on Wittgenstein's view of the matter, the sense-data constituting that context would be just as problematical as the original one and the recognition and classification of all of them alike would lack any independent criterial authentication.

However, Ayer denies that Wittgenstein's point is a valid one, and he claims that he is

> overlooking the crucial fact . . . that anyone's significant use of language must depend sooner or later on his performing what I call an act of primary recognition. . . . The point I am making is not the trivial one that the series of checks cannot continue indefinitely in practice, even if there is no limit to them in theory, but rather that, unless it is brought to a close at some stage, the whole series counts for nothing. Everything hangs in the air unless there is at least one item that is straightforwardly identified. If this is correct, Wittgenstein is wrong in taking the corroboration of one memory by another, or that of a memory by an item of sense-experience as an inferior substitute for some other method of verification. There is no other method. Whatever I have to identify, . . . I have only my memory and my current sensations to rely on.[8]

This is a difficult controversy to assess, partly because Wittgenstein never gives a complete, stepwise exposition of his argument. It is, therefore, important to observe two features of the passage that Ayer is criticizing. First, Wittgenstein is not concerned with particular exercises of memory after a language has been set up, but, rather, with the question whether the beginner's memory would be sufficient to enable him to set one up in the Cartesian original position. Second, and consequently, he is not interested in the train-traveller's mental processes for their own sake, but only because they illustrate a failure to achieve an independent check. Of course, the lack of an independent check in the Cartesian original position is more radical, because, if Wittgenstein is right, it would stop the beginner in his tracks. For his point is that the beginner

could use the phenomenal context as a check of the correctness of his reaction to a problematical sense-datum only if he had already established a proficiency at recognizing and naming the sense-data that constituted that context.

It is very important not to allow the similarity to obliterate the difference between the predicament of the beginner in the Cartesian original position and the everyday predicament of the train-traveller. When they are kept distinct, it can be seen that the beginner's handicap is not just that he cannot *recognize* the contextual sense-data, but the more radical one, that he has not yet set up any system for classifying them. So what he lacks in the case of the contextual sense-data is precisely what he may lack, but hopes to confirm that he has, in the case of the original sense-datum, namely an established practice of consistent reactions. How can the postulation of any kind of recognition, primary or non-primary, meet this need? What is lacking for all his sense-data alike is the kind of regular practice which is the pre-condition of any recognition. So the search for criterial authentication remains infinitely regressive.

It is tempting to suppose that Ayer is using the word "recognition" in a very special way: the importance of a sensory type is recognized when it is given a name just as the importance of a person is recognized when he is given an honorific title. If that is Ayer's point, his idea would be that the underlying commerce between world and mind moves in the opposite direction: in ordinary recognition a word is required to fit a thing and the result is truth, but in this special case the thing, if it is sufficiently important for such treatment, is fitted to the word and the result is meaning. In short, what Ayer is describing is ostensive definition.

However, this is too far-fetched an interpretation of his introduction of 'primary recognition'. For he introduces this concept in the course of a discussion of the search for contextual confirmation. Also, he never disagrees with Wittgenstein's criticisms of the emptiness of an ostensive definition that lacks any background or sequel. Nor does he dissent from Wittgenstein's thesis that even after a lengthy series of applications the next application of a rule is not completely determined. Therefore the recognition in his primary cases must be ordinary recognition, except that, paradoxically, it lacks all the usual pre-conditions of ordinary recognition.

The paradox cannot possibly be removed by any further analysis of the train-traveller's predicament. It is not important that, if he were a strong visualizer, his image of the figures on the page might provide him with some independent confirmation of his initial memory-impression, so that he is not so foolish as the man who seeks confirmation of an event

by buying several copies of the same newspaper. As I have already argued, the lack of independent confirmation that hampers a beginner who is trying to set up a language in the Cartesian original position is radical. So, given the need for independent confirmation, it looks as if he could never get going.

However, as I have already hinted, behind Ayer's specific criticism of Wittgenstein's Private Language Argument there is a bolder and more general criticism. Ayer can simply point out that it is equally hard to see how a beginner would ever get going even when he could exploit the resources of the physical world. So, however difficult it may be to analyze primary recognition, it is an indispensable condition of the establishment of any language, and the Cartesian original position and Wittgenstein's realist starting-point must be treated in an even-handed way.

The criticism is "Tu quoque" and Ayer is not the only philosopher who has made it.[9] It has an extremely simple structure and it must be admitted that it makes an impact on the argument in § 258 of *Philosophical Investigations*. What Wittgenstein says there is ". . . I impress on myself the connection between the sign and the sensation.—But 'I impress it on myself' can only mean: this process brings it about that I remember the connection *right* in the future. But in the present case I have no criterion of correctness. One would like to say: whatever is going to seem right to me is right. And that only means that here we can't talk about 'right'."

If this were the whole of Wittgenstein's Private Language Argument and not just its nucleus, the "Tu quoque" response to it would be convincing. For he would be using against his adversary's position an argument which also destroys his own. This is what gives Ayer's criticism its power. The idea is that, if it is difficult to give a convincing analysis of "primary recognition" the onus rests on Wittgenstein as much as on Ayer.

It would be unsatisfactory to leave the matter there, because the admitted fact that we have managed to set up language would remain utterly mysterious. It would be as if a philosopher said that it does not matter that the concept of time is riddled with insoluble paradoxes, because there certainly are temporal facts, such as the fact that he had an egg for breakfast. There is also a further consideration in the case of Private Language: it may be that the unravelling of the mystery would show that one of the antagonists was right and the other wrong.

A complete unravelling of the mystery is beyond the scope of this paper, but perhaps I can make a start. I have already emphasized the fact that setting up a language is an example of the acquisition of a skill,

something which is practised intentionally and for which, therefore, an independent criterion of success is needed, especially in the early stages. That, however, is conceded by Ayer and the dispute is only about the nature of the criterion.

If § 258 does not carry conviction, because it uses an argument which seems to destroy Wittgenstein's position too, it is reasonable to ask whether it needs to be supplemented by points made elsewhere in the book. After all, he himself never used the phrase "Private Language Argument" to pick out a particular text. He is, of course, offering a *reductio* in § 258, but it may be a *reductio* with a premiss not included in that remark but to be found elsewhere in the vicinity.

The most plausible candidate for the post of "missing premiss" seems to be that in the Cartesian original position the setting up of a language would be a purely intellectual undertaking. The sense in which it would be purely intellectual is this: if the learner is confronted by unconnected items of sensory input, as he is in the Cartesian original position, his task is the purely intellectual one of naming each separate type in a kind of void. As Ayer says, he only has his "memory and current sensations to rely on". But that starts an infinite regress which cannot just be ignored. Given that the beginner's task was in the sense specified, "purely intellectual", he could not possibly carry it out. For his quest for criterial authentication at one point would always lead to further similar quests at other points. He would be like a marksman trying to learn to shoot on a target, but always frustrated, because he was never told the pattern of his shots categorically, but only that he hit the bull's-eye on that target only if he hit it on the next target and so on *ad infinitum*.

But what non-intellectual resources could rescue the beginner from this predicament and where are they mentioned by Wittgenstein? Consider his remarks about pain near the beginning of the Private Language Argument. In this case there is already a natural connection between feeling and reaction and so there is a ready-made place for the word.[10] I think that he intended this point to be extended to other sensory words. For example, we do not learn spatial words in the purely intellectual, separatist way. Instead, we can rely on systematic links between position in the visual field and position in the cone of visual space ahead of us, because these links antedate language. The connections which constitute what may be called "the pre-linguistic network" are of many different kinds and the point is not confined to natural expression. Nor is there any suggestion that all sensory words need to have a well-marked place in the network. The idea is only that, unless some had it, there would be no way of stopping the regressive quest for criterial authentication.

When this consideration is added to the nucleus of Wittgenstein's Private Language Argument, it becomes a selective weapon which, at least, has some prospect of destroying his adversary's position without destroying his own. Whatever the outcome, the mystery surrounding "primary recognition" is dispelled.

DAVID F. PEARS

OXFORD UNIVERSITY
SEPTEMBER 1988

NOTES

1. *Perception and Identity: Essays Presented to A.J. Ayer with His Replies to Them*, ed. G.F. Macdonald (New York: Macmillan, 1979).

2. Wittgenstein, *Philosophical Investigations* (Oxford: Blackwell, 1953), I § 242, S.A. Kripke, *Wittgenstein on Rules and Private Language* (Oxford: Blackwell, 1982), pp. 24, 134–39, and Ayer, *Wittgenstein* (London: Weidenfeld & Nicolson, 1985), pp. 71–75.

3. Ayer did say this at an earlier stage in the development of his ideas on this subject. See *Language, Truth and Logic*, Introduction to the second edition, 1946, pp. 10–11.

4. Austin's example. See his article, 'Other Minds', in J.L. Austin, *Philosophical Papers* (Oxford: Oxford University Press, 1961).

5. At that stage he treated them as purely ostensive and so entirely based on a one-to-one relation. See *Language, Truth and Logic*, first edition, 1936, Ch. V.

6. A.J. Ayer, *Wittgenstein* (London: Weidenfeld & Nicolson, 1985), pp. 75–76.

7. *Philosophical Investigations*, I, § 265.

8. A.J. Ayer, *Wittgenstein*, p. 76.

9. See e.g. S.W. Blackburn, *Spreading the Word* (Oxford: Oxford University Press, 1984).

10. *Philosophical Investigations*, I, §§ 244–45.

REPLY TO DAVID PEARS

I shall not deal with Professor Pears's question about the ways in which our descriptions of the sense-data with which we are directly presented can be mistaken, mainly because I have nothing of interest to add to our discussion of this topic in *Perception and Identity* and also because I have restated my position in my reply in this volume to Professor Park.

I have nothing to add either on the score of Wittgenstein's private-language argument to the objections which I set out once again in my reply to Professor Eames. These objections have been frequently ignored but seldom seriously disputed, let alone met, and I am delighted that Pears acknowledges their force. He does complain at one point that it is not clear what my response is to the claim, attributed to Wittgenstein by Kripke, 'that in default of anything firmer, we rely on agreement in judgements with other people using the same word', but there is surely no difficulty for me here. On the contrary, Kripke's version of Wittgenstein's argument, at least in Pears's summary, is particularly weak. 'In default of anything firmer', the fact that I observed what I took to be other speakers of my language uttering the same sign as I was disposed to utter would be of no use to me at all, unless I construed their utterances as being directed upon the same target as my own. But this presupposes that I have already given an interpretation to my use of the sign. If each of us had to wait upon the judgement of others before he made his own judgement, no judgement would ever be made.

This is not to deny that at a stage where I am using signs meaningfully, consulting other persons can help me to test whether my use of some expression is conventionally correct and, even if it is deviant, whether it is consistent. But now I must again insist that this does not take me from the private into the public domain, in any way that underpins a theory of meaning. For the fact remains that, apart from the problem of ascribing

the 'right' reference to them, I have to identify the signs that the other persons utter. And there is a sense in which this identification, even if it is made overtly, must be a private operation. This sense is just that it must issue from an exercise of what I call 'primary recognition'.

It surprises me that Pears should be in any doubt as to what I mean by 'primary recognition'. It seems to me that my use of the expression is quite straightforward. The recognition consists in treating whatever it may be as an instance of its kind, as being '*the same*' as a previous specimen which, if no label has yet been applied to it, may itself be remembered simply as being, in a more or less shadowy context, the same as *this*. If the kind has been labelled, the disposition to apply the same label enters into the process of recognition; and here it must not be forgotten that the labels themselves have to be recognized.

The reason why I speak of such recognition as primary is that I take it to be the indispensable foundation on which all significant use and understanding of language is built. I am willing to concede that a wolf-child could probably not invent and employ a system of signs that would qualify as a language, though I insist that this is at most a causal and not a logical impossibility: there is no a priori reason why he should not re-invent and employ some sizable portion of a natural language. The simple point which I am making is that no child could be taught a language unless he were able to perform acts of primary recognition. He has to recognize the visual, tactile, and vocal manifestations of his mother as the same as their forerunners, and he has, in the same fashion, to recognize the sign 'Mamma' or something like it, as designating these phenomena. I have spoken of them as instances of one or other kind, because I assume that to acquire the concept of one's mother, or indeed of oneself, as a particular object, persisting in time, is a relatively sophisticated achievement, proceeding from a prior identification of recurrent patterns. That this is the natural order is borne out by the fact that particulars, whatever their duration, can always be analyzed in terms of the distribution of properties, which can, at the lowest level, be demonstratively located.

But how can we be sure that we are right when we greet some phenomenon as 'the same again'? How can we be sure that if the predecessors to which we are assimilating it could be recalled we should not judge that they were not of the same kind after all, in terms of the method of classification to which we believed ourselves to be adhering? The answer is that we are not entitled to be sure. We can increase our confidence by finding that the phenomenon has the same associates as those that are associated in our memory with what we are taking to be its predecessors, and here, as Pears admits, it is not necessary that these

supports should be physical: sensory associations will serve just as well; even so, these pieces of scenery have themselves to be identified. If, as Pears's argument requires, the whole process is set in the initial stage of the acquisition of the use of language, all that we have is a set of acts of primary recognition re-inforcing one another. And every member of the set is exposed to Wittgenstein's charge that 'whatever is going to seem right to me is right'?

Does it follow, as Wittgenstein claims, that 'here we can't talk about "right"'? I deny that it does, on the ground that if we can't talk about 'right' here, we can't talk about 'right' at all, since it can be shown that whatever tests we carry out to assure ourselves of the correctness of our usage, we shall be relying in the end upon acts of primary recognition. Neither is this peculiar to the domain of language. Without a primitive power of recognizing features of its environment, no organism could survive.

In Pears's view, this leaves the fact that we have managed to set up a language 'utterly mysterious'. I too find this a mystery, but not for the same reason as Pears. My difficulty is to explain in what the use of language consists. What is it exactly for someone to interpret a sound or a mark or a touch as a sign of something else? What was it that Helen Keller suddenly realized when it dawned on her that her governess's taps on her hands *meant* water? I suppose that the answer must lie in some causal theory, but I have not yet come across a causal theory of meaning that I find satisfactory.

Pears is not troubled, at least in this paper, by the meaning of meaning. His problem is that of our ability to satisfy ourselves that our use of signs is consistent. Since I believe that the mere assumption of consistency is all that we can ultimately rely on, and since this falls short of satisfying his requirement, I have to infer that his requirement is too strong. Still, let us consider how he thinks that it might be met.

Since it is common ground that we are concerned with 'the setting up of a language in the Cartesian original position' and that if this were a purely intellectual undertaking it would be building a house of cards, without anything further to hold the structure together, Pears thinks that the intellect has to receive help from elsewhere. He then suggests that a hint as to the whereabouts of this help is to be found in Wittgenstein's stock example of the feeling of pain. Here the non-intellectual element is the reaction to pain, between which and the feeling there is 'a natural connection'. Pears has, indeed, admitted that pain is a biased example, in that our natural reactions to it are more uniform than those that are produced by other emotions, let alone such states of consciousness as daydreams, of which there is no characteristic outward expression.

However, the fact that the case of pain can not be fully generalized does not worry him, so long as it is mirrored in some other instances. And he cites 'the systematic links between position in the visual field and position in the cone of space ahead of us' as relations that antedate language.

But even in the special case of pain is it true that adverting to our 'natural reactions' to it carries us beyond language in the way that Pears requires? I think not. The reactions themselves may be non-intellectual just as the feeling of pain is, but if they are to mediate one's reference to pain they need to be intellectually identified. And anyhow what sort of mediation do they offer and why should it be needed? It looks to me as if Pears, having been liberated from the Wittgensteinians, has fallen back into their clutches. There being natural reactions to pain, which a child can be expected to display, does assist us in our task of teaching him the various words that refer to it and to the ways in which it affects him. In the case of a physical object like a tree when we note their respective positions, his being in contact with it, or his seeming to be looking at it, we simply assume that he perceives what we do and tell him the appropriate word. But in both cases we go by his behaviour and in both cases, so far as he is concerned, it is a matter of being induced to associate a sign of a particular type with a particular type of experience. It is a contingent fact that children have to be taught to do this and seldom, if ever, do it spontaneously. At the level at which Pears is posing the problem the public-private distinction should not come into it.

Neither is his example of the links between physical and sensory space felicitous. It is true that children learn to identify places in physical space through learning to identify the physical objects which occupy them or stand in some spatial relation to them. It is true that their learning is facilitated by the 'non-intellectual' process of their moving in physical space. It is, indeed, only at a later stage, if ever, that they engage in the sophisticated practice of talking about positions in their visual fields. Nevertheless they do not have any visual access to physical objects, or a fortiori to their physical positions, except through the contents of their visual fields, whether they explicitly refer to the contents or not. More generally, they do not perceive any aspect of the physical world except by the use of their senses. Moreover, as Hume realized, it is only through the fortunate 'constancy and coherence' of our sense-data that we are able to posit the existence of enduring physical objects, let alone that of the places which they occupy.

A.J.A.

16

Azarya Polikarov and Dimitri Ginev

REMARKS ON LOGICAL
EMPIRICISM AND SOME OF
A.J. AYER'S ACHIEVEMENTS:
SOME FIFTY YEARS LATER

With our title we have in mind the appearance of A.J. Ayer's work *Language, Truth and Logic* (London, 1936), which belongs to the fundamental works of Logical Empiricism (or: logical positivism, neo-positivism, neo-empiricism; also scientific, or else 'consistent empiricism' [Moritz Schlick]). In another context, as opposed to historicism, it is considered as logicism.

Our stance on the creative deeds of Sir Alfred, this outstanding representative of a momentous movement in contemporary philosophy, implies a more general stance on Logical Empiricism. This would be quite different if our paper had been written some thirty, twenty, or even ten years ago. At the current stage, where Logical Empiricism (further on: "LE") has been surmounted, we consider it suitable to point out, along with critical remarks, its contributions, especially those of Sir Alfred.

I

One may be impressed by the circumstance that the logical empiricists, despite having a preference for axiomatized theories, do not offer a coherent (quasi-axiomatic) presentation of their philosophy, and it was contested whether a systematic account of LE would be in the spirit of this philosophy, but such accounts are provided by some contemporary critics of the LE doctrine, like Frederick Suppe and Cliff Hooker.

Far from intending to attempt a coherent reconstruction of LE, we should suggest, for the modest needs of this paper and with an eye to the critical examination of this philosophy, a simplified description of the latter. To begin, we shall (I) list the three background elements of the preceding history of science and philosophy which LE used in one way or another in erecting its system. We shall then (II) outline the nine basic statements of this doctrine, relating them, to some degree conditionally, to the three aforementioned 'building blocks'.

I. Logical Empiricism rested upon certain presuppositions, or, in historical respect, on some received doctrines. Amongst these are:

1. That both (a) everyday or common language, and (b) scientific language (see 2.a', 2.b[O] and 2.b[T]) are available.

2. There are sciences, including: (a) formal sciences, to which mathematics (in an axiomatic presentation) belongs and (a') logic, or better, mathematical logic, to which a primordial significance is attached; (b) science (natural sciences), especially physics, consisting of (b[O]) an observational or empirical part (terms, language) and (b[T]) a theoretical part (terms, language) (This view was supported by lessons drawn from Einstein's general theory of relativity.[1]); (c) social sciences and humanities, especially (c') ethics. Plus, they had a notion of (d) sciences branching off of philosophy, and, as a result, eventually exhausting its content (Carnap, Ayer).

3. LE presupposes a subset of philosophical positions, including: (a) idealistic (metaphysical, speculative) philosophies; (b) materialist-realist conceptions, e.g., critical realism, and (b') dialectical materialism; (c) empiricism including inductivism, phenomenalism, positivism, especially Hume's and Mach's conceptions; (d) epistemology, to which belongs the theory of truth, (d') the correspondence theory, or (d'') the coherence theory; (e) philosophy of science associated with various trends: rationalism, conventionalism, historicism, etc.

The statement (2.a') presupposes that logic is not a part of philosophy, but rather an independent branch of science, either from its origins, or as a result of its development, viz., as mathematical logic.

Within the framework of LE one can distinguish relatively independent parts, like philosophy, epistemology, philosophy of science, theory of language, (psychological) theory of man, etc.[2] Any exposition of LE may begin with the philosophical (or epistemological) doctrine, and then move on to logicism (and the method of analysis.) Or, one may go the other way around: put logicism first (as with Victor Kraft, Ernan McMullin, et al.), then proceed to philosophy of science and the notion of a unification of science. This approach presupposes a conception of science and of language, i.e., a (claim for) scientific attitude, a theory of language; and accordingly it starts with one or the other of these

conceptions (as A.J. Ayer, Frederick Suppe, or Gerard Radnitzky). Bearing in mind this mutual stipulation, or circular dependency, we begin an approximative exposition of the basic statements of LE in a linear sequence.

II. Basic Statements:

1. Philosophy or epistemology (I).

The function (task, end, or activity) of philosophy (= LE) is to analyze the concepts of scientific (and everyday) language. Thus, philosophy is reduced to logical (syntactic, semantic) analysis of existing theoretical systems. Philosophical problems are primarily about language.

1.1. Scientism, which determines the possibilities and the place of philosophy reducing it to LE.[3]

Scientism, it is well known, emphasizes the primordial relevance of science, especially physics, as a general pattern for knowledge. According to the neo-empiricist interpretation, the latter proceeds from facts, as they are established experimentally in the laboratory, or as they are fixed in protocols for performed observations and results obtained. (This explains the significance attached to the so-called protocol (observational, experimental) statements, in the initial formulation of LE.)

These facts are described by physical theories involving a definite mathematical or/and logical structure. The theory consists of an uninterpreted calculus and coordinating rules, which connect that calculus with empirical data. Theories are superimposed on a set of empirical data, figuratively speaking, like a net on several points. This is the 'received view' of theories, a hypothetic-deductive account for scientific (physical) theories, maintained by some neo-empiricists in an inductivist version (Hans Reichenbach, Rudolf Carnap, Carl Hempel).

In a certain sense, as Ayer puts it, philosophy was to merge with science.[4] In our opinion, it became rather an epiphenomenon of science. According to a statement of Moritz Schlick, "science is the pursuit of truth, and philosophy is the pursuit of meaning".[5]

2. Philosophy of science, containing certain elements:

2.1. Empiricism.

A. Within the framework of empiricism was formulated the Verification Principle, according to which the meaning of a statement is the method of its verification (Wittgenstein). Hence the basic units of meaning are statements (propositions). This involved an observation language (to which all other propositions may be reduced) and a corresponding calculus.[6]

2.2. Logicism (i.e. the notion of logic having a purely formal character.)

Conforming to the above, there were for LE two classes of propositions: factual, i.e., empirically verified (or in general verifiable), and

formal (logical, mathematical) necessary for the consistency and coherence of a scientific system. From this stems the following important distinction.

B. There is a division of the propositions into synthetic and analytic, as well as a

B'. dichotomy of terms (languages) into observational and theoretical.

Unlike sensualistic positivism (Ernst Mach et al.), an important role is attached to logic and to the mathematical (axiomatic) model of framing scientific theories.

In addition, LE held the following views:

C. Phenomenalism.

D. Conventionalism and a coherence theory of truth.

E. Subject-matters for philosophy of science are problems of justification (substantiation) for ready-made theories, and not problems connected with the discovery or invention of theories, following the distinction (from Hans Reichenbach) between a 'context of discovery' and a 'context of justification'. This opinion is shared by proponents of other philosophies as well (e.g., Karl Popper).

F. Axiomatization as the ideal presentation of scientific theories.

G. Physicalism and the unification of science. The intersubjective character of verifiability (H) was associated with physical events described in the language of physics. All meaningful statements must be reducible to the physical terms of space-time (Otto Neurath), or to the 'physical-thing-language' (Rudolf Carnap). This was to be a universal language, through which a unification of science could be achieved.

3. Epistemology (II) with the following statements.

H. Knowledge is intersubjective.

I. As an alternative to C and D, some held to realism and a correspondence theory of truth. This variation actually characterizes two trends in LE (sometimes even in various works by the same author). One may speak of a splitting of LE into two polar versions (LE1 and LE2), and correspondingly distinguish various groups among the neo-empiricists (see next section of this paper).

A very important consequence of LE is its antimetaphysical attitude. Metaphysical assertions, being not verifiable, are meaningless.

Among the new conceptions, we mention the logic of confirmation and explanation, views about the nature of ethics, theory of man, etc.

The Logical Empiricists considered their doctrine a 'turning point' in philosophy (Moritz Schlick, et al.), radically changing the physiognomy

of philosophy (and philosophy of science), while being at the same time its completion.

A dissatisfaction with dominating neo-kantian and other philosophical doctrines, on the one hand and LE's notion of scientific disciplines branching off from philosophy, on the other, played an important role in framing the philosophy of LE.

In summary: Empiricist philosophy was arguing for a scientific conception of the world. It was looking for a stable foundation (fundamentalism, view stressing certainty, incorrigibility, or indubitability) in empirical knowledge and in phenomenalism. The only reliable method for philosophy was logical analysis. Hence, idealist metaphysical doctrines and synthetic a priori propositions had to be discarded.

Almost all of these statements are open to criticism. And from that begins the odyssey of the neo-empiricists, who have attempted in various ways to surmount the difficulties which arose (e.g., the problems of the external world, other minds, past experience, etc.). Most of them, however, were something like an iatrogenic disease, i.e., inherent to the doctrine adopted.

The demand for verifiability does not apply to the principle of verifiability itself, and the representatives of LE have qualified it as truism (Schlick), method, or recommendation (Friederich Waismann), as definition,[7] methodological principle,[8] or convention.[9]

Neo-empiricists were forced to accept a more liberal attitude, substituting testability and confirmability, due to the difficulties with verifiability. Thus Ayer renounced the demand for conclusive verifiability as a too stringent criterion for meaning.[10]

Realism was a very controversial issue. Schlick and others maintained a (non-platonic, quasi-materialistic) realism.[11] This is especially valid for physicalism. Some neo-empiricists, however, have held the view that statements may be compared with other statements (and not with experience) which amounts to committing themselves to a coherence theory of truth. Ayer (who is not a physicalist) argued already in 1936 for a correspondence theory of truth.[12]

Later some representatives of LE also abandoned the radical thesis of logical analysis as the unique method for solving philosophical problems. They no longer rejected metaphysics because this "makes one blind to the interest that metaphysical questions may have", and they acknowledged that "the metaphysician may sometimes be seeing the world in a fresh and interesting way".[13]

Besides, there has always been a tradition in criticizing empiricism on the part of rationalism and dialectics (dialectical materialism). We may recall the controversy between Mill and Whewell, and the critique of

Mach's positivism by Wilhelm Wundt, Ludwig Boltzmann, Vladimir I. Lenin, etc. LE too has had its opponents in the camps of contemporary rationalists, dialectical materialists, and postpositivists.[14]

An examination of the statements of LE in connection with the development of science discloses that most of them are untenable. Briefly, we can adduce the following comments:

Ad II.1.1: This apparently intelligible requirement is founded on a vicious circle, since their conception of science is not independent of a philosophical position. Indeed, the LE view of science (or any other philosophy's view) presupposes an interpretation of science along the lines of the philosophy in question.[15]

Ad A: Theoretical concepts (ought to) have meaning independently of the verification (procedure). The distinction between facts (observations) and theory is not a sharp one. Observations are dependent on the theory (Einstein's Principle[16]), in other words, they are theory laden. Correspondingly, they undergo changes.

Attention has been drawn to the fact that scientific systems as a whole, and not single statements, have a bearing on reality (Duhem-Quine Thesis).

Statements about physical objects cannot be deduced from statements about sense data (actual and possible) because this presupposes an infinite number of observers, and hence an infinite set of statements about sense data. As Morick puts it, "The observer cannot be defined phenomenalistically."[17]

The principles of LE disagree with contemporary methodology, wherein it is taken for granted that scientific knowledge is not built upon empirical facts alone, but rather on the basis of theoretical premises as well.

Ad B and B': The analytic/synthetic dichotomy, as also the distinction between observational statements (about the world) and theoretical statements (about language), are untenable. There is an organic connection between empirical and theoretical knowledge, each presupposing the other.[18] This means that they are mutually stipulated.[19]

Ad C and D: Both of these conceptions are untenable because there exist counter-examples: structural theories (like the molecular-kinetic theory in physics[20]) and theoretical statements with a non-conventional character (as Schlick pointed out with the law of energy conservation). Very important in this respect is the attempt to use relativity theory as a support for conventionalism. However, the analysis of the theory, as well as the way it was framed substantiates the realistic interpretation.[21]

Ad E: Problems of discovery are a subject of philosophy of science,

and as a matter of fact, are gaining in importance (Håkan Törnebohm, Mario Bunge, Imre Lakatos, et al.).[22]

Ad F: The possibilities of axiomatization are restricted in several respects, even in physics. As opposed to mathematics (geometry), science is not amenable to axiomatic construction.[23]

Ad G: Since quantum mechanics (indeterminacy relations, complementarity) has been established, the idea of an all-embracing space-time language has to be revised. Reduction is altogether not feasible, especially in view of the 'incommensurability' of paradigms or fundamental theories. The problems of a unification of science turned out to be much more complex (and even insoluble, in a general way) than assumed in the simplistic view of some neo-empiricists.[24]

Ad Antimetaphysics: Logical Empiricists may be reproached for arbitrarily reconsidering philosophy irrespective of its traditional character. However, this does not mean that the discussion framework in this field is predetermined.[25]

Notwithstanding the redrawing of the map of science, we do not believe, both for motives of principle and practice, that there is an essential change in the subject-matter of philosophy due to some sort of transfer of philosophical problems to the special sciences. The subject of philosophy, as well as those of the special sciences, shows an altogether remarkable stability.[26]

The main philosophical problems are 'timeless' and they admit a relatively small number of basic conceptions. These logical possibilities were outlined at an early stage in the development of philosophy. Thus, according to Engels, in the manifold forms of Greek philosophy we can already find almost all later kinds of contemplation in germ.[27]

The LE account of science (and its history) suffers also from one-sidedness. Scientists, especially theoreticians, do not share the positivistic standpoint. Moreover, in Einstein's words, "every genuine theoretician is a humble metaphysician, no matter how pure a 'positivist' he imagines himself to be".[28]

The inductivism entailed by LE does not conform with the conviction that the concepts and basic laws of a scientific system are "free inventions of human spirit" (Einstein). Along these lines, Popper insists that refutation, and not confirmation, is the main scientific method.

In general, the weak points of LE are seen in the restriction of the real meaningful propositions, the sweeping negation of metaphysics, the narrowing down of the domain of philosophical problems, and the confrontation of cognition and values.[29]

Hence, the neo-empiricist programme turned out unsuccessful. The simplification of the world's real complexity does not protect us from the

danger of an artificial sophistication of knowledge by fictitious entities (John Synge's 'Pygmalion Syndrome').

The claim for universality and completeness is a hallmark (and Achilles Heel) for many philosophical doctrines. As concerns LE it runs against the empiricist attitude in a wider sense because it neglects changes due to scientific growth.

Engels already stated along these lines that both idealism and materialism went through a series of developmental stages. With every epoch-making discovery, even within the domain of natural science, materialism must change its form.[30] Therefore, not only "in science the important thing is to modify and change one's ideas as knowledge advances" (Claude Bernard); this holds for philosophy as well.

From this view, LE had an altogether temporary validity, mainly in the English-speaking world of philosophy. In our time, since about the 1960s, it has been superseded by postpositivism (historicism, new philosophy of science).[31]

To LE's lasting merits belong, for one thing, some contributions which are independent of the doctrine. Positive aspects of LE are the connection with science: scientification of philosophy and progress in the philosophy of science by posing important problems, the endeavor for exactness, applying a precise method and obtaining relevant results in the foundations of science, definitions and explication, of concepts, patterns of confirmation and explication,[32] as well as problems of language, etc.

It is widely acknowledged that the criticism of LE further stimulated the development of philosophy of science. Thus, Toulmin admits: "Yet, even though we slay our intellectual parents, we cannot help but inherit from them. . . . While many of us whose philosophical careers began after 1946 reject the positivism of our forebears, it would be presumptuous for us to deny our inheritance entirely. At the very least, we share with our analytic predecessors a common stock of questions and problems about whose answers and solutions we *dis*agree".[33]

Despite significant differences between LE and Popperianism, as Hooker has shown, they overlap in their meta-philosophical presumptions.[34]

On the other hand, historicism is also not free from significant shortcomings, and has been subjected to criticism on several important points.

In the light of this, the idea has emerged to consider LE and historicism as complementary and to envisage the possibility of a combination of the positive elements of both. This is an opinion held by several contemporary philosophers. In a discussion carried out in the late

1960s on the peculiarities of contemporary inductive logic, Bar-Hillel pointed out that there had been established a specific division of labor: "the Carnapians concentrating mostly on rational synchronic reconstruction of science and the Popperians remaining mostly interested in the diachronic growth of science".[35]

Allen Newell and Herbert Simon drew attention to the polarization of good (significant) problems and good (efficient) methods in psychology. Behaviorists adhere to the latter, whereas Gestalt psychologists put essential problems up front. An analogy to this may be seen in the relation between historicism as interested in important problems, and LE as holding on to strong method.

Of course, there is a more or less necessary sequence in the elaboration of (philosophical) problems. Thus, for example, the clarifying of the statics (system) of science precedes—has to precede—*grosso modo* the tackling of issues in its dynamics.

II

Our attention now will be focused on the lasting character of two basic ideas of Sir Alfred's, initially formulated and substantiated in *Language, Truth and Logic* and subsequently elaborated in many of his works. These are: (a) the necessity of a verifiability criterion and (b) the importance of logico-critical analysis of scientific knowledge. Undoubtedly, these ideas take a central place in LE in general. However, in Ayer's works they have a specificity the revealing of which will be our first task. Their enduring character can be shown by a comparison with those ideas, brought into being by the so called "post-positivistic revolution", which are regarded as alternatives to them. We shall try to show that some of the "vanguard anti-positivistic" views nowadays are not so alien even to the early works by Ayer.

It seems that here an unofficial classification has been established of neo-empiricists in three groups: typical, less typical, and marginal ones. The authors who have signed "The Scientific Conception of the World: The Vienna Circle" manifesto (Carnap, Hahn, and Neurath) as well as Schlick and Hempel (irrespective of later changes in their views) belong to the first group. Authors like Edgar Zilsel, Heinrich Gomperz, or Felix Kaufmann who share only the general spirit of the programme of LE should be placed in the third group. The second group is perhaps the largest one. Here belong the authors who insist on the main principles of LE: the reduction of philosophy to the logical analysis of science; the elimination of metaphysics; the proclaimed absence of theoretical mean-

ing in value statements etc., but who at the same time maintain other ideas which are "deviations" from orthodox LE. Karl Menger, Kurt Gödel, Eino Kaila, and Herbert Feigl, as well as Ayer belong to this group.

What is the difference between Ayer's views (we mean those propounded in his papers published before the second edition of *Language, Truth and Logic* [1946]) and the views of the "typical" neo-empiricist? To begin with, in comparison with Carnap, Neurath, and Hempel, Ayer is more closely connected with traditional philosophical empiricism which in our opinion determines his principal interests not in the philosophy of science but in the theory of knowledge. His commitment to traditional empiricism (which of course does not mean that his conception of philosophy is old-fashioned) reveals itself already in the discussion on "protocol statements". He criticized Carnap for his formalism expressed in the claim that the linguistic formalism and the transformation rules are independent of the meaning of symbols, and that the distinction between analytic and empirical statements could be made only in virtue of a difference in the form of the symbols involved, or on purely syntactic grounds.

Ayer points out the following: in order that a language should be intersubjective and serve to communicate propositions about matters of fact "it is necessary that at least some of the expressions that it contains should be given a meaning".[36] Instead of Carnap's syntactic criterion for observation sentences Ayer suggests "the method of ostensive definitions" as the only method which provides empirical meaning to the statements. The renunciation of the coherence theory of truth is a consequence of Ayer's anti-formalist position. "One does not become an empiricist merely by a free use of the word 'empirical' or the word 'observation'," he says.[37]

A second essential difference from the views of 'typical' neo-empiricists consists in Ayer's more tolerant attitude towards traditional philosophy in general. According to him even in the years of the Vienna Circle classical philosophical problems do not lose their importance. Sir Alfred's purpose is not so much "the elimination of metaphysics" but rather the representation of these problems in logico-empiricistic form. Or, to put it in another way, his initial purpose is the framing of a "logico-empiricist code of philosophizing". For this reason, already in his first book Ayer rejects the thesis that "there are no philosophical propositions".[38]

This rejection determines another essential specific feature on his views. The final aim of the 'typical' logical empiricists is the construction of 'unified science' whereas Ayer's endeavour is to achieve "not so much

the unity of science as the unity of philosophy with science".[39] He has never upheld a reductionist programme about a universal scientific language. On the contrary, on various occasions he has criticized the conception of physicalism.[40] Even the weak version of the idea of a unified science, viz., that there is an absolute reference frame of rational standards valid for all branches of science, has never been maintained by Ayer.

Let us now turn to our main point. To what extent are the above mentioned ideas of Ayer surmounted by the 'post-positivistic revolution'? By the latter notion we do not mean a certain homogeneous process of qualitative change in philosophy of science but rather a trend composed by a methodological and epistemological variety of 'antipositivistic conceptions' which appeared in the late 1950s and early 1960s. We shall pay more attention to two post-positivistic conceptions which *appear as if* they are alternative to Ayer's ideas. These conceptions are:

(1) the thesis formulated by Hanson that the observational language within each theoretical system is 'theory-laden', and

(2) Kuhn-Feyerabend's incommensurability thesis and the historicisms growing out of it as an alternative to the logical analysis of science.

Does the thesis of theory-ladenness of observational language supersede the necessity to formulate a verifiability criterion?[41] In order to answer this question a comparison between Hanson's thesis and Ayer's criterion is needed. The thesis at issue can be summarized as follows: the observations become empirical facts only within the framework of a certain conceptual system, and as a result the semantics of language through which the empirical facts are expressed depends on the system's principles.

Hanson illustrated the significance of his thesis most convincingly by the analysis of causal relations. He wrote: "Notice the dissimilarity between 'theory-loaded' nouns and verbs, without which no causal account could be given, and those of phenomenal variety, such as 'solaroid disc', 'horizoid patch', 'from left to right', 'disappearing', 'bitter'. Causal connections could not be expressed in a pure sense-data language. All words would be on the same logical level: no one of them would have explanatory power sufficient to serve in a causal account of neighbour-events".[42]

This thesis puts the emphasis quite correctly on the relativity of the empirical basis of scientific knowledge. There is no historically and epistemologically invariant observational language to which all terms expressing theoretical concepts can be reduced. Whether a term will

designate any direct perception (and in this sense will be an element of a 'protocol proposition'), or will be 'theory-loaded' depends on the concrete context in which it is used. Hence, Hanson's thesis is logically incompatible with the idea of constructing a universal observational language; an idea which, as we have already pointed out, has never been maintained by Ayer. But does this thesis contradict the idea of the verifiability criterion?

The answer should be negative because the formulation of this criterion does not demand the existence of an invariant observational language. The verifiability criterion suggested by Ayer is ontological but functional and for that reason it is entirely compatible with the relativism implicated by the thesis of the theory-ladenness of observational language.[43] Be it classical or relativistic mechanics, Lamarckian or Darwinist theory of evolution, Arrhenius's theory of electrolytic dissociation or Debye-Hückel's theory, Chomsky's generative grammar or Bloomfield's linguistics, behaviouristic or gestaltist theories, the observational languages in such pairs of incommensurable theories are different in principle because of their theory-ladenness.

However, in each theory one should define the class of those statements which are not analytical and can be directly or indirectly (in Ayer's sense) verifiable with respect to their empirical bases. (It is irrelevant here that Ayer's formulation of the criterion is logically imperfect, since the defect detected by Church is still not removed). Thus the 'theory-ladenness' thesis and the verifiability criterion are results of two different but complementary approaches to the empirical content of scientific knowledge. Why are they complementary?

The main epistemological presupposition underlying the thesis of the 'theory-ladenness' is that there is no *immediate* reducibility to Carnap's sufficient reduction basis, or to the factual level of knowledge (there is no such thing as the logico-empiricistic 'immediately given') but the reducibility of theoretical terms to observational language is *mediated* by a set of factors (experimental devices and techniques, stylistic patterns of scientific thinking, 'background knowledge', etc.). All these factors make the empirical basis of a theory *possible*. To a certain extent the 'theory-ladenness' thesis rehabilitates Kant's idea of synthetic a priori statements rejected by neo-empiricists.

In conformity with this idea empirical knowledge is always organized by certain a priori principles (like Hanson's 'Gestalts' and Kuhn's 'paradigms') which express the impact of the mediatory factors. The main epistemological presumption of the verifiability criterion, on the contrary, allows for an immediate building up of the theoretical frame-

work on its empirical basis. The simultaneous investigation of scientific knowledge both in its immediate reducibility to empirical facts and in its 'synthetic a priori mediation' is impossible.

At the same time the two approaches reveal two aspects of the problem of the empirical content of scientific knowledge—*conceiving the criterion for empirical meaningfulness and conceiving the empirical confirmation mechanism*—which cannot be isolated from one another. If the empirical confirmation mechanism is sought in the presumption of an immediate reducibility of scientific knowledge (e.g., whether the fact e confirms the hypothesis h or not by considering only the logical forms of e and h), then the so-called paradoxes of confirmation are unavoidable. This explains why with respect to the problem of the empirical confirmation of scientific knowledge the logical theory of confirmation (stemming from the 'immediacy postulate') is not an equal competitor to the historical theory of confirmation (stemming from the 'mediation postulate').[44]

On the other hand, one can distinguish meaningful (analytical and synthetical) statements from meaningless ones only on the presumption of the immediate reducibility of the whole theoretical system to its empirical basis.[45] If one accepts the "mediation postulate", then potentially each statement can be meaningful, for in certain cases it can play the role of a synthetic a priori statement. For instance, as an ingredient of background knowledge indicating when the test of a prediction from our hypothesis will be a crucial test.

Now, yet another question arises. Since each statement can play potentially the role of a mediatory factor, how can we eliminate the sentences which express neither tautologies nor empirical hypotheses? The authors accepting the criterion of falsifiability have of course an answer to this question. But even they could not definitively eliminate metaphysical sentences because of their potential heuristic role. A demarcation line can be drawn between science and metaphysics but no elimination of the latter is possible. Thus in the tradition of critical rationalism conceptions emerged like Watkins's "confirmable and influential metaphysics", or Agassi's idea that scientific problems have their roots in metaphysics.

More radical in their attempts to rehabilitate the significance of metaphysics are the post-positivists not belonging to critical rationalism. It is obvious that the rehabilitation of the synthetic a priori means at the same time a rehabilitation (at least partially) of metaphysics. But that is a very special rehabilitation; not in the sense that metaphysics meets the criteria of scientific rationality but only as an acknowledgement of its

heuristic value. And that acknowledgement is not in disagreement with Ayer's claim of the meaninglessness of metaphysics. There is no explicit passage in Ayer's writings where the possible heuristic value of metaphysics is rejected. But the revealing of this value is not in the competence of logical analysis and hence this problem does not belong to Ayer's sphere of interests. If we use Reichenbach's distinction, this is a problem belonging to the "context of discovery" and not to the "context of justification". Only the latter is compatible with the aims of logical analysis.

Now, we come to the second point.

Does the incommensurability thesis denounce the importance of logical analysis of science as an activity aimed only at the logical clarification of thoughts? Feyerabend's initial version of the incommensurability thesis states that by the transition of a theory T' to a wider theory T, the process is much more radical than the incorporation of T' into the context of T. "What does happen is rather a *complete replacement* of the ontology (and perhaps even of the formalism) of T' by the ontology (and the formalism) of T and a corresponding change of the meanings of the descriptive elements of the formalism of T' (provided these elements and this formalism are still used). This replacement affects not only the theoretical terms of T' but also at least some of the observational terms which occur in its test statement."[46]

Kuhn as well as Feyerabend in his later writings generalize this initial version: the incommensurability doesn't concern only the theory replacement process (incommensurability between theories) but also involves the epistemological and methodological standards of scientific rationality (incommensurability between structures at a metatheoretical level). This sophisticated version of the incommensurability thesis contradicts the idea that there are universally valid and historically invariant epistemological standards by means of which scientific knowledge can be logically clarified.

The rejection of this idea has as a consequence the introduction into philosophy (more exactly, in the apparatus of philosophy of science) an autonomous "body of doctrine", a model which explains the changes in epistemological standards in the process of their historical dynamics (e.g., Kuhn's paradigmatic model). The same is valid for the conception in which the incommensurability thesis is not accepted but which defends the historical variability of scientific rationality (e.g., Toulmin's intellectual evolutionary ecology, or Laudan's reticulated model of scientific rationality). Thus the incommensurability thesis and the historicism connected with it disclose a new avenue for building up philosophy as an autonomous body of knowledge; an avenue which is not pre-

empted from other branches of knowledge. That new avenue is provided by the theories of the historical dynamics of science.

Does the sophisticated version of the incommensurability thesis, however, contradict the logico-empiricist view of analysis? No, because the view of meaning variance and the idea that there are universally valid (historically invariant) epistemological standards are not logically interconnected (i.e., it is not the case that the one cannot be accepted without the other). Indeed, this idea is an important "tacit assumption" for many logical empiricists. But not for Sir Alfred. He has never maintained the historical invariance of scientific rationality. On the contrary, in his first book we read: "There is no absolute standard of rationality, just as there is no method of constructing hypotheses which is guaranteed to be reliable. We trust the methods of contemporary science because they have been successful in practice. If in the future we shall adopt different methods, then beliefs which are now rational might become irrational from the standpoint of these new methods."[47]

This passage supports the suspicion of many authors that there is no genuine controversy between logicism and historicism. As in the former case one can prove that logical analysis and historical reconstruction of science are two quite different but complementary approaches. (Even the incommensurability thesis imposes few restrictions on the applicability of logical analysis; it forbids the pure logical approach only in a certain class of intertheoretical relationships.)

We are not going to discuss the complementarity between logicism and historicism, for that is a subject with more than twenty-five years of history and with too many ramifications to be examined here. We should only like to point out that for many themes put forth by the historically oriented philosophy of science—e.g., the changes in the "balance" between explanation and prediction in the development of a given science, the competition between alternative theories during a certain period, the resistance of a theory with respect to the demands of a new style of scientific thinking, etc.—the "old-fashioned" logical analysis is unavoidable.[48]

AZARYA POLIKAROV

SCIENTIFIC INFORMATION CENTER
BULGARIAN ACADEMY OF SCIENCES, SOFIA

DIMITRI GINEV

CENTER FOR CULTUROLOGY
UNIVERSITY OF SOFIA
FEBRUARY 1989

NOTES

1. Cp. Philipp Frank, *Modern Science and Its Philosophy* (N.Y.,1961), pp. 34, 36. Besides 2.a admits, and at some stages, is combined with, the idea of logicism, i.e., of the reducibility of mathematics to logic (Bertrand Russell)—a programme which could not be brought about. Nor did the formalist programme in mathematics (Hilbert) succeed. According to the famous Gödel theorem, the requirements for consistency and completeness of an axiomatic system turned out to be mutually exclusive.

2. C.A. Hooker, *A Realist Theory of Science* (N.Y., 1987), Chap. 3.

3. Rudolf Carnap, Hans Hahn, Otto Neurath, "Wissenschaftliche Weltauffassung der Wiener Kreis," in Hubert Schleichert, ed., *Logischer Empirismus der Wiener Kreis* (Munich, 1975).

4. A.J. Ayer, "The Vienna Circle," in *The Revolution in Philosophy*, (London, 1970), p. 79.

5. Moritz Schlick, "Meaning and Verification," in Oswald Hanfling, ed., *Essential Readings in Logical Positivism* (Oxford, 1981), p. 41.

6. Frederick Suppe, "The Search for Philosophic Understanding of Scientific Theories," in Frederick Suppe, ed., *The Structure of Scientific Theories* (Urbana, IL: University of Illinois Press, 1974), p. 50.

7. A.J. Ayer, "The Principle of Verifiability," in Oswald Hanfling, ed., op. cit. /5/, p. 59.

8. A.J. Ayer, *Language, Truth and Logic* (London: Victor Gollancz, 1946), p. 21.

9. A.J. Ayer, Editor's Introduction, in *Logical Positivism* (Glencoe, IL: Free Press, 1963), p. 15.

10. Ibid., p. 14.

11. Moritz Schlick, "Positivism and Realism," in A.J. Ayer, ed., *Logical Positivism*, op. cit. /9/, p. 82; J. Richard Creath, "Carnap's Scientific Realism: Irenic or Ironic," in *The Heritage of Logical Positivism*, N. Rescher, ed. (N.Y., 1985), p. 117; Herbert Feigl, "Some Major Issues and Developments in the Philosophy of Science of Logical Empiricism," in *Foundations of Science and the Concepts of Psychology and Psychoanalysis*, Minnesota Studies in the Philosophy of Science, Vol. 1, Herbert Feigl, Michael Scriven, eds. (Minneapolis: University of Minnesota Press, 1964), pp. 16, 19; Philipp Frank, *Modern Science and Its Philosophy*, op. cit. /1/, p. 91; A.J. Ayer, op. cit. /4/, p. 82; Id., op. cit. /9/, p. 9; W.C. Salmon, "Empiricism: The Key Question," in N. Rescher, ed., op. cit. /11/, p. 17. et al.

12. A.J. Ayer, "Verification and Experience," in *Logical Positivism*, l.c. /9/, p. 234, also p. 238.

13. Id., op. cit. /9/, pp. 8, 16, 17.

14. *Challenges to Empiricism*, H. Morick, ed. (London, 1980).

15. Azarya Polikarov, *Matter and Knowledge* (Sofia, 1961), Chap. 3 (in Bulgaria.).

16. Werner Heisenberg, "Der Teil und das Ganze," *Gesammelt Werke*, W. Blum et al., eds., Abt.C. Bd.III (Munich, 1985), p. 92; cf. C.F. v. Weizsäcker, "Classical and Quantum Description," in *The Physicist's Conception of Nature*, J. Mehra, ed. (Dordrecht: Reidel, 1973), p. 637.

17. Harold Morick, "Introduction: The Critique of Contemporary Empiricism," in H. Morick, ed., l.c. /14/, p. 10.

18. Albert Einstein, *Mein Weltbild* (Zürich, 1983), pp. 114–15, 117, also 36, 113; G. Bachelard, *L'activité rationaliste de la physique contemporaine* (Paris, 1951).

19. A. Polikarov, op. cit. /15/.

20. Lorenz Krüger, "Einführung zu den Teilen," I bis V., in *Erkenntnistheoretische Probleme der Naturwissenschaften* (Cologne, 1970), pp. 21–22; Paul Churchland, C.A. Hooker, eds., *Images of Science* (Chicago: University of Chicago Press, 1985).

21. M. Friedman, *Foundations of Space-Time Theories* (Princeton, N.J.: 1983), pp. 7, 17.

22. *Scientific Discoveries, Logic and Rationality*, Thomas Nickles, ed. (Dordrecht, 1980); A. Polikarov, *Methodological Problems of Science* (Sofia, 1983).

23. R. Feynman, *The Character of Physical Law* (London, 1965), pp. 54, 57, 59.

24. A. Polikarov, "Integration of the Sciences," *Filosofka misl.* 45 (1989), No. 1 (in Bulgaria).

25. Hans M. Baumgartner, "Philosophie," in *Handbuch der philosophischen Grundbegriffe*, Herman Krings et al., eds. (Munich, 1973), Bd 4, p. 1073.

26. We do not agree with the underlying view of a successive emancipation of special sciences from philosophy (cf. A. Polikarov, *Science and Philosophy* [Sofia, 1973], p. 25).

27. Karl Marx, F. Engels, *Werke*, Bd. 20 (Berlin, 1962), p. 333.

28. A. Einstein, "On the Generalized Theory of Gravitation," *Ideas and Opinions* (1950; reprint N.Y.: Dell, 1981).

29. Kurt Salamun, in *Was ist Philosophie?*, K. Salamun, ed. (Tübingen, 1986), p. 7–8.

30. K. Marx, Frederick Engels, *Werke*, Bd 21, p. 278.

31. Cf. L. Laudan, "Historical Methodologies: An Overview and Manifesto," in *Current Research in the Philosophy of Science*, P.D. Asquit, H.E. Kyburg, Jr., eds. (East Lansing, MI, 1979), pp. 47–48.

32. D. Ginev, A. Polikarov, "The Scientification of the Methodology of Science," *Zeitschrift für allgemeine Wissenschaftstheorie* 19 (1988).

33. Stephen Toulmin, "From Logical Analysis to Conceptual History," in Peter Achinstein, Peter Barker, eds., *The Legacy of Logical Positivism* (Baltimore, 1969), pp. 50–51.

34. C. Hooker, l.c. /2/, p. 81 ff.

35. Y. Bar-Hillel, "Inductive Logic as 'the' Guide of Life," in *Inductive Logic*, I. Lakatos, ed. (Amsterdam, 1968), p. 69.

36. A.J. Ayer, *The Foundations of Empirical Knowledge* (London: Macmillan, 1940), p. 85.

37. Ibid., p. 86.

38. A.J. Ayer, *Language, Truth and Logic* (Middlesex: Pelican Books, 1980), p. 34.

39. Ibid., p. 200.

40. Cf., e.g., A.J. Ayer, *The Central Questions of Philosophy* (Middlesex: Pelican Books, 1978), pp. 126–36.

41. Hanfling distinguishes between the verification principle according to which the meaning of a statement is the method of its verification, and the verifiability criterion aimed at discerning the meaningful from meaningless statements. In his opinion Schlick and Waismann usually continued to deduce

the criterion from the principle, whereas Ayer advocates the criterion of verifiability without the verification principle (O. Hanfling, ed., op. cit. /5/, pp. 5–7). Concerning Ayer's views, this claim is justified only with regard to some of his early writings (e.g., A.J. Ayer, "The Principle of Verifiability," *Mind* [1936], pp. 199–203). Later Ayer does not distinguish between the principle and the criterion in question. Nevertheless there remains a certain difference between Ayer's formulation of the verifiability principle and that of 'typical' logical empiricists because for him "the principle supplies a rule for determining only whether a sentence is meaningful. In Schlick's version it takes the further step of giving a procedure for determining what meaning a sentence has" (A.J. Ayer, l.c. /40/, p. 24).

42. Only the 'strong' version of the verifiability criterion (a proposition is verifiable if and only if its truth could be conclusively established in experience) is compatible with the 'theory-ladenness' thesis since this version presupposes the existence of 'basic propositions' determined solely by experience and not by theory postulates. But such propositions are fictions because no synthetic proposition could be purely ostensive and therefore the strong version of the verifiability criterion has no possible application. It is only an ideal methodological construction.

43. Norman Hanson, *Patterns of Discovery* (Cambridge, 1958), p. 59.

44. For a splendid argumentation for this view see A. Musgrave, "Logical versus Historical Theories of Confirmation," *British Journal of the Philosophy of Science* 25 (1974): 1.

45. Here arises an interesting question posed primarily by Schlick (cf. M. Schlick, *Philosophical Papers*, Vol. 2 [Amsterdam, 1979], pp. 309–12), namely: what kind of truth (analytical or empirical) can be claimed for the verification principle (or for the verifiability criterion, respectively). Ayer's answer to that question is ambiguous because he considers the criterion of verifiability both as a definition and as a methodological principle.

46. P. Feyerabend, "Explanation, Reduction, and Empiricism," in *Scientific Explanation, Space and Time*, Minnesota Studies in the Philosophy of Science, Vol. 3, Herbert Feigl and Grover Maxwell, eds. (Minneapolis: University of Minnesota Press, 1962), p. 29.

47. A.J. Ayer, l.c. /38/, p. 133.

48. Recently Daniel Garber arrives at the conclusion that the history of science is no better accommodated by the new large-scale theories than it was by the earlier positivist philosophies of science. Large-scale methodologies too are not better than positivist methodologies they have tried to replace (D. Garber, "Learning from the Past . . .," *Synthese* 67 [1986]): 91.

REPLY TO
PROFESSORS POLIKAROV AND GINEV

I have already had occasion to say, in my answer to Mr Foster, that the length of my reply to an essay is not a measure of the value that I set upon it. If my reply to Professors Polikarov and Ginev is relatively brief, the reason is not that I think their contribution unimportant but rather that they have covered the ground so well that they have left me without much to say. Their account of the standpoint of the Vienna Circle and its limitations is very thorough and predominantly fair, and their suggestions as to the way in which my analytical approach can be reconciled with the 'historicism' of such writers as Kuhn and Feyerabend are not only acceptable to me but show a deeper command of the philosophy of science than I am able to claim for myself.

Concerning the Vienna Circle I have little to add to what I have written in my reply to Professor Tscha Hung. In retrospect, I find that its members were, indeed, united in their rejection of metaphysics and in their acceptance of the analytic-synthetic distinction, but were not in such complete agreement over the other issues that Polikarov and Ginev have picked out. The Unity of Science was a favourite theme of Otto Neurath's but one in which even the other leaders of the group took relatively little interest. Neurath was a sociologist and his principal motive for stressing the unity of science was to combat the view, which was prevalent among his German colleagues, that there was a radical distinction between the social and the natural sciences, arising among other things from the employment in the social sciences of a faculty of intuitive understanding. The unity of science was taken to consist not only in a unity of method but also in the use of a simple form of language. This was not so much the terminology of theoretical physics as the 'physical' terminology in everyday use.

Carnap was converted by Neurath to the view that this physical language was 'the universal language of science' by the argument that it alone was 'inter-subjective'. Previously Carnap had been a phenomenalist to the extent of claiming in his *Logische Aufbau der Welt* to construct 'the world' on the basis of the single relation of 'remembered-similarity' between items of 'my' experience. In fact, he got little further than the construction of sensory qualities and even that was subsequently shown by Nelson Goodman to be unsound. The principal reasons which Polikarov and Ginev give for the failure of phenomenalism, its leading to an infinite regress, is one that I also gave in my paper "Phenomenalism" which I delivered to the Aristotelian Society in 1947.

It was Neurath again who converted Carnap and Hempel to the coherence theory of truth, only for Carnap to be re-converted in 1935 at the famous congress in Paris when Tarski's summary of his theory of truth convinced him that Neurath had been wrong in taking semantics to be metaphysical. As I showed soon after, in a paper to which Polikarov and Ginev refer, Carnap's attempt to meet the obvious objection to the coherence theory that mutually incompatible systems of sentences could each be internally coherent, by saying that one should opt for the system which was accepted by 'the scientists of our culture-circle', was no better than a fudge. Each of the competing systems could contain the *sentence* that it alone was accepted by those scientists and to pick out the one that really *was* so accepted would be to restore the correspondence with fact that the recourse to the coherence theory was intended to obviate.

Moritz Schlick, the acknowledged leader of the Circle, never wavered either in his fidelity to the correspondence theory of truth or in his championship of sensory statements, '*Konstatierungen*', rather than physical statements as the fundamental records of fact. For him, indeed, they were not so much statements as avowals of what was immediately given in sense-experiences. He hoped to secure inter-subjectivity by arguing that we did not need to trouble ourselves with the undecidable question whether the experiences of different persons were similar in content: all that mattered was that they be similar in structure. I remark in my reply to Professor Sprigge that this is a good point so far as it goes but that in order to keep ourselves safe from the pitfall of solipsism, we need to start with neutral rather than initially private items of experience.

Except for my insistence in my later writings on the vital importance of a neutral starting point, I have consistently sided with Schlick on this issue. Indeed, in my restatement of the sense-datum theory I come closer to the concept of a 'pure' observational language than Polikarov and Ginev would think desirable. Even so, I do not claim that my basic

sentences are framed without any regard to theory. On the contrary, they are expressed in a terminology which looks forward to the theory which they sustain, a procedure which I defend in my answer to Professor Sosa. I agree also with Polikarov, Ginev, and Hanson, whom they quote, that 'causal connections could not be expressed in a pure sense-data language'. Not that I take causal connection to amount to anything more in the end than *de facto* concomitance. The point is that the 'constancy and coherence' that Hume found in our 'perceptions' need to be supplemented. The regularities required for causal connection first occur at what I take to be the theoretical level of the physical world of common sense.

I am grateful to Polikarov and Ginev for reminding me that I was already maintaining in *Language, Truth and Logic* that there is no absolute standard of rationality. It was also in *Language, Truth and Logic*, as I noted in my reply to Professor Dummett, that I acknowledged that the propositions of a scientific theory confront observation not singly, but as a whole. I did not then admit that the theory might include statements which were metaphysical, by my criterion of verifiability. Indeed, if the theory is to be viewed holistically, it is not immediately obvious how its metaphysical elements are to be picked out. I suggest that it is through their failure to have any bearing on the testability of the theory. The question then arises what purpose they serve, and here I accept Polikarov's and Ginev's suggestion that the purpose is heuristic. I am puzzled, however, by their saying that these metaphysical statements acquire meaning through serving as meaning postulations: for statements which are ingredients in background knowledge are not metaphysical by my criterion. Neither are they 'synthetic *a priori*' in Kant's original sense. If they are not taken to be true by convention, and they turn out not to be metaphysical, they will indeed be synthetic but they can be said to be a priori, not in themselves, but only relatively to the theory which they mediate.

Consequently I do not yield to Polikarov's and Ginev's verdict that Logical Empiricism, as represented, for example, in my *Language, Truth and Logic*, placed an undue restriction on the range of meaningful statements. On the other hand, I think that they are right to object to its 'sweeping negation of metaphysics'. I have already made this acknowledgement in my paper "Metaphysics and Common Sense" to which Professor Naess refers in this volume, and have gone a little way there towards remedying this defect, though not far enough for Naess, and probably not for Polikarov and Ginev either, since I concede that metaphysics may have a heuristic value for philosophy but do not there say that it may also have a heuristic value for science.

When Polikarov and Ginev cite 'the confrontation of cognition and values' as another of the weak points of Logical Empiricism I take them to be referring to the thesis that statements of value are non-cognitive. It should perhaps be noted that while Carnap accepted this thesis, laying greater stress on the imperative and less on the emotive aspect of value-judgements than I did in *Language, Truth and Logic*, it was not one of the 'official' theses of the Vienna Circle. For example, it was not endorsed by Schlick, who treated ethics in his *Fragen der Ethik* as an empirical science, relating to human desires and the possibility of their fulfilment. I say something, though not very much, about the extent to which I remain a non-cognitivist in my reply to Professor Tscha Hung. Since Polikarov and Ginev have advanced no arguments on this question for me to answer I can only refer them to the first chapter of my fairly recent *Freedom and Morality*.

I think that some Logical Empiricists have been vulnerable to Polikarov's and Ginev's fourth accusation of unduly 'narrowing down the domain of philosophical problems' but I am not one of them. The greater part of my professional career has been devoted to the problems of philosophical logic and, most of all, the theory of knowledge. Moreover I have followed Russell and Moore rather than the later Wittgenstein or his disciples, in taking them to be genuine problems and capable of solution. I regret only that I have not had more success in solving them.

A.J.A.

17

Hilary Putnam

IS IT NECESSARY THAT WATER IS H₂O?

Ayer ended his *Philosophy in the Twentieth Century* with a criticism of both Kripke's views and my own. He summed up the criticism in the closing sentences of the book: "I feel there to be more loss than profit in any . . . talk of essence or necessity or possible worlds. In my opinion, such talk is regressive, although currently in vogue. I should be more proud than otherwise if my opposition to it led to my being taken for an old-fashioned empiricist." I want to do two things, namely (1) to discuss Ayer's criticism, and (2) to distance myself a bit more from Kripke than I have in the past. I say "discuss" and not "reply to". I think that Ayer's views are of deep interest, and what I propose to engage in will be reflection on those views, rather than a polemical "reply". But the extent to which I am still recalcitrant will emerge in the course of my meditations.

Let me begin with what looks like a misunderstanding (in part, I think it *is* a misunderstanding, though not a straightforward one). Ayer obviously reads me as holding that it is *inconceivable* that water is not H₂O, and Ayer finds this view dotty. In fact, I have never asserted that it is *inconceivable* that water isn't H₂O, but only that it is *impossible* that it isn't H₂O; and most philosophers who have kept up with the discussion since Kripke published *Naming and Necessity* read that book as denying that there is any inference to be drawn from *p is conceivable* to *p is possible*. So (or so it seemed to me when I encountered this criticism by Ayer), Ayer just doesn't "get" what Kripke (and I) were driving at. But this reaction on my part was less than completely just.

I will explain why my reaction now seems less than completely just in a moment. But another complication must be mentioned. Some years ago Ayer and I were at a conference in Florence,[1] and Ayer read a paper attacking Kripke's essentialism, to which I replied. The gist of my

"minimalist" interpretation of Kripkean essentialism was subsequently incorporated in volume III of my *Philosophical Papers*[2]; but in that same place, I also began to worry about the flat claim that *it is metaphysically necessary that water is H_2O*. My worries have since deepened, and since the notion of "metaphysical necessity" is just what worries Ayer, philosophical honesty (as well as plain friendliness) requires that I "come clean". And I shall "come clean"—but rather late in this paper. And this is why I say that one of the things I will do is "distance myself from Kripke more than I have in the past."

CONCEIVABILITY AND METAPHYSICAL POSSIBILITY IN KRIPKE

Although everyone—including me—read *Naming and Necessity* as denying the "conceivability implies possibility" inference, I am now not so sure we read it correctly. Kripke does advance the view that it is "epistemically possible" that water is not H_2O in the sense that we can imagine a world in which an "epistemic counterpart" of water—something which looks like water, plays the role of water, and about which (up to the present time) we have all the same well-confirmed information that we have in the actual world about water—turns out in the future (as the result of new information which we get in that world) not to be H_2O. But does this example show that *it is conceivable that water is not H_2O*, or only that *it is conceivable that stuff that resembles water should turn out not to be H_2O*? If only the latter, then Kripke, at least, may hold the view that Ayer finds dotty—the view that *it isn't conceivable* that water isn't H_2O.

I recall a conversation I had with Kripke many years ago in which I was describing a thought experiment. I was defending Quine's scepticism about analyticity, and I was trying to show that such analytic-seeming statements as "tigers are not glass bottles" aren't analytic. I proceeded in stages. First I argued (following a suggestion of Rogers Albritton's) that glass bottles might turn out to be organisms (we discover their nervous system). Then, having made this astounding discovery, I suggested that we might later make the still more astounding discovery that *tigers are just the form that glass bottles take when frightened.* Kripke's comment on this thought experiment rather surprised me. He said, "I don't think you've shown that it's conceivable that tigers are glass bottles; I think you've shown that *it's conceivable that it could become conceivable.*" *(Perhaps Kripke had in mind a modal logic in which the "diamond"—the possibility operator—is interpreted as "conceivable" and in which "$\Diamond \Diamond$ p entails \Diamond p" is rejected.)*

At any rate—it now seems to me—it may be that Kripke *doesn't* think that "water isn't H₂O" is conceivable; it may be that he only thinks that *it's conceivable that it could become conceivable that water isn't H₂O.* (One piece of further evidence for this reading is that the famous argument at the end of *Naming and Necessity* against the theory that sensations are brain-processes rather obviously presupposes the principle that conceivability entails possibility.)

PHYSICAL NECESSITY AND METAPHYSICAL NECESSITY

To explain how I (and, I assume, most people) understood *Naming and Necessity*, it is easiest to begin with an analogy: the analogy between the metaphysical modalities (metaphysical possibility, impossibility, necessity) and the physical modalities (physical possibility, impossibility, necessity). The commonsense picture, I believe, is of physical necessity (and, hence, of physical possibility and impossibility) as something *non-epistemic*. The empiricist tradition rejects this commonsense picture, but I don't see how one can deny that it *is* the commonsense picture. The picture (like the commonsense picture of mathematical necessity) may or may not, in the end, *explain* anything—that is another question. But I think it undeniable that the man on the street thinks of physical necessity as something independent of our knowledge.

An example may help: a perpetual motion machine is "physically impossible". I think the commonsense picture is of this fact as something quite independent of whether anyone ever has known, does know, or will know this fact. Moreover, this fact is *not*—on the commonsense view, anyway—the same as the fact that no one ever has built, or will succeed in the future in building, a perpetual motion machine. The truth of the universal generalization:

(x) x is not a perpetual motion machine

is not the same fact as the truth of the statement:

Perpetual motion machines are a physical impossibility.

There are—according to common sense—objective facts about what is *possible and impossible in the world.* We discovered that perpetual motion machines are a physical impossibility by discovering the First and Second Laws of Thermodynamics; but it would have been a physical impossibility even if these laws had never been discovered.

Now, for one who accepts this picture—and it is certainly the picture of the working scientist—it is simply obvious that the "conceivability"

of a perpetual motion machine has nothing to do with its possibility. Perpetual motion machines may be conceivable, but they aren't physically possible. And, assuming high school chemistry,[3] water that isn't H_2O may be conceivable, but it isn't (physically or chemically) possible.

Now, what Kripke claimed to do in *Naming and Necessity*—and this is what generated all the excitement—was to discover another, stronger, notion of *objective* (non-epistemic) necessity, a notion of objective necessity stronger than physical necessity. (In "The Meaning of 'Meaning' ", I referred to it as "logical necessity". The difference in terminology may prove interesting.)

RIGID DESIGNATION

This stronger notion of necessity was explained in terms of the celebrated notion of "rigid designation". Let me try to explain this notion as clearly as I can. To begin with, we will be talking about situations in which we employ modal idioms, subjunctive conditionals, and other non-truth-functional modes of speech. In such situations, it is convenient to say that we are talking about various "possible worlds". This does *not* mean that we think possible worlds really exist (Kripke is very emphatic about this). Although Kripke's colleague at Princeton, David Lewis, has advanced a metaphysics in which possible worlds have real existence, Kripke has repeatedly insisted that for him "possible worlds" are only hypothetical situations. Moreover, Kripke has also emphasized that his examples do not require the assumption of a totality of "all" possible worlds (although I think he believes there is such a totality); in a typical conversational situation we can take the "possible worlds" to be some set of mutually exclusive (but not necessarily exhaustive) hypothetical situations.

I shall now make a rather risky move; I shall try to explain the notion of "rigid designation" using a notion that Kripke himself very much dislikes, the notion of "sortal identity". I do this to avoid presupposing too many of Kripke's own metaphysical convictions at the outset.

Consider such a puzzle as the following: would this table have been "the same thing" if one molecule had been missing from the start? One familiar way of dissolving the puzzle (though *not* one Kripke accepts) is to say "the table would have been the same *table* but not the same *mereological sum of molecules.*" We can formalize this reply by relativizing identities to sortals, while rejecting "unrelativized" identity questions (e.g., we reject the question, "Yes, but would the table have been the same, if "same" means the *logical relation of identity* ["="] ?")

Now, suppose that while Nixon was still president of the United States, someone had said, "The President would never have become president if his mother had not encouraged him to aim high." The hypothetical situation envisaged is one in which an entity which is *person-identical* with the actual President at the time of the speech act (i.e., with Richard Nixon) fails to become President (and hence fails to be denoted by the definite description "the President". Suppose, however, that the speaker had said, "The president might have been Hubert Humphrey". In this case, he is obviously *not* envisaging a situation in which Richard Nixon is identical with Hubert Humphrey; rather he is envisaging a situation in which the definite description "the president" denotes Hubert Humphrey.

In the same conversation, then, a definite description ("the president") can be used *either* to speak of whomever in the hypothetical situation is person-identical with the actual president *or* to speak of whomever in the hypothetical situation is the one and only president of the United States *in* the hypothetical situation. In the first use, the person denoted is the same (Richard Nixon) whether we are speaking of the actual world or of a hypothetical world; this is the "rigid" use. In the second use, the person denoted may not be the same, but the person denoted must satisfy the descriptive condition *in* the hypothetical situation (whether he satisfies the descriptive condition in the actual world or not).

In the same way, in talk about hypothetical situations, "the table in this room" may mean *this very table* ("The table in this room might have been exported to China, in which case it would never have been in this house"), or it may mean whichever table fulfills the descriptive condition *(x is the one and only table in this room) in* the hypothetical situation—even if that table is not table-identical with the table that fulfills the descriptive condition in the actual world ("Your table might have been the table in this room").

The distinction between rigid and non-rigid uses is not restricted to *descriptions*; it is easily extended to substance names, for example. Thus, if I were to use the word "water" to refer to whatever stuff has certain observable characteristics *in* the hypothetical situation (regardless of its chemical composition), Kripke would say I was using the term "non-rigidly". (He would regard this as a very abnormal use of a substance term.) If I were to use it to refer to whatever stuff is substance-identical with the stuff that has those observable characteristics in the actual world, *whether or not it has them in the hypothetical situation*, then Kripke would say I was using the term "rigidly". The normal use of substance-terms is the rigid use, according to Kripke.

But what is the criterion of substance-identity when we are speaking of hypothetical situations? It is at this point that I found a convergence between Kripke's views and my own.

Starting in the 1950s, I had taken the position that the reference of natural kind terms and theoretical terms in science is typically fixed by a *cluster* of laws,[4] and I had later pointed out[5] that the connection between the cluster and the natural kind term or theoretical term cannot be represented by an ordinary analytic definition of the form:

> *x is water (or multiple sclerosis, or whatever) if and only if most of the following laws are obeyed (or approximately obeyed) by x: . . . (list of laws) . . .*

I developed a more detailed view in "Is Semantics Possible?"[6] When I came to write a lengthier version ("The Meaning of 'Meaning'"[7]), I put the point in the following way: when we first think of "water", what we think of are the laws that we know (in a pre-scientific period, these may be low-level generalizations about observable characteristics); but if we were to travel to another planet, we could not determine once and for all whether some liquid that filled the lakes and rivers on that planet was water *merely* by asking whether it did or did not obey (or approximately obey) those laws or possess those observable characteristics. What would ultimately decide the question is whether it *possessed the chemical composition—whether we knew that chemical composition or not—and whether it obeyed the laws—whether we knew all of them or not*—that the stuff we call "water" on Earth possesses and obeys. If the so-called "water" on Twin Earth turned out to consist of XYZ while the water on Earth turned out to consist of H_2O, then the correct thing for the scientist to say would be "the stuff on Twin Earth turned out not to be water after all", even if at the beginning (before he discovered that water is H_2O) he knew of no property of Earth water which was not also a property of Twin Earth "water". Moreover, the fact that a scientist would talk this way (I claim he would, anyway) does not mean that he *changed the meaning of the word "water"* upon discovering that water is H_2O. It's not that he now uses "water" as a synonym for H_2O. *What he intended all along*—I claimed—was to refer to whatever had the "deep structure" of his Terrestrial paradigms, and not to whatever had the superficial characteristics he knew about.

Even when it is a question of Earth alone, the idea that "water" is *synonymous* with a description in terms of clusters of (known) laws, observable properties, and the like is wrong. For if it turns out in the future that some bit of putative "water" does not have the "normal" chemical composition—the chemical composition that is shared by most of the paradigms—then it will be correct to say that that bit of stuff

"turned out not to be water after all." The "cluster" of observable properties and known laws fixes the reference by enabling us to pick out paradigms; but those paradigms are *defeasible* paradigms. Future discoveries—discoveries of the "deep structure" common to most of the paradigms—may lead us to say that *some of the paradigms themselves were not really water.*

All this I still believe. But it is easy to see—I saw at the time, having learned of Kripke's work by 1973, when I wrote "The Meaning of 'Meaning' "—that there is a close relation between these ideas and Kripke's ideas. Far away planets in the actual universe were playing the very same role in my own discussion that hypothetical situations ("possible worlds") were playing in Kripke's. In the terms I am using today (making use of the *un*-Kripkean notion of "sortal identity"), it is sufficient to take "has the same physico-chemical composition and obeys the same laws" to be the criterion of "substance identity" to see the relation. (Kripke himself only mentions composition and not laws, but this seems a defect of his version to me.) In my own example, discovering that the "water" on Twin Earth did not have the same composition as the water on Earth was discovering a failure of substance-identity.

It may help to present the theory in the form of an idealized model (which is what all theories of language are, after all). We picture the term "water" as becoming connected at some point in its history with the idea that substances possess a sub-visible structure (speculations about atomic structure are quite old, after all). It is part of that picture that the sub-visible structure explains why different substances obey different laws. (That's what makes *composition* important.) Thus, "has the same composition and [therefore] obeys the same laws" becomes the criterion of substance identity. We picture "water" as acquiring a "rigid" use: as being used to denote whatever is substance-identical with [most of] the paradigms in our actual environment [limited both to the actual world and to the available part of the actual world].

Now suppose, for example, that after the discovery of Daltonian chemistry but before the discovery that water is H₂O, someone wrongly conjectures that water is XYZ. He would say that it is possible that water is XYZ, certainly. But what should we say *later, after* we have discovered that water is not XYZ but H₂O? If we really are using the term "water" rigidly, we ought to say that the "hypothetical situation in which water is XYZ" is misdescribed, any such hypothetical situation is properly described as one in which XYZ plays the role of water (fills the lakes and rivers, etc.), or (if that is impossible, because XYZ couldn't actually have those properties), as a situation in which an "epistemic counterpart" of XYZ is *warrantedly assertible* to be XYZ and to have those properties. What this means is that we will *now* be unwilling to say that *any*

logically possible situation is "one in which water is XYZ". And that means that *it is impossible—metaphysically impossible—for water to be XYZ.*

But then what should we say if we later find out that we made a huge mistake? That water is XYZ after all and not H_2O? We should say that what we said before was wrong. Water was XYZ after all. *What was metaphysically impossible was that water was H_2O.* What we formerly believed could not possibly have been true.

This is what Ayer finds too paradoxical to be right. But notice! This "paradox" only arises in the case of the *rigid* use of terms. It is built into the rigid use (plus the given criterion for substance-identity) that our empirical discoveries may lead to revisions in what we are willing to call "water" in a given hypothetical situation. That is what makes the decision as to whether a given hypothetical case really is a case in which water is XYZ always subject to revision. In spite of the term "metaphysical possibility", no real metaphysics is involved over and above what was already involved in taking *physical* possibility to be an objective notion.

Why did I want to say that the conceivability of "Water may turn out *not* to be H_2O" does not imply the *logical possibility* (Kripke's "metaphysical possibility") that water is not H_2O? If water does turn out not to be H_2O, then of course it will have turned out to be *both* conceivable and possible that water is not H_2O. So that case doesn't help me to show that "conceivability doesn't entail possibility". (Nor does it help Ayer to show that it isn't necessary that water is H_2O—the claim that it is necessary that water is H_2O is a *defeasible* claim, according to my theory, and discovering that water is not H_2O in the *actual* world is what it takes to defeat it.[8]) What, however, if someone says "it is conceivable that water turn out not not to be H_2O" and it turns out that water *is* H_2O? Well, consider a mathematical analogy. If I say, "There may turn out to be a mistake in this proof", and it turns out there was no mistake, was I wrong in holding that "it is conceivable that there is a mistake"? If "it is conceivable that there is a mistake" means "it is logically possible that there is a mistake", then it is not conceivable that there is a mistake in a mathematical proof unless there *is* a mistake in the proof. (If a proof is right, then it is logically necessary that it is right.) But that isn't what "conceivable" means. If an *epistemic counterpart* of this proof—a proof with respect to which I have the same evidence that it is a proof of this theorem—could be wrong, then it is right to say, "it is conceivable there is a mistake in the proof." And if an epistemic counterpart of H_2O could turn out to be such that we mistook it for H_2O up to now (everything we know of H_2O up to now at least appears to be true of it), but—in the hypothetical situation—it is discovered in the future that the counter-

part isn't H_2O, then it is right to say "it is conceivable that there is a mistake in our chemistry, conceivable that water is not H_2O". What is conceivable is a matter of epistemology (as I said above, I am not sure this is how Kripke would use the term "conceivable"), while what is possible is a matter of two things: the range of self-consistent possible situations[9] we have in mind *and* the conventions for describing those situations in our language. If we decide that what is not substance-identical with the water in the actual world is not part of the denotation of the term "water", then that will require redescription of some possible situations when our knowledge of the fundamental characteristics of water (the ones relevant to questions of substance-identity) changes. When terms are used rigidly, logical possibility becomes dependent upon empirical facts. But I repeat, no "metaphysics" is presupposed by this beyond what is involved in speaking of "physical necessity".

In fact, even without rigid designation there is some dependence of what we take to be "logical possibility" on empirical facts. A term may turn out not to be well defined for *empirical* as opposed to conceptual reasons. Thus, when we discovered that Special Relativity was correct, we also discovered that "simultaneous" is not as well-defined as we thought it was in the actual world. But this means that whereas we previously thought that "it is possible that a radioactive decay on Mars and a radioactive decay on Venus happen simultaneously" described one definite possible state of affairs, we have learned that there are many different states of affairs that could be so described—learned this through empirical investigation.

Similar remarks apply (up to a point) to the case of personal identity and to the case of table-identity. If we accept that a hypothetical person is, say, Aristotle just in case the hypothetical person comes from the same fertilized egg (same atoms in the same arrangement) in the hypothetical situation as the actual Aristotle did in the actual world, or in case it is simply stipulated that the hypothetical person is Aristotle and nothing in the stipulations that govern the hypothetical situation contradict the 'same fertilized egg' criterion of person-identity, then we can decide which counterfactual situations are situations Aristotle himself could have found himself in and which are not. Aristotle could not have been Chinese or have had a different sex, but he could have failed to be a philosopher. If we accept that a hypothetical table is, say, this table just in case it consisted of at least ninety percent the same atoms at the time of its making and the arrangement of those atoms did not differ from their arrangement in the actual table at the point of origin by more than a specified extent, then we can decide which counterfactual situations it makes sense to stipulate concerning this table. This is what I called my "minimalist" interpretation of Kripke. Whether this does justice to the

depth of Kripke's metaphysical ambitions I now doubt, but it is worth
noticing that *one* way (probably not the intended way) of reading Kripke
is as a rational reconstructionist with a proposal for making sense of
various identity questions across "possible worlds".

WHY KRIPKE REJECTS SORTAL IDENTITY

To leave matters here—which is where I left them when Ayer and I
discussed these questions at the "Levels of Reality" Conference in
Florence so long ago—would, however, be unfair to Ayer, I now think.
For I now agree with Ayer that Kripke intends something really "meta-
physical" with his talk of Aristotle's "essence". And what I was doing at
the "Levels of Reality" Conference (and also in "Necessity and Possibili-
ty") was presenting a theory which was related to Kripke's, but which
was stripped of metaphysical assumptions to the point where Carnap
might have accepted it. (Carnap did believe there is a non-epistemic
notion of physical necessity to be reconstructed, by the way.)

I had worries about this myself at the time. And when I was lucky
enough to see a transcript of Kripke's unpublished lectures on "Time and
Identity" (given at Cornell University in 1968) I saw just how far from a
Carnapian "rational reconstructionist" Kripke really is.

In those lectures Kripke categorically rejected the whole notion of
"sortal identity". Before sketching his argument, I would like to say a
word about the "philosophical atmosphere" surrounding the notion of
"sortal identity". The notion has been used by philosophers who are
concerned, at least some of the time, to reconstruct our "linguistic
intuitions". Now, Kripke also talks about "intuitions" and gives great
weight to them. What I was trying to do with my "minimalist"
(re)interpretation of Kripke was assimilate his *metaphysical* intuitions to
the *linguistic* intuitions other analytic philosophers talk about. This is
what I now think cannot be done.

For someone who thinks the question is one of "linguistic intuition",
sortal identity will appear as a convenient device. (From such a point of
view, anyway), the device presupposes criteria of substance identity,
person identity, table identity, etc., but this will not appear to be a
metaphysical problem. We just have to consult our intuitions and lay
down a set of conventions which seem reasonable in the light of those
intuitions. If two philosophers disagree about what are reasonable
criteria of, say, person identity across possible worlds, then (unless one of
them thinks the other has a "tin ear", i.e., no ear for the way we actually
speak at all) they may well agree that "one can do it either way". E.g., the

criteria for person identity "across possible worlds" are, to some extent, to be *legislated* and not *discovered.*

I don't mean to suggest that a philosopher who uses the device of "sortal identity" in his logical theories is *committed* to this quasi-"conventionalist" attitude, but only that that attitude seems, as a matter of fact, to be associated with the appearance of the device. And this attitude is precisely what Kripke dislikes.

Kripke thinks there is a *fact of the matter* as to whether Aristotle— "Aristotle *himself* ", as he likes to say—*could have come from a different fertilized ovum.* We cannot *legislate* an answer to this question, much less say "we can do it one way in one context and another way in a different context, depending on what the *point* of the counterfactual talk is." There is (according to Kripke) a fact of the matter as to what it is to *be* Aristotle. Intuition is not just a mode of access to our culture's inherited picture of the world, it is a fundamental capacity of reason, a capacity that enables reason to discover "metaphysical necessity." This, I think, is what Ayer rejects (and I too think it should be rejected), and what I was trying to whitewash out of Kripke's text.

Consider the question of whether a hypothetical table one percent of whose matter differed at the moment of completion from the matter in this table would have been "this very table". No—first consider the question, "What—from a scientific philosopher's point of view—*is* a table, anyway?" Some "scientific philosophers"—e.g., Wilfrid Sellars— would say that "tables" don't really exist, that there are objects which really exist and which answer to what the layman calls "tables", but the layman's "tables" are part of a hopelessly prescientific picture of the world. This view Kripke certainly rejects. For Kripke, it is hard to say if *electrons* are really "objects" (scientists tell us such weird things about them—perhaps we should just wait for the scientists to make up their minds), but tables and chairs (and, curiously, *numbers*) are certainly objects. Tables certainly exist. Other scientific philosophers—e.g., Quine— would say that "tables" are on a par with electrons; they are theoretical entities just as electrons are. In fact, Quine proposes, tables should be identified with *space-time regions.* Still other philosophers— perhaps David Lewis would say this—would agree with Quine's attitude, but would identify tables with mereological sums of time-slices of elementary particles.

I am not forgetting that this is a paper about Ayer's philosophy and not Kripke's; but Ayer's criticisms *of* Kripke's views are my take-off point. And I think that the difference between Kripke's views and Ayer's will come out most clearly if we go into just a little bit more detail about Kripke's view at precisely this point. Kripke, first of all, thinks that

objects have modal properties. (Remember, for Kripke modality is non-epistemic.) It is an objective (non-epistemic) fact about this table that *it could have been elsewhere.* But a space-time region obviously lacks this modal property. So the table is not any space-time region. Quine is wrong. (Quine, like Ayer, rejects these non-epistemic modal properties; so Kripke's argument does not impress him.) Of course, a "sortal identity theorist" would say that if the world had been such that "this" table was in a different place at least some of the time (occupied a different space-time region), then *it would have been the very same table but not the very same space-time region.* This is just what Kripke does *not* want to say.

Is the table a "mereological sum of time-slices of particles"? Well, the table has the modal property that *it could have consisted of different particles* (or so Kripke would argue). And a mereological sum of time-slices of particles obviously lacks this property. So David Lewis is wrong. The table is not identical with any mereological sum of time-slices of particles. Of course, a "sortal identity theorist" would say that if the world had been such that "this" table consisted of different particles at least some of the time (its matter formed a different mereological sum of particle-slices), then *it would have been the very same table but not the very same mereological sum of time-slices of particles.* This is just what Kripke does *not* want to say.

What Kripke does want to say is that the table is *not identical* with the particles-and-fields that make it up. It is not identical with the space-time region (Quine takes the space-time region and not just the particles because he considers the electromagnetic and other fields to also be part of the table). And it is not identical with the particles (not identical with the mereological sum of time-slices of particles). The particles-and-fields that make it up are the *matter* of the table. But the table is not identical with its matter. If the table had been in a different place, it would have been *the very same* table. What does "the very same" mean? It means— Kripke says—precisely what "=" means in logic. It means *identity.* Identity is a *primitive logical notion,* Kripke claims, and it is a fundamental philosophical error to think it can or should be "explained". Kripke rejects the very idea of "criteria of identity".

The distinction between "the table" and its *matter* is, of course, reminiscent of Aristotle. But Kripke's view is very different from Aristotle's. According to Kripke, it is "essential" to the table that it consist of pretty much *this very matter (at least at its "origin"),* while for Aristotle the *particular* matter is never part of the essence of anything. (Also, it is doubtful if Aristotle ever recognized any such thing as an *individual* essence, as opposed to the essence of a kind.)

At any rate, since the table is not identical with its matter, the need for

the dubious notion of "sortal identity" disappears. Instead of saying, "the hypothetical object you describe would be the same table, but not the same space-time region," one can simply say "it would be the very same table, but it would not *occupy* the same space-time region. We can do everything we want with just the good old "primitive logical notion" of identity. (Kripke rejects the notion that the matter of the table is a mereological sum of time-slices of *anything*, by the way—he says that he doesn't know what a time-slice is, "unless it's the ordered pair of an object and a time", and objects certainly aren't sums of ordered pairs of themselves and times.)

For these reasons, the explanation I gave of rigid designation using the notion of sortal identity would be wholly unacceptable to Kripke. For example, instead of saying that the assignment of truth-values to counterfactual statements about "this table" requires the adoption of an explicit or implicit criterion of table-identity,[10] Kripke would say that it requires an intuitive knowledge of what is "essential" to the table—an intuitive grasp of the limits of the possibilities in which the hypothetical object would bear the primitive logical relation "=" to the table I am pointing to. Criteria of table-identity are conceived of (by me, anyway) as to some extent *up to us*. Facts about "=" are not (in Kripke's view, anyway) at all up to us. Kripke is not doing rational reconstruction; he is engaged in (what he views as) metaphysical discovery.

Ayer would doubtless say that he cannot fathom what this sort of "metaphysical discovery" is supposed to come to. And I must admit that neither can I. The table can, after all, vary *continuously* across hypothetical situations (just imagine a series of hypothetical situations such that in the $n + 1$st the table has one less molecule in common with the table I am pointing to than it does in the nth). Is there supposed to be a fact of the matter as to when the hypothetical table stops being "=" *(identical)* with the table I am pointing to? Kripke might say that every possible borderline determines a different "essence", and that it is vague which "essence" our concept "this table" connects with, but then what are we being asked to "intuit"? A "fuzzy set" of "essences", perhaps? If we can connect the description "this table" with different essences by adopting a different *convention*, then Kripke's view seems only verbally different from the quasi-conventionalist view; if not, then . . . ?

I myself have always been much more attracted to Kripke's ideas about natural kinds than to his ideas about individual essences (which I could understand, at best, only by regarding them as linguistic proposals for assigning truth-values to certain counterfactuals in a not implausible way). So let us return to natural kinds, and in particular to the example which Ayer took up, the "water is H_2O" example.

The "Identity" of Substances

I shall not further consider the question of how to *formalize* questions of substance identity (i.e., I shall not worry about whether the question concerns "sortal identity" or a unitary notion of identity). If it still seems to me that questions of the identity of chemically pure substances are much clearer than questions of the "identity" of the table in hypothetical situations, the reason is simply this: I accept (up to a point—I'll say what the limits are later) the commonsense picture of *physical* necessity. I accept, at least for ordinary scientific purposes, the idea that it makes sense to talk of laws of nature (physically necessary truths) and the idea that the search for such laws is a search for something objective (as objective as anything is). Given this picture, I would propose the following as a condition for the adequacy of any proposed criterion of substance identity: the criterion must have the consequence that A and B are the same substance if and only if they obey the same *laws*.

I don't claim that there is no vagueness *at all* in this condition of adequacy.[11] The notion "same laws" is, to be sure, somewhat vague. (I'll say in a moment how I get around this.) For example, consider an ordinary sample of iron. This is "chemically pure" by the standards of high school chemistry. But it consists of different isotopes (these occur in fixed proportions—the same proportions—in all naturally occurring samples, by the way. Some philosophers who use isotopes as examples appear not to know this.) Any naturally occurring sample of iron (which is sufficiently free of impurities) will exhibit the same lawful behavior as any other (unless we go to a quantum mechanical level of accuracy). But if we use a cyclotron or some other fancy gadget from atomic physics to prepare a sample of iron which is mono-isotopic, that sample will—if the tests are sensitive enough—behave slightly differently from a "natural" sample. Should we then say that a hunk of iron consisting of a single isotope and a hunk of natural iron (consisting of the various isotopes in their normal proportions) are two different substances or one? Indeed, two natural occurring samples may have tiny variations in the proportions with which the isotopes occur. Perhaps this will result in a slight difference in their lawful behavior. Are they samples of different substances? Well, it may depend on our interests. (This is the sort of talk Kripke hates!) But the fact that there is some component of interest relativity here, and, perhaps, some drawing of arbitrary lines here, does not change the fact that *the degree of arbitrariness is infinitesimal compared to the arbitrariness in the 'almost the same matter at the same time of origin' criterion for identity of* tables.

Some of my readers will recall that in "The Meaning of 'Meaning' " I

took *microstructure* as the criterion for substance identity. But I pointed out that differences in microstructure invariably (in the actual world) result in differences in lawful behavior. (For example, *no other substance has the same boiling point at sea level or the same freezing point as H_2O.*) Since there is a standard description of microstructure, and microstructure is what determines physical behavior (laws of behavior), it seemed to me that the only natural choice for a criterion of substance identity was the microstructure criterion. (In this way one also reduces the vagueness in the "same laws" criterion, although one does not completely eliminate it for the reasons just given.)

Another relevant point is that "possible worlds" were mentioned in "The Meaning of 'Meaning' " only in connection with the discussion of Kripke; my own ideas were presented in terms of a thought experiment that has already been mentioned: the thought experiment of imagining that we discover a superficially "Terrestrial looking" planet. We were to imagine that a liquid on this "Twin Earth" superficially resembles water. How do we decide whether it really *is* water? Since the question only concerned *actual* substances, questions about "all possible worlds"—in particular, questions about worlds in which the *laws of nature can be different*—were not in my mind.

Even at this stage, my motivations were somewhat different from Kripke's. But I did not think through the consequences. Today I would add two qualifications to what I wrote in "The Meaning of 'Meaning' ". First of all, I would distinguish ordinary questions of substance identity from scientific questions. I still believe that ordinary language and scientific language are interdependent;[12] but the layman's "water" is not the chemically pure water of the scientist, and just what "impurities" make something no longer water but something else (say, "coffee") is not determined by scientific theory. Secondly (and, in the present context, more important), I do not think that a criterion of substance identity that handles "Twin Earth" cases will extend handily to "possible worlds".[13] In particular, what if a hypothetical "world" *obeys different laws*? Perhaps one could tell a story about a world in which H_2O exists (H still consists of one electron and one proton, for example), but the laws are slightly different in such a way that what is a small difference in the *equations* produces a very large difference in the *behavior* of H_2O. Is it clear that we would call a (hypothetical) substance with quite different behavior *water* in these circumstances?[14] I now think that the question, "what is the necessary and sufficient condition for being water *in all possible worlds*?" makes no sense at all. And this means that I now reject "metaphysical necessity".

Are Ayer and I now in total agreement on these matters, then? Well, up to a point we are. (But I warned at the beginning that there is a point at

which I am still "recalcitrant".) If the question about substance identity in all possible situations can be dismissed (especially if the answer is required not to be a conventional stipulation but a metaphysical fact), then there is no need to make an issue about the "logical possibility" of water not being H_2O. If you have a hypothetical situation you want to describe that way, describe it that way—as long as it's clear *what* hypothetical situation you are describing. I won't insist (anymore) that "it is conceivable that water may turn out not to be H_2O but it isn't logically possible that water isn't H_2O". But Ayer and I are still not in total agreement.

We aren't in total agreement for two reasons. The first would take a much longer paper to discuss, and that is the difference in our theories of reference. I still believe that a community can stipulate that "water" is to designate *whatever has the same chemical structure* or *whatever has the same chemical behavior* as paradigms X, Y, Z, . . . (or as most of them, just in case a few of them turn out to be cuckoos in the nest) *even if it doesn't know, at the time it makes this stipulation, exactly what that chemical structure, or exactly what that lawful behavior*, is. But this still has some of the consequences Ayer objects to: I may discover that something that satisfied all the existing tests for water wasn't really water after all—not by discovering that it failed some qualitative criterion that I had in mind all along, but by discovering that *it doesn't obey the same laws that most of X, Y, Z, . . . do.* We didn't *know* those laws when we introduced the term *water*, but we already had the *concept* of a physical law, and the concept of discovering a physical law,[15] and that is all we need to formulate this notion of substance identity.

The second disagreement is more fundamental than the first. The criterion of substance identity which still seems fine to me (a little vagueness at the boundaries doesn't hurt, after all) presupposes the non-epistemic character of the notion of a "physical law". I still accept a notion of *objective non-logical modality.* And this, I think, is where the real disagreement arises.

EMPIRICISM AND NECESSITY

The empiricist tradition has always been sceptical of the modalities. Although empiricist doubts have lately gone out of fashion, they should not, I think, be lightly dismissed. There *is* a prima facie difficulty about modality—a prima facie *epistemic* difficulty, and it runs very deep.

The difficulty, in its simplest form, may be stated thus: modal realists claim that we have knowledge about what is and is not possible. This is

not believed to be a matter of pure logic, since knowledge of physical possibility is supposed to be synthetic knowledge. It must, then, somehow be based on observation. (No one any longer believes the laws of nature are *synthetic a priori.*) But how? *We only observe what happens in the* actual *world.* How then, are we supposed to know what happens in non-actual "possible worlds"? (To appreciate the difficulty, try reading David Lewis's books with it in mind!)

Kripke's answer: that "possible worlds" are only hypothetical situations, and we know what is true in hypothetical situations because we *stipulate* them, may help with issues of metaphysical possibility (but there is the big problem of what is an *admissible* stipulation—the problem of criteria of identity across possible worlds is a small part of this big problem); but we are not now talking about "metaphysical" possibility but about *physical* possibility. We cannot just stipulate physical possibilities.

The answer I myself find most attractive is the following: the distinction between what is and is not physically possible is not an external distinction imposed by philosophers; it is a distinction *internal* to physical theory itself. Just as in modern logic there are complicated devices for representing *logical* possibilities—state descriptions, and infinitary analogues of state descriptions ("models"), so in modern physics there are complicated devices for representing *physical* possibilities—phase spaces and Hamiltonians. A state of affairs is logically possible if it can be represented by a disjunction of state descriptions,[16] or more generally by a "model"; a state of affairs is physically possible if it can be represented by a wave function and a Hamiltonian. Physical theories have to agree with observation, but hypothetico-deductive inferences have led the scientist to accept as real many things that are not "observable". The machinery of "physical possibility" is just part of what we accept when we accept a modern physical theory as well confirmed.

Empiricists (including Ayer at the time he wrote *Language, Truth and Logic*—a book I, for one, still regard as a masterpiece, for all my disagreements with it) have sometimes replied by suggesting that physical theory itself is just highly derived talk about sense data. This is a bad move for the empiricist to make, however, since it plays into the modal realist's hands. The empiricist who makes this reply has now assumed the whole burden of proof—the burden of showing that some version of phenomenalism can be made to work—and the modal realist is off the hook.

A better reply—and the one Ayer would now make, if I am not mistaken—is the following: "there may indeed be a distinction of the

kind you describe within physical theories, but that distinction is obviously *relative* to the physical theory you select. The question is not 'Can we make sense of possibility relative to Newtonian physics (or to Special Relativity, or to General Relativity, or to Quantum Mechanics, or to supergravity, . . .)', but 'Can we make sense of an *unrelativized* notion of physical possibility?'. And this is indeed the question. For what I need to support my argument is a notion of substance identity; *not* a series of notions (identity relative to high school chemistry, identity relative to quantum mechanics, identity relative to . . .). The nineteenth-century chemists who discovered that water is H_2O were not implicitly using the criterion that something is water if it has the same "nature" as (most of) the paradigmatic samples *relative to future quantum mechanics*, after all.

The empiricist can also tell a fairly convincing story about how the habit of speaking as if "possibility" was *non*-relative might have arisen. When something is possible/impossible relative to *the currently accepted* physical theory it is natural to drop the relativizer. We say, "In Daltonian chemistry, transmutation of elements is impossible", because Daltonian chemistry is not the currently accepted theory on the subject. But if someone asks, "Is it possible to transmute elements?", today we might reply, "We have learned that it is, though not by purely chemical means—you need an atom smasher." This reply does not say "it is possible relative to contemporary physical theory", because it is understood that we are employing the best theory available. Thus possibility in an *epistemic* sense—possibility relative to our best available knowledge —gets spoken of as if it were some kind of knowledge-independent fact.

Indeed, one can see something like this happening in certain "vulgar" uses of the possibility concept. If someone told me that my neighbors Bernie and Marie had painted their house lavender, I would reply "I don't believe it. They wouldn't paint their house such an ugly color. It's impossible." But I would be much less likely to say, "It is impossible for me to paint my house lavender." Instead I would say, "I hate lavender. I would never choose that color." What is happening here?

What is happening is that I represent the hypothetical situation in terms of most likely causal histories (Bernie and Marie deciding to paint their house lavender; my deciding to paint my house lavender). If the contemplated event is not unlikely to occur, I say "it is possible." (Note the explicitly epistemic "not unlikely".) If it is extremely unlikely, something interesting happens. I divide causal histories into those in which the event happens for reasons independent of *my* will and those in which the event happens because I will something I am not, in fact, likely to will. In the first kind of case, I may well say, "It's impossible." In the

second kind of case. I am much more likely to say, "I would never do that." Yet, obviously, there is no "objective" sense in which it is *impossible for Bernie and Marie to paint their house lavender but possible for me to do so.*

Moreover, suppose (Heaven forbid!) that Bernie and Marie *do* paint their house lavender. I wouldn't say, "Well it was impossible that they **would** relative to my evidence then, but it is possible relative to my evidence now." Rather, I would say, "I was wrong." *I was wrong in saying it was impossible.* Even in a case like this, a case in which the "impossibility" spoken of is obviously epistemic, we speak *as if* possibility and impossibility were "tenseless" (and hence *non*-epistemic). Obviously, the fact that we speak the same way about physical possibility and impossibility cannot be given much weight.

Again, the modal realist may claim that thc impossibility of, say, a perpetual motion machine *explains* the fact that every attempt to build one has failed. But we can deduce from the laws of physics (which can themselves be formalized without difficulty in a first-order extensional language), not only *that* there are no perpetual motion machines, but *how* and *why* each particular attempt to build one fails. The "deduction" of each law of physics L from the statement "it is impossible to violate L" adds no real explanatory content to these marvelously informative deductions; *what it adds is only metaphysical comfort.*

PHYSICAL POSSIBILITIES AND CAUSAL POWERS

The power of this critique is undeniable. The best response, I think, is to undermine the original premise: the premise that what is at stake is knowledge of what happens in non-actual "possible worlds". Grant that premise, and the entire critique unfolds in the way we have just seen. An alternative way of looking at the situation is the following: think of talk of "physical possibility" and "physical impossibility" as a late refinement of ordinary causal talk. (Talk of "bringing about", talk of "dispositions", talk of abilities and capacity, all stem from this common root.) To say something is impossible is to say nothing has the capacity to bring it about. No system has the capacity to go on repeating its motions forever; this is the "impossibility of a perpetual motion machine of the first kind." Capacities and dispositions and other sorts of causal powers are possessed by things in the actual world; they are descriptions of what is the case in this world, not of what is (or isn't) the case in a variety of "non-actual worlds". Physics is concerned to describe the capacities of things—starting with the individual particles. Indeed, each physical

magnitude, e.g., *charge* is associated with a set of causal powers from the day it is introduced into physical theory.

To this move, there is an ancient empiricist countermove. Causality itself, Hume argued, poses just the problem we have been discussing (and it is clear that Ayer agrees with Hume). If I say

A always brings about B

the "objective" content of the assertion is that A-events are always followed by B-events. The supposition of something over and above the regularity—the assumption of a genuine "bringing about" is just the assumption of something that is neither observable nor really explanatory.

The empiricist need not make the mistake of suggesting that he can *translate* causal talk into regularity talk. Like possibility talk, causal talk arises from a variety of "vulgar" ways of speaking and has a variety of uses. The sophisticated empiricist will keep the burden of proof on the side of the causal realist. *Show me what the notion of "bringing about" actually adds to the individual regularities we observe and their use in explanation and prediction*, he will say.

But the situation is a little different than it was with sophisticated "possibility" talk. No one supposes that we observe either physical possibility (except when it is actualized) or physical impossibility. But, as Anscombe has stressed,[17] our ordinary descriptions of what we observe are *loaded* with causal content. Ask someone what he saw, and he will talk about people *eating, drinking, moving* things, *picking up* things, *breaking* things, etc. . . . and every one of these verbs contains causal information. It isn't just that John's hand came to be in contact with the glass before the glass moved to the floor and separated into pieces; John *broke* the glass, etc. Moreover, even the statement that "the glass moved" uses notions of space and time; and ever since Kant, there have been strong arguments to the effect that assignments of space-time location are dependent on causal ascriptions. The Kantian view is, in this respect, an early forerunner of contemporary "holist" views of belief fixation. Kant can be interpreted (I think correctly) as holding that judgements as to how objects are distributed in space and judgements as to how objects send causal signals to one another are interdependent and are confirmed as a corporate body. (Michael Friedman has recently done a close study of Kant's *Metaphysical Foundations of Natural Science*, showing how Kant analyzes Newton's *Principia* in just this way.) If we cannot give a single example of an ordinary observation report which does not, directly or indirectly, presuppose causal judgements, then the empiricist distinc-

tion between the "regularities" we "observe" and the . . . "causality" we "project onto" the objects and events involved in the regularities collapses. Perhaps the notion of causality is so primitive that the very notion of observation presupposes it?

Again there is an empiricist reply, but this time the reply does involve the empiricist in defense of a positive doctrine. The burden of proof cannot forever be shifted to the realist side. The famous empiricist doctrine of observation (which Ayer supports) is that *ultimately* there is a level of observation—an absolutely fundamental level—which is free of causal hypotheses. This is the level of sense qualities. When I observe that I have a particular sense experience, say a blue star against a white background, I observe something which is absolutely "occurrent", something which is independent of all alleged facts about "what causes what".

Whether this is right is, not surprisingly, the fundamental issue on which everything turns. I can hardly hope to do justice to it at the end of a paper. Many of the questions which have been raised in connection with it cannot even be discussed here. (For example, whether even sense qualities can really be described in a language which is independent of our causally-loaded "thing language". And, for another example, the question—which was first raised by Kant—whether the ascription of a *time order* to even sense qualities does not indirectly presuppose the objective material world and its causal structure.) But I shall single out one strain for discussion, because I am especially interested in discovering what Ayer's response will be.

CAUSALITY AND THE MIND

From this point on, I shall focus on Ayer's own version of empiricism. Ayer holds that we are directly acquainted with our "sense qualities". By this he does not just mean that we *have* sense qualities; he means that we can attend to them, give them names, and so on. Indeed, if we could not name them, there would be a sort of epistemological inconsistency in the position. ("I say we can't talk about X's." "Can't talk about *what*?") This ability to have *knowledge* of our sense qualities is the epistemological foundation for every other sort of knowledge, in Ayer's view. As he himself puts it in the book I quoted from at the beginning of this essay, "Any check upon the use of language must depend sooner or later on what I call an act of primary recognition" (p. 151).

But what conception of the mind does Ayer have, when he speaks of

"an act of primary recognition"? Isn't Ayer thinking of the mind as distinct from its sense qualities, as something with *active powers*?

Perhaps not. In order to test the consistency of this pair of views (View 1: *the objective content of our causal descriptions is the regularities that those descriptions encapsulate.*[18] View 2: *the mind has the ability to be aware of and represent its sense qualities*), I should like to employ a thought experiment (it may resemble the one Wittgenstein employed in the Private Language Argument, but the idea of "in principle privacy" will play no part). Imagine a situation which is epistemologically ideal from the point of view of a sense-quality theorist. John is attending to his sense qualities, and he is describing them in the vocabulary specified by the epistemologist. Moreover, his reports are sincere. Suppose the epistemologist instructs him to use "E" as a name for a particular sense experience (say, a blue star against a white background), and to say "E" out loud when he has it. What could it come to to say that John successfully represents the sense experience in question by the sign "E"?

One wants to say that John doesn't *just* say "E" whenever the sense experience in question occurs (in this context), but that its being E is what *causes* him to say it, what "brings it about". But for Ayer, it seems, this can at most mean that other regularities obtain in John's behavior as well (e.g., if asked "Why did you say 'E'?", John gives some 'appropriate' reply, such as "Because that's what it looked like—a blue star on a white background.") The story in terms of sense qualities and regularities is *complete*; there is no need to supplement it with talk of "bringing about".

Let us grant, for the sake of argument, that it might just be an *ultimate* fact that in certain circumstances people do produce certain representations only when they have certain sense qualities (apart from occasional and inevitable slips). Is this all that Ayer means by saying that they recognize and describe those sense qualities? *Could* this be all it means?

I just mentioned "slips". In fact, slips are inevitable—slips of the mind as well as slips of the tongue, and one isn't always aware that one is making one. Suppose John occasionally, without noticing, says "E" when he is shown a *green* star on a white background. I assume that he is not at all blue-green colorblind, and that when this is pointed out to him (say, we point it out fifty percent of the time, and let his report stand the other fifty percent) he doesn't say, "Well, it looks blue to me", but rather says, "Oh my, I don't know what's the matter with me." In fact, he may even say, "Of course it looked green. I don't know why I said 'E'." (I have had very similar experience myself, of looking at someone wearing a green sweater—a sweater that, I would swear, *looked* green—and referring to it as a "blue sweater". And I would never have noticed the slip-of-the-mind if other people hadn't pointed it out.)

This possibility—the possibility of error in one's *representation* of the sense experience—shows that one cannot take the hallmark of reference to a sense experience to be perfect correlation between the name and the experience (even under the special circumstances envisaged). But one might, I suppose, say that *nearly perfect correlation* is enough. Is nearly perfect correlation between occurrences of E and occurrences of a sense experience good enough to guarantee that the name *refers* to the experience?

It seems that it cannot be. For consider the whole class of cases in which John says "E" and does not subsequently retract his judgement. These may not all be occurrences of one sense experience (there will still be some slips, let us imagine, even though no one noticed them), but they will be cases of one *sense shmexperience*; that is of a Goodmanesque predicate (apologies to Nelson Goodman!) such as "Is E and occurs at time t_1 or is E' and occurs at time t_2 or . . .". Now what makes it the case that "E" does not refer to this *sense shmexperience* and not to the sense experience? Well, the epistemologist told John to use "E" as the name of a sense experience. *But what makes it the case that the epistemologist's term "sense experience" stands for sense experiences and not for sense shmexperiences?*

In effect we have gone from a species ("E") to a genus ("sense experience"). But the problem is the same. If the term ("E" or "sense experience") is correlated (very well but not perfectly) with a particular class or a particular class of classes, it is also correlated in the same way with many other slightly different classes. A unique association between a particular representation and a particular universal (first order or higher order) cannot be a matter of mere "very high correlation". The moral is: if all we are given to work with is sense experiences and "regularities" we will never get *reference*.

Perhaps Ayer's picture is different from this, however. Perhaps Ayer's picture is that there is a primitive *relation* R between the mind and the sense quality (*the universal itself,* not the instances). But is this relation itself something *observable*? Obviously it isn't a sense quality! If it is a *capacity*, on the other hand, and we can know without observation that we are exercising a capacity (I observe the sense-quality and I observe myself saying "E" and I know without observation that my saying "E" was an exercise of my capacity to report the sensation), then the argument that capacities (and causal powers in general) are *epistemically inaccessible* collapses. It is not, after all, as if we had any kind of serious scientific account of what the relation R is, or how it can connect us to universals (sense qualities), or how we observe that it *is* connecting us to universals.

Empiricism and Ayer

I hope to have gotten it across that I find a great deal of power in the empiricist critique of our modal and causal notions. Not to feel the power of that critique, not to feel disturbed by it, is to miss much of what philosophy is about. Yet ultimately the critique succeeds too well. If we reject everything but sense qualities and regularities as unnecessary metaphysical baggage,[19] then even our ability to refer to sense qualities becomes mysterious; and just *positing* a primitive relation to do the job is no solution. Not *everything* the scrupulous empiricist regards as a human projection can really be so.

Empiricism is a mighty tradition, and Ayer is one of its foremost representatives in our time. To see the depth of the empiricist critique is, I think, to see the limits of our philosophical understanding. In this sense, empiricism performs an immensely valuable service. It is when empiricism turns from critique to construction that we become dissatisfied. Empiricism sees that our scientific picture of the world—the picture of the scientist as discovering what is physically necessary and what is impossible, as discovering the nature of substances and forces and processes—does not really provide the kind of philosophical security that one has wished for, that I myself have often wished for. But that picture, like the common sense picture of things "bringing about" events, of things having "capacities" and "dispositions", is deeply interwoven with our practice—so deeply interwoven that our very notions of observation and reference rest on this picture. To give up the picture for the alternative picture—the desert landscape of sense qualities and regularities—associated with classical empiricism does not seem a real possibility to me. But I await Ayer's reply!

<div align="right">Hilary Putnam</div>

Department of Philosophy
Harvard University
March 1987

NOTES

1. The conference on "Levels of Reality" took place in the late nineteen seventies; the proceedings were published in Italian (ed. Massimo Piatelli-Palmerini), but have never appeared in English.

2. Cf. "Possibility and Necessity", in *Realism and Reason*, vol. 3 of my *Philosophical Papers* (Cambridge: Cambridge University Press, 1983). See, especially pp. 63–64.

3. I shall stick to high school chemistry because the actual quantum-mechanical picture of the structure of water is immensely complicated.

4. Cf. "The Analytic and the Synthetic", reprinted in *Mind, Language and Reality*, vol. 2 of my *Philosophical Papers* (Cambridge: Cambridge University Press, 1975), pp. 33–69. This was originally published in H. Feigl and G. Maxwell, eds., *Minnesota Studies in the Philosophy of Science*, vol. 3 (Minneapolis: University of Minnesota Press, 1962).

5. Cf. "Brains and Behavior", first published in R. Butler, ed., *Readings in Analytical Philosophy*, 2nd. Series (Oxford, 1963); reprinted in *Mind, Language and Reality*, pp. 325–41. See especially the footnote on p. 328.

6. Published in H. Kiefer and M.K. Munitz, eds., *Language, Belief and Metaphysics*, vol. 1 of *Contemporary Philosophical Thought, The International Philosophy Year Conferences at Brockport* (Albany: State University of New York Press, 1970); reprinted in *Mind, Language and Reality*, pp. 139–52.

7. This appeared originally in K. Gundersen, *Language, Mind and Knowledge*, vol. 7 of *Minnesota Studies in the Philosophy of Science* (Minneapolis: University of Minnesota Press, 1975), and was reprinted in *Mind, Language and Reality*, pp. 215–71.

8. On the last page of *Philosophy in the Twentieth Century*, Ayer gives a thought experiment to *show* that it is logically possible that water is not H₂O. "Suppose that in some part of this world we came upon stuff which had the chemical composition H₂O but did not have the properties of falling as rain, allaying thirst, quenching fire, and so forth, perhaps even failed to appear in liquid form." I would reply that *this is conceivable but not possible.* If the question is "What would you say if we actually discovered that composition is not what determines behavior," the answer is that I *would say that my view was wrong*—I never claimed it was a priori! If we discover that substances with identical composition can obey different laws, then our whole picture of the world—not just our philosophy—will have to be revised. A case that would be closer to my own reasons for becoming sceptical about "metaphysical possibility" is the following: suppose Ayer had stipulated that in the actual world water *is* H₂O and composition *does* determine behavior, but asked what I would say about a *possible* world in which composition does not determine behavior and some H₂O does not fall as rain, allay thirst, quench fires, etc.? Would that *hypothetical* stuff still be water? Kripke would apparently answer "yes"; but this seems to me a case in which the answer is utterly arbitrary.

9. As I explained in "Possibility and Necessity", I would identify "possible situations" in a given context with states of affairs relative to some specified language (what Carnap calls 'state descriptions'). This relativization of the notion of a possible situation to a language is something Kripke would reject.

10. Kripke appears to think that the only available notion of a criterion is something that is exceptionless, unrevisable, and can be known a priori. I don't at all agree that this is the most illuminating use of the notion, but it would take us away from the topic to discuss this here.

11. And I don't claim the condition of adequacy is a priori, either!

12. For example, if the scientist tells a layman that fifty percent of the liquid in the glass he has just drunk is actually a (harmless) chemical that does not occur as a constituent of normal water, the layman will *not* say "Well, it tasted like water and—you tell me—it didn't poison me, so it *is* water." The "man on the street" isn't that instrumentalist. The chemist can convince the layman (sometimes) that something isn't water *even in the lay sense*, where this isn't something

that the laymen could determine by "ordinary" non-scientific criteria. This is why I say that the lay sense and the scientific sense are *interdependent—different but interdependent.*

13. I believe that Nathan Salmon was the first to argue that this is the case, in "How *Not* to Derive Essentialism from the Theory of Reference," *Journal of Philosophy* 76, no. 12 (Dec. 1979): 703–74.

14. Further examples occur in the reference cited in n.2.

15. It may be objected that the Greeks (who, of course, used the word *hydor*, which is cognate to our present *water*) did *not* have *our* concept of a physical law. That is, of course, true. But they did have an implicit notion that all samples of a pure substance must behave in the same way—that is what underlay Archimedes's search for a way to tell if the King's crown was gold: he assumed that if it was gold it would behave the same way under a density test as the known paradigms of gold. And they believe that the behavior of a substance depended upon its *ultimate* composition. These ideas were refined into something close to our present notions of a law and of a microstructure by the time of Newton—well *before* anyone knew that water is H_2O. The nineteenth-century chemists already had this criterion of substance identity in place when they discovered that water is H_2O. (Philosophers of science who reject this account have a notorious tendency to describe the discovery as a meaning stipulation!)

16. I ignore the thorny problem of "Meaning Postulates". On this, the *locus classicus* is, of course, Quine's "Two Dogmas".

17. See "Causality and Determination", in *The Collected Papers of G.E.M. Anscombe*, vol. 2, *Metaphysics and the Philosophy of Mind* (Minneapolis: University of Minnesota Press, 1981), pp. 133–47.

18. I am not ascribing to Ayer the view that causal statements can be translated into regularity statements. The view I would ascribe to him, the Humean view, is compatible with the idea that there can be other elements in a causal description as well—e.g., information about the epistemic status of certain regularities—but those elements are not "objective" in the sense of being independent of the evidence available to the speaker.

19. I should also list "material objects", because Ayer accepts an inference to these. It is not clear to me whether their existence comes to more than the fact that *theories which posit them correctly predict sense experiences*, in Ayer's current view, however.

REPLY TO HILARY PUTNAM

I am extremely grateful to Professor Putnam for his careful and acute discussion of the points of agreement and divergence between our philosophical positions. His account of my views is always fair and he displays an almost uncanny ability to predict the responses that I should make to the difficulties which he raises. For the most part it will be seen that I am content with these responses. It is only at the conclusion of his paper when he raises what he calls the 'fundamental issue' that I am driven into a corner from which I shall confess to not having found an avenue of escape.

While I am pleased to learn that Putnam's present views are closer to mine and further from those which he now believes to be Kripke's than I took them to be on the occasion of the Florence conference, I shall leave Kripke out of this discussion, beyond saying that I agree with him in taking 'possible worlds' to be no more than hypothetical situations, and apart from any light upon his opinions that may be cast by Putnam's interpretation of his concept of a 'rigid designator.'

If I remember rightly, the concept of a rigid designator first came into fashion as a device for distinguishing our use of proper names from that of definite or indefinite descriptions. Thus, to employ one of Putnam's examples, Aristotle might not have been a philosopher, or the tutor of Alexander the Great, but he could not have failed to be Aristotle. If the name 'Aristotle' is used rigidly, as it is supposed to be, it refers to the same person in all situations, whether actual or hypothetical. But what is it to be Aristotle? In virtue of what does he remain the same person in these different situations? Putnam's suggestion is that it is a matter of his origin. We are invited to stipulate 'that a hypothetical person is Aristotle just in case the hypothetical person comes from the same fertilized egg'. It is assumed that we should thereby be limiting the range of counterfactual hypotheses that Aristotle could satisfy. He might still have

died in infancy, or grown up to become a carpenter, but, according to Putnam, he could not have been Chinese or have had a different sex. It is not at all clear to me, however, that these conclusions follow. Surely there might have been other ways in which the ovum in question came to be fertilized. And why should these other ways not allow room for the hypotheses which Putnam excludes?

A deeper objection, which applies equally to Putnam's proposal to identify a hypothetical table with the table at which he was sitting 'just in case it consisted of at least ninety percent the same atoms at the time of its making and the arrangement of those atoms did not differ from their arrangement in the actual table at the point of origin by more than a specified extent' is that these criteria of identity, in so far as they make any connection at all between identity and identification, do so the wrong way round. It is only because I have already identified my writing table, in this case ostensively, that I am able even to make any sense of talk about the atoms which composed it at the time of its origin. A reference to the fertilized egg out of which Aristotle eventually emerged is useless as a pointer unless one has already discovered, by acquaintance, or, as in this instance, by some more informative description, who or what Aristotle is supposed to be. What is more, if someone were, in error or in fancy, to assign a different origin to Aristotle from that which he actually had, I do not think that he could not be referring to him. It would depend on the extent to which the other descriptions on which the speaker was relying were correctly satisfied.

I admit that the notion of proper names as 'rigid designators' is not entirely worthless since it does make the point that a proper name retains its reference in counterfactual contexts, whereas a definite description need not. At the same time I am not persuaded that it achieves anything more than this. In particular, it does not entail that there is any such thing as an individual essence. It would, indeed, be a mistake to identify the sense of a proper name with any one description of the object to which it refers, or even with a disjunction of them. Nevertheless, except when it is introduced ostensively, it needs to be associated with one or more descriptions if its target is to be identified. My view, as I have argued elsewhere,[1] is that there is no clear line of demarcation between the cases in which someone makes a false statement, or entertains a counterfactual hypothesis, about some particular object to which he can properly be taken as referring, and those in which the descriptions or the hypotheses go so far astray, or their application is so diverse, that we should be disinclined to say that he was referring to that object at all. The question is further complicated by the fact that the success or failure of an intended reference depends, in hypothetical cases, not only upon

the properties of the object at which it is aimed, but also on the identity, the beliefs, and the imaginative powers of the person who is making it.

Up to this point, if I understand his present position rightly, Putnam and I are in agreement, except possibly over the merits of the proposal to bind an object to its origin. Our serious differences begin when it comes to the question of sortal identity, or what amounts to the same thing, at least in the present context, to the question of the criteria for the identity of substances. When there is need to particularize, I shall follow Putnam in taking water for my example, but for the most part I shall present the points at issue in general terms.

Let me begin by stating what I take Putnam's position to be. This is made difficult for any casual reader by his manner of presenting it. Throughout more than the first half of his paper he writes as if he adhered to the views which I attacked in Florence. The manifest properties of a substance like water supply us with paradigms for the application of the term. We are made aware that these properties can be subsumed under natural laws and these laws themselves are explained in terms of the chemical composition of the substance. In the special case of water, this is H_2O. So the prestige of science leads us to identify the substance with what is responsible for its manifest properties. Here Putnam is not quite consistent. Sometimes he writes as if A and B were to be of the same substance if and only if they obeyed the same laws; sometimes it is said to be sufficient that they obey the same laws; sometimes the criterion is that they both obey the same laws and have the same microstructure; most frequently no more is required than that they have the same micro-structure. There is of course the underlying assumption that if they have the same micro-structure they will obey the same laws.

But now it occurs to Putnam that this assumption might be false. It might be the case that in some other possible world, or, to put it more straightforwardly, under conceivable conditions in the actual world, a substance which was composed of H_2O obeyed quite different laws. In that case Putnam no longer wishes to claim that we should be bound to say, or even disposed to say, that the substance in question was water. So far indeed is he from persisting in this claim that he now declares that 'the question "what is the necessary and sufficient condition for being water in all possible worlds" makes no sense at all'. One important result of this conversion is that Putnam no longer maintains the proposition on which he previously insisted: 'It is conceivable that water may turn out not to be H_2O but it is not logically possible that water is not H_2O'. What he is actually rejecting is Kripke's fantasy of metaphysical necessity,

which he now agrees with me in finding unintelligible. He can surely never have thought that water's being H_2O, if that is what it is, was a truth of logic.

This leaves just two points of disagreement between us. The first of them is not very serious and Putnam's account of it is insufficiently careful. He thinks that I should dissent from his belief that 'a community can stipulate that "water" is to designate whatever has the same chemical structure or whatever has the same chemical behaviour as paradigms XYZ . . . even if it doesn't know, at the time it makes this stipulation, exactly what that chemical structure or exactly what that lawful behaviour is'. He forgets, when he allows this disjunction, that he has already admitted that a substance with the same chemical structure as XYZ might under conceivable conditions exhibit very different behaviour from theirs and that in that case he would attach no sense to the question whether it shared their sortal identity; and here I am crediting him with the view that the members of his model community would not attach any sense to it either. So what are the circumstances in which they would be impelled to say 'that something that satisfied all the existing tests for water wasn't really water after all'? Only, it would appear, when further tests had showed them that the thing in question did not obey the same laws as most other things that satisfied the existing tests. And how would this be discovered? How else than by discovering that it differed from them in certain aspects of its behaviour? But let it be remembered that these differences could not be very extensive. There is quite a narrow limit to the variations, ascribed to special circumstances, which are allowed to be consistent with common obedience to the same set of laws.

Where does this leave us? Almost back with John Locke. We note that certain clusters of qualities are repeatedly found together and bestow a collective name on to the 'unknown somewhat', that is to say, substance, which is postulated as their supporter. These substances are credited with 'minute parts' the behaviour of which is supposed to explain the phenomena in virtue of which we ascribe the cluster of qualities to one and the same substance. The coherence of these qualities furnishes what Locke chooses to call 'the nominal essence' of the substance which they characterize. Because he assumes that this coherence and indeed the entire behaviour of the substance, is dependent upon the operation of its minute parts, he chooses to call them its 'real essence'. Locke's choice of this expression might lead one to suppose that his criterion for the identity of the substance was the behaviour of its minute parts; and indeed this may have been so; his text leaves this point unclear. If it were so, then I agree with Putnam that it would have been open to him, and to others, to interpret the name of the substance as applying to anything

that possessed the real essence in question, even if the character of this real essence were unknown to them. In fact, Locke preferred to correlate names with nominal essences. As he put it in his first letter to Stillingfleet, 'The real constitutions or essences of particular things existing do not depend on the ideas of men but in the will of the Creator; but their being ranked into sorts, under such and such names, does depend, and wholly depend, upon the ideas of men', that is, as Fraser rightly phrases it, 'upon the partial and superficial manifestations of themselves which things make to the senses and understanding of men, and upon the manifestations which men select for forming them into classes.'

I doubt if Putnam would wish to argue that Locke was mistaken in postulating an original correlation between the names of substances and their nominal essences. At the same time I concede that the diffusion of scientific information has created a tendency for real to replace nominal essences in this role, in cases where the character of the real essence, in Locke's sense of this term, is thought to be known. Thus I should not be surprised to learn that most educated English speakers were disposed to identify water with H_2O. Whether they have acquired a general disposition to sort objects according to their 'real essences', even when these are unknown, and allow this to govern their use of language, seems to me very much open to doubt. In fact, however, Putnam does not go so far. If he is content only to claim that such a criterion of substance identity could be formulated, I have no quarrel with him.

This brings me to what I agree to be the most serious point of dissension between us. Putnam accepts and I do not 'a notion of objective non-logical modality'. What this implies is that we take different views of what can properly be meant by saying that such and such an event is physically necessary or physically impossible. A point to be set aside without further ado is that when Putnam speaks of an event as being physically necessary he does not mean that the affirmation of its occurrence is true in all possible worlds. To extend this concept beyond logic is to relapse into the quagmire of metaphysical necessity from which we have seen that Putnam has freed himself. The necessity or impossibility of physical events is derived from the necessity of the laws of nature which obtain in this world; we agree in dismissing talk of there being any others. So what does Putnam mean by saying that these laws of nature are not logically but still objectively necessary?

The answer that he admits to finding most attractive is one with which at first sight I see no reason to disagree. I also believe that 'the distinction between what is and is not physically possible is a distinction *internal* to physical theory itself'. What surprises me is that Putnam proceeds to speak of this notion of physical possibility as *unrelativized;* or

rather it would surprise me if he did not immediately embark on an obvious disclaimer. His elaboration of the question makes it clear that to conceive of physical possibility as internal to physical theory is to render it epistemic. Admittedly we are not in the habit of adding the qualification in terms of Einstein's Theory of Relativity, to the statement 'It is impossible that anything should exceed the speed of light', anymore than we qualify the statement 'Nero fiddled while Rome was burning' by adding 'according to the evidence provided by ancient historians'. In every domain, our beliefs are tailored to what we take to be the best evidence at our disposal, or at a more abstract level, to what we regard as the most credible theory. There is, indeed, the complication that what Putnam calls 'the currently accepted physical theory' may be contested. In the field of biology, for example, I assume, knowing Putnam to be rational, that he accepts a neo-Darwinian account of evolution, but notoriously many of his countrymen do not. In the present context, however, this complication can be disregarded. The point is that whatever the source of one's beliefs there is no way in which one can currently distinguish between what is true and what one holds to be true. One can, indeed, allow that there may be such a distinction; one can go further and even think it probable that some of one's current beliefs are false. But then if one is called upon to say which these are one is frustrated. For to pick out any particular belief as being false is no longer to hold it true. And what one holds to be true one holds to be true objectively. When new evidence leads us to change our historical opinions, we do not say that our old opinions were true when we held them; we say that we have discovered that they were mistaken. Similarly when one physical theory supersedes another, we do not say that events which were accommodated by the previous theory were formerly possible but have ceased to be so; if the prevalent theory excludes them, we say that they were impossible all along. What we accept we always accept as perenially true, which does not mean that we are resolved to adhere to it come what may. Except possibly in the case of propositions which are counted as analytic, we are always prepared to discover, in the light of new evidence or the emergence of more impressive theories, that the truth is different from what we now take it to be. There may be those who share C.S. Peirce's vision of absolute truth as the object of total consensus at the ultimate conclusion of all scientific enquiry but, in Putnam's own felicitous phrase, this is a piece of metaphysical comfort, of which it is not easy to see why anyone should stand in need.

The remarks that I have just been making are not only very largely borrowed from Putnam but not seriously contested by him. Instead, he

switches his line of attack. We are now invited 'to think of talk of "physical possibility" and "physical impossibility" as a late refinement of ordinary causal talk' and to think of ordinary causal talk as referring to episodes of 'a genuine bringing about' which go beyond anything that is ever actually observed. It is these episodes that are supposed to exhibit the natural necessity in which Putnam believes. As it turns out, he makes no attempt to justify this assumption. The last part of his paper is devoted to querying my assumption that there is a level of observation which is free of causal hypotheses and developing an argument, which I confess to finding it difficult to rebut, that I deny myself the resources for giving a tenable account of the most elementary steps that we take in ordering our experience.

Before I attempt to meet this challenge, I think that I should briefly comment on the few further remarks that Putnam makes about physical necessity. He thinks it worth noting, with an acknowledgement to Miss Anscombe, that 'our ordinary descriptions of what we observe are *loaded* with causal content'. But this is a fact that neither Hume nor any of his followers would ever have thought to deny. The question is how this causal content is to be interpreted. Putnam goes on to say 'It isn't just that John's hand came to be in contact with the glass before the glass moved to the floor and separated into pieces; John *broke* the glass'. But what is the italicization of the word 'broke' intended to convey to us? There may indeed be an aura of violence about the word which is lacking in the preceding description of what happened, but this is not to say that the violence is embodied in the fact. If anything needs to be added to the anodyne description, it is something about there being a limited number of ways in which glasses habitually come to be separated into pieces, and contact with a human hand of such and such a sort, moving at such and such a speed, being the one that was present on this occasion, perhaps also something about the persistence of such a concomitance in other actual instances as well as its hypothetical projection. The reference to hypothetical instances poses problems with which I shall try to deal in my reply to Professor Honderich. All that I wish to say at this point is that the use of an undefined concept of natural necessity is of no help in solving them.

I am equally unmoved by Putnam's rather tentative appeal to the authority of Kant. I do in fact attach very little weight to the argument of Kant's Second Analogy but I do not want to make an issue of this because I am quite happy to concede to Putnam that physicists do make use of causal considerations in arriving at the objective ordering of objects and events in space and time. All that I need to maintain for my purposes is

that there are spatial and temporal relations straightforwardly discoverable in our sense-experience. And this is a something that Kant himself allows to be true of his 'representations'. His argument could not get started otherwise.

I come at last to Putnam's criticisms of my version of empiricism. Among the propositions which he queries, the one that I am most ready to defend, is that 'Any check upon language must depend sooner or later on what I call an act of primary recognition'. This proposition is not tied to my view that physical objects are posited by us on the basis of our reception of instances of sense-qualia. Whether it is a matter of sensing the pattern of 'a blue star against a white background' or perceiving a star in the sky, one must have acquired the habit of distinguishing the item in question as a specimen of a particular sort, and this means relying on a criterion of similarity, by the use of which the material with which we are presented is brought under different headings. I have frequently acknowledged that our classifications can be subjected to tests, but have also insisted that this process of testing must have a terminus, not merely because we fairly soon decide that enough is enough, but because any method of one's reassuring oneself that what one has taken to be the same colour or phase of a star, or what not, as such and such a previous item, really is so, itself reposes on a recognition of something or other as 'the same again.'

I may remark in passing that this is not merely a question of language. No animal could survive for a day unless it distinguished objects of one type from those of another. The simplest machine would not function unless it reacted differently to different sorts of input. In neither case does it seem to me to follow that they possess a concept of natural necessity.

The case in which we are interested, however, is that in which recognition does involve the use of language. I may begin by saying that I am not worried, in this context, by the menace of Nelson Goodman's predicates. The first point to note is that they are not confined to the domain of sense-experience. Their range is unlimited. Just as someone may find it natural to apply the word 'grue' to anything that the ordinary run of English speakers would call 'green' when it was observed before a given time t, and if it were observed after t, to what they would call 'blue', so someone might find it natural to apply the word 'trair' to anything observed before t that speakers of correct English would call a tree and to anything observed after t that they would call a chair. In both cases at any time before t their 'grue' and 'trair' would appear to be equivalent to our 'green' and 'tree'. How can we make sure that the equivalence is genuine?

The answer is that we can not make sure until the discrepancy is revealed at t, and even then the possibility will remain that someone whom we have no reason to suspect of using the word 'green' idiosyncratically is really using it in a way analogous to the uncovered use of 'grue', except that in his case the time t is set further in the future. This is no more than the problem of induction; miscalled a problem, because Hume made it obvious that there can be no guarantee that the future will resemble the past in just the ways that are adjusted to our current beliefs.

Why then, in the present context, does the lack of the relevant guarantee not worry me? My answer, which turns out to be Goodman's also, is that I find it natural to sort items into greens and blues and trees and chairs, rather than into grues and bleens and trairs and chees, that I take it for granted that this habit of mine will persist and that it accords and will continue to accord, sufficiently for comfort, with the linguistic practices not only of the majority of English speakers but also of those who speak other languages, for I have never been able to follow Quine in thinking it doubtful whether 'the ordinary usage' of the French word *vert* or the German *grün* is significantly different from that of the English word 'green'. No doubt there are good physiological reasons why there should be such a large measure of coincidence in the standards of similarity which different people find it natural to adopt, but these reasons do not come into the picture at this level of discussion. What matters at this point is that these criteria obtain and that we remain faithful to them so long as they continue to serve us. What else should we be expected to do?

I concede to Putnam that slips are possible even in the recording of one's current sense-experience though I am not sure whether the slips can amount to more than slips of the tongue. In the case of Putnam's sweater I acknowledge that his use of the word 'blue' to refer to the colour of the green sweater was deviant but I am not clear what sense is to be made of the statement that he was so careless as to believe that it looked blue to him on an occasion when it really looked green. Perhaps one could come to accept such a statement retrospectively on the basis of further evidence, though here again I insist that the evidence must terminate in our simply accepting one or more items as specimens of such and such sorts.

Putnam's mention of slips is an indulgence in painting the lily, since he holds that even a perfect and unique correlation between the overt occurrence of a noise or mark E and the manifestation is the same total sense-experience of a given sense-quale q would not entail that E referred to q. And here of course he is right. The correlation would be neither

necessary nor sufficient: not sufficient because the concomitance of E and q does not make E a sign of q; it might be that E was a sound which just happened to occur always and only in the presence of q without its fulfilling any linguistic function at all: not necessary because signs are very frequently used in the absence of what they are understood to stand for.

I am not trying to minimize the seriousness for me of this concession when I point out that Putnam's proposal that we conceive of the manifestation of q as 'bringing about' the occurrence of E does no better: it is not necessary because it equally fails to cover the use of E to refer to q in the absence of any manifestation of q; it is not sufficient because there is a host of things which the presence of q may 'bring about' which are not linguistic at all.

This is not to deny that children are taught the use of words that stand for sensory qualities, or many physical objects for that matter, by having the relevant noises made to them in the presence of the qualities or objects or possibly pictures of the objects of which they are intended to treat the noises as signs. But this does not tell us what it is for something to be treated as a sign, or how it fulfils its function in the absence of what it denotes. Nor do I deny that the sight of the green leaves above me causes me to believe that there are green leaves there, though so far from the concept of causality playing a fundamental role in this matter, it is easy to show that unless some watered-down concept of the tree had already been constructed out of my percepts there would be no secure terms on which the relation of causality could be anchored, whatever frills were allied to it. But this takes us away from the problem of reference, which we have already seen that a simple appeal to causality does not solve.

At this point I own defeat. A formula which attracts me, given that we have been able to use the same technique to explain the use of 'p' and 't' to stand for places and times, whether at the sensory or physical level, is 'x is a sign of y for A if A's sincere assent to the sentence "x is at pt" is uniquely correlated with his belief that y is at pt'. But apart from the objections that even if 'sincere assent' is allowed to pass, we need a better analysis of 'belief' than I am capable of providing, the formula fails if there is a synonym for a value of x or the sentence is translatable into another language. It fails also if some other sense-quale z is always spatio-temporally coincident with y in A's sense-experience, which appears at least to be theoretically possible. I am left only with a faint hope that these objections can be overcome. As it is, I see it as a grave defect in my philosophy that I have not developed a satisfactory theory of

reference and take only small comfort from my belief that no one else has either.

A.J.A.

NOTE

1. See *Perception and Identity*, pp. 306–14.

18

Francisco Miró Quesada C.

AYER'S PHILOSOPHY OF
LOGIC AND MATHEMATICS

"Seventeen years have elapsed since in 1951, Freddie, you attended the Lima Congress of Philosophy during the celebration of the fourth-century founding of San Marcos University. Do you still think that logic and mathematics are what you thought they were at that time?"

Alfred Ayer (nowadays Sir Alfred) was silent for a few seconds, giving me the impression of having serious doubts about the whole matter. Then, with slow and hesitating words, he replied:

"Well, . . . I guess I don't think now the same way . . ."

"And, what do you now think logic and mathematics are?"

"Huu . . . I don't know. Do you?"

"Of course not!"

We were having lunch together in a small restaurant in one of the imposing buildings of Vienna University during the XIVth World Congress of Philosophy, in August 1968. When we organized the Philosophy Congress of San Marcos, the first person we thought of inviting was Bertrand Russell. We were convinced that he would not even reply. But to our surprise he did. Very politely he thanked us for the invitation, but he said that, unfortunately, he was already eighty years old, and his physician had forbidden him to travel. But he suggested that we invite Alfred Ayer who was very near to him, and, as a young professor, had become one of the most important British philosophers of the day.

We didn't doubt a second. We immediately invited Professor Ayer, who, to our delight, kindly accepted our invitation. We were deeply interested in having in our Congress an Anglo-Saxon philosopher, and I especially so, for in those days I was beginning to study mathematical logic and was strongly motivated by Russell's philosophy and by the

desire to read *Principia Mathematica*. There was at the time an overwhelming influence of German philosophy with strong predominance of phenomenology and Heideggerian existentialism. My first academical book had been about the phenomenological movement, and it included as its main theme Husserl's thought up to the *Ideas* (the *Husserliana* had begun to be edited in 1950, but when the San Marcos Congress was being held I still did not know they existed) and as secondary items an exposition of the phenomenological conceptions of Scheler, Hartmann, and Heidegger. But my position in the book, although recognizing Husserl's importance, was critical. I thought at the time that the exaggerated influence of phenomenology and of Heidegger's existentialism presented the danger of excessive philosophical speculation and, still worse, of conceptual vagueness. So I was eager to listen to Ayer's exposition and to be able to talk personally with him about logic, philosophy of mathematics, and, generally, about the new philosophy of knowledge that was being created by the British. I was lucky for I was able to have long talks with him about these matters and many others. And since then a cordial and lifelong friendship was established between us.

His participation in the congress was unforgettable. He was, of course, a principal character of the meeting, and he showed an intellectual style that was uncommon in Latin America. He was quite interested in clear and well informed expositions, but he didn't pardon the vague, garrulous, and flat expositions which in that epoch were frequent in our subcontinent. We were at the same time deeply amused and a little horrified when after listening to a paradigmatic example of this kind, he intervened and said: "I heard the noises, but I didn't catch the meanings."

When he came to Lima, he had already written his famous book *Language, Truth and Logic* (in 1936, and a second edition in 1946). The book was rightly considered the most lucid exposition of the new philosophy known as logical positivism. It was a book written not only with deep knowledge of this philosophical movement but with a fervent faith in the ideas it set forth. It was a kind of philosophical manifesto, a proclamation of the principles that ought to guide all future philosophical investigation. The book was a success, and thanks to it Ayer became an important personality in the philosophical world. D.J. O'Connor, in the article devoted to Ayer in *The Encyclopedia of Philosophy*, says about *Language, Truth and Logic* that: "Its combination of lucidity, elegance, and vigor with an uncompromisingly revolutionary position has made it one of the most influential books of the century." And, moreover, it was amazingly easy to read. The ideas he communicated to me in Lima were

contained in this book. A year after the Lima Congress I saw him in London and, thanks to him, I met Bertrand Russell. It was one of the most wonderful personal and philosophical experiences I ever had. But on that occasion, although we spoke a lot about philosophy and referred several times to the *Principia*,[1] I did not ask specific questions about logic and mathematics. Of course, being in London I acquired Ayer's book and read it avidly. I was completely convinced. After reading his book I thought that the Kantian thesis of synthetic a priori knowledge was indefensible. Ayer's arguments were simple, clear, and persuasive. I had never read anything with such a marvelous style. As a matter of fact, it was my full initiation into analytical philosophy.

But, for good or for bad, I continued studying logic and mathematics very hard, and at the end of 1954 I was completely stupified when I discovered intuitionist logic. My discomfiture increased when I received the North Holland edition of J.R. Rosser and A.R. Turquette's *Many-Valued Logics*.

The well established fact of non-classical logics and, particularly, the existence of a non-classical type of mathematics led me to think that the problem of logical and mathematical knowledge could not be solved in such a simple manner as Ayer proposed. In a way the existence of different systems of logic and mathematics could be considered as a verification of Ayer's thesis; but in another way it showed that the new systems were not arbitrary, that they had been created out of deep reasons; very especially, intuitionist mathematics and logic. The fact that this logic was only a tentative formalization of a new kind of mathematical reasoning which presupposed a new ontology showed me that I had to revise my whole conception of logic and mathematics. So I decided to go as deep as possible in the philosophical study of these disciplines.

Of course, I read Ayer's new books, and I tried to follow the evolution of his thought. I found that he had definitively abandoned logical positivism but that it was not easy to find what he really thought about logic and mathematics. In what follows I shall try to explain which are the differences I have been able to find between his former and his later position. To do this I must exhibit first the ideas he maintains in *Language, Truth and Logic*.

In the preface of the first edition of *Language, Truth and Logic*, Ayer says:

> I divide all genuine propositions into two classes: those which . . . concern "relations of ideas," and those which concern "matters of fact." The former class comprises the *a priori* propositions of logic and pure mathematics, and these I allow to be necessary and certain only because they are analytic. That

is, I maintain that the reason why these propositions cannot be confuted in experience is that they do not make any assertion about the empirical world, but simply record our determination to use symbols in a certain fashion.[2]

This conception of logical and mathematical propositions, according to Ayer, is the only way to conciliate a genuine empiricist philosophy with the undeniable fact that those propositions appear to everybody to be necessary; for, according to this philosophy, no proposition which has a factual content can be necessary. So if logical and mathematical propositions are necessary, they cannot have a factual content. And the only possible way out of this difficulty is to consider that their necessity is due to the consequences of a linguistic convention. Due to this convention, the validity of some propositions depends solely on the definition of the symbols they contain. That is why their truth is completely independent of empirical verification and cannot be factually confuted. These propositions are *analytic*.

For instance the proposition "Either some ants are parasitic or none are" (Ayer's example) does not provide the least information about the behavior of ants nor about any matter of fact whatsoever. Its truth depends on the way logical connectives are used in it. If one wants to know what is the function of the words "either", "or", and "not", one can see that any proposition of the form "Either p is true or p is not true" is valid independently of experience. The proposition in which we substitute the propositional variable "p" for the proposition "some ants are parasitic" provides no information at all about the behavior of ants. It is analytic or tautologous.[3] All a priori propositions without exception are analytic.[4]

This last thesis is equivalent to the thesis that synthetic a priori propositions are impossible. Ayer attacks with pungent argumentation the Kantian position. Besides employing words with vague meaning like "concept" and the unwarranted assumption that every judgment is of a predicative type,[5] Kant does not give a clear criterion for distinguishing between analytic and synthetic propositions. To characterize analytic judgments Kant proposes a logical criterion: the predicate can be extracted from the subject in accordance with the principle of contradiction. But when he tries to prove that $7 + 5 = 12$ is a synthetic judgment, he says that the concept of 12 is by no means already thought in merely thinking the union of 7 and 5. And from this he concludes that this fact proves that arithmetical judgments like $7 + 5 = 12$ do not found their truth on the principle of contradiction. But Ayer rightly says that concepts are intensional. So the fact that a person can think the union of 7 and 5 without thinking the concept of 12 has nothing to do with logic.[6] The offered criterion is in this case psychological. So, a proposition can

be considered as analytical according to the former (logical) criterion, and synthetical according to the latter one. But, according to this second criterion, it is quite possible for two symbols to be synonymous without having the same intensional meaning for anyone.[7] The conclusion is unavoidable: from the fact that one can think the sum of 7 and 5 without necessarily thinking of 12, it doesn't follow at all that the proposition 7 + 5 = 12 can be denied without contradiction.[8]

But not only arithmetical propositions but also the truth of geometrical propositions is analytical. The axioms of geometry are simply definitions, and the theorems are the logical consequences of these definitions.[9]

Although both kinds of propositions, logical and mathematical, are analytical, mathematics cannot be reduced to logic.[10] Ayer gives no reason to justify this assertion. I suppose he took for granted the well established fact, known when he wrote his book, that not even second order logic is sufficient to develop mathematics. In addition it is necessary to add the axiom of choice and the axiom of infinity, which are not logical at all.

Now, the necessary truth of logical and mathematical propositions is only the record of our determination to use words in a certain fashion. But this fashion is not imposed by the nature of our minds. It is perfectly conceivable that we could have employed different linguistic conventions from those which we actually employ. Whatever these conventions might be, the propositions in which we recorded them (they would also be tautologies) would always be necessary.[11]

But there is a fact that seems to present a serious difficulty to this analytical and full-blooded relativistic conception of logic and mathematics: the amazing richness of their cognitive content. If logical and mathematical propositions were mere tautologies, then all of them could be reduced to propositions of the form "A = A". But Ayer doesn't flinch from this difficulty. The explanation of this fact is very simple, says he. The power of logic and mathematics to surprise us depends on the limitations of our reason. The a priori complicated expressions surpass our power to analyze at a glance all their implications. But an infinitely powerful intellect would be able to grasp at first sight all of them, and so he would lose all interest in logic and mathematics. Quite a Leibnizian reply indeed!

Such was Ayer's philosophy of logic and mathematics when he wrote *Language, Truth and Logic* and during some years after, perhaps up to the first years of the fifties. But, in any case, in 1956 he did not consider himself anymore a logical positivist. Nevertheless he did not fully reject his former position. In the chapter entitled "The Vienna Circle" which he wrote for the collective book *The Revolution in Philosophy*, he declares

that "The Vienna Circle, as a movement, is a thing of the past. So, in a way, is logical positivism. But many of its ideas live on."[12]

I think the reason for this change of position was that he clearly saw that a systematical conventionalism like the one he assumed in older days is untenable. He doesn't say so in that chapter. But in other books published years after, he declares that he is no more a conventionalist. In *Metaphysics and Common Sense* he says that he parts company with Carnap because to solve the problem posed by the distinction between existent and nonexistent entities Carnap says that this distinction depends on declaring a preference for a certain sort of linguistic framework.[13] But, and this is important, he adds that his disagreement with him is not very radical.[14] In 1972 he goes further. In the chapter devoted to *Language, Truth and Logic* in his autobiographical book *Part of My Life*, he says: "The conventionalist view of logic and mathematics encounters more serious difficulties than I realized. . . ."[15]

So, it can be affirmed that Ayer dropped, for good, conventionalism. But it is much more difficult to know his position regarding the other two fundamental theses of logical positivism: the clear-cut cleavage of all propositions into analytic and synthetic, and the impossibility of synthetic a priori propositions. The impression one has when one reads the few things Ayer wrote on the subject, is that he was not any more fully convinced about the first thesis, but that he did not resign himself to drop it once for all. I think the reason for this vacillation was that he kept very firmly to the rejection of the synthetic a priori. He never doubted its impossibility.[16] But if the clear-cut division of propositions into analytic a priori and synthetic a posteriori is dropped, there are two possibilities: either we must accept the existence of synthetic a priori propositions, or we must accept Quine's thesis that it is impossible to find a rigorous criterion of separation. In the first instance he should have accepted what seemed to him a complete impossibility; and in the second case he ought to have accepted the possible existence of some a priori synthetic propositions. Because Quine doesn't say that this kind of proposition does not exist, he considers that logical propositions are analytic, and he gives examples of propositions that are non-logical but that, according to the classical criterion, are certainly a priori. If we classify them among the analytic we find unsurpassable difficulties. But if they are a priori and not analytic, then they must be synthetic. Of course Quine does not explicitly reach this conclusion. He only says that it becomes a folly to seek a boundary between synthetic statements which hold contingently on experience and analytic statements which hold come what may.[17] For him, it is not even intelligible to try to establish the boundary between analytic and synthetic, logic and fact.[18] But one thing is the nonexistence

of a clear boundary between two classes of objects, and another quite different, that there is no way to distinguish at least some objects that belong to the one or the other. As a matter of fact, the ordinary situation is that most extensions of concepts have blurred boundaries but that they also have very nitid nuclei. Let us think, for instance, of the classes of red and yellow objects. There are certainly many objects of which it is very difficult to know if they are red or yellow; but there is an immense number of objects which are unmistakably red and unmistakably yellow. And the same can be said about analytic and synthetic propositions. In some cases it is impossible to know if a proposition is analytic or synthetic, a priori or a posteriori, necessary or contingent; but in other cases these traits can be easily recognized. So, if Quine is right, it is quite possible that some propositions could be clearly recognized as synthetic a priori. But Quine, by temperament, wouldn't like this possibility at all. For this reason he takes the only possible issue that is left if the thesis of the blurred boundary is affirmed but the existence of synthetic a priori propositions is rejected: pragmatism.[19]

So if Ayer had also rejected the clear-cut thesis, he would have had to confront the dilemma. Did he reject it? We have not found conclusive texts that permit us to prove that he did. Nevertheless, there are some paragraphs that suggest that, in any case, he had serious doubts about the matter. In his book *The Origins of Pragmatism*, by the way, a most illuminating book, he says, "I believe this position to be basically correct, though it may be doubted whether the distinction between relations of ideas and matters of fact, which is anyhow not easy to define, is quite so clear-cut as James supposed."[20]

In this text Ayer is referring to James's theory of truth. A priori truth is conceived as a mere relationship of ideas, whereas empirical truth is referred to matters of fact.[21] To justify this distinction it is necessary to presuppose a clear-cut division between relations of ideas and factual relations. This division is of Humean origin and, with some variations of detail, has been incorporated as a central part of the doctrine of logical positivism.

And in *The Concept of a Person*, he writes,

Thus if we admit the distinction between *a priori* and empirical statements, it is quite plausible[22] to say that what makes an *a priori* statement true is either that it exemplifies a rule of usage, or that it is tautologous, in the sense of tautology which is defined by the truth tables, or that it follows, in accordance with certain specifiable rules of deduction, from axioms which themselves can be treated as implicit definitions. The existence of Gödelian sentences does introduce a complication here. We now know in any formal system which is rich enough to express arithmetic, there are true statements which are not provable within the system. But it is not obvious that even

these statements cannot be accommodated within some general formula of this kind.[23]

This is a very important text because it clearly reveals that Ayer had become aware of some logical and metamathematical results about whose meaning he felt uncomfortable. He knew that Gödel's proof of the undecidability of arithmetic made it very difficult to maintain the thesis that all mathematical propositions are analytic.[24]

The impression one has when one reads with care the former text is that he had lost his unflinching faith in the clear-cut thesis, but that the fact that he held very firmly to the thesis of the impossibility of synthetic a priori propositions, hindered his stepping out of the impasse. Because if conventionalism is rejected, then to maintain the thesis of the analyticity of a priori propositions, one must hold that the linguistic conventions made about the use of words are not wholly arbitrary. But, if they are not, then what are they? What is the meaning of logical principles? If their necessity is derived only from the fact that we use our language in a certain way, why do we have to accept this kind of usage? If we no longer accept the conventionalist theory of truth, there must be convincing reasons for using our words in one way rather than in another. A possible reply could be that our linguistic conventions are made because they are the best we can adopt to be able to deal successfully with *empirical* situations. But Ayer rejects the pragmatic theory of truth. The reasons he gives for this rejection are, I think, thoroughly convincing. The cardinal feature of pragmatic theories of truth, he affirms, is that true propositions are characterized as those that we accept.[25] But when I say that a proposition is true I do not mean *only* that I accept it. On the contrary, I am bound to admit the possibility that what I believe is false. Warranted assertibility won't do either, because what gives a warrant for the truth of a proposition is that I have evidence in favor of its truth. As we see, the pragmatic theory of truth presupposes the concept of objective truth.[26] This refutation also demolishes the pragmatic thesis (not accepted by all pragmatists) that efficacy is the criterion of truth; because to know which propositions are efficacious one must have an objective criterion of efficacy or else one must rely exclusively on the acceptance criterion. To appeal to those propositions which are warranted by scientific method does not alter the situation.

Besides rejecting the pragmatic theory of truth he also rejects the coherence theory. The reasons he gives for rejecting this theory are also strongly convincing: if the coherence theory of truth is accepted, then we can have two theories which, though in themselves coherent, are incompatible. So they cannot both be true. But their sole coherence does not offer at all a criterion to know which one is true or false.[27]

Ayer also rejects the correspondence theory of truth.[28] In my opinion the reasons he offers, although quite acute, are less convincing. And he finally adopts a position that could be called the "meaning-fact relationship theory of truth". To know if a statement is true, he says, the only thing we must do is to be willing to accept or reject it according to determined conditions. For instance, to know if the sentence "It is a fine day" is true we must just look out of the window.[29]

Of course the sentences Ayer is talking about in this context are empirical. So even if we accept his theory, in case we drop the clear-cut thesis, we cannot explain the necessity of logical and mathematical propositions, because they are not empirical.

I think the analysis I have made gives not a bad idea of Ayer's trajectory concerning his conception of logic and mathematics. The first part of this trajectory was characterized by a very firm, even aggressive position. He was deeply convinced that he had really found what logic and mathematics were about. Logic and mathematical propositions were necessarily true because their truth could be derived from linguistic convention; this convention was arbitrary; there were only two kinds of propositions: analytical and synthetical; the first were a priori and necessary and the second contingent and empirical. Consequently he emphatically rejected the possibility of synthetic a priori propositions. But as time passed his faith began to soften. In his mature years he was acutely aware of the difficulties of the conventionalist position (not only concerning logic and mathematics, but in general), and he had to change his point of view. He had to revise his ideas about the concept of truth. I think the criticism he made of the coherence and the pragmatic theories of truth is one of the most brilliant aspects of his philosophical work and, in general, an important contribution to the modern treatment of the problem.

But when he began to doubt about the solidity of his juvenile position, his trajectory lost the impressive easiness of the first years. He had to change his opinions *malgré soi*. And because of this he was never very emphatic about it. He always speaks about his rejection of conventionalism in rather indirect ways; for instance, he says that he has parted company with Carnap, or that he doubts whether the distinction James makes between relations of ideas and matters of fact is as clear-cut as James thought, or that looking at his former work he feels unsatisfied. So he is very wary in this auto-criticism, he does it in a reluctant manner. When he admits that Gödel's theorem introduces a complication concerning the thesis that analytical propositions owe their truth to rules of usage, he immediately says that *it is not* obvious that Gödelian sentences *cannot* be accommodated within this thesis.[30] Speaking in a double

negative way he lets the reader understand that the thesis of analyticity might be doubted but that he has not lost hope that it can, after all, with due ingenuity, be rescued from the unfathomable abyss created by Gödel's theorem.

In my opinion, as I have already said, once the conventionalist theory is rejected, it is very difficult to sustain the linguistic theory of truth, especially concerning mathematical propositions. The objections of Quine against the linguistic thesis are very difficult to answer, and I think there are powerful reasons that show that it is impossible to understand what mathematics is about without recognizing that human reason is able to establish truths that are not completely language dependent.[31]

I see nothing objectionable in Ayer's attitude. Quite the contrary, I think it shows a full philosophical authenticity. If one has a theory one must try to defend it to the utmost. If unsurpassable difficulties are met, one must have the intellectual honesty to recognize them, but one also must try to retain as much as possible of the original conception. That is precisely what Ayer did. He never had dramatic conversions of Wittgensteinian style. So much the better. I am not fond at all of conversions; irrationality is always lurking deep in them. The changes Ayer had to make in his original theory were sober and rationally unavoidable. But he has been life-long faithful to the fundamental principles of his philosophy. This is why his trajectory is characterized by an impressive coherence and by a remarkable unity. A beautiful, paradigmatic trajectory.

FRANCISCO MIRÓ QUESADA C.

INSTITUTE OF PHILOSOPHICAL INVESTIGATIONS
UNIVERSITY OF LIMA
NOVEMBER 1987

NOTES

1. It would be out of context to relate the conversation I had with Bertrand Russell. But I cannot resist the temptation to say what he replied to me when I, very timidly, confessed that I had not read the whole text of *Principia Mathematica*. "Don't worry," he said, "I am convinced that nobody has. I have only read the chapters I have written, and Whitehead only read what he wrote." I suppose he was showing off the purest British wit, but it was a wonderful reply.

2. A.J. Ayer, *Language, Truth and Logic* (1936, 1946; reprint, New York: Dover Publications, 1952), p. 31.

3. *Language, Truth and Logic*, p. 79.

4. *Language, Truth and Logic*, p. 84.

5. *Language, Truth and Logic*, p. 78.
6. Ibid.
7. Ibid.
8. Ibid.
9. *Language, Truth and Logic*, p. 84.
10. Ibid.
11. *Language, Truth and Logic*, p. 84.
12. A.J. Ayer, "The Vienna Circle" in *The Revolution in Philosophy* (1956; reprint, London: Macmillan; New York: St Martin's Press, 1957), p. 73.
13. Ayer, *Metaphysics and Common Sense* (London: Macmillan, 1967, 1969; San Francisco: Freeman, Cooper, 1970), p. 52.
14. Ibid.
15. Ayer, *Part of My Life* (London: Collins, 1977), p. 155.
16. Ayer, *The Foundations of Empirical Knowledge* (London: Macmillan, 1940, 1964), p. 215; "The Vienna Circle," pp. 76–77; *The Concept of a Person and Other Essays* (London: Macmillan; New York: St Martin's Press, 1963), p. 170; *The Origins of Pragmatism* (London: Macmillan; San Francisco: Freeman, Cooper, 1968), pp. 195–96; *Probability and Evidence* (New York: Columbia University Press, 1972), p. 4.
17. W.V. Quine, *From a Logical Point of View* (1953; 2d ed., Cambridge, Mass.: Harvard University Press, 1961), p. 43.
18. W.V. Quine, *The Ways of Paradox and Other Essays* (1966; rev. and enl. ed., Cambridge, Mass. and London: Harvard University Press, 1976), p. 127.
19. Quine, *From a Logical Point of View*, p. 20.
20. Ayer, *Origins of Pragmatism*, p. 196.
21. As is well known, and Ayer is quite rigorous on this matter, James's theory of truth is quite complicated and not totally coherent. But there is no doubt that he clearly differentiated a priori truth from factual truth.
22. Ayer is extremely precise in the use of words. The word "plausible" means *seeming reasonable or probable*. When he was thoroughly convinced of the clear-cut thesis, he would never have made this rather weak affirmation.
23. Ayer, *Concept of a Person*, p. 170.
24. For an attempt to prove that Gödel's proposition is a priori and synthetical, see Francisco Miró Quesada, "Kant y el problema de la verdad matematica," *Cuadernos de Filosofiá* (Buenos Aires) 11, no. 20 (1973): 321–39.
25. Ayer, *Concept of a Person*, p. 180.
26. Ayer, *Concept of a Person*, p. 181.
27. Ayer, *Concept of a Person*, p. 179.
28. Ayer, *Concept of a Person*, pp. 181–86.
29. Ayer, *Concept of a Person*, pp. 185–86.
30. Ayer, *Concept of a Person*, p. 170.
31. On this subject see Miró Quesada: "Truth in the Formal Sciences," Palermo Encounter of the Institut International de Philosophie, Palermo, 1985.

REPLY TO F. MIRÓ QUESADA

I have to confess that I have not yet wholly freed myself from the perplexity concerning the status of the propositions of formal logic and pure mathematics which my friend, Miró Quesada, remembers my displaying when we discussed the subject at the Vienna Congress in 1968. While I have frequently changed my mind, both before and after that date, concerning most of the particular problems which I claimed to have solved in my *Language, Truth and Logic*, my philosophical outlook has not undergone any radical change in the fifty-two years since that book was published. In the present instance, I should be happy if I could satisfy myself and my critics that the propositions of logic and pure mathematics, *qua a priori*, are analytic and that they owe this to their being true by convention. I acknowledge, however, that the objections to this position are more serious than I realized when I first put it forward.

I am the more anxious to overcome these objections as I cannot discover any tenable alternative to the conventionalist view. Miró Quesada seems content to characterize the propositions in question as synthetic a priori and leave it at that. What he has apparently failed to realize is that the notion of the synthetic a priori loses all positive content when it is severed from Kant's system. It is well known that one of the chief aims of Kant's critical philosophy was to provide an answer to the question: how are synthetic a priori propositions possible? and that his answer, which gave sense to his concept of the synthetic a priori, is that their possibility follows from their necessity, and that their necessity results from their explicating the conditions which require to be satisfied if human experience is itself to be possible. Thus, the true propositions of mathematics are necessarily true, in Kant's system, because they flesh out the a priori intuitions that process the material to which our understanding applies its categories. But then, if one dismisses those

intuitions, as Miró Quesada surely must, since he knows too much mathematics and physics to be able to believe, as Kant did, that space is necessarily Euclidian, Kant's notion of the synthetic a priori collapses with them. The point in saying that there are synthetic a priori propositions will then be to say no more than that there are true propositions which are neither analytic nor empirical. Those who do say this usually maintain that such propositions are necessary, and include mathematical and perhaps also logical propositions among them. The ground of their alleged necessity remains totally obscure.

But let that pass. The proof that there are synthetic a priori propositions, in this purely negative sense, would be worth having even if we were at a loss to say anything more about them. Then, do we have such a proof? I shall argue that we do not.

To sustain my argument, I need to establish two theses: first, that there are analytic propositions, in the sense that there are true propositions the truth of which depends solely on the meaning of the symbols which serve to express them; secondly, that these propositions include the propositions of formal logic and pure mathematics. The first of these theses is easier to defend than the second.

Fifty years ago hardly any philosopher called my first thesis in question; by now it has become unfashionable. Its falling out of favour has been due, almost entirely, to the influence of W.V. Quine. His reason for rejecting analyticity, at least in the form in which I have just defined it, is that the concept of it is too imprecise to carry the weight that it is made to bear, or, indeed, to deserve a place in the armoury of a rigorous philosopher.

Quine's argument, to which Miró Quesada refers, is that when we try to elucidate the notion of a proposition's being true, solely in virtue of the meaning of any sentence which expresses it, we fall into a vicious circle. We start by pointing out that the propositions which satisfy our conditions are those the contradictories of which are logically or semantically impossible, and then we find ourselves asserting that the propositions of which the contradictories are logically or semantically impossible are those that are analytic.

This objection is watertight but, in my opinion, not decisive. As several philosophers, notably Professor Grice and Sir Peter Strawson, have pointed out, the fact that the concept of analyticity can not be explicated without circularity is not a sufficient reason for discarding it. The need for it is most obvious when it comes to propositions which are accepted on semantic grounds alone. Contrast the propositions 'Brothers are male' and 'Brothers engage in sibling rivalry'. The second of these propositions is dubious but it may be true. The point is that if it is true,

its truth is established in quite a different way from that of the first proposition. The only research in which we need engage to discover the truth of the first proposition is research into the use of the English words which express it, or into the use of the words of some other language in which it may happen to be expressed. To discover the truth of the second proposition we need not only to understand the words that are being used to express it but also to be in a position to call upon extensive observational data about the behaviour of brothers, or else some well established psychological theory in which the second proposition is incorporated.

Here too there is circularity. The proposition that brothers are male does not emerge as analytic on every legitimate construal of the English word 'brother' or the French 'frère' or the German 'Bruder'. In the slogan that all men are brothers, the word 'brothers' is not being used to designate only male siblings; the word 'men' is not being used to designate only men, and the sentence is not descriptive but normative. Its message is that human beings ought to treat one another with fraternal kindness and goodwill. It is understood in this context that the norm set for brothers extends also to sisters and indeed to siblings in general. In spite of efforts to reform it, especially in the United States, correct English usage remains biased in favour of masculinity.

Consequently, if one wishes to maintain the analyticity of 'brothers are male' one needs to explain that one is using the word 'brothers' not in the sense in which one may desire that all men should be brothers or in the sense in which one refers to Plymouth brethren, many of whom are female, but just in the sense in which the English word 'brother' is treated as equivalent to the English expression 'male sibling'. Hence the circle. A difficult question, into which I shall not enter here, is how the proposition that all brothers are male, apart from being susceptible to a charge of circularity, escapes being trivial. It is not a proposition about English words, as is shown by the fact that it can be expressed in French or German or many other languages. All the same anyone who learns its truth for the first time has made a linguistic discovery.

Having referred to Quine, I think that I should follow Miró Quesada's example by noting that in his latest writings Quine makes provision for a concept of analyticity as applying to propositions to which we adhere 'come what may'. Or rather, since such fidelity is always precarious, in Quine's estimation, he is now disposed to apply the concept to propositions which anyone who fully understands the language in which they are expressed accepts immediately without demur. This applies to some of the propositions of logic but not to all; for instance, it does not apply to

the law of excluded middle, which intuitionistic logicians reject. It applies also to what Quine calls 'observation sentences'.

For all my respect for Quine, I am bound to say that I regard this as a most infelicitous proposal. In the first place, it is manifestly circular, since the criterion for the full understanding of the language in question is just the acceptance of these 'analytic' sentences as expressing truths. But its drawbacks are much worse than that. For instance, it generates ridiculous anomalies. A fairly competent mathematician, such as I am, can tell at a glance that $37 + 37 = 74$. He has to use pen and paper to discover that $37 \times 37 = 1369$. Yet since multiplication is definable in terms of addition, it is absurd to put these propositions into separate categories. Neither is it the case that every proposition which competent English speakers assume to be obvious is true. The members of the Committee investigating 'Un-American activitics' containcd at lcast some competent English speakers. Yet they unanimously accepted the conclusion that everyone who refused to answer their questions was a Communist on the basis of the premiss that Communists refused to answer their questions. In short, it suited them to commit the fallacy of the undistributed middle. In saying that it suited them, I am not implying that they knew it to be a fallacy. A partisan, who wished to believe that not all these men were fools, might argue that they were using the word 'all' deviantly, to mean 'all and only', but I am confident that the empirical evidence would be against him. Blinded by prejudice they became incompetent logicians.

It is not true either that every sane and competent speaker of a given language unhesitatingly accepts the same observation sentences when he is affected by the same external stimuli as the other observers. To suffer from a perceptual error is not to have lost one's sanity or one's linguistic competence, but it does bring one into momentary disagreement with those whose responses to the same external stimuli are not deviant. Illusions and hallucinations are, indeed, less common than philosophers who embrace the sense-datum theory may have seemed to imply; but they do occur.

By any criterion, the propositions expressed by observation sentences will not be analytic, however ready and widespread their acceptance. They will not be analytic, because their truth will depend not only on the meaning of the observation sentences but also on the matters of fact which these sentences are understood to report. This is not to say that it is always clear what is a matter of fact and what it is not. As Henri Poincaré was one of the first to remark, scientific axioms, like the proposition that nothing exceeds the velocity of light, can be assigned an

empirical content but they can also be treated as conventions. I am grateful to Miró Quesada for stressing the point that the fuzziness at the borderline of the concept of analyticity does not make it useless, since there are many instances to which there is no doubt that it applies.

Does it apply to the propositions of pure mathematics? Having overcome the hesitations of which Miró Quesada retains such a vivid memory, I now maintain that it does. We can define zero in Frege's and Russell's fashion by equating it with the null class, that is, the class defined in terms of propositional functions which nothing satisfies. We can then avoid the need for an axiom of infinity, which is a blemish on Russell's system, by following Von Neumann's procedure of equating each cardinal number with the class of classes which constitute its predecessors. So the number 1 is the class whose only member is the null class, 2 is the class consisting of 0 and 1, 3 the class consisting of 0, 1, and 2, and so forth. All this is plainly conventional. Then having helped ourselves to the laws of logic by defining the other logical operators in terms of double negation and double negation in terms of its truth tables, we can derive mathematics from Peano's axioms. We can presume on the acceptance of irrational numbers like the square root of 2 and the invention of imaginary numbers like the square root of -1 where it is felt that we need them. I have assumed the validity of classical logic, but I could manage just as well with intuitionistic logic, if I had a reason for preferring it. I do not understand why Miró Quesada believes that the respectability of intuitionistic logic creates a difficulty for my thesis, for it seems to me that just the contradictory is true as Miró Quesada himself at one point seems disposed to admit. The fact that there are alternative logics, just as there are alternative geometries, supports the claim that the validity of any given logic, like the validity of any given geometry, depends only upon its internal structure. We are then at liberty to choose which one to prefer. This is not to say that our choice is purely arbitrary. It depends, as we shall see, on the empirical circumstances to which our logical and mathematical reasoning is applied. If it is correct to say that our preference for a particular logic or geometry is conventional, it is because the empirical circumstances which favour it are not necessary in any way at all.

The principal objection to the thesis that the true propositions of mathematics are analytic has always been that it fails to account either for the extraordinary fertility of mathematics or for its occasional drought. If all mathematics reduces to the identity 'A = A', how is it possible that mathematicians have made such discoveries as that the number 2 has no rational square root or that there is no greatest prime number? How in defiance of the rule that the squares of both positive and

negative numbers are positive, could they have got away with postulating a square root for the negative number -1? On the other hand, how is it possible that they have not yet succeeded in proving or disproving Fermat's last theorem or found out whether Goldbach was right in conjecturing that every even number greater than 2 is the sum of two primes?

I believe that it is mainly for this reason that the conventionalist view of their subject has been so unwelcome to mathematicians themselves. Unlike many of his colleagues, Henri Poincaré was not averse from the philosophy of mathematics. If he campaigned against Russell's 'logistics', as symbolic logic was known in the first decade of this century, it was because he could not believe that mathematics was one vast tautology. Consequently, he was delighted by Russell's discovery of his class paradox. 'Logistics,' he wrote, 'is no longer sterile. It breeds contradiction.'

In my opinion, Poincaré's contribution to the philosophy of science makes him the best philosopher that France has produced since Descartes; nor have his French successors in the twentieth century as yet come up to his mark. Even so, his solution to the problem of the richness of mathematics is not impressive. He admitted that all Peano's axioms were analytic with one exception. The exception was the principle of mathematical induction, affirming that what is true of the number zero and true of any number $n + 1$ if it is true of n is true of all numbers.

Russell's rejoinder was that this principle is analytic, inasmuch as it formulates one of the defining properties of the series of cardinal numbers. I should have thought that a better answer would have been that there is nothing synthetic about the proposition that what is true of each member of a series is true of all of them. Moreover, even if the principle of mathematical induction were synthetic, it is difficult to see how it would suffice to explain either the resources of mathematics or its conundrums.

For my own part, I adhere to the line that I took in *Language, Truth and Logic* all those years ago; and it may well seem that my disposal of our problem is even less convincing than Poincaré's. I accounted for the fact that mathematics appears to contain secrets which sometimes but not always yield to the brain waves of its devotees by appealing to the limitations of human intelligence. Echoing Hans Hahn, a leading member of the Vienna Circle and consequently one of the few mathematicians to acquiesce in the triviality imputed to his subject, I announced that an Omniscient Being would have no need of either logic or mathematics. It would all be immediately obvious to him.

But the best mathematicians are exceptionally intelligent men. Can

one seriously maintain that if only they were even more intelligent, the propositions the truth or falsehood of which it takes such brilliance and industry to demonstrate would immediately appear to them to be nothing more than tautologies and contradictions? Surely this assumption is just not credible.

I feel the force of this objection and am by no means sure that I can parry it. In attempting to parry it I shall depend on the sort of analogy that Wittgenstein has brought into fashion. I am addicted to puzzles, including bridge and chess problems. To solve these problems, one need not possess any skill at playing either bridge or chess: one needs only to know the rules. In a bridge problem, all four hands are set out, and one is told what is the best contract that it is possible for the declarer to make; in a chess problem one is given the positions of the pieces, and told whether white or black is in a position to force mate and in how many moves. It is an exercise in nothing more recondite than deductive logic. Yet these problems can be surprisingly hard to solve. In my case at least, the ease with which I solve them is inversely proportional to my skill at the respective games. I am a poor bridge player, yet though it may take me some time to find my way through a bridge problem, it is rarely the case that I do not eventually find the one and only path to its solution. I am a better than average chess player, yet even when the problem is exceptionally easy, I am unable to solve it very much more often than not. What is maddening is that once the solution is pointed out to me it seems obvious. Nor is this surprising since from the premiss that the pieces are disposed as they are, the solution follows analytically in accordance with the laws of chess. I have much the same experience in mathematics. That there is no greatest prime number is a proposition which I should never have been able to prove on my own. Once I am shown the proof, it seems obvious.

Having mentioned Wittgenstein, I allow myself to add that I am baffled more than enlightened by his *Remarks on the Foundations of Mathematics*. Nevertheless he does make one point of the utmost importance: he calls attention to the dependence of arithmetic upon contingent matters of fact. Let us take Kant's example of the sum: $7 + 5 = 12$. It happens to be the case with physical objects of nearly every type that if one counts out seven of them and then five of them and puts the two sets together and counts the result, it comes to twelve. It is, however, easy to imagine that this was never so. It might easily have been the case that when a set of seven and a set of five objects were brought together, one was subtracted or one was added or two of them coalesced, so that the physical outcome of combining the two sets would never be 12, but always either 11 or 13. Would the proposition that $7 + 5 = 12$ be false in

such a world? No. It would still be valid within the framework of standard arithmetic. It would have become not false but useless. If it proved generally impossible to give physical values to the processes of addition and subtraction, as they were in standard arithmetic, it would, says Wittgenstein, be the end of all sums. I am not convinced that this would be so. Although it is beyond my competence I do not find it inconceivable that someone should devise an arithmetic which was adapted to such natural facts.

Have we now discovered a reason for denying that mathematical truths are a priori? Yes, in so far as they are abstracted from processes of counting and measurement which are believed to fit contingent empirical facts. No, in so far as the methods of proof to which these truths owe their status do not embody any reference to empirical theories or observations. They depend upon experience, only in the sense that if the system in which they functioned had no empirical application there would be no point in carrying them out.

Have we discovered that mathematical propositions are not necessary? I think not. There are four different lines that one can take with regard to the notion of necessity. One, which is currently fashionable, is to make provision for both logical and empirical necessity, not following Leibniz, who fused the two concepts, but setting up two sets of criteria which are held to be independently satisfied by a priori propositions and by a subset of empirical propositions such as the expressions of causal laws. A second course, which I favour, is to admit logical necessity, as applying to propositions which cannot be consistently rejected without changing the meaning of the sentences which express them, or the logical consequences of such propositions, while refusing to ascribe necessity to causal laws or to empirical propositions of any other type. I am not aware that any philosopher has countenanced empirical but not logical necessity, but it seems to me to be a possible option. Finally, one may contest the legitimacy of both concepts of necessity. I take this to be Quine's position.

Quine mentions sentences rather than propositions. For him a necessary sentence would be one that no speaker of the relevant language could bring himself to discard, once it had found a place in the corpus of his beliefs. He holds that there are no such sentences. Observation sentences come nearest the mark, but they too can be discarded if we have a strong enough motive for doing so. This is what Neurath was saying in the early nineteen thirties and it is worth remarking how much Quine is indebted to Neurath, for example for his favourite simile of the ship which is repaired at sea.

Not only observation sentences but also sentences of logic can be

discarded if that seems the best policy. An obvious instance would be the law of excluded middle which is not retained in intuitionistic logic.

Here once again I dissent from Quine. I hold that a proposition is logically necessary if and only if its rejection entails a change in the meaning of the sentence which expresses it. Thus I can continue to regard the law of excluded middle as logically necessary because the intuitionists who reject it work with a different concept of disjunction. The difference results from their replacing the classical concept of truth by a concept of provability. A proposition must be either true or false: there is no third option. *Tertium non datur.* It need not be provable or disprovable: it can be neither. We are thereby presented with a three-valued logic.

In spite of his assimilating the laws of logic to the laws of physics I doubt if Quine has ever held that the logic is an empirical science. Nor do I believe him to have held that mathematics is empirical. Though a staunch Russellian in many ways, he does not believe that mathematics is reducible to logic. He believes that it is reducible to set theory, but rules that set theory is not part of logic. Again this appears to be a fairly arbitrary ruling. At least, to use a favourite expression of his own, there is no fact of the matter in such a case.

It is not generally recognized that Russell adulterated mathematics, and formal logic also, as the parent of mathematics, with a vital empirical element. I doubt if Russell recognized it himself. The empirical element intrudes on his definition of a cardinal number as a class of similar classes. Now for Russell the members of these similar classes are not abstract entities, but concrete individuals, natural objects of some sort. It does not matter whether these are taken to be atoms, or quarks, or sensibilia. It might be thought that the number of sensibilia at any rate was infinite, but this would not be the case if space-time is finite, as physicists now take it to be. For not only will there be a finite, though very large, variety of qualities that a sense-datum can possess: there will also be a finite, though very large, variety of positions that a sentient being can occupy.

But if the number of individuals in the world is finite, and numbers are classes of classes of individuals, the supply of numbers will eventually give out. One of Peano's axioms will be violated. There will be a very large number which has no successor. This may not matter in our everyday transactions; but it will prevent the series of natural numbers from proceeding to infinity.

Logicians who continue to follow Russell admit that there comes a point when his relation of similarity is, as they put it, only notional; it will not be a relation that actually obtains in anyone's experience. But not only does this sacrifice the grounding in reality that Russell claimed

for his construction: it also makes his theory circular. For we now have to enumerate the members of two very large classes before we can introduce the notional relation of similarity that we are taking to subsist between them.

Miró Quesada thinks that Gödel's theorem furnishes an objection to the view that I am defending. I am not convinced that this is so. Admittedly Gödel's theorem was a nuisance in that it ruined Hilbert's programme which was favourable to the view that the propositions of mathematics are true by convention. If it is granted that the whole of mathematics is an ordered series of unmeaning marks, it is not difficult to allow that the selection of the marks and of the rules for their derivation from each other is a matter for choice. Gödel proved that any system which was adequate for the expression of arithmetic must contain a truth that is not derivable from the premisses of the system. Nevertheless, Gödel's example of such a truth is clearly analytic. A sentence belonging to a consistent system which says of the proposition which it expresses that the proposition is not demonstrable within the system is obviously true; for if it were false the system would not be consistent. Moreover, the truth of the proposition is obviously guaranteed by the meaning of the sentence which expresses it.

If Gödel's theorem is true by convention, could we not alter our conventions so that it became inexpressible? Wittgenstein's slighting references to Gödel suggests that he believed this to be possible but he did not say how it could be done. Nelson Goodman has taken it as a point in favour of his nominalism that Alonzo Church objected that one of the things of which Goodman's rejection of classes would deprive logic was Gödel's theorem, but Goodman has not said how Church arrived at this conclusion. I have not worked the problem out, but I am inclined to think that one could get rid of Gödel's theorem by something of the order of Russell's theory of types.

Oddly enough, the domain in which there appears to be the strongest objection to the conventionalist thesis is that of formal logic itself. The objection was raised by Quine as long ago as 1936 in a paper entitled "Truth by Convention" which he contributed to a set of essays in honour of Alfred North Whitehead. Quine conceded that the premiss of a logical system could be secured by a convention. For instance, we could secure the classical law of excluded middle by the ruling: 'Let p or q be held true, if and only if not-p is held true or q is held true'. But then we are using disjunction to state the convention to which it owes its meaning. I have to say that I do not see how this circularity can be avoided. Quine also objects that we need logic in order to derive conclusions from our premisses. But could not the rule of detachment itself be a convention:

for instance, Let q be held true if and only if p is held true and if p then q is held true. This is all right so long as it is not regarded as a premiss. Otherwise we fall into Lewis Carroll's infinite regress. But how are we to distinguish it from a premiss?

Once more I take refuge in an analogy. That a bishop cannot operate on squares of different colours is not a rule of chess but it follows from the rules. Obviously it is as conventional as they are. It is a prohibition that could be abrogated. For instance, a bishop could be allowed to operate a square of both colours or to change their colour if its fellow bishop had been taken. The result would no longer be chess but it would be a game that could be played.

A.J.A.

19

Anthony Quinton

AYER AND ONTOLOGY

1. AYER AND RUSSELL

Sir Alfred Ayer has always considered himself to be a follower of Bertrand Russell, or, perhaps one should say, to be closer to Russell than to any other philosopher. In the first volume of his autobiography he says, "though there were many crucial points on which I disagreed with him, my approach to the subject and my general standpoint were similar to his own" (POML, p. 300). There is clearly a good deal of overlap between their methods, interests, and doctrines. Both hold that the object of philosophy is to contribute to an understanding of how our beliefs are justified, to the extent that they are, and that some procedure of analysis, in which comparatively doubtful or questionable beliefs are shown to be dependent on ultimate empirical beliefs of a minimally suspect kind, is the best way of acquiring such an understanding.

Ayer has always defended Russell's theory of descriptions, both as a way of showing that proper names are eliminable from discourse and, more generally, as the paradigm of correct analytic procedure. However, his loyalty to the second thesis has been fitful and qualified since his rejection of full-blooded reductionism in favour of a somewhat more anaemic operation called descriptive analysis in *The Problem of Knowledge* (1956). The phenomenalism that Ayer propounded in his first two books and only marginally diluted in his discussion of the subject in *Philosophical Essays* (1954) is close to the account of material things as classes of appearances or *sensibilia* to be found in Russell's *Our Knowledge of the External World* and in some of the essays in *Mysticism and Logic*. Russell, after rejecting the idea of a persistent substantial self in *The Problems of Philosophy*, while still prepared to admit a momentary one, brought himself a few years later to the point of abandoning the latter as well, identifying it with a collection of mental states.

Ayer has followed him in this since chapter 5 of *Language, Truth and Logic.*

Russell was a reluctant convert to the view that all necessary truth is analytic, where Ayer was from the first an ardent true believer, but he was converted none the less. Both have tended to see science as rather radically in conflict with common sense and not merely over such matters of comparative detail as the flatness of the earth or the sun's motion around it. Both are attracted by behaviourist accounts of meaning and belief and also by partially behaviourist accounts of the mind which still make some room for private, introspectible mental states. Both are somewhat crusadingly hostile to religion, although the emphasis is moral in Russell's case, intellectual in Ayer's. Both deny the cognitive status of judgements of value. Both adopt libertarian moral positions and hold left-wing political opinions, although Ayer does not share Russell's pacifism.

But there is one major issue on which they differ. Ever since his early demonstration of its impossibility, in *Mind* for 1934, Ayer has always been much more hostile to metaphysics than Russell has. Admittedly, he has in his later writings taken a more sympathetic view of it than his early conception of it as meaningless verbiage which calls only for diagnosis, an account of the logical confusions from which it derives. But he has remained convinced that it must fail in its professed aim of supplying a general picture of the world, of its real nature as contrasted with the appearances it presents. In *The Central Questions of Philosophy* (1973) he concludes his discussion of metaphysics in these words:

> Zeno's paradoxes are not just ingenious sophistries. By taking them seriously, we obtain unexpected insights into the behaviour of our concepts of space and time and motion. The same result, the clarification of a fundamental concept, was yielded by our examination of McTaggart's argument. It is, however, to be noted that in both cases these benefits were compensations for the failure to establish a metaphysical position. (CPQ, p. 21)

Russell has never been so dismissive. Even in his most enthusiastically analytic phase the last of his lectures of 1918, *The Philosophy of Logical Atomism*, is entitled, without irony, "Excursus into Metaphysics: What There Is". The crucial point of difference between them is the attitude they take up to the bearing of philosophical analysis on ontology. For Russell the reducibility of material objects and minds to what he calls events implies that the latter are part of the ultimate furniture of the world and that the former are not. For Ayer the reducibility of material objects to sense-data, actual and possible, does not reveal any difference of ontological status between them. It makes only an epistemological

point, that the empirical evidence on which any justified claim about the existence of a material object depends must consist of some fact about sense-data. Indeed, far from showing that material objects do not exist, their reducibility to sense-data, in Ayer's opinion, makes clear the conditions under which the claim that a material object does exist can be made good.

He acknowledges this difference between Russell and himself. In *Russell and Moore: the Analytical Heritage* (1971) he says,

> (Russell) takes himself to be putting forward a probable theory about the composition of the world, overlooking or disregarding the fact that once it goes beyond the question of scientific truth or falsehood there is no possible way, apart from the consideration of logical coherence, in which the validity of such a theory could be decided. In Russell's system . . . he takes as fundamental the notion of 'event'. Physical continuants are equated with events in causal lines, and . . . point-instants, if they are needed, are found to be constructible out of assemblages of overlapping events. I believe that these constructions are both feasible and illuminating, though I cannot agree with Russell that in failing to make them we should be giving unnecessary hostages to fortune. The only sense which I can give to the question whether there really are point-instants is whether they are logically eliminable. . . . He is not always clear what issue is involved when he raises the question whether or not a certain type of entity is to be regarded as part of the furniture of the world. Nevertheless, his actual handling of these questions does often result in giving us a clearer understanding of their nature. (RMAH, p. 132–33)

2. ANALYSIS AND ONTOLOGY

It must be admitted that Russell nowhere provides any explicit defence of his assumption that if things of one kind can be analyzed in terms of things of another the former are thereby shown to be not part of the ultimate constituents of the world. In part that may be because his use of analysis as ontology grew on him gradually. In *Our Knowledge of the External World* (1914) he was mainly concerned to establish the empirical credentials of various kinds of more or less puzzling or questionable entity. Material objects, space and time, the points and instants of which the latter are composed all have properties which are incompatible with their being objects of sense-experience: (comparative) permanence in the case of material objects, infinite extent in the cases of space and time, infinitesimality or unextendedness in the cases of points and instants.

For each of these kinds of item Russell outlines a procedure of construction from what is directly accessible to the senses which preserves the characteristic counter-empirical properties of the constructed items.

The construction is carried out by drawing on some logical or logical-mathematical notion. Thus material objects are seen as constructed out of *hypothetical* sense-data (viz. *sensibilia*), points and instants are interpreted as the *limits of series*, related by enclosure, whose earlier members are finite and so directly perceivable extents and durations. Instead of inferring problematically transcendental things from what is given to the senses, the purposes for which they are needed can be served by constructions wholly composed of sensible ingredients. To follow that course is to abide by the "supreme maxim of scientific philosophizing", namely, "wherever possible, logical constructions are to be substituted for inferred entities". (ML, p. 155)

At that stage of the development of his thought Russell did not deny the existence of the inferred entities which the logical constructions were devised to displace. He was agnostic about them. The purposes which lead us to take the risk of inferring their existence can be served by more empirically respectable constructions which replace them. But the constructed substitutes gradually come to be seen as what the supposed inferred entities actually are. By *The Philosophy of Logical Atomism* in 1918 common objects, the fundamental particles of the physicist and selves are now understood as actually being what Russell confusingly calls 'logical fictions' (as contrasted, presumably, with such illogical fictions as Lockean substance). Analysis has turned into discovery, not just the provision of empirically wholesome *ersatz*.

Although these constructions exist in some way or other, as contrasted with such straightforward fictions as phlogiston or Mr Pickwick, in Russell's view their reality is inferior to that of the empirically given items from which they are constructed. Logical atomism, he says, is

> the view that you can get down in theory, if not in practice, to ultimate simples, out of which the world is built, and . . . these simples have a kind of reality not belonging to anything else." (LA, p. 129)

The theory of logical constructions or fictions, he goes on, shows "the unreality of things we think real" (LA, p. 133). In his essay of 1924, *Logical Atomism*, he says "I do not believe that there are complexes or unities in the same sense in which there are simples" (LA, p. 157) and, as a final statement of his position:

> the world consists of a number, perhaps finite, perhaps infinite, of entities which have various relations to each other, and perhaps various qualities. Each of these entities may be called an 'event' (LA, p. 162) (More specifically) bits of matter are not among the bricks out of which the world is built. The bricks are events and bits of matter are portions of the structure to which we find it convenient to give separate attention. (LA, p. 150)

The question that Russell nowhere confronts directly is that of why it should be concluded from the premise that space, time, matter, minds, and so forth are constructions out of events, sensed, or, at any rate, capable of being sensed, that they are not truly real, not real in the ultimate or primary way that the events out of which they are constructed are. If he had reflected on his brick metaphor he would have seen that his principle of the comparative unreality of the constructed stands in need of argumentative support. A wall can be made entirely of bricks without any adverse implications in respect of its being as real as the bricks of which it is made.

It may be possible to explain why he made this assumption by reference to a traditional, and by no means wholly gratuitous, way of interpreting Hume. Hume has ordinarily been understood to say that belief in necessary connection, the continued and distinct existence of material objects and the existence of the self as a persistent something over and above the experiences it has are the effects, respectively, of observed constant conjunction, observed constancy and coherence and, less persuasively, of observed resemblance and causation. This theory is held to imply radical scepticism about the existence of causal connections, material objects, and minds. But it can be reinterpreted as an account of what causal connections, objects, and minds actually are.

Another relevant consideration is that there is a substantial philosophical tradition, stretching back behind Russell, which takes constructedness to be a proof of comparative unreality. Bentham is its most impressive member; Vaihinger its most encyclopedic. Bentham's theory of fictions, helpfully assembled from various bits and pieces by C.K. Ogden, was much in advance of its time. An entity is whatever is denoted by a noun. Entities of other categories than that of substance are all fictitious. They are defined, not *per genus et differentiam*, a procedure which inevitably relates terms referring to entities of the same category, but by what he calls *paraphrasis*, an exact anticipation, as Quine has pointed out, of contextual definition or definition in use. Fictitious existence is not to be confused with fabulous existence, which contains what we should ordinarily call fictitious objects.

There are many loose ends in Bentham's position, natural enough in a set of rough drafts. Sense-impressions and material objects are run together. All mental entities, he asserts with a measure of Rylean excess, are fictitious, on the ground that all discourse about the mind consists of physical metaphor. The soul and God are described as *inferential* entities, but the idea is not explored.

Fictitious entities are, for Bentham, not part of the real constitution

of the world, which is wholly body: either material in a characteristic shape or unformed matter, that is to say, stuff. Among them are space and time; motion or rest; shapes, surfaces, and lines; classes and even existence itself. Beyond these there are the denizens of Bentham's main field of interest: the fictions of law and politics. Generally, everything we can intelligibly refer to and of which we can have reason to assert or deny existence is either perceptible or referred to in sentences that are paraphrasable into sentences in which only what is perceptible is denoted. No argument is given for the crucial ontological step from this distinction to the corresponding distinction between real and fictitious entities, perhaps because no need was seen for it.

Vaihinger does not make up for the argumentative deficiencies of Bentham's doctrine. But he applies it with much greater copiousness of detail. He writes of the abstractive fictions of mechanics (e.g. frictionless movement), of economics (e.g. strictly egoistic motivation), of 'schemata' or ideal types, of personificatory fictions (e.g. force in physics or the conception of cause as a kind of volition), of heuristic fictions (e.g. the ether, teleology, animal spirits), of mathematical fictions (empty space and time, points, lines, surfaces, atoms, negative, fractional, real and imaginary numbers, the infinite and the infinitesimal) and, finally, in a more strictly positivistic spirit than Bentham, declares that matter is a fiction.

Neither Russell, then, nor the chief earlier believers in the unreality of the constructed make an explicit case for that assumption. And there are others, besides Ayer, who have agreed that whatever is not perceptible must be paraphrased in terms of what is, but have not gone on from that to conclude that the existence of the constructed is in any way inferior to that of the perceptible and basic. Schlick, in his article "Positivism and Realism", maintains that to assert that only the given is real *(es gibt nur das Gegebene)* is to make the same sort of mistake as the traditional metaphysician does when he asserts that there is a transcendent reality. This line of thought is developed in Carnap's *Logical Structure of the World* (part V, sections C and D) and in his *Pseudoproblems in Philosophy* (II B) where he distinguishes between the empirical and the metaphysical problems of the reality of the external world and of other minds. The empirical reality of these things is a genuine question which can be settled by observation; the metaphysical question of their reality is meaningless. The theory that material things are constructions, Carnap says, agrees with realism in holding such things to be distinguishable from dreams and hallucinations, to be intersubjective, to be capable of existing when not being perceived by anyone and to be governed by regularities which permit prediction. On the other hand it agrees with

various forms of idealism that all statements about material objects can be translated into statements about the given. To say that material things are constructed out of my experiences amounts to the idealistic thesis that material objects 'are created in thought'.

3. AYER ON ONTOLOGY: FIRST PHASE

Ayer's remarks on ontology in his early writings, prior, that is, to *The Origins of Pragmatism* (1967), are generally negative in the manner of Schlick and Carnap, although he nowhere confronts the subject as directly or in such detail as they do. In *Language, Truth and Logic* he says that "the activity of philosophizing is essentially analytic" (1st ed, p. 50). It is a matter of supplying definitions, specifically definitions in use and "we define a symbol in use not by saying that it is synonymous with some other symbol, but by showing how the sentences in which it significantly occurs can be translated into equivalent sentences, which contain neither the *definiendum* itself, nor any of its synonyms" (LTL, p. 68). Commenting on the paradigm of definitions in use, Russell's theory of descriptions, he says "the effect of this definition of descriptive phrases, as of all good definitions, is to increase our understanding of certain sentences" (LTL, p. 69). Such an increase of understanding will be beneficial to "those who believe that there are subsistent entities such as the round square or the present king of France. But the fact that they do maintain this shows that their understanding of these sentences is imperfect. For their lapse into metaphysics is the outcome of the naive assumption that definite descriptive phrases are demonstrative symbols. And in the light of the clearer understanding which is afforded by Russell's definition, we see that this assumption is false" (LTL, p. 70). There is a flavour of ontological elimination in what Ayer says here.

But a few pages later he declares "what one must not say is that logical constructions are fictitious objects" (LTL, pp. 73–74). By that stage in the argument he is about to put forward the view that material things are logical constructions out of sense-contents, "which may be loosely expressed by saying that to say anything about a table is always to say something about sense-contents" (LTL, pp. 74–75). And he goes on later to maintain that the self is also a logical construction out of sense-experiences, namely those containing organic sense-contents which are elements of the same body (LTL, p. 184). That leaves out of the self all the mental states composing it that are not sense-experiences, but, for example, thoughts, beliefs, desires, and emotions. The difficulty could, no doubt, be circumvented by some such shift as adding the clause "and

also the other mental states which are coexperienced with those sense-experiences". More questionable is a passing reference to *possible* sense-experiences. A self, he says at one point, "is, in fact, a logical construction out of the sense-experiences which constitute the actual and possible sense-history of a self" (LTL, p. 184). These possible elements of the construction are not heard of again. Perhaps they were conceived as mental states of which the subject was not conscious; introspectible, but not, in fact, introspected. More probably they were introduced to make the account of the self approximate more closely to the phenomenalist account of the nature of material things.

In the discussion of realism and idealism in the last chapter of the book, Ayer contends that whereas the question of whether something is real rather than illusory or fictitious (in the ordinary sense of that word) is straightforwardly empirical, the question of whether it has the "completely undetectable" property of being real, as opposed to the "equally undetectable property of being ideal" (LTL, p. 219) is itself a fictitious question, by which he must mean, not that no one has ever raised it, but that it is emptily metaphysical.

By 1951, in a discussion of Quine's "On What There Is" in *Philosophical Essays* (chap. 9) Ayer distances himself a little from an unflinchingly negative attitude to ontology. "It is tempting to dismiss all talk about ontology as merely a question of how we use, or how we propose to use, such expressions as 'is real' or 'exist' or 'there is'. But while I do not wish to say that this procedure is incorrect, I think that there are cases in which it somewhat misses the point" (PE, p. 227). He goes on:

> the interest of an ontological dispute lies in someone's denying that something is. The denial of being is, in philosophy, the prelude to an explanation; the affirmation of being more often a refusal to provide one. (PE, p. 228)

And he concludes:

> Questions about ontology can legitimately be interpreted as questions about the choice of conceptual schemes and about the relationships of their various elements, and in so far as the adoption of an ontology is simply a matter of choosing a conceptual scheme it is to be attacked or defended on purely pragmatic grounds. (PE)

At an earlier stage of the discussion he had considered the notion of a basic predicate, understood as one of a kind to which predicates of other kinds are reducible (in a sense rather weaker than that of strict translation) but which itself consists of irreducible predicates. Of the restriction of existence to items to which basic predicates apply, he then remarks, "This, it may be said, is a very arbitrary procedure. What right have we to

assume that nothing exists but what can be experienced?" (PE, p. 223), surely a rather un-Ayerian invitation to self-control?

By 1960 and his Oxford inaugural lecture, "Philosophy and Language", Ayer is opposing analytic ontology from another direction. After enumerating a number of deflationary theses, he observes:

> Nowadays, claims of this kind are usually made in a more sophisticated way. 'Points are really classes of volumes'. 'Material things are logical constructions out of sense-data'. This brings out more clearly what is involved in these denials of reality. The thesis is always that some category of objects is dispensable. . . . The assumption is that certain types of entity are philosophically suspect, and the purpose is to show that references to such entities are nevertheless innocuous; they can be construed as disguised references to entities which are relatively less problematic. (*The Concept of a Person*, pp. 12–13)

But he does not challenge the assumption that, since the apparently existence-imputing references are in fact disguised ways of referring to something else, that the apparent objects of these references can be dispensed with, either be not taken to exist or be taken not to exist. He directs his fire, rather, at the claim that the required reductions can in fact be carried out. But that objection is weakened in force by his own liberalisation or dilution of the requirements for reducibility. Furthermore, although the objection is well-founded in the case of the reduction of material objects to sense-data, it is much less so in the case of the reduction of points to volumes. Would Ayer want to affirm the reality of points?

4. Analysis as Elimination

There are two main ways of defending the principle that a constructed entity is not fully real, not part of the ultimate furniture of the world. The first is direct and general, the second indirect and specific. The direct general argument is that to show that some entity is a construction is to show that what appear to be names, implying the existence of the objects apparently named, are not really names at all, so that no implication of existence is involved. (The name implies a claim to existence when used to refer. It requires the existence of the object named if the sentence it figures in is used to say something true.)

The somewhat suspect sentence "*a* is a construction" is a way of saying "'*a*' is an apparent name", that it can occur in a grammatically referring position in a sentence without actually referring to or implying the existence of any corresponding entity whose name it is. The actual

but concealed, reference of the sentences in which '*a*' figures is to the entities out of which it is ultimately, or, as the fortunate phrase has it, in the last analysis, constructed.

Bentham offers a preliminary sketch of the argument:

> (By the term 'fictitious entity') is here meant to be designated one of those sorts of objects which in every language must, for the purpose of discourse, be spoken of as existing—be spoken of in the like manner as those objects which really have existence, and to which existence is seriously meant to be ascribed, are spoken of but without any such danger as that of producing any such persuasion as that of their possessing, each for itself, any separate, or strictly speaking, any real existence. (*Bentham's Theory of Fictions*, ed. C.K. Ogden, p. 16)

Quine endorses it (and, as one might expect, with cleaner hands in the matter of use and mention):

> Contextual definitions, or what Bentham called paraphrasis, can enable us to talk very considerably and conveniently about putative objects without footing an ontological bill. It is a strictly legitimate way of making theories in which there is less than meets the eye. Bentham's idea of paraphrasis flowered late, in Russell's theory of descriptions. Russell's theory affords a rigorous and important example of how expressions can be made to parade as names and then be explained away as a mere manner of speaking, by explicit paraphrase of the context into an innocent notation. (*Ontological Relativity*, p. 101)

If that argument is accepted it does not directly follow that there are no such things as the entities apparently referred to. There are such things to the extent that there are what had better be non-committally called complexes of the elements out of which the logical constructions are constructed. But Ockham's principle of economy denies existence to such things conceived as something over and above the elements, complexly arranged. To substitute logical constructions for inferred entities is to abandon the latter, rather than to suspend judgement about them in an agnostic spirit.

Those who believe in logical constructions commonly acknowledge a distinction between them and other sorts of constructions, in particular between logical and literal, or physical, constructions and, more inclusively, between a logical construction and a whole made up of parts. Ayer himself stresses that

> when we refer to an object as a logical construction out of sense-contents, we are not saying that it is actually constructed out of those sense-contents, or that the sense-contents are in any way parts of it, but are merely expressing, in a convenient, if somewhat misleading, fashion, the syntactical fact that all sentences referring to it are translatable into sentences referring to them. (LTL, p. 190)

But this recognition is, both in his case and that of others, to some extent a matter of lip service. He and others have frequently invoked the relation between a nation and its citizens as a paradigmatic illustration of the relation between a logical construction and its elements. But a nation is a whole whose citizens are its parts. (Cf. my *Thoughts and Thinkers*, pp. 87–90.) The same is true of a wall and the bricks of which it is, in this case literally, constructed. A nation is, indeed, more naturally said to be composed of its citizens, but the metaphorical aspect of this verb as a literal putting together is dead.

An interesting case is that of the relation of a self to its states. These states are, according to a theory like Hume's which dispenses with mental substance, the related parts of a series extended over a period of time. On such a theory it is not a logical construction at all but a whole of parts. The crucial difference is that a whole is the same sort of entity, or falls within the same category as, the parts of which it is made. A wall is, like its component bricks, a material thing. A theory, like its component propositions, is an abstract or conceptual entity. The unpursued reference to possible sense-contents in Ayer's early account of the self is an uneasy symptom of his recognition of the fact that the self, as he then understood it, in the style of neutral monism, is not a logical construction out of a set of mental states, but is a large mental whole made up of literally mental parts.

Some wholes, such as walls and cars and pieces of furniture, are literally, physically constructed out of preexistent and coordinately physical parts. Some, such as theories and narratives, are metaphorically, or, at any rate, non-physically, constructed out of categorially identical parts: propositions or accounts of episodes. Also worth noticing are what might be called epistemic constructions. Geography, terrestrial or celestial, begins with the identification of relatively small items: Taunton, Yeovil, Chard; the sun, the moon, Mars. It arrives by a process of summation at ordered wholes: Somerset, the solar system. Much empirical investigation goes in the opposite direction: from whole to part; from flower to petals, stamen, and stalk; from cloth to threads—epistemic analysis, so to speak. But epistemic constructedness is not an intrinsic property of things. It depends on the point of view of the investigator. A Martian geographer would start with Africa and then, getting nearer or improving his telescope, would find the river Niger as part of it. An African geographer would work the other way around.

One distinguishing feature of a true logical construction, as contrasted with these other types of case with which it is liable to be confused, is that sentences in which it occurs are equivalent to general, hypothetical sentences about the elements to which it is reducible. That

is conspicuously the case with the phenomenalist account of the nature of material things—only lightly concealed in Mill's reference to permanent possibilities of sensation or Russell's to *sensibilia*. It is also true of thoroughgoing logical behaviourism about the mind, a doctrine struggling to emerge from a thicket of qualifications in Ryle's *Concept of Mind*. For a phenomenalist, indeed, a material thing is a wholly hypothetical entity. Its existence is assured, for the phenomenalist, provided that the relevant hypothetical statements about its elements are true. It is not required that any categorical statements about these sense-data be true, although unless some are there will be no *direct* evidence of that thing's existence.

The hypothetical nature of true logical constructions helps to explain the secondary or derivative nature of their existence as compared with that of their elements. Nothing is true about a Millian material thing or a Rylean mind that implies its existence unless something is true about sense-data or bodily behaviour. But there could be sense-data or bodies moving about without there being material things in the one case or minds in the other if the appropriate body- and mind-constituting regularities of appearance and of behaviour did not obtain. There is an asymmetry in the relations between a logical construction and its elements.

In fact philosophers have advanced theories about the relations between entities of different categories that go in opposite directions. For Mill sensations are elements, bodies are constructions. For Ryle it is the other way about. Even where, as in neutral monism, there is a superimposition of these two reductions it is necessarily incomplete. Even if some mentality in such a system is constructed—the mental states of others or, mistakenly in my view, minds as wholes as distinct from their states— some is not: the neutral elements themselves, Carnap's 'autopsychological' items, which are the ultimate basis of the whole system.

One pair of reductive enterprises seems to exemplify the situation of the Kilkenny cats. Animated by empiricist suspicion of both substances and universals, some have held both that a thing is a bundle of qualities and that a quality is a class of similar things. A stop to the threatening infinite regress has been sought by D.C. Williams (*Principles of Empirical Realism*, chap. 7) and Keith Campbell (*Metaphysics*, chap. 14) in their theory of 'tropes' or abstract particulars, Stout-like individual instantiations of properties, combined by compresence to make concrete particulars and by similarity to make abstract properties.

A whole or aggregate, then, is not a logical construction out of its parts, although, like Africa or the solar system, it may be, relative to a specific point of view, an epistemic construction. The constructions that chiefly command the attention of philosophers—those of material things

and minds—are, or are thought to be, hypothetical constructions. They are introduced to register regularities in the occurrence of sense-impressions or the behaviour of human (and animal) bodies. It is because of the hypothetical nature of the sentences into which sentences apparently referring to the construction in question are analyzed that the reference in the latter is only apparent and so fails to imply the real existence of the things apparently referred to.

A large collection of trees, close to one another, but surrounded by a tract of more or less treeless ground, is a forest. In the same way, if a little more elusively, a nation is a collection or aggregate of people, culturally integrated by shared language, customs, values, and, usually, territory. A Millian object, on the other hand, is a collection of *possible* sensations of a regular kind, a Rylean mind a collection of *dispositions* to behave in certain regular ways, in other words not an actual collection at all. 'Forest' and 'nation' are definable in terms of their parts, *per genus et differentiam*; in the forest case the genus being that of spatially bounded groups of trees, the differentia being largeness. But 'material thing' for Mill and 'mind' for Ryle can be defined only contextually.

5. A Menagerie of Constructions

The second, indirect and specific, way of showing that constructions do not have real existence, in the sense of being part of the ultimate furniture of the world, argues from particular examples of ontologically questionable types of entity. Some of these are hypothetical constructions, in the way that Mill's bodies and Ryle's minds are, but others are not obviously so, if they are so at all. These others, however, are still not wholes or aggregates, and so not possible epistemic constructions, and they have to be introduced into discourse by contextual rather than explicit definition. The point of the specific instances is to serve as comparatively philosophically uncontroversial examples of reducibility, in which the reduction both establishes the empirical credentials of the constructed items in question and yet does not encourage the idea that the items are self-subsistent things, real components of the world.

A good example of a further truly hypothetical construction is force as conceived in physical science. To attribute the movement of unsupported bodies towards the earth's center of gravity to the operations of gravitational force is not to report the discovery of some literal physical link between the gravitating body and the earth. It is, rather, to say that *if* a body at a distance from the earth's surface is allowed to fall freely, it will accelerate towards the centre of the earth at 32 feet/second2 until it is

stopped. To realise that is a mildly liberating intellectual discovery. The idea of some invisible string or wire hauling the cannon ball towards the earth as the pressure of some equally invisible pusher, emanating from the cannon's mouth, dies down is shown to be mythical.

The notion of force is a special case of the more general notion of a causal connection. There is a causal connection between a switch and a light, but, although it does not obtain unless there is the physical connection of a length of wire between them, it is not itself that length of wire. It consists in the regular relationship between them, expressed in the general, hypothetical statement that whenever the switch is pressed down the light goes on and whenever it is pressed up the light goes off.

For all his closeness to Hume, it was not this example which led Russell to believe that his technique of contextual definition could be applied in epistemology with metaphysically economical consequences. The crucial influence, as he makes clear in *Our Knowledge of the External World*, was the 'method of extensive abstraction' developed in Whitehead's *Principles of Natural Knowledge* and *The Concept of Nature*. In these works the basic items in the vocabulary of theoretical physics—point, instant and particle, mass point or atom (in much the sense of Boscovitch)—are defined in terms of convergent series of extents, durations and objects including their successors in the relevant series. In a well-known passage Whitehead appears to reject the idea that the dramatis personae of physical theory are logical constructions. He opposes the idea that:

> though atoms are merely conceptual, yet they are an interesting and picturesque way of saying something else which is true of nature. . . . Surely, if it is something else that you mean, for heaven's sake, say it. (*The Concept of Nature*, p. 45)

But that is really a way of insisting that these entities are not merely fictions or conventions but must be interpreted in terms of what experience reveals as really existing.

Points and instants owe their ontological insecurity to two factors. In the first place they are positional rather than material things. They share with respectably extended spatial and temporal items, up to and including space and time themselves, the feature of being dependent, not merely for their identification but for their existence, on other things, material objects, that is to say, and events or changes in the history of material objects. Bentham expressed the relational nature of space and time by describing them as 'semi-real'.

Secondly, points and instants, as well as unextended material particles or mass-points, are, along with lines and surfaces, idealisations or

limiting cases. It is reasonable to suppose that there are no straight lines in nature, meaning by that that no material body has an exactly straight line as one of its boundaries. Indeed, more generally, all material things are indeterminate or fuzzy at their edges. If these edges are conceived at the lowest particulate level, the particles involved will be in constant motion and at relatively great distances from each other; the object will be like a crowd in a dance-hall, with an irregular and constantly changing periphery. If the object is conceived as a field its intensity will diminish continuously and have no clear cut-off point.

Points and instants, spaces and times, Space and Time as relational entities are not hypothetical constructions. But direct reference to them can be eliminated. 'There is an empty space between the cupboard and the washbasin' can be analyzed as 'the cupboard is some distance away from the washbasin and there is nothing between them'. The original sentence has to be so understood if it is to say anything that can be found out and it would not be true unless there were two things in the relation specified and nothing in between. Space and Time, the great all-inclusive wholes, are no doubt what I have called epistemic constructions— indeed, if unbounded, they have to be. But it is not to that that they owe their lack of substantial existence.

Idealisations are not straightforward hypothetical constructions either, but they have a hypothetical aspect. A Whiteheadian point at the centre of a plum could be defined as the limit of the series: surface of the skin—surface of the flesh—surface of the stone—surface of the kernel—. . . . The volumes contained within these surfaces might be 4, 2, 1, ½, . . . cubic inches. In fact the series is not continuous. It has an actual limit in some minimal but still extended particle. A point could be defined in hypothetical terms as what would be the limit of some series if it were to be continued beyond the minute particle at which it in fact stops in accordance with the regularity exemplified by the finite number of its actual constituents. That makes it something like the average man. To treat it as an actual constituent of the world is like worrying about the consistency of the statements, which could both be true, that the average man is thirty-five years old and that fifty years ago the average man was only thirty.

I have cited the examples given here to argue that, although to show that a supposed entity is some kind of construction does not show it to be less real than its elements, at least when it is a whole, literally constructed or epistemically constructible, from its parts, in other kinds of case constructedness does carry a negative ontological implication. A hypothetical construction, a relational construction or an idealisation is not

part of the ultimate furniture of the world in the way that the things are from which it is constructed or which it relates or of which it is an idealisation. As far as Space, Time, and their extended parts are concerned it will not do to express this conclusion by saying that they are not real. Mystics and mystically-inclined philosophers like McTaggart have appropriated that characterization to convey the thought that they are illusions. Quine's phrase 'simulated objects' less misleadingly conveys the ontological conclusion derivable from their reducibility. But would anyone maintain that points and instants are real?

6. AYER'S POSITIVE ONTOLOGY

Ayer's doubts about the ontological implications of analysis or contextual definition have persisted from *Language, Truth and Logic* (1936) to *The Central Questions of Philosophy* (1973). In *Russell and Moore: The Analytical Heritage* (1971) he acknowledges the importance of the matter to Russell.

> The central part which this ontological question plays in Russell's treatment of philosophy has not, I think, been at all widely recognised. . . . The motive for his search for definitions is that successful definitions reduce ontological commitments. (pp. 10–11)

But, in opposition to Russell, he maintains that:

> ascription of reality is just a matter of how we choose to picture the world. . . . It is a choice which there may be respectable motives for making . . . (but) it is still a choice. (RMAH, p. 132)

His description of these determinants as *motives* rather than *reasons* accentuates what he takes to be the arbitrary nature of the choices involved.

Further on in the same book he goes into the motives in some detail. The first is that the objects denied ultimacy and supposed to be mistakenly hypostatised "do not fit in with a preconceived idea of what the world is really like." Secondly, "it may be that certain types of entity, like numbers or universals, strike us as mysterious and we wish to explain them in terms of other sorts of entities which we find less problematic". Thirdly, "epistemological considerations may also play a part. . . . If it is believed . . . that one type of entity is accessible only through another then there may be an inclination to try to reduce the more remote entities to those that give us access to them". Finally, there is the consideration "that the category, or concept, which is put in question is somehow defective". The examples he cites, which include Parmenides's dissatis-

faction with plurality and that of neo-Hegelians with space and time show that the defect he has in mind is logical inconsistency (RMAH, p. 185).

Logical inconsistency is a very good ground for an inference to unreality. But it is not relevant to the matter in hand since a sentence that is self-contradictory cannot be analysed into sentences capable of saying something true. Failure to fit a preconceived idea is, admittedly, not a reason for ontological disgrace, nor, as it stands, is mysteriousness. But the epistemological point about accessibility does provide, for those in the tradition of Bentham, Russell, and Quine, a crucial reason for taking that which is only indirectly accessible to exist in a less fundamental way than that to which access is direct. In *Metaphysics and Common Sense* Ayer explicitly rejects the principle, which I have argued for in general terms in section 4 above and which underlies the denial of ultimacy to the contextually definable, saying, "I see no reason to assume that epistemological and ontological priority necessarily go together" (p. 58). He nowhere considers the reason proposed: that the names of constructions are only apparent names.

However, both in the essay just cited and in the concluding section, on William James's account of what there is, in *The Origins of Pragmatism*, he goes beyond asserting his Carnapian doctrine that ontology is a matter of choice to considering more concretely what the options for choice are and what reasons there are for making one of them in preference to others. In his view, there are three serious candidates: first, 'experientialism', the doctrine of James that only experiences really exist, which is at any rate in the same corner of the field as Russell's ontology of events; secondly, 'naive realism', which treats everyday common objects alone as real, only with "fluids, vapors, shadows, images, perhaps minds and their contents, considered as distinct if not separable from bodies" (MCS, p. 59), but which treats "the entities which figure in scientific theories as explanatory fictions" (MCS, p. 60); and, thirdly, 'physical realism', which "consists in awarding the ontological palm to the entities, the atomic particles or whatever, which figure in physical theories" (MCS, p. 60).

Experientialism is rejected because it does not provide us with "a viable picture of the world" (OP, p. 335). One reason for saying that is that "not only is it logically possible that the world should not contain any sentient beings but there is good empirical evidence that it did not do so at some time in the past and will no longer do so at some time in the future" (OP, p. 330). Although "the world is constructible out of experiences" (OP, p. 330), "not only does it gain independence of its origins, but . . . it obtains sovereignty over them" (OP, p. 331), that is by

incorporating them in that world and explaining them in terms of its other contents.

It must be agreed that experientialism is pretty hard to swallow, whether solipsistic or more generally mind-dependent. In James's somewhat loose and rapturous exposition it is not too clear whose experiences are involved. Should the class of ultimately real things not be confined to my experiences, since these are the entire ultimate basis for the whole construction so far as I am concerned? To avoid the metaphysical vertigo induced by this proposal, defenders of this type of ontology enlarge the class of experiences beyond those of a single subject to include those of all sentient beings or, as Russell did in *Our Knowledge of the External World*, to include *sensibilia*, possible sense-experiences as well as actual ones. (These were still going strong, under the less provocative name of 'events', in his *My Philosophical Development* in 1959.)

The legitimacy of this absorption, either of the experiences of others or of possible experiences, is very questionable. The experiences of others are, for those who see experiences as prior to objects, themselves constructions, and of the second order, unless, like W.T. Stace they adopt the bold, but none too convincing, manoeuvre of contending that other minds are prior to material things (*Theory of Knowledge and Existence*). Schopenhauer's first proposition—the world is my idea—follows from the premises that only the unconstructible is real and that everything but my ideas is constructible from them. It is perhaps Ayer's reasonable conviction that Schopenhauer's proposition is false, together with his continuing loyalty, somewhat diluted with the passage of time, to the second premise that compels him to reject the first. An alternative, for which there are excellent reasons, would be to drop that second premise and put in its place the Benthamite thesis that all that is not material is constructible from what is.

Possible experiences, Russell's *sensibilia* or events, are, perhaps, less epistemologically questionable than the experiences of others. Russell would claim that they are exactly the same kind of thing as the experiences I actually have, except that they occur without the relation to events constituting a brain and nervous system that my experiences enjoy (unless, of course, they are the experiences of others). The partial regularities I discern in the flow of my own experience allows a purely extrapolative inference to these events that are not experienced by me without any prior theory about material things and other minds.

The two remaining options are seen by Ayer as inconsistent with each other.

> These two forms of realism must be rivals. . . . They compete for the same region of space. . . . I do not see how we can consistently think of some area

both as being exclusively occupied by a solid, continuous, coloured object and as being exclusively occupied by a group of discontinuous, volatile, colourless, shapeless particles. (MCS, p. 61)

This apparent conflict can be circumvented by commonsensically taking the straightforwardly perceptible object to be a whole of which the particles are the parts. Instrumentally assisted observation can be used to enlarge the domain of the perceptible to support the belief that molecules, for example, are literally parts of common objects in a way that the forces that hold those parts together are not. Continuity, as ascribed to material things, is not an absolute notion. A piece of canvas is solid as compared with a fishing net, but on close inspection gaps can be seen in its fabric. Further gaps appear, no doubt, when an even more continuous-looking thing, like a bit of tin, is put under an electron microscope. Other elements of apparent inconsistency can be resolved along similar lines (Cf. my *Nature of Things*, pp. 202–7). Science corrects common belief in matters of comparative detail: the sky is not a roof, the earth is not flat, the sun does not go round the earth. What it does not do is undermine the claim to reality of the everyday, straightforwardly perceptible world, the mechanical laws of whose behaviour are indispensably presupposed by our investigations of the fine structure of nature.

7. Conclusion

I suggested that Ayer's rejection of the principle that logical constructions are not part of the ultimate furniture of the world arises from his adherence to the view that all else is reducible, even if weakly, to one's own experience together with his rejection of a solipsist ontology which would otherwise follow. His difference from Russell in this respect can be linked to the fact that he has always been more rigorously Cartesian than Russell, both as to the degree of certainty we can have about our experiences, as contrasted with our beliefs about anything else, and as to the radical distinction between mind and body. A neutral monist ontology seems a good deal more tolerable in the comparatively objective form it assumes in Russell's theory of events. Russell's events really are neutral: some—those where brains are—are mental; others are physical —those that are members of the law-like system of events constituting a material thing; others again are both—non-hallucinatory perceptions.

Ayer's sense-data, on the other hand, are literally mental, as *parts* of minds and are related to physical objects only causally or as elements in their construction. So, if he were to take reducibility as ontologically significant, he would be saddled with a mentalist ontology, which would

not cohere very well with his respect for natural science. His preference, in his later writings, for qualia, conceived as repeatable characters, over sense-data, conceived as private particulars, may be partly designed to desubjectivise the fundamental elements of the process of construction.

Ayer's closeness to Descartes is a matter of style as well as doctrine, taking style in a large sense to cover not merely the excellence of the prose but also his delightful concision and continuous flow of supple and explicit argument. *Language, Truth and Logic*, like Descartes' *Meditations* and Berkeley's *Principles*, shows how much can be contained in a small book. Although I differ from Ayer on many matters I have never qualified my admiration for the way he reaches and expresses his conclusions. Of the more notable philosophers of our time he is the purest, the least encumbered by waywardness or mannerism.

ANTHONY QUINTON

BRITISH LIBRARY BOARD
MARCH 1989

REPLY TO LORD QUINTON

I am grateful to Lord Quinton for the generosity and discernment with which he has written of my work and flattered by his comparison of my philosophy with that of Bertrand Russell. I also regard the main part of his essay as an illuminating contribution to the difficult subject of ontology. It is to this that I shall devote the greater part of my reply.

Quinton neither endorses nor attacks my view that the question what there is, when treated as an internal question in Carnap's sense, is one for our decision. As the examples which I gave in my reply to Mr Foster indicate, there are standard procedures for deciding such internal questions as whether there are pyramids or golden mountains, whether there is an even prime number or a highest prime. When it comes to external questions, such as the question whether there really are numbers or really are physical objects, I follow Carnap in holding that the answers to them are, finally, a matter of choice. This is not to say that one's answers are arbitrary. Indeed, Quinton is mistaken in saying that I recognize only motives, and not reasons, for deciding what sorts of things are to be given a title to real existence. For example, although I am not a thoroughgoing materialist, I think that a philosopher, like Quinton, who maintains that only pieces of matter, in one form or another, make up what Russell called the ultimate furniture of the world can present a better case for his view than, let us say, a philosopher who insists that only the spiritual is ultimately real. Once it has been shown that the phenomenalist reduction of the physical to the mental can not be effected, the denial of reality to physical objects is left untrue to the natural interpretation of our experience. On the other hand, even if the arguments in favour of identifying mental with corporeal states are not conclusive, they are not demonstrably fallacious.

What, then, constitutes reduction and what implications does it have for ontology? The simplest type of reducibility of A's to B's is that in which every A is a logical construction out of B's. As Quinton explains, this is a way of saying that every statement about an A can be rephrased, without loss or dilution of meaning, as a statement about B's. The most straightforward example of a logical construction is the average whatever it may be. To say that the average English mother has 2 ¹⁄₁₆ children is a way of saying, most probably falsely, that the result of dividing the number of their children by the number of English mothers is 2 ¹⁄₁₆. Once this has been made clear, it would be strange if anyone included the average English mother among the ultimate furniture of the world, if only because 2 ¹⁄₁₆ is not a number of children that any mother can have. Admittedly, one could maintain that just for this reason, the average English mother, along with the average French mother and so on, had to be included as a peculiar sort of mother, but no purpose would appear to be served by such perversity.

The case of points and instants, which Quinton also cites as logical constructions, is not so straightforward. To refer to them is not so obviously a means of simplifying a reference to something else. The reason why Quinton treats them as logical constructions is that he follows Russell in accepting Whitehead's method of extensive abstraction. A point is to be identified with the infinite class of volumes that could be represented as converging on it; an instant with an infinite class of similarly converging events. So far as I know, it has never been shown that what is said about points and instants can be rephrased in statements about these infinite classes, but let us assume that this is so. What conclusions should be drawn?

The first thing to be noticed is that this case differs, in an important respect, from that of the average such-and-such. It is not because statements about points and instants are manifestly doing duty for statements about volumes and events that points and instants are regarded as logical constructions. On the contrary, it is only because points and instants are considered unqualified to be parts of the ultimate furniture of the world that substitutes are sought with a better title to that honour. In fact, the title of infinite convergent classes is far from secure, but volumes and events, as entities, have good empirical credentials which they are supposed not to forfeit when enrolled in series that are neither observable as wholes nor in all of their parts.

Quinton takes it for granted that no one believes that there really are points and instants. I am not sure that this is true of all mathematicians, but there is no doubt of its being a view that is widely held. Why should this be so? The answer is that points and instants are disqualified because

they are endowed with properties that banish them from physical space and time. It is assumed that no part of space can fail to be extended in any direction any more than a unit of time can have no duration.

A mathematician who would like to rescue points might argue that it was a mistake in the first place to treat them as candidates for membership of physical space. There are several pure geometries of which it is true that they can be adapted to its measurement. It is an empirical question which of them best serves this purpose. Considered in itself, however, Euclidean geometry, from which nearly all of us first derived our concept of a point, is an uninterpreted formal system. Since one of the interpretations is algebraic, the question whether there really are such things as points can be merged into the more general question whether there really are such things as numbers.

This is a question that Quinton does not discuss though, as a materialist, he is committed to giving a negative answer to it. What makes numbers suspect, to say the least, is that they are not physical and that they cannot be observed. Unfortunately, there are those who take this to be in their favour. Notoriously, Plato regarded numbers as supremely real, partly because they are not, like physical objects, vulnerable to change and decay, partly because they are not, like sensory appearances, relative to different organs and to different points of view. Their title to reality was that they were objects of thought, and the relations between them objects of knowledge. Contemporary mathematicians are not in the habit of disparaging physical objects in the way that Plato did, but many of them still conceive of numbers as having at least as good a title to reality. The very large part that mathematics has come to play in the formulation of theoretical physics may have strengthened this opinion.

All the same, the mathematics that physicists employ is often very abstruse. Can it seriously be maintained that imaginary numbers, like the square root of -1, are part of the ultimate furniture of the world? And let us not forget that Whitehead's treatment of points and instants was patterned on Dedekind's identification of irrational numbers like the square root of 2, with the infinite series of fractions of which they are the limits. In this way, we may hope to arrive at a position where no numbers but the cardinals are candidates for reality.

For those who are suspicious even of the cardinals, as purely abstract entities, the trouble is that they are not at all easy to eliminate. If Russell and Whitehead had succeeded in reducing mathematics to logic, there would be no problem: no sensible person is going to maintain that logical constants like 'or' or 'not' or the existential and universal quantifiers have counterparts in ultimate reality. But the basis for arithmetic is set-theory

and it will not do to make the purely verbal move of counting set-theory as part of logic. The difficulty remains that Russell's definition of a cardinal number as a class of classes which are similar to a given class does not preserve the 'feeling for reality' that he insists on. As the numbers mount towards infinity, the supply of co-ordinating relations between concrete individuals gives out. The terms and their relations become notional and the reality of the classes which include more members, let us say, than there are atoms in the universe, grows dubious, even if we do not go so far as the nominalists in denying the reality of classes altogether.

To escape from this predicament, I shall use Quinton's term 'epistemic construction' in a narrower sense than his. I propose to say that x's are epistemic constructions out of y's if and only if our sole initial access to x's is through our observation of y's. This is true of cardinal numbers. However adventurous the ideas may be of which they are the source they are conceptually derivative from perceptible groups of physical or sensory particulars. This gives us a motive for ruling that numbers are unreal relatively to their origins.

It is, however, no more than a motive, serving to reinforce a prejudice against abstract entities. I at least cannot make it a general rule that epistemic constructions are relatively unreal since I try to show that physical objects are epistemic constructions out of percepts and proceed to downgrade percepts into mental states of persons whose continuous identity depends, at least in part, upon that of the physical objects which are their bodies.

Quinton takes this procedure as evidence of my rejecting the principle that logical constructions are not part of the ultimate furniture of the world, but here he is mistaken. I accept the principle but since my abandonment of classical phenomenalism, I no longer believe that physical objects are logical constructions out of actual and possible sense-data. As Mr Foster has so well explained, I treat them as epistemic constructions out of percepts, which in turn depend for their identity on the location of sensory qualia in particular sense-fields.

Quinton is right in saying that my motive for starting with qualia, the heirs of Berkeley's sensible qualities, is to avoid the trap of solipsism. Thus, unlike Berkeley, I do start out by locating sensible qualities in any one person's mind. From the point of view of the theory which is based upon them, they are available to anyone who has the requisite experiences. My reason for dissociating ontological from epistemological priority is, as Quinton says, that actual percepts are too fragmentary to make up an intelligible picture of the world: nor is there any point in having recourse to such possible percepts as Russell's sensibilia, if

physical objects cannot be presented as logical constructions. I rely here on the assumption that the question what sorts of things there are invites us to select the sorts of things that figure in the theory that most closely reflects the structure of our experience. This has led me to opt for physical continuants with phenomenal properties. My problem has then been to accommodate the particles, said to be discovered rather than invented by physicists, which seemed to me to be competing with objects of more familiar sorts for the same regions of space. I used to share Quinton's view that the particles could be held to be 'literally parts of common objects' but was persuaded out of it. I now again prefer it to the alternatives of awarding these scientific entities an ontological victory over common objects or treating them as nothing more than 'entities of reason'.

Persons come into the dominant theory as sub-sets of physical objects. In the last section of *The Origins of Pragmatism* I made a serious attempt to give an account of personal identity that would vindicate Hume's and William James's conception of the self as a series of experiences but having failed, as Hume did, to find any relation that would unite the members of such a series throughout time, I had to fall back upon bodily continuity. In theory it need not always be the same body, though the brain transplants that might be regarded as a source of bodily transference remain in the realms of scientific fiction. What I have not yet been able to do is give a proper account of the relation of mental states to the body of the person whose states they are. My old view, to which Quinton refers, that it is a matter of their compresence with bodily sensations may be part of the answer but this is clearly not sufficient on its own.

In Quinton's usage an epistemic construction is a whole which one observes, if at all, only subsequently to its parts, or a part which one observes antecedently to a whole. In many cases this could go either way. Since the sight of a whole does not in general enable one to infer the nature of its parts or vice versa, and since the parts are not constructed out of the whole, this usage could be misleading. I also think that he is mistaken in saying that "a nation is a whole whose citizens are its parts". Considered as a geographical unit, England is indeed a whole of which its cities and countryside are parts. But England, as a nation, is not a whole of this sort. It is not "the same sort of entity" nor "falls within the same category" as its citizens. I take it rather to be a logical construction. Everything that is said about England, in this sense, can be rephrased as a statement about English men and women or other persons. For example, "England is no longer a great power" is a concise way of saying that English citizens and those who govern them are less respected than they

once were by foreign citizens and those who govern them, that Englishmen administer fewer foreign persons than they once did, that English people have become less prosperous on the average than such and such sorts of foreigners, and so forth. Politicians, jingoists, and absolute idealists personify nations, but there is no call to follow them. England is not as unreal as Ruritania: indeed, in that internal sense, it is not unreal at all: but it is unreal, relatively to English men and women.

One of the most interesting of Quinton's examples is that of particulars and universals. I do not think that he is quite right in comparing them to Kilkenny cats. I share the view that things are bundles of qualities, if this is understood as a way of saying that singular terms can be eliminated in favour of predicates, though, for practical purposes at least, we should still need demonstratives for the purposes of spatio-temporal location, a fact which may be taken to save particulars from being logical constructions and consequently extruded from the ultimate furniture of the world. On the other hand, it is false that qualities are classes of similar things, if this is understood to imply that references to qualities can be replaced by references to particulars and their relations. For one needs to specify in what way the particulars are similar and this brings back the reference to the quality. Nor is it possible to represent qualities as classes of particulars, where the classes are defined by enumeration. For once all the members of a class have been enumerated, to add that one of them is a member will be to express a tautology, which the attribution of a quality to a particular normally is not.

But if particulars come nearer to being logical constructions out of universals than universals do out of particulars why do nearly all of us think that particulars have the better title to ultimate reality? I suppose that the prejudice against abstract entities is again at work, coupled with the fact that particulars are epistemically prior, in my sense, if not in Quinton's. It might, indeed, be objected that infants most probably respond to universals before they achieve acquaintance with particulars. The mother starts as a recurrent pattern and it needs some sophistication to turn her into a particular continuant. Even so, the pattern is always presented at a location in space and time, so that the infant does start with particulars, even if he is not aware of it.

If abstract entities are to be downgraded, we must find a way of dealing with propositions, about which Quinton says no more than that they are abstract or conceptual entities. I know no way of doing it except by enlisting the contested concept of simultaneity. A proposition can then be treated as a logical construction out of synonymous sentences, the synonymity obtaining both within a language and between the sentences of different languages. These sentences are types but they can

be reduced to synonymous tokens, with a measure of physical similarity within a particular language.

If physical objects are not logical constructions out of events, it is only because our references to events themselves often incorporate references to physical objects. A physical event is frequently the state of a physical object at a particular time. Not always, however, as in the examples of a peal of thunder or a flash of lightning. This could be taken as a reason for sharing Russell's preference for events. Another could be the fact that events are epistemically prior. A physical object is accessible only as an ingredient in a physical event.

In this respect I remain a follower of Wittgenstein. Not the later Wittgenstein but the Wittgenstein of *The Tractatus*. "The world consists of facts not of things." Not facts in general, but 'atomic facts', an infelicitous translation of Wittgenstein's *Sachverhalten*. The more literal 'states of affairs' is better. A mental state of affairs is a mental property or group of mental properties of a person at a particular time; a physical state of affairs is a physical property or set of properties at a particular space and time. A physical object of the common sort is a series of physical states of affairs in a spatio-temporal relation. I take mental states of affairs to be items of sensation or introspection, and physical states of affairs to be perceptible. To appease scientific realists, I refrain from asserting that it is only the actual or possible occurrence of such states of affairs that makes any empirical proposition true. I do assert that it is only in this way that any empirical proposition can be verified.

A.J.A.

20

Emanuele Riverso

AYER'S TREATMENT OF RUSSELL

1. The Unity of Russell's Philosophy

In his charming book, *Russell and Moore: The Analytical Heritage*,[1] Professor Ayer accomplished the momentous task of extracting from the turbulent ocean of Russell's doctrines the main assumptions on which these doctrines are based. He suggested that they amount to the following ten:

1. There are propositions that we accept with certainty and employ as premises for all our beliefs on matter of fact.
2. These propositions are atomic (not compounded and logically independent of one another).
3. These propositions have their expressions in sentences made up of proper names and predicates.
4. The meaning of a name is the object which it denotes.
5. The only things that I can name are my percepts or sense-data and mental states.
6. Predicates stand for universals that are abstract entities with which we are in some way acquainted.
7. Things that we know, but are not acquainted with, are known to us by descriptions that reduce them to things known by acquaintance (this assumption was probably sometimes forsaken by Russell).
8. Every description involves a tacit induction from things we are acquainted with to another thing that is supposed to be related to the former ones. But induction is always liable to the risk of error.
9. The validity of logic and pure mathematics implies the existence

of abstract entities, but it is impossible to exclude all doubts
about them.
10. It is impossible to reach a scientific knowledge that is fully
warranted against all danger of error.

Nobody can deny that such a suggestion by Ayer can be very useful for a
first approach to the philosophy of Russell. But as Ayer contends that
from these assumptions all characteristic doctrines of Russell are de-
rived, we are induced to ask whether *each doctrine* by Russell is derived
from *the compound adoption of such assumptions* or from *one or more of
them*. No explicit indication is given by Ayer to make this point clear, but
taking into account the whole of his exposition the first alternative is
strongly suggested as the proper one. Consequently we are faced with a
sort of short-form system, that would be the *nuclear* doctrine that
Bertrand Russell would have constantly accepted in spite of all transfor-
mations of his views. Were we willing to adopt the picture of *scientific
research programmes* suggested by Lakatos,[2] we could qualify this nuclear
doctrine as the *hard core* of Russell's research programme and regard his
changing views as the *protective belt*, in which he was always ready to
operate requested modifications on or substitutions of doctrines,
provided that the *hard core* was kept safe against all objections.

The short-form system maintained by Russell and resulting from the
composition of the ten assumptions extracted by Ayer would say some-
thing like this:

The only existing things we are assured of are percepts (or sense-data
or sensibilia) and universals; they are combined into atomic propositions
and denoted respectively by names and predicates that form sentences.
We are acquainted with both percepts (or sense-data or sensibilia) and
universals, and are able to attain also the knowledge of other things by
description and induction setting out from what we are acquainted with,
but this knowledge would never be warranted against errors and doubts.

Were we to accept Ayer's treatment of Russell's philosophy, we should
assume this short-form system as a metaphysical doctrine against which
we are forbidden to direct *modus tollens* and of which no demonstration
can be requested. Only an indirect justification was hinted at by Russell
as he thought that the only possible alternative to his views was monism,
which makes mathematics and science impossible. So we should be faced
with the dilemma: either of adopting Russell's short-form system with
the label of *pluralism in nuce* and be content to enjoy the clarifications it
provides for philosophical and scientific problems, or of endorsing
monism and giving up all claims to build mathematics and science. It
would be interesting to know if Ayer is ready to agree upon the adoption
of the Lakatosian picture of scientific research programmes to under-

stand the connection between the ten assumptions and the different doctrines propounded by Russell. But no other connection is to be found though he speaks rather loosely of derivation and of dependence. Certainly he did not have in mind a sort of analytical deduction or entailment or strict implication, nor could he have intended the material or the formal implication mentioned by Russell's logic, when he invoked that sort of dependence by which a doctrine is connected with the premisses, the distinctions or the procedures which it takes for granted.[3]

It is plain that Ayer, though very sympathetic with Russell as a man and as a philosopher, showed in no moment a tendency to adopt his scientific research programme and its *hard core*. He did not hesitate to declare that "Russell's conception of philosophy is old-fashioned".[4] Nevertheless his undertaking to discover a class of assumptions whose logical product would be a hard core doctrine outliving all the philosophical views that Russell abandoned and reappearing again and again in the new views he adopted, is certainly remarkable. It avenges Russell of the remarks made (for example by Broad[5]) on the subject of his readiness to abandon philosophical doctrines for new ones.

2. RUSSELL ON UNIVERSALS

Unfortunately the exquisite result obtained by Ayer is not safe from all doubts. He strongly reduces the transformations that the philosophy of Russell underwent in the years of the First World War, and suggests that Russell always maintained the existence of universals as things in their own sense and never really gave up his initial views on them. He shows a tendency to read a large part of Russell's papers and books in the light of *The Problems of Philosophy*, that was written in the early part of 1912 and contained the most mature form of Russell's Platonism. In this book we can find that the word 'universal' is adopted "to describe what Plato meant" by the word 'idea'. "The essence of the sort of entity that Plato meant is that it is opposed to the particular things that are given in sensations".[6]

Universals are introduced as what substantives, other than proper names, adjectives, propositions, and verbs stand for and as essential elements of propositions, so that "no sentence can be made up without at least one word which denotes a universal".[7] Their being (Russell makes a distinction between *existence* and *subsistence* or *having being*, but here we can ignore it) is qualified as "not merely mental" or as "independent of their being thought of or in any way apprehended by minds".[8] The possibility that substantives, adjectives, prepositions, and verbs stand for universals is wholly irrelevant for their being and for their nature.

When Russell adhered to this view, he was strongly convinced that though the study of grammar "is capable of throwing far more light on philosophical questions than is commonly supposed by philosophers", language is not an object of philosophical inquiry and philosophy is concerned not with words but with reality, which includes universals.

The import of the theory of description was placed in its disclosure of the logical structure underlying sentences that include descriptions, by conveniently remoulding the syntactic features of such sentences; but what Russell thought important for philosophy, were logical structures and he conceived of them as made up of a certain sort of universals named *relations*. The first edition of *Principia Mathematica* was written by Russell (together with Whitehead) when he adhered wholeheartedly to this form of Platonism and he was persuaded that in such a book he was making evident the marvelous system of relations underlying mathematical formulae, the "ordered cosmos, where pure thought can dwell as in its natural home, and where one, at least, of our nobler impulses can escape from the dreary exile of the actual world".[10] In the autumn of 1911 Russell read a Presidential Address to the Aristotelian Society of London entitled "On the Relations of Universals and Particulars," where the ontological firmness of particulars was almost forfeited in favour of that of universals to the point that Henri Bergson who was present in the audience wondered if according to Russell the real problem was the one of demonstrating the existence of individuals and not the one of universals.[11]

Such a view of Russell about universals was disturbed when he met Wittgenstein who had come to Cambridge to study logic. Wittgenstein was deeply interested in the logical inquiries of Russell but, as he had not previously received an idealistic education comparable to that of Russell, he was unable to appreciate the doctrine that made universals into a sort of things denotable by special words, just as individuals are denoted by proper names. Whatever his view about universals was, there can be little doubt that he strongly discouraged Russell from maintaining his allegiance to Platonism and when we read that Russell suffered from Wittgenstein leading him to regard mathematics as nothing but tautologies,[12] we have good grounds to suspect that tautologies were disturbing for Russell, because they needed to be conceived of as mere equivalences between symbols, unable to denote subsisting realities. Be that as it may, a new epoch began for the philosophical development of Russell, and an important feature of this epoch is the struggle he fought to be free from universals as beings endowed with a sort of existence of their own.

He matured a new interest in language and symbolism and tried to conceive of universals, mainly relations, as linguistic features. The whole logical world (inclusive of mathematics) previously conceived of as a

huge system of relations, was now to be conceived of as merely linguistic: "logical constants, therefore, if we are able to say anything definite about them, must be treated as part of the language, not as a part of what the language speaks about. In this way logic becomes much more linguistic than I believed it to be at the time when I wrote the *Principles*. It will still be true that no constants except logical constants occur in the verbal or symbolic expression of logical propositions, but it will not be true that these logical constants are names of objects, as 'Socrates' is intended to be."[13]

In a manuscript of 1951 now in the Bertrand Russell Archives of McMaster University,[14] Russell expressly discussed the question as to whether mathematics is purely linguistic and reached the conclusion "that the propositions of logic and mathematics are purely linguistic, and that they are concerned with syntax". The suppression of logical entities in favour of syntactic features called for a similar fate for all universals. In *An Outline of Philosophy* of 1927 Russell, while abstaining from facing the "metaphysical question" as to whether there are universals, and, if so, in what sense, openly affirmed that "the correct use of general words is no evidence that a man can think about universals" and "there is no need to suppose that we ever apprehend universals, although we use general words correctly".[15] In *The Analysis of Mind* he spoke approvingly of the view of Berkeley that rejected *abstract* ideas and suggested that an idea which is particular in itself becomes general by being made to represent or stand for all other particular ideas of the same sort, and declared that what made an idea into a general one was "a certain accompanying belief" that no individual is represented by it.[16]

Much can be said to criticize this sort of turning by Russell towards psychologism, but he had not abandoned the field of pure logic and had not slid into psychologism, if he had not lost the confidence that predicates and logical constants denote subsistent things endowed with a Platonic nature, that can be labelled *universals*. When in 1959 he affirmed "I still hold to the doctrine of external relations",[17] he did not show any intention to revive Platonism but only to assert his constant allegiance to pluralism. When in *An Inquiry into Meaning and Truth* he mentioned universals,[18] he took care to specify that universals are only words, that is to say "a number of more or less similar noises which are all applicable to a number of more or less similar" cases[19] and "this does not imply that there are universals."[20] He did not avoid the extensional definition of universals, when he incidentally said that "the word 'dog' is a universal, just as *dog* is a universal. . . . There is thus no difference of logical status between *dog* and the word 'dog': each is general, and exists only in instances. The word 'dog' is a certain class of verbal utterances, just as *dog* is a certain class of quadrupeds".[21] But he did not exploit the

notion of universal as a class of individuals and preferred to manage with universals as words, to suggest that they can be conceived of as names not of something abstract or Platonic but of definite portions of space-time.[22]

In *The Philosophy of Logical Atomism* Russell had made a different attempt to dispense with universals as subsisting beings by resorting to facts as correlates of propositions (now conceived of as merely verbal entities or statements). In a proposition he included names as proper symbols to use for individuals[23] and predicates as words expressing relations (monadic or dyadic, etc.)[24]; but to express is not the same as to denote or stand for as a symbol. Unfortunately "the words which symbolize relations are themselves just as substantial as other words"[25] and this is misleading. In fact Russell intended that universals be reduced completely to relations and relations are to be conceived of entirely as *a way of being together of individuals* that could be represented by a word. In his analysis of the sentence "Caesar loves Brutus" he did not find a dyadic relation of love between Caesar and Brutus, which had imported the universal of love, but a triadic relation among Caesar, Brutus, and love, symbolized not by a word but by the order of words.[26] So he tended to reduce all universals to relations and these to a simple disposition of individuals in the complexes called facts.

Russell did not think of the structure of facts as something endowed with a sort of being of its own, so he did not think of relations as beings but only as a way of being of the components of a fact in reference to each other. Professor Strawson hinted at the "disastrous theory of names developed in the *Enquiry into Meaning and Truth* and in *Human Knowledge*"[27] and the same label of *disastrous* could be attached also to the doctrine of facts and propositions in *The Philosophy of Logical Atomism*, but we can hardly impute such failures by Russell simply to the difficulties he incurred with logical subjects and values for individual variables as Strawson contends. What mostly disconcerted Russell was his resolution to dispense with universals as Platonic entities while maintaining his allegiance to the program of making a picture of the world *sub specie aeternitatis*, as he thought that science needs to be. If we ignore all the vicissitudes of Russell's philosophy after 1913 and all the accidents it incurred after he had abandoned his Platonism, we are liable to misrepresent the real import of the doctrines he devised; the suggestion that he simply admitted universals throughout the whole development of his philosophical career is therefore to be rejected as misleading.

Professor Ayer has valid grounds to stress the philosophical achievements of Russell preceding the First World War as they were the most

technically relevant, but it is deceptive to believe that his later books and papers should always be read in the light of the earlier ones. Ayer admits that "the generous Platonism of *The Principles of Mathematics* in which reality was conceded to every object of thought [was subsequently] pared away to the point where even such comparatively respectable abstract entities as classes and propositions appear as logical fictions, and we are left only with universals and perhaps with facts".[28] But the point is that we need to understand what happened to universals in the philosophy of Russell, when Platonism was pared away and they became mere words or linguistic symbols.

3. THE EMPIRICISM OF RUSSELL

Professor Ayer both in his *Russell and Moore* and in his *Russell* gives some information on the logical views of Russell that are more relevant for his philosophy. His exposition is neat and concise and avoids complications and technicalities. It includes a summary of the fundamental notions of Russell's logic, a sketch of the Theory of Types and one of the Theory of Descriptions, but omits giving any suggestion which helps us understand the role of logic in his philosophy. It would be interesting to ask why Russell dedicated such a large part of his time and so much mental exertion to logical exercises. Was it only because he liked the thesis that mathematics and logic are identical and because his attitude to mathematics was almost mystical? Or because he made "the now unfashionable assumption that all our beliefs are in need of philosophical justification"?[29]

If Russell is introduced "as a figure in the high tradition of British empiricism" who stands "much closer to Locke and Berkeley and Hume and John Stuart Mill than he does to the followers of Moore or Wittgenstein or Carnap",[30] the way to a full understanding of his philosophy is barred. In fact he was no more in the tradition of British empiricism than he was in the tradition of British Platonism and he got into the most serious trouble, when he decided that Pythagoras and Plato had to be dismissed from his philosophy and their heritage had to be sold to purchase the more fashionable implements of linguistic and psychological analysis. George Santayana, who made a survey of Russell's philosophy in 1913,[31] did not experience the least suspicion that he was dealing with a philosopher in the tradition of British empiricism and illustrated "the inspiration and imprudences . . . of this young philosophy" as a sort of mathematical Platonism.

Are we to ignore that his philosophical attitudes were firstly moulded

by Hegelian and Kantian doctrines? Is it of no significance that in his youth he was strongly motivated by the problem of foundation and inquired into how these doctrines could supply solid grounds on which geometry, mathematics, and all sciences could be built? Should we compare the strength of Russell's commitment to logical research in the years before the First World War with the strength of his commitment to the analysis of experience in the same time-span, we would easily realize that his use of the Humean doctrine was definitely not of a primary moment. Still in 1959 Russell declared "that experience is a very restricted and, cosmically trivial aspect of a very tiny portion of the universe".[32]

In his logical enquiries Russell looked for foundations. He feared groundlessness. He needed philosophical justifications because he needed solid foundations to rely upon, because he wanted to expel all doubts and all fears of falsehood. Ayer correctly says that Russell's conception of philosophy is old-fashioned because of his need for philosophical justification. In fact from the late nineteenth century to the first part of the twentieth century in Europe a strong philosophical attitude existed that was dominated by the need for sureness and the quest for foundations. Philosophers wanted foundations for mathematics, foundations for science, foundations for aesthetics, foundations for morals. In the decades that followed, philosophers got accustomed to living and thinking without eternal principles and to dispensing with warranted truths; we do not feel any need for things like Absolute or Transcendental. So the needs that had started the tremendous exertion of Russell's philosophical career and whose frustration compelled him to be content with a *passionate scepticism*,[33] have become obsolete; people don't feel them any more and Russell's conception of philosophy has become old-fashioned. But if somebody wants to understand what he aimed at when he ventured on to the path of philosophy and gave logic the momentous role we know, he should trace Russell's problems back to their origin and to the need for sureness and for warranted foundations that was strongly felt by philosophers of the late nineteenth and the early twentieth centuries.

The Kantian a priori and Hegelianism had supplied Russell with some sort of solid grounds, but he had realized that such grounds were unreliable. He resorted to formal logic as he felt uneasy with Hegelian logic. Hegelianism that flourished in England in the late nineteenth century, was more a method of conceiving of the absorption of plurality into unity than a method for building a system of truths on warranted grounds. The study of Leibniz occasioned by a course of lectures which, substituting for McTaggart, Russell gave at Cambridge in 1899, made

him think that metaphysics could be derived from formal logic though the logic of Leibniz relied on the mistaken assumption that all propositions are of the subject-predicate form.[34] Formal logic could be the correct picture of the structures of the world, which do not admit of any doubt, and can be the warranted foundations for the certainties he needed. It could open to him the world of *pure reason* that he dreamed of as a world that "knows no compromise, no practical limitations, no barrier to the creative activity embodying in splendid edifices the passionate aspiration after the perfect from which all great work springs".[35] Russell had not been greatly impressed by the researches on formal logic that had been carried out in the wake of Boole's work and of which the *Treatise on Universal Algebra* by Whitehead[36] was a recent and comprehensive product; he "had not found that they threw any light on the grammar of arithmetic" and had not found in them "even a beginning of solving the problems which arithmetic presents to logic".[37] On the contrary he was impressed by the notation of Giuseppe Peano, because it became clear to him "that his notation afforded an instrument of logical analysis" of the sort he had been seeking for years.[38] Professor Ayer rightly remarks that "Peano's notation is rather cumbersome and Russell himself was greatly to improve upon it, but it opened his eyes to the technical possibility of carrying out a reduction of mathematics to logic".[39] The difference between Peano's notation and the ones used by other students of logic that followed in the wake of Boole, is that while these were generally intended to supply the implements for an algebra of logic, or the means to operate in logic as in a sort of algebra, Peano's notation showed how some very simple concepts or ideas could be used as elements to build up mathematics. This possibility persuaded Russell that, if mathematics were shown to be a construction made up of purely formal elements, its validity could be warranted. So the reduction of mathematics to logic was intended by him as a procedure that would expel all doubts and suspicions from the field of mathematics and would make it into a warranted support of the whole science. His philosophical mind could not conceive of logic as a merely symbolic contrivance; he could not be satisfied with the translation of mathematical symbols into logical ones; he needed to think that logical symbols are representatives of universals (relations) endowed with a sort of objective being and consequently also mathematics is to be conceived of as being made of symbols that stand for universals. The theory of description and the theory of types were intended to discover the system of relations that really underlie linguistic constructs, for example the sentences including descriptions or the sentences in which a paradox appears.

The logic of *Principia Mathematica* was a sort of language or

grammar that could be used without accepting any sort of Platonism. So Russell could still keep to it when he decided that universals as subsistent beings were to be dropped. In *The Philosophy of Logical Atomism* he proposed "to consider what sort of language a logically perfect language would be", and suggested that "the language which is set forth in *Principia Mathematica* is intended to be a language of that sort. It is a language which has only syntax and no vocabulary whatsoever. . . . It aims at being that sort of a language that, if you add a vocabulary, would be a logically perfect language".[40] The time had come in which he was interested in the way of maintaining symbols of universals without admitting of universals as beings.

The new way of conceiving of the logic of *Principia Mathematica* as a mere language which has only syntax and no vocabulary, was conducive to a new success, because Logical Positivism found no difficulty in adopting it in its project of building science strictly on experience with the rigid proscription of all metaphysics. The logic of *Principia Mathematica* was found noninformative. In *Language, Truth and Logic* Ayer approvingly remarked that the meaning of the sign of implication in Russell's and Whitehead's system of logic is something contingent and a proposition like "q. ⊃ .p ⊃ q" gives no information in the ordinary sense; what it does is "to elucidate the proper use of this logical constant".[41] He stated that this system makes it clear that formal logic is concerned "simply with the possibility of combining propositions by means of logical particles into analytic propositions, and with studying the formal relationship of these analytic propositions in virtue of which one is deducible from another."[42]

As universals were expelled from the furniture of the world, the balance between particulars and universals that previously had been more favourable to the latter became decidedly more favourable to the former."

4. Was Russell a Phenomenalist?

Professor Ayer gives much attention to the different sorts of things that Russell proposed as individuals: *sense-data, sensibilia, objects, percepts, events.* What Russell said on such things is rather embarrassing; he frequently changed his mind and expressed conflicting and not very coherent views. The most important change his view underwent, was the consequence of his abandoning the dualism of knowing subject and known thing. When he had accepted such a dualism, he had been interested in describing the world and all things that we have to include in it; as for the knowing subject he was satisfied in conceiving of it as a

term of the relation that constitutes knowledge. But when he came to the conclusion that such a dualism is philosophically untenable and managed to bring forth some sort of monism, he could no more be satisfied with simply describing the world; he felt obliged to describe things in a sort of system in which minds and objects were included as made of the same stuff. Ayer painstakingly collects the different views expounded by Russell under the headings of "Russell's Theory of Knowledge" and "Russell's Conception of Reality",[43] but it is difficult to decide if a view of Russell on what we perceive or know should be better classified as regarding knowledge or regarding the world, because Russell's theory of knowledge became strictly intermingled with his conception of reality. Perhaps it would be useful to mention that Russell was in some way stimulated by the views that Alfred North Whitehead had expounded in *The Concept of Nature*, where he protested against "the bifurcation of nature into two systems of reality, which, in so far as they are real, are real in different senses."[44] The first system is the one of entities such as electrons which are studied by speculative physics and are conceived of as the *cause of awareness*. The second one is *the nature apprehended in awareness*. This bifurcation was central to the problems of philosophical interpretation of scientific views in the early twentieth century and had caused Mach and Avenarius to build up their philosophies known under the label of Empiriocriticism. As Russell was becoming more and more interested in the problems of physics and of psychology and was anxious to build up a philosophical background for both sciences he felt it important that the system of awareness experienced by scientists should not be made extraneous to the things they spoke of in their theories. In the time of his Platonism he had conceived of the experienced world as built up of sense-data and subsisting relations, had adopted as a starting point his own purely private experiences, had admitted that "there is no logical impossibility in the supposition that the whole of life is a dream in which we ourselves create all objects that come before us",[45] but he had thought that we can go beyond our purely private experiences through knowledge by description. In the subsequent development of his philosophy he looked for the way of constructing causal chains among homogeneous entities, part of which should constitute experience, with the proviso "that experience is a very restricted and cosmically trivial aspect of a very tiny portion of the universe".[46]

Professor Ayer, after suggesting that "the starting point of Russell's theory of knowledge . . . is very much the same as that of Locke", correctly says that "where he mainly differs from Locke is in wishing to avoid any suggestion that these sensory elements are mind-dependent",[47] and that "he therefore concludes that there is no logical reason why

sense-data should not exist independently of being sensed".[48] This possibility of independent existence that Russell gave rather early to what is offered to sensible awareness, kept him away from idealism and from Humean sensationalism and paved the way for his subsequent efforts to build up a philosophical background for physics, that prevented the bifurcation of nature against which Whitehead protested.

Professor Ayer shows a preference for *The Analysis of Mind*, when he describes the views accepted by Russell, when he gave up his belief in the existence of mental acts and before he wrote *Human Knowledge*. He makes very little use of *The Analysis of Matter*. Yet Russell said that in this book "in the main there is a fuller and a more careful statement of theories not very different from those of *The Analysis of Mind*".[49] This statement is supplemented by frequent references to the achievements of Whitehead "to whom is due the whole conception of a method which arrives at 'points' as systems of finitely-extended events".[50] Russell declared himself "unable to accept Dr Whitehead's construction of points by means of enclosure-series as an adequate solution of the problem which it is designed to solve".[51] Nevertheless he elaborated his method in the wake of Whitehead's method and the very concept of *event* as a piece of space-time including a bundle of qualities, that he employed in reconstructing the physical world, is a concept that Whitehead had invented as a *homogeneous* term to be used where we are thinking about nature without thinking about thought or about sense-awareness to mean a spatio-temporal unity and the ultimate fact for sense-awareness.[52] We should not ignore that the physical world that Russell was pledged to reconstruct through the rejection of dualism between mind and matter and between sense-awareness and physical speculations was a world that had been deeply remoulded by Einstein through the theory of relativity. This theory had shattered some views concerning space and motion that Russell had suggested in *The Principles of Mathematics*, and had changed many things in the structures of science. The attempt to bridge the gulf between physics and perception by assimilating the physical world to the world of perception and the world of perception to the physical world was profoundly conditioned by the views of Einstein, and Whitehead had made the first useful contribution to it. Russell followed in his wake with his insight and his knowledge of mathematics and physics. It would not be fair to him if his commitment to physical speculations is ignored and the theories of knowledge and reality built up by him from 1914 onwards are described only as philosophical interpretations of everyday experience. Professor Ayer was well acquainted with the links existing between Russell's views and Logical Positivism. He included an essay by Russell on Logical Atomism[53] in the volume entitled *Logical Positivism*[54]

he edited in 1959. So he was well acquainted with the interests that Russell shared with the representatives of this philosophy in finding the best way to rebuild science by means of a sort of perfect language. The very project of Carnap and Ayer himself of eliminating metaphysics from science and philosophy has a strong debt towards the logic of *Principia Mathematica* interpreted as a syntax. We can hardly suspect that in any moment Russell really thought that modern science can be built only from immediate sense-awareness as Hume suggested.

Russell was constantly stimulated by the problem of relating sense-awareness to physical objects. In spite of his *supreme maxim in scientific philosophizing* that stated "Wherever possible, logical constructions are to be substituted for inferred entities",[55] he always looked for a plausible way to move from sense-awareness to other things connected with them, that could stand for the objects spoken of by physics. In fact at the very time he was giving his *supreme maxim* for scientific philosophizing, he introduced *sensibilia* as "those objects which have the same metaphysical and physical status as sense-data without necessarily being data to any mind".[56] It is hardly possible to say which sort of things could be sense-data that are not data to any mind except that they are the same things admitted of by *naive realism*, and it is hardly possible that Russell seriously intended to arrive "at a theory which permitted the transformation of propositions referring to physical objects into propositions which referred only to percepts".[57] Ayer correctly believes "that the most that can be achieved in this direction is to show how a primary system of percepts can be developed and how this can serve as a theoretical basis for our belief in the physical world of common sense".[58] My view is that what Russell in fact strove to achieve was simply a theory that could entitle scientists to start from percepts or sense-awareness, to infer the physical objects they needed for their doctrines though such objects could be described as homogeneous in some way to percepts. The transformation of propositions referring to physical objects into propositions referring only to percepts is not a reductionism of the same sort as the one we can find in *The Analysis of Mind* as Ayer seems to suggest;[59] the former would be the suppression of any object existing in addition to percepts, the latter one had to be a reduction of physical objects and of percepts to a neutral stuff. However Russell was soon disappointed with his achievements in *The Analysis of Mind* and restated his views in *The Analysis of Matter*, where he made use of the term 'event'. The iterated efforts made by Russell to build up a justification for going beyond percepts and discover the world of physics dressed in a way suited to the critical requirements of philosophers is a strong reason to deny that Russell was in the tradition of Hume even when he abandoned the

Platonism of universals. His empiricism was truly a new sort of philosophy, certainly open to criticisms and rich in possibilities, that has nothing to do with that of Hume.

5. THE KNOWLEDGE OF THE PHYSICAL WORLD

Professor Ayer is not content with describing the views of Russell. He adds some criticisms that are always acute and also useful towards a better understanding of what he describes. When he discusses Russell's theory of knowledge, he shows great concern for the conception of physical objects as inferred entities, that he correctly finds more intensely promoted and refined by Russell than the conception of physical objects as logical constructions. He remarks that the first conception is more firmly maintained in Russell's later work;[60] but I wonder if Russell had ever been confident that the world of physical objects depicted by scientists can adequately and usefully be described by converting them into functions of sense-data as he suggested in 1914.[61]

Perhaps the concern of Ayer for Russell's conception of physical objects as inferred entities is partly a consequence of his tacit assumption that Russell intended to be in the trend of Humean phenomenalism. "The great difficulty with any theory of this kind is to see how we can be justified in inferring that any such external objects exist at all. This difficulty is particularly acute for someone like Russell who holds a basically Humean view of causation; for if causal relations are to be analysed in terms of observable regularities, it will seem inconsistent to ascribe causal properties to objects which are in principle unobservable".[62]

But was Russell's view on causation really Humean in the sense that causal relations are to be analysed in terms of observable regularities? In *The Principles of Mathematics* Russell held the view that "causality, generally, is the principle in virtue of which, from a sufficient number of events at a sufficient number of moments, one or more events at one or more new moments can be inferred".[63] So he suggested that the proposition "*A* causes *B*" should be taken as a short form for "*A*'s existence at any time implies *B*'s existence at some future time".[64] The only difficult question that he found was if a causal relation holds between particular events or only between the whole present state of the universe and the whole subsequent state.[65] It was important for him that the implication of *B*'s existence by *A*'s existence did not locate *B* in a moment consecutive to the moment in which *A* is located because, as time is assumed to be a compact series, there cannot be any consecutive

moments; so he thought that to assert a causal connection between A and B is to assert the existence of B after an interval from A. The problem was made more complex, when the theory of relativity made its appearance in physics and Russell hurried to assimilate it in his philosophy. In the essay "On the Notion of Cause" published in *Proceedings of the Aristotelian Society* (1912–1913) and reproduced in *Our Knowledge of the External World*[66] he formulated the concept of causal law as "any general proposition in virtue of which it is possible to infer the existence of one thing or event from the existence of another or of a number of others"[67] and practically made the notion of cause dependent on this concept. In *The Analysis of Matter* he plainly affirmed that "the conception of 'interval', upon which the mathematical theory of relativity depends, is very hard to translate even approximately, into non-technical terms. Yet it is difficult to resist the conviction that it has some connection with causality".[68] He suggested that the adoption of a discontinuous theory of interval might make the thing easier by making causality into a matter of discontinuous transitions, where the magnitude of the interval could be measured by the number of intermediate transitions. The new definition he offers for causality is that "there is a causal relation whenever two events, or two groups of events of which one at least is copunctual, are related by a law which allows something to be inferred about the one from the other".[69] This definition was intended to face the sort of changes described by quantum theory and the recent discoveries in the field of radio-activity, but it offered also the means to adopt a new way of conceiving of bodies and of material identity with the help of the concept of *causal lines*, that entailed the notion of causal law: a causal line is a series of events generated by a causal relation and a unit of matter is a causal line whose neighbouring points are connected by an intrinsic differential law,[70] therefore continuity is not in the essence of material identity; the identity of a body along a span of time is constituted by the causal relation that connects the events located in neighbouring places of space-time. Causal lines build up bodies or pieces of matter and other causal lines connect one piece of matter with another or with events scattered in the space-time (in the case of radiations); some causal lines reach some special events that are percepts included in systems called minds.

Russell included causality among the *postulates of scientific inference*[71] and gave it a new illustration in *Human Knowledge*,[72] insisting that it is a postulate we can't dispense with if we are willing to make some scientific inference. We can conclude that Russell was constantly interested in the notion of causality throughout his life and constantly assumed causality as a relation that simply produces an order among

distant things or events according to a law that is called *causal law*. He
admitted that no logical necessity compels us to think that there are
really causal laws and causal relations in the world, but he contended that
it would be impossible to build up the world of science if we were to reject
causal laws and causal relations, therefore he constantly conceived of
causality as a postulate necessary for effecting scientific inference. This
view by Russell on causality was largely known in the fifties and it was
common opinion that if one event is said to be the cause of another it is
only because the former precedes the latter. This opinion stimulated the
question: "Can effect precede its cause?"[73] and Professor Ayer observed
that "apart from the stipulation that a cause must not succeed its effect,
we would seem to have just as much reason in believing that earlier
events are caused by later events as in believing that they cause them".[74]
It is therefore rather surprising to read that Russell "holds a basically
Humean view of causation" with the consequence that "if causal
relations are to be analyzed in terms of observable regularities, it will
seem inconsistent to ascribe causal properties to objects which are in
principle unobservable".[75] In fact Hume thought that causal relations
were to be analysed in terms of observable regularities in which causes
and effects must be contiguous in space and time.[76] But Russell *never*
conceived of causality in this way; he *never included contiguity nor
observability* in the notion of causal lines or in the concept of causal laws.
In his view causal relations give the Universe internal structures and
supply pieces of matter with identity not in consequence of observed
regular contiguities but by virtue of a postulation that makes science
possible. There is no logical necessity nor anything observable that
compels us to accept causal relations. If we prefer to reject them in all
possible cases, we may do so; but in such case we are prevented both
from building up science and from admitting of external causes for our
percepts. If we comply with postulating causal laws, we can build up the
world of science in which induction is possible and can take our percepts
as effects of external stimuli. So we substitute a scientific conception for
the primitive and unscientific belief in the external causation of our
percepts[77] and have a basis for understanding the existence of other
people and of their having percepts like ours: the similarity of our world
with the world of other persons makes us accept the theory of a common
origin of such worlds in external physical objects for similar simultane-
ous perceptions.[78]

Russell did not ignore the possibility of a phenomenalist view that
would preserve the whole of physics by giving an interpretation in terms
of percepts to every accepted proposition of physics with the conse-
quence that "whatever is, is perceived" is always true. But he thought

that this view is highly improbable and this completion of our science is not possible at present. At any rate this was not the view that he accepted. He only said that such a view is possible. So, if we ask how Russell's theory could justify the inference that external objects exist, the answer would be that no real justification is supplied or even thought possible: there is an option in favour of a scientific view of the world in which causal lines (internal and external to objects) are accepted, some of them connecting percepts with physical objects.

6. History of Philosophy

Professor Ayer is the author of very charming books on the history of philosophy and his books on Russell are among these. Some years ago he published a book, *Philosophy in the Twentieth Century*,[79] originally conceived as a sequel to Bertrand Russell's *A History of Western Philosophy* and confined to some outstanding philosophers of our century. In the preface to this book he expressed the view that Russell's excursions into social and political history included in his history of philosophy "did not throw much light upon the views of the philosophers with which he sought to associate them";[80] he added that since he was not confident in being able to improve on Russell's performance he had abstained from following him in his project of looking into social and political history to find some additional light for a better understanding of philosophers and had been content with concentrating on their views and reciprocal influences. This short account is much more telling than it seems to be. It includes a criticism on Russell's way of writing the history of philosophy and implies the rejection of the method that Russell had tried to employ. My view is that Russell's attempt though not very effective, cannot be so summarily dismissed. First of all it is not a case of mere excursions into social and political history intended to throw light upon the views of the philosophers. The purpose that Russell had set himself was "to exhibit each philosopher, as far as truth permits, as an outcome of his *milieu*, a man in whom were crystallized and concentrated thoughts and feelings which, in a vague and diffused form, were common to the community of which he was a part".[81] This purpose was supported by the belief that philosophers are both effects of their social circumstances and of the politics and institutions of their time, and causes of beliefs which mould the politics and institutions of later ages. This view oversimplifies the matter. Philosophers and socio-political circumstances are functions of a greater number of variables than Russell seemed to suspect and many intermediate factors are operating that

should be taken into account. In fact in the Introduction to his book he enriched the picture by inserting other factors, particularly theology and science. However it is essentially true that "philosophy, from the earliest times, has been not merely an affair of the schools, or of disputation between a handful of learned men. It has been an integral part of the life of the community".[82] Russell concluded his Preface to the *History of Western Philosophy* by observing that if there is any merit in his book, then it is derived from this point of view. If we take this point of view to be a failure, we are pledged to say that there is no merit in his book and we can hardly understand why Professor Ayer conceived of the intention to write a sequel to a book destitute of merit or decided that his book was a sequel to another one planned according to a very different methodology.

Be that as it may, the project of writing history of philosophy not by merely describing the various doctrines of philosophers and the ways in which they influenced one another but also by inquiring into how the social, economic, and political circumstances of each age, acting in the context of a cultural system, contributed to the production of the same doctrines, is a serious one. It is perhaps the only one that can make understandable the development of philosophy through the ages and justify its very existence in the world of humans.

In his "Appraisal of Bertrand Russell's Philosophy" Professor Ayer had made a different criticism of the attempt by Russell to relate philosophical ideas to the social conditions under which they were produced. He said that "for the most part the exposition of the ideas and the description of the social background proceed side by side: no very serious attempt is made to integrate them".[83] This criticism deserves careful attention. Probably Ayer made it with the sincere view that the program of relating philosophical ideas to social conditions is indeed feasible and useful but Russell had not found the way to put it into action. In fact such a program can be a true philosophical problem for students who are not willing to endorse the Hegelian attempt to make the history of philosophy understandable.

Russell realized that the history of philosophy does not develop according to a sort of logic (Hegelian or formal), that philosophical doctrines are not useless exercises of otiose people, that they are not necessarily or simply concerned with science and scientific inquiries, that they are frequently a sort of abstract, symbolic, or strange formulation of wishes, views, and problems present in the life of common or eminent people or of scientists; so he thought of philosophy as a No Man's Land lying between theology and science.[84] So what explication could he find for the fact that in a particular age there existed some specific philosophi-

cal doctrines and not others? How could he relate specific philosophical doctrines to the life of their age if not by describing the most general social and political features of this life? Certainly this is not sufficient, but in some cases it works. In the treatment of ancient philosophy and also of philosophies of the Middle Ages Russell indeed gave some useful suggestions that relate philosophical doctrines with real life. It is true that they are not sufficient to the attainment of the end for which they were designed and it is evident that the treatment of more recent philosophies by Russell is too hasty to include analogous suggestions. But probably the attempt made by him deserves improvement rather than dismissal.

7. RUSSELL'S SOCIAL AND POLITICAL VIEWS

Professor Ayer declared that the section of Russell's work devoted to ethics, political philosophy, social philosophy, the philosophy of education, the history of philosophy, and the philosophy of history contains some of his best writing but "it has not the same theoretical interest as his work in the field of logic and the theory of knowledge".[85] Consequently he completely abstained from mentioning it in his book, *Russell and Moore*. In his book *Russell*,[86] he gave it a less extended treatment than the one reserved for Russell's work in the fields of logic, knowledge, and metaphysics. Professor Ayer is lucid and acute in this exposition as elsewhere. The most serious criticism that can be made in reference to this exposition is that it totally ignores the views of Russell on education. Russell was strongly interested in education; he not only devoted an important part of his marriage with Dora Black to educational problems in the school that he and Dora established at Beacon Hill, but he also wrote some very beautiful and influential papers and books that had a significant role in the transformation of the educational views of our time. In 1964 Joe Park published a book on Russell's views on education;[87] in this book thirty-four entries by Russell relevant to educational problems are mentioned. The most important of them are *On Education* (1926) and *Education and the Social Order* (1932), where some extremely new suggestions are made concerning, among other things, the exclusion of all sex taboos from school, the aims of education, the relation between education and the strengthening of democratic institutions. He was among the first promoters of the importance of the nursery school as a means for the improvement of less favored people.[88] Education was intended by him mostly as a means to produce moral habits, so his treatment of moral problems cannot be satisfactorily dealt with if his

views on educational practices are ignored. For example his suggestion that reward and punishment can be justified only on the expectancy of an influence on future choices and that the retributive idea of punishment is not justifiable, strictly connects education with morality. Professor Ayer affirms "that this is the correct conclusion to be drawn from Russell's premisses" and declares himself "of the opinion that the notion of our deserving reward or punishment cannot be rationally upheld".[89] But the best treatment of punishment by Russell is the one he makes from the educational point of view.[90]

Ayer usefully remembers that Russell held very strong moral convictions but devoted comparatively little attention to ethical theory;[91] the whole of his doctrines in the field of pure philosophy of morals can be found in the essay on "The Elements of Ethics,"[92] and in *Human Society in Ethics and Politics*.[93] The first one adopts the view of G.E. Moore in treating good as an indefinable non-natural quality, in assuming intuition as the only means of discovering the degree of objective goodness of some state of affairs and in defining the objectively right action as the one that yields the best consequences. The second book is less concerned with abstract problems and shows a preference for the definition of good in terms of desire or pleasure. Ayer makes some comments on the views expressed by Russell in these books. He says that Russell underrates the extent to which his rejection of the retributive idea of punishment conflicts with our ordinary moral outlook: "inconsistently, we are more inclined to let virtue be its own reward than vice its own retribution".[94] While agreeing with Russell that the cruelty of somebody does not justify the cruelty of another towards him, he says that "this reasoning is surely sound, but it is not always emotionally easy to accept".[95] Here both Russell and Ayer are not supporting a philosophical doctrine but rather they are in the position of social and moral reformers who do not care much for the logical and critical justifications of their views but rather are more interested in promoting new social attitudes among people. Russell wrote with the belief and the enthusiasm of a prophet announcing a new age that will be dominated by new feelings and will benefit humanity with more happiness than past years. Unfortunately, he was not always conscious that he was talking as a reformer does and preferred to believe that he was speaking as a scientist. He needed to think of himself not only as the promoter of what is better but also as the supporter of what is true. Ayer approximately endorses his hopes and moral suggestions without distinguishing between what in Russell's views can be considered as philosophical and what should better be taken as the proposal of a social reformer. But he correctly observes that Russell's ethical doctrines are not exempt from some difficulties and that "one reason why Russell gets into these difficulties is that he insists on

making ethics descriptive, because he wants to be able to say that ethical propositions are true or false in the same sense as if they were propositions of science".[96] The effort of making ethics descriptive inclined Russell towards utilitarianism, but he was not ready to adhere completely to this position; he did not assume that all desires are for pleasure; he admitted that certain desires cannot be good, that the measure of the amount of pleasure produced sometimes cannot help decide if an action or its opposite is good and that there are things such as freedom and justice, that are valuables independently of their being desired or not. If Russell, Ayer says, had preferred to make his ethics not descriptive but prescriptive, and if he had not departed from the view he had expressed in the thirties[97] that a judgement of value is not an assertion but an expression of desire, he would have been more consistent with himself. Ayer correctly concludes: "It is because so many people do want something more tigerish that Russell's theory of ethics falls short as a descriptive theory. As a prescriptive theory, which is predominantly but not entirely utilitarian I find it altogether acceptable".[98] Unfortunately, Russell was able to label an ethical doctrine as emotional or prescriptivist only when it was other people's doctrine; his doctrines had to be descriptive and scientific.

Russell thought that morality was strictly linked to social order and education, by producing moral habits, and was productive of a particular sort of social order. Consequently his project of political reforms and social improvements were strictly connected with his views on moral codes and education. Professor Ayer gives a short but lucid account of criticisms and suggestions made by Russell on political themes. The most prominent among the books that Russell wrote on politics is *Power* (1938); in it some acute and interesting descriptions and analyses of political institutions can be found. Perhaps the most notable is what he says on governments usually called *democratic* in our time. Under such governments almost every adult citizen has the right to vote, to adhere to a political party, and to stand for election if he can afford it, but the share of power that he obtains is very little. The importance of representatives is strongly reduced and the one of leaders is enhanced. Parliaments are no longer effective intermediaries between voters and governments. In practice all that a citizen can do, as a rule, "is to vote for one or another of two men, whose programmes may not interest him, and may differ very little, and who, he knows, may with impunity abandon their programmes as soon as they are elected".[99] Professor Ayer correctly summarizes these remarks by Russell and adds that his description is cynical but perhaps not "a wholly false account of the way in which representative government is conducted".[100] We must take this statement as a sort of veiled declaration of agreement

with Russell, or we would feel obliged to ask him which part of this account is false.

Unfortunately Russell did not pay attention to the consequences that majority rule produces or can produce in democratic countries. Had he noticed how majority rule can work where there are not only parties but also internal structures of parties, he would have perceived that the pyramidal organization of a democracy can differ little from the pyramidal organization of all dictatorship.[101]

Professor Ayer pays sufficient attention to Russell's views on religion and gives a clear summary of his criticisms against the arguments for the existence of God, against religions in general, and against Christian religion in particular. He makes generally no comment on such views, but where Russell contends that an elevating moral influence can be acknowledged to Christianity only by wholesale ignoring or falsifying of historical evidence, he remarks that "this is to some extent unfair since it ignores the part played by individual Christians in such moral advances as the abolition of the slave-trade of prisoners, the reform in the condition of child-labour, and, at the present time, the opposition to racial discrimination",[102] but the heavy responsibilities of Christian hierarchy are out of question.

On the whole the treatment of Russell by Ayer is sympathetic and acute. The remarks I have made are not intended to diminish its value but only to point out its character. People that remember, as I do, the intellectual life of England in the fifties and for the most part of the sixties, surely remember how in the mind of many students Russell and Ayer were there associated for the best and for the worst. If this association had no better ground, it was because Ayer was the fittest to understand the problems and the views of the Great Old Man and the ablest to expound them with the same lucidity as their author.

EMANUELE RIVERSO

INSTITUTE OF THE HISTORY OF PHILOSOPHY
UNIVERSITY OF NAPLES
DECEMBER 1986

NOTES

1. (London: Macmillan, 1971), pp. 12–15.
2. I. Lakatos, *The Methodology of Scientific Research Programmes*, vol. 1, ed. J. Worrall and G. Currie (Cambridge: Cambridge University Press, 1978), pp. 48–52.

3. A.J. Ayer, *Russell and Moore: The Analytical Heritage*, p. 15.

4. A.J. Ayer, *Russell and Moore*, p. 11; Id., *Russell* (London: Woburn Press, 1974), p. 35.

5. C.D. Broad, "Critical and Speculative Philosophy", reference in M. Weitz, "Analysis and the Unity of Russell's Philosophy" in P.A. Schilpp, ed., *The Philosophy of Bertrand Russell*, 3d ed. (New York: Tudor Press, 1951; La Salle, IL: Open Court, 1989), pp. 57-58 n.

6. B. Russell, *The Problems of Philosophy* (London: Oxford University Press, 1912), p. 53.

7. Ibid.

8. Ibid., p. 55.

9. B. Russell, *The Principles of Mathematics* (London: Allen and Unwin, 1937), p. 42.

10. B. Russell, "The Study of Mathematics" (written Oct. 1902, publ. 1907) in *The Collected Papers of Bertrand Russell*, vol. 12 (London: Allen and Unwin, 1985), p. 86 (30–34).

11. B. Russell, *My Philosophical Development* (London: Allen and Unwin, 1959), p. 161.

12. B. Russell, "My Mental Development" in P.A. Schilpp, ed., *The Philosophy of Bertrand Russell*, p. 19.

13. B. Russell, "Introduction to the Second Edition" of *The Principles of Mathematics* (London: Allen and Unwin, 1937), pp. xi-xii. Here Russell acquiesces to the view expressed by Wittgenstein (*Tractatus* 4.0312) when denying that logical constants are representatives.

14. Published in B. Russell, *Essays in Analysis*, ed. D. Lackey (London: Allen and Unwin, 1973), p. 306.

15. B. Russell, *An Outline of Philosophy* (London: Allen and Unwin, 1927), p. 57.

16. B. Russell, *The Analysis of Mind* (London: Allen and Unwin, 1921), pp. 217–22.

17. B. Russell, *My Philosophical Development*, p. 63.

18. B. Russell, *An Inquiry into Meaning and Truth* (London: Allen and Unwin, 1940), pp. 24, 36, 95, 313, 343, 346.

19. Ibid., p. 24.

20. Ibid., p. 26 n.

21. Ibid., p. 24.

22. Ibid., pp. 94–98. This view strangely hints at the Bradleyan doctrine that unifies the two terms of a judgement into one: "It is not true that every judgement has two ideas. We may say on the contrary that all have but one", F.H. Bradley, *The Principles of Logic*, 2d ed. (London: Oxford University Press, 1922), p. 11.

23. B. Russell, "The Philosophy of Logical Atomism", in *Collected Papers*, vol. 8, 1986, p. 167 (23).

24. Ibid., p. 177 (36–38).

25. B. Russell, *The Analysis of Matter* (London: Allen and Unwin, 1927), p. 243.

26. Ibid.

27. P.F. Strawson, "On Referring" in *Logico-Linguistic Papers* (London: Methuen, 1971), p. 16.

28. A.J. Ayer, *Russell*, p. 38.

29. Ibid., p. 35.

30. Ibid.

31. G. Santayana, *Winds of Doctrine*, 2d ed. (London: Dent; New York: Scribner's, 1940 [1913]), pp. 110–54.

32. B. Russell, *My Philosophical Development*, p. 64.

33. Here a reference is made to the beautiful book of Alan Wood: *Bertrand Russell, The Passionate Sceptic* (London: Allen and Unwin, 1957).

34. Cf. A.J. Ayer, *Russell*, p. 15.

35. B. Russell, "The Study of Mathematics", p. 86 (27–30).

36. A.N. Whitehead, *A Treatise on Universal Algebra* (Cambridge: Cambridge University Press, 1898).

37. B. Russell, *My Philosophical Development*, p. 66.

38. B. Russell, *The Autobiography of Bertrand Russell*, vol. 1 (London: Allen and Unwin, 1967), p. 144.

39. A.J. Ayer, *Russell*, pp. 15–16.

40. B. Russell, "The Philosophy of Logical Atomism", in *Collected Papers*, vol. 8, p. 176.

41. A.J. Ayer, *Language, Truth and Logic*, 2d ed. (London: Gollancz, 1946), p. 17.

42. Ibid., p. 81.

43. A.J. Ayer, *Russell*, pp. 72–115.

44. A.N. Whitehead, *The Concept of Nature* (Cambridge: Cambridge University Press, 1920), p. 30.

45. B. Russell, *The Problems of Philosophy*, p. 10.

46. B. Russell, *My Philosophical Development*, p. 64.

47. A.J. Ayer, *Russell*, p. 72.

48. Ibid., p. 73.

49. B. Russell, "Reply to Criticisms" in P.A. Schilpp, ed., *The Philosophy of Bertrand Russell*, p. 707.

50. B. Russell, *The Analysis of Matter*, p. 290.

51. Ibid., p. 294.

52. A.N. Whitehead, *The Concept of Nature*, pp. 3, 15, 52.

53. B. Russell, "Logical Atomism" in J.H. Muirhead, ed., *Contemporary British Philosophy*, first series (London: Allen and Unwin, 1924).

54. A.J. Ayer, ed., *Logical Positivism* (New York: Free Press, 1959).

55. B. Russell, "The Relation of Sense-Data to Physics" (1914) in *Mysticism and Logic* (London: Allen and Unwin, 1917), p. 115.

56. Ibid., p. 110.

57. A.J. Ayer, *Philosophy in the Twentieth Century* (London: Allen and Unwin, 1984), p. 36.

58. Ibid.

59. Ibid.

60. A.J. Ayer, *Russell*, p. 85.

61. Cf. B. Russell, "The Relation of Sense-Data to Physics", p. 109.

62. A.J. Ayer, *Russell*, p. 85.

63. B. Russell, *The Principles of Mathematics*, p. 478.

64. Ibid., p. 476.

65. Ibid., p. 477.

66. B. Russell, *Our Knowledge of the External World*, 3d ed. (London: Allen and Unwin, 1926 [1914]), pp. 214–46.

67. Ibid., p. 216.

68. B. Russell, *The Analysis of Matter*, p. 367.

69. Ibid., pp. 367–68.

70. Ibid., pp. 322–23.

71. B. Russell, "Postulates of Scientific Inference" in *Proceedings of the Xth International Congress of Philosophy*, vol. 1 (Amsterdam: North Holland Publishing Co., 1949), fas. I, pp. 33-41.

72. B. Russell, *Human Knowledge: Its Scope and Limits* (London: Allen and Unwin, 1948), pp. 471–93.

73. Cf. A.E. Dummett, "Can Effect Precede Its Cause?" in *Supplementary Proceedings of the Aristotelian Society*, vol. 28.

74. A.J. Ayer, *The Problem of Knowledge* (London: Macmillan, 1956), p. 194.

75. A.J. Ayer, *Russell*, p. 85.

76. D. Hume, *A Treatise on Human Nature*, I, III, 15, ed. L.A. Selby-Bigge, 1902.

77. B. Russell, *Human Knowledge*, p. 474.

78. B. Russell, *The Analysis of Matter*, pp. 200–210.

79. A.J. Ayer, *Philosophy in the Twentieth Century* (London: Allen and Unwin, 1982).

80. Ibid., p. vii.

81. B. Russell, *History of Western Philosophy* (London: Allen and Unwin, 1945), p. 5.

82. Ibid., p. 6.

83. A.J. Ayer, "An Appraisal of Bertrand Russell's Philosophy" in R. Schoenman, ed., *Bertrand Russell, Philosopher of the Century* (London: Allen and Unwin, 1967), p. 177.

84. B. Russell, *History of Western Philosophy*, p. 10.

85. A.J. Ayer, *Russell*, p. 177.

86. Short mentions of Russell's views on morality can be found also in A.J. Ayer, *Philosophy in the Twentieth Century*, pp. 39–40 and in "An Appraisal of Bertrand Russell's Philosophy", p. 177.

87. J. Park, *Bertrand Russell on Education* (London: Allen and Unwin, 1964).

88. B. Russell, *On Education* (London: Allen and Unwin, 1960 [1926]), p. 125.

89. A.J. Ayer, *Russell*, p. 120. (In the 1974 edition, the last word appears as "unheld" but that is obviously a misprint.)

90. B. Russell, *On Education*, pp. 92–98.

91. A.J. Ayer, *Russell*, p. 116.

92. B. Russell, "The Elements of Ethics" in *Philosophical Essays* (London: Longmans, Green and Co., 1910).

93. B. Russell, *Human Society in Ethics and Politics* (London: Allen and Unwin, 1963).

94. A.J. Ayer, *Russell*, p. 120.

95. Ibid., p. 121.

96. Ibid., p. 127.

97. B. Russell, *Religion and Science* (London: Oxford University Press, 1935), p. 235, and *Power* (London: Allen and Unwin, 1960 [1938]), pp. 155–71.

98. A.J. Ayer, *Russell*, p. 128.

99. B. Russell, *Power*, pp. 132–33.

100. A.J. Ayer, *Russell*, p. 140.

101. E. Riverso, *Democrazia e gioco maggioritário* (Rome: Armando, 1977).

102. A.J. Ayer, *Russell*, pp. 133–34.

REPLY TO EMANUELE RIVERSO

I do not believe that Professor Riverso's reference to Lakatos's concept of a scientific research programme throws any light on Russell's philosophical career. As I see it, its constant features were a view of philosophy as an attempt to evaluate, and if possible justify, the various ingredients of what is generally accepted, at least by educated persons, as an account of what is true; an adherence to pluralism, after he had followed G.E. Moore in rejecting McTaggart's brand of neo-Hegelianism; after *The Principles of Mathematics*, a fidelity to Ockam's Razor, abandoned only at the point where he found that his preference for logical constructions over inferred entities put the natural sciences out of his reach, and even then leading him to be as parsimonious as possible in the assumptions that he felt obliged to make; after his initial uncritical acceptance of Moore's *Principia Ethica*, a naturalistic moral theory which he mistakenly took to be at odds with his very strong moral and political convictions; a mischievous defiance of common sense as when he maintained that a physiologist who inspects his patient's brain is in fact inspecting his own. This follows quite straightforwardly from Russell's abiding assumption that the only particulars with which one is acquainted, other than one's elusive and eventually eliminated self, are one's own sense-data, or 'percepts', and his scientific belief that one's percepts are physically located in one's head.

Riverso exaggerates Russell's Platonism. Russell is indeed excessively ready in *The Principles of Mathematics* to multiply entities, but here he is following Meinong rather than Plato. It too often escapes notice that the logicism of *Principia Mathematica* is basically empiricist. The members of the sets which are members of those that identify numbers are supposed to be actual individuals; as the numbers increase there is the danger that the supply of individuals will run out: hence the need for

such dubious devices as the axiom of infinity. In the last resort the similarity between the requisite classes is simply postulated.

Russell does indeed claim acquaintance with universals in *The Problems of Philosophy* but he does not commit himself to a Platonic rather than an Aristotelian conception of their status. Bergson was shrewd in his comment that the Problem of Universals, in Russell's treatment of it, should rather have been called the Problem of Particulars, in view of Russell's distaste for the concept of substance, and indeed Russell ended in his *Inquiry into Meaning and Truth* by rejecting substance in favour of a relation of compresence. Riverso is, however, quite mistaken in saying that Russell had come to treat universals as linguistic expressions. What the relations of compresence collected were sets of qualities. Russell's predilection for universals marked his rejection of what he took to be the programme of nominalism. He saw no point in attempts to subordinate universals to particulars by invoking relations of similarity, since similarity was itself a universal.

Riverso makes far too light of the period lasting from 1914 to 1927, in which Russell seriously espoused the doctrine of neutral monism. He refers to the essay "The Relation of Sense-data to Physics", which Russell reprinted in *Mysticism and Logic*, but so far misunderstands it as to identify Russell's sensibilia with the physical accusatives of naive realism. There was hardly any philosophical doctrine which Russell so consistently opposed as naive realism. The reason why he forsook neutral monism is that he could not reconcile it with the causal etiology of perception. This led him to draw an impenetrable curtain between the world of percepts and the world of physical objects, with a consequent gulf between perceptual and physical space. Contrary to what Riverso implies, Russell's conclusion that such a theory is required by the causal etiology of perception is wholly at variance with his own analyses of causal relations.

Because Russell remarked, disingenuously, in the preface to his *History of Western Philosophy* that if there was any merit in his book it consisted in its situating the writings of philosophers in their social contexts and because I declined to follow Russell's example in my *Philosophy in the Twentieth Century*, partly on the ground that Russell had allowed the historical and philosophical sections of his book to run side by side, without making any serious attempt to integrate them, Riverso draws the patently fallacious inference that I find no merit in Russell's book. As for my book's appearing as a sequel to Russell's, the reasons are that I took up the story at the point where he left it and that in my conception of philosophy and moral outlook I remained very close to Russell, however much we came to differ on points of detail. Russell

himself acknowledged this and it partly accounts for our personal friendship during the last twenty-five years of his life.

I plead guilty to the charge that in writing about Russell I have overlooked his treatment of the topic of Education. In mitigation, I can say that while the experiment of running Telegraph House, which Russell himself judged not to have been altogether successful, played an important part in his life, his work on education was not of any great theoretical importance. I do not accept Riverso's opinion that Russell's "treatment of moral problems cannot be satisfactorily dealt with if his views on educational practices are ignored."

A.J.A.

21

Ernest Sosa

AYER ON PERCEPTION AND REALITY

The ". . . problem of perception has always occupied a central place in my philosophical thinking and . . . the movement of my thought about it over the course of forty years has been from the phenomenalism of *Language, Truth and Logic* to what I describe in *The Central Questions of Philosophy* as a sophisticated form of realism."

A.J. Ayer[1]

A. Introduction

Perceptual experience has been a pivot for Ayer's views on meaning, knowledge, and reality throughout a productive career. I discuss highlights of his relevant work, and conclude with a proposal which builds on that discussion.

B. Language, Truth, and Logic

1. Neutral Monism

Language, Truth and Logic[2] postulates only one kind of fundamental entity: phenomena, said to be neither physical nor mental. Both persons (LTL, 125) and objects (LTL, 122–23) are "constructions" from phenomena. Big Ben is a complex of such phenomena, which at the times when it is "seen" or "heard" by Ayer and Russell overlaps with the complexes of phenomena that correspond to them respectively.

Total sense experiences are composed of sense fields which in turn comprise sense-contents. (LTL, 66). Sense-contents may be actual (LTL, 122–23) or possible (LTL, 66).

Principles of sense-content grouping are provided for the composition or "construction" both of physical objects and of selves. Out of all the sense-contents associated with an object, which determine its "real" qualities? This is said to be a matter of convention. For example, convention selects the conditions allowing greatest discrimination as those within which objects show their true colors.

2. Problems

Neutral Monism raises problems of two sorts: first about the self, and secondly about physical objects.

a. About the Self

We are told (LTL, 130) that:

> . . . just as I must define material things and my own self in terms of their empirical manifestations, so I must define other people in terms of their empirical manifestations—that is, in terms of the behaviour of their bodies, and ultimately in terms of sense-contents. The assumption that "behind" these sense-contents there are entities which are not even in principle accessible to my observation can have no more significance for me than the admittedly metaphysical assumption that such entities "underlie" the sense-contents which constitute material things for me, or my own self. And thus I find that I have as good a reason to believe in the existence of other people as I have to believe in the existence of material things. For in each case my hypothesis is verified by the occurrence in my sense-history of the appropriate series of sense-contents.

If I am defined in terms of my actual and possible sense-contents, however, and if, further, you and I are not identical, then (given some plausible assumptions) presumably I would not define you in terms of *all* my sense-contents, but would define you at most by means of some proper subset. Can you then be just as real as I am? Ayer answers (LTL, 130):

> It must not be thought that this reduction of other people's experiences to one's own in any way involves a denial of their reality. Each of us must define the experiences of the others in terms of what he can at least in principle observe, but this does not mean that each of us must regard all the others as so many robots. . . . If I know that an object behaves in every way as a conscious being must, by definition, behave, then I know that it is really conscious. And this is an analytical proposition. For when I assert that an object is conscious I am asserting no more than that it would, in response to any conceivable test, exhibit the empirical manifestations of consciousness.

But the response rings hollow. If Mary is reducible to my experience, in the way suggested by Ayer, then it is hard to see how I could in turn be

reducible to hers. That is to say, if I can define Mary, then she would seem unable to return the favor. For all the actual and possible sense-contents constitutive of Mary must be at my disposal, but they cannot exhaust my total account of sense-contents, lest Mary and I be one. At least that seems so on plausible assumptions about the methods of construction available to the phenomenalist-behaviorist along with facts about spatiotemporal perspective. And it then plausibly follows that Mary's account will fall short of what it takes to define me.[3]

b. About Physical Objects

Concerning the construction of physical objects out of sense-contents, there is a fundamental point where the construction seems too weak, which concerns its use of possible as well as actual sense-contents (LTL, 66). A sufficiently sophisticated psychophysical technology would be able to induce series of sense-contents in us. So the actual specification of the conditions seems essential. But how is that to be done without reference to physical objects?

Besides, it is hard to see how physical object statements are to be unpacked into pure sense content statements. How is it to be shown that the content of a physical object statement involves reference to nothing more than sense-contents or collections of sense-contents? Consider:

1. This snowball is white.

Can 1 be reduced to the following?

2. There is a white sense-content.

If so, there must be mutual entailment, which there is not. Nor does it help to add assumptions like the following: that one is looking at the snowball and only at the snowball; that we ignore the experience of everyone else, etc. This last assumption is especially problematic if we wish to construct selves from sense-contents. But let's waive that for now, and consider just the following:

3. The light shining on this is red.

The conjunction of 1 and 3 together with assumptions of the sort indicated will entail not-2. Hence that conjunction cannot entail 2. And it is then hard to conceive of any sense-contents whose existence would be entailed by a particular physical fact, even one as simple and observational as that reported by 1, even when combined with assumptions like those above (exclusive of 3).[4]

Compare 'Key K opens lock L', which in its dispositional sense

remains true throughout a time interval because of a series of actual or possible openings of L by K. The relevant possible openings must involve not just logical possibility but some sort of "real" possibility, moreover, since otherwise any key opens any lock!

Similarly, when I walk in a mine-free field there are logically possible explosions that I could set off, but in some sense there aren't any *really* possible explosions. When I walk in a heavily mined field, however, every step calls to mind the *real* possibility of an explosion.

Perhaps then Ayer could appeal to something involving this stronger notion of possibility. But what *is* the difference between real possibility and merely logical or abstract possibility? Consider:

1. Relative to S, E is a *logical* possibility within an interval I iff there is an action (or a course of action) ø that S could perform within I, and conditions C that could hold within I conjointly with S's ø'ing, *such that* if, within I, S were to ø and C held, then E would occur.

2. Relative to S, E is a *real* possibility within an interval I iff there is an action (or a course of action) ø that S could perform within I, and conditions C that *both* do hold within I and could hold within I conjointly with S's ø'ing *such that* if, within I, S were to ø and C held, then E would occur.

Compare the logical possibility of an explosion as you walk in an unmined field with the real possibility of an explosion as you move to one that is mined.

Let C = (there being a live mine before me a step away). And let's assume that, given this C, there is a very real possibility of an explosion. Now it seems plausible that in a sense the following would be true in such circumstances, whereas it would not be true in the different circumstances of the mineless field: that if I were to take a step forward there would be an explosion.

For comparison, let C = (there being an unobstructed snowball before me, in good light, at arm's length). And let's assume that, given this C, even if my eyes are closed there is a very real possibility of a visual experience of roundness and whiteness. In a sense the following would be true in such circumstances, whereas it would not be true in the different circumstances of a snowless environment: that if I were to open my eyes, there would be a visual experience of whiteness and roundness.

Perhaps then Ayer's "possible sense-contents" involve not merely logical possibility but *real* possibility. There is of course no hope of isolating the single condition of *there being a snowball before me* by means of the one conditional that if I were to open my eyes I would have a visual experience of whiteness and roundness. There are ever so many

different conditions that do not include the presence of any snow and still give rise to the truth of that conditional.

But perhaps the idea is rather this: if we consider the possible courses of action open to me at the moment and the experiential outcomes of those courses of action, some such infinite set of conditionals would capture the single condition of there being a snowball before me. We could then say that there being a snowball before me was necessarily equivalent to the joint truth of that set of conditionals.

The claim that there is a snowball before one (or at least the claim that there is something white and round before one) would thus perhaps reduce to a claim about phenomena. Not just the phenomena one actually experiences, however, since one's eyes may be closed; but rather the phenomena one does or *would* experience. So the snowball (the white and round object) is perhaps reducible to the subject and his phenomena, just as the average person reduces to flesh and blood people. Ayer himself seems at times inclined to favor a view of this sort, as in his *Problem of Knowledge:*

> The phenomenalists are right in the sense that the information which we convey by speaking about the physical objects that we perceive is information about the way that things would seem, but they are wrong in supposing that it is possible to say of the description of any particular set of appearances that this and only this is what some statement about a physical object comes to. Speaking of physical objects is a way of interpreting our sense experiences; but one cannot delimit in advance the range of experiences to which such interpretations may have to be adjusted. (PK, 146–47)

However, the introduction of *possible* phenomena imports a complication, for the possibility in question must be *real* and not just logical. But real possibility is grounded in actual conditions, as in the lock-opening and mine-explosion cases. And what would be the "base" or "ground" for the phenomenalist's actual conditions relative to which his possible phenomena are to be defined? Berkeley had his answer in the will of the Allmighty Atlas, and materialists have their answer in the physical world beneath phenomenal appearance. For the materialist underlying grounds could be rather like those which underlie the following conditional:

This pencil would fall if released.

The actual conditions that ground this conditional presumably include the spatial relation of this pencil to the Earth, the relative masses of the two, etc. Compare:

I would have an experience of white if I opened my eyes.

What actual conditions ground this? Let's try the relation between myself and God and certain properties of each of us: e.g., God's willing now that

I not open my eyes without experiencing white. That may be a start for a theist, but is of little use to more radical phenomenalists who reject God along with matter. What then can ground such conditionals as: I would experience a sense content of something white if I ø'ed? What is now left as a base or ground for this? Presumably it would be just myself and my properties.[5] If so, then the fact that there is a white piece of paper before me has a status relative to me similar to the status of the elasticity of a rubber band relative to the rubber band. The rubber band can be elastic even when unstretched, so long as it *would* snap back if stretched and released. And this conditional can be true though unfulfilled, in virtue of the rubber band's intrinsic properties. Similarly, there can be a white and round snowball before me even when I experience no relevant phenomena. For the phenomenalist the white and round snowball can nevertheless exist in virtue of the fact that I *would* experience appropriate phenomena if I acted in certain ways. And this conditional is then true (for the solipsist phenomenalist) in virtue of my intrinsic properties.

A major problem for such phenomenalism stems from perceptual relativity: white paper looks white under white light, red under red, etc. Any possible course of experience resulting from a possible course of action will apparently underdetermine our surroundings: it will determine, e.g., that there is *either* white paper under red light *or* red paper under white light, or the like. No finite set is likely to do the work required for the phenomenalist's reduction, so defenders of phenomenalism have appealed to infinite sets. Of course no-one is ever going to list the members of such a set. Instead, the argument is indirect. Empiricism dictates that we understand the existence of bodies in terms of experience. The best way we can find of understanding the existence of bodies in terms of experience requires such sets. So, since we do understand bodies (or propositions about them) and since empiricism is true, we have good reason to believe in such sets.

Ayer long ago granted that reductionist phenomenalism with its ubiquitous finite translations of physical object statements is unacceptable; and, as we have seen, he once seemed favorably disposed to the reduction to infinite sets recently mentioned. In any case, he has not ever abandoned his commitment to the primacy of experience. And what we need now to consider is the *form* that this primacy most recently takes. Before doing so, however, it may be helpful to take up some closely related questions, and the approach to them by Bertrand Russell, whose thought has been an important influence on Ayer.

C. Russell on the Primacy of Experience

The Principle of Acquaintance is fundamental for understanding Russell's philosophical development, and it joins him to the tradition of British Empiricism, which is also Ayer's:

(PA) Every proposition which we can understand must be composed wholly of constituents with which we are acquainted.[6]

A crucial concept here and a central concept of Russell's philosophy is that of acquaintance. We have ". . . *acquaintance* with anything of which we are directly aware, without the intermediary of any process of inference or any knowledge of truths" (POP 46). In addition, we

have acquaintance in sensation with the data of the outer senses, and in introspection with the data of what may be called the inner sense—thoughts, feelings, desires, etc.; we have acquaintance in memory with things which have been data either of the outer sense or of the inner sense. Further it is probable, though not certain, that we have acquaintance with Self, as that which is aware of things or has desire towards things. (POP, 51)

The Empiricist's Dilemma (to give it a convenient label) arises for Russell from the following argument.

(a) The Principle of Acquaintance (PA, given above).
(b) One cannot be directly acquainted with any external thing (e.g., with any snowball).
(c) The constituents of the proposition that the external round thing before me is white are that round thing itself (the snowball) and the property of whiteness.
(d) Therefore, we cannot understand the proposition that the external round thing before me is white.

In order to allow understanding of the commonsense world of ordinary objects, therefore, the empiricist who adheres to PA (premise a) must give up either premise b or premise c. Russell can opt to reject premise c, and can buttress that choice by appeal to his Theory of Descriptions, which analyzes the proposition (P) *that the round thing before me is white* as the conjunction of the following three propositions:

(i) There is at least one round thing before me.
(ii) There is at most one round thing before me.
(iii) Whatever is a round thing before me is white.

No particular round thing figures as an element of any of the propositions i through iii, which except for the reference to oneself are quite general, involving only certain properties and quantification. Thus the snowball

itself could be the "subject" of P—of the conjunction of i, ii, and iii—only indirectly, by being the one thing that satisfies both i and ii. This enables Russell to reject c and hence avoid the unwanted conclusion d. Thus could an empiricist advocate of PA make room for understanding of the commonsense world of snowballs, etc., and the propositions descriptive of it. That is not a complete solution, however, since a question yet remains.

Can one have direct acquaintance with the property of being round? I mean the roundness which applies to snowballs, basketballs, and billiard balls, the roundness of external objects. For if we cannot have such acquaintance, then we are still led to d, by a very similar route:

(a) The Principle of Acquaintance (as above).
(b') One cannot be directly acquainted with the quality of (external) roundness.
(c') The quality of (external) roundness is among the constituents of the proposition that the round thing before me is white.
(d) As above.

The question of our direct acquaintance with universals is taken up by Russell in chapter X of *The Problems of Philosophy*. But there is not in that chapter an unambiguous answer to our question. We do find that, among universals," . . . there seems to be no principle by which we can decide which can be known by acquaintance, but it is clear that among those that can be so known are sensible qualities, relations of space and time, similarity, and certain abstract logical universals" (POP, 109). No primary quality is listed among the examples of sensible qualities, however, so the status of roundness is left somewhat ambiguous.

The solution may be found in the following passage:

> Many universals, like many particulars, are only known to us by description. But here, as in the case of particulars, knowledge concerning what is known by description is ultimately reducible to knowledge concerning what is known by acquaintance. (POP, 58)

What we need now in order to implement the suggested solution is some *connection* between the external roundness of snowballs and our visual experience of a certain sort, on the assumption that among visual qualities only those present in our visual experience are of our acquaintance. What connection might Russell propose?

The foregoing has pieced together scattered hints and remarks by Russell and is hence somewhat speculative as a reconstruction of Russell's own thought. I myself find it very plausible that the line of reasoning above was for Russell a substantial reason in favor of his Theory of Descriptions. But it leaves open our question as to just what

connection could be used to gain knowledge by description of the properties of external things. And here our reconstruction becomes even more speculative.

Chapters II and III of *The Problems of Philosophy* suggest that the needed connection would be provided by causation. For example, we could view the property of being (externally) round as *the property whose exemplification by something bearing a certain spatiotemporal relation to one causes in one certain sense experiences (visual and tactual)*. Thus we appeal only to certain qualities present in our experience, which are hence direct objects of our acquaintance, to causality, and to relations of space or time. If for Russell we can have direct acquaintance with relations of space, time, and causality, therefore, we have the general lines of a solution for the Empiricist's Dilemma: namely, how to gain understanding of the concepts that give us access to our commonsense world of snowballs, etc.

Indeed, it all comes down to relations of space and time, given Russell's famous essay "On the Notion of Cause" (his Presidential Address to the Aristotelian Society in the year he published *The Problems of Philosophy*, 1912).[7] That essay suggests that the useful and clear content or replacement for ordinary or philosophical notions of causation involves the notion of natural or scientific law, which amounts to nothing more than certain "functional relations between certain events at certain times, which we call determinants, and other events at earlier or later times or at the same time" (ONC, 201). On the present reconstruction, we end with a question for Russell: Can we have acquaintance with the relations of space and time needed for access to the world of common sense via the route suggested by the Theory of Descriptions?[8]

D. AYER'S CONSTRUCTION OF THE PHYSICAL WORLD

Ayer's thought on perception and reality has responded to three questions which, though related, may be distinguished as follows:

QO The question of ontology: What sorts of things are there?

QU The question of understanding: What sorts of concepts can we understand, and how do we philosophically understand such understanding? (Are there any general restrictions on it? How is it attained? Are there any general principles in terms of which we might attain a general understanding of our own understanding?)

QE The question of epistemology: What in general terms can we

know or believe with justification as to what there is, and how do we attain such knowledge or justification?

In the first section above we focused on QO. At first Ayer's answer was as we saw that fundamentally reality consists of phenomena. All other things, including physical objects and selves, are reducible to phenomena.

In the second section, on Russell, we focused on QU. The answer there, with which I believe Ayer once agreed, is that what we understand is of two sorts: (a) what we understand directly, by ostension, which corresponds to the items of our direct acquaintance; and (b) what we understand indirectly, which we must understand by relation to what we understand directly.

Analytical phenomenalism, which requires that all acceptable physical object terms and sentences be translated into phenomenal equivalents plausibly establishes a connection between QO and QU (and the same goes for Russell's PA together with his methodology of analysis or reductive definition). But Ayer long ago abandoned analytical phenomenalism:

> . . . I once held that not only every perceptual statement, but also every statement about a physical object, was reducible to a set of sense-datum statements, in the strong sense of being translatable into them, but this thesis . . . is one that I have long since given up.[9]

What are Ayer's more recent views on these matters?

First of all, on reducibility his position is somewhat ambiguous. Take Michael Dummett's form of "reductionism," which for a given class of statements is as he puts it that ". . . a statement of the given class cannot be true unless some statement, or perhaps set of statements, of some other class, which I shall call the *reductive* class, is true."[10] Referring explicitly to this "relatively weak sense of the term" *reduction*; Ayer writes: "I no longer hold that statements about physical objects are capable of reduction. . . ."[11] And he gives the following as his reason:

> . . . I do not think that, in the case of every statement about a physical object to which I assign a truth value, it would always be possible to formulate a set of subjunctive conditionals about percepts which would be such that, unless they held good, the physical object statement in question could not be true.[12]

But this does not define Ayer's position on the "reduction" of the physical to the phenomenal with all desirable specificity. For it is not clear enough what it means to say that "it would always be possible to formulate a set of" statements of a certain sort. Possible for whom? For us? In what circumstances? As we are presently constituted? With what allowance of time? For a better sense of the worry here, compare the

following two statements: (a) for every finite set of numerals there is a conceivable being who could formulate it, (b) for every finite set of numerals, some of us, as we are presently constituted, with our present life span, etc., could formulate it. Dummett's account of "reduction" leaves open as a possibility reduction to infinite sets. And we have just seen that Ayer's rejection of the reduction of physical object statements to phenomenal statements does not clearly extend to the case where the reducing set of phenomenal statements is infinite.

In any case, what such reduction to the infinite would *not* enable is an explanation of how we could gain understanding of the reduced set by appeal to the reducing set. Suppose it is part of our answer to QO that fundamentally only phenomena exist, where physical object statements are reducible to infinite sets of phenomenal statements. Even so, that would not help answer QU, unless we are capable of operating with infinite lists of statements which are not even guaranteed to be organized in any simple way. So Ayer's rejection of the "reducibility" of physical object statements to phenomenal statements may be based on an implicit assumption that the reducing sets are to be finite (and indeed reasonably manageable), given the objective of answering not only QO but also QU.

That Ayer was long fundamentally concerned not only with QO but also with QU is open to little reasonable doubt. From the days of his advocacy of verifiability criteria to the present, QU was a focus of his thought. In this he joined Russell and other empiricists. He took up therefore not only the question of what fundamentally there is, but also the question of our conceptual resources for beliefs about what there is. At first, with Russell and other empiricists, he admitted only acquaintance and/or ostension as modes of direct access to allowable concepts. Our access to other concepts was to be derived by definition or otherwise from those we access directly. And this returns us to Russell's question of how we can gain access to physical object concepts given only a basis of acquaintance.

To this question Ayer first rules out the answer of a Lockean scientific realist:

> . . . It is not disputed that the scientist is able to explain the workings of our apparent objects of perception, as well as our perception of them, in terms of the workings of the imperceptible objects which figure in his theories. But then, if he is a realist, in the relevant sense of the term, he proceeds to expel the apparent objects from the places which they are needed to mark out, and allow his imperceptible object to enjoy the vacant possession. The obvious objection to this procedure, as made by Russell and others, is that, when the appearances go, the places go with them . . . [13]

And with the places presumably also "go" spatial relations. What is more, recourse to causation would be ineffective, even if we did not

require its reduction to spatiotemporal relations and functional relationships:

> Put succinctly, the decisive objection to the version of the causal theory which turns physical objects into unobservable occupants of an unobservable space is that if this were so we should have no means of identifying them, and if we had no means of identifying them, we should have no reason to believe that they played any part in the production of our sensations, or even that they existed at all. The point which the advocates of this position have overlooked is that physical objects cannot be identified in the first instance as the causes of our sensations: they have to be independently identified before we can have any right to say that the causal relation holds. It is only because I can, through perception, independently establish the fact that the table is there in front of me, that I can subsequently explain my seeing it in terms of its effects upon me.[14]

This attitude to causation and the spatiotemporal framework is a fixture of Ayer's thought about perception and reality. Elsewhere he expresses it in attacking the dispositional account of phenomenal properties:

> [If] . . . our average man does think of phenomenal properties as merely dispositional, he can be faced with a set of questions. . . . What is the object which possesses these properties? How does he distinguish it from other objects? How does he visually locate it? It is no good his answering that it is the one and only object that satisfies such and such absolute descriptions, since the properties which answer to these descriptions are not phenomenal. If we knew nothing about an object except that it possessed these properties, we should not know where to look for it, nor should we have any means of recognising it if we did know where to look. [The reply that] . . . the object is being observed . . . conveniently forgets that all that its being observed amounts to [on the dispositional account] . . . is its producing a variety of sensible effects. It is these effects, not *its* visible colour and shape, for it has none, but the colour and shape of its sensory products that originally serve to distinguish it and to locate it in a space of which the other occupants are equally phenomenal. But how can it be conceived to occupy *this* position unless it is somehow identified with its effects or abstracted from them? If from the very outset it is set apart from them as their cause, we have nowhere to place it, indeed no object to place except an unknown somewhat of which *these* are the effects. We have to conceive of it, in Russell's way, as a wholly inferred entity; an unobservable occupant of an unobservable space.[15]

Ayer has increasingly shifted his attention to question QE from questions QO and QU. He now writes: "I treat the question of what there is as one that arises only in terms of a theory for which sense data provide *no more than an epistemological basis.*"[16]

And how do we attain understanding of this theory? No longer is it plausible to suppose that we do so through the combined power of ostension and definition. But then how? How do we answer QU? It might be thought that Ayer's answer is contained in his "Construction of the Physical World." But now we are told that this could at best explain how

AYER ON PERCEPTION AND REALITY 557

sense data provide an *epistemological* basis for the commonsense, physical object framework. And this theme is repeated elsewhere:

> The account, which I have sketched in *The Central Questions of Philosophy* and elsewhere, of the way in which an individual observer might arrive at something approaching what I have called the common-sense view of the physical world was not designed either as a work of fiction or as a contribution to genetic psychology, though I should naturally be gratified if the psychological evidence supported it. It was intended rather as a form of analysis of the common-sense view. . . . On the assumption that the common-sense view can be treated as a theory with respect to the immediate data of perception, my purpose . . . is to bring out those features of sensible experience which make it possible for us to employ the theory successfully and concurrently justify our acceptance of it.[17]

It emerges that the "construction of the physical world" proposed in *The Central Problems of Philosophy* is in the first instance only of epistemological interest. It is meant to show how our commonsense theoretical framework of physical objects surrounding us in space and time is epistemically vindicated: "The theory is vindicated not indeed by any special set of observations but by the general features of our experience on which it is founded, and since these features are contingent, it could conceivably be falsified, in the sense that our experiences might in general be such that it failed to account for them."[18] The construction itself and Ayer's comments on it are shot through with metaphor. Qualia are "turned into" particulars, sensory patterns are "concretised" into percepts, which in turn are "standardised" and "transmuted," by postulation, into "visuo-tactual continuants." And eventually the resulting theory "predominates" over its "origins," and the "visuo-tactual continuants" are "cut loose from their moorings." The point and result of the whole effort, it now emerges, is to provide an *epistemological* account of our justification for accepting the commonsense physical object framework. Only question QE would be answered directly by the construction, therefore, and we are left wondering what to do about QO and QU, the predominant questions of the earlier stages of Ayer's thought, once shared with fellow empiricists of Vienna and closer to home.

Conceivably, Ayer's "epistemological basis" is meant to address both QU and QE. But in that case, the metaphors really need to be explained. We do have a sort of explanation of them so long as we restrict ourselves to QE. The metaphors of "predominating" and of "cutting loose the moorings" can be understood if the real point is the epistemological claim that our general view of commonsense reality gains its justification and its right to independent standing by means of its explanatory relation to the general features of our experience, features which might have been different, so that their being as they are can and does receive

some explanation in terms of commonsense realism—this last being a claim that Ayer makes explicitly and lucidly. But all such reasoning still does little to explain the way we understand that general commonsense view in the first place.

So far as I can determine, then, Ayer has abandoned QU. Once having satisfied himself that the answer by appeal to ostension and definition is unacceptable, he resorts to metaphor or simply speaks of "positing,"[19] without explaining how we gain conceptual access to the physical object concepts in terms of which to do our positing. The same is not true with regard to QO, fortunately, and here we are offered some new and interesting ideas, echoing basic attitudes found in Ayer's thought from its beginnings. Returning to our theme of perception and reality we approach our issue by first considering a critique of Ayer's views by P.F. Strawson, along with Ayer's response.

E. PERCEPTION AND REALITY

In "Perception and its Objects"[20] Strawson argues first, contra Ayer, that our realist conception of the world must not be considered any sort of "theory" based on "data" provided by the senses or by sense experience. Secondly, that conception of ours is said to postulate our immediate awareness of physical continuants in a spatial framework, things with visual and tactile properties causally responsible for our occasional perceptions of them. Third and finally, our conception is critically examined with one question uppermost: Can we rationally sustain it more or less as it stands despite the rise of science? Throughout, Ayer's views are discussed in some detail.

The "common realist conception of the world does not have the character of a 'theory' in relation to the 'data of sense'. . . . It is rather, something given with the given."[21] Strawson disputes "the doctrine that a realist view of the world has, for any man, the status of a theory in relation to his sensible experience, a theory in the light of which he interprets that experience in making his perceptual judgements."[22] What is the argument?

> In order for some belief or set of beliefs to be correctly described as a theory in respect of certain data, it must be possible to describe the data on the basis of which the theory is held in terms which do not presuppose the acceptance of the theory on the part of those for whom the data *are* data. But this is just the condition we have seen not to be satisfied in the case where the so-called theory is a general realist view of the world. The 'data' are laden with the 'theory'. Sensible experience is permeated by concepts unreflective acceptance of the general applicability of which is a condition of its being so

permeated, a condition of that experience being what it is; and these concepts are of realistically conceived objects.[23]

This passage is richly suggestive, however, and several different arguments might be drawn from it. Of those that have occurred to me I formulate now the one that seems strongest and most interesting, placing in italics some interpretational suggestions:

1. No description of the ordinary experience of a normal adult can be full enough and adequate to support the general realist view unless it makes use of concepts of realistically conceived objects, concepts which are unreflectively supposed to be generally applicable *(both by the describer and by the experiencer, presumably)*.
2. *But to accept the general applicability of such concepts is to accept the general realist view.*
3. And no view can be a theory relative to certain data if the data cannot be described *fully enough and adequately to support the view* unless the view is already accepted; i.e., if the description of the data in that sense presupposes the view.
4. Therefore, the general realist view cannot be a theory relative to the ordinary experience of a normal adult.

It may be granted that, relative to normal attitudes and linguistic resources, a normal adult's ordinary experience would be best described by the subject in terms of the "as if" device: by saying that the experience is just like the experience that one has when facing a scene of a certain realistic sort in good light, etc. But is it clear that the ordinary experience of a normal adult *could not possibly be described* except through some such use of realistic concepts? Strawson makes the claim almost baldly (on pp. 43–44), and then repeats it twice in combination with a thesis about experience which does not seem obviously equivalent:

> . . . [N]ow it appears that we cannot give a veridical characterisation even of the sensible experience which these judgements, as Ayer expresses it, 'go beyond', without reference to those judgements themselves; that our sensible experience itself is thoroughly permeated with those concepts of objects which figure in such judgements.[24]
>
> Sensible experience is permeated by concepts unreflective acceptance of the general applicability of which is a condition of its being so permeated, a condition of that experience being what it is; and these concepts are of realistically conceived objects.[25]

If we distinguish, as surely we must, between sensible experience itself, and descriptions of it, then if one cannot describe one's experience except by use of realistic concepts it may be derived from this that one's

descriptions of one's sensible experience will be "permeated" by such concepts, but I see no immediate way to derive that one's sensible experience *itself* will also be so "permeated," whatever exactly this may mean. Of course, if one's sensible experience itself were so permeated, that might provide an argument for the claim that it could not be adequately described without appeal to the permeating concepts. However, as things stand, it needs first to be shown that permeation of the description entails permeation of the described.

It may be replied that we needn't assume experience itself to be permeated by realistic concepts. Though it may be put that way for a more lively form of expression, the real point is that the *description* of experience must be so permeated. Fair enough. But that removes our only argument for this "real point." Either way, therefore, one feels an important lack here.

Ayer dissents from the view that either our experience or our descriptions of it must be permeated by ordinary realistic concepts. He sees no reason to suppose that a Berkeleyan idealist or a Lockean or scientific realist must have sense experiences "radically different in character from those of the ordinary man." The commonsense realist would simply adopt "a different manner of accounting for experiences of the same sort as those for which the scientific realist thinks that he can give a better account."[26] Here I must side with Ayer at least to the extent of seeing no compelling reason for the claim that one's experience *itself* will differ with the adoption of a different view of the world around us, and that (hence) it is *impossible* to describe ordinary experience except by use of ordinary realist concepts.

We are next shown important features of the commonsense realist conception of the world: "From the standpoint of common-sense realism we take ourselves to be immediately aware of real, enduring physical things in space, things endowed with visual and tactile properties; and we take it for granted that these enduring things are causally responsible for our interrupted perceptions of them."[27] By contrast, scientific or Lockean realism attributes to physical objects only properties postulated by science, and denies to the objects themselves the visual and tactile qualities of ordinary perception:

> To perceive physical objects as, according to scientific realism, they really are would be to perceive them as lacking any such qualities. But this notion is self-contradictory. So it is a necessary consequence of this form of realism that we do not perceive objects as they really are.[28]

Finally, on the basis of these descriptions Strawson subjects the scheme of common sense to critical examination. "The main question to

be considered . . . is whether we are rationally bound to abandon, or radically to modify, the scheme in the light of scientific knowledge."[29]

We need first to recognize fully the great sway of commonsense realism over ordinary consciousness. When we use concepts like that of "the lips and hair of the beloved," we mean not sensa or ideas but independent existents, immediately perceptible and possessed of phenomenal qualities, visual and tactile. But this results in a clash. "If scientific or Lockian realism is correct, . . . [and if] . . . the things we talk of really have phenomenal properties, then they cannot, on this view, be physical things continuously existing in physical space. Nothing perceptible . . . [immediately] . . . is a physically real, independent existence."[30]

The scientific realist might respond, in a Kantian vein, by granting the sway of commonsense realism while holding it to be rationally inferior to the world view unveiled by science. Kant himself consigned even the framework of space and time to our subjectivity, which exempts his philosophy from a weighty objection to scientific realism, an objection of a sort urged already by Berkeley in rejecting Locke's bifurcation of nature—Locke's divorce of primary from secondary qualities (among other things). Against scientific realism we may now urge that the spatiotemporal framework cannot possibly be devoid of all phenomenally accessible objects. We cannot remove all colored and shaped bodies and expect to make sense of a universe composed of imperceptible particles arrayed in a spatiotemporal system. Ayer has used this objection repeatedly through the years, expressing doubt for example as to "whether the notion of a spatial system of which none of the elements can be observed is even intelligible."[31]

That is not clearly an insuperable difficulty, according to Strawson, but it obviously makes him uneasy, and he would prefer to avoid it if possible, so he will try to avoid the clash. A compatibilist solution would "blend" the two images—the scientific and the manifest[32]—by combining the two without downgrading either. Ayer recommends such compatibilism, but Strawson takes note of dissent on the part of John Mackie, who proposes instead the sort of "error theory" that he defends also in metaethics. For Mackie ordinary consciousness posits phenomenally propertied occupants of an objective space and time. And this is held to be not absurd or impossible, but only plain wrong, wrong because a rival explanatory system, derived from contemporary science, defeats our ordinary realism.

The "error theory" is charged with outright absurdity, however, since the colors of ordinary consciousness could not possibly be present in

bodies comprising a spatiotemporal system without being immediately perceptible. "Whatever may be the case with shape and position, colors are visibilia [*immediately* visible qualities] or they are nothing."[33]

Both images might be combined in one irenic view by identifying the bodies of the manifest image with the particle-configurations of the scientific image. Scientific particles should be considered *not* necessarily imperceptible, moreover, but only imperceptible as "simply an empirical consequence of their being so minute,"[34] or so Ayer suggests. Though individually imperceptible, besides, by coming together they form the perceptible, colored groups that constitute the bodies of our manifest image. Strawson doubts that this proposal "can be regarded as satisfactory." Here he reasons as follows. The particles are supposed imperceptible only contingently, because they are so small. Suppose the conditions that make them imperceptible were changed somehow; by sufficiently reducing our size differential, for example, or by granting us better vision. Would the particles of the scientific image then become immediately perceptible to us in the way required by the manifest image? Not so. Reason: The colors that the manifest image would wish to attribute to the now supposedly perceptible particles and configurations of particles would still play no role in scientific theorizing and explanation. But only properties that play such a role are allowed as truly present in the entities of the scientific image such as particles and their configurations. In response Ayer concedes the force of this argument and is "inclined to agree . . . that 'no phenomenal properties we seemed to perceive [these particles] as having would figure in the physical explanation of our success' in perceiving them."[35]

Having argued aside both the error theory and the irenic blend, Strawson now has a proposal of his own. Color ascriptions, he points out, are often relative to the standards in force, which may shift from context to context. A fabric may be green to the bare eye, and *really* green, as compared with its appearance under abnormal light. If viewed under a microscope, nevertheless, its surface may *really* exhibit a polka-dot pattern of blue and yellow. Remove the relativity and you have incoherence: no surface can be both homogeneously green and polka-dot blue and yellow. With the relativity, coherence is restored: *to the bare eye*, the fabric is green; *under the microscope*, it is polka-dot blue and yellow.

We are now invited to move from the relativity of color ascriptions to a similar relativity of world views. Relative to the commonsense realism of the "human perceptual standpoint," Eddington's table is hard and solid and homogeneously brown. Relative to the scientific standpoint of contemporary physics, it is a swarm of charged particles and not brown

at all. No conflict here. One can be both scientist and diner. We combine both standpoints, sometimes in a single sentence: " 'This smooth, green, leather table-top', we say, 'is, considered scientifically, nothing but a congeries of electric charges widely separated and in rapid motion.' " Here the subject of our sentence is relative to the commonsense standpoint, whereas the predicate is relative to the scientific standpoint, and once this is recognized the appearance of incoherence is dispelled.[36]

Ayer responds in writing to Strawson's critique, and reaches the following conclusion:

> We can admit the explanatory force of scientific theories without construing them instrumentally and still without letting them govern our conception of what there is. For that we can choose to remain at the level of theory which yields us a manifest picture of the world. This implies, I think rightly, that it is in the end a matter of choice. So long as the rival theories are intelligible and coherent, and can each within their own domains make good their claims to truth, there may, in Quine's terminology, be no further fact of the matter that would even give a sense to the question which one is correct. I see that this brings me back to something very close to Strawson's position, but it needed a consolidation which I hope I have been able to supply.[37]

How do we choose or so much as compare standpoints? Is the standpoint of common sense on a par with that of science? Strawson does not enter these questions, which Ayer hastens to shut: *It is "in the end a matter of choice" and there may even be no sense to the question which one is correct.*[38] But it is just at this point that we need to slow down and be careful. What are we to say of superstitions like astrology? Suppose they too can, some of them, "within their own domains make good their claims to truth." Is it then a mere matter of choice between them and science? And from what standpoint are we making this extraordinary claim? Is it from a standpoint of science itself? Surely no scientific view can undercut itself so blatantly. And if we do not adopt a scientific standpoint, which one do we turn to? Manifest common sense? But if we take refuge in common sense then the table must be declared solid and brown: and hence science must be thought wrong to deny it these properties. By prying open what Ayer was willing to shut, we glimpse a Pandoric mess.

Having taken a wrong turn somewhere, let's retrace our steps. In particular let's go back to Ayer's compatibilist blend of common sense with science. I myself agree with Strawson, as does Ayer, that science is unlikely to invoke colors in physical objects for the sake of explaining color vision. If the scientific standpoint commits us to accepting only the properties that science postulates for its explanatory purposes, then we could not from that standpoint accept colors in physical objects. Here we

might object that the scientific standpoint ought to be softened so that it commits us to *accepting* the properties postulated by science but not to *rejecting* all other properties. This would open the possibility of enjoying colors in our paintings with no scientific bad faith or false consciousness. And there seems no *incoherence* here. Even if individual particles are too minute to be seen as colored, indeed to be seen at all; even if the attribution of color to them is very unlikely to play any role in scientific explanation; even so, why should this preclude their being colored anyhow, and colored in the full-fledged phenomenal sense of the ordinary commonsense realist consciousness? That being so, it is even more to be wondered why large enough configurations of such particles may not constitute the ordinary bodies of everyday life, including Eddington's table with not only its shape but also its color. Again, there is no incoherence here unless we turn the scientific world view into an imperialist ideology which attempts not only to occupy but also to annihilate and supplant. Thus according to imperialist scientism a supposed property may always be rejected or eliminated reasonably if science has no need of it for its explanatory purposes. But there is a large gap between this aggressively negative plank of scientism and the positive view that a property may be postulated if useful for scientific explanation. And it is not clear how this gap in argument is to be filled. For instance, not all properties accepted would seem justifiable by the scientistic proviso. Could properties F1, . . . , Fn be justified solely through their usefulness for explaining phenomena constituted by properties G1, . . . , Gm, while these in turn are justified solely through their usefulness for explaining phenomena constituted by properties F1, . . ., Fn? Might there not be some way to justify the acceptance of *some* properties by appeal to something other than their service in the explanatory project of science? And what precludes the possibility of a less imperialist standpoint for science, one which irenically occupies and commingles rather than aggressively eliminating and supplanting?

That response seems acceptable in principle. But what if science manages to explain our visual experiences, and does so with no appeal to colors in ordinary objects? Normally we can think that a snowball at arm's length in sunlight looks white because it *is* white. If science develops a much better explanation of why that snowball looks white (and of all similar phenomena) without attributing color to physical objects, can we still insist that the snowball looks white because it is objectively white? What relation or relations might there be between this objective whiteness of that snowball and the scientific property of it in terms of which science would explain why it looks white to us at the time? Could they be totally separate and logically unrelated properties each of

which just happens to provide its own separate explanation for why we have the relevant experience in that situation?[39] This would seem an unreasonable duplication and a prime candidate for Ockam's razor. But if we deny that the physical objects around us are truly colored we are just back to the error theory.

Following through on the move to relativism, as does Ayer, leads to disaster. Of the views considered above, the most attractive alternative is Ayer's irenic blend of common sense and science. That was earlier rejected because the scientific standpoint allegedly abhors all supposed properties superfluous for explanatory purposes. And although, just on its own, this seemed too imperialistic a scientific standpoint, we are still left with a problem if science is able to explain perceptual experience without appeal to any visual or tactile properties in physical objects themselves. If we nevertheless persist in attributing visual or tactile properties to physical objects themselves, do we not fall into an absurd and unnecessary duplication? And if by hypothesis the scientific explanation is better than the commonsense explanation, then we seem driven to an error theory: we are just plain wrong when we attribute phenomenal properties to the objects themselves.

The retreat to an error theory is unappealing, however, in part for the reasons indicated by Strawson; in the end it may suggest some acceptable insights, but that remains to be seen, and in any case it cannot on its own give us a fully satisfactory account of perception. More specifically, a response to the error theory is suggested (to me, at least) by Strawson's paper and by recent talks of Barry Stroud's not only about secondary qualities but also about values.[40] If any full enough description of our perceptual experience must use the "as if" device, then such description is necessarily permeated by the realist phenomenal concepts of common sense. But we cannot properly describe our perceptual experience thus—as we must describe it if we are to do it justice and describe it fully enough—unless we seriously accept the realism of common sense, including its commitment to realist phenomenal concepts. So it would be incoherent to accept a scientific realism which describes our perceptual experience, purports to explain it by appeal to a scientific psychology of perception, and concludes from this that we are mistaken to attribute realist phenomenal properties to physical objects themselves. The incoherence lies in accepting commonsense realism of phenomenal properties, which is required for adequately describing our perceptual experience, while claiming that such acceptance is mistaken since we can explain our perceptual experience without attributing phenomenal properties to physical objects themselves.

The Strawson-Stroud objection is plausible, and indeed compelling, if

to describe an experience as "of something white and round" is to say that it is a sort of experience one would normally have when facing something white and round (something middle-sized, in good light, etc.). For if it is right to say that one would *normally* have such an experience when facing such a thing, it seems implied that there are really such things for one to face. This seems implied, if only through what is epistemically required for the saying. The whole question deserves further study, but already we have a prima facie case against any error theory. Accordingly, we would like some way of combining common sense and science without declaring either one a wholesale mistake. Strawson-Ayer relativism is such a way, it has that virtue, but we have glimpsed its consequences and they seemed intolerable. Is there a better way?

In conclusion I would like to sketch an alternative proposal, which I hope to develop and defend elsewhere:

1. For a physical object to be white is (at least in important part) for it to be such that it would cause certain visual sensations or experiences in those who see it (in certain circumstances).

2. A scientific explanation of why an object appears white would not appeal to its objective whiteness, but on the side of the object would appeal only to such scientifically fruitful theoretical properties as its surface reflectance, and on the side of the subject to rods and cones, and the like.

3. Indeed, the objective whiteness of objects is unlikely ever to have any significant role in scientific theory or explanation.

4. Nevertheless, we are unable to describe the relevant *visual experience* of whiteness without believing in the objective whiteness of things around us, for we describe it as an experience normally caused by seeing something white, which would seem to require that there be such things to do the causing.

5. But that does not preclude our grasping the concept of objective whiteness. We escape vicious circularity because the grasp of such a concept does not involve first identifying or recognizing the visual experience in question, and then finding its cause in the objective whiteness of the object before one, on the basis of that prior identification or recognition of the experience in question. Indeed there is no need for us thus to identify or recognize such an experience in order to grasp objective whiteness, even if by its very nature objective whiteness involves causing such an experience in onlookers. It seems required only at most that the experience in question be operative in our discrimination of objectively white objects. And for it to be thus operative there

seems no need that such an experience be in turn identified or recognized by the subject, but only that it be present and active.

6. It is compatible with the above, and in particular with 1, that properties of objects such as their whiteness be objectively and really properties of theirs, even if they are at least in part dispositions to affect subjects in certain ways in certain circumstances.[41]

7. Finally, it is also compatible with the above that our perception of the whiteness of an object should be direct and immediate (at least in several relevant senses of these protean words). In particular, we may be able to tell justifiably and knowledgeably the whiteness of an object without having to be aware of any white ideas or sensa—not in the sense of having to identify or recognize such ideas or sensa, anyhow—and without having to go through any conscious inferences at all.

8. It may enhance the plausibility of theses 1–7 and their joint coherence to compare the concept of whiteness with the concept of cubicity, which seems clearly graspable and directly applicable to a die by someone who nevertheless lacks any grasp of its analysis in terms of six square sides, and so on. Similarly for whiteness and its analysis as a disposition to cause a certain sort of experience in onlookers, et cetera.

The foregoing blends common sense and science with fairness both to scientific and to commonsense realism. It avoids the pitfalls of radical relativism, of the error theory, and of the duplication of explanation (by rods and cones, etc., along with objective whiteness in good light, for example). Pitfalls there may still be, of course, but these if real remain to be perceived.

ERNEST SOSA

DEPARTMENT OF PHILOSOPHY
BROWN UNIVERSITY
FEBRUARY 1989

NOTES

1. "Replies," in *Perception and Identity*, ed. G.F. Macdonald (Ithaca: Cornell University Press, 1979), pp. 277–333; p. 277.

2. London: Victor Gollancz Ltd., 1967, second edition (first published in January, 1936). Parenthetical page references to this book will use the abbreviation LTL.

3. Ayer has now granted that his account of the self and of one's conception

of others in LTL is defective: in *Perception and Identity*, p. 326. But he goes so far as to say that his earlier view was "inconsistent." And the question of how one so much as *understands* concepts of oneself and others is not answered by Ayer's new appeal to an inference to the best explanation for the justification of our belief in other minds: in *The Central Questions of Philosophy*, ch. VI. A similar distinction between the question of understanding and the question of epistemology will be drawn and elaborated below in connection with physical objects in the external world.

4. Compare Roderick M. Chisholm, "The Problem of Empiricism," *Journal of Philosophy* 45 (1948).

5. Though the neutral monism once advocated by Ayer could not countenance the self as bedrock, and would require the reduction even of the self to phenomena.

6. Bertrand Russell, *The Problems of Philosophy* (Oxford: Oxford University Press, 1959), p. 58. (First published in the Home University Library, 1912.) Parenthetical page references to this book will use the abbreviation POP.

7. *Proceedings of the Aristotelian Society*, 1912–13.

8. In fact I believe that this need for such relations of space and time is only the beginning, and that we would need also a location of one's own, notions of body and of one's own body, along with concepts of various features of one's body corresponding to eyes, ears, skin, etc., in order to arrive at concepts of the shapes, sounds, colors, and textures of external bodies. But the need for relations of space and time is fundamental.

9. *Perception and Identity*, p. 280.

10. "Common Sense and Physics," ibid., p. 3.

11. *Perception and Identity*, p. 278.

12. Ibid., p. 281.

13. Ibid., p. 297.

14. *The Central Questions of Philosophy*, p. 87.

15. *Perception and Identity*, p. 295. Compare Russell's *Human Knowledge: Its Scope and Limits*, p. 220, according to which it is a "serious error" to suppose "that the space in which perceptual experiences are located can be identified with the inferred space of physics. . . ."

16. Ibid., p. 281. My emphasis.

17. *Perception and Identity*, p. 289.

18. *The Central Questions of Philosophy*, p. 108.

19. See ibid., p. 102.

20. *Perception and Identity*, pp. 41–60. Reprinted in *Perceptual Knowledge*, ed. Jonathan Dancy (Oxford: Oxford University Press, 1988).

21. Ibid., p. 47.

22. Ibid., p. 45.

23. Ibid.

24. Ibid., p. 44.

25. Ibid., p. 45.

26. Ibid., p. 292.

27. Ibid., p. 53.

28. Ibid., p. 49.

29. Ibid., p. 53.

30. Ibid., p. 54.

31. Strawson points to passages in *The Central Questions of Philosophy* at pages 84, 86–87, and 110.

32. See the opening paper of Wilfrid Sellars's *Science, Perception, and Reality* (London: Routledge & Kegan Paul, 1963).

33. *Perception and Identity*, p. 56. P. 54 had already stipulated that thenceforward 'perceptible' was to mean '*immediately* perceptible'.

34. *The Central Questions of Philosophy*, p. 110.

35. *Perception and Identity*, p. 296.

36. Ibid., p. 59.

37. Ibid., pp. 297–98.

38. This is moreover not just an isolated remark by Ayer or a convenient escape from Strawson's critique. Over and over in Ayer's writings, from the earliest, we find a steady commitment to the necessity of verification criteria or procedures that would permit an answer if a question is to be so much as literally sensible or comprehensible. And one gets the sense that these procedures and criteria are in the end a matter of choice or convention. The present passage is in my opinion just an especially forthright statement of a longstanding view.

39. For an extended discussion of explanatory exclusion see Jaegwon Kim's "Mechanism, Purpose, and Explanatory Exclusion," in James Tomberlin, ed., *Philosophical Perspectives* 3 (Atascadero, CA: Ridgeview, 1989).

40. I refer here to his Tanner lectures delivered at the University of Buenos Aires in June of 1988, and to a talk on secondary qualities delivered to the Sociedad Argentina de Análisis Filosófico.

41. Note as an aside that different sorts of dispositions may be involved. Thus heft may involve effects on the relevant subjects in such a way that the constitution of the subjects would affect the heft of things around them. If we were stronger things would be lighter. But it is not so clear that colors are like heft in this respect. Would grass suddenly become blue if our visual receptors changed appropriately? Or is the color of grass determined rather by how looking at it in good light visually affects subjects constituted *as we are now in the actual world?*

REPLY TO ERNEST SOSA

I am rather sorry that Professor Sosa has gone to so much trouble to attack an inaccurate version of my old thesis of phenomenalism; a thesis which he knows me to have abandoned as long ago as 1947. Can he seriously believe that I, or indeed any other phenomenalist, ever maintained that the statement "This is a white snowball" was reducible to "There is a white sense-content"? If the word 'there' is being used as a demonstrative, not only is the first of these statements not equivalent to the second; it does not so much as entail it. Sosa is obviously right in saying that the datum through which the white snowball is presented need not itself be white; he could have added it need not even be visual: someone who became aware of the presence of the snowball only through touching it might then make the true statement that the snowball was white. To give the example some point, let us suppose that a blind person who has been informed of the colour of snowballs and the condition of the light is teaching a small child the use of colour-words.

The entailment does not hold even if the expression "there is" is understood existentially. It might be objected that nothing could be said to be white without the implication that something had actually looked white on at least one occasion, but this would be to fall into a tempting fallacy, a confusion of use and mention. It is true that an actual appearance of the colour white is a causal condition of there being a word to denote the colour, but in using the word one is not at the same time talking about it; one is not actually saying anything about the way in which it comes to be used.

Continuing with the example, we can follow G.E. Moore in translating "This is a white snowball" into "There is one and only one white snowball to which this sense-datum bears the relation R." The problem which Moore never solved to his own satisfaction is then to give R its

proper value. The phenomenalist answer is to reduce the snowball to a set of possible sense-data, not all of them white, of course, but all of them identifiable as appearances of the snowball. None of them need be actual since the statement "This is a white snowball" not only does not entail that anything is being seen; it does not entail that the snowball is the object of any other perception of any kind at all. To speak of possible sense-data is in this context to say that the sensory statements in question are only hypothetical. Since these hypothetical statements would each need to state a condition in which the snowball would in fact be perceived, the possibilities would all be real and not merely logical, in the special senses that Sosa has given to these terms.

Even so, I fail to see how this enterprise could succeed. When, in the passage from *Perception and Identity* which Sosa quotes, I denied that "it would always be possible to formulate a set of subjective conditionals" that fitted the bill, I had in mind not just that the number of statements would need to be infinite but that every protasis of every conditional would develop into an infinite regress; to make sure that the apodosis held good, we should have, among other things, to rule out the possibility of a failure of observation; to rule this out, we should have, among other things, to test the possible observer; to rule out the possibility of a failure of observation at the second stage, we should have to describe, in purely sensory terms, a hypothetical testing of the hypothetical tester; and so *ad infinitum*.

Moore's formula does owe a debt to Russell's Theory of Descriptions, but Sosa, in his employment of the theory, makes a serious mistake. Under the presupposition that the round thing before me is an object of even possible direct acquaintance, Russell could not have consistently selected the snowball itself as a value for the variable x in the sentence "For some x, x is the round thing before me, and for all y, if y is the round thing before me, y is identical with x." Whenever a singular term occurs in a sentence as its grammatical subject, the technique of the theory is to strip it of its connotation and insert the connotation into the predicate. Consequently, we are left in the end with sentences in which the values of the existential variable are denoted only by demonstratives. In *The Problems of Philosophy*, published in 1912, Russell did indeed maintain that persons were acquainted with their selves; a view which he had abandoned by 1921, when he published *The Analysis of Mind*; but otherwise, throughout his career, he held fast to the thesis that the only demonstrable particulars, the only ones with which anybody can be directly acquainted, are sense-data, or, in his later terminology, percepts.

Sosa is not sure whether Russell's principle, enumerated only in *The Problems of Philosophy*, that "Every proposition which we can under-

stand must be composed wholly of constituents with which we are acquainted" can be reconciled with the ascription of "the primary quality" of roundness to a snowball. He thinks that there could be a reconciliation if snowballs are held to be known by description as the causes of sense-data, and causality is reduced, as Russell proposed, in his essay "On the Notion of Cause", to functional relations between events occurring at the same or different times. But this will not work if the events are physical, as at least one of them needs to be if the snowball is to come into play. Indeed, Sosa answers his own question: "Can we [in Russell's view] have acquaintance with the relations of space and time needed for access to the world of common sense?" by quoting Russell as saying that it is "a serious error to suppose that the space in which perceptual experiences are located can be identified with the inferred space of physics". Admittedly, the book, *Human Knowledge: Its Scope and Limits*, from which this quotation comes, was published thirty-six years after the lecture "On the Notion of Cause" and, admittedly, he considered the world of common sense to be a philosophical monstrosity, but already in *The Problems of Philosophy* he puts such things as snowballs into the space of physics, allowing only sensibilia to be the objects of perceptual acquaintance. It is surprising that he failed to see that, on his own showing, this rendered the concept of an external object unintelligible and so disqualified such objects from being knowable by description, even if they had not been otherwise excluded by his Humean account of causality, which required both terms of a causal relation to be at least potentially observable.

It may have been a realization of this inconsistency, as well as the desire, which he always had, to minimize his ontological commitments, that led Russell to the neutral monism which he advocated in *Our Knowledge of the External World*, which he published in 1914, and upheld at least until the publication of *The Analysis of Matter* in 1927. The sensibilia to which he reduced physical objects during this period were not actual objects of acquaintance but at least they came into the same category as sense-data. Lord Quinton may be right in saying that Russell never wholly foresook neutral monism, but he did argue that if one took the scientific account of perception seriously, one had to put physical objects, *qua* the causes of percepts, beyond the reach of perception. In a private letter to me, he admitted that this did not entail that they lacked phenomenal properties, such as colour, but said that there was no reason at all to believe that they had any.

As Sosa remarks, my rejection of Russell's two-world theory leaves me with the problem of specifying the relation between the particles of physical theory and the physical objects of common sense. When I

replied to my critics in *Perception and Identity*, I had been persuaded by Sir Peter Strawson that the particles could not reasonably be held to be literal parts of "common objects". I am now inclined to agree with Lord Quinton that I gave way too easily. Strawson's argument that the particles cannot be perceptible, under any conditions, if they are to continue to play their scientific roles, no longer convinces me any more than it altogether convinces Sosa. I agree with Sosa that the properties which figure in the scientific account of perception need not be the only properties that the particles have. Moreover, by refusing to make physical objects inaccessible to observation we avoid Russell's objection that even if it is logically possible for them to have such a property as colour, we have no reason to believe that they do. Whatever may be true of single particles, colour will be manifested by them when they form a sufficiently large group. Some particles may, indeed, be such that it is theoretically impossible for them to possess anything but primary properties. In this case, if we are going to treat them as minute parts of common objects, we shall be forced to rule that colour is not a dissective property. This runs counter to the popular conception of colour, but I do not see it as an absurdity.

Strawson's own attempt at reconciliation now seems to me to fail because it depends on a poor analogy. The difference between "the scientific standpoint" and "the human perceptual standpoint" is just not of the same order as the difference between two perspectives or the difference between the appearance of an object seen with the naked eye and its appearance when seen with the assistance of some artificial instrument. A distinction between two methods of perception cannot serve as a model for a distinction between things that are and things that are not perceptible.

Nevertheless Strawson makes a valuable point when he speaks of "the relativity of our 'reallys' ". It supplies me with my answer to Sosa's objection to my having said that it is for us to decide which of Eddington's "two tables" is really there. For the way in which these two standpoints are competitive, if they are so, is not such as to deny truth to the accounts which are delivered from either one of them. To that extent Strawson is right. The threat of conflict comes from the seeming disparity of the ways in which they invite us to conceive of physical objects as they are "in themselves": I avoid saying "picture physical objects" only because the scientific account is not pictorial. If they cannot be unified, we have the alternatives of taking scientific particles as being what there is and treating common objects as disguises which the particles don for us, or taking common objects to be what there is and treating scientific particles as mere explanatory tools. The reasons why it comes to a choice

between these alternatives, so long as they are unreconciled, are, first, that there literally is not space for them both and, secondly, that while there are internal criteria on either hand for determining what is really the case, there are no criteria for determining the external question how things really are in themselves, independently of anything but a god's-eye view. We are not provided with any use for the word 'really' in this absolute sense. Consequently, if we have to make a choice, the best that we can do is to pick the alternative that has the greater imaginative appeal. My own preference is for "the human perceptual standpoint", not on philosophical grounds but because it is the standpoint that governs all my other activities.

Sosa's remark that this puts respectable science on a level with astrology is acceptable only as making the rather different point that judgements about the way things work are also relative. Astrology is a theory about the influence of the stars upon human character and conduct. The objection to it is that its hypotheses are not supported by the empirical facts. To some extent, indeed, the objection is rather that they would not be supported if their champions allowed them to be tested. If a date for a marriage is rejected because the stars are unpropitious, one can protest that the marriage would turn out no worse if it were celebrated on that date, but in a society which regulates such matters by the stars, there will not be much evidence to sustain the unfulfilled conditional. When assessed scientifically, the astrologer may be marked down for the comparative failure of his predictions, but if he avoids making testable predictions, he continues unscathed. This is not to say that he should not be judged scientifically; it is just that to call a judgement scientific is itself to make the choice of a particular point of view.

I am not so wedded to relativism as to lack sympathy with attempts to overcome it, but Sosa's proposals do not convince me. He claims to have grasped the concept of objective whiteness, but since he distinguishes it both from the scientific and the phenomenal concepts of the colour, I fail to understand what he supposes it to be. Later he claims that we can tell that a physical object is white "without having to be aware of any white ideas or sensa" and without making any conscious inference from them. If what is being denied is merely that in order to ascribe colour to physical objects one needs to possess the concept of a sense-datum, this is obviously true but irrelevant. The fact remains that such ascriptions of colour do require one to have been aware of the way things look. Nor have I ever maintained that the inductive passage from percepts to common objects embodied a conscious inference.

Sosa complains that my account of this passage is "shot through with

metaphor". True enough, but the metaphors are easy to cash. To speak of qualia turning into particulars or sensory patterns being concretized into percepts is to say the same thing in different ways. In either case the percept, which is a particular, consists in the location of a sensory quality in a given sense-field. A standardized percept is one chosen for its normal properties as the representative of a group: in the case of Sosa's snowball, the standardized visual percept would be round and white. The process of transmuting it into a visuo-tactual continuant consists first in associating it with a standardized percept of touch, if it is visual, or of sight, if it is tactual, and then conceiving of the combination as persisting through time either in the same position or in a series of neighbouring positions, with the possibility, which may or may not be actualized, of further percepts being added to the groups which it represents. The positing of such entities with their spatio-temporal relations was characterized as a theory. When I spoke of this theory as predominating over its origins and of the visuo-tactual continuants as being cut loose from their moorings, I was again saying the same thing in different ways. What I was trying to describe was the process by which the visuo-tactual continuants, after being credited with causal properties and so given the status of physical objects, are held to be what there really is, while the percepts out of which they have been fashioned figure in the theory as no more than states of the members of the sub-class of physical objects that constitute persons.

While Sosa accepts my construction of "the commonsense physical object framework" as providing a justification for our belief in the existence of the physical object in question, he complains that it fails to account for our ability to understand what is said about them. This criticism surprises me. There is surely no problem about our ability to understand the signs that are used to refer to the phenomenal properties which are presented to us in sense-experience. Consequently, a satisfactory description of the way in which our conception of the physical world of common sense is developed out of our acquaintance with these properties should be sufficient to account for our ability to discourse about the objects which this world is held to contain. I cannot see that anything more is required.

A more difficult question, which Sosa does not raise, is that of our ability to understand the abstract talk of physicists. Since I have only a rather vague idea about the ways in which their hypotheses are related to the phenomena which they are supposed to explain, I think that I belong to the vast majority of persons who understand very little of it.

A.J.A.

22

T.L.S. Sprigge

AYER ON OTHER MINDS

I

Most of Professor Ayer's books have been successive attacks on a particular set of very basic philosophical questions. One cannot reflect fruitfully on his treatment of any one of them in isolation. Here I am particularly concerned with the relations between his views on the "problem of other minds", (and of minds generally) and his views on the physical world, and our knowledge of it.

Ayer's views concerning one's knowledge of other minds, and the meaning of statements about them, have passed through three main stages. (1) He began, in *Language, Truth and Logic*, with a behaviouristic analysis of statements about other minds, coupled with an essentially "mentalist" account of statements about one's own mind. This is what he has since called the asymmetrical view. (2) Then he moved on to a sophisticated version of the argument from analogy, associated with a uniform mentalistic understanding of statements about the speaker's and about others' minds. (3) More recently, he has looked on the postulation of other minds as an explanatory hypothesis (while retaining the uniform analysis). This account may oversimplify, inasmuch as the position in *The Problem of Knowledge*, though close to that of phase 2, belongs more to the stance of descriptive analysis (call it [2a]) which avoids that kind of firm thesis.

In *The Problem* Ayer distinguishes four ways of defeating scepticism about ordinary knowledge claims. (1) Naive realism, according to which we have direct access to that about which the knowledge is at issue; (2) reductionism which reduces the objects to the evidence for their existence; (3) the scientific approach, for which inference to the objects from the evidence is to a scientifically respectable explanation; (4) descriptive

analysis, which exhibits the peculiarities of each case and how it is in order in the only way it could be.

I take it that the asymmetrical position on other minds is reductionist, and that the argument from analogy and explanatory hypothesis view are both versions of the scientific approach. As noted, there is also a stage of "descriptive analysis" between 2 and 3. The one slot never filled by a view of Ayer's own on other minds is naive realism. Yet Ayer has always taken what is effectively a naively realist view of one's knowledge of one's own mind, for which one knows about it by direct access. (As he puts it, statements about one's experiences are based on those experiences themselves.)

Ayer's classifications, though primarily epistemological, have bearings on the meaning of the statements classified, and thus on the ontological status of the objects they concern. Though he may not like it expressed in ontological terms (a point I shall consider later) they surely classify views which are both about the nature of our knowledge of the objects in question and about the meaning of statements concerning them. For reductionism the objects are not, we might put it, part of the ultimate furniture of the world, while for naive realism they are. Descriptive analysis, indeed, leaves their status in this regard unclear. As for the scientific approach, it may seem evident that it implies a realist ontology regarding the objects in question. However, I am not at all sure that Ayer does not think of some of the items only postulated in scientific theory as solely posits in a theory rather than as there in some way quite independent of the utility of their postulation. If so, the only items given an unambiguously realistic ontological status are those to which there is supposed to be access of a naively realistic sort.

Once the asymmetrical view is abandoned the essentially realistic conception of one's own mind, implied in Ayer's naive realism concerning one's access to it, carries over to the minds of others, whose realistically conceived status is therefore assured as the posits of scientific theory are not. So I think one can say that Ayer has (at least after *Language, Truth and Logic*) always been ontologically a realist about minds while it took him much longer to become, if he ever did, a realist about the physical.

He may have been a realist, rather than an anti-realist, about the physical in Michael Dummett's very special sense, which relates it to the holding of the laws of excluded middle and bivalence in the region in question, but that does not make him a realist in the more fundamental sense of thinking that there must be quantification over physical objects in an account which limns reality in the most basic way. (See my *The Vindication of Absolute Idealism*, 1983, pp. 281–82.) (Though this way of

putting it derives from Quine, I am thinking of the realist about something as claiming more for it than that it should be posited in an irreducible way for practical purposes.)

It may be suggested that even if Ayer has always been an ontological realist about mental states he has not been so about minds. However, by and large, he has taken a person's mind, at any one moment, as being the sum total of his conscious mental states, his perceptions, images, feelings, etc.—roughly a cross section of the Jamesian stream of consciousness. As for a mind as a continuant, Ayer seems to regard this as much the same as the whole stream of consciousness, though he sees it as a major problem to analyse what it is for experiences to belong to the same stream. Personally, I think an individual consciousness should be distinguished from a stream of consciousness. The latter is the history or life of the former, and the former is a "concrete" universal exemplified in each cross section of the latter, but I pass that by here. (See my *The Vindication*, pp. 9–20.)

It might have been better to have talked of the problem of other consciousnesses than of the problem of other minds, since Ayer himself holds that statements about a person's mind are as much about his public behaviour as about his "private" experiences. I endorse this with a qualification. If one once thinks of there being two aspects to psychological fact, publicly observable behaviour and behavioural dispositions, on the one hand, and private experience, on the other, it is natural to think that what is problematically hidden and private is something sharply contrasting with behaviour—such as imagery or sensations of pleasure and pain. This tends to obscure the fact that if I wonder whether another person is conscious I am not wondering merely whether he has images and feelings, but much more whether his behaviour is felt from the inside as mine is, together, of course, with his personal perceptual perspective on his public situation in the world. By contrasting consciousness, as private, with behaviour as public, we may forget that what is problematically hidden is just as much his public behaviour, and situation in the world, as he experiences it, as his experience of objects, like images, which are described, and sometimes reviled, as private.

The view, sometimes propounded by Ayer, that what counts as public and what private is partly conventional, risks setting discussion on what I see as the same wrong path. (See "Privacy" in *The Concept of a Person*.) The idea is that, if headaches came to all at the same time and places, we might think of them as public objects while if visible objects were less readily available to all we might call these private. But whether an experience is of a public or private object, its inaccessibility to others remains the same, so that if we had cause to make pleasures and pains

public in this way, the real problem about their privacy would remain, as part of the general problem of another's experience of the public world. So even if Ayer is right about private objects, that has little bearing on the problem of other minds. Nor does it do much towards "blunting the distinction between the mental and the physical" ("Privacy," p. 58).

II

Consider now Ayer's developing views on our knowledge of the physical. I think that there have been three fairly clear cut phases. (1) Strict phenomenalism; (2) phenomenalist instrumentalism; (3) sophisticated realism. There has also been a somewhat unstable phase (call it [2a]) of "descriptive analysis", chronologically and conceptually lying somewhere between (2) and (3).

Using the above fourfold classification, we can say that strict phenomenalism and phenomenalist instrumentalism are versions of reductivism and that sophisticated realism is a form of the scientific approach (as pointed out by Ayer himself). There is, however, no phase which comes under the heading of a naive realist one. Thus Ayer initially inclined to views which were ontologically non-realist about the physical and has only ever taken a fully realist view about it if this is implied in sophisticated realism, which I shall be suggesting grounds for doubting.

So Ayer seems (very sensibly) always to have been a realist about his own mind and this implies a realist view concerning the ontological status of other minds, once phase (1) was past, and allowing for certain complications in phase (4). His views on the physical, in contrast, were for a long time more or less strongly reductionist and perhaps at bottom have remained so.

This raises the question whether there is not a strong undercurrent of radical empiricism, or even idealism, in Ayer. By radical empiricism here I understand what William James meant by it, namely the thesis that ultimately there is nothing but experience. For James that did not imply that there was nothing but mind or consciousness since he believed that experiences could occur which were not related to others so as to form a mind. If we reject this possibility, as Ayer does, then radical empiricism points to the view that there is nothing but mind or consciousness and becomes indistinguishable from some sort of idealism. So we can put the question equally as concerning a possible idealist undercurrent in Ayer.

Of course, there are plenty of reasons for dissociating Ayer from the idealist label. But idealism can be taken in a larger or a more limited sense. In the larger sense it implies some rather lofty view of the place of

spiritual values in the world, and, in that sense, there is no suggestion of idealism in Ayer. But one can also understand it, in the sense I have in mind here, as simply the view that all that genuinely exists is conscious experience.

In both *Language, Truth and Logic* (hereafter *LT and L*) and in *The Foundations of Empirical Knowledge* Ayer took an essentially reductionist view of the physical world. In the former, the existence of physical objects consists in hypothetical facts about sense data, or sense contents. In *Foundations* there is no possibility of reducing statements about the physical to hypothetical facts about sense data, but this is only because an infinity of hypothetical statements would be needed to complete any translation and because sense datum statements have a kind of precision to them lacking in physical object statements. (I have never seen this last as much of an objection to phenomenalism. Why should not sense data as much as physical objects be described indefinitely?) All the same, no genuine information is provided by physical object statements beyond facts about the sense data which would occur under various sensory circumstances. Surely this is to say that the only real facts of the case concern sense data and that these are the ultimate existents (or occurrents).

Ayer has always resisted such interpretation of his thought as confused. In reply to critics who held that for the phenomenalist a physical thing is not something actual, and physical object statements never truly categorical, he has insisted that the fact that statements about physical objects are equivalent to (or at least yield their true factual content in) hypothetical statements about sense data does not impugn their categoricality at their own physical level. Actual physical objects are not less actual as physical objects because their existence is equivalent to facts about merely possible sense data.

Let us grant this. It is true, nonetheless, that if the whole story of all the sense data which have ever occurred were told, there would, according to phenomenalism, be nothing to add (so far as physical reality goes) except truths as to what would have occurred if certain other sense data had occurred. (Of course, if unfulfilled conditionals are just a kind of embroidery on the facts, as Ayer has come to hold, then the real truth of things would lie solely in the actual sensory story. However, Ayer abandoned phenomenalism in the light of that view of conditionals.) One cannot similarly say that if the whole physical story were told, then talk about sense data would add nothing to our knowledge of what has actually existed, since not only may there be wild sense data, not helping in the constitution of any physical thing, but even sense data involved in perceiving a physical thing do not have their existence entailed by the

purely physical story, since that does not imply that anything is consciously perceived.

Thus from the sensory point of view physical actuality is not additional actuality as sensory actuality *is* additional actuality from the physical point of view. Surely this shows that actual sense data are, for the phenomenalist, part of the real filling of the world, as physical things are not. So if sense data are mental, the phenomenalist makes the actuality of the world consist in the mental, and not in the physical.

But are sense data mental? Well, for Ayer phenomenalism has gone hand in hand with one kind of neutral monism. For this, I believe, a mind consists in a series of compresent sets of sense data (together with such quite similar items as images) constituting a single bundle in virtue of certain relations holding between them and not between any of them and similar items pertaining to another bundle. In contrast to this, a physical object consists in a series of sets of *possible* sense data, (or if partly in actual ones, it is only as possible that they are required for the strictly physical being of the object). Surely if the mind is composed of such things as actual sense data, and physical objects of possible sense data, this makes actual sense data "mental". Their occurrence is a fact about a mind. And whether we call them mental or not, the mind is nearer to the actual, as being composed of the actual, than is the physical.

But is not the view more correctly expressed as the thesis that both minds and physical objects are logical constructions? They are not composed of actual or possible sense data as a house is built of bricks. Rather, statements about them were reducible to a different sort of statements, categorical in the first case, hypothetical in the second, about sense data. However, I do not think that this subtlety makes much difference. The fact of a mind existing is a fact about what is actual, while a fact about a physical object existing is a fact about what is possible. This is only marginally different from holding that mind itself belongs to the actual filling of the world as the physical does not.

If actual sense data could exist apart from any mind, things would be rather different, though even then I think Ayer would conceive them as unowned experiences rather than as bits of the physical. Anyway, as noted, Ayer, though he recognizes that it is strongly suggested by his Humean view of them as distinct existences, has disallowed this possibility.

These considerations go a long way to showing that for Ayer, when he was a phenomenalist, nothing actually existed except what was mental. To complete such a demonstration we would have to show that he gave no countenance to any further things which are neither physical nor mental. Since he has never had much truck with the main supposed examples of

such things, abstract objects, and still less with noumena, that should be easy.

III

If we now look in more detail at Ayer's successive dealings with the other minds problem, and its relation to his dealings with the problem of our knowledge of the physical, we will find the view confirmed that he has always tended to be a realist about the mental, as he has not about the physical (though the mental about which he is most evidently a realist is the sensory rather than the intentional mental). This is more obviously true by the time of *Foundations* than it is of *LT and L*. However, I think one can say that for the early Ayer (in effect) the ultimately actual was—for each of us—his own experience. The hyphenated phrase, as Ayer soon became clear, is incoherent, but needed to give any plausibility to the view.

A. If we use the scheme of *The Problem* to understand the position of *LT and L* we can say that the problem of how I infer the existence of physical things from the evidence for their existence (sense data or contents) is answered reductively there. I infer inductively that the occurrence of certain sense data is a reliable sign that others will occur, and this is what the existence of physical things consists in. The case is similar when I infer the existence of other minds from the behaviour of human organisms. It is facts about the actualities and possibilities of such behaviour that constitute the existence of those minds. However, I do not infer the existence of my own mind from behaviour. Rather, in noting the occurrence of the sense data through which I verify the truth of all statements whatever I am directly noting those items and something of their relations one to another which actually *are* my mind. Events in my own mind are the ultimate actualities and everything else consists in the possibility of other events in my mind. If this is not how it is put, it is surely what it comes to.

Of course, this whole asymmetrical view is radically muddled as Ayer has often pointed out since. It invites each of us, qua philosopher, to realize that everyone else is testing the truth of every factual statement by reference to the sense data and so forth occurring in their own mind (and ultimately constituting it) while at the same time denying that I can think of the sense data of anyone else as having the kind of reality they require if they are to serve as such an ultimate test. Thus, as a philosopher, I have both to be a realist about other minds, and postulate the sense data by which others test their statements, and say of myself that I cannot

understand statements about the sense data of others, except insofar as these are converted into logical constructions out of my own. Still, the general upshot is a kind of realism about my own mind and reductionism about other minds.

B. Let us now look at Ayer's next position on other minds. This is put forward in *Foundations.* Much the same position is presented more fully in "Other Minds" (1953) (in *Philosophical Essays*), though there are thirteen years between them. As propounded in the former work it is contemporary with the espousal of phenomenalism, and I think that in 1953 Ayer was still what I call an instrumentalist phenomenalist.

Ayer here sees the problem of other minds as arising because when I say of you that you have a certain experience I am saying of you just the same as I would say of myself if I said that I had that experience. Yet I am in principle unable to check up on the truth of the statement about you as I can with the statement about myself.

The standard account (he observes) of how I know that another is conscious, and on occasion what experiences he is having, is that I know it on the basis of an argument from analogy.

To say that one's knowledge of other minds has its rational basis in an argument from analogy is to say that one experiences a regular conjunction between various sorts of consciousness and various sorts of physical behaviour on one's own part and that one infers that similar behaviour in others is associated with similar consciousness. The great similarity in physical make up between myself and other humans (which indeed is required for much analogy in behaviour) is a further basis for the inference.

Ayer notes that certain difficulties have been found in this argument. First, its basis seems weak. Basing a generalisation on an association known directly only in one case seems risky. Second, there is the apparent fact that the inference is to a conclusion not susceptible of direct confirmation. An ordinary argument from analogy, or inductive argument, takes indirect evidence as a substitute for direct evidence ("Other Minds," p. 201). Where there could not be direct evidence it is doubtful whether it makes sense to speak of indirect evidence. Yet that is the case here.

Ayer evidently regards the argument from analogy as an inductive argument. But I am not clear whether he simply identifies arguments from analogy with inductive arguments or regards them as a sub-class thereof. Perhaps an argument from analogy is a particular case(s) to particular case(s) inductive argument (in which the element of generalisation remains implicit) with a rather narrow base, as opposed to a particular case(s) to universal or statistical law. Nothing much hangs upon this, however.

The first objection is not explicitly dealt with in this essay, but in *The Problem* (pp. 249 et ff.) Ayer suggests that it depends partly on what exactly we are counting. The correlation between a particular sort of experience and particular sort of behaviour can be checked up (in one's own case) again and again.

The main aim of the essay is to meet the objection that the conclusion from an argument to other minds from analogy is a conclusion which could not be reached directly and as such is bogus. Ayer claims that it is not logically impossible that one should know the conclusion directly, and that therefore, this, the main objection to the argument, can be met. He tries to show this by comparing our knowledge of other minds to that we have of events remote in space and/or time.

If I infer from spatially near events to spatially far events I infer to what I could have observed directly, since I could (now) have been elsewhere. Events in the past are further away from the possibility of direct verification. A historian infers that a battle took place here on the basis of buried bones, armour, etc., and says "There was a battle here about a century ago". As Ayer sees it, his statement has two features. He expresses the proposition that a battle occurred at a certain place at a certain rough date, and he uses language which indicates that the proposition is expressed at a later time, therefore by one not in a position to observe the battle. There is nothing intrinsically unobservable, so far as the speaker goes, in what the proposition affirms. It is a contingent fact that he's not in the best temporal position to observe it. This fact is suggested by his language, but it's not what his proposition essentially affirms. His indirect evidence is a substitute for the direct observation he could have made if he had been existing then rather than now, as he might have been, just as some indirect evidence I may have for what is going on next door is a substitute for the direct evidence I could have had if I had been there rather than here.

There seem to be considerable difficulties in this. Let us be clear, first, that Ayer is not concerned with the possibility that the historian might have been born in time to observe the battle for himself. The fact that if he had been born earlier he might have observed the battle and remembered it now is not really to the point. For the problem concerning statements about the past applies just as much to statements I make about past events which occurred during my adult life time, and even to ones which I did observe and perhaps remember. The point is that they are inaccessible now and therefore the propositions about them are now not verifiable directly. Thus the now fashionable question, whether it is of my personal essence that I was born when I was, is not relevant.

Ayer's contention was that although any evidence one can now collect for events described as past is bound to be indirect, this is simply because

in calling it past I indicate that I am not now existing at the right time to observe it directly, this being a contingent fact about the date now. But surely it is rather problematic what it is that *is not*, but *might have been*, the case. As we have seen, it is not that *I* might have existed then, for perhaps I did. So the meaning must be that *this time* might have been another date from what it is. But could this *now* have been that *then*? It's most unclear what that could mean. Perhaps Ayer's view is that it is this utterance which might have occurred then (in which case it would have been verbally otherwise) but that ascribes a strange power of remaining identical in changed circumstances to an utterance.

However that may be, Ayer did conclude that it is only contingent that I, speaking now, am not in a position to verify correctly inferred facts about the past directly. It is in a somewhat similar way, he suggests, that my statements about your experiences may be only contingently unverifiable by me. Although he later abandoned this view, it remains worthy of attention.

I see you holding your head and taking aspirins and say "Evidently you have a headache". The proposition I am affirming is, perhaps, that a certain pretty young punk girl student known as 'Lotte' has a headache, but since I am someone speaking to Lotte, rather than someone who is Lotte, I refer to the sufferer as 'You'. It is not, however, a logical impossibility that I, the speaker, might have been Lotte in which case I would have directly verified the proposition and reported it in the first person. Granted it is only a contingent fact that I am not Lotte, it is only a contingent fact that I cannot verify the proposition directly. Thus my indirect knowledge is a substitute for an in principle possible direct knowledge, and not therefore suspect as an analogy argument to a conclusion not independently verifiable would be.

One difficulty with this line of thought is this. It is suggested that I might have been, but am not, Lotte. But it's unclear what would have been different if I had been. Those who believe in some kind of nonempirical ego, as neither Ayer nor I do, can think this would have been some different state of affairs uncapturable in empirical and objective terms. In my view it would have made no difference because the only facts about experiences concern their character and empirical context, and there is no further fact that it is one person rather than another who had them. To imagine that I had Lotte's experiences is just to imagine the actual fact that they occurred. There is a sense in which I did have them and reported them in the person of Lotte, for the fact I imagine in imagining myself having them is a fact which actually exists, if Lotte felt what I think she did.

Everything turns on the meaning of 'I'. Surely if this can be equated with any definite description, it must be one including indicator words. I

quite incline to the view that 'I' means something like "The owner of *these* experiences". That would mean that statements about persons specified as other than myself (especially by the word 'you') have as part of their meaning "The owner of experiences not belonging to the same stream of consciousness as *these*". If 'I' is understood thus, I certainly could not have been *you* or *she*. The analogy with statements about the past supports this point. Part of the trouble was that since 'now' is an indicator word, it seems senseless to suppose that it could *now* have been *then* and it seems senseless in a rather similar way to suppose that *I* might have been *you* in some sense in which I am not.

But perhaps it would be sufficient for Ayer's purposes that it be possible that *I* should have been *Lotte* even if not possible that *I* should have been *she*. For according to Ayer's position at that time my statement about Lotte says that a person of a certain description had a certain experience and I might have known the truth of that statement directly if I had answered to that description, as is quite possible. Thus if I had simply meant "The person sitting on that chair at time T has a headache" then if I had sat there I would have known its truth or falsehood directly.

But surely this would have had nothing whatever to do with the fact that I am now asserting. I could easily have sat there instead of her but I would have hardly got the relevant direct knowledge thereby. Even if we have a more intimate description of the other person, and even if we build into it an account of the observable facts which are especially related to her having the headache (say that she drank a lot last night, is now rubbing her head, even that her brain is in a certain state) there is no sense in which the experience which I would have had if I had answered to that description would have been the experience of which I have indirect knowledge. This applies even if 'I' is equated with some definite description in general terms. In a situation in which relevant unique descriptions of me and of Lotte respectively applied to one person, the experiences of that person could not have been the very experiences which, in fact, are had by a person answering to only one of these descriptions.

Here there is a vast difference between publicly observable events and experiences. One can often think of a public physical event which in fact was not observed by a person of a certain description as having been so observed while remaining the same event. Moreover, whatever 'I' means, if any counterfactual at all makes sense, it makes sense to think of a situation in which I observe the very same physical event as one which in fact I did not observe. But one can hardly make gross imaginative variation in the character (still less the identity) of the person who *has* an experience and leave it as the same particular experience.

The fact, if it is somehow a fact, that if I had been Robespierre I would have had certain feelings, when executed, is not related to (whether as support or supported) the fact that Robespierre did have those feelings as the fact that if I had witnessed Robespierre's execution I would have seen certain things relates (whether as support or supported) to the fact that those things actually occurred.

It may be said that there is something nebulous in the notion of a particular experience, as opposed to one of a certain description. But although there can be dispute about the nature of particularity, I think any reasonable scheme would have to allow that there is some sense in which the experiences of Lotte whose knowability to me is in question and anything I might have lived through if I had had a different history would not have been the same particular experiences.

Ayer's line of thought was admirably ingenious and thought provoking. But why did he struggle so hard on behalf of such a very tortuous conclusion? It was surely because his actual beliefs extended beyond any reasonable notion of what he could directly verify, and yet he had a residual allegiance to the verifiability principle. Surely he could otherwise have resolved the issue far more easily by insisting only that meaningful propositions must concern facts which are capable of being directly known to *someone*, not necessarily their assertor. (Perhaps this was his final view. See *Wittgenstein*, p. 36.)

C. In *The Problem* Ayer still maintains that I could have been any historical person, inasmuch as the name of that person must stand in for a definite description and I can always specify myself in such a way as to make it logically possible that it was I who answered to it. In this sense I could have been Disraeli. Or if this is dubious when the historical person is very remote, there is no clear line between cases where it is intelligible and those where it is not (pp. 199–212). However, Ayer now sees more significance in the fact that I could not have been someone else, so that what is specified as someone else's experience could not have been mine (pp. 247–49). Still, he seems to stick to the point that what I primarily assert when I ascribe an experience to another person is that someone answering to a certain description had a certain experience and I can know what it would be like to be a person answering to that description and having that experience (p. 249).

He says that "if I can know what it would be like to satisfy a certain set of descriptions and to have a certain experience, then I can understand a statement to the effect that someone else who satisfies these descriptions is having that experience, independently of the question whether that person is, or could be, myself" (p. 249). What is the force of this 'what it would be like'? Why not say 'what it is like'? If it is a matter

of what it would be like for me to satisfy them, obviously it is inappropriate (if I don't satisfy them) to say I know what it *is* like. But if I mean that I know what it would be like for you (who do satisfy them and do have the experiences) to do so then one might as well say "I know what it is like" (unless perhaps I am not quite sure of the fact). In short, there seems some hesitation here between simply ascribing to people the ability directly to imagine the experiences of others and grounding the meaning of talk of other minds in this, and ascribing to them the ability to imagine verification opportunities which are not actual. I endorse the first sort of ascription, but if this was Ayer's position there was here a final break with verificationism, at least of any first personal kind and in this context. Perhaps the issue would become sharper if we considered what is involved in ascribing experiences to animals. (In his autobiography Ayer mentions wondering how far sheep are conscious.)

At any rate, Ayer thinks he can still meet the objection that the conclusion of an argument by analogy must be one which could have been reached more directly. After dealing with a few lesser objections, he concludes that the argument from analogy supplies us with grounds for belief in other minds which are as good as it makes sense to expect.

In all these battlings with the argument from analogy Ayer retains a clearly non-reductionist view of other minds and holds that each of us should think of other minds (or at least their experiences) as just as real as the one which he encounters directly—directly in the sense that his statements about its present experiences are asserted simply on the basis of the experiences themselves. This completely realist view of other minds goes together with a treatment of the physical world and our knowledge of it which is much more sympathetic to reductionism.

In *Foundations* and in *Philosophical Essays* there is a more or less strong commitment to a kind of phenomenalism. In *The Problem* we have, indeed, a move towards the later "sophisticated realism". However, after saying that physical objects are posited in a theory "with respect to the evidence of our senses" but which transcends its evidence as not being merely a redescription of it, he says that the theory has no "supply of wealth other than the phenomena over which it ranges" (p. 147). (See also the largely favourable remarks about phenomenalism on p. 146.) If this comes somewhere near, as I think it does, to saying that there is in the end nothing the theory tells us which does not concern the experiences there are to be got, then he is not a realist about the physical as he is about other minds (or at least others' experiences). For our experiences are not postulated as a device for gaining knowledge about something else. It is this something else (sense data and the minds they constitute) which are the ultimate constituents of the world.

D. Let us turn now to *Central Questions*. The discussion of other minds is now set in the context of a new account of the physical and our knowledge of it (to which *The Origins of Pragmatism* had already shown him moving). The existence of the physical world is viewed as a theory which explains the occurrence of sensory qualia such as would be reported by a new kind of basic statement concerning qualia, which differ from sense-data mainly in being repeatable universals. This theory of the physical world is not, however, what Ayer had previously called an iron curtain theory for which the physical is never directly encountered. The qualia whose occurrence is explained become, in terms of the theory, aspects of physical things, and as such are separated into distinct particulars. The conception of the physical is arrived at, initially, by regarding the given relations between given qualia (relations such as "to the left of") as relating the given to what is not presently given, but might be. There is quite a resemblance here to Bradley's idea that the physical world is a construction arrived at by synthetic judgements of sense which incorporate the given in a *more* of the same sort. One reason for Ayer's moving to a theory of this kind and away from anything approximating to phenomenalism is that it does not make use of subjunctive conditionals whose genuinely factual character he has come to deny. The given is interpreted as an element in a larger actual whole, in the light of which interpretation it is ascribed a somewhat fresh set of characteristics.

With this goes Ayer's new account of our knowledge of other minds as likewise a theory, one by means of which we explain people's observed behaviour. More specifically, he agrees with Hilary Putnam, that the conception of there being other minds is a common substratum to all our normal ways of explaining human behaviour. The detailed explanations are testable, so that the hypothesis of other minds, though not testable on its own in the abstract, is an element in what is testable. Moreover, there are no serious rival explanatory hypotheses which do not involve this idea.

One difficulty with this is that purely physicalist explanations of human behaviour may become available in the light of which the ascription of consciousness will be otiose so far as *explanation* goes. If one rejects an identity theory, as Ayer rightly does, that points towards epiphenomenalism. But then there is the difficulty that the consciousness which accompanies brain process can be thought of as absent in some or all others without affecting the explanations we can supply of their behaviour. To counter this it seems one might have to return to the argument from analogy, disassociating it from a 'best explanation' strategy.

However this may be, Ayer still holds to his basically realistic view of

minds. A person's own mind is not supposed to be a purely theoretical posit for him such as he does not directly encounter. I need my own encounter with my own mind to know what mental states are, and the minds of others are composed of mental states which are real in the same fundamental way (*Central Questions*, pp. 134–35).

Is Ayer now an unqualified realist about both minds and the physical? I find it hard to see him as a true realist about the physical. One reason is this. A straight description of the qualia which make up the immediate (though, of course, partly conceptually determined) sensory array can hardly be fitted in to a straight description of the scene perceived. For example, if one tries to think of one's visual field as literally contained in a larger visual field (as part of it is contained in it) one arrives at puzzles which show that the idea is incoherent. There is a quality pertaining to what belongs at the edge of the visual field which is unaccountable if it really lies within a larger visual whole. Moreover, if one seeks to think of one's visual field as a slice of the physical world, it is difficult to understand how it relates to a visual display of largely the same scene from another point of view. I suppose that there have been philosophers who have taken the immediate sensory array as simply being that part of an independently existing physical world which they are perceiving and were too naive to be troubled by such problems, but one only has to go back to criticisms Ayer made of Moore to doubt whether this could be true of him. So I can only think that Ayer is not really troubled by them because he is seeking to explain the basis of our ideas of the physical without attributing any literal truth to them. I surmise that if he tries to imagine another's experience he is entertaining the possibility that he is experiencing a picture or icon of something which is pretty like what it represents for him, but that if he imagines a *more* of the same sort, which extends beyond his visual field and includes it, he does not suppose there is anything existing really like this in the same basic sense. So I doubt that he has a genuinely realist view of what is posited in the theory of the physical as he does of the most important part of what is posited in the theory of other minds.

IV

I conclude that while Ayer has long been a realist about minds and their contents he has never been a clear-cut realist about the physical. For the phenomenalism, or near phenomenalism, of his earlier works the only actualities involved in the existence of the physical were sense data, themselves only actual when the physical is perceived. For the position

advocated in *The Problem* the theory of the physical is an instrument f or predicting or retrodicting actualities and possibilities of sensory occurrence. For the sophisticated realism of *Central Questions* the physical world is what is spoken of in a theory which Ayer is not concerned to see coherent enough for literal truth.

I am, admittedly, bringing Ayer's thought under concepts he rejects. However, I think that Ayer would agree that it is not illegitimate in principle to bring the thought of another under concepts alien to him.

I am doing this because I am ascribing an implicit view on the ultimate constituents or stuff of reality to Ayer, where this is not a matter of what is asserted to exist in the theory or theories which constitute our best way in practice of dealing with reality in our thoughts. In short, I am operating with a notion of the 'really real' which Ayer thinks illegitimate. Secondly, I am taking one's way of picturing reality as the best clue to what one thinks there really is. Ayer, in contrast, thinks one should dissociate questions about how, if at all, we are to picture the world from questions as to what is true.

Thus Ayer may well object to my foisting such an ontology on him. After all, he explicitly dissociates himself from James's radical empiricist ontology. He does so by taking a "pragmatic view of ontology" (*The Origins of Pragmatism*, p. 335). The question what there is can only properly be taken as either a straightforward enquiry conducted within a given conceptual scheme, or as concerning what ontology it is best to adopt. Taken in the latter philosophical way the choice should be made on grounds of convenience, or even taste. Physical reality is constructed out of facts about qualia, but once the construction is made qualia and experiences drop to a minor place within the scheme of things.

Still, Ayer does not dismiss the search for a more ultimate ontology out of hand. Although he thinks of such ontological claims as arising primarily when people have pragmatic grounds for wishing to change our conceptual scheme, he allows that people are tempted to say, for example, "What is *really* there, the table or the particles?" (p. 333) quite apart from our theorising. But he regards this as not a matter of truth or falsehood, (since there are no "criteria for determining what there really is, in this sense" [p. 334]) but of how we like to picture the world. It is at most a minor disadvantage when a theory provides no pictures, or only clashing ones.

These points are made with force in his 1968 essay "What Must There Be?" in *Metaphysics and Common Sense*. He talks of naive realism as providing us with the most comfortable picture of the world, somewhere between the phenomenalist picture which is too fragmentary and the physical realist one which is too abstract (p. 63). However, this is a matter of taste rather than truth.

This view that questions as to how reality should be pictured have no serious factual content seems to rest squarely upon verificationism. Otherwise, why should one not ask which of our pictures are most like what lies outside our personal consciousness? (This allows as one possible answer that none are, because reality is unpicturable, or—what I think is one form of picturability—only resembles our pictures in the most abstract ways.)

Personally, I have always felt that one only really knows the nature of what one can in a broad sense picture, (allowing presenting an abstract structure to oneself in pictures of which the sensory content is irrelevant as a case of this, though one must then allow that the reality has an unpicturable concrete way of filling up the structure). And I suspect that Ayer does not worry about unpicturable elements in the physical world as he constructs it, just because he does not think of the world as independently there to be known or not. Up to a point, indeed, Ayer allows this, for he has come to the opinion that reality in the only reasonable sense is partly constituted by our way of conceiving it.

But in thinking about the experiences of others are we not concerned with a reality which has nothing especially to do with *our* way of conceiving it? In trying really to empathise with another, am I not trying to form a "picture" (that is, an icon, not visual except where visual experiences are imagined) of what it is like to perceive, feel, and conceive things as he does? If Ayer agreed with this, and thus held that here the mental stands in contrast with the physical, I would be confirmed in my suspicion that he holds the admirable view that sentience is the final reality. I do not claim firm evidence for this suspicion, but the fact that he has never (since 1936) taken seriously a reductionist account of other minds (or minds in general)—as he has with regard to the physical— would be well explained if this did turn on a firm conviction that another's feeling of anxiety, or particular sort of perceptual experience, is *really there* in the most knockdown ultimate sense, and not primarily a posit in a more or less useful theory.

These remarks must be qualified in the light of Ayer's thoughts about intentionality. He has never wished to adopt a view like that of Husserl's, according to which it is a brute fact about the inherent character of a state of mind that it intends objects which are not elements within it. Ayer is inclined rather to see this as a matter of how my speech links up with action. Thus a mere icon of another's state of mind would not of itself put me in touch with his conception of the world. It remains my suspicion that for Ayer when I try to imagine another's experience I am trying to produce an imaginative icon of something which is either correct or not in virtue of corresponding to a distinct reality with its own quite definite character usually owing nothing to my thought of it.

V

I shall finish by considering some serious difficulties with the argument from analogy to which I think Ayer is insufficiently attentive. So far as I can see they remain as difficulties for his final view.

One of the main objections is that it is based on the assumption that the relations between a person's behaviour, and indeed any other publicly accessible facts about him, and his states of consciousness is quite contingent. This implies that there is nothing particularly odd about the idea that avoidance behaviour might have been correlated primarily with stimuli which produced pleasurable experience rather than pain, that behaviour guided by stimuli reaching the eyes might as well have been inwardly controlled by experience of the kind which is now auditory rather than visual, that liveliness in action might more often have gone with depression than cheerfulness, that the full moon might have typically produced the experience which now counts as seeing something square rather than round. Unless these abnormal correlations conflict only with empirical fact which can coherently be conceived otherwise, it cannot be true that I learn what experiences go with what external behaviour from noting a contingent correlation in my own case.

It is very difficult to think that all such relations are totally contingent. The simplest cases are pleasure and pain. Does it really make sense to say that pleasure might have been the negative reinforcer of behaviour and pain the positive? To me it seems plain that it does not make sense. (I suggest that the masochist's pain is overlaid with a pleasurable quality without which it could not reinforce and entice.)

That this is so is the main argument in favour of views tending to the behaviourist or alternatively to halfway house positions for which to call an experience a pain, say, is to say that it is an experience of an otherwise unspecified kind which, in that individual organism, acts as a negative reinforcer and perhaps that an experience is visual if it is an experience of that kind which in that individual organism relates to its guidance by light. In contrast, Ayer holds to the full-blooded traditional mentalist or empiricist view that we can use expressions like 'pain', or (I think) 'visual experience' as labels for the actual sorts of feeling or experience in question without reference to its publicly observable causes or effects. (See *Wittgenstein*, p. 78.) This view seems to me correct, so far as it goes. But if it leaves us with the idea that the experiences so labelled could have played utterly different roles in our lives in the public world I feel that something has gone wrong. For although experiences seem to me to have their own reidentifiable characters (something for which Ayer has argued effectively in insisting on the unavoidability of the appeal to "primary

recognition") I cannot accept that it is quite contingent what their external manifestations are.

I believe that there are two ways in which we can make sense of the idea that the type of consciousness going together with certain behavioural manifestations, which serve as a criterion of their presence, must be of a certain sort, or at least cannot be of certain other sorts. The first of these should be acceptable to Ayer; the second must be profoundly unacceptable to him.

(1) When I believe that another is conscious, I do not believe merely that there is some kind of consciousness linked up with his body or brain. I believe, rather, that what I see of him is the manifestation in my world of the fact that that world is revealed in another perspective. A consciousness which was not revealing what can count as the same world from the point of view occupied by your body would not be what I mean by your consciousness. Thus once granted that I believe in your consciousness there are strong constraints on what I can take as going on within it. It must at least have structural and perspectival characteristics of a sort which fit it to perform this role. It would require a long discussion to support any particular view about how far these constraints go, (whether for example the spatial layout of objects could be represented auditorily) but they certainly go far enough to dispel the idea that your consciousness might have any character whatever. Thus once consciousness is granted you I do not need to appeal to contingent generalisations, established inductively from my own case, for thinking that it has these characteristics.

It may be said that I only know by experience that the world is revealed to me in a certain way. But this is not so. There are just the same constraints on how some determinately characterised part of the world could have been revealed to me. We are touching on another misleading feature of the argument from analogy. It suggests that I am confronted with two different things, the public physical and the private experiential, and notice correlations between them in my own case which I then extend beyond them. In fact, the bulk of my experience is of the public physical, and there is no question of noting the correlation of two things. Rather, there is one thing which can be considered in two ways, either as a world revealed or as the revelation of a world. My consciousness, once infancy is passed, is of a world, and learning about other minds is learning that the world is given in other perspectives too. This is quite compatible with Ayer's main positions but it qualifies the appropriateness of talking about analogy (or induction) as the ground for ascribing experiences of certain sorts to you, and also puts the treating "other minds" as representing the best theory for explaining people's behaviour

in a different light, since it shows that it is a theory in which the particular phenomena posited in the explanation have a uniquely intimate relation to what they explain.

(2) However, there are aspects of consciousness which are not so much a matter of the perspective in which the common world is being revealed, as of how I feel about it where I could feel quite differently without my consciousness ceasing to be the perspective on the world determined by my body. This is true especially of pleasure and pain, cheerfulness and gloom.

These may be regarded as a way in which my behavioural propensities are presented to me, and here again it seems that not just any feelings will serve to present any such propensities. However, the constraints this puts upon the possible forms of consciousness of another cannot be explained as above in terms of the structural isomorphism required between the presentation and the presented. We must appeal rather (I suggest) to an intrinsic fit between certain feelings and certain behavioural propensities. Feelings and behaviour are distinct, and could exist apart, but they fit each other in a way incompatible with any radical change in the way they go together, when they do.

I would go further still and claim that we can actually find in pleasure and pain, although they are definite characters of experience, determinate apart from what they produce, an intrinsic capacity to produce certain effects. Pleasure and pain are *both* definite qualities of feeling, *and* intrinsically liable to sustain or repel experiences found together with them, so far as nature allows them to have efficacy at all. Ayer could not follow me in this, for it is a flat denial of his Humean view that an event, described in terms of what it essentially is within its own boundaries, could have an intrinsic tendency to produce certain sorts of results. This is persuasive if we think of the different bits of the world as objects in public space, or space-time, not so persuasive for bits of the world which are personal experiences.

This does not imply that analogy, induction, or best explanation, may not play a part in the ascription of consciousness to others, for perhaps any necessity is from consciousness to behavioural tendency not vice versa (though in the end I doubt this). But it does suggest that it is a misconception to think of the argument from analogy, conceived as a process of inductive inference which establishes purely contingent connections, as the sole source of our knowledge of the character of the consciousness of others, once granted they *are* conscious. And I believe that this is how Ayer has conceived the argument.

There are two things on which I would especially like to be clearer. (1) Does Ayer believe that any kind of conscious feeling or sense experience could lie behind any kind of behavioural propensity and that all relations

between them are contingent? That he would seem committed to this seems the main objection to his treatment of the other minds problem, much more sensible as it is than most of the others on the market. (2) Is it a mere travesty to suggest that there is an idealist aspect to his thought?

<div align="right">

T.L.S. SPRIGGE

</div>

DEPARTMENT OF PHILOSOPHY
UNIVERSITY OF EDINBURGH
JUNE 1986

NOTE

I should like to note here my appreciation of my contact with Freddie Ayer who supervised me for my Ph.D. thesis on ethics at University College London. His great quality as a supervisor, one which might not be obvious from his writings, was his interested tolerance of views very divergent from his own, and helpfulness to his students in working their own positions out. My own philosophical views are now even further apart from his than they were once, but I have been deeply influenced by his approach, combining as it does great rigour with a complete absence of unnecessary jargon and cumbrous paraphernalia. His philosophical style is a model many would benefit from following today. I am lucky to have worked under such a major philosopher.

REFERENCES

Ayer, A.J. 1973. *The Central Questions of Philosophy.* London: Weidenfeld & Nicolson.

——. *The Foundations of Empirical Knowledge.* 1940. London: Macmillan.

——. 1946. *Language, Truth and Logic.* 2d ed. London: Victor Gollancz.

——. 1969. *The Origins of Pragmatism.* London: Macmillan.

——. 1954. "Other Minds." *Philosophical Essays.* London: Macmillan.

——. 1973. "Privacy." *The Concept of a Person and Other Essays.* London: Macmillan.

——. 1956. *The Problem of Knowledge.* London: Macmillan.

——. 1969. "What Must There Be?" *Metaphysics and Common Sense.* London: Macmillan.

——. 1985. *Wittgenstein.* London: Weidenfeld & Nicolson; New York: Random House; Penguin Books, 1985.

Sprigge, T.L.S. 1990. "A.J. Ayer: An Appreciation." *Utilitas* (Spring): 1–11.

——. 1983. *The Vindication of Absolute Idealism.* Edinburgh: University Press of Scotland.

REPLY TO T.L.S. SPRIGGE

I suppose that none of my philosophical preoccupations has given me so much trouble as the problem customarily, if somewhat imprecisely, described as that of our knowledge of other minds. Professor Sprigge distinguishes three successive and radically different ways in which I have attempted to dispose of the problem, and criticizes all of them. A fourth way, which he also criticizes, is classified by him perhaps not altogether justifiably, as a refinement of the second.

While it will be seen that I do not accept the conclusions to which Sprigge argues that I should regard myself as being committed, I am nevertheless grateful for the acuity of his criticisms. I had already abandoned all but the last of my tentative solutions of the problem, but on one point at least he has detected a weakness in my argument which I had not previously noticed.

The course which I originally pursued in *Language, Truth and Logic* was that of taking statements about my own experiences at their face value, which meant construing them mentalistically, while adopting a behaviouristic analysis of statements about the experiences of other persons. This distinction appeared to me then to be required by my acceptance of a verification principle, according to which empirical statements had a literal meaning for me only if they referred to what it was conceivable that I should verify. Statements about my own experiences fulfilled this condition; for statements about the experiences of other persons to do so, I was bound to take them as referring to the observable behaviour which I had to regard as constituting the experiences, not to anything "behind" this behaviour, which would even theoretically lie beyond my reach.

Sprigge agrees with my later admission, itself originating in a doctoral thesis by my pupil Martin Shearn, that such an asymmetrical analysis of

statements about one's and other people's experiences is actually incoherent. As I put it in *The Problem of Knowledge*, a philosopher who takes such a course "does not merely wish to argue that the statements which he makes about his own feelings have a different meaning for him from that which they can have for anyone else. He wishes his theory to have a general application; it is supposed to be true of all of us that when we talk about our own mental states, we are referring to experiences of which we can be directly aware, but when we talk about the mental states of others we are referring to their physical condition or behaviour. But if the theory were correct, this distinction between the mental and the physical . . . could not be made in any case but one's own. If I cannot distinguish between another person's feelings and their physical expression, I cannot suppose that he distinguishes them . . . I cannot both admit the distinction that he makes and say that it has no meaning for me."[1]

This argument is unanswerable, as it stands. It occurs to me now, however, that its validity depends on its incorporating a particular interpretation of the verification principle, as a theory of meaning. I shall be suggesting in a moment that this is not the only possible interpretation, nor the one that I should now favour. In the meantime, let us just assume that our theory of meaning, whatever it may be, allows us to construe statements about the experiences of other persons in the same fashion as we construe statements about our own. This would at least leave room for the hypothesis that we interpret both sorts of statements mentalistically. In that case the asymmetrical treatment that I adopted in *Language, Truth and Logic* would escape the charge of incoherence, while losing the motive which deluded me into thinking that I had no other option. It could, however, still be defended. Suppose that someone were to maintain that one should make only such factual statements as one was evidentially warranted in asserting. He might then proceed to argue that whereas each of us was warranted in making mentalistic statements about his own experiences, on the basis of actually having them, remembering them, or having good reason to predict them, no one can ever have sufficient warrant for making corresponding statements about the experiences of others; the most that we can ever be warranted in asserting is what our observations disclose to us about their actual or potential behaviour. It might indeed be argued that this view would also be incoherent, on the ground that one could not consistently credit another person with a warrant for making an assertion which it was logically impossible that one should have a warrant for making oneself, but I do not think that this objection would be valid. For instance, I shall

be conceding to Sprigge that a difference in one's temporal position may furnish a logical basis for making a difference in what one can warrantably assert.

But even if the asymmetrical solution avoids self-contradiction, I am not now prepared to adopt it. Setting aside the cases where considerations of morals or good manners, or pursuing the means to some desirable end make it pardonable or even obligatory to lie, I approve of the principle that one should make only such factual statements as one has an evidential warrant for asserting, and should be happy to see it generally adopted. At the same time I cannot rid myself of the belief that when some other person makes a statement about an experience of mine, when, for instance, he ostensibly agrees with me that a physical injury is causing me pain, he is interpreting the statement in the same way as I do myself. Nor am I disposed to believe that in every such case the others are violating the principle of warranted assertibility. I have therefore the same motives as I had when I took my asymmetrical theory to be inconsistent, for finding a good reason for construing statements that are made about the experiences of other persons in the same fashion as I construe statements that are made about my own. It will, however, appear that my present rejection of the way in which I interpreted the principle of verifiability makes a difference to the course which I take to be requisite for achieving this end.

The acceptance of the view that statements about the experiences of oneself and others are to be construed symmetrically does not itself entail that one is bound to give a mentalistic interpretation of statements about the experiences of others. It could be held, and indeed has been held by some philosophers, notably Carnap and intermittently Ryle, that both sets of statements, those about one's own experiences and those about the experiences of others, are to be understood in behaviouristic or at any rate in purely physical terms. My rejection of this view is couched in a phrase originally formulated by Ogden and Richards in their book *The Meaning of Meaning*. I am not willing to feign anaesthesia.

It should be remarked that this conclusion does not exclude every form of physicalism. It does exclude physicalism in the form in which it is advocated by such philosophers as David Armstrong who valiantly but vainly attempt to conjure mental events away. On the other hand it is compatible with the currently fashionable view that every mental state is contingently identical with some physical event, usually conceived as a process occurring in the brain of the person to whom the mental state is ascribed. But while I think it very probable that every item in a person's mental history is causally dependent upon the condition of his brain, it has never been clear to me on what grounds the transition is made from

concomitance to identity. In this instance, a mere appeal to Ockham's razor does not appear to me to be sufficient. The ingenious philosopher, Donald Davidson, is unique, so far as I know, in deriving a proof of psycho-physical identity from premises which include the rejection of any chance of there being psycho-physical laws, but I believe that I have been able to show in the last chapter of my book *Philosophy in the Twentieth Century* that his argument is invalid.

I have in my reply to Sprigge already twice referred to the fact that the principle of verification is capable of being interpreted in two important-ly different ways. This point, which seems not to have been appreciated by the members of the Vienna Circle and was overlooked by me in *Language, Truth and Logic*, was brought out by Gilbert Ryle in his essay "Verifiability by Me". It concerns the scope of the notion of verifiability in principle, or rather the fact that the scope of this concept will vary according as the process of verification is or is not linked to the identity of the author or interpreter of the statement in question, a feature of this identity being the position that he actually occupies in space and time. If one takes the view that it is so linked, as I did, at least implicitly, in *Language, Truth and Logic*, one will be disposed to construe the attribution of experiences to others behaviouristically, on the assump-tion that one has no direct access to them, and one may also feel oneself obliged to equate statements ostensibly about the past with whatever present or future evidence would commonly be regarded as supporting them. This view of the past was taken by the pragmatists, C.S. Peirce and C.I. Lewis, and it is indeed very plausible to argue that a sentence has no meaning independently of the way in which it is understood by some person, that a person's understanding of a sentence coincides with his estimate of the difference that the truth of what it expresses would make to his experience, and that limits of his possible experiences are set by his identity and his spatio-temporal position; just as the only experiences that he can have are his own, so there is no way in which he can return to the past.

Nevertheless the consequences of this view are counterintuitive. I have already set out the objections to the asymmetrical treatment of statements referring to experiences, and the proposed analysis of histori-cal statements, even if it runs no risk of being inconsistent, is hardly persuasive. It is difficult to believe that the statement that Wellington defeated Napoleon at the Battle of Waterloo entails the report of a conversation in the memoirs of Thomas Creevey, still less that it is equivalent to that report and a number of similar pieces of evidence. Should I say that my current statement that the leaves of the tree under which I am seated are rustling slightly in the wind will mean no more to

me tomorrow than that I have such and such a memory, supported perhaps by a meteorological report? Does the fact that I am now in France and not in England entail that anything that is said about what is happening in England now is equivalent, so far as I am concerned, to the various sources of news, such as conversations over the telephone, which are available to me?

This last example may be challenged on the ground that the concept of verifiability in principle allows for displacement in space. I am not now in England but I might be and if I were I should be able to observe events about which, as it is, I gain all my information at second hand. Even this supposition, however, is not entirely free from difficulty. For instance, it has to be assumed that my presence as an observer would not alter the character of the event in question; but I will not pursue this matter here.

The possibility of displacement in time is more contentious. There are, indeed, some philosophers, who reject it altogether. They make the circumstances of one's birth a necessary feature of one's identity. I give reasons in my reply to Professor Putnam why I cannot share this view. My own inclination has been to go to the other extreme. I have argued that a historian who gives what is in the main a correct description of the career of one of his subjects but assigns a wrong date, measured even in centuries, to the events which he recounts may yet be held to have succeeded in his references. How great a scope this provides for subjunctive conditionals which transport a person in time without infringing his identity is another question which I shall not here pursue.

The main reason why I shall not pursue it is that Sprigge has convinced me that even the greatest latitude in this respect would not give the upholder of the verification principle, in what may be called its pragmatic form, the result that he needs. A phenomenalist may be able to make do with such subjunctive conditionals as "If I had been present at the Battle of Waterloo I should have observed etc." but the pragmatist, in the present context, requires conditionals of the form "If I were currently present at the battle I should be observing etc."; and it is at least very doubtful whether it makes sense to talk of being a current observer of past events, especially, as Sprigge remarks, when the events in question were items in one's own biography.

These considerations suggest that if one is to accept the verification principle, not merely as requiring that a factual statement should at the very best be part of a theory which is empirically testable, a demand that I should still maintain, but in its much more ambitious version as fixing the literal meaning of factual statements, the principle should be interpreted in such a way as to become independent of the identity and

spatio-temporal position of the person who utters or interprets the statement to which it is applied. Instead, the person who carries out the verification is deemed to be the one best qualified to do so. In the case of a given person's experience at any time it would be the person himself at the time in question. For all its merits, this interpretation seems to me to come to grief when the statement refers to a time before there were any sentient creatures or after they have all ceased to exist, for then we have to rely on the fiction of an ideal observer; but to develop this theme would take us too far from my treatment of the problem of our knowledge of other minds.

In my second attack upon this problem I appear to have attempted to combine both interpretations of the verification principle. I ascribed to statements about the current experiences of other persons the meanings that they would have for those who were in the best position to verify them and at the same time maintained that it was not logically impossible that I should be in such a position myself. My argument, as Sprigge reminds me, was that persons are identified by the descriptions which they satisfy, that it is a contingent matter that a particular person satisfies any given description, and that consequently all the descriptions that another person satisfies might conceivably have been satisfied by myself. But, to take Sprigge's example, if Lotte and I are in fact different persons, is it even conceivable that we should have been identical? This is badly put, since it is surely conceivable that neither of us should have existed and conceivable also that there should have been only one of us. If the question which Sprigge intended is whether it is conceivable that we should be both different and identical, the answer is obviously, No. I do not, however, wish to tie this to the question of the use of demonstratives. It is enough that if we have assented to the premiss that we are different persons we are precluded even from supposing that all the descriptions which serve on given occasions to fix the reference to one of us are on that occasion satisfied also by the other.

I believe that I was not fully aware in 1953 how little I should have accomplished even if my argument had been valid. At the best it would have removed the a priori objection to any argument from analogy, that its conclusion is in principle unverifiable. It would have gone no way towards showing that I actually commanded any strong support for an inductive argument.

I made some attempt to remedy this omission in *The Problem of Knowledge*. My purpose, which Sprigge should be forgiven for overlooking, since I did not clearly distinguish my pursuit of it from my revival of my argument about the possibility of having direct access to the experiences of others, and my assimilation of the latter question to that of the analysis of statements about the past, was to provide the argument

from analogy with a broader foundation. Instead of basing it on a single instance, the association of physical with mental phenomena in my own person, I proposed to multiply the instances by associating mental phenomena with the variety of conditions in which they had, in some cases repeatedly, been manifested, making light of the fact that all these conjunctions figured only in my own biography. I now think that this approach would acquire greater force if it were introduced at a stage where percepts had been transmuted into bodies, the central body marked out as my own, and other bodies distinguished, if only on behavioural grounds, as persons. Then, if I am entitled to assume the existence of a special relation of my experiences to my own body, even though my account of it may be disputable, the location in other bodies of physical states with the like of which experiences had been associated in my own case might supply me with a ground for a belief in the occurrence of experiences which stood in the same relation to the other bodies in question. A series of such experiences would then constitute this or that other mind.

This is the best that I can do for the argument from analogy and I still doubt whether it is enough. The disanalogies which obtain between the properties of my own body and those of other persons are numerous enough to deny me the right to be as confident as I am in the existence and character of their experiences. Moreover I have drawn very heavily upon my "construction" of the external world, which is avowedly the development of a theory, so that I have effectively passed from what might have passed for my second line of attack on the problem of our knowledge of other minds to what Sprigge counts as a third. It might be better if I were just content to say that the attribution of experiences to others is so much a feature of the theory which I propounded first in *The Origins of Pragmatism* and then in *The Central Questions of Philosophy* as my grant of independence to the physical objects of perception.

Sprigge gives an accurate account of my present position, except perhaps at one point. He suggests that I now claim to justify my belief in the attribution of experiences to others on the ground that it provides the best available explanation of their behaviour, and he fairly raises the objection that if a purely physical explanation were to become available, a possibility which I have no wish to exclude, this ground would be removed. It is not, indeed, clear to me why the two forms of explanation should not persist side by side, without our having to give the physical explanation priority. Sprigge could, however, adduce the fact that even if the physical explanation were given priority, I should not feel any the less justified in attributing experiences to others.

What Sprigge does overlook here, though he refers to it elsewhere, is

the point that Mr Foster brings out so well. I attach no sense to asking, What is "really there", as Sprigge puts it, "in the most knockdown ultimate sense". In my view, what there is is what there is presumed to be in the theory to which I give preference on pragmatic grounds over any others that tally with my experience. In the present instance, this is a theory that attributes experiences to persons other than myself. Provision has originally been made for this option by my starting with qualia which can be manifested in any sense-field.

Sprigge's account of the development of my views about physical objects is substantially correct. In particular, he is right in saying that traces of phenomenalism remain in *The Problem of Knowledge* though I had officially renounced it ten years earlier in my essay "On Phenomenalism", republished in my *Philosophical Essays*, my main reasons being not only my disinclination, which Sprigge notes, for having my basic statements principally take the form of conditionals, but also the fact that the constant need to multiply conditionals would always defeat the project of translating statements about physical objects into statements about sense-data.

Sprigge makes two slips, neither of any great consequence. It is not true that in the theory of Neutral Monism, which went hand in hand with my phenomenalism, minds are logically constructed solely out of actual data, whereas physical objects are formed out of possibilities. Admittedly, what Russell called sensibilia are allotted the leading role in the construction of physical objects, but both for him and for William James, the principal exponents of the theory, any sense-datum that is not "wild", in the sense of being part of an hallucination, is Janus-faced. In virtue of its relation to one set of elements it helps to constitute a mind; in virtue of its relations to another set it helps to constitute a physical object. Furthermore, since James, at least, draws heavily on the concept of possible experience, a number of the data out of which minds are logically constructed will also be no more than possible.

Sprigge is also mistaken in thinking that I now take my present visual field to be part of the physical world. The ingredients of my visuo-tactual continuants are not actual, but what I call standardized percepts and the prolongation of the relations between their present representatives so as to bring into play absent percepts the likes of which have been found through past experiences to be obtainable effaces any rough edges that might be treated as an impediment to their existence.

I come at length to the two questions which Sprigge ends by putting to me. Do I believe that all relations between behavioural propositions and sense experiences are contingent and is there an idealist aspect to my thought?

I shall try to deal first with the second of these questions. I think that my answer to it should be, Yes, since although my theory of the world is realistic, in the sense that it allows me to believe that physical objects have existed and probably will exist in the absence of any sentient creatures, I also look upon the world, in the phrase that I used in my *Central Questions*, as "structured by our method of describing it", adding in echo of Kant, that "the idea that we could prise the world off our concepts is incoherent".[2] It is true that I by no means agree with Sprigge that all that there is is sentience, but ever since my early involvement with behaviourism I have attributed experiences to other persons in the same literal way as I attribute them to myself.

Perhaps more surprisingly, I think that my answer to the first question has also to be Yes. Though I agree with Sprigge that the phenomena posited in the explanation of the behaviour of other persons, or at any rate the percepts which I assume that they organize in the same fashion as I do my own, "have a uniquely intimate relation to what they explain", insofar as they serve as the basis of the construction of our common world, I am not prepared to identify this "intimate relation" with natural necessity. I take it to be contingent that our sense-experiences take the form which lends itself to the interpretations that we put upon them.

When we consider the etiology of perception, such questions as whether it is contingent that we see with our eyes, hear with our ears and so forth are complicated by a tendency to make such statements true by definition. If we start with the premiss that the eye is an indispensable organ of sight, we can indeed conclude it to be necessary that we see with our eyes. It should, however, be clear that we are not bound to take this course. If we restrict ourselves to describing our eyes purely in terms of this qualitative constitution and the position that they occupy in the human body, then the fact that they play a causal role in the product of visual rather than auditory data is one that I see no reason not to deem contingent.

As for human emotions, and feelings such as pain and pleasure, there is again a complication in that the words which we use to denote them normally carry a reference to overt behaviour. This is a natural consequence of the way in which the use of such words is originally taught. At the same time it is possible to distinguish, and indeed refer to, the feeling in question independently of the behaviour with which it is causally associated. So far Sprigge agrees with me. Where we differ is in my affirming, what he denies, that these causal relations are contingent. He speaks, for example, of pleasure and pain as being "*both* definite qualities of feeling, *and* intrinsically liable to sustain or repel experiences found together with them". Considering the perspicacity of his essay, I regret

that I am unable to fathom his understanding of this concept of "intrinsic liability."

A.J.A.

NOTES

1. *The Problem of Knowledge,* p. 125.
2. *Central Questions,* p. 49.

23

Barry Stroud

AYER'S HUME

Ayer admires Hume as "the greatest of all British philosophers" (*H*, p. 1). In our own century, he has the highest regard for Russell (*W*, p. 145). He would no doubt look with favour on a history which placed his own work as the next giant step in the march of British empiricist philosophy from Hume through Mill to Russell and beyond. He defended the positivism of his first book as "the logical outcome" of the empiricism of Berkeley and Hume (*LTL*, p. 31). But Berkeley, for all his cleverness, seems never to have been Ayer's cup of tea. He certainly was not sound theologically. On that score, and most others, Hume is more reliable—and truly *simpatico*. Many of the specific doctrines of *Language, Truth and Logic* have been abandoned or revised beyond recognition over the years, but Ayer's general philosophical outlook has scarcely changed since then. There remains at its centre his endorsement of what he sees as the achievement of Hume.

But even Russell found that Hume, "by making [the empirical philosophy of Locke and Berkeley] self-consistent, made it incredible. He represents, in a certain sense, a dead end: in his direction, it is impossible to go further" (*HWP*, p. 659). That did not seem to stop Russell from trying to go further in that same direction. He continued to "hope that something less sceptical than Hume's system may be discoverable" (*HWP*, p. 659). It cannot be said that he discovered it.

I think that is because Russell's verdict was right. It *is* impossible to go further in the direction he had in mind. But what direction is that? And was it Hume's direction? Ayer thinks it was. He has remained committed to a certain conception of what the only or at least the proper task for philosophy can be. And that conception, combined with his admiration

When Professor Stroud heard of Sir Alfred's death he telephoned to see whether I still wanted his essay which he had not yet mailed, and I assured him I did.—ED.

for Hume, is what I think leads him to his understanding of the aims of Hume's philosophy. But that seems to me to ignore or at least to distort what is most important and still most fruitful in that philosophy. Ayer also shares many specific doctrines with Hume. But I think those views, given Ayer's conception of the philosophical enterprise, are the real source of the dead end which Russell encountered and, if I am right, Ayer still faces. I therefore would like to take up Ayer's understanding of Hume, his conception of philosophy, and the relation between the two.

<div style="text-align: center;">I</div>

It is not easy to say what Ayer thinks Hume was up to as a philosopher. Or rather, it is not easy to say what he thinks Hume was up to; he seems to have no doubt what it had to be if it can be called philosophy. He invokes Hume's views often in his philosophical writings, but always in the treatment of some specific issue or as the source of this or that particular problem. Even the brief general introduction to Hume in the Past Masters book gives no satisfyingly comprehensive description of what Hume himself was trying to do or saw himself as doing.

Ayer duly reminds us that seventeenth- and early eighteenth-century writers did not distinguish philosophy from the sciences as we do today. He mentions Kemp Smith's interpretative emphasis on Hume's attempt to "explain the principles of human nature" (*H*, p. 18). He acknowledges Hume's wish to develop a "science of human nature" (*H*, p. 24) or a "science of the mind" (*H*, p. 25). He quotes Hume's remark in the Introduction to the *Treatise* that " 'Tis impossible to tell what changes and improvements we might make in these sciences [of "*Mathematics, Natural Philosophy, and Natural Religion*"] were we thoroughly acquainted with the extent and force of human understanding, and cou'd explain the nature of the ideas we employ, and of the operations we perform in our reasonings" (*T*, p. xix). But he identifies Hume's project with the program of Locke's *Essay Concerning Human Understanding*: to answer the questions "What are the materials with which the mind is furnished, and what uses can it make of them?" (*H*, p. 25). Perhaps Hume's Lockean phrases here suggest endorsement of the humble "underlabourer's" task of "clearing the ground a little, and removing some of the rubbish that lies in the way to knowledge" (*EHU*, p. 14). But that does not account for the unmistakable optimism of Hume's Introduction—the expectation of untold "improvements" in those sciences promised by leaving aside "the tedious lingring method" and marching up "directly to the capital or centre of these sciences, to human

nature itself", from which "we may extend our conquests over all those sciences, which more intimately concern human life"(*T*, p. xx). We do not have to believe that Hume's hopes for "the science of MAN" have been realized in order to ask what those hopes might have been, what reasons he had for entertaining them, and how he thought they might be fulfilled.

The *Treatise* bears the conspicuous subtitle "Being an Attempt to introduce the experimental Method of Reasoning into MORAL SUB-JECTS". Hume stresses that "as the science of man is the only solid foundation for the other sciences, so the only solid foundation we can give to this science itself must be laid on experience and observation" (*T*, p. xx). He warns that it is "impossible to form any notion of [the mind's] powers and qualities otherwise than from careful and exact experiments, and the observation of those particular effects, which result from its different circumstances and situations" (*T*, p. xxi). Ayer does briefly explain the division between natural philosophy and moral philosophy, and he notes Hume's attachment (which he says is shared with Locke) to the idea that the experimental method of reasoning is applicable to the moral sciences. He concedes that Hume would probably describe his own work as falling within the domain of "experimental reasoning" (*CQ*, p. 23). But he thinks Hume did not really understand that method as it was employed to such impressive effect in the great work of Newton. And he thinks that it was only to a very limited extent (and then chiefly in writing about morality) that he advanced any empirical generalizations which could be tested by experiment (*CQ*, p. 23).

Whatever Hume might say he is doing or wants to do, for Ayer it is clear that "his main business is with concepts" (*CQ*, p. 23). His philosophical task was to "analyze" them. In this he is apparently not unique. "The majority of those who are commonly supposed to have been great philosophers were primarily not metaphysicians but analysts" (*LTL*, p. 52). Without a sharp distinction between philosophy and science Hume could not be expected to have understood his philosophical work in this way. Ayer sees him as to that extent confused, often expressing his views or his problems in misleading psychological terms, and sometimes even pursuing questions of what we would nowadays call psychology.

But apparently he was not completely confused. There is the famous concluding passage of *An Enquiry Concerning Human Understanding* which Ayer quotes often as a statement of Hume's own understanding of his enterprise.

> When we run over our libraries, persuaded of these principles, what havoc must we make? If we take in our hand any volume; of divinity or school metaphysics, for instance; let us ask, *Does it contain any abstract reasoning*

concerning quantity or number? No. *Does it contain any experimental reasoning concerning matter of fact and existence*? No. Commit it then to the flames: for it can contain nothing but sophistry and illusion. (*E*, p. 165)

In *Language, Truth and Logic* Ayer sees this as a rhetorical version of his own thesis that "a sentence which does not express either a formally true proposition or an empirical hypothesis is devoid of literal significance" (*LTL*, p. 54). In *The Central Questions of Philosophy* he takes this same passage "implicitly" to express the view that analysis is the only proper activity for philosophy (*CQ*, p. 23). In *Hume* he quotes it again, as the best short summary of Hume's whole "general outlook", this time linking it most closely with resistance to the "licence" of the imagination which breeds theology and superstition (*H*, p. 96).

These different claims for this stirring passage are not obviously equivalent. Is it really making a claim about the nature of philosophy at all? It says nothing directly about the "literal significance" or insignificance of any sentences. It is true that it is based on Hume's division of "all the objects of human reason and enquiry . . . into two kinds, to wit, *Relations of Ideas*, and *Matters of Fact*" (*E*, p. 25). But for Hume a "matter of fact" is something the opposite of which is possible in the sense of implying no contradiction. It is also something that comes to be known or even believed only on the basis of experience. But that does not imply that no "matter of fact" would be intelligible, and hence would even be a "matter of fact" at all, unless its holding or not holding were to some degree verifiable in human experience. That is what Ayer's verifiability criterion of meaningfulness says.

Even if Hume were concerned with meaningfulness, and were expressing Ayer's verifiability criterion in this passage, it would not follow that he is here declaring that philosophy, or what he is trying to do in the *Treatise* and *Enquiries*, is exclusively an exercise in conceptual analysis or reflection on "relations of ideas". He could hold the criterion and reject everything that violates it while still seeing his own writings as perfectly meaningful applications of "the experimental method of reasoning" to the study of human nature. That is what he says he is doing.

Ayer thinks the view that philosophy is analysis "can be made to follow" from Hume's attack on "school metaphysics" in this passage (*CQ*, p. 23). But what Hume says here about "divinity or school metaphysics" is, first, that any book treating of such matters will contain nothing but sophistry and illusion if it does not contain abstract reasoning concerning quantity or number or experimental reasoning concerning matter of fact and existence. And on Hume's view that is true of any book on any subject. Second, he suggests, but without documentation, that there is no such reasoning in books of those kinds. But that is

the complaint that those books lack certain kinds of reasoning, or that they lack reasoning altogether, not necessarily that they do not contain any sentences of certain legitimate kinds. Again, if Hume thinks their sentences are indeed meaningless, it does not follow that he thinks the proper task for philosophy is analysis. But even if their sentences are perfectly meaningful those books would still be nothing but sophistry and illusion if they give no reasons for believing anything they say. That will be so if, as is likely, they appeal only to the imagination, which is "naturally sublime, delighted with whatever is remote and extraordinary, and running, without control, into . . . distant and high enquiries" (*E*, p. 162).

That does seem to be what Hume has in mind. The passage occurs at the end of the last section of the *Enquiry* where Hume is listing the advantages to mankind of the various forms of mitigated scepticism he has been recommending. One "natural result of the Pyrrhonian doubts and scruples, is the limitation of our enquiries to such subjects as are best adapted to the narrow capacity of human understanding" (*E*, p. 162). To see where it is best to concentrate our efforts "it suffices to make the slightest examination into the natural powers of the human mind and to . . . find what are the proper subjects of science and enquiry" (*E*, p. 163). We can then leave "the more sublime topics to the embellishment of poets and orators, or to the arts of priests and politicians" (*E*, p. 162). There the imagination runs free, with its inevitable sophistry and illusion. Ayer's third reading of the oft-quoted passage therefore seems to me closest to the truth. But it implies nothing about philosophy as exclusively, or even partly, analysis of concepts.

Hume does not think his own *Treatise* and *Enquiries* are to be committed to the flames. He thinks they contain lots of good reasoning. But not because he thinks they contain only a priori reasoning concerning "relations of ideas". He would exempt them from the charge of sophistry and illusion because he thinks they contain experimental reasoning concerning matter of fact and existence as well, even reasoning on questions of "the most profound metaphysics" (*T*, p. 189).

II

The problem of finding a place for a special subject called philosophy on a complete map of human knowledge or enquiry was especially pressing to the logical positivists, in whose name Ayer was writing in 1936. It could be said indeed that the nature and possibility of philosophical knowledge was one of the major concerns of that movement. It certainly

dominates *Language, Truth and Logic*; four—and indirectly a fifth—of its eight chapters are fully occupied with the nature of philosophy or with the special character of philosophical issues or disputes. The problem was how philosophy as a serious intellectual enterprise was possible.

For Kant philosophical knowledge was synthetic and a priori. Its results were known independently of experience, they were genuinely ampliative—extending beyond the contents of their constituent concepts—and we could be assured that they could not be otherwise. For Wittgenstein in the *Tractatus* there could be no philosophical propositions and so no genuine philosophical knowledge or statable philosophical results. Philosophy was not a body of doctrine but an activity; its aim was the logical clarification of thoughts. Any necessity apparently possessed by certain sentences was due entirely to their empty, tautological character; they say nothing about the world. The positivist account of philosophy was a combination of these views, remaining on the whole much closer to Kant than to Wittgenstein while rejecting the central idea of the *Critique of Pure Reason*. All genuine knowledge of the world is part of empirical science, and so not philosophy. All mathematics and logic—in fact, everything knowable a priori—is analytic, true solely by virtue of the meanings of its constituent terms. There is no synthetic a priori knowledge. Any philosophical knowledge will therefore be independent of experience, it can be knowledge of what could not be otherwise, but it will be only analytic. It can reveal nothing about the way the world is, but only about the concepts in terms of which we understand and come to know things about the world.

Ayer sees this conception of philosophy as the unavoidable result of a straightforward process of elimination (*LTL*, p. 33). Philosophy must be conceptual analysis if it is anything respectable because "all the other avenues of knowledge are thought to be already pre-empted", and the philosopher has "no right to trespass" (*CQ*, p. 22). The crucial step is the assumption that philosophy cannot be empirical because all knowledge of the world is part of empirical science. Kant thought philosophy could not be empirical because its results were known to be necessarily true; and for him necessity was a "sure criterion" of the a priori (*CPR*, B4). Ayer shares with Kant that assumption about necessity and a priori knowledge, but it alone does not imply that philosophy must be a priori. Even combined with the thesis that all necessity is due to meaning it implies only that all a priori knowledge is only of analytic truths. But that still does not yield the conclusion that the philosopher can legitimately "trespass" only on the analytic or a priori side of the line and not on the synthetic or contingent or empirical side. It does not even imply that the philosopher must be restricted to one side or the other.

With respect to many of the particular philosophical doctrines which were thought to support this conception of philosophy as analysis Hume was of course much closer to Ayer and the positivists than he was to Kant. He held that of all those thoughts we can form that are capable of truth or falsity, some are necessarily true in the sense that their negations are contradictory, but they are true solely in virtue of the relations among their component ideas. We can accordingly know such things to be true by the operation of pure thought alone, by reflection on our ideas. All the rest are such that their negations are not contradictory, so whatever the actual truth-value of each of them happens to be, it at least could have been otherwise; it is not guaranteed by "relations of ideas" alone. Reflection on ideas therefore could never in itself produce belief in one such "matter of fact" rather than its opposite, or give us any reason to believe it. Only actual sense-experience could do that. All beliefs in matters of fact are founded on experience.

But this set of largely epistemological views is consistent with a number of different conceptions of philosophy, or with holding no very determinate conception of it as a special discipline at all. The problem for the positivists was largely a problem inherited from Kant, or more precisely from their otherwise accepting the Kantian framework while rejecting the synthetic a priori. The terms in which it had to be solved were Kantian terms. But Hume was a pre-Kantian philosopher.

III

Ayer shares a number of other specific theses or doctrines or problems with Hume, but here again I think we cannot assume on that basis alone that Hume therefore was pursuing what Ayer holds to be the only legitimate goal for philosophy. And when we look at what Hume actually does, I think we find that he was not in fact pursuing that goal. Insofar as he could even formulate it or understand it, he thought it was impossible —and precisely because of his attachment to a number of views which Ayer also holds.

Some of the most important of those shared views could be expressed somewhat loosely as follows. We never directly perceive physical objects or states of affairs in the public world, but only fleeting and momentary impressions or sense-data which we cannot be wrong about at the time they are present to our minds. Each of us has thoughts of or beliefs about a great many things other than our current impressions or sense-data—past or future impressions, for example, or enduring physical objects and their properties, causal connections between objects or

events, laws of nature, the thoughts and feelings of other people, our own past and future selves, the goodness or badness of people's characters and actions, the existence of a supernatural God, and so on. Any such thoughts we can form, any beliefs we might arrive at about anything, must be constructed by mental operations working only on materials derived from our immediate sense-experience.

No impression or sense-datum ever provides us with an instance of the identity of a physical or a mental thing (including ourselves) over time, or of the causal connection we believe to hold between two things when we believe that one is the cause of the other. No impression or sense-datum provides us with an instance of the thoughts or feelings of other people, or of what we ascribe to an action or character when we believe it to be good or bad, virtuous or vicious.

What we experience at one moment can give us reason to believe some other matter of fact which we are not experiencing at that moment only if we have reason to believe that it is connected in some way with that absent matter of fact. But the connection in question could not be necessary and so discoverable by the operation of pure thought alone, since for any two distinct matters of fact, there is no contradiction involved in supposing that one of them holds and the other does not. Whether there is a connection between what we experience and what we believe on the basis of it must therefore be a further matter of fact, so any reason we might have for believing in such a connection must also be found in our experience.

These doctrines are baldly stated and not very carefully formulated in either Hume's terms or Ayer's. I make no claim of completeness or of any order of logical priority among them. But even in this summary form I think it would be granted that they capture a great deal that is important and central to each philosopher. Ayer combines them with the view that the task of philosophy is analysis. For him that implies that its results are not empirical or contingent. Philosophy is not empirical science.

I have mentioned Hume's stated attachment to "the experimental method of reasoning", his devotion to "experience", and his resolve in the investigation of human nature not to "establish any principles which are not founded on that authority" (*T*, p. xxii). But it is not just a matter of programmatic announcements at the beginning. When he gets down to work in detail he seeks "the origin of our ideas" and offers "plain and convincing" "phenomena to prove" that all our simple ideas are preceded into the mind by their corresponding simple impressions (*T*, pp. 4–5). He tries to discover how we come to have the idea of causation, since " 'tis impossible perfectly to understand any idea, without tracing it up to its origin, and examining that primary impression, from which it

arises" (T, pp. 74–75). He notes the fact that past experience of a conjunction of things of two kinds and a present impression of something of one of the kinds inevitably leads us to think of something of the other kind, and he asks "whether experience produces the idea by means of the understanding or of the imagination" (T, p. 88). He wants to know what "determines" us to make that transition (T, pp. 88–89). He asks "what causes induce us to believe in the existence of body" (T, p. 187) or what "makes us attribute to [our impressions] a distinct and continu'd existence" (T, p. 194), and he identifies to his satisfaction the "principles" or "propensities" of "the imagination" that are responsible for it. He asks what "gives us so great a propension to ascribe an identity to [our] successive perceptions, and to suppose ourselves possest of an invariable and uninterrupted existence thro' the whole course of our lives" (T, p. 253). And to the question of how that particular thought is "produc'd" he never finds an answer that satisfies him. In moral philosophy as well the problem is to find the impressions from which our judgements of moral good and evil are derived, to discover "after what manner they operate on us" (T, p. 470), and thereby to "find those universal principles, from which all censure or approbation is ultimately derived" (E, p. 174).

These are the words of someone who wants to understand in each case certain very general facts of human nature—how and why human beings come to think or feel or judge in the ways they do. And he wants to answer such questions in the only way he thinks they can be answered, by relying on what can be found out by observing human beings and the world they live in.

> As this is a question of fact, not of abstract science, we can only expect success, by following the experimental method, and deducing general maxims from a comparison of particular instances. (E, p. 174)

Since thought, belief, and attitude are in question, the project might involve an occasional "analysis" or definition of one or another of our ideas—or more likely a denial of equivalence or implication between two ideas—but the goal throughout is an empirically-based explanation of highly general ways of thinking, feeling, and acting that are deeply characteristic of human beings as we know them. The facts in question, and the principles introduced to explain them, although extremely general, are still to be understood as contingent. Things could have been otherwise.

Ayer is obliged to find Hume's way of putting his project unfortunate—a product of confusion or naivete. He is not surprised that Hume's views have been so often misunderstood; the fault does not all lie

with his interpreters. One difficulty is what he sees as Hume's "misguided insistence on tracing ideas to their origin" (*H*, p. 55). But if our ideas have an origin, as it would seem they must, what can be wrong with trying to find out what it is? Presumably what is misguided about it in Hume's case is the "confusion of psychological with logical questions of which he is generally guilty" (*H*, p. 57). Ayer praises the *Enquiry* over the *Treatise* account of causation on the ground that it is "less encumbered with what would now be reckoned as psychology" (*H*, p. 6). But to have done something in 1740 that would now be reckoned as psychology is not necessarily to have been confused, any more than it is a sign of confusion to have done something in 1740 that would now be reckoned as economics, especially if psychology, economics, and other specialized subjects regarded in some quarters as "sciences" today grew directly out of the more encompassing "science of MAN" of the eighteenth century, as they did. I think the confusion Ayer has in mind is the confusion of thinking that empirical investigation of the origins of human thoughts, feelings, and attitudes can answer questions about the meaning, structure, and logical relationships among the contents of those thoughts and attitudes. But it will follow that a philosopher explicitly concerned with origins is guilty of that confusion only given a determinate conception of philosophy as properly restricted to the a priori analysis of concepts or ideas. And that was not Hume's conception of what he was doing.

Analysis for Ayer "covers quite a number of activities, which differ from one another either in their methods or their aims or both" (*CQ*, p. 44). One is giving explicit definitions of individual words or ideas by means of synonymous words or equivalent ideas. Another is producing what he called in *Language, Truth and Logic* "definitions in use" (*LTL*, pp. 59ff.) which state that, or show how, sentences containing the term in question can be translated into equivalent sentences which do not contain that term or its synonyms. He saw "the traditional problem of perception", for example, as the problem of showing how sentences about material things can be translated without remainder into sentences about "sense-contents" (*LTL*, p. 64). That would be to provide a phenomenalistic reduction of material things to "sense-contents", or to show that material things are "logical constructions" out of "sense-contents". I think it is in that same sense of "analysis" that he there saw Hume's treatment of causation as an attempt to answer "the analytic question, What is it that we are asserting when we assert that that one event is causally connected with another?" (*LTL*, p. 54). The task was to reduce the problematic idea to some combination of elements which are immediately available in sense-experience. The same was true of Hume's problem of giving "an analysis of the notion of a self" or personal

identity; what relations must obtain between sense-experiences for them to belong to the same self (*LTL*, p. 125)?

Hume usually concentrates on our possession of individual ideas or terms. I doubt that he can be credited with the notion of defining a problematic term by eliminating it from full sentences in which it can appear in favour of equivalent full sentences which make no use of that term. That is an idea that had to await recognition of the primacy of the judgement or sentence over the idea or term, something conspicuously lacking in much modern philosophy before Kant. It is the key to the notion of reduction so prominent in analytic philosophy of this century. Ayer himself has largely abandoned the search for tight reductions, especially phenomenalistic reductions, of the ideas that interest him, and seems accordingly to have become more circumspect in attributing precisely that analytical goal to Hume. But he continues to take it for granted that when Hume considers perception, causation, enduring bodies, personal identity, and moral judgement he primarily wants somehow to account for the content of what we think in each case in terms of what is available to us in our immediate experience. The point is to analyze our ideas or concepts or beliefs.

There is one promising exception to this general line of interpretation. In his *Hume* he expresses some to my mind well-justified doubts, but only in the case of morality. Hume famously declares: "when you pronounce any action or character to be vicious, you mean nothing, but that from the constitution of your nature you have a feeling or sentiment of blame from the contemplation of it" (*T*, p. 469). This is just the kind of remark which has seemed to many to support the idea that he is engaged in analyzing the meanings of the things we say or think, but Ayer believes that that is not the way to understand what Hume is doing here. He is not advancing a thesis about the logical equivalence of moral judgements and descriptive statements about someone's actual or possible feelings, or claiming that in making moral judgements we are covertly asserting something about ourselves or other moral judges (*H*, p. 84).

Ayer thinks that what he is doing can still be called "analysis".

> There is indeed a sense in which he is offering an analysis of our moral judgements, but the analysis is not intended to supply us with a recipe for translating the sentences which express them. It consists rather in an account of the circumstances in which we are induced to employ moral predicates, and of the purposes which their employment serves. (*H*, p. 84)

Whatever it is called, it is clear that a study of the circumstances in which we are induced to employ moral predicates, and the purposes served by that employment, could be carried out only by observation of human beings and the circumstances in which they find themselves. That they

think and behave in those ways is a contingent matter of fact. The results of an investigation into those facts would not be true by virtue of the relations of ideas alone. This task would therefore be "analysis" in name only. It would not issue in "analytic" truths, true by virtue of meaning alone. If it is nonetheless a proper task for philosophy, it would leave Hume the philosopher free to develop an empirical "science of human nature" in just the way he so clearly seems to say he wants to. That is just the interpretation of Hume that I am suggesting is to be preferred everywhere, not only in his treatment of morality.

Ayer does not say much to explain why he rejects in this case what he elsewhere has taken to be the proper understanding of Hume's philosophical task. Perhaps it is because no account of "the circumstances in which we are induced to employ moral predicates, and of the purposes which their employment serves" would in itself yield an account of the meaning of those predicates or provide translations of their content in terms of those "inducing circumstances" alone. That would be to distinguish questions of meaning from questions of origin. And of course it is right to distinguish them. But that is the very distinction that Ayer usually charges Hume with blurring, or not even seeing. Why then in this case does he think Hume saw it and abided by it? And if he did, what prevented him from doing so in his treatment of the other important ways of thinking he considers?

Perhaps Ayer makes an exception in this case because he thinks the reductive or definitional strategy would commit Hume to the mistaken view that moral or evaluative statements are strictly equivalent to descriptive or factual statements. Ayer seems to agree that that view is mistaken in his discussion of the relation between 'is' and 'ought' two pages later in *Hume*. Even in *Language, Truth and Logic* he rejected any definitional equivalence between normative and factual propositions on the ground that whatever factual statement might be true of a thing there is no particular normative statement that it would at the same time be self-contradictory to deny of it. That general failure of implication is what led him to the emotive theory of moral judgements, a theory he says would probably be closest to Hume's intentions if he were indeed searching for an analysis or reformulation of their content. But Ayer thinks that is not what Hume is doing.

I surmise that Ayer does not attribute to Hume the search for a reduction or definitional equivalence in this case because he thinks Hume holds an even more radical view of morals which in broad outline Ayer thinks must be correct. An equivalence in content between moral judgements and statements about actual or possible feelings would imply that something's goodness or badness consists in the fact that people do

or would feel a certain way towards it. Denial of the equivalence could be taken to support the view that moral facts or states of affairs are completely different in kind from all such natural facts. But the more radical view says that there is no such fact as a fact of something's being good or bad at all. Of course, things have a tendency to make us feel one way or another towards them, and that is a fact. But when we make a moral judgement we are not simply asserting that dispositional state-ment about the thing in question. Nor are we asserting something "non-natural" about it. We are evaluating the thing, or making a normative judgement about it, but on the radical view there is no fact or state of affairs in the world that could make the normative aspect of the judgement either true or false. The normative judgement in that sense has no factual content, so no definition of its normative content can be given. Any attempt to give one would either employ an equally unex-plained evaluative term or, if it did not, would reduce the evaluative judgement to a statement of fact and hence erase its special evaluative character. So we can perhaps say what people are doing when they make moral judgements, and we can investigate the conditions under which they make them, and why, but we cannot understand them as evaluative judgements and at the same time give an analysis or definition in equivalent factual terms of their content. If Ayer thought that Hume held some such view of morals it would explain why he does not think he tries to provide translations or reductions of the contents of moral judge-ments.

I think this is just the kind of view of morals Hume does hold. Because he finds nothing in the world that could correspond to the special evaluative aspect of our moral judgements, the problem of understanding them is the problem of explaining how we come to make moral verdicts or put forward moral judgements at all, and why we arrive at the particular moral views that we do. That is not a question of analysis in the sense of being answerable by reflection on relations of ideas alone or issuing in analytic truths. It is a question of fact, to be answered by empirical observation of human beings and the world they inhabit. But the same is true of each of the other major objects of study in Hume's pursuit of "the science of MAN".

In the case of causality Hume insists from the beginning that part of what we ordinarily believe when we think that two things are related as cause and effect is that there is a "necessary connection" between them. That is more than contiguity and temporal priority. "An object may be contiguous and prior to another, without being consider'd as its cause. There is a NECESSARY CONNEXION to be taken into consideration" (*T*, p. 77). Of course, we do not get that idea from a single instance, but

when we have found things of one kind constantly conjoined with things of another "we then call the one object, *Cause*; the other, *Effect*. We suppose that there is some connexion between them; some power in the one, by which it infallibly produces the other, and operates with the greatest certainty and strongest necessity" (*E*, p. 75). Hume's question is how we come by this idea of necessity; how that special modal aspect of our thought about cause and effect comes into our minds, and what leads us to apply it in the ways we do.

In the course of his search for the source of that idea he finds that it is not derived from any impression of the qualities of objects or of the relations between them. Only the repeated observation of a conjunction between things of two kinds gives rise to it. But mere repetition cannot reveal something new in the single instances which was not there to begin with, or produce something new in them. So the idea of necessary connection must have its source solely in our minds, not in the objects the observation of which eventually produces that idea. In summing up this genetic story Hume allows himself to say such things as:

> When we say, therefore, that one object is connected with another, we mean only that they have acquired a connexion in our thought, and give rise to this inference, by which they become proofs of each other's existence: (*E*, p. 76)

> Upon the whole, then, either we have no idea at all of force and energy, and these words are altogether insignificant, or they can mean nothing but that determination of the thought, acquired by habit, to pass from the cause to its usual effect. (*A*, p. 657)

I do not think this talk of "meaning" should be taken any more strictly or literally here than Ayer is prepared to take it in Hume's remarks about moral judgements. The kind of view he is propounding is structurally similar to his account of morality. The point is, first, that there is no logical equivalence between causal statements containing the idea of necessity and any factual statements about the qualities or relations of objects which actually exist in the world independently of us. If there were, we could get the idea of necessity directly by observing those qualities or relations. But the idea of necessity for Hume has an entirely subjective source. It is an idea to which no fact or state of affairs in the world could correspond; there is nothing objective that could render that special modal aspect of our causal judgements either true or false. We can try to understand how and why we make causal judgements, but any attempt to express in equivalent terms what they mean would either leave the problematic modal idea unanalyzed or would eliminate it in favour of some purely extensional condition to which it is not equivalent.

Hume explicitly draws a parallel between our idea of necessity and

our ideas of colours as "the modern philosophy" understands them. In each case we get the ideas only from something that occurs in our minds, and we mistakenly suppose that the qualities the ideas are ideas of are somehow conjoined with objects outside our minds, "tho' the qualities be of such a nature as to admit of no such conjunction, and really exist nowhere" (*T*, p. 167). There is really nothing in the world corresponding to them. This "propensity" of the mind to project the features of which it gets internal impressions on to objects outside the mind that cause those impressions but do not really possess those features is equally present in the case of morality. There too Hume draws a parallel with our ideas of colours (*T*, p. 469). The same treatment is clearly to be applied both to the idea of goodness or badness and to the idea of necessity, and for the same reason. No equivalents for those ideas can be found in our experience, so the task is to explain what it is about human beings and their interactions with the world that leads them to get them. That is Hume's main philosophical task, and it is an empirical investigation into a matter of contingent fact.

The same is true of his account of the idea of the continued and distinct existence of objects. There is no question of fully analyzing the content of that idea in terms of elements that are directly available in immediate experience, or giving a phenomenalistic reduction of talk of enduring objects in purely sensory terms. For that we need the idea of the identity of an object over time, and we are never presented with instances of such identity in our experience, nor can we construct the idea solely out of any relations which actually hold among the ingredients of our immediate experience. Hume identifies those features of our experience which "give rise to" or "produce" the idea of continued and distinct existence, but they are not proposed as equivalent to its content. "Constancy" and "coherence" are certain forms of noticeable resemblance among our impressions which lead us into the thought of something continuing to exist, but " 'Tis a gross illusion to suppose, that our resembling perceptions are numerically the same" (*T*, p. 217). Nothing in our experience does in fact continue to exist. "The fiction of a continu'd existence, . . . as well as the identity, is really false" (*T*, p. 209).

Hume's task then is to explain how that false idea arises. There is no doubt that we have it. He first identifies (in Ayer's phrase) "the circumstances in which we are induced to employ" it, and then seeks those "principles of the imagination" which are activated by the constancy and coherence among our impressions to eventually produce the idea in question. The "imagination" is the place to look because neither the "senses" nor "reason" alone or in combination could give us the idea. As in the case of morality and of causation, there is for Hume no logical

equivalence between anything we can find in our experience and the content of the new, richer idea we possess and want to explain. There is in that sense nothing in the world corresponding to our idea of continued and distinct existence—it is a "fiction"—just as there is nothing corresponding to the idea of goodness or badness or of causal necessity. The challenge in each case is to explain how we nevertheless come to think in those ways. We would not be human without them.

The same is true of our very thought of ourselves—the idea of personal identity. We think of a person as one thing that remains the same through time. But there is no hope of finding some relations which actually hold among perceptions and which constitute their all belonging to the same self or person. We are "nothing but a bundle or collection of different perceptions, which succeed each other with an inconceivable rapidity, and are in perpetual flux and movement" (*T*, p. 252). That is all there is. "There is properly no *simplicity* in [the mind] at one time, nor *identity* in different; whatever natural propension we may have to imagine that simplicity and identity" (*T*, p. 253). We do have such a "propension", and Hume is interested in its source and in how it works to give us an idea of ourselves and others. For him that is all there is to be understood about our thoughts of persons.

The factual question about how we come to think in a certain way is all there is to be answered, in this case as in the others, because the world simply does not contain anything that fulfills the contents of these thoughts about it. We think of a person or a mind as made up of a series of perceptions, but "identity is nothing really belonging to these different perceptions, and uniting them together; but is merely a quality, which we attribute to them, because of the union of their ideas in the imagination, when we reflect on them" (*T*, p. 260). In that sense, "the identity, which we ascribe to the mind of man, is only a fictitious one" (*T*, p. 259), just as the ideas of goodness, of necessity, and of continued and distinct existence are "fictions" in relation to what actually holds in the world we apply them to. As in those cases, so with regard to personal identity, "The only question, therefore, which remains, is, by what relations this uninterrupted progress of our thought is produc'd, when we consider the successive existence of a mind or thinking person" (*T*, p. 260). And that is not a question of the analysis of concepts.

Two caveats must be entered about this way of describing Hume's strategy. First, "the world" which is here said not to contain such items is for Hume the world of immediate experience. What there is and what we can be presented with in experience are taken to be one and the same. That is because for Hume all our ideas must be derived from impressions; there can be no other source of our thoughts and beliefs. But the

point about "analysis" remains. For all the important ideas and attitudes Hume considers and spends most time trying to explain, they are interesting and challenging precisely because they go beyond anything that could be found among our impressions. They are the only ideas which Hume as a philosopher is interested in. "Analysis" of their contents in terms of those original data is therefore out of the question. So "principles of human nature" or "propensities" of the mind or the imagination must be appealed to to explain how those richer thoughts can make their appearance in the mind.

Because of his official commitment to the principle that every simple idea is preceded into the mind by its corresponding impression, Hume sometimes troubles to find a new impression that is produced by the mind or the imagination in the process of generating one of those rich, important ideas. That is true of his account of the idea of necessary connection, for example. An impression of reflection, i.e., an impression generated by goings-on in the mind, is said to be the source of that idea. So in that case there is a sense in which the idea in question cannot be said to go beyond anything that is found among our impressions. The idea of necessity is produced directly by something among our impressions, viz., an impression of necessity. But how that impression gets that particular content—what makes it an impression of *necessity*—is not something that Hume ever manages to explain. He knows what goes on in the mind when the idea of necessity makes its appearance, so what he calls the impression is just something that has to be there to produce the idea of necessity, given the principle that all simple ideas are derived from impressions and the further assumption that the idea of necessity is a simple idea.

When much more complicated processes of the imagination have to be appealed to, as in the case of continued and distinct existence, or personal identity, Hume does not bother trying to find a single impression from which the problematic idea might be said to be derived. The highly elaborate "suppositions", "feignings", and "fictions" that the mind has to indulge in are quite enough to have to invoke, without their also having to produce individual impressions which then give rise to the idea. He does not acknowledge that the explanations he offers in these cases in terms of operations of the mind alone violate his principle of impressions as the source of all ideas. That could be because in these cases he regards the ideas as complex, not simple, so the principle does not apply.

The second warning about the claim that there is nothing in the world corresponding to these important ideas is that of course it does not represent what those who already have those ideas ordinarily believe. We

make moral judgements, we believe causal statements, we think of objects and persons as enduring over time. That is the way we take the world to be, once we have those ideas. And our thinking of the world in those ways is just what Hume wants to understand and explain. He does not suppose that his philosophical demonstration of the "fictitious" character of all those ideas could ever persuade people not to employ them. We cannot help thinking in those ways, whatever the relation between those ideas and reality might be.

This is the source of the "melancholy" plight Hume finds himself in. His philosophical reflections reveal to him the gap between the restricted data available to us in experience and the richness of the ideas we all somehow arrive at on the basis of them. Obviously only the operations or products of our own minds could be responsible. But then it seems impossible to "conceive how such trivial qualities of the fancy, conducted by such false suppositions, can ever lead to any solid and rational system" (*T*, p. 217). And "this sceptical doubt . . . is a malady, which can never be radically cur'd" (*T*, p. 218). It can never be cured by more or deeper thought because it is an unavoidable result of reflecting on the relation between our important ideas and their source in our experience; the ideas just are much richer in their content than anything available to us, so they could only have a subjective source. Those who never reflect philosophically are spared Hume's malady. They continue to believe in a world of causal connections, enduring objects and persons, and good and bad actions and characters without ever realizing the "illusion" involved in the possession of all those ideas. Hume's "science of human nature" is a study of the position they are actually in, and how they get to be that way.

Another form philosophical "analysis" can take for Ayer is what he calls "the theory of knowledge". Its aim is "to arrive at a satisfactory definition of knowledge; to determine what sorts of propositions can be known to be true; and to explain how these propositions can be known to be true" (*CQ*, p. 58). The first is relatively unimportant and the second and third combine into the task of showing how we are justified in accepting the propositions we accept. So far I have been discussing Hume's account of our ideas or thoughts, but when we move to the question of our beliefs or knowledge it remains true that his main task is not one of analysis in this epistemological sense either. He demonstrates that none of our beliefs about matters of fact we are not observing at the moment is to any degree justified by any present and past experience we might have, however rich and varied it might be. His conclusion is:

> *That there is nothing in any object, consider'd in itself, which can afford us a reason for drawing a conclusion beyond it;* and, *That even after the observa-*

tion of the frequent or constant conjunction of objects, we have no reason to draw any inference concerning any object beyond those of which we have had experience. . . . (T, p. 139)

This is perhaps the most famous and certainly the most devastating element of Hume's sceptical legacy. It represents a complete dead end for the project of showing our beliefs to be empirically justified. If it is right, it really is impossible to go further in that direction.

Of course, Hume's reaching that conclusion does not in itself show that his main task was not to answer the question of how our beliefs are empirically justified. It might be said that he just gave a sweepingly negative answer to his main philosophical question. But that sceptical answer, for all its importance to subsequent epistemology, is only a small part of Hume's philosophical interest in our beliefs in unobserved matters of fact. He wants to know how they arise, and why we believe the particular things we do, and he looks for answers among the conditions which "cause" or "produce" those beliefs in us. No such beliefs arise without some present experience, and that experience will lead to a particular belief only with the help of some relevant past experience. But the question is "Whether experience produces the idea [of something currently unobserved] by means of the understanding or of the imagination; whether we are determin'd by reason to make the transition, or by a certain association and relation of perceptions" (T, pp. 88–89). That is an empirical, causal question about how the mind works.

Hume eliminates "the understanding" as the source of the "transition" and establishes that "reason", even "reason" combined with past experience, is not what "determines" us, by showing that past experience, however rich, can never give us any reason for believing what we do about what we are not observing at the moment. And that clears the field for his positive project of discovering what does in fact "determine" us to believe what we do, and how. The "imagination" is the only possible source; nothing more than "a certain association and relation of perceptions" can be appealed to. And the task then is to describe those connections among perceptions, to identify the "principles of the imagination" that are actually at work in the genesis of our beliefs. That is not a question of "analysis" in Ayer's sense of "theory of knowledge".

Again, the idea that no beliefs are ever justified by past experience is not something that those who never reflect philosophically on their position believe. In everyday life we cannot help regarding some beliefs as more reasonable than others and forming and acting on one set of expectations rather than another. Hume denies none of that. His question is how we do it; what leads us to think and act in those ways. His answer conflicts with what we all believe in everyday life. It docs not just

analyze everyday or scientific concepts; it reveals what there really is in the world that they purport to represent, and why and how we continue to employ them despite our having nothing we could acknowledge as a defence of our thinking, believing, and acting as we do.

Hume would not suggest that he had done all there is to be done towards understanding human thought, belief, and action, even at the very high level of generality on which he operates. His project is in that sense still wide open; no dead end threatens. But he pursues that project with a number of specific views about the nature of our thoughts, beliefs, and feelings—indeed, about what it is to *have* a certain thought, belief, or feeling—which can seem too obscure or restrictive to allow even for fruitful description of the kinds of human phenomena he wants to explain. It would still be fully within the spirit of Hume's enterprise to jettison the rigid theory of impressions and ideas in terms of which he conceives of the mind, and try for a richer and therefore more realistic description of the actual position ordinary human beings naturally find themselves in. It is an illusion to suppose that at present we have a proper understanding even of the nature of the very phenomena that we would expect a science of the human to explain—such things as our holding causal beliefs and making inferences from past experience, our possessing a conception of an independent world, our thinking of ourselves as persons who endure through time, our evaluating actions and characters, even our perceiving something that is right before our eyes. It will be time to search for explanations of such phenomena—if that is what will then be wanted—once we have described them more accurately and so have a better understanding than we do at present of just what those phenomena amount to. That is only one of the ways in which Hume's philosophical project could be extended.

There is no reason to suppose that even that job would be simple, or one-dimensional. And whether any of it, or which parts, could properly be given the name 'philosophy', is perhaps of little concern. But it is continuous with what has been called philosophy. And it remains within what Hume calls "the science of human nature".

IV

I have tried to explain why I think Ayer's understanding of Hume tends to obscure or distort what Hume is really up to and what is most characteristic and most fruitful in his philosophy. But it is not just a question of the interpretation of a long-dead philosopher. Ayer's philosophical aims, along with his closeness to Hume and his conception of

the British tradition in which he sees himself carrying on Hume's work, seem to me to leave him too close for comfort to the philosophical dead end that so clearly threatens in that direction.

The threat comes from what Ayer shares with Hume. They both are impressed by the poverty of the data available to us in immediate experience in relation to the richness of the ideas or concepts we come to form on that basis. That gap is the source of Hume's explanatory challenge: how do we actually get across it? Ayer at first aspired to reduce those thoughts to their sensory bases, so no gap would be left. That was the point of the thesis of *Language, Truth and Logic* that all empirical statements are equivalent to statements about sense-data. He abandoned that phenomenalism when the promised equivalences were not forthcoming; no conditions expressed in purely sense-datum terms could plausibly be said to be necessary for the existence of a physical object, nor could any be said to be sufficient (*CQ*, pp. 106–7).

But even if phenomenalism or other forms of reductionism had worked they would not have accounted fully for our understanding of the concepts they served to reduce. Talk of physical objects was to be equivalent to talk of sense-data which *would* be had under certain conditions, not just of a collection of actual sense-data alone. And that involves the idea of natural necessity or law-like connection, or at any rate something nonextensional typically implied in subjunctive conditionals. Without that special modal feature reductionism would never have got off the ground. Something like Berkeley's God would have been needed to make it plausible. But that necessity or nomic connection is not something we can ever be aware of in an individual sense-datum or in any collection of them. That is a point on which Ayer has always agreed with Hume. But it represents an obstacle for the purely "analytic" project of specifying in experiential terms what that necessity amounts to—what it means. Phenomenalistic reductionism offers no answer; it makes essential use of the idea without explaining its content. To try to reduce necessity or law-likeness in turn to discoverable features of experience such as "regularity" or the "constant conjunction" of properties would in effect obliterate the very distinction between extensional generalizations of fact and nomic or law-like generalizations that is needed to leave any hope for plausible analytic reductions of any interestingly problematic notions. No such obstacle arises for Hume. He insists on the impossibility of defining necessity in terms of what is available in immediate experience, and concentrates instead on explaining how in fact we come to think that way, despite the obvious gap.

Ayer has suggested avoiding the definitional obstacle in the case of natural necessity by concentrating instead on the different attitudes

people might take to generalizations they accept (*WLN*, pp. 230–34). No explanation of the notion of natural law along these lines would yield an analytic equivalence: human attitudes are neither necessary nor sufficient for laws of nature to hold. So whatever illumination might be gained would not help further the explicit reductionism of *Language, Truth and Logic*. Ayer has in any case moved away from that project in general in favour of a looser relation between experience and the possibility of thought and belief which nevertheless preserves the spirit of empiricism he has always defended. That has meant in effect a shift away from questions of meaning and understanding, strictly speaking, to questions of belief and justification. The focus is more and more on "theory of knowledge": how our beliefs or theories about the world are sustained or supported by our experience.

Here too there remains a huge but familiar obstacle. Ayer now sees all those beliefs which go beyond the strict contents of immediate experience as something like hypotheses or postulates which gain their empirical support from their explanatory function. Our view of the world is to be vindicated in more or less the same way as a scientific theory is thought to be supported by its success. All forms of this widely-held type of view still face the Humean challenge of showing how actual experience can support any inference that goes beyond it. Most philosophers simply ignore it. Not Ayer. But he is too close to Hume to meet the challenge, or even to deflect it.

He accepts, albeit in slightly qualified form, Hume's principle of the "atomicity" of observed matters of fact: the inference from one matter of fact to another is never demonstrative (*PE*, pp. 6–10). And he agrees that we have reason to believe a matter of fact we are not observing at the moment only if it is connected in some way with what we are observing now or have observed in the past. But he also accepts what he has always rightly seen to be the further Humean requirement that not only must there be such a connection or similarity between the observed and the unobserved, we must in addition have reason to believe that there is. That is the fatal step that leads to the general sceptical conclusion. The only reason we could have for believing in a connection or similarity between the observed and the unobserved must be found in what has already been observed, and so to rely on it at any given time would be, in Hume's words, "evidently going in a circle, and taking that for granted, which is the very point in question" (*E*, p. 36). The conditions necessary for justified belief in unobserved matters of fact can therefore never be fulfilled. There is no evading this conclusion on Hume's, and Ayer's, premises. Given that starting point, it is impossible to go further in the

direction of justifying any beliefs or theories about the world. Ayer seems to endorse Russell's gloomy verdict when he writes:

> What we want and cannot obtain, except by circular argument, is a justification for our actual interpretation of the lessons of the past; a justification for adhering to a special corpus of beliefs. That we cannot obtain it is an insight which we owe to Hume. (*H*, p. 74)

BARRY STROUD

DEPARTMENT OF PHILOSOPHY
UNIVERSITY OF CALIFORNIA AT BERKELEY
JULY 1989

KEY TO REFERENCES

A: D. Hume, "An Abstract of a Treatise of Human Nature" in *T*.

CPR: I. Kant, *Critique of Pure Reason*, tr. N. Kemp Smith, London, Macmillan, 1953.

CQ: A.J. Ayer, *The Central Questions of Philosophy*, Harmondsworth, Penguin Books, 1977.

E: D. Hume, *Enquiries Concerning the Human Understanding and Concerning the Principles of Morals*, ed. L.A. Selby-Bigge, Oxford, Oxford University Press, 1962.

EHU: J. Locke, *An Essay Concerning Human Understanding*, ed. A.C. Campbell, New York, Dover, 1959.

H: A.J. Ayer, *Hume*, New York, Hill and Wang, 1980.

HWP: B. Russell, *A History of Western Philosophy*, New York, Simon and Schuster, 1945.

LTL: A.J. Ayer, *Language, Truth and Logic*, 2nd ed., New York, Dover, 1952.

PE: A.J. Ayer, *Probability and Evidence*, London, Macmillan, 1973.

T: D. Hume, *A Treatise of Human Nature*, ed. L.A. Selby-Bigge, 2nd edition revised by P.H. Nidditch, Oxford, Oxford University Press, 1978.

W: A.J. Ayer, *Wittgenstein*, London, Weidenfeld and Nicolson, 1985.

WLN: A.J. Ayer, "What is a Law of Nature?", in his *The Concept of a Person and Other Essays*, London, Macmillan, 1963.

24

David Wiggins

AYER ON MORALITY AND FEELING: FROM SUBJECTIVISM TO EMOTIVISM AND BACK?

I

In 1936, in *Language, Truth and Logic,* Ayer claimed that judgments of value, insofar as they are not scientific statements, are not in the literal sense significant but are simply expressions of emotion which can be neither true nor false. To say "You acted wrongly in stealing that money" is not to state any more than one would have stated by merely saying"You stole that money". To add that the action was wrong is not to make a further statement about it, but simply toe vince one's moral disapproval. "It is as if I had said 'You stole that money,' in a peculiar tone of horror, or written it with the addition of some special exclamation marks. The tone, or the exclamation marks, adds nothing to the literal meaning of the sentence. It merely serves to show that the expression of it is attended by certain feelings of the speaker" (p. 107).

Ayer claims that, if a speaker then generalizes his previous statement and puts down the claim "Stealing money is wrong", then it is as if he had written "Stealing money!" where "the shape and thickness of the exclamation mark shows, by a suitable convention, that a special sort of moral disapproval is the feeling which is being expressed".

Ayer adds that ethical terms like "wrong" do not only express feeling. "They are also calculated to arouse feeling and to stimulate action" (p.

Although I did not receive Professor Wiggins's paper until after Sir Alfred's death, the latter had asked me when we were speaking of deadlines to include his paper if possible, correctly predicting that it would be well worth waiting for.—ED.

108). Some, for instance, like the term "duty" as it occurs in "It is your duty to tell the truth", may be regarded both as the expression of a certain sort of feeling about truthfulness (or whatever other vice or virtue comes into consideration) and as the expression of a command, "Tell the truth". What distinguishes the phrases "You ought to" and "It is good to" from "It is your duty to" is simply a diminution of emphasis that can reduce a command such as "Tell the truth" to a less categorical command and then to a mere suggestion. "In fact, we may define the meaning of the various ethical words in terms of the different feelings they are ordinarily taken to express and the different responses they are calculated to provoke" (p. 108).

What this implies about moral disagreement, Ayer says, is that, since there are really no specifically moral *statements*, strictly speaking (whatever their makers may think) there is no moral disagreement. "Another man may disagree with me about the wrongness of stealing, in the sense that he may not have the same feelings about stealing as I have, and he may quarrel with me on account of my moral sentiments. But he cannot, strictly speaking, *contradict me*. For in saying that a certain type of actions is right or wrong, I am not making any factual statement, not even a statement about my own state of mind. I am merely expressing certain moral sentiments" (p. 107, my italics). This is what C.L. Stevenson later called disagreement in attitude. It feels like real disagreement, perhaps. But, given the real nature of the conflict, which is revealed by philosophy, Ayer claims that there is no point in asking which of the parties is *in the right*. Contrast the position taken up by Hume. And contrast the actual practice of Ayer, who never wrote about moral, social, and political subjects as if there were no point in asking which party was in the right. But on the level of theory—at least at the time of writing *Language, Truth and Logic*—he drew this negative conclusion from his claim that neither is putting forward what philosophy can count as a genuine proposition. (For Ayer's further claims about agreement and disagreement, see below § XIII.)

II

It seems clear that, like the distinct but comparable formulations of emotivist views by Ogden and Richards (See *The Meaning of Meaning*, London, Kegan Paul, 1926, p. 125) and by C.L. Stevenson (see "The Emotive Meaning of Ethical Terms", *Mind*, 1937), Ayer's account of morals lies directly under the influence of the work of G.E. Moore, especially Moore's indictment of naturalism in *Principia Ethica* and the hostile characterization he gave of subjectivism in Chapters III and IV of

his shorter work, *Ethics*. It is not just that Ayer acquiesces in Moore's articulation of the philosophical possibilities. Even that which is new and distinctive in emotivism, namely its non-descriptivism, arises from Moore, by reaction against Moore's positive doctrine of non-natural properties.

It will be useful to engage in due course with some of the choices Ayer made when he was arriving at his emotivist position and was persuaded to reject the naturalist and subjectivist options to which, if Moore had not influenced him so much, he would surely have felt drawn. But before we go any further, we must note in more general terms that Ayer's formulation of emotivism was also shaped by his positivism.

III

At the time of writing *Language, Truth and Logic*, Ayer held that every significant sentence was either analytic and, as such, the (however complex or indirect) upshot of symbolic conventions, or else synthetic and, as such, possessed of a content controlled (and strictly speaking exhausted) by the method associated with the sentence of accepting or rejecting the sentence on the basis of sense perception.

Such a position leaves no room at all for declarative sentences in morals. But when Ayer wrote the introduction to the second edition of *Language, Truth and Logic*, he claimed that the merits of the emotivist account of morals were independent of his arguments for positivism. "I believe this analysis to be valid in its own terms", he wrote (p. 20). If I still insist on passing comment on Ayer's positivism, it is not because I have something original to say about positivism or because I am unwilling to take Ayer at his word on the independence of his separate subscription to emotivism and to positivism. It is because I believe that the positivism Ayer brought into Anglo-Saxon philosophy bequeathed more to us than we now find it easy to identify and more than we know how to retain or renounce consciously or deliberately. And part of this concealed legacy is the confidence many philosophers feel—a misplaced confidence, I believe—in their conception of what it takes for a sentence to state a matter of fact. It is this conception, I think, that supports the demand for some general "epistemology of morals," [a non-moral epistemology(?)] and that sustains the various expectations which it appears that such an epistemology would have to satisfy, if only we had it. I suppose that it is these expectations that moral philosophers are seeking to assuage when they repeatedly insist that every defensible judgment of value must *supervene* upon some non-valuational truth.[1] I would not do this claim the compliment of straightforwardly contradict-

ing it.[2] The point I want to make about it here is only that it would not be too great a tribute to Ayer to see some residue of his positivism as the source of the itch to make so much of it.

IV

What then should one now think about positivism? The unexciting view I take of the matter is that logical positivism fails badly on both sides of the division it makes between analytic and non-analytic statements.

In the case of the analytic, its first difficulty is that, if we say that an analytic statement is one that is true in virtue of meaning, then, since our grasp of the meanings of most verbs, substantives, and adjectives is actually a posteriori, it seems there is a danger that most of the sentences that Ayer wanted to say expressed analytic truths will be a posteriori.[3] If Ayer responds to this unwelcome conclusion by reverting to Frege's much clearer and less fugitive definition of "analytic" (See *The Foundations of Arithmetic*, p. 4) and he says that an analytic sentence is one whose truth follows from logic and explicit definitions, then our second difficulty is that terribly few verbs, substantives, or adjectives have the explicit definition that Fregean analyticity will require. This is surely a reflection of our grasp of these senses being empirically conditioned. And our third difficulty is that it is perfectly obscure, in any case, how the stipulative theory of the a priori, or any other account that seeks to demystify non-empirical truths and cut them down to size in this way, can furnish an account of "follows from" that will confer upon analytic sentences the property of *truth* (contrast the property of being an accepted stipulation) that analytic sentences aspire to. How in particular can they share in the very same property of truth that is enjoyed by non-analytic sentences, or stand side by side with the non-analytic in arguments that are advertised as preserving that property? How can stipulation confer on a sentence the same property that another sentence gets by empirical confirmation?

Further difficulties make their appearance when we pass from the positivist's attempt to explain all in one go how necessary truths have their meaning and status to his attempt to show how contingent judgments in general, or (coextensively for the positivist) synthetic judgments in general, are meaningful. If it is obscure (and surely it is obscure) how a species of brute sensation can sustain the meaning of a synthetic sentence, and if it seems arbitrary to try to delimit in advance just how far a meaningful sentence can sit from direct observation without lapsing into cognitive meaninglessness, then it is hard to find any non-arbitrary ruling about what else can sustain the full cognitive import or understanding of a sentence.

I conclude that the situation is this. It seems that to every declarative sentence that actually declares anything there must correspond something that is at issue or something on which the truth or falsity of the sentence turns or depends. So maybe it is right that to every a posteriori sentence (indeed to every sentence) there corresponds some kind of test that can help, however weakly, in some suitable context to confirm it. (Certainly there is something special about the test of observation. Observation is one of the things that can force us independently of our will, albeit not independently of cognitive background, into a belief or out of a belief. That is what we want truth to be like. That is why stipulation was so mysterious a way of making truths.) But waiving any need there may be to qualify the claim about every sentence possessing a test, the relation thus claimed to hold between cognitive meaning and tests of truth provides no remit for us to reverse the order of quantifiers and make a stronger assertion: namely that there is a kind of test such that, for every non a priori sentence, a test of that kind can confirm the sentence.[4] For there is simply no prospect of rolling up once and for all in terms of tests or observation as the positivist understands these (or in terms of any other single thing) the nature and extent of non-analytic truths. How *could* one delimit in advance the whole province of non-analytic cognitive meaning? Of course we can say, if we like, that for every sentence there has to be *some* way that arises from its sense of making the claim stick that is made by the sentence. But at most this is a schema for the piecemeal criticism of different kinds of cognitive pretension. The schema creates no general problem for a cognitive or declarative view of ethics. What one hopes it will do is something utterly different, namely reveal the deficiencies of the particular claims (among them no doubt particular ethical claims) that we really ought to single out from among the less suspect as positively suspect.

V

So much for what was good and what was bad in positivism. If, as I conclude, what was good in it creates no general presumption against ethical cognitivism as such and leaves it open whether the valuational might not be some species of the factual, then we have to ask what sound reasons Ayer had to think that emotivism is "valid on its own account".

First, I suppose, there is the plausible point that it represents human morality as independent of revelation and as a matter to be determined by human assessment.

Second, emotivism is in harmony with explanatory (or Humean) naturalism, the sensible and defensible position (not to be confused with

the reductive moral naturalism that provoked the passion and fury of Moore), that tries to see man as part of nature and tries to explain morality as arising out of man's nature and situation. Naturalism of this kind surely survives the obsolescence of positivism. Positivism was at best one way of working out such an explanatory world view.

The third point is more special to morals as such. The emotivist theory delivers, vindicates, and explains the independently manifest truth (or so Ayer and I would count it) that, in tens of thousands of uses (even if not in all, e.g. as used in questions or conditionals or some past-tense statements etc.), evaluative sentences both express feelings and arouse feelings, some of these being feelings that are strong enough to issue directly or indirectly in action. Thus acceptance of a judgment *commits* us to respond in a certain way. Even if emotivism is not alone in having this merit, it vividly portrays at least some of the connections that exist between judgment and action.

VI

These are substantial virtues in a theory of morals, and ones I salute as such. Not only that. They are indeed independent of positivism. The chief question is whether emotivism is alone in the claim to possess them. More particularly, is the non-descriptive analysis of moral language that distinguishes emotivism from its predecessors essential to their attainment? The question is important not least because (as I must now try to show) the non-descriptive analysis of moral language offered by emotivism appears both as the source of all the difficulties of the position and as inessential to the emotivist's upholding of the plausible claim that valuational language is expressive.

The non-descriptive analysis appears inessential to the expressiveness of moral language because in the right context I can surely express a feeling such as hate by saying in the right way, either to or about the person hated, any of all sorts of things. I can say imperatively "There go my heart's abhorrence" or "Water your damned flower pots do". Or interrogatively I can say "If hate killed men would not mine kill you?". Or simply indicatively I can come out with the words "You are odious". In the right context (a Spanish cloister, an allotment, a back garden) any or all of these will represent expressions of hatred.

The non-descriptive analysis appears as a source of difficulty for emotivism for two reasons. First because one finds it hard to understand along the lines that the emotivist suggests the negative or conditional uses of valuational language or its use in judgments about things remote from all present concern. (Whereas a descriptive analysis would make it easy

to understand these things and easy to predict which of the more straightforward uses are likely to turn out to be apt vehicles for the expression of feeling. All this will be especially easy, if, as we shall see later, an account can be offered of how feelings enter into the determination of the sense of valuational language.) The second difficulty with the non-descriptive analysis offered by emotivism is that, if one looks outwards to real life, it is simply not believable that, when I say "x is odious", all that I am doing is making as if to growl "G-r-r-r!" at x. One can find this no more credible than that, when one makes the fully fledged and sufficiently reflected utterance "That hurts", one is simply doing as if to say "Ouch".

On this last claim, I offer one more point. When I say "x is odious", I give voice to a reaction in which I expect others to concur with me and to concur not mindlessly or tropistically but on the normal basis that this man really does "possess qualities whose tendency is pernicious" (as Hume puts it, *Inquiry Concerning the Principles of Morals*, Section IX, part 1). But surely I do then say something about x. Just as I say something when, instead of crying "Ouch", I say I am in pain or that that hurts. When I say that I am in pain, I can expect to be asked how it hurts and how that resulted from whatever else happened to me. In each of these cases, the valuational and the mental, what one says in the fully fledged case can have its *origin* in something expressive like "G-r-r-r" or "Ouch". But in the sophisticated language that we actually speak, things have moved a long way from that simple origin. If the declarative has indeed come into existence out of the expressive, it now has an altogether new relation to the expressive.

VII

All these points about emotivism and its doubtful claim to unique possession of the three advantages it does possess I should labour much more if it did not seem that Ayer had come very close even in 1936 to conceding that one can express one thing by making the declaration of another (see *Language, Truth and Logic*, p. 111), if the "Grrr"/"Ouch" comparison were not suggested by what Ayer himself wrote and if Ayer himself had not recently volunteered another important concession. This is that there is even

> something to be said for devising an assertoric form which could be adapted to the use of emotive expressions in conditional contexts and apparently deductive reasoning. Suppose that we render 'This is good' as 'This is to be approved of', where 'is to be' is construed in a purely prescriptive fashion. Then we can rewrite our examples ['If he did that, he acted rightly' and 'He

would have been a better man if he had had a stricter upbringing'], admittedly in a somewhat clumsy English, as 'If he did that, he is to be approved of', 'He would be more to be approved of if he had been more strictly brought up'; and [in the case of 'If A is better than B and B is better than C then A is better than C'], more straightforwardly, as 'If A is more to be approved of than B and B is more to be approved of than C, then A is more to be approved of than C'. This device has the advantage of locating the emotive reaction in the present, whatever the dating of its 'object', and whether the object is actual or hypothetical, and it also has the advantage of bringing out the prescriptive element in our use of ethical terms. (*Freedom and Morality* [Oxford, 1984], p. 30)

It may be unclear that this quotation, conveying what I claim is the third of the three concessions, really amounts to what I say it does, however. So I shall offer a commentary on it before going any further.

Ayer, says that "there is something to be said for devising [the] assertoric form ['this is to be approved of']." At least one thing Ayer means to discourage by his careful choice of language in the passage I have just quoted is the idea that the use of the assertoric form carries with it some automatic commitment to find full-blooded truth in normative or value judgments so paraphrased. In this I concur. That is indeed a further question. (See § XII, XX below.) But what are we to make of Ayer's claim that in 'this is to be approved of' the 'is to be' is to be 'construed' in a 'purely prescriptive' fashion? Scarcely that the form 'is to be approved of' is a variant on 'Hurrah' that just happens—this being the *only* difference —to behave as a predicate. That would be tantamount to the denial that there was ever any difficulty in the first place. If such a variant were possible then we ought to have been able to do what we found we could not and understand 'Hurrah' itself *both* in the ordinary way *and simultaneously* as a predicate. But if indeed we cannot do that, then it seems that Ayer must be deemed to have allowed that it is possible for a value predicate to have transcended the condition of 'Hurrah' and to have graduated, with some corresponding semantic shift, to the status of a genuine predicate—the transition from 'Ouch' to 'That hurts' again points the way—and all this *without* loss of prescriptivity, i.e. (presumably) without the linguistic form's ceasing to be cut out to commend the act or object in question, or without any weakening in the link between assent and being motivated. But if so much is true, then surely 'is to be approved of' must really mean '*merits* or *deserves* approval' or 'is such as to make approval *appropriate*'.

The immediate importance of this is that it appears that, by 1984, Ayer no longer saw the rejection of the indicative construal of moral language as essential to the general view he wanted to take of evaluative judgments. In effect he had *given up* the idea that his position required any strict analysis of moral language or any reduction of the normative to

the non-normative.[5] One with Ayer's world view need not dismiss ethics. (Of course, he never did dismiss it.) But he need not give definitions of its content. What he has to do is to try to understand it better, first in its own terms and then perhaps in more ambitious terms (see below § XVIII).

VIII

So much for the commentary upon the third of the three points I take Ayer to have in some way conceded about the special difficulties of emotivism, and so much for the possibility of gaining all the advantages of emotivism without actually embracing the claims that chiefly distinguished the position from all its predecessors. But in the course of the argument I think it has become plain that there is a further interest in the conclusion that Ayer arrived at so many years after writing chapter 6 of *Language, Truth and Logic*. What we catch sight of in the passage from the 1984 essay is the possibility of a reconciliation between emotivism and the older position that went under the name of 'subjectivism'. Such a reconciliation may be all the easier to effect if the older position can be brought to life by allowing Hume's authority to outweigh Moore's over what exactly that position is.[6] (Even as Moore's authority will be allowed to outweigh the authority of his successors in the determination, later in this paper, of what naturalism and non-naturalism amount to.)

IX

Ayer's proposal then is that x is good if and only if x is to be approved of. (A suggestion we may see as furnishing a schema that one could elaborate further: x is [a] good [f] iff x is good [as among the fs] iff x is to be approved of [as within the reference group of fs] . . . and similarly *mutatis mutandis* for other value predicates.) Whereas Hume, for his part, declares that he defines virtue to be any mental quality that occasions an agreeable sentiment of approbation in the observer, and that "when you pronounce any action or character to be vicious, you mean nothing but that from the constitution of your nature you have a feeling or sentiment of blame from the contemplation of it" (T.469).

There are similarities and there are differences here, and there is room for mutual accommodation. Insofar as what we have here are rival proposals for the *philosophical analysis* of moral terms, Ayer's version obviously comes closer to satisfying the subtle and exacting standards of necessity and sufficiency to which Ayer himself worked and encouraged others to work.[7]

On the other hand, there could be an accommodation in the opposite direction. As Ayer himself perceived on occasions when he wrote directly about Hume, it seems that, even when Hume said he would "define" virtue or vice, Hume's real concern was not definition or analysis as twentieth-century philosophers have conceived this, but explanation and commentary—aims that can be pursued in Hume's fashion without any elaborate attention at all to the semantic. Indeed, had Hume been confronted with the delicate questions of analysis that exercised G.E. Moore in *Principia Ethica* and *Ethics* and Ayer in *Language, Truth and Logic,* then, so far from responding to them either with Ayer's device or with the "x is good if and only if I approve of x" type of equivalence implausibly attributed to the subjectivist by Moore, he would surely have done best to respond by saying that, wherever taste or morals "gilds or stains natural objects with colours borrowed from natural sentiment" *(Inquiry into Principles of Morals,* Appendix One), what they raise up is always "in a manner a new creation"—not, that is, something it is the business of the moral scientist (or of any sane philosophy) to try to define or analyse, but something *sui generis* that can be recognized as *sui generis* by explanatory naturalist and positivist alike. The philosopher's or moral scientist's business, he might have said, is not to reduce the content of what is said to something else, but to explain as well and as fully as he can the enabling conditions of its emergence (see below, § XVIII) and to determine in detail the contribution of feeling to the fixing of the sense of the language that conveys this content.[8] Roughly speaking, value terms have their sense by being annexed to that which *in the object* calls for certain shareable responses of feeling and action, the responses that it makes *appropriate.*

In proposing this possibility of alliance between Ayer and Hume, I am asserting in effect that the important thing is to disentangle the central aims and insights of subjectivism—the real position of Protagoras, Hobbes, Hume, and (I like to think) Ayer—from niceties of linguistic analysis that were as inessential to Ayer's world view as they were to Hume's. It is true that it was an important theme of *Language, Truth and Logic* that the proper business of philosophy was analysis. (Yet another thing Ayer inherited from G.E. Moore.) But in time Ayer came to insist less and less upon this. (There are other signs, for instance in the 1984 essay from which I have quoted, that Ayer was in retreat from that general stand about the nature of philosophy.)[9] And in any case, as I said, we are invited in the preface to the second edition of *Language, Truth and Logic* to consider Ayer's moral philosophy both independently of positivism and strictly on its own merits. Once we acquiesce in that invitation and reassess the attractions of subjectivism in that light, I think it is apparent that subjectivism was not only a position that

Ayer needed to borrow from (as he did) but a position he should have embraced on equal terms as an ally to his main philosophical concerns.

A further claim I would now make—but this is potentially more controversial—is that it would then have been open to Ayer, having proceeded in this way, to decide that it was not essential to subjectivism as such that the theory be introduced either by philosophical denials of the type with which Hume introduces the theory in the *Treatise* (some of these being wisely relegated in the *Inquiry* to an appendix) or by the *enfant terrible* pronouncements about moral judgments with which Ogden and Richards, Ayer, and others once affrighted polite society and the worlds of learning and letters. What really matters is not to issue shocking and imprecise denials but to elaborate and refine Hume's positive account of the genesis in feeling and emotion of morality and moral language and then to study and improve Hume's account of how a social process that ignores partial sentiments, but reinforces sentiments and judgments which depart from our private and particular situation and appeal to the point of view that shall be common to one man with another, can cause there to emerge public standards, standards at once contestable and impersonal, for the assessment of personal merit and the discrimination of right and wrong acts. It may pose a problem for positivism that the moral language that is talked at the end of this process is fully as declarative in its aspirations as the language that is talked at the end of the process by which psychological states come to be singled out and described by their possessors. But it need not pose any problem for the world view itself to which Ayer gave expression in his positivism. Or so I claim. But to be fully satisfied of this, it becomes necessary to determine the relation of subjectivism to naturalism (see below, § X) and then to refine the relevant ideal of naturalistic understanding (below, § XVIII).

X

The position I am commending to Ayer is a naturalist position in the familiar sense in which Hume's speculations were naturalist. But is it also naturalist in the more technical sense in which Moore denounced naturalism, and alleged a systematic failing in naturalism? To answer this question in the negative will not only pacify one who arrived at emotivism by a route similar to the one Ayer took in 1936. It ought to enhance understanding of the terms of the alliance between emotivism and subjectivism.

Reading G.E. Moore's *Principia Ethica* in the way I want to read it (a

way further encouraged and fortified by Casimir Lewy's résumé and interpretation of the new preface Moore drafted for a reprint of *Principia Ethica* but never published),[10] a naturalistic property is *either* one with which it is the business of the natural sciences or experimental psychology to deal (cp. p. 40 *Principia*) *or* a property which can be completely defined in terms of such properties.[11] Naturalism is the philosophical position that seeks to *define* good by predicates that stand for such naturalistic properties. And the most interesting and challenging among all the objections Moore made against naturalism so conceived (I say objections rather than charges of fallacy, for it appears that in the new preface Moore withdrew the claim that there was any formal fallacy in such positions) is the so-called open question argument.

Suppose the naturalist defines or elucidates the *summum bonum* in terms of aggregate well-being or happiness. Then as directed against that suggestion, the open question argument runs as follows (cp. *Principia* p. 44, § 27 *ad fin*): an act or practice may well contribute to aggregate well being or happiness but, even allowing that it does contribute in that way, it must still be an open question whether the act or practice is good.

Now, as it stands, an argument of this sort may appear to threaten only the position one might call *definitional* naturalism. It makes an important point about the senses of moral predicates and what it will require for any philosophical proposal to match these. Whereas subjectivism as reconstituted from emotivism is no longer a definitional theory at all. I suppose one might leave the matter there, saying "subjectivism is not involved in the business of chasing after senses; so subjectivism is not naturalism in Moore's sense". One might leave matters there except that Moore's argument leaves one with such a strong sense of unfinished business and the feeling that, if the open question purports to show anything at all, it purports to make a point that needs to be better understood about the reference as well as the sense of value-predicates. Surely there is more to the naturalism that Moore attacked than definitional naturalism. If so, then one had better address the further question, which is a question about reference not sense, whether subjective properties are or are not natural properties.

XI

To advance better we must retreat one step. We must begin by admitting that Moore would have greatly improved his deployment of the open question argument if he could have given *a reason* for us to expect, in advance of the presentation of any conceivable naturalistic definition of

good, that always and invariably every such definition would fall short. What reason could Moore have given? It is hard to state the answer in the language of *Principia*. But the reason that I would myself offer (forcing upon Moore some reconsideration of his hostility towards Hume, but why not?) is that the properties discerned by the natural or experimental sciences are properties that engage with interests in the prediction and control of processes that fall within the purview of the sciences of matter, interests that are theoretical and explanatory; whereas valuational properties arise from interests and concerns with the ethical as such or the aesthetic as such, which are for the most part quite alien to the interests of experimental science. This is a point that was surely within Moore's line of sight, and that he could have expressed in his own way. Leaving him to say it in his own way, let me say in my subjectivist way that one important respect in which valuational and theoretical subject matters differ is this. Any general connection linking the natural properties discerned by the experimental or empirical sciences with human striving can be expected to be perfectly adventitious. (An understandable exception would have to be a special science carved off from a more general science by a special human interest, e.g. dietetics.) But the possession of some connection with striving or with the will, by virtue of which the assent to a judgment attributing a valuational property to a thing commits the thinker—however defeasibly—to some inclination of the will, must be expected to be the normal condition of a valuational property. Any predicate that stands for a valuational property and has a sense that is cut out to subsume objects within the extension of a property with this power must be expected by a subjectivist to have its sense fixed in a manner that depends directly or indirectly upon sentiment or affect.

Suppose further explanation were offered along these lines of the failures of necessity or sufficiency predicted by the open question argument. And suppose what I have said were edited or transposed to avoid arousing Moore's own antipathy to subjectivism. The result would cohere well with Moore's anti-scientism, and it would lend what must have seemed to almost everybody to be an inappropriately inductive-seeming consideration the promise of becoming an argument of real theoretical power. As directed against definitional naturalisms, the open question argument would then turn upon a principled divergence in the kinds of sense enjoyed by predicates defined or elucidated naturalistically and the kinds of sense enjoyed by predicates not defined naturalistically. Moore can have his own way of saying all this. But a subjectivist can say that an ethical or aesthetic predicate has to have a sense that connects it in the right sort of way with the right sort of affective concern and it has

to engage thereby with the right sort of motive. For each non-natural predicate with its lexically given sense, there will be some such connection determined by its sense.

So much for the objection to *definitional* naturalism. But can Moore's argument reach further? It may seem that it stops here, because nothing prevents the Fregean concepts or properties which non-natural predicates stand for from being picked out by different predicates with different senses. And could these *others* not be naturalistic predicates?

Well, what we must now expect, given the proposed supplement to Moore's argument and given also a Fregean view that associates concepts or properties with functions from objects to truth-values,[12] is that any concept or property that *can* be picked out by an expression with the sense of a non-natural predicate will have as its extension the inverse image of the True under some corresponding particular function from objects to truth-values and that this function will give expression to a distinctively ethical or valuational interest. Not only then must it project this interest faithfully across a circumscribed set of putative cases that happen to be actual, and place in the inverse image of the True the things that make a certain sentiment *appropriate*: it must also project the interest non-accidentally faithfully across any and every case that could arise. I take this to be an exigent and substantial requirement. It is not easy to see how any naturalistic predicate could correspond to such a function. Across a fixed number of cases, no doubt any function that projects a moral or valuational interest and collects objects that deserve a certain response can be mimicked by some function that projects an explanatory-cum-predictive or physical scientific interest. But that is not enough. What is required is a function from objects to truth-values that will faithfully and systematically mimic the non-natural function over *indefinitely many new cases*. If the claim that that can be a physical function is to be substantially made out, then the function itself must be explainable or specifiable in physical terms, that is terms that pull their weight in the experimental sciences. It is because I do not see how that is possible that I see myself as justified in speaking not only of the non-natural *senses* of predicates but also, on the level of reference, of *concepts* or *properties* that are non-natural.

XII

I conclude that subjectivism is not naturalism in any sense even cognate with that in which Moore used the term. And any other danger that subjectivism might resemble an attempt at reduction of the normative to

something else disappears so soon as we avail ourselves of Ayer's 1984 statement and say x is good iff x is to be approved, i.e. x is such as to make approbation appropriate. Such a subjectivism seems to be exempt from any conceivable objection to naturalism as such.

Concentrating at last then on what subjectivist doctrine positively asserts about the origin and basis of morality, rather than on what Hume and Ayer deny about the prospects of morality's constituting a subject matter in which there can be knowledge or truth, what we now find is that the negative claim they put into the exposition of subjectivism turns up rather in the guise of a real, undecided *question*, a question that has to be resolved by *working out* the consequences of the positive subjective view. Pending that working out, we have non-natural predicates with a distinctive sentiment-involving kind of sense, which may or may not turn out to stand for genuine or real properties. In the only serious and appropriate sense of 'real', they will stand for real properties according as whether the indicative form 'x is good' (etc.) does or does not prove capable of sustaining a more than merely formal attribution of truth. Having already sought in conversation with him to interest Ayer in my own view (expressed elsewhere[13]) of what it turns on whether or not value-statements can sustain such an attribution, I shall not however pursue that particular matter any further here. For if we are to focus on Ayer's own views, it seems much more important to fill out the subjectivism we have recovered from his emotivism by drawing for this purpose upon Ayer's account of moral dispute and disagreement. Then in conclusion it will also be necessary to say more about the theoretical and ethical aspirations, demystificatory and/or explanatory, that are proper to any upholder of the non-reductive subjectivism I have tried to recommend to Ayer.

XIII

Ayer's account of moral dispute and moral disagreement may be reproduced as follow:

α we hold that one really never does dispute about questions of value. This may seem, at first sight, to be a very paradoxical assertion. For we certainly do engage in disputes which are ordinarily regarded as disputes about questions of value. But, in all such cases, we find, if we consider the matter closely, that the dispute is not really about a question of value, but about a question of fact. When someone disagrees with us about the moral value of a certain action or type of action, we do admittedly resort to argument in order to win him over to our way of thinking. But we do not attempt to show by our arguments that he has the "wrong" ethical feeling towards a situation whose

nature he has correctly apprehended. What we attempt to show is that he is mistaken about the facts of the case. We argue that he has misconceived the agent's motive: or that he has misjudged the effects of the action, or its probable effects in view of the agent's knowledge; or that he has failed to take into account the special circumstances in which the agent was placed. Or else we employ more general arguments about the effects which actions of a certain type tend to produce, or the qualities which are usually manifested in their performance. We do this in the hope that we have only to get our opponent to agree with us about the nature of the empirical facts for him to adopt the same moral attitude towards them as we do. (119–120)

β ... if our opponent happens to have undergone a different process of moral "conditioning" from ourselves, so that, even when he acknowledges all the facts, he still disagrees with us about the moral value of the actions under discussion, then we abandon the attempt to convince him by argument. We say that it is impossible to argue with him because he has a distorted or undeveloped moral sense; which signifies merely that he employs a different set of values from our own. We feel that our own system of values is superior, and therefore speak in such derogatory terms of his. (120. Cp. 2nd edition, intro., p. 22)

γ But we cannot bring forward any arguments to show that our system is superior. For our judgement that it is so is itself a judgement of value, and accordingly outside the scope of argument. It is because argument fails us when we come to deal with pure questions of value, as distinct from questions of fact, that we finally resort to mere abuse. (120)

δ In short, we find that argument is possible on moral questions only if some system of values is presupposed. If our opponent concurs with us in expressing moral disapproval of all actions of a given type t, then we may get him to condemn a particular action A, by bringing forward arguments to show that A is of type t. For the question whether A does or does not belong to that type is a plain question of fact. Given that a man has certain moral principles, we argue that he must, in order to be consistent, react morally to certain things in a certain way. What we do not and cannot argue about is the validity of these moral principles. We merely praise or condemn them in the light of our own feelings. (120)

XIV

Here, as so often in Humean and latter-day subjectivist writings, one finds much to admire in what is affirmed positively about the nature and substance of morals and moral disputation (especially e.g. under [α]), but one finds precipitate and less persuasive the negative claims, which may or may not turn out to be correct when the subjectivist viewpoint is properly recovered and more fully developed. It may turn out that vindicating explanations of moral beliefs, explanations that explain the existence of beliefs by virtue of their correctness, can be mustered for the more important contentions of morality as subjectively conceived.[14] Or it may not turn out that way. But until the possibility is disproved, it is

premature to declare that the only response to deep-seated disagreement is abuse (see [γ]).

Another assumption that Ayer makes and that seems unwarranted by the emotivist or subjectivist starting point concerns the inner structure and cohesion of a moral outlook. Ayer's picture of a person's moral outlook in potential collision with the moral outlook of some other person is that of a tree-like structure in which less general beliefs and context-dependent reactions to practical questions or to actions or situations are directly or indirectly supported by one or more general attitudes which either *are* or *repose upon* fully general attitudes, attitudes that are pictured as basic, as mutually independent and (if not as immutable) as not mutable by ordinary moral persuasion. (For this, having always to presuppose more basic principles, cp. [δ], is seen by Ayer as cut off from the scrutiny of the most basic, load-bearing principles.) But I should say that Ayer has no adequate reason to embrace this particular picture or conception. Conceiving morality as the subjectivist conceives it, Ayer should be wide open to the possibility that what sustains it is a vast multiplicity of sentiments of varying origin and strength, and he should be ready for the possibility that logically distinguishable feelings or sentiments (sentiments intentionally directed, sentiments that are thoughts) can be either loosely or tightly intertwined in the economy of feeling. Why should these not sustain one another *without* standing in formal relations of entailment? Why is Ayer not open to the possibility that in some cases, contrary to what he assumes, more general beliefs are sustained by much less general particular responses and tendencies? It is a matter of fact, an empirical question, not something to be settled by philosophical preconception (especially not by misconceived analogy with the case of a theory that is susceptible to being hypothetico-deductively presented), how to picture the structure of a moral outlook and how best to understand what happens when disputants with different moral outlooks find themselves in serious conflict over what to say about an object of shared attention or about an act that both agree that some agent has done. As long as this empirical question goes unexplored, there is *no clear thing to mean* by a distinction between fundamental and non-fundamental moral disagreements, and there is no reason to believe that, if we imagine two people agreeing over all non-moral facts but disagreeing in their moral reaction to some shared object of attention, then we are imagining a case where no scope remains for anything beside abuse. For any x and any y, for x and y to dispute with one another there must be something x and y agree about. No doubt. But perhaps there is nothing such that x and y must agree about it in order that they dispute—not even some basic thing. We don't,

I repeat, know yet what "basic" means here. For all that subjectivism says, perhaps x and y can begin almost anywhere. No doubt it is culture and context that combine with human nature to determine a moral outlook. But it is an open question what forms of moral argument this determination must in a given case foreclose or render for ever ineffective. In advance, there is nothing a subjectivist or emotivist is committed to think about *any* of this.

XV

So much for what seems unconvincing. It is what Ayer says under (α) that seems fresh, admirable, and capable of taking on an altogether new life when Ayer's theory forms an alliance with subjectivism, especially if this is a version of subjectivism that accepts that moral thinking is as it is (namely persistent in what it sees as the pursuit of consistency, agreement, and truth) and that leaves open the possibility that the moral is a subspecies of the factual, while at the same time refraining from seeking to ground the moral within the non-moral or searching for formal implications from the non-moral to the moral.

Ayer begins by boldly denying that we dispute at all about questions of value. But his real view is that we do dispute. All he wants to deny here is that for us to dispute is for us to seek to show anyone who disagrees with us the wrongness of their ethical feeling towards some act or situation whose nature they have correctly apprehended. Rather, what we do is try to show our opponent that he has misconceived what has happened or been done, or misconceived either the agent's motive or the circumstances in which his act was undertaken. We do *not* try to dispute with our opponent about right and wrong ways, as it were, of hooking attitudes of appraisal to agreed descriptions—as if moral disagreement standardly consisted in the participants to a disagreement being adherents of different ways of moving from statements of how things are to statements of how things ought to be or ought to have been.[15] For what is at issue is not normally a question of moving from an "-is-" judgment to an "-ought -" verdict at all. Rather it is a question of moving from some object or situation, concretely given, to "good" or to "ought" or "must". What is centrally typical of moral difference, including the moral difference that issues in actual disagreement, is that, in the face of one and the same action or context (some actual object of awareness), different moral agents begin by bringing different sensibilities or different moral emphases to bear. They respond to significantly different properties or features of the object. Each can try to persuade the other to be party to his or her own way of seeing things, as Ayer says, and each can

seek to understand the other's way. To this end, all sorts of things can be said or conveyed or pointed to. But, at least for a subjectivist, there is simply no reason to insist that what is said, either in the process of persuasion or in the course of justification of the stand taken up, should stand in a relation of *implying* the judgment for which the disputant is trying to gain favour. What the disputant mainly needs to do is to draw full attention to the saliency that engages with the sentiment which he expects the object to draw down upon itself, and which, if it does not already do that, he seeks to enable the other disputant to learn to be receptive to when confronted with such an object. For in so far as the two disputants are within dialectical reach of one another, the language in which they dispute is language whose understanding *presupposes* the great fund of sentiments in which those who learn that language can learn to concur. What they have to find ways to do is to cause one another to exploit the *full* range, reach, and resonance of these sentiments.

Here I think Ayer's positive claim (if I have not traduced it altogether by transposing it to the context of subjectivism) solves at one stroke the problem that so many of Hume's commentators have bogged down upon in their attempts to understand how, and with what putative special precautions, Hume himself proposed to get from "the usual copulations, *is* and *is not*" to "the new relation or affirmation" of an *"ought* or an *ought not"* (cp. *Treatise* 3.1.1). Ayer's proposal simply removes that problem by forcing upon us the thought that what disputants must focus upon is the object of attention itself.

XVI

So Ayer's doctrine of disagreement has this great merit, while enabling us to leave open the large questions of cognitivism and noncognitivism. It permits us to abandon (if we wish and as it seems Ayer has himself later wished) the dubious speech-functional theory of emotive meaning that philosophy devised in one moment and then took decades fully to repent of. Of course, Ayer's claim (α) postpones the question of what else goes on when moral disputants seek to get the measure of one another, and it postpones other business too. What the doctrine would have to do next is to say how property-mediated linkages between kinds of thing and kinds of subjective response are altered and refined in the processes of instruction and persuasion.[16] But where the first instaurator of moral science has provided so much already for the subjectivist to start out from,[17] I simply note the debt that is still owed here and advance to the question I announced as our last.

XVII

What kind of understanding of morality is to be obtained from a theory like subjectivism?

At the time when Ayer wrote "Man as a Subject for Science",[18] it was his task to confront such a mass of ingenious or obscurantist objections of principle against allowing causality into the explanation of human behaviour or against the very idea of a social science that it would have been unreasonable to expect him to find space to try to say what sort of thing he would have expected could be learned from explanatory naturalism or to be more specific about what wisdom it could give. There have been other opportunities for Ayer to do this, but contemplating his literary and philosophical affinity with the philosopher I have proposed to him as his ally in ethics, I confess, well, if not to a feeling of disappointment, then to a strong sense of unfinished business. There is no other option, I think, but to construct for ourselves the alternatives between which Ayer would have to choose, if he were to agree to an alliance between emotivism and subjectivism and were to try to describe the kind of insight one ought to be in search of here. There is no other option (I mean) unless we are to content ourselves with saying as the *status-quo-ist* philosopher Jenkinson says to the deteriorationist Escott in the concluding words of *Headlong Hall*: "thus the scales of my philosophical balance remain eternally equiponderant, and I see no reason to say to [any] of them, ΟΙΧΕΤΑΙ ΕΙΣ ΑΪΔΑΟ."[19]

XVIII

As good a place as any to begin upon this matter is a question recently raised whether, even as understanding starts to glimmer, the very effort to understand norm and valuation in explanatory naturalist terms does not entirely denature the phenomenon. "Our best attempts to understand evaluative thought of all kinds . . . seem to me to distort or threaten to obliterate the very phenomenon we want to understand" writes one critic.[20] In his development of the dilemma that he sees here, Barry Stroud claims that any philosophical attempt to understand morality or evaluative thought leads inevitably to something he calls "subjectivism". Subjectivism Stroud identifies not by the positive characteristics by which I have tried to commend to Ayer a position of that name but by describing it as the negation of various things:

(i) It is the denial of objectivity;
(ii) It is the denial that the value of a thing is a value of it as it is in itself or independently of us;

(iii) More generally, subjectivism is the denial that there are evaluative facts. The world, according to subjectivism, is simply the totality of facts and it is value free. Values are too queer to be part of it. "If we tried to specify all the things we believe and we took that list to express our conception of what the world is like, what we believed would be incompatible with subjectivism [as Stroud specifies it]. One thing I believe is that grass is green, another is that some acts are vicious murders, that the deliberate killing of a human being is a very bad thing . . . [But] in saying how things really are, [subjectivism] must not mention the colour of things or their value."

(iv) The subjectivist says that, *qua* subjective, values are not part of the world. Nevertheless people have beliefs that involve them, and this is what chiefly needs to be explained. This explanation must draw on what human beings are really like, and on what the world is really like. Such a subjectivism must, however, be consistent with the *denial* that there are values. It is true that "Whatever we cannot help regarding as true in order to explain our thinking and experiencing what we do must be reckoned as part of the way the world is". But according to the subjectivist as Stroud defines him, values are not in this way indispensable to the explanation of our convictions.

Items (i) to (iv) are all Stroud offers by way of initial exposition of what he calls subjectivism. The sense in which this position is properly called subjectivism is presumably one that *combines* the sense in which the subjective is the *non-objective* (i.e. that for which the question of truth lapses) and the sense in which the subjective imports the *contribution of conscious subjects.* (It is the idea of such a contribution that leads Stroud's subjectivist thinker *straight* to the idea of non-objectivity.)

The criticisms Stroud urges of the 'subjectivist' position he has proposed for consideration correspond in some cases to relatively familiar criticisms that we see Ayer trying to accommodate by the concessions he makes in the 1984 essay, from which I have already quoted. In other cases they correspond quite closely to difficulties that I too would urge against any version of subjectivism that represented the position as offering a reduction of the normative to the non-normative or represented it as made up of the denials (i), (ii), (iii), and (iv). Evidently then subjectivism as Stroud attacks it differs, differs in other ways and also differs under each of these heads, from subjectivism as I suggest Ayer ought now to defend it. What Stroud and I do agree about (even if Ayer would not) is that a position like the subjectivism Stroud sketches must make it a mystery that any one thing could be meant by those who

converse of value, and that it must create another (related) mystery what it is that the word 'approbation' stands for. Indeed, I believe Stroud is right to insist that neither values as subjects conceive them nor the feelings or attitudes essential to evaluative judgment can even be caught sight of from a position of theoretical disengagement from values. "It is only our very engagement in a set of values [he writes] that makes it possible for us even to recognize the phenomenon of evaluation. The demand of evaluative neutrality would have the effect of denying or obliterating the very phenomenon we want to understand" (237).

XIX

When all this is so plain and obvious as I think Stroud contrives to make it, why should anyone espouse a position that has this effect? Why, except from delight in exposing deception or fraud, if that is what they think morality is (but this is clearly not Ayer's view[21]), should anyone be content with an explanation like that offered by the position Stroud calls subjectivism, an explanation which is *bound* to denature the explanandum? Stroud's answer to this question is interesting. The dilemma that he puts before us inherits this interest.

Stroud derives the position that he vexes me by calling subjectivism from the methodological constraints upon the whole project of gaining proper understanding of ourselves. The derivation is as follows. If the explanation is to explain anything at all, the explanation we are looking for must draw upon what we are like and what the world is like. And it must not take for granted the very phenomenon it seeks to explain, namely values and norms.[22] For instance, it will not count for us as a satisfying explanation of ourselves or of what we do or say simply to declare that there is viciousness in wilful murder as it is in itself, and that in due course we human beings come to discover this viciousness and then respond to it. That would not explain anything, Stroud says. No, if we want to explain, then we must take the world as we know it *independently* of the question of value and we must take ourselves as natural beings within that world, and then we must seek to understand on *that* basis the moralized second nature we find within ourselves. But if that is what we have to do (Stroud's explanation continues), then morality is bound to appear as our own extra contribution.[23] Of course this is not *yet* to say that our contribution is a projection. But, once we look for that which our contribution represents, well that is something we cannot find in the world as it is in itself, or in the world as we know it independently of the question of values and norms. Maybe we

could start to look for this thing that our contribution represents as real. But under the explanatory rules proposed, it seems to Stroud that nothing could ever count as the theorist's actually finding it. In which case, the final verdict has to be that our contribution is simply a projection, an invention, a balloon without ballast, something that simply floats forth from the mind.

I find this is too quick. In parallel, though at risk of departing too far from Stroud, consider scientific theories. Scientific theories of the world are our contribution too. It does not follow that theorizing is projection. And the reason for stopping short of saying that is that, in this case, if theories are any good, we can try to *find* what these theories represent. It is not excluded that we should find this whatever-it-is in the world.

A difference between valuation and science, it will now be said, is that, in the scientific case, theory can be constrained, to almost any degree that is demanded (provided that theories may be tested together), by observation. But our thoughts about values and norms are not constrained in this way. *Observations* can occur where the responses of observers to something presented are markedly insensitive to collateral beliefs. But nothing like this, it will be said, is seriously imaginable in the valuational case.[24] (See also § XI above.)

XX

So much for the dilemma Stroud presents us with. In due course, he points in the direction of more modest explanatory projects and he mentions more piecemeal, already moralized, forms of understanding that may be expected to be exempt from the pernicious tendency that he is concerned with. But, in connection with these more modest projects, he makes no mention of the role therein of sentiment, which is strange, and he does not, by re-examining the explanatory ground-rules, explore the possibility of conceiving of *less* piecemeal explanatory aspirations. At the very end of his second lecture, he points the finger of blame at the "traditional dichotomy" between objectivism and subjectivism as the real source of the projectivist view. But then, instead of actually blaming the traditional dichotomy, he pessimistically adds that the fact that this is the source "would help explain why we can expect that some form of the view will *always* be with us."

What one might have expected here is that Stroud would respond to the dilemma he has posed by distinguishing the objective/non-objective distinction, which surely needs to be characterized in terms of the prospects of a class of judgments attaining substantial truth, from the

non-subjective/subjective distinction, which may best be characterized in terms of the senses of certain kinds of sentences not involving (or not always involving) for their proper elucidation some allusion to the states or responses of conscious subjects.[25] Surely, if these are distinct distinctions, it is a sad mistake to use the word "subjective" to serve simultaneously as the second term of both distinctions. Not only that. It is important to go on from there and consider the possibility of a subjectivism like that which I have commended to Ayer—a subjectivism called after the "subjective" in the sense corresponding to the second of the two distinctions—which consists, not of denials like (i) to (iv), but of a positive account of the nature and basis of morality. There is room for choice, no doubt. But surely Ayer's own candidate theory should be the Humean or neo-Humean account of the way in which morality originates in the feelings that it flows from subjects' nature for them to have in the face of this or that. On this account, morality starts with these feelings and then graduates to the condition in which the natural virtues that are expressed in those primitive feelings are supplemented by artificial virtues, which are expressed in attachment to certain practices whose observance will gratify (i.a.) those primitive feelings etc.

Such a theory can be criticized, improved, replaced. What is methodologically crucial is that it need not denature the normative by offering a reductive analysis. (But of course *that* point is already secure in Ayer's 1984 account of these matters.) What the position requires is not so much philosophical analysis as the *elucidation* of content and the imaginative reconstruction of what makes that content possible. It requires hard, corrigible effort. Its most distinctive basic claim will be that *any* satisfactory attempt to elucidate what is meant by a value term must display the use of the term in its involvement with the sentiments of subjects.[26]

If what we learn from Stroud's dilemma is that this is how subjectivism ought to be characterized as an explanatory theory, what else can we say about the alternative explanatory project? First, that he who would understand better the nature and prospects of a certain kind of thinking *either* must have an open mind about what the world itself compromises *or else* (better perhaps)[27] must refrain from identifying the world with the whole of reality. In the second place, Stroud's dilemma shows the need for some explanatory ideal other than the naturalistic reconstruction of values and norms. To understand ourselves and our own natures and second natures in a better way, we need to be able to accept as given but then to stand back a little from, our practices. We need to try to generalize a little. We need to speculate about the difference between the moralized and the non-moralized condition. We need to identify more basic and less basic components in morality, and speculate afresh

what might explain the emergence of the more sophisticated norms that Hume seeks to explain in his doctrine of the artificial virtues. But so far from exposing deception or error in morality, the results we shall arrive at in this way will at least begin by leaving it as a real possibility—a possibility to be further investigated—that in many cases we think what we think and we do what we do because there is nothing else to think or to do. (That of course is what Hume himself claimed about justice.) Such an account need not take a plane or an adze to what it finds. It can simply accept it for what it is, engage with it, and hope to reveal in due course both the strength and the weakness of the case for thinking or acting in this or that particular way within morality. A theorist who engages like this with morality, who seeks the enabling conditions of morality's emergence and the rationale of its further development, can be rightly accused of being cool or not warm "in the cause of virtue"—as Hutcheson accused Hume of being. But *cool* not ice-cold. If he were ice-cold, the theorist would be disengaged, and he would suppose that he knows already that no explanation of a moral belief will ever vindicate it. He would think that the only properties anything has are those that physical science attributes to it. (Compare Stroud's account of the explanatory ideal that animates what he calls subjectivism.) To be ice-cold the theorist would have to know already that the only properties are scientific properties. (How does he know it?) But to be *cool* is to be ready (as surely one should) for anything.

XXI

I think Ayer will now ask: if we think that ways of thinking can emerge and find their own subject matter, if we distinguish, as I have advocated that we should, between morality as the contribution of conscious subjects, on the one hand, and how that contribution represents things as being, on the other; and if we do not constrain the search for the thing represented by the criterion of observationality, but rather by what we claim to be the rational criteria that are immanent within the practices that make up that contribution; then is there any limit to what we shall end up countenancing? Could we not end up satisfied by saying almost anything about the absolute or about Mumbo Jumbo or whatever else at all? Could Mumbo Jumbo–discourse not bring itself into being and then claim to have caught up with Mumbo Jumbo himself? What could one in my theoretical position say in criticism of the supposition that this had actually been done, and that Mumbo Jumbo himself had been "identified"?

The reply to this question must hark back to § IV. To every sentence there corresponds *something* that its correctness must turn upon, even perhaps some test that can help in some suitable context to confirm it. But this is consistent (I claimed) with there being no prospect of circumscribing in advance or once and for all what can *count* as a test or as a thing at issue. We have to take each purported case on its merits, and accredit or discredit it on these individual merits. What Ayer wants is some non-vacuous *general* criterion of success or failure. Is there such a thing? It would indeed be wonderful to have a substantial but completely general account of what can force us (*malgré nous*, as Leibniz would say) to believe or disbelieve something. But are we utterly lost if we cannot find this? Why can Ayer not see it as more than enough of a problem for those who want to talk of God that habitually (or so one like Ayer or me might declare) *either* these people say nothing that even a disbeliever need reject *or* they put forward an account of things that is internally incoherent *or* they put forward an account of the origin and nature of the world that generates at least as many questions as it answers? Why is it not enough of a challenge to theology for Ayer to ask it to find a way to do better than that? If Ayer thinks it is not enough and this is Ayer's ground for rejecting the option I offer him (an option which leaves it an open question, remember, whether or not a subjective morality will admit truth, knowledge, and objectivity, and which does not "*postulate*" its own adequacy to do that!), if Ayer insists that he must have belt *and* braces, then he will force me to suppose that he has not really given up the difficult old business of trying to establish the bounds of sense from within the bounds of sense. He will force me to doubt what I previously did not doubt, namely the separateness of his original subscription to emotivism and his original and (it will seem) residually persisting subscription to positivism.

DAVID WIGGINS

DEPARTMENT OF PHILOSOPHY
BIRKBECK COLLEGE
UNIVERSITY OF LONDON
JANUARY 1990

NOTES

1. Of course it was G.E. Moore who made supervenience a talking point here. But, contrary to what some may now assume if (understandably) they spare themselves the pain of looking at *Principia*, he did so for a reason that had absolutely nothing to do with anything that leads to positivism. Moore began by characterizing the non-natural in terms of that which lies outside the provinces of

the natural/experimental/empirical sciences. (See *Principia*, p. 40. "By nature, then, I do mean and have meant that which is the subject matter of the natural sciences and also of psychology.") Then, by transitions that may surprise us, based on a further claim, viz. the equivalence between being natural and being in time, he claims that that which lies outside this subject matter of the natural, is not in time. Non-natural properties do not exist in time. We can imagine a natural property existing by itself in time but we cannot imagine a property like good doing so. But what then, we may wonder, is the connection between Good and the temporal world in which we have to act and think? Moore's answer would seem to be that Good *supervenes* upon those temporal properties.

2. Perhaps there is some way of understanding the declaration of supervenience as both non-truistic and true. It is because I suspect that the claim boils down in the end to a special case of a truism (namely that any putative property of x must be expected to rub shoulders, or have relations of compatibility and incompatibility in respect of its presence in x, with endlessly many other putative properties of x in all sorts of other ranges) that I refuse to issue a simple denial of what is affirmed by the supervenience thesis. The thing I do want to say here about the claim of supervenience is that, however real the question is about how it ought to be construed, the most pressing question is the nature and source of the philosophical impulse and the (utterly non-Moorean) convictions that now find their expression in the claim and in the associated demand for an "epistemology of morals". My hypothesis is that the answer has to do with the residue of positivism.

3. For a brief account of this matter with references to relevant writings of Putnam, Kripke, and others, see my *Sameness and Substance* (Oxford: Blackwell, 1980), Chapter 3, ad init.

4. The claim is not made very much more plausible by saying instead that there is a kind of test such that for every a posteriori sentence *s*, a test of that kind can in some cognitive context of the right kind for *s* confirm the sentence *s*.

5. Thus Ayer comes by his own route to anticipate a conclusion reached in different ways and with different motivations from his by John McDowell at pp. 117–20 of his "Values and Secondary Qualities", in *Morality and Objectivity* (London: Routledge & Kegan Paul, 1985) and by myself at p. 187 of "A Sensible Subjectivism?", in *Needs, Values, Truth* (Oxford: Blackwell, 1987).

6. See my "A Sensible Subjectivism?", op. cit.

7. I would also note that, if Hume's claims were amended on the model of Ayer's (using his "is to be approved of"), the possibility would loom that Hume was not irrevocably committed by his subjective starting point or by his doctrine of the sovereignty of moral subjects to the claim (*Treatise*, p. 547) that "There is just so much vice or virtue in any character as every one places in it and 'tis impossible in this particular *we can ever be mistaken*". The subjectivist can say something more subtle than this. Hume makes a start upon this himself in "Of the Standard of Taste". For my interpretation of this later essay, see again "A Sensible Subjectivism?", op. cit.

8. See my op. cit., pp. 196–202.

9. In *Language, Truth and Logic* Ayer had a fourfold division of ethical propositions. These were roughly (1) definitions (2) descriptions of the phenomena of moral experience (3) exhortations (4) actual ethical judgments. The analysis of (4) was the only thing Ayer invested with strictly philosophical interest. For Ayer's relaxation of this restrictive ruling see "Are There Objective Values?", op. cit., paragraph 3 following; also the sixth paragraph from the end.

10. Casimir Lewy, "G.E. Moore on the Naturalistic Fallacy", *Proceedings of the British Academy* 1964–65.

11. Then in *Principia* the idea of the natural is extended to the metaphysical. A metaphysical property is a property that stands to some supersensible object in the same relation in which natural properties stand to natural objects. See Lewy, op. cit.

12. For reasons I explain, along with other matters germane to the sense, reference and extension (≠ reference) of predicates, in "The Sense and Reference of Predicates", *Philosophical Quarterly* 1984, I believe we should always speak in these connections not of properties but of concepts. But in this place, I concur with custom and speak of properties.

13. Op. cit. and Chapter 4 of *Needs, Values, Truth*, op. cit. (Also, ibid., Postscript § 3–4.)

14. For this use of the idea of a vindicatory explanation, see *Needs, Values, Truth,* pp. 150, 156, 354. Also see §XX below.

15. Even if isolated cases of this could be produced, the point is that they are not at all typical of normal disagreement.

16. For an attempt to say some of this, see my op. cit., p. 196 following.

17. Especially "Of the Standard of Taste", op. cit.

18. Auguste Comte Memorial Lecture 1964, London School of Economics, Athlone Press, reprinted in *Metaphysics and Common Sense* (London: Macmillan, 1969).

19. See *A Part of My Life*, index sub Thomas Love Peacock.

20. See p. 213 of Barry Stroud, "The Study of Human Nature", *Tanner Lectures on Human Values* X (1989), University of Utah, ed. G.B. Peterson.

21. If Ayer thought this, he could not so earnestly or regularly commend one particular moral and ethical position to us (namely, Utilitarianism) as he does.

22. Note the difficulty and/or ambiguity of this requirement. Strictly speaking, we *cannot* ever explain anything without taking it for granted. What we cannot take for granted is what the phenomenon is to be explained as *like*.

23. Aptly, Stroud quotes at this point (244) from page 5 of W.V. Quine's *Word and Object*, "we can investigate the world and man as part of it and thus find out what cues he could have of what goes on around him. Subtracting his cues from his world view, we get man's net contribution as the difference. This difference marks the extent of man's conceptual sovereignty".

24. Cp. W.V. Quine's reply to Morton White in *The Philosophy of W.V.Quine*, ed. Lewis E. Hahn and Paul A. Schilpp, The Library of Living Philosophers, Vol. 18 (La Salle, IL: Open Court, 1986).

25. I have tried to explore the consequences of distinguishing these distinctions in *Needs, Values, Truth*, op. cit., p. 201.

26. See my op. cit., p. 189.

27. Consider here the reality of the subject matter of mathematical thinking. Not that ethical thinking is mathematical thinking, or is in many ways like it. I simply mention mathematical thinking again as the counterexample to preconceptions imported by crasser empiricism—and as one reason why one might not think it trivial to say that "the world"and "reality" stand for the same thing. No doubt my issuing this reminder will appear to many as my announcing myself as a Platonist realist in mathematics. But insofar as I am entitled to assume any position in philosophy of mathematics, my position would be that of mathematical *objectivism,* in the first instance, this objectivism then motivating and explaining my speaking of mathematical reality. (Call that Platonism if you will.)

PART THREE

BIBLIOGRAPHY OF THE WRITINGS OF A.J. AYER

Compiled by Guida Crowley

A.J. AYER: BIBLIOGRAPHY

1930 Review of Ernest Dimnet, *The Art of Thinking* (London: Jonathan Cape; Greenwich, Conn.: Fawcett Publications), in *Oxford Outlook* 10, no. 53.

1933 "Atomic Propositions", *Analysis* 1, no. 1: 2–6.

1934 "The Genesis of Metaphysics", *Analysis* 1, no. 4: 55–58; reprinted in *Philosophy and Analysis*, ed. Margaret Macdonald (Oxford: Blackwell, 1934), chap. 2.

 "On Particulars and Universals", *Proceedings of the Aristotelian Society* 34 (1933–34), pp. 51–62.

 "Demonstration of the Impossibility of Metaphysics", *Mind* 43, no. 171: 335–45; reprinted in *A Modern Introduction to Philosophy*, ed. P. Edwards and A. Pap (Glencoe, Ill.: Free Press, 1957, 1965; London: Allen & Unwin, 1957).

1935 "Internal Relations": Symposium, *Proceedings of the Aristotelian Society (Supplementary)* 14 (1935), pp. 173–85.

 "The Criterion of Truth", *Analysis* 3, no. 2: 28–32; reprinted in *Philosophy and Analysis* (cited above [1934]), chap. 9.

 "The Analytic Movement in Contemporary British Philosophy", in *Histoire de la Logique et de la Philosophie Scientifique [Actes du Congres International de Philosophie Scientifique]* (Paris: Hermann & Cie, editeurs).

1936 *LANGUAGE, TRUTH AND LOGIC* (London: Victor Gollancz; New York: Oxford University Press, Rev. ed. 1946; Pelican Books, 1971. Trans. Dutch, Italian, Italian Braille, French, Swedish, Spanish, Japanese, Hindi).

 "The Principle of Verifiability, *Mind* 45, no. 178: 199–203.

 "The Freedom of the Will", *The Aryan Path.*

 "Concerning the Negation of Empirical Propositions", *Erkenntnis* 6: 260–63.

 "Truth by Convention": Symposium with C.H. Whiteley and M. Black, *Analysis* 4, nos. 2 and 3.

 "Learning to Talk", review of M.M. Lewis, *Infant Speech* (London: Kegan & Paul), in *Spectator* (14 August 1936).

 "Proto-Locke", review of *An Early Draft of Locke's Essays*, ed. R.R. Aaron and Jocelyn Gibbs (Oxford: Clarendon Press), in *Spectator* (21 August 1936).

 "A Sanctified Voltaire", review of Alfred Noyes, *Voltaire* (London: Sheed & Ward), in *Spectator* (11 December 1936).

1937 "Verification and Experience", *Proceedings of the Aristotelian Society* 37 (1936–37), pp. 137–56; reprinted in *LOGICAL POSITIVISM*, 1959 (see below, p. 667).

 "Does Philosophy Analyse Common-Sense?", *Proceedings of the Aristotelian Society (Supplementary)* 16 (1937), pp. 162–76.

 "New Books VII", review of Heinrich Scholz and Hermann Schweitzer, *Die sogenannten Definitionen durch Abstraktion: eine Theorie der Definitionen*

durch Bildung von Gleichheitsverwandtschaften [Forschungen zur Logistik und zur Grundlegung der exakten Wissenschaften, Heft Nr. 3] (Leipzig: F. Meinder, 1935), in *Mind* 46, no. 182: 244–47.

YOUR WESTMINSTER: political pamphlet, published by Divisional Labour Party (Westminster City Council local election [Great Marlborough Ward]).

1938 "On the Scope of Empirical Knowledge": a rejoinder to Bertrand Russell, *Erkenntnis* 7: 267–74.

1940 *THE FOUNDATIONS OF EMPIRICAL KNOWLEDGE* (London: Macmillan, 1940; St. Martin's Library edition, 1964. Trans. Arabic, Spanish).

1944 "The Concept of Freedom", *Horizon* 9, no. 52: 228–37; reprinted in *THE MEANING OF LIFE AND OTHER ESSAYS*, 1990 (see below, pp. 679–80).

1945 "The Terminology of Sense-data", *Mind* 54, no. 216: 289–312; reprinted in *PHILOSOPHICAL ESSAYS*, 1954 (see below, p. 665).

"Jean-Paul Sartre", in the series Novelist-Philosophers (no. 5), *Horizon* 12, no. 67: 12–26.

"Deistic Fallacies", *Polemic*, no. 1.

"'Secret Session'", review of English text appearing in *Horizon* of Jean-Paul Sartre's *Huis Clos*, in *Polemic,* no. 2.

1946 "Albert Camus", in the series Novelist-Philosophers (no. 8), *Horizon* 13, no. 75: 155–68.

"Freedom and Necessity", *Polemic*, no. 5; reprinted in *PHILOSOPHICAL ESSAYS*, 1954 (see below, p. 665).

"Other Minds", *Proceedings of the Aristotelian Society (Supplementary)* 20 (1946), pp. 188–97.

"Contemporary British Philosophers", broadcast on BBC Third Programme; reprinted in *The Listener* 36, no. 934 (5 December 1946).

1947 "The Claims of Philosophy", *Polemic*, no. 7; reprinted in *Reflections on Our Age* (New York: UNESCO, 1947), and in *THE MEANING OF LIFE AND OTHER ESSAYS*, 1990 (see below, p. 679).

THINKING AND MEANING: Inaugural Lecture as Grote Professor of the Philosophy of Mind and Logic in the University of London at University College London published by H.K. Lewis & Co., London, 1947.

"Phenomenalism", *Proceedings of the Aristotelian Society* 47 (1946–47), pp. 163–96; reprinted in *PHILOSOPHICAL ESSAYS*, 1954 (see below, p. 665).

1948 "The Principle of Utility" in *Jeremy Bentham and the Law*, ed. G.W. Keeton and G. Schwarzenberger (London: Stevens); reprinted in *PHILOSOPHICAL ESSAYS*, 1954 (see below, p. 665).

"Philosophy without Science", *Philosophy* 23, no. 84: 65–66.

"Portrait of a Victorian Liberal: John Stuart Mill", broadcast on BBC Third Programme; reprinted in *The Listener* 39, no. 990 (15 January 1948).

"Science and Philosophy", broadcast on BBC Third Programme; reprinted in *The Listener* 39, no. 1002 (8 April 1948).

"Some Aspects of Existentialism", *The Rationalist Annual* (London: Rationalist Press Association).

"What Can Logic Do for Philosophy?", *Proceedings of the Aristotelian Society (Supplementary)* 22 (1948), pp. 167–78.

1949 "On the Analysis of Moral Judgements", *Horizon* 20, no. 117: 171–84; reprinted in M.K. Munitz, *A Modern Introduction to Ethics* (New York: Free Press, 1949); in *Intelligenz*, and in *PHILOSOPHICAL ESSAYS*, 1954 (see below, p. 665).

"Uber die Gedankenfreiheit", *Der Monat*.

"There is No Mystery" in "A Philosophers' Symposium", with Viscount Samuel and Gilbert Ryle, broadcast as part of a series on BBC Third Programme; reprinted in *The Listener* 41, no. 1066 (30 June 1949), and included in *The Physical Basis of Mind* (Oxford: Blackwell, 1951. Trans. Italian).

"Mr Koestler's New System", review of Arthur Koestler, *Insight and Outlook* (London: Macmillan), in *New Statesman* 38, no. 960 (30 July 1949).

"Ockham's Razor and Modern Philosophy", broadcast on BBC Third Programme; reprinted in *The Listener* 42, no. 1089 (8 December 1949).

1950 "Religion and the Intellectual", *Partisan Review* [New York] 17, no. 3.

"Basic Propositions" in *Philosophical Analysis*, ed. Max Black (Ithaca: Cornell University Press); reprinted in *PHILOSOPHICAL ESSAYS*, 1954 (see below, p. 665).

"Jean-Paul Sartre's Definition of Liberty", broadcast on BBC Third Programme; reprinted in *The Listener* 44, no. 1135 (30 November 1950).

1951 "Statements about the Past": Presidential Address to the Aristotelian Society, *Proceedings of the Aristotelian Society* 52 (1951–52), pp. i–xx; reprinted in *PHILOSOPHICAL ESSAYS*, 1954 (see below, p. 665).

"On What There Is": Symposium with P.T. Geach and W.V.Quine, *Proceedings of the Aristotelian Society (Supplementary)* 25 (1951), pp. 137–48; reprinted in *PHILOSOPHICAL ESSAYS*, 1954 (see below, p. 665).

"The Philosophy of Science" in *Scientific Thought in the Twentieth Century*, ed. A.E. Heath (London: Watts, 1951).

1952 *BRITISH EMPIRICAL PHILOSOPHERS* (Locke, Berkeley, Hume, Reid and Mill), ed. with Raymond Winch (London: Routledge & Kegan Paul, 1952).

"Individuals", *Mind* 41, no. 244: 441–57; reprinted in *PHILOSOPHICAL ESSAYS*, 1954 (see below, p. 665).

"Negation", *Journal of Philosophy* 49, no. 26: 797–815; reprinted in *PHILOSOPHICAL ESSAYS*, 1954 (see below, p. 665).

1953 "Cogito Ergo Sum", *Analysis* 14, no. 2: 27–31.

"To see the world rightly", *Twentieth Century* (London).

"The Identity of Indiscernibles", *Proceedings of XIth International Congress of Philosophy* 3, pp. 124–29 (Amsterdam: North Holland Publishing Co.); reprinted in *PHILOSOPHICAL ESSAYS*, 1954 (see below, p. 665).

"L'immutabilité du passé, *Etudes Philosophiques*, no. 1: 6–15.

"One's Knowledge of Other Minds", *Theoria* 19: 1–20; reprinted in *PHILOSOPHICAL ESSAYS*, 1954 (see below, p. 665).

"Truth", *Revue Internationale de Philosophie* 7: 183–200; reprinted in *THE CONCEPT OF A PERSON AND OTHER ESSAYS*, 1963 (see below, p. 669).

1954 *PHILOSOPHICAL ESSAYS* (London: Macmillan; New York: St. Martin's Press, 1954; Papermac, 1963. Trans. Spanish).

Contents: "Individuals", "The Identity of Indiscernibles", "Negation", "The Terminology of Sense-data", "Basic Propositions", "Phenomenalism", "Statements about the Past", "One's Knowledge of Other Minds", "On What There Is", "On the Analysis of Moral Judgements", "The Principle of Utility", and "Freedom and Necessity".

Report on "*Analysis* Problem No. 5: 'Does it make sense to say that death is survived?' ", *Analysis* 14, no. 6.

"In China", *The Times* (6 October 1954).

"Impressions of Communist China", broadcast on BBC Third Programme; reprinted in *The Listener* 52, no. 1344 (2 December 1954).

"Sur la preuve en philosophie", discussion in *Revue Internationale de Philosophie* 8: 92–105 and 158–69.

"Can There Be a Private Language?", Symposium with R. Rhees, *Proceedings of the Aristotelian Society (Supplementary)* 28 (1954), pp. 63–76; reprinted in *THE CONCEPT OF A PERSON AND OTHER ESSAYS*, 1963 (see below, p. 669), and in *Philosophy of Language*, ed. A.P. Martinich (Oxford: Oxford University Press, 1985; 2nd ed., 1990).

"Beyond the Pleasure Principle", review of Michael St. John Packe, *The Life of John Stuart Mill* (London: Secker & Warburg, 1954), in *Encounter* 3, no. 1 (July 1954).

"Philosophical Perplexities", review of Gilbert Ryle, *Dilemmas* (Cambridge: Cambridge University Press, 1954) in . . .

"Philosophy at Absolute Zero: An Enquiry into the Meaning of Nihilism", *Encounter* 5, no. 4 (October 1954), and *Jamtid Ock Framted.*

1955 "What is Communication?": One of a series of lectures organized by the Communication Research Centre of University College London and first published in *Studies in Communication* (London: Secker & Warburg, 1955); reprinted in *METAPHYSICS AND COMMON SENSE*, 1969 (see below, p. 672).

1956 "What is a Law of Nature?", *Revue Internationale de Philosophie* 10: 144–65; reprinted in *THE CONCEPT OF A PERSON AND OTHER ESSAYS*, 1963 (see below, p. 669).

"The Vienna Circle", in a series of radio lectures on Philosophy broadcast by the BBC and published under the title of *The Revolution in Philosophy*, with an Introduction by Gilbert Ryle (London: Macmillan; New York: St. Martin's Press, 1956. Trans. Japanese, Swedish, Spanish, Italian).

"Philosophical Scepticism" in *Contemporary British Philosophy*, ed. H.D. Lewis [Third Series] (London: Geo. Allen & Unwin, 1956).

"The Philosophy of Bertrand Russell", *Observer*.

"Mr Wilson's Outsider", review of Colin Wilson, *The Outsider* (London: Victor Gollancz, 1956), in *Encounter* 7, no. 3 (September 1956).

"Le memoire exposé" *Bulletin de la Société Française de Philosophie* (Paris).

"A Lot of Learning", review of Aldous Huxley, *Adonis and the Alphabet and Other Essays* (London: Chatto & Windus, 1956), in *Spectator* (9 November 1956).

THE PROBLEM OF KNOWLEDGE (London: Macmillan; New York: St. Martin's Press, 1956; Penguin paperback. Trans. Spanish, Italian, Serbo-Croatian, Polish, Portuguese, Hindi).

1957 "Arithmetical Regression", review of *Ludwig Wittgenstein: Remarks on the Foundation of Mathematics*, ed. G.H. von Wright, R. Rhees, and G.E.M.

Anscombe (Oxford: Blackwell; translation from the German by G.E.M. Anscombe), in *Spectator* (8 March 1957).

"The Ghosts of Versailles and Others", broadcast on the BBC Third Programme; reprinted in *The Listener* 57, no. 1469 (23 April 1957).

"The Freedom of Genius", review of Alan Wood, *Bertrand Russell: The Passionate Sceptic* (London: Geo. Allen & Unwin, 1957), in *Spectator* (31 May 1957).

"In Defense of Reason", review of Ernest Nagel, *Logic Without Metaphysics: And Other Studies in the Philosophy of Science* (Glencoe, Ill.: Free Press, 1957), in *Encounter* 9, no. 3 (September 1957).

"Folie de Grandeur", review of Colin Wilson, *Religion and the Rebel* (London: Victor Gollancz, 1957), in *Spectator* (25 October 1957).

"Perception" in *British Philosophy in the Mid-Century*, ed. C.A. Mace (London: Geo. Allen & Unwin, 1957).

"Logical Positivism": A radio debate with Professor F.C. Coplestone, S.J., originally broadcast on BBC Third Programme in 1947 and reprinted in *A Modern Introduction to Philosophy* in 1957 (cited above as item 3 in 1934, p. 663); reprinted in *THE MEANING OF LIFE AND OTHER ESSAYS*, 1990 (see below, p. 679).

"The Concept of Probability as a Logical Relation" in *Observation and Interpretation*, ed. S. Körner [*Proceedings of the Ninth Symposium of the Colston Research Society* held at the University of Bristol] (New York: Dover).

1958 "Meaning and Intentionality", *Proceedings of XIIth International Congress of Philosophy* at Venice, vol. 1: 141–55 (Florence: G.S. Sansoni); translated as "Significacion e Intencionalidad" in *Noesis*, I:II (April-June 1960); reprinted in *METAPHYSICS AND COMMON SENSE*, 1969 (see below, p. 672).

"Philosophy and Ordinary Language", *Proceedings of the Pakistan Philosophical Congress*, vol. 5: 131–54; translated as "Philosophie et language ordinaire" in *Dialectica*.

"Biographies" of Ernst Mach and Moritz Schlick in *The New Encyclopaedia Britannica [Micropaedia*, vol. 6 and vol. 8).

"Critical Notice" of J.R. Smythies, *Analysis of Perception* (London: Routledge & Kegan Paul, 1956), in *Mind* 67, no. 268 (1958): 554–59.

"Make it Simple, Make it Quick", review of G.J. Warnock, *English Philosophy Since 1900* (Oxford: Home University Library, Oxford University Press), in *Spectator* (16 May 1958).

"Wittgenstein", review of Ludwig Wittgenstein, *The Blue and Brown Books*, and Norman Malcolm, *Ludwig Wittgenstein: A Memoir* [with a biographical sketch by G.H. von Wright] (Oxford: Oxford University Press), *in Spectator* (14 November 1958).

"Homosexuals and the Law" on the Wolfenden Report, in *New Statesman* 56, no. 1445 (22 November 1958).

1959 *LOGICAL POSITIVISM*, ed. A.J. Ayer (Glencoe, Ill.: Free Press, 1959; [n.e. Greenwood Press, 1978], London: Geo. Allen & Unwin. Trans. Spanish).

"On Scientific Method", review of Karl R. Popper, *The Logic of Scientific Discovery* (London: Hutchinson), in *Spectator* (30 January 1959).

"The Philosophy of Bertrand Russell", review of Bertrand Russell, *My Philosophical Development* (London: Geo. Allen & Unwin), in *Spectator* (15 May 1959).

"Privacy": Annual Philosophical Lecture, Henriette Hertz Trust, British Academy, *Proceedings of the British Academy* 45, and separately published by Oxford University Press; reprinted in *THE CONCEPT OF A PERSON AND*

OTHER ESSAYS, 1963 (see below, p. 669), and in *Studies in the Philosophy of Thoughts and Action*, ed. P.F. Strawson (Oxford: Oxford University Press, 1968).

"The Heart of Hampshire", review of Stuart Hampshire, *Thought and Action* (London: Chatto & Windus), in *Spectator* (21 August 1959).

"Why I shall vote Labour", *Observer* (27 September 1959).

"Critical Notice of P.F. Strawson's *Individuals*", *Indian Journal of Philosophy* (Bombay).

"Linguistic Philosophy", review of Ernest Gellner, *Words and Things* (London: Victor Gollancz, 1959), in *Spectator* (20 November 1959).

"Phenomenology and Linguistic Analysis", Symposium with Charles Taylor, *Proceedings of the Aristotelian Society (Supplementary)* 33 (1959), pp. 111–24; major part reprinted in *Perception and the External World* (USA: Colliers Books).

1960 "Russell" in *The Concise Encyclopedia of Western Philosophy and Philosophers*, ed. J.O. Urmson (London: Rainbird, 1960); n.e. ed. J.O. Urmson and Jonathan Rée (London: Unwin Hyman, 1989).

"The New Left", review of E.P. Thompson et al., *Out of Apathy* (London: Stevens), in *Spectator* (17 June 1960).

"Professor Malcolm on Dreams", *Journal of Philosophy* 57, no. 16: 517–35; reprinted in *METAPHYSICS AND COMMON SENSE*, 1969 (see below, p. 672).

"Fatalism", Lecture given to Oxford University Humanists, and Leicester and Leeds Universities and subsequently published in *THE CONCEPT OF A PERSON AND OTHER ESSAYS*, 1963 (see below, p. 669).

"Philosophy and Language": Inaugural Lecture as Wykeham Professor of Logic delivered before the University of Oxford on 3 November 1960 and published by the Clarendon Press, Oxford; reprinted in *THE CONCEPT OF A PERSON AND OTHER ESSAYS*, 1963 (see below, p. 669).

"Imiona Wlasne a Deskrypcje" ["Names and Descriptions"] in Polish journal *Studia Filozoficzne*, no. 5 (20).

1961 "The Concept of a Person": Lecture delivered to the Royal Institute of Philosophy; subsequently published in *THE CONCEPT OF A PERSON AND OTHER ESSAYS*, 1963 (see below, p. 669).

"Reply to Mr Anfinn Stigen's paper 'Descriptive Analysis and the Sceptic' on A.J. Ayer, *THE PROBLEM OF KNOWLEDGE*, 1956" (cited above), in *Inquiry* 4: 291–304.

"Rejoinder to Professor Malcolm", *Journal of Philosophy* 63, no. 11: 297–99.

"Jean-Paul Sartre", review of Philip Thody, *Jean-Paul Sartre: A Literary and Political Study* (London: Hamish Hamilton, 1961), in *Encounter* 16, no. 4 (April 1961).

Review of Ernest Nagel, *The Structure of Science* (USA: Harcourt Brace & World Inc.; London: Routledge), in *Scientific American* 204, no. 6: 197–203 (June 1961).

"On the Probability of Particular Events", *Revue Internationale de Philosophie* 15: 336–75; reprinted in *THE CONCEPT OF A PERSON AND OTHER ESSAYS*, 1963 (see below, p. 669).

"Bertrand Russell", review of *The Basic Writings of Bertrand Russell 1903–1959*, ed. Robert E. Egner and Lester E. Dennon (London: Allen & Unwin), in *Times Literary Supplement* (13 April 1961).

"Cock-a-Double-Do" [on the double win by Tottenham Hotspur: Football League Cup and Football Association Cup], in *New Statesman* 61, no. 1574 (12 May 1961).

1962 "Our Universities", *Encounter* 43, no. 1 (January 1962).

"Breaching the Dialectical Curtain—Philosophy in Russia", *Observer* (8 April 1962).

"Impressions of the Russians" [following A.J. Ayer's lectures at Moscow University], on "Radio Newsreel", BBC Light Programme; reprinted in *The Listener* 67, no. 1724 (12 April 1962).

"How a Marxist critic got an invitation to lecture in Russia", *Observer*.

"A History of Logic", review of William and Martha Kneale, *The Development of Logic* (Oxford: Oxford University Press, 1962), in *New Statesman* 63, no. 1625 (4 May 1962).

"America doesn't want war", *Daily Herald* (defunct).

"Names and Descriptions": delivered at the International Institute of Philosophy Conference, at Oxford (11–15 September 1962) and published in the 1963 *International Institute of Philosophy Proceedings:* 50–63; reprinted in *Logique et Analyse*, new series, 5, no. 20.

"The Ghost Revives", review of John Beloff, *The Existence of Mind* (London: MacGibbon & Kee), in *New Statesman* 64, no. 1646 (28 September 1962).

"Going into Europe": A Symposium, *Encounter* 19, no. 6 (December 1962).

1963 "Professor Popper's Work in Progress", *New Statesman* 65, no. 1664 (1 February 1963).

"Sacco and Vanzetti", review of Francis Russell, *Tragedy in Dedham* (London: Longman, 1963), in *New Statesman* 66, no. 1686 (5 July 1963).

"Scandals still shock", in the series "Morality 1963", *Punch* (31 July 1963).

"Impressions of Contemporary Russian Philosophy": Lecture and tape-recorded at Willesden Public Library, London.

"The Philosophy of Bertrand Russell", in *Into the Tenth Decade* (London: Geo. Allen & Unwin, 1963).

"Carnap's Treatment of Other Minds", in *The Philosophy of Rudolf Carnap*, ed. P.A. Schilpp, The Library of Living Philosophers, vol. 11 (La Salle, Ill.: Open Court; Cambridge (UK): Cambridge University Press).

"Brain, Mind and Memory" . . .

"Philosophy and Science", *Ratio* 5, no. 2; first published in Russian translation in *Voprosy Filosofii* 1962; reprinted in *METAPHYSICS AND COMMON SENSE*, 1969 (see below, p. 672).

"The Best and Worst of America", *Sunday Times* [Colour *Supplement*].

THE CONCEPT OF A PERSON AND OTHER ESSAYS (London: Macmillan; New York: St. Martin's Press; paperback, 1973. Trans. Spanish, Dutch, Italian).

 Contents:"Philosophy and Language", "Can There Be a Private Language?", "Privacy", "The Concept of a Person", "Names and Descriptions", "Truth", "Two Notes on Probability: (i) The Conception of Probability as a Logical Relation; (ii) On the Probability of Particular Events", "What Is a Law of Nature?" and "Fatalism".

"On Making Philosophy Intelligible": Guildhall Lecture, organized by the British Association for the Advancement of Science and sponsored by Granada

Television; first published by Granada Television under the title of *Communications in the Modern World—Guildhall Lecture 1963*; reprinted in *META-PHYSICS AND COMMON SENSE*, 1969 (see below, p. 672).

"The Legacy of Hume", review of *A Symposium*, ed. D.F. Pears (London: Macmillan); Richard Wollheim, [Selections] *Hume on Religion* (London: Fontana); *Objections to Humanism*, ed. H.J. Blackham (London: Constable), in *New Statesman* 66, no. 1708 (6 December 1963).

"Personal Choice" in "Best Books of the Year", *Observer* (December 1963).

1964 "Reply to Mr Gettier" on *Personal Identity* (USA: Wayne State University Press).

"Man as a Subject for Science": The August Comte Memorial Lecture for 1964, delivered at the London School of Economics and Political Science on 7 February, 1964, under the auspices of the August Comte Memorial Lectureship Trust, and published by the Athlone Press, London; reprinted in *METAPHYSICS AND COMMON SENSE*, 1969 (see below, p. 672).

"Mr Wilson's Programme", review of Harold Wilson, *Purpose in Politics* (London: Weidenfeld & Nicolson), in *New Statesman* 67, no. 1724 (27 March 1964).

"Freedom and Happiness", *New Statesman* 68, no. 1749 (18 September 1964).

"My Philosophical Position", "Perception" and "Contemporary British Philosophy": [Russian University of the Air—BBC].

"Knowledge, Belief and Evidence": first published in the *Danish Yearbook of Philosophy*, vol. 1 (Copenhagen: Munksgaard, 1964), in a number dedicated to Professor Jørgen Jørgensen; reprinted in *METAPHYSICS AND COMMON SENSE*, 1969 (see below, p. 672).

"Personal Choice" in "Best Books of the Year", *Observer* (December 1964).

1965 "Philosophy and Politics": The Eleanor Rathbone Memorial Lecture for 1965, delivered at the University of Bristol, under the auspices of the Trustees of the Eleanor Rathbone Memorial Fund, and published by the Liverpool University Press in 1967; reprinted in *METAPHYSICS AND COMMON SENSE*, 1969 (see below, p. 672).

Review, E. Gellner, *Thought and Change* (London: Victor Gollancz, 1965), in *Sunday Times*.

"Chance", *Scientific American* 213, no. 4: 44–54 (October 1965); reprinted in *METAPHYSICS AND COMMON SENSE*, 1969 (see below, p. 672).

"Reflections on Hiroshima" . . .

"Labour's First Year: A Review of the Government's Record" [Comments by A.J. Ayer et al.] in the *New Statesman* 70, no. 1805 (15 October 1965).

"The Relevance of Humanism": one of a series of interviews conducted by Kenneth Harris on the BBC Home Service; published in *The Listener* 74, no. 1908 (21 October 1965); reprinted in *An Inquiry into Humanism*, ed. Kenneth Harris (London: BBC Publications, 1966).

"The Making of a Logical Positivist", broadcast on the BBC Third Programme, and published in *The Listener* 74, no. 1910 (4 November 1965).

"Personal Choice" in "Best Books of the Year", *Observer* (December 1965).

1966 "New Books": review of Niels Egmont Christensen, *On the Nature of Meanings* (Copenhagen: Munksgaard), in *Mind* 75, no. 299: 444–47.

"Metaphysics and Common Sense" in *Metaphysics*, ed. W. Kennick and Morris Lazerowitz (Englewood Cliffs, N.J.: Prentice-Hall); reprinted in *META-PHYSICS AND COMMON SENSE*, 1969 (see below, p. 672).

"Humanism and Reform", *Encounter* 26, no. 6 (6 June 1966).

"What I Believe" in *What I Believe*, ed. George Unwin (London: Geo. Allen & Unwin, 1966).

"The Relevance of Humanism: An Inquiry into Humanism" (BBC publications).

"Personal Choice" in "Best Books of the Year", *Observer* (December 1966).

1967 "An Appraisal of Bertrand Russell's Philosophy" in *Bertrand Russell, Philosopher of the Century*, ed. Ralph Schoenman (London: Geo. Allen & Unwin, 1967); reprinted in *METAPHYSICS AND COMMON SENSE*, 1969 (see below, p. 672).

"Scientific Thought", review of P.B. Medawar, *The Art of the Soluble* (London: Methuen, 1967), in the *New Statesman* 73, no. 1875 (17 February 1967).

"Reflections on Existentialism": Presidential Address to the Modern Language Association in 1966, and first published in *Modern Languages* 48, no. 1 (1967); reprinted in *METAPHYSICS AND COMMON SENSE* (see below, p. 672).

"Bertrand Russell", review of Bertrand Russell, *The Autobiography of Bertrand Russell 1872–1914* (London: George Allen & Unwin, 1967) , BBC Third Programme.

"Has Austin Refuted the Sense-datum Theory?", *Synthèse* 18: 117–40; reprinted in *METAPHYSICS AND COMMON SENSE*, 1969 (see below, p. 672).

"What are Philosophers for?", interview with Robert Kee and Olivier Todd on BBC Home Service, published in *The Listener* 78, no. 2005 (31 August 1967).

"Induction and the Calculus of Probabilities": delivered at the International Institute of Philosophy Conference at Liège (4–9 September 1967) and published in the *International Institute of Philosophy Proceedings* (1968): 95–104.

"Philosophy as Elucidating Concepts", "Philosophy and Conceptual Systems" and "Berkeleianism and Physicalism": Three lectures delivered at the University of Notre Dame, Indiana, in 1967, and published in *The Nature of Philosophical Inquiry*, ed. Joseph Bobik (Notre Dame: Notre Dame University Press, 1970); reprinted in *THE MEANING OF LIFE AND OTHER ESSAYS*, 1990 (see below, p. 672).

"Personal Choice" in "Best Books of the Year", *Observer* (December 1967) .

1968 "Prejudice", *T.V. Times* (January 1968).

"Solidarity": BBC Russian Service. [Broadcast of the Statements addressed to Larissa Daniel/Pavel Litvinov made by A.J. Ayer et al. in a telegram sent by Stephen Spender], published in *The Listener* 79, no. 2026 (25 January 1968).

"Do you believe in God?", *Western Mail* (9 April 1968).

"On What There Is": Lecture delivered before the Israel Academy of Sciences and Humanities in the Spring of 1968, and published in their *Proceedings* 111, no. 8, 1969; reprinted in *METAPHYSICS AND COMMON SENSE*, 1969 (see below, p. 672) under the title "What Must There Be".

"Why I do not believe in God", *Observer*.

"Bertrand Russell in his Prime", review of Bertrand Russell, *The Autobiography of Bertrand Russell 1914–1944* (London: George Allen & Unwin, 1968), in *Spectator* (10 May 1968).

"Mind and Matter", review of D.M. Armstrong, *A Materialist Theory of Mind* (London: Routledge, 1968), in *New Statesman* 75, no. 1934 (5 April 1968).

"G.E. Moore on Propositions and Facts" in *G.E. Moore: Essays in Retrospect*, ed. M. Lazerowitz and A. Ambrose (London: George Allen & Unwin, 1968).

"Doing Justice to Bentham", review of *Correspondence of Jeremy Bentham*, ed. Timothy L.S. Sprigge, vol. 1: 1752–1776 and vol. 2: 1777–1780 (London: Athlone Press, 1968), in *Observer* (25 February 1968).

"Philosophy and Scientific Method": delivered at the XIVth International Congress of Philosophy at Vienna (2–9 September 1968), and published in their *Proceedings*: 536–42.

"Sartre on the Jews", review of Jean-Paul Sartre (translated by G.J. Becher), *Anti-Semite and Jew* (New York: Schocken Books); and Paul Nizan (translated by Joan Pinkham), *Aden-Arabie* (Monthly Review Press), in *Spectator* (20 September 1968).

"Rebels and Morals": Five articles published as a series in *Evening Standard* [London] (23–27 September 1968).

THE HUMANIST OUTLOOK (London: Pemberton with Barrie & Rockliff, 1968), edited and introduced by A.J. Ayer; "Introduction" reprinted in *THE MEANING OF LIFE AND OTHER ESSAYS*, 1990 (see below, pp. 679–80).

THE ORIGINS OF PRAGMATISM (London: Macmillan; San Francisco: Freeman Cooper & Company, 1968).

"Personal Choice" in "Best Books of the Year", *Observer* (December 1968).

1969　"An Honest Ghost": *Festschrift* in Honour of Professor Gilbert Ryle; *Ryle: A Collection of Critical Essays*, ed. Oscar P. Wood and George Pitcher (New York: Doubleday).

"Qu'est-ce que la communication?", *Revue Internationale de Philosophie* 25: 385–403.

METAPHYSICS AND COMMON SENSE (London: Macmillan; San Francisco: Freeman Cooper & Company, 1969).

> *Contents*: "On Making Philosophy Intelligible", "What is Communication?", "Meaning and Intentionality", "What Must There Be?", "Metaphysics and Common Sense", "Philosophy and Science", "Chance", "Knowledge, Belief and Evidence", "Has Austin Refuted the Sense-datum Theory?", "Professor Malcolm on Dreams", "An Appraisal of Bertrand Russell's Philosophy", "G.E. Moore on Propositions and Facts", "Reflections on Existentialism", "Man as a Subject for Science" and "Philosophy and Politics".

"An Evening with A.J. Ayer", televised on BBC 2; "*The Autobiography of Bertrand Russell, 1944–1967*" radio discussion with Bryan Magee on BBC Third Programme (both programmes quoted at length in *The Listener* 81, no. 2098 (12 June 1969).

"Personal Choice" in "Best Books of the Year", *Observer* (December 1969).

1970　"William James Lectures": Delivered at Harvard University, Cambridge, Mass., in 1970 on which *RUSSELL AND MOORE: THE ANALYTICAL HERITAGE*, 1971, was based (see below, p. 673).

"John Dewey Lectures": Delivered at Columbia University, New York, in 1970 on which *PROBABILITY AND EVIDENCE*, 1972 was based (see below, p. 673).

"Russell the Philosopher", *New Statesman* 79, no. 1934 (6 February 1970).

"Comments on Professor Bernard Williams's 'Knowledge and Reasons' " at the International Institute of Philosophy Congress at Helsinki (24–27 August

1970) and published in *International Institute of Philosophy Proceedings:* 12–16.

"Has Harrod Answered Hume?": *Festschrift* in Honour of Sir Roy Harrod; *Induction, Growth and Trade*, ed. W.A. Eltis, M.FG. Scott, and J.N. Wolfe (Oxford: Clarendon Press).

"Pragmatism and Logic", review of W.V. Quine, *Philosophy of Logic* (Englewood Cliffs, N.J: Prentice-Hall, 1970), and *Ontological Relativity and Other Essays* (New York: Columbia University Press, 1970), in *Times Literary Supplement* (9 October 1970).

"A Philosopher's Progress": conversation with Bryan Magee in the 13-part series "Conversations with Philosophers", broadcast on BBC Radio 3 in the winter of 1970–71; reprinted in *The Listener*, vol. 84, no. 2179 (31 December 1970); subsequently in *Modern British Philosophy,* ed. Bryan Magee (London: Secker & Warburg; Paladin paperback, 1973).

"Personal Choice" in "Best Books of the Year", *Observer* (December 1970) .

1971 *RUSSELL AND MOORE: THE ANALYTICAL HERITAGE* (London: Macmillan; Cambridge, Mass: Harvard University Press, 1971). Trans. Spanish (Ariel).

"Le Problème de la confirmation", *Revue Internationale de Philosophie* 25: 1–31.

"The Glass is on the Table": Discussion between A.J. Ayer and Arne Naess, with Mr Fons Elders as interviewer, broadcast in English on Dutch Television, and subsequently published in *Reflexive Water: The Basic Concerns of Mankind*, ed. Fons Elders (London: Souvenir Press, 1974); reprinted in *THE MEANING OF LIFE AND OTHER ESSAYS*, 1990 (see below, pp. 679–80).

"Marketeering": Contribution to "Views on the UK's joining the E.E.C. [European Economic Community]" in *The Listener* 86, no. 2221 (21 October 1971).

"Personal Choice" in "Best Books of the Year", *Observer* (December 1971).

1972 *PROBABILITY AND EVIDENCE* (London: Macmillan; New York: Columbia University Press, 1972; paperback, 1979).

"Bertrand Russell", *Evening Standard* [London].

"Bertrand Russell as a Philosopher": British Academy Master Mind Lecture for 1972; published in *Proceedings of the British Academy* 58 (London: Oxford University Press).

RUSSELL (London: Fontana; New York: Viking Press, 1972). (Under the title *BERTRAND RUSSELL* [Chicago: University of Chicago Press, 1988]). Trans. Italian (forthcoming).

"Football crazy", review of Hunter Davies, *The Glory Game* (London: Weidenfeld & Nicolson, 1972), and Deryk Brown, *The Arsenal Story* (London: Arthur Baker, 1972), in *Sunday Times* (29 October 1972).

"The Gifford Lectures": Delivered at the University of St Andrews, Scotland, 1972–73; subsequently published as *THE CENTRAL QUESTIONS OF PHILOSOPHY*, 1973 (see below, p. 674).

1973 "Bertrand Russell as a Philosopher", review of Ronald Jager, *The Development of Bertrand Russell's Philosophy* (London: Allen & Unwin, 1973), in *Times Literary Supplement* (23 March 1973).

"Wittgenstein on Certainty": Royal Institute of Philosophy Lecture, subsequently published in vol. 7 of "The Royal Institute of Philosophy Lectures 1972–73", under the title *Understanding Wittgenstein* (London: Macmillan), with Foreword by Godfrey Vesey.

"The Claims of Theology" [excerpt from *THE CENTRAL QUESTIONS OF PHILOSOPHY*, 1973, broadcast on the BBC Third Programme; reprinted in *The Listener* 90, no. 2315 (9 August 1973).

"Two Debatable Points—'Body and Mind' and 'Extra Sensory Perception'", broadcast on the BBC Third Programme and published in *The Listener* 90, no. 2316 (20 September 1973).

"Reflections on the Varna Congress". *International Institute of Philosophy Proceedings.*

"Quinton's Case for Materialism", review of A.N. Quinton, *The Nature of Things* (London: Routledge, 1973), in *Encounter* 41, no. 5 (December 1973).

"Dummett on Frege", review of Michael Dummett, *Philosophy of Language* (London: Duckworth, 1973), in *The Listener* 90, no. 2333 (13 December 1973).

"On a Supposed Antinomy", *Mind* 82, no. 325: 125–26; reprinted in *FREEDOM AND MORALITY AND OTHER ESSAYS*, 1984 (see below, p. 667).

THE CENTRAL QUESTIONS OF PHILOSOPHY (London: Weidenfeld & Nicolson; New York: Holt Rinehart & Winston Inc., 1973; Penguin Books, 1974. Trans. Dutch, Hindi, French, Portuguese, Spanish, Italian, Japanese, German).

"Personal Choice" in "Best Books of the Year", *Observer* (December 1973).

1974 "Morality, Perception and Existence", review of Professor P.F. Strawson, *Freedom and Resentment and Other Essays* (London: Methuen, 1974), in *New Statesman* 88, no. 2261 (19 July 1974).

"Wittgenstein, the School Master", review of W. Warren Bartley III, *Wittgenstein* (USA: Lippincott Co., 1973: London: Quartet Books, 1974), in . . .

"Shooting Arrows into the Air". Discussion on the "Function of Religious Broadcasting", broadcast on BBC Radio 3 and published in *The Listener* 92, no. 2370 (29 August 1974).

"Truth, Verification and Verisimilitude" in *The Philosophy of Sir Karl Popper*, ed. P.A. Schilpp, vol. 14 in The Library of Living Philosophers (La Salle, Ill.: Open Court; Cambridge: Cambridge University Press, 1974).

"Viewpoint" [original title "Immortality"], leading article on W.H. Mallock's *The New Republic*, Philip Toynbee and Maurice Richardson's *Thanatos* and Hyam Maccoby's *Revolution in Judaea*, in *Times Literary Supplement* (8 March 1974).

"Personal Choice" in "Best Books of the Year" *Observer* (December 1974).

1975 "Nineteenth and Twentieth Century French Philosophy", review of Professor Frederick Copleston, S.J., *A History of Philosophy, vol. 9, Maine de Biran to Sartre* (Tunbridge Wells: Search Press), and Joseph Chiari, *Twentieth Century French Thought from Bergson to Levi-Strauss* (Paris: Paul Elek), in . . .

"Self Evidence" in *Phenomenology and Philosophical Understanding*, ed. E. Pivcevic (Cambridge: Cambridge University Press, 1975).

"Maurice", review of *Maurice Bowra—A Celebration*, ed. Hugh Lloyd-Jones (London: Duckworth) in *London Magazine* (April/May, 1975, pp. 101–4).

"Pyrrhonic Victory", review of Peter Unger, *Ignorance: A Case for Scepticism* (Oxford: Clarendon/Oxford University Press), in *Times Literary Supplement* (5 September 1975).

"The Referendum Choice" [On the UK remaining in the E.E.C.], in *New Statesman* 89, no. 2306 (30 May 1975).

"Identity and Reference", *Philosophia* 5, no. 3: reprinted in *Language in Focus: In Honour of Y. Bar Hillel*, ed. A. Kasher (Dordrecht: Reidel, 1975).

"Philosophy" in *The Owl of Minerva: Philosophers on Philosophy*, ed. Charles J. Bontemps and S. Jack Odell (USA: McGraw-Hill, 1975); reprinted in *THE MEANING OF LIFE AND OTHER ESSAYS* (see below, pp. 679–80).

"Personal Choice" in "Best Books of the Year", *Observer* (December 1975).

1976 "The Early Novels" in *Malraux: Life and Work*, ed. Martine de Courcel (London: Weidenfeld & Nicolson).

"Personal Choice" in "Best Books of the Year", *Observer* (December 1976).

1977 *PART OF MY LIFE* (London: Collins, 1977; paperback, Oxford: Oxford University Press, 1978).

"The Causal Theory of Perception": Symposium with Dr L.J. Cohen at the Joint Session of the Mind Association and the Aristotelian Society 1977; published in Proceedings of the Aristotelian Society (Supplementary) 51, pp. 105–27; reprinted in *FREEDOM AND MORALITY AND OTHER ESSAYS*, 1984 (see below, p. 677).

"Learn All About It", review of Christopher Booker, *The Booker Quiz* (London: BBC Publications with Routledge, 1976), in *Spectator* (15 January 1977).

"Personal Choice" in "Best Books of the Year", *Observer* (December 1977).

1978 "Introduction to William James" in William James, *Pragmatism and Meaning of Truth* (Cambridge, Mass: Harvard University Press, paperback, 1978).

"Logical Positivism and its Legacy": one of a series of 15 dialogues televised on BBC 2 and published in *Men of Ideas*, ed. Bryan Magee (London: BBC Publications, 1978).

"Oxford—Revival of Oxford Philosophy", *Guardian Weekend* (1 July 1978).

"Analytical Philosophy": delivered at a Philosophical Congress at Düsseldorf in 1978; published in *Proceedings*.

"Personal Choice" in "Best Books of the Year", *Observer* (December 1978).

1979 "Meaning and Truth", review of Michael Dummett, *Truth and Enigmas* (London: Duckworth, 1979), in . . .

"Weight of Evidence", review of J.L. Cohen, *The Possible and the Probable* (Oxford: Clarendon/Oxford University Press, 1979) in *Books and Bookmen* (now defunct).

"Mind and Body" ("Geist und Körper") in *Seele und Leib: Geist und Materie* (Berne: Peter Land, 1979).

"Labour's Lost Leader", review of Philip Williams, *Hugh Gaitskell* (London: Cape, 1979) in *London Review of Books* (23 November 1979).

" 'Le Penseur': Thinking about Thinking", review of Konstantin Kolenda, *On Thinking* (Oxford: Blackwell, 1979), with an introduction by Professor Gilbert Ryle, in *Encounter* 53, no. 6. (December 1979).

PERCEPTION AND IDENTITY: Essays presented to A.J. AYER with his Replies to them (London: Macmillan, 1979). *Contributors:* Michael Dummett, P.F. Strawson, David Pears, D.M. Armstrong, Charles Taylor, J.L. Mackie, David Wiggins, John Foster, Richard Wollheim, Peter Unger, Bernard Williams, and Stephan Körner.

"Hume": The Four Gilbert Ryle Lectures delivered at Trent University, Ontario,

sponsored by the Machette Foundation and the Victoria and Grey Trust Company, and subsequently published, with an additional biographical chapter, as *HUME*, 1980 (see below).

"Personal Choice" in "Best Books of the Year", *Observer* (December 1979).

1980 "Free Will and Rationality": *Festschrift* in Honour of Sir Peter Strawson; *Philosophical Subjects*, ed. Z. van Straaten (Oxford: Clarendon, 1980).

"A Meeting of Minds", review of Randall Collins, *The Case of the Philosopher"s Ring* (London: Harvester Press), in *Times Literary Supplement* (3 October 1980).

HUME, Past Masters Series (Oxford: Oxford University Press; New York: Hill & Wang, 1980; reprinted 1986. Trans. Spanish, 1988).

"Personal Choice" in "Best Books of the Year", *Observer* (December 1980).

1981 "Goronwy Rees: A Memoir", *Encounter* 56, no. 1 (January 1981).

"The Vienna Circle": Lecture delivered to the Wittgenstein Congress in Kirchberg, Austria, in 1981 and published in *Rationality and Science*, ed. E.T. Gadol (Vienna: Springer Verlag, 1982) to commemorate the centenary of the birth of Moritz Schlick; reprinted in *FREEDOM AND MORALITY AND OTHER ESSAYS*, 1984 (see below, p. 677).

"What is What?", review of David Wiggins, *Sameness and Substance* (Oxford: Blackwell, 1981) in *London Review of Books* (22 January 1981).

"Saving the Appearances", review of Bas Van Fraassen, *The Scientific Image* (Oxford: Oxford University Press, 1981), in *London Review of Books* (19 March 1981).

"Cause and Effect", review of Tom Beauchamp and Alexander Rosenberg, *Hume and the Problem of Causation* (Oxford: Oxford University Press, 1981), and Knud Haakonssen, *The Science of a Legislator* (Cambridge: Cambridge University Press, 1981), in *London Review of Books* (15 November 1981).

PHILOSOPHY IN THE TWENTIETH CENTURY (London: Weidenfeld & Nicolson, 1981; New York: Random House, 1982; paperback, London: Allen & Unwin; New York: Vintage Books, 1984. Trans. Dutch, Japanese, French, Spanish, Italian).

"A Controversial Murder Case", *Times Higher Educational Supplement* (6 November 1981).

1982 "Past, Present and Future", review of G.E.M. Anscombe, *Collected Philosophical Papers:* vols. I–III (Oxford: Blackwell), in *London Review of Books* (21 January 1982).

"Philosophical Enlightenment" review of Anthony Quinton, *Thoughts and Thinkers* (London: Duckworth, 1982), in *Spectator* (6 February 1982).

"Koestlerkampf", review of Iain Hamilton, *Koestler* (London: Secker & Warburg, 1982), in *London Review of Books* (20 May 1982).

"Contemporary Problems in Philosophy", *Medical Journal* (London: BMA).

"Personal Choice" in "Best Books of the Year", *Observer* (December 1982) .

1983 "My Reasons for Becoming President of the new *Society of Applied Philosophy"*, *Sunday Times* (26 June 1983).

"Freedom and Morality": The Whidden Lectures delivered at McMaster University, Hamilton, Ontario, 18–29 October 1983; reprinted in *FREEDOM AND MORALITY AND OTHER ESSAYS*, 1984 (see below, p. 677).

"Diary", *London Review of Books* (22 December 1983).

"Personal Choice" in "Best Books of the Year", *Observer* (December 1983).

1984 "Untangling the Law", review of H.L.A. Hart, *Essays in Jurisprudence and Philosophy* (Oxford: Oxford University Press, 1984), in *The Listener* 111, no. 2839 (5 January 1984).

"Let Us Calculate", review of J. David Bolter, *Turing's Man: Western Culture in the Computer Age* (USA: North Carolina University Press) in *New York Review of Books* 31, no. 3, (1 March 1984).

"A Theory of Meaning", review of Donald Davidson, *Inquiries into Truth and Interpretation* (Oxford: Oxford University Press, 1984), in *Times Educational Supplement* (May 1984).

"Russell": Panel discussion at a Conference on Russell's early technical philosophy held at the University of Toronto in June 1984; *Proceedings* reprinted in *Russell: The Journal of the Bertrand Russell Archives*, ed. Kenneth Blackwell and Ian Winchester.

"Philip Toynbee—Charmer", review of Jessica Mitford, *Faces of Philip: A Memoir of Philip Toynbee* (London: Heinemann, 1984), in *The Listener* 112, no. 2866 (12 July 1984).

MORE OF MY LIFE (London: Collins; paperback, Oxford: Oxford University Press, 1985).

"The Foundations of Ethics", review of Derek Parfit, *Reasons and Persons* (Oxford: Oxford University Press) and Jennifer Trusted, *Free Will and Responsibility* (Oxford: Oxford University Press), in *The New Humanist* 99, no. 2 (Autumn 1984).

"The Sources of Evil", review of Mary Midgeley, *Wickedness: A Philosophical Essay* (London: Routledge & Kegan Paul, 1984), in *The Listener* (13 September 1984).

FREEDOM AND MORALITY AND OTHER ESSAYS (Oxford: Clarendon Press, 1984; New York: Oxford University Press. Trans. Italian (Edit. Pratiche— forthcoming in 1991).

> *Contents:* "Freedom and Morality", "On Causal Priority", "The Causal Theory of Perception", "On a Supposed Antinomy", "Identity and Reference", "Self-Evidence", "Wittgenstein on Certainty", "An Honest Ghost?" and "The Vienna Circle".

"The Scope of Reason": Delivered at the International Institute of Philosophy Congress at Magdalen College, Oxford, (3–8 September 1984) and published in the *International Institute of Philosophy Proceedings* 1985: 265–77.

"Russell's Logicism", review of C.W. Kilmister, *Philosophers in Context* (USA: Harvester Press, 1984), in . . .

"Spy Myths", review of Nigel West, *Unreliable Witness* (London: Weidenfeld & Nicolson, 1984), in *The Listener* 112, no. 2879 (11 October 1984).

"Incompetent Intelligence" [original title "Quis Custodiet?"] review of Chapman Pincher, *Too Secret Too Long* (London: Sidgwick & Jackson, 1984), and Nicholas Bethel, *The Great Betrayal* (London: Hodder & Stroughton, 1984), in *The Listener* 112, no. 2885 (22 November 1984).

Review of *Theory of Knowledge: The 1913 Manuscript—Bertrand Russell*, ed. Elizabeth Ramsden Eames and Kenneth Blackwell (London: Allen & Unwin) in *Times Literary Supplement* (7 December 1984).

"Tribute to Graham Greene", *Sunday Times* (6 September 1984).

"Russell: The Theory of Descriptions, Names, and Reality" from *RUSSELL AND MOORE: THE ANALYTICAL HERITAGE* (see under 1971), pp. 10–17 and 28–47 with excisions, in *Philosophy Through Its Past*, ed. Ted Honderich (London: Pelican Books, 1984).

1985 "What is Christianity?", review of A.N. Wilson, *How Can We Know?* (London: Hamish Hamilton, 1985), in *Sunday Times*.

"Morality is Hard" [original title "Ethics Without Morality"], review of Bernard Williams, *Ethics and the Limits of Philosophy* (London: Collins/Fontana, 1985), in *The Listener* 113, no. 2904 (11 April 1985).

"Sources of Intolerance": Delivered at the University of York on 10 May 1985, as one of the J.B. and W.B. Morrell Memorial Addresses on Toleration, sponsored by the C. and J.B. Morrell Trust; subsequently published in *On Toleration*, ed. Susan Mendus and David Edwards (Oxford: Clarendon Press, 1987. Trans. Italian, forthcoming).

"In Piam Memoriam", review of Victor Lowe, *Alfred Whitehead: The Man and His Work*, vol. 1, 1861–1910 (Baltimore: Johns Hopkins University Press, 1985), in *London Review of Books* (20 June 1985).

"Comments on Works of Fiction deserving to be better known", *Times Literary Supplement* (18 October 1985).

WITTGENSTEIN (London: Weidenfeld & Nicolson; New York: Random House; Penguin Books. Trans. Japanese, French, Italian, Spanish).

1986 "Sex in the Head" [original title "Love and Lust"), review of Roger Scruton, *Sexual Desire* (London: Weidenfeld & Nicolson, 1986), in *Observer* (2 March 1986).

"Music and Immunity", review of Peter Medawar, *Memoir of a Thinking Radish: An Autobiography* (Oxford: Oxford University Press, 1986), in *The Listener* 115, no. 1954 (3 April 1986).

"World Cup", *London Review of Books* (24 July 1986).

"The Will To Believe", review of Gerald F. Meyers, *William James: His Life and Thought* (USA: Yale University Press, 1986), and Graham Bird, *William James* (London: Routledge, 1986) in *Sunday Times* (23 November 1986).

VOLTAIRE (London: Weidenfeld & Nicolson; New York: Random House, 1986; Faber and Faber, paperback, 1988. Trans. Italian, Spanish, Japanese, German).

"Personal Choice" in "Books Most Enjoyed", *Sunday Times* (7 December 1986).

1987 "A Grievance with the Guru" [original title "The Phenomenon of Sartre], a review of Annie Cohen-Solal, *Sartre: A Life* (Paris: Gallimard, 1985); [translated by Anna Cancogni], in *Sunday Times* (25 October 1987).

"Introduction" to J.S. Mill, *The Logic of the Moral Sciences* [Book VI of *A System of Logic*] (London: Duckworth, 1987; reprint of the eighth edition of 1872); reprinted in *THE MEANING OF LIFE AND OTHER ESSAYS*, 1990 (see below, pp. 679–80).

"Frege, Russell and Modern Logic": A BBC television series of dialogues, published in *The Great Philosophers*, ed. Bryan Magee (London: BBC Publications, 1987).

1988 "Owning Up", review of David Berman, *A History of Atheism in Britain: From Hobbes to Russell* (London: Croom Helm, 1988), in the *New Humanist* 103, no. 1 (Spring 1988).

"My Week", *Independent* (4 February 1988).

"Empiricism": Inaugural Lazerowitz Lecture delivered at Smith College, Northampton, USA (publication forthcoming).

THOMAS PAINE (London: Secker & Warburg; New York: Atheneum, 1988; Faber and Faber, paperback, 1989).

"Psychoneural Pairs", review of Ted Honderich, *A Theory of Determinism: The Mind, Neuroscience and Life-Hopes* (Oxford: Oxford University Press, 1988), in *London Review of Books* (19 May 1988).

"The Meaning of Life": 64th Conway Memorial Lecture delivered at the Conway Hall, London, and published under that title by the South Place Ethical Society on 19 May 1988; reprinted in *THE MEANING OF LIFE AND OTHER ESSAYS*, 1990 (see below, pp. 679–80).

FOLLOWING A.J.A.'S SERIOUS ILLNESS IN EARLY SUMMER 1988

"The Other Side", letter to the *Spectator* (30 July 1988), reply to comments made by Mr Peregrine Worsthorne's "Diary" column in a previous issue (16 July 1988).

"In Defence of Empiricism": Concluding Paper (read *in absentia* by Professor A.P. Griffiths) at the XVIIIth World Congress of Philosophy at Brighton on 27 August 1988; [publication forthcoming in *Proceedings*]. Trans. Polish (forthcoming).

"What I saw when I was dead", Sunday *Telegraph* (28 August 1988); reprinted in a slightly revised version under the title of "That Undiscovered Country" in *THE MEANING OF LIFE AND OTHER ESSAYS*, 1990 (see below, pp. 679–80).

"Professor Ayer defends Bertrand Russell", long letter to the Sunday *Telegraph* (4 September 1988), on the first extract published in that newspaper of Paul Johnson, *Intellectuals* (London: Weidenfeld & Nicolson, 1988).

"Postscript to a Postmortem", *Spectator* (15 October 1988); reprinted in *THE MEANING OF LIFE AND OTHER ESSAYS*, 1990 (see below, pp. 679–80).

"Unspiritual Ayer", letter to the *Spectator* (12 November 1988), in reply to one from Professor Anthony Flew published in previous issue.

"Personal Choice" in "Books Most Enjoyed", in *Sunday Times* (27 November 1988) .

1989 "Someone Might Go into the Past", comment on Stephen Hawking, *A Brief History of Time: From the Big Bang to Black Holes* (London: Bantam Books, 1988), in *London Review of Books* (5 January 1989).

"Bertrand Russell" in *Philosophy Catalogue*, ed. Ray Monk (London: Waterstone, 1989).

N.B. A.J.A. ADMITTED TO UNIVERSITY COLLEGE HOSPITAL ON 24 MAY 89: DIED 27 JUNE 89

"Thoughts on the French Revolution", *Spectator* [posthumously] (8 July 1989).

"Albert Einstein", *Independent Magazine* [posthumously] (2 September 1989).

THE MEANING OF LIFE AND OTHER ESSAYS [posthumously] (London:

Weidenfeld & Nicolson; New York: Scribner's [under the title, *The Meaning of Life*]. Trans. Serbo-Croatian, forthcoming in 1991).

Contents: Introduction by Ted Honderich, "The Claims of Philosophy", "Logical Positivism—a Debate", "Philosophy", "The Nature of Philosophical Inquiry: a) Philosophy as Elucidating Concepts; b) Philosophy and Conceptual Systems; c) Berkeleianism and Physicalism","The Glass is on the Table—a Discussion", "The Concept of Freedom", "J.S. Mill", "Bertrand Russell as a Philosopher", "The Humanist Outlook", "The Meaning of Life", "That Undiscovered Country", "Postscript to a Postmortem".

1991 "Free Will and Determinism": *Festschrift* in Honour of Professor D.J. O'Connor; *Logical Foundations*, ed. Indira Mahalingam Carr and Brian Carr (London: Macmillan, 1991).

LETTERS TO THE PRESS

Frequent and too many to cite—published *inter alia* in:

The Times and *Sunday Times*
Times Literary Supplement
Times Educational Supplement
Times Higher Educational Supplement
Spectator
London Review of Books

The subject matter ranged widely: Jewish refugees, political prisoners, immigration, state of universities, education, government policies, philosophical points, and so on.

INDEX

(by S.S. Rama Rao Pappu)